BERTHE MORISOT

THE FIRST LADY OF IMPRESSIONISM

To

RALPH GIBSON

1943–95

Reader in French History
Lancaster University

A distinguished scholar and a good friend

BERTHE MORISOT

THE FIRST LADY OF IMPRESSIONISM

Margaret Shennan

SUTTON PUBLISHING

First published in 1996 by
Sutton Publishing Limited · Phoenix Mill
Thrupp · Stroud · Gloucestershire · GL5 2BU

British Library Cataloguing in Publication Data
A catalogue record for this book is available from the British Library

ISBN 0 7509 1226 X

ALAN SUTTON™ and SUTTON™ are the
trade marks of Sutton Publishing Limited

Typeset in 10/13pt New Baskerville
Typesetting and origination by
Sutton Publishing Limited
Printed in Great Britain by
Butler & Tanner, Frome, Somerset

Contents

Foreword

Sigmund Freud suggested that 'the public's real interest in art lies not in art itself, but in the image it has of the artist as a "great man"'. This confusion between the meaning of art and the significance of the artist as a model or ideal began with art history itself, with Giorgio Vasari's many-volumed *Vite*, that is his *Lives of the Most Excellent Painters, Sculptors and Architects*, first published in 1550 in Florence and enlarged in 1558. Initially modelled on the hagiographic tradition celebrating the lives of the saints, artistic biography was shaped by the varying contemporary influences of the period in which it was written. In the nineteenth century Romanticism and its offspring fostered the modern interest in what we would nowadays recognize as personality and the inner life, suggesting that art is a reflection of the person who produces it.

From this perspective, artists are entirely different from the rest of us by virtue of expressing their artist-selves – their genius – in an aesthetic form, while the artist also offers ordinary mortal beings some insight into the general characteristics of humanity, ensuring that their work is endowed with a universal humanist value. Freud's writings on biography addressed those he called the 'connoisseurs', those who imagined themselves specially sensitive to artists and to the interpretation of art, and who, at the end of the nineteenth century, in the process of writing new biographies of the major artists who would form the modern Western canon, Leonardo, Caravaggio and Titian, were creating artists as idealized figures. The idea of the artist produced in these new art historical biographies was, according to Freud, the product of ambivalent feelings. On the one hand, he detected a religious attitude akin to infantile idealization of the father, and on the other he noted narcissistic gratification for the writer who identified with the heroic projection of the great artist, the supreme individual, making his own mark, often against the grain of his society. Thus Freud wrote in his own study of Leonardo da Vinci:

> Biographers are fixated on their heroes in a quite special way. In many cases they have chosen a hero as the subject of their studies because – for reasons of their own personal emotional life – they have felt a special affection for him from the very first. Then they devote their energies to

the task of idealization, aimed at enrolling the great man among the class of infantile models . . . To gratify this wish, they obliterate the individual features of their subject's physiognomy; they smooth over traces of his life's struggles with internal and external resistances, and they tolerate no vestige of human weakness or imperfection. They thus present us with what is in fact a cold, strange, ideal figure, instead of a human being to whom we might find ourselves distantly related.[1]

Writing a biography of an artist is, therefore, both an interesting and a treacherous business. It is all the more complex when the subject is an artist who is a woman. Not only is the model that I have but briefly sketched above decidedly about 'great men', heroes and masculine ideals in a way that has participated in identifying the term artist as exclusively masculine, but the models that do exist for writing about women are in many ways difficult to adapt to the study of the artist. Nanette Saloman has argued:

> Whereas Vasari used the device of biography to individualise and mystify the works of artistic men, the same device has profoundly different effects when applied to women. The details of a man's biography are conveyed as a measure of the 'universal', applicable to all mankind; in male genius they are simply heightened and intensified. In contrast, the details of a woman's biography are used to underscore the idea that she is an exception; . . . her art is reduced to a visual record of her personal and psychological make-up.[2]

Using the case study of Artemisia Gentileschi, a seventeenth-century Italian painter, Saloman shows how biographical detail can be used to swamp the art with too much life, a life that is already imagined for a woman only in stereotyped fashion. So instead of a study of the life of an artist who is a woman, we are served up a limiting example of a woman who happens to make paintings that can never escape the overwhelming tendency of women only to speak of or reflect their individual, private lives and feelings. Women's art is never allowed the status of universal relevance, being always partisan, local and completely tied into its own personal sources.

I hope it is clear by now that writing a biography of an artist like Berthe Morisot might plunge the author into difficult waters. Traditions of biography skewed by the politics of gender contend with the continuing debates about the relevance for artistic analysis of the life of the artist. If we

[1] S. Freud, 'Leonardo da Vinci and a memory of his childhood', *Art Literature*, Pelican Freud Library XIV, Harmondsworth, 1985, p. 223.
[2] N. Saloman, 'The Art Historical Canon: Sins of Omission', in *(En)Gendering Knowledge: Feminists in Academe*, ed. J.E. Hartman and W. Messer-Davidow, Knoxville, University of Tennessee Press, 1991, p. 229.

know who the artist was, will we understand the art? Are they reflexive? Complementary? Disjunctive? Contradictory? How will we negotiate the necessity to consider the impact of lived experiences on the work with the tendency to reduce women's work only to the impact of lived experiences?

In recent years, critical theories in the study of the humanities have tended to downgrade the importance of the figure and hence the life of the artist because the life had acquired an uncritical hegemony in the explanation of art. The biographer creates a picture of the artist – possibly according to the ideals and fantasies of the biographer – and this determines the dominant interpretations of the art. Thus the historical conditions of the production of art through participation in conventions and sign systems, ideologies and institutions become invisible and instead artists became the projections of the ideals and ideologies of the culture and moment to which the biographer belongs. To escape this fabrication, focus shifted away from 'The Life and Letters' or 'The Life and Works' model, in order to situate artistic practice as a social and historical practice within a complex of forces of which the individual artist's lived experiences might only be a marginal one. But with the revitalization of feminism as an intellectual and critical project, the question of 'the life' was posed, but with a difference. For feminism asks us to attend to the differences that matters of social experience, class, culture, gender, sexuality, location and temporality make in the production of social life and cultural artifacts. We can hardly argue that gender matters and that what women make art about is significant if we have put social and individual experience out of bounds. But feminists were still very cautious in distinguishing between categories of social experience, for instance, cultural constructions of femininity, and the unique trajectory of a woman's life perceived through the distorting lens of bourgeois individualism. In my own writing on women involved in the Impressionist project in Paris, I tried to examine the relation between the literal and ideological spaces occupied differently by men and women of all classes: the café, the street, the garden, the interior, the theatre, the beach, and so forth, in order to suggest that the spatial structures characteristic of the paintings produced by women inscribed these specific relations between the spaces of femininity and masculinity and the modern city. Since the social structures of home, family, and limited social mobility and access to the quintessential sites of modern leisure and pleasure were also experienced as formative of a psychic femininity, i.e. of a woman's inner life and sense of sexed identity, I could explore the relations between the social and personal in ways that bypassed conventional biography and drew upon anthropology and psychoanalysis.

Increasingly, it has become clear to me that we have made a caesura between Romantic and pre-Freudian fantasies about the artist which produced a biographical tradition that was heroic, religious, narcissistic,

individualist and, one has to say, ultimately masculinist, and on the other hand, the current, post-poststructuralist interest in the significance of singular social and personal experience as a necessary complement to the study of art as a matter of social convention and sign systems, ideologies and institutions.

Berthe Morisot, together with her American colleague Mary Cassatt, have never been completely erased from the history of Impressionism in France, though they were marginalized in the major histories of art dedicated to this period throughout the twentieth century. They occupy a curious position. Highly acclaimed and admired in their lifetimes, they became shadowy figures in the twentieth century's views of modernism, leaving, however, enough of a trace immediately to attract attention when feminism began to reclaim the 'hidden heritage' of women artists. Berthe Morisot's place in art history had been shaped by a specific legacy of admiration and family curatorship which used the terms of contemporary approbation – that her art was truly impressionist because it was so truly 'feminine' – in ways that, by the early twentieth century only served to collapse her singular artistic voice into a stereotyped version of femininity that was antithetical to modernism's muscular masculinity. She was damned by the very terms in which she had once been so enthusiastically acclaimed.

Screened by family loyalty and cultural etiquette, defined by a modernist art history unable to grapple with the specificity of her relations to another modernist moment that included Manet, Renoir and Mallarmé as her closest artistic intimates, Morisot became a puzzling and almost unintelligible artistic figure. Exhibitions of her work in the 1980s at last allowed a new look at this *oeuvre* of which so much is in private hands. It is significant, however, that while the Réunion des Musées Nationaux and several major American museums curated a series of blockbuster exhibitions celebrating her contemporaries, the *masters* of impressionism: Manet, Degas, Monet, Pissarro, no exhibition was organized for either Morisot or Cassatt. In the 1980s scholars like Kathleen Adler, Tamar Garb, Anne Higonet and many others began the necessary work of reintroducing Morisot into contemporary art history and knowledge, using all the available revisions to art history that two decades of feminist thought had made possible.

But the more that was written the more perplexing the case of Morisot became. The art historical question 'what is Morisot's work about?' necessitated a surer foundation of knowledge about the family she came from, the circles in which she moved, the structures, regulations and possibilities of haute-bourgeois Parisian life, lived in Passy, yet in intellectual and personal rapport with an undoubtedly avant-gardist culture as well as the visual arts. But such knowledge is not there for the asking. Biography is never a matter of simply reassembling the archive, sifting the documents

and telling the story. There is more than a coincidence in the co-emergence of detective fiction and forms of modern urban life and psychological experience. The great detective is not simply a good archivist but has accumulated a 'feel' for the field in which she/he works, a discernment and judgement based on a deep, extended and general understanding of the social environment in which the particular people act. So too the biographer of a woman of modernity must be such a detective, sure in her knowledge of the period, willing to risk hypothesis that will be more revealing than the *données* of art historical opinion.

Margaret Shennan addresses the biography of an artist from outside the convention and traditions I have sketched. Her study allows us to approach Berthe Morisot primarily as a historical figure, a participant in a fascinating moment of French, particularly Parisian, cultural history. Examining in detail the documents that allow us to reconstruct the milieu and the moment in which Berthe Morisot defied many of the expectations of her family to become a professional artist and play a considerable role in some of the major dissident currents of Parisian culture, Margaret Shennan also tries to draw a psychological portrait. While following the biographer's injunction to tell the story, the author opens up the complexity of her subject, the still unanswered and unanswerable questions, the puzzles, the silences as well as the conflicts, difficulties and compromises. Margaret Shennan has not used the paintings and drawings to provide supplementary evidence. She marks their production in ways which are necessary to recognize Morisot as a painter and a professional. What emerges is something truer to the emotional depth and conflict that confounds us when we contemplate some of the artist's devastating self portraits in conjunction with her otherwise exquisitely handled *impressions*.

This biography suggests that it is possible to produce a study of an artist's life which is neither idealizing nor heroic, which produces neither a strange, cold, ideal fantasy: the artist, not an ordinary mortal just like us. What makes a person dedicated to making art sets them apart from those who do not do it, don't feel the need to, or experience the gratification of doing it. This is not mystical, but it is historically and sociologically significant what fosters and what inhibits someone according to the possibility of being an artist, and a particular kind of artist, in a certain class, place, moment. To have become an artist in the manner, style and purpose that Morisot did demands an analysis attentive to the minute particularities of a cultural and historical moment mediated via a particular family and social network. This is where the grave distance that separates traditions of heroic biographical individualism and the emerging practice of a self-critical and theoretically informed study of women's histories is most marked. Margaret Shennan's immensely researched analysis of the life of Berthe Morisot offers the general public, hungry for understanding, a

rewarding insight into this psychologically complex and artistically significant Frenchwoman. It will also complement the growing art historical studies on a figure who, in living the complexities of modernity and femininity, also struggled to explore them through the novelties of what Edmund Duranty, in 1876, called 'the new painting'.

Griselda Pollock, 1996

Preface

By an inexplicable quirk of history, a galaxy of brilliant stars appeared in France in a period of little over three years between January 1839 and September 1842. Time proved they were a remarkable generation. Their talents were as varied as their achievements were conspicuous; and, except for two, who died too young to achieve the fame that comes with fulfilled potential, their reputations were enduring. They included Georges Clemenceau, the statesman who led his country through the First World War, the legendary sculptor Auguste Rodin, the novelists Emile Zola and Alphonse Daudet, the opera composer Jules Massenet and the musician Emmanuel Chabrier, the ethereal ballerina Emma Livry, two prominent Symbolists, the artist Odilon Redon and the poet Stéphane Mallarmé, and a group of painters who became known collectively as the Impressionists, Claude Monet, Pierre-Auguste Renoir, Paul Cézanne, Alfred Sisley, Frédéric Bazille, Armand Guillaumin – and Berthe Morisot.

Since posterity is so often arbitrary in its judgements, the name of Berthe Morisot is probably the least well known. Though a trickle of scholarly appraisals of her work has appeared in the course of this century, only in the last decade or so has her reputation emerged from a century of relative, undeserved neglect. Yet as a painter she was held in the highest esteem by her fellow artists, and by judicious art critics and collectors in France and the United States; and examples of her work may be seen today in public galleries and museums of art as far apart as Los Angeles and Stockholm, Cleveland and Oslo.[1] Recently, however, there have been signs that Europe is catching up with America in its appreciation of her consummate artistry. At last her rightful place within the school of French Impressionism is being acknowledged.

There could be several explanations for her belated international recognition. One factor is the availability of her painting. The European viewing public is certainly less familiar with her work than it is with the painting of Renoir, Monet, Cézanne or Degas. Some areas of Europe are particularly badly endowed, and there are more of Berthe Morisot's oil paintings in the city of Copenhagen than are on show throughout the British Isles. For understandable reasons, much of Morisot's artistic legacy and many memorabilia have remained in private hands, and therefore –

crucially – inaccessible to the general public.[2] That is slowly changing. And other circumstances have played their part. Her first major retrospective since 1896, held in Paris in 1941 to commemorate the centenary of her birth, coincided with the German Occupation of France in the Second World War. Publicity was stifled and even today the publications relating to that exhibition are almost impossible to acquire in Britain. In addition, we should not underestimate the force of popular prejudice against female genius, even into the second half of this century. Only with the abandoning of the traditional hierarchical pecking order of artistic subject matter (introducing the possibility that small genre paintings could be as significant in their originality and quality as major religio-historical commissions) has a sea-change occurred in public opinion. There has been a gradual reassessment of the output of many female artists who were in their time conditioned by powerful social forces to concentrate on painting domestic scenes, miniatures or still life.

The accelerated change in attitudes of the past fifteen years has been due largely to the determined pressure of the feminist movement, bearing down on the general reader and the male art establishment with a passionate concern to promote the achievements of female artists.[3] The natural interest within the USA in the American artist Mary Cassatt, who shared with Morisot the distinction of contributing to the Impressionist exhibitions, gradually turned the spotlight upon her contemporaries. A spate of articles about Morisot by art historians, translations, specialized studies – not to mention that visually compelling genre, the 'coffee-table' book – have collectively transformed public perceptions of her contribution to Impressionism.[4]

For all that, Berthe Morisot has been misunderstood. Her life has rapidly taken on the mantle of myth. It is a charming myth, originating with the critic Théodore Duret, but elaborated by Paul Valéry, the renowned philosopher, critic, essayist and poet and her nephew by marriage. Indeed, it is a magical myth, perpetuated by friends, relatives and descendants for the best part of a century. Certain aspects of her life are ignored. Details are fudged with unverified – possibly unverifiable – information. Her memory has been cocooned in a virtuous web of elegance and refined fulfilment. With effortless ease, her personal coterie has conspired – so it would seem – to present her story with disarming partiality. It is as if her work was the summation of her life, and nothing ever ruffled the serenity of that comfortable middle-class existence.

As a young man in the 1890s Valéry appreciated her fragile genius. He sensed in Berthe Morisot a touch of the Baudelairean heroine: the cauldron of inner feeling, the thwarted passion. Behind her 'strong-willed countenance' he saw 'something tragic in the expression'.[5] Yet it was not this sensitive, even highly charged issue that he was to elaborate. It was

another feature of Baudelaire, the fact that his work was forever identified with his life, his life with his work. It was a fashionable dictum when Valéry was an impressionable young writer. In 1889, in his essay 'The Decay of Lying', Oscar Wilde had promoted the notion that life imitated art. Valéry saw a clear analogy in the experience of Berthe Morisot. He promoted the theory of the indissoluble relationship between the artist's ideals and the intimate details of her life. 'Her sketches and paintings keep closely in step with her development as a girl, wife, and mother. I am tempted to say that her work as a whole is like the diary of a woman who uses colour and line as her means of expression.' By implication, it was a life as pure, exemplary and straightforward as Baudelaire's was adulterated and complex. But the parallel was there. Tante Berthe, he mused conclusively, lived by painting and painted her life.[6] It was the kind of remark that was to infuriate feminist writers like Germaine Greer because of its patronizing implications. But it has to be said that Valéry's interpretation became the touchstone for later commentaries on Berthe Morisot.

It coloured the verdict of her first biographer, Armand Fourreau, a family acquaintance. In a book dedicated to Madame Ernest Rouart, the artist's daughter, Fourreau elaborated the point with a sentimental simile. Her life was 'like some very sheltered lake which no storms have ever stirred, was calm, straightforward and of a piece with her Art'. Then, with bewildering insouciance he went on to testify, 'It was a life to drive to despair a biographer who is eager for adventures, starving for emotional agitations, hunting for pathetic situations, or even for mere picturesque anecdotes.'[7]

Incredibly, this view was still being repeated throughout the 1980s. In language strikingly reminiscent of Fourreau's, Jean Dominique Rey, the art critic, concluded that 'biographers avid for anecdotes find little to satisfy them in this tranquil existence where events seem to glide past as gracefully as a swan on a lake'.[8] Even the American art historian Anne Higonnet (who acknowledges the help of Morisot's Rouart descendants) starts from the premise of 'an art so radiant and calm, a life led soberly'.[9]

But it was Berthe Morisot's grandson, Denis Rouart, who strained the credulity of readers a generation ago – unintentionally perhaps, since he was a recognized expert on Impressionism. Taking his cue from Valéry and from the received family truths, confirmed by Fourreau and Monique Angoulvent (who had the advantage of being presented by Madame Rouart with all the family papers in order to write her monograph in 1933), he disclosed in his edition of Berthe Morisot's correspondence that her letters held no intimate confessions, propounded no ideas on art, and, above all, at no point touched on 'fundamental questions'.[10] Could this be yet another attempt to mislead, one has to wonder? Was this a deliberate playing down of the artist's perspicuity, a calculated suppression of bitter disappointments, the traumatic strains and stresses in her life?

The desire to protect the family reputation is an understandable instinct. So, too, is the impulse to eliminate embarrassing questions, untidy episodes, difficult relationships. Better to simplify the life-history to one of quiet professional and personal achievement, to the joys of marriage, motherhood and modest lifetime success: to describe her 'enchanting world' in terms of innocent children, gleaming lakes and silent swans; to sum up the subject matter of her work with the title of Watteau's famous painting, *Les Charmes de la Vie* . . .

However, as Shakespeare reminds us, 'to gild refined gold, to paint the lily . . . is wasteful and ridiculous excess'. There is no reason to hide the true picture. In any case, fame is a magnifying glass through which the lives of public figures are inevitably scrutinized. And Berthe Morisot can be no exception.

Who doubts her lucid, iron will or that intense brand of individualism which Paul Valéry himself identified? 'There is a contradictory quality in the middle classes which makes them suddenly produce artists', he observed. 'It is as if the moderation, the fear of risk, the clear-cut and well-tried beliefs, the cult of security and solidity in all its forms, were suddenly defied – and mystified – by the daemon of painting or poetry.'[11] Others noted her unexpected originality even before Valéry. In 1877 the art critic Paul Mantz dubbed her the 'only one Impressionist in the whole revolutionary group'.[12]

In fact, Berthe Morisot consciously risked society's derision by taking part in the first avant-garde Impressionist Exhibition of 1874. Indeed, she became one of the most committed contributors, involving herself in all but one of the subsequent exhibitions. Hers was as imaginative a decision as it was courageous. Such bold gestures were part of the mental fibre of this coolly intelligent and well-informed woman, a woman who could not help but raise 'fundamental questions', whether they were personal, artistic, political or moral.

She lived in an age that was neither serene nor sober. It was a world that was routinely savage, insanitary, uncomfortable and insecure; a world that was routinely stifling, exploitative and discriminatory, especially towards women. She was fully aware of these things. Outside the domestic scene, she was in touch with artists, musicians, painters, sculptors, poets, doctors and the prominent politicians of the day, such as Thiers, Clemenceau, Gambetta, Emile Ollivier and Jules Ferry. Though never involved in politics – it would be surprising if she had been – she was, undoubtedly, politically aware. Before the age of thirty she had observed the disastrous results of people's political miscalculations. Despite her privileged existence, she was certainly not insulated from the blood-letting of nineteenth-century France: from the events of two French Revolutions, a ruthless *coup d'état*, the catastrophic civil uprising of the Commune, the humiliating Prussian invasion of France and wartime deprivation in a Paris under siege. But in

quieter times she craved stimulus. She travelled abroad – to Spain, England, the Channel Islands, Italy, Belgium and Holland – besides making countless forays into provincial France. Friends recalled that her dinner parties were a focal point for lively argument and serious discussion of a range of issues. During the more settled years of the Third Republic, she lived a restless, semi-satisfying existence, divided between the urban scene and the countryside.

By the 1890s, when her character had matured through many personal vicissitudes, Paul Valéry noted that 'distinction was of her essence'.[13] A cluster of devotees could testify to her reserved personality whose grace and remoteness combined to create extraordinary charm. As if to underline Berthe Morisot's particular place in their hearts as well as in the history of French art, her retrospective exhibition in 1896 involved a unique quartet of friends: the artists Pierre-Auguste Renoir, Claude Monet and Edgar Degas, and the poet Stéphane Mallarmé. It was Mallarmé who wrote in the preface to the catalogue that she was a 'magician' – 'enchantress' is perhaps a more flattering word – 'whose work is . . . exquisitely bound up with the history of painting during an epoch-making period'.[14]

But there is one name that has not been mentioned, the name she assumed on marriage, the name of Manet. Of all her many close and deeply felt relationships, none was so profound as that between Berthe Morisot and perhaps the greatest and most original French artist of the nineteenth century, Edouard Manet. It had the special strength of being both professional and personal although there can be no doubt that their private affections subsumed their mutual professional respect with ever-deepening intensity. Although she married his brother, her love for Edouard Manet was the seminal, the most intimate experience of her life.

While it would be absurd to underestimate the time and creative energy which Berthe Morisot poured into her painting, with all the consequences for her thoughts, her feelings and her lifestyle, the prime purpose here is not to analyse or to reinterpret her art. This book is about the woman who produced that art. And so the story flits across the nineteenth century in search of her experiences. It reflects upon the milieu into which she was born and surveys her childhood and adolescence, for, as with most artists, that was when her eye and her vocation were formed. It observes the circles in which she grew to maturity, the people she knew, the relationships she treasured and the bitter-sweet world which made her what she was. If there is a closer focus, it is upon those years when she was, in nineteenth-century terms, in her prime. 'A woman lives from sixteen to forty', observed her contemporary, the artist Marie Bashkirtseff.[15] In one sense this was profoundly true of Berthe Morisot. In another, it was not: she proved that she was capable of new levels of artistic creativity even when she was visibly past her prime and her hair had grown white.

Finally, there is one intriguing aspect of Berthe Morisot's life about which art historians have been curiously cavalier. The assertion that she was a relation of the great eighteenth-century rococo painter Jean-Honoré Fragonard is repeated in every monograph and in most articles on Berthe Morisot's work. This genealogical conundrum is an irritant and a challenge to an historian. Seemingly, some art critics regard the connection with Fragonard as apocryphal. Was it just that her painting shared the delicacy and feminine quality of Fragonard's work? The Goncourts, publicists of Fragonard's genius, saw him as 'a magical artist who could produce so rapidly the effects of light and sun . . . with his misty palette . . . vivid tints, poppy, sulphur, ash green . . . rapid manner of painting which grasps the general impression of things and flings it on to the canvas like an instantaneous image'.[16] George Moore had no doubt about the *artistic* affinity. 'The history of Impressionist art is simple', he wrote. 'In the beginning of this century the tradition of French art – the tradition of Boucher, Fragonard and Watteau – had been completely lost; having produced genius, their art died. Ingres is the sublime flower of the classic art . . . and his art died. Then the Turners and Constable came to France, and they begot Troyon, and Troyon begot Millet, Courbet, Corot, and Rousseau, and these in turn begot Degas, Pissaro, *Madame Morisot* and Guillaumin.'[17]

However, the latest tendency is to be distrustful of a blood relationship. One theory is that the story was invented, perhaps inadvertently, by Berthe Morisot's friend, Stéphane Mallarmé. The American artist Mary Cassatt certainly believed that. On the other hand, Cassatt may have been sceptical for other reasons. Time and arrogance could have blurred the accuracy of her recollections. Despite an optimistic assumption that she and Berthe Morisot were firm friends, it is more likely – beneath their veneer of polite civility – that little love was lost between them. In this case we cannot afford to give too much weight to Cassatt's repudiation of Berthe as a descendant of 'Frago', a relationship stated in explicit terms by two contemporaries, Mallarmé and Jacques-Emile Blanche. At any rate, while the question of the Morisot–Fragonard connection remains unresolved, the possibility of a personal bridge existing across the Revolutionary divide, of family associations stretching between the *ancien régime* and the *fin de siècle*, teases the imagination.[18]

In later life, Berthe Morisot reflected on the passing of the years and on ancestors who had left no record of their time on earth. She pondered on immortality, 'the trace which our lives might leave behind'.[19] She told her own story vividly in letters and in notebooks and she established her own niche in history through a substantial output, over 850 recorded works of art. Yet there was no arrogance or vainglory in these memorials; she saw them as mere expressions of hopes and joys.

The pity is that too few have shared in the joy of her artistry, have been granted access to her paintings by accident of birth or geography. The revelation of her precious legacy to a world-wide viewing public, though fraught with practical difficulties, is long overdue. But the task of revealing the woman behind the pictures and the letters is a very different type of challenge, one that can only partly be accomplished in museums and galleries of art, archives and libraries, or by hours spent at the desktop. It involves footwork: searching elegant urban streets, provincial corners and rural byways in pursuit of the visual backcloth and rhythm of her life. And at journey's end, perhaps all the historian is left with is an impression of this woman, an impression which is the poetry of history: a vivid awareness 'that once on this earth, once on this familiar plot of ground, walked other men and women . . . thinking their own thoughts, swayed by their own passions, now all gone, one generation vanishing after another . . . like ghosts at cock-crow'.[20]

Margaret Shennan

Acknowledgements

I discovered Berthe Morisot through Edouard Manet some twelve years ago while gazing at a reproduction of his portrait of her, entitled *Le Repos*. It carried the usual cryptic caption: 'Sister-in-law and model of the artist, and artist herself'. The picture was intriguing and I wanted to know more. I went to the library in search of a readable modern biography but there wasn't one. The bookshops also yielded nothing. In time I found there existed some short essays and critiques of individual paintings, as well as a couple of dated monographs. I also discovered Denis Rouart's original version of her correspondence with her family and friends, then the English translation by Betty Hubbard; and finally the Klincksieck edition of Julie Manet's *Journal*, all of which opened my eyes to a life packed with interesting people and events. The astute observations which appeared on these pages provided a mini-history of nineteenth-century France from informed but highly personal points of view. I vowed there and then to write a life of this unusually gifted woman, and in doing so, I owe a great deal to these books.

That was in 1984. After three years' research, I was diverted by other projects and commissions. In the ensuing years new articles and essays on Berthe Morisot appeared, and monographs focusing on her stature as an artist. Fortunately, I was able to visit Paris in the summer of 1987 to see the Morisot exhibition at the Galerie Hopkins-Thomas. At the same time a major retrospective was being mounted in the United States, arising from the celebration of the Mount Holyoke College sesquicentennial and held in conjunction with the National Gallery of Art, Washington, DC. By a happy coincidence, my daughter-in-law, Elizabeth Doherty, is an alumna of Mount Holyoke, so I was kept informed about this important and imaginative venture. In due course I gratefully received from her family a copy of Charles F. Stuckey and William P. Scott's impressive official publication on *Berthe Morisot – Impressionist*, which has proved invaluable. When time became available in 1993 I resumed my labour of love. However, what follows would not have been possible without the support of a great many people, most of whom are friends from the academic world; by helping me in countless ways they have enabled me to produce this biography.

I should like to acknowledge the assistance of staff in the principal

Parisian archives mentioned in the bibliography; of Mr Philip Goldman of the Archives Municipales de Bourges, M. Robert Chanaud, director of the Departmental Archives of the Haute-Vienne, and Mme Chandelle, also of these archives. At the same time I am grateful to staff at several English institutions: the Barber Institute of Fine Arts, Birmingham University; the British Library, London; Cambridge University Library; and the library of the University of Central Lancashire, Preston. More especially, I should like to take this opportunity to pay tribute to the help and support of the staff of Lancaster University Library, under Arthur Davies and Jacqueline Whiteside: to Dr Lindsay Newman, whose knowledge of the Parisian archives is immensely reassuring; to Miss Thelma Goodman for dealing promptly with Inter-Library Loan requests on my behalf; and to the unfailing kindness and efficiency of Mrs Winnie Clark, the deputy librarian.

I should also like to record my gratitude to Chanoine Joël Massip, curé-archiprêtre of the Cathedral of Saint-Etienne at Bourges, for giving me access to Berthe Morisot's baptismal record. I thank, too, M. Pierre Bailly, attaché principal à la Conservation of the Musées de Bourges, and his staff who provided me with a photograph and information about the *esquisse* of a young woman in white signed by Morisot. I am very grateful to Mikael Wivel, curator of the Ordrupgaardsamlingen, Copenhagen, for information concerning Marie Hubbard and her family. To Mme Delphine Montalant of the Galerie Hopkins-Thomas, I offer my heartfelt thanks in graciously providing me with certain illustrations and facilitating my use of the English translation of the Morisot correspondence edited by Denis Rouart.

I am also grateful to M. Yves Rouart, Paris, and Lund Humphries Publishers, London, for kind permission to quote excerpts from this edition. I should also like to extend my appreciation to all those institutes and individuals who have kindly loaned photographic transparencies, and who have helped with regard to copyright. Individual credits are given with each illustration.

Over a number of years, I have received much encouragement from friends such as Naomi Roth and Ruth Hanham, and university contacts, experts in French history, literature and art, who have kindly answered my queries and offered advice: too many to name individually. Some, however, have given me invaluable assistance in the pursuit of source material, for which I am deeply grateful: in particular, Dr David Parker of the University of Leeds; Dr Julian Swann of Birkbeck College, London; Marjorie Bell, formerly resident in Paris; and Carla Newbould, Mount Allison University, New Brunswick, Canada. Of friends at Lancaster University, I particularly wish to thank two members of the French Studies department, Mr Gordon Inkster and Dr David Steel, both of whom helped me generously with their time and knowledge of France and French culture. Finally, I must place on record the debt I owe to the late Dr Ralph Gibson for his practical kindness

on many occasions and for the benefit I received from his immense scholarship. I am pleased to list his great-grandfather's personal account of Paris during the Commune as one of my primary sources.

I cannot conclude, however, without acknowledging the support of my family. Through my eldest son, Dr Andrew Shennan of Wellesley College, Massachusetts, I have been able to visit a number of American galleries, including Mount Holyoke College Art Museum and the Sterling and Francine Clark Institute in Williamstown. I am also very grateful for his help in acquiring material from the USA. My husband, Professor Joe Shennan of Lancaster University, has, as always, played a crucial role, accompanying me several times to France to further my research. Together we have seen and photographed almost every residence of Berthe Morisot, visited galleries and exhibitions, walked endlessly around Passy, and constantly discussed her life and achievements. I owe him the greatest debt of all.

Margaret Shennan

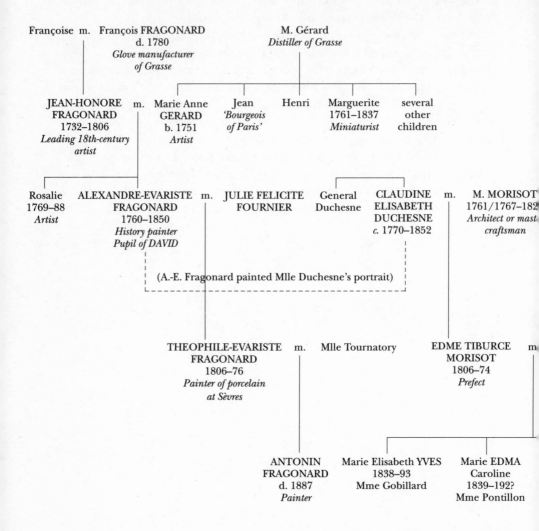

Françoise m. François FRAGONARD
d. 1780
*Glove manufacturer
of Grasse*

M. Gérard
Distiller of Grasse

JEAN-HONORE m. Marie Anne Jean Henri Marguerite several
FRAGONARD GERARD *'Bourgeois* 1761–1837 other
1732–1806 b. 1751 *of Paris'* *Miniaturist* children
Leading 18th-century Artist
artist*

Rosalie ALEXANDRE-EVARISTE m. JULIE FELICITE General CLAUDINE m. M. MORISOT
1769–88 FRAGONARD FOURNIER Duchesne ELISABETH 1761/1767–182
Artist 1760–1850 DUCHESNE *Architect or mast*
History painter *c. 1770–1852* *craftsman*
Pupil of DAVID

(A.-E. Fragonard painted Mlle Duchesne's portrait)

THEOPHILE-EVARISTE m. Mlle Tournatory EDME TIBURCE m
FRAGONARD MORISOT
1806–76 1806–74
Painter of porcelain *Prefect*
at Sèvres

ANTONIN Marie Elisabeth YVES Marie EDMA
FRAGONARD 1838–93 Caroline
d. 1887 Mme Gobillard 1839–192?
Painter Mme Pontillon

GENEALOGIES OF THE FRAGONARD, MORISOT AND MANET FAMILIES

MANET FAMILY

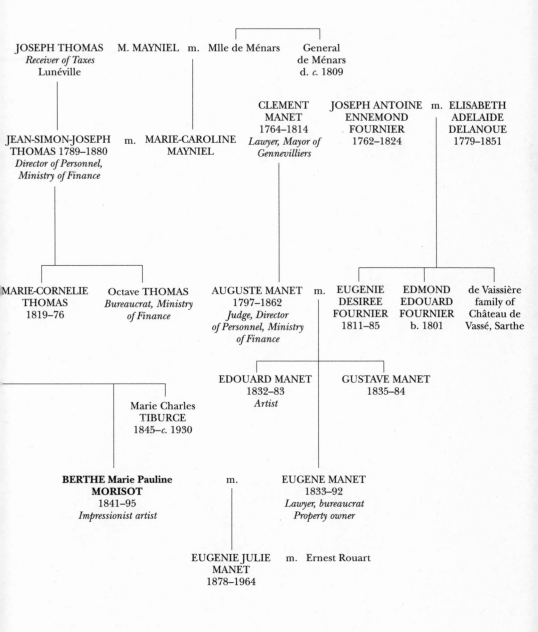

JOSEPH THOMAS
Receiver of Taxes
Lunéville

M. MAYNIEL m. Mlle de Ménars

General
de Ménars
d. c. 1809

JEAN-SIMON-JOSEPH
THOMAS 1789–1880
Director of Personnel,
Ministry of Finance

m. MARIE-CAROLINE
MAYNIEL

CLEMENT
MANET
1764–1814
Lawyer, Mayor of
Gennevilliers

JOSEPH ANTOINE
ENNEMOND
FOURNIER
1762–1824

m. ELISABETH
ADELAIDE
DELANOUE
1779–1851

MARIE-CORNELIE
THOMAS
1819–76

Octave THOMAS
Bureaucrat, Ministry
of Finance

AUGUSTE MANET
1797–1862
Judge, Director
of Personnel, Ministry
of Finance

m. EUGENIE
DESIREE
FOURNIER
1811–85

EDMOND
EDOUARD
FOURNIER
b. 1801

de Vaissière
family of
Château de
Vassé, Sarthe

EDOUARD MANET
1832–83
Artist

GUSTAVE MANET
1835–84

Marie Charles
TIBURCE
1845–*c.* 1930

BERTHE Marie Pauline
MORISOT
1841–95
Impressionist artist

m.

EUGENE MANET
1833–92
Lawyer, bureaucrat
Property owner

EUGENIE JULIE
MANET
1878–1964

m. Ernest Rouart

PART ONE

Prelude

CHAPTER ONE

Lineage

1789–1841

The provincial town of Bourges lies in the very heart of France, where the low but undulating plateau of Berry slopes gently northwards from the edge of the Massif Central. Julius Caesar described it as one of the most beautiful cities of ancient Gaul. The settlement flourished, and medieval Bourges became in turn the capital of the duchy of Aquitaine and the province of Berry, its history associated with legendary figures from the Gallic chieftain Vercingetorix to Jacques Coeur, royal counsellor and merchant-banker *extraordinaire*. But the crowning glory of Bourges is its colossal Gothic cathedral, which has dominated the urban landscape since the thirteenth century. The architectural scale and beauty overwhelm the eye. The wealth of stained glass is redolent of the shimmering, suffused light of an Impressionist painting. It was here, in this *bonne ville*, that Berthe Marie Pauline Morisot was born on a winter's afternoon early in 1841.

On the following day, 15 January, precisely twenty-four hours after her delivery, the infant's father, Monsieur Edme Tiburce Morisot, appeared at the elegant fifteenth-century Hôtel de Jacques Coeur, which served as the town hall at that time, and formally registered his daughter's birth with the deputy mayor, Monsieur Boucheron. Congratulations and smiles were in order at the news from the prefecture. It was only appropriate that the act of registration should be held in the presence of two of the town's leading citizens, the mayor himself, Monsieur Mayer Genêtry, and the chief financial officer, Monsieur Louis Berard.

The ceremony was conducted with due pomp and circumstance, for both the distinguished-looking father and the status-conscious, middle-aged mayor were among the nation's élite, proud holders of the award of *chevalier de la Légion d'Honneur*. However, in the heat of the moment a flustered Monsieur Boucheron must have forgotten to sign the record for he rectified this three weeks later before legal witnesses.[1] Of course, the formality of the mayoral presence was not accorded to every new-born baby of Bourges. This was not an everyday occurrence. It was the fact that Monsieur Morisot was the Prefect of the Department of Cher and the leading representative of the Orleanist government in the region that accounts for all the fuss that went on in the town hall that day.

3

Tiburce Morisot had been Prefect for almost a year. His position gave him enormous prestige and authority in the area. He was there effectively as political watchdog, electoral agent and social symbol on behalf of the July Monarchy, as Louis Philippe's regime was known. His appointment to Bourges represented valuable promotion. This he attributed to his own perseverance and the warm support of his political patron, Adolphe Thiers, for the previous six years. Things looked even better when Thiers had been appointed the king's first minister and foreign secretary in March 1840. But, as the system worked, it could have been a political blow to the Morisots that a rumbling foreign policy row with England over the Eastern Question caused the prime minister to resign before the year was out. By that time Madame Morisot was heavily pregnant.

It was a solemn time in other ways too. In December 1840 the ashes of the Emperor Napoleon Bonaparte were brought back to France for interment. Despite the bitter cold, the ceremony in the great-domed Invalides of Paris, conducted to the sound of Mozart's *Requiem*, was attended by all the great and the good of France. That night the Republican poet Victor Hugo jotted down his private observations, that Adolphe Thiers, who had instigated the event, was at heart a supporter of Napoleon. Had Tiburce Morisot known this about his patron, it might have given him serious pause for thought. However, he was reassured by the latest news from Paris concerning the cabinet reshuffle. The newly appointed foreign minister, and the most able and influential member of the cabinet, was to be his father-in-law's political patron, François Guizot. One way or another, as the Morisot family faced the arrival of its newest member, their future seemed secure.

So far Prefect Morisot could look back with considerable satisfaction on his career. He had been born in Paris on 11 March 1806 into a bourgeois family who gave him a fashionably imperial name, Tiburce or Tiberius. In 1841, at the age of thirty-five, he had five years of responsible government service behind him. It seems he had inherited artistic inclinations from his father who was described as an architect by profession. Joséphin Morisot (or, variously, Joseph-Madeleine-Rose Morisot) who was born in 1761, had studied with Delagrange, the Inspector for Buildings for Louis XVI's younger brother, the Comte de Provence, before the French Revolution.[2] Joséphin Morisot apparently achieved the post of Architectural Inspector of Crown Buildings, a position he held under the First Empire (1806–14) and also after the Restoration (1814–15) when the Comte de Provence became King Louis XVIII. He retained the post in charge of works until his death at Versailles at the age of sixty in 1821. This suggests that Joséphin Morisot had done extremely well for himself through the Delagrange connection. However, Edme Tiburce Morisot's death certificate identifies his father not as Joséphin but as Tiburce Pierre Morisot, while his mother, named as Claudine Elisabeth Duchesne of Paris, had been forced into hiding during

the Terror.[3] The evidence leads us to suppose that Joséphin Morisot was only a relative, possibly Prefect Morisot's uncle. Another authority indicates that his father was a skilled craftsman, possibly a master carpenter.[4] This does not preclude the possibility that Tiburce Pierre Morisot gained extensive practical experience of building and architecture. There were different routes to becoming an architect in nineteenth-century France. One was to study for a number of years at the Ecole des Beaux Arts to gain professional qualifications; another was to master architectural skills on site while working in conjunction with a builder. Some enterprising ex-carpenters or bricklayers had grown extremely rich by borrowing money to speculate on the properties market, building dwellings to rent in partnership with a landlord. The point is simply this: it was not uncommon for 'jobbing' builders to claim the status of architect.[5]

At this juncture there is another twist to the family mystery. It concerns the persistent belief in a blood relationship between Tiburce Morisot and the painter Fragonard.[6] The 'proof' rests on oral tradition and circumstantial evidence, in part on the existence of a portrait of Claudine Elisabeth Duchesne, Tiburce's mother, by Fragonard's son, the artist Alexandre-Evariste Fragonard.[7] The Morisots, Duchesnes and Fragonards mixed in the same circle of talented artists who were in effect government servants, seeking commissions for their skills in the many royal and imperial enterprises centred on Versailles and Paris. In the course of his professional life Fragonard knew both Antoine Duchesne, provost of the King's Buildings, and the Duc de Marigny, overall director of Buildings under Louis XV and brother of the king's mistress, Madame de Pompadour. Consequently, during the Terror both Fragonard and Elisabeth Duchesne had been forced to keep low profiles because of their association with the aristocracy of the old regime. A supplementary point is the fact that the two families came originally from Grasse, in the distant Midi, and relationships were honoured in that land of vines, drenched in the myriad perfumes of lemon, orange blossom, jasmine, lavender and thyme.[8]

It is a fascinating, half plausible theory. If there *was* such a connection it must either have been indirect, that is to say, by the marriage of relatives such as cousins, or through an illegitimate liaison which has remained a well-guarded secret. The anonymity of her forebears was something that intrigued and even frightened Berthe Morisot: it reminded her of the fleeting nature of human existence: 'so many mute dead behind us, who lived, ate, drank and slept, leaving nothing behind to help their children to understand'.[9] It may be that she was thinking particularly of the Morisot side of the family. At any rate, until more evidence is forthcoming, the only honest verdict on the link with the Fragonards is an open one.

However, even if there remains a question mark over his paternal ancestry, Tiburce Morisot was clearly not without plenty of financial support.

Conceivably the source was his uncle, his mother's brother, General Duchesne, a commander in Portugal during the Peninsular campaign. It was Napoleon's policy to reward his officers substantially; in 1808 a general's salary was as much as 40,000 francs – enough to live comfortably and provide a settlement for a promising nephew.[10] What is beyond dispute is that young Tiburce Morisot was given a sound education in the classics and the arts. As a youth he attended the prestigious Collège Bourbon, later renamed the Lycée Fontanes and subsequently the Lycée Condorcet. Here he took his baccalaureate which was the key to a professional career. However, he had probably left before a certain Georges Haussmann, a student three years his junior, arrived there. From school Tiburce Morisot moved on to the Ecole des Beaux Arts to study fine arts and develop his understanding of architecture under Hurtault.[11] Then between 1829 and 1832, in the tradition of privileged bourgeois gentlemen he enjoyed travelling through Italy, Greece and Sicily to complete his cultural education. By the age of twenty-six, when he returned to Paris, Tiburce Morisot was evidently a polished and well-informed young man but perhaps still somewhat wet behind the ears. A brief publishing venture in 1832–3 (when he edited a journal on property and architecture) proved abortive, and he was left to carry the can for his dishonest partners. He did his best to make financial amends before slipping off again to Greece until the affair had died down, after which he could reassess his career prospects.[12]

This he appears to have done with conspicuous success. He was aware that industry and commerce, even the liberal professions, were financially risky ventures. So if the law and the entrepreneurial world were not for him, the civil service, the hierarchical machine which ran the country, was probably his natural milieu. In his grandfather's day a position in the bureaucracy would have been a matter of class privilege. In the Napoleonic period the principle of 'merit' was introduced, but by this time entry was more a matter of going to the right secondary school, of personal contact and recommendation: in effect, the old boy network.

So a shrewd patron was Morisot's first priority. He saw his opportunity in the rising star of Adolphe Thiers, a diminutive but cultured and ambitious firebrand who had taken over the Ministry of Commerce and Public Works. Thiers was destined for highest office in the fullness of time. In 1833 Paris was poised to undergo the second of its nineteenth-century transformations. In April the minister had secured from the government a pledge of one hundred million francs over five years to implement a major project for the completion of the great monuments of the capital which had been started under Napoleon – the Arc de Triomphe, the Madeleine, the Place de la Concorde and the Panthéon. In addition, certain important buildings, the basilica of St Denis, the Collège de France, the Bibliothèque Royale and the Palais Bourbon, were scheduled for repair, while outside the capital an

infrastructure of roads, canals and railways was to be started. This government-sponsored architectural and construction programme brought young Morisot in sight of the promised land. It is an interesting fact that one of the artists working on the Palais Bourbon project was Alexandre-Evariste Fragonard, his putative relation. Be that as it may, Tiburce Morisot found a way to ingratiate himself with Thiers. (Perhaps the key lies in Provence. Thiers came from Marseilles, Grasse was not too far away, and family roots were a factor in the business of 'getting on'.)

But more to the point, in the months between his return from Greece in 1834 and the end of 1835 he achieved a triple triumph. First, (though how precisely is not clear) he acquired a civil engineering qualification.[13] Since the Restoration there had been a concerted effort to boost commerce and engineering by raising it to the level of the older professions.[14] The Ecole centrale des Arts et Manufactures had been set up in 1829 to attract would-be engineers. The Conservatoire des Arts et Métiers had a fine technical library and lecture facilities. There is a possibility that Tiburce Morisot took advantage of these to master the subject. But without hard evidence it is impossible to judge his achievement. The fine detail of an ambitious man's qualifications could be fudged in the furtherance of a career. When Georges Haussmann, the former Collège Bourbon student, took up his post in the Department of the Seine in 1853 to become one of the most powerful men in France, his personal records mysteriously elevated his ordinary law degree into a doctorate.[15]

Morisot was fortunate. In March 1834 the king reappointed Thiers to the Ministry of the Interior and gave him wide powers of responsibility. For Tiburce Morisot this opened up new prospects. He secured a post as secretary-general (a position that was actually less elevated than it sounds), which, if he played his cards right, might put him in line for a good career in public service. With diligence and charm – and one may suppose, with a good deal of appropriate petitioning – he worked at extending his contacts and achieving promotion.

Thiers was his model. Thiers had perfected the art of ingratiating himself with his political superiors. He had connections in every department of government. Before reaching the Interior, he had worked round the clock as the deputy minister of finance, running the ministry single-handed, with advice from its permanent officials. Then in 1833, at the age of thirty-five, while he was in charge of Commerce and Public Works, the minister had found himself a suitable wife in Mademoiselle Elise Dosne, a mature fifteen-year-old and the daughter of a prosperous financier and business contractor from whom Thiers had bought his Paris mansion.[16]

Now – in 1835 – Tiburce Morisot was approaching thirty. With letters after his name and a niche in the Ministry of the Interior, he proceeded to make the acquaintance of a senior civil servant in the Finance Ministry, the director of personnel, Joseph Thomas. He may also have observed that

salaries in the Ministry of Finance were higher than those of other ministries. Then, not surprisingly, it was only a matter of months before he had won the heart of Monsieur Thomas's daughter.

Marie-Joséphine-Cornélie Thomas was sixteen and still finishing her education at boarding school when she met Tiburce. She fell in love with him instantly. She was a charming girl, articulate, gregarious, bubbling with life; his good looks and urbane manners matched hers. They made a promising pair and from Morisot's point of view it was the perfect marriage he had been seeking. With Joseph Thomas's blessing and support, by the beginning of 1836 he had a desirable wife and a private income of some 8,000 francs in state shares.[17] And he was also offered a new job. A sub-prefect's post in the Department of Haute-Loire had become vacant. Four years earlier Georges Haussmann had been posted to the same place. It had been his first sub-prefectoral position, too: his first sure step on the ladder.

Meanwhile, by another stroke of good luck, a further cabinet reshuffle was taking place. On 16 February 1836 Louis Philippe asked Monsieur Thiers to head a new ministry. Five days later Edme Tiburce Morisot, Berthe's father, was nominated by Thiers as sub-prefect of Yssingeaux. His prefectoral career was effectively launched.[18]

This was an age when Parisians were mesmerized by the acquisition of wealth and social advancement, none more so than the middle and upper levels of the bourgeoisie. The Thomas family were senior civil servants and decidedly upper middle class. So it is worth taking the trouble to chart the success of Berthe Morisot's formidable grandfather, Jean-Simon-Joseph Thomas – because it was his influence and wealth that set the parameters of family ambition and helped to sustain the family's gracious lifestyle for the duration of the century.[19] The Thomas ancestors were financial officials, treasurers and paymasters in the provinces. Before the Great Revolution, Berthe's great-grandfather, Joseph Thomas's father, was the receiver of taxes at Lunéville, in the Meurthe region of eastern France. Joseph himself was born the year the revolution broke out – 1789 – and as a young man followed in his father's footsteps as an apprentice inspector of finance in 1809. From there his career took off thanks to the benevolence of his first patron, Baron Louis, who was later Minister of Finance under Louis XVIII. Thomas was given rapid promotion through the inspectors' ranks and had been inspector-general for two years when the July Revolution of 1830 overthrew the diehard Bourbon monarchy again.

It could have been the end of the road for Joseph Thomas's career. But luck was still on his side. Baron Louis, a liberal-minded politician who was also a great survivor, joined the new Orleanist government. He sent Joseph Thomas on a couple of sensitive diplomatic missions and, despite the failure of the second assignment, he made sure Thomas was rewarded in 1831 with the

directorship of personnel in the Ministry of Finance. There he came under the patronage of François Guizot, an academic-turned-politician, whose long political career was in a sense complementary to that of Adolphe Thiers. No one understood the political system better than Guizot. Contrary to the dull image posterity has given him, he was in fact a warm personality and an articulate man who inspired and returned deep affection. As it happened, he was also known to favour with his patronage up-and-coming men from the Meurthe region. Under him Joseph Thomas continued to prosper.[20] He was made paymaster-general of the Treasury and was finally nominated director of this service. Appointed *chevalier de la Légion d'Honneur* back in 1824, he reached the rank of *commandeur* in 1844 and three years before he retired, in 1859, his career was crowned with the accolade of *grand officier*. By all accounts he was a man blessed with high intelligence, loyal patrons, good health and longevity. In a real sense, he was the lynchpin of the Thomas–Morisot family.

Joseph Thomas and his wife had three children whom we know of, Marie-Cornélie, who married Edme Tiburce Morisot in 1835, a second daughter born in 1813 and a son, Octave, who kept in close touch with the Morisot family. Indeed, many years into the future, Berthe was to make a pastel drawing of Octave's daughter, Madeleine, and a number of pictures of Jeannie and Charley, the children of his son, Gabriel, a financier and art collector. Yet it was Marie-Caroline Mayniel, then Madame Thomas, rather than the indomitable civil servant of the Finance Ministry, whom Berthe remembered with real affection and admiration.[21]

Quick-witted and beautifully spoken, Madame Thomas was a frank and outgoing personality. Not much is known about the family except that she came from Toulouse. Her mother had been Mademoiselle de Ménars before her marriage to Monsieur Mayniel.[22] Marie-Caroline had been given the best education available to girls at the time, at the school at Saint-Denis founded for the daughters of Napoleonic officers. By a strange coincidence, her uncle, General de Ménars, had also taken part in the Peninsular campaign, only to be killed in 1808 during the unsuccessful French onslaught on Saragossa. It pleased Berthe to know that she inherited something of her Grandmother Thomas's striking looks. But charm was the quality that Mesdames Thomas and Morisot shared; charm was the quality they passed down to the next two generations.

It was a priceless gift for a sub-prefect's wife and one that helped to smooth over the inevitable little *faux pas* and class difficulties of a backwoods posting. Monsieur Morisot and his young bride reached Yssingeaux, in the eastern Massif Central, on 2 June 1836. It was their first experience of the wild, remote country of the high granite plateau of Velay. Things could have changed little since 1832, when sub-prefect Haussmann complained that the peasants were habitually dour or unruly, the aristocracy unenlightened and the clergy rigid and interfering.[23] Even in the idyllic

summers social life and communications were restricted. But winter found them snowbound. It was a relief when news reached Morisot early in the new year, 1837, of his transfer to the sub-prefecture of Valenciennes on the Belgian border. His perception and good taste had been noted by his superior, the Prefect of Haute-Loire. Two months later the couple were installed in the north.

The industrial belt of Flanders was a stark contrast to the sweeping forests, extinct volcanoes and tortuous hill roads of the Massif Central. The manufacturing city of Lille was the seat of the Prefect of the Nord; Monsieur Morisot's area of control, the *arrondissement* of Valenciennes, was in the south of the *département*. An old working town where coal mining had superseded lace as the main industry, it had a reputation for trouble in the 1830s, as he was only too aware from his official briefing. Since law and order was one of the Prefect's main concerns, Morisot was determined to show that he could be relied on as an efficient and alert deputy. The opportunity came later that year.

The civil authorities and the directors of the mining Company of Anzin were still smarting from the lenient attitude of the courts in 1833 to the striking coal-miners of Anzin and the acquittal of thirteen of their number. All the same, the company claimed that since the 1833 strike they had increased miners' wages and benefits. However, on 10 July some 500 to 600 Anzin miners went on strike again. The middle classes saw their demands as quite unwarranted and a threat to social order. On hearing the news, Monsieur Morisot and the local prosecuting magistrate, rode to the Anzin pit and tried to calm the workers. The miners were in no mood to capitulate, so the two officials felt they had no alternative but to summon the troops. Not wishing to take risks, the sub-prefect called in 500 infantry, 50 cavalry and 100 National Guards from Valenciennes to disperse the strikers. Night patrols were also organized in case the miners tried sabotage tactics.

All the same, trouble spread to other pits in the area. But again Tiburce Morisot responded speedily, posting military reinforcements where they were needed. By 14 July, when the Prefect of the Nord arrived to take stock of the situation, everything was under control. Morisot was congratulated on his prompt action. Coal production had resumed as normal. At the Valenciennes correctional court the authorities could find no mitigating circumstances as they had done in 1833. The strikers' leaders received prison sentences, which were later increased on appeal by the Douai royal court. For the rest of Morisot's period of service in Valenciennes there was no sign of industrial unrest.[24]

In 1838 he was decorated for his initiative, entering the honoured ranks of the *Légion d'Honneur*. But a more valuable prize was to come his way, almost certainly through Thiers's patronage after the skilled opportunist

came back to power as first minister in March 1840. Morisot was given the official appointment of *maître des requêtes* of the Council of State, with the function of *rapporteur*. This was a considerable achievement and honour for someone without a legal background. It meant that he had gained an entrée to the élite world of administrative law, an experience that would serve him well in the future. A quick glance at his curriculum vitae would indicate that Tiburce Morisot was a man of many parts.[25]

In an official report to the authorities in Paris, Morisot's superior, Saint-Aignan, the Prefect of the Nord, analysed Morisot's qualities. Diligent attention to detail, a reserved but kindly manner and enlightened judgement which he managed to combine with a firm touch: this was the thrust. Furthermore, he enjoyed good relations with the citizens of Valenciennes and his private life was beyond reproach.[26]

In conclusion, Tiburce Morisot was properly ambitious to become a full Prefect, bearing in mind his 'services and devotion' to the government. And there were pressing financial reasons for applying for promotion. On 4 October 1838 nineteen-year-old Madame Cornélie Morisot gave birth to her first child, a daughter, whom they called Marie Elisabeth Yves Morisot, and fourteen months later, on 13 December 1839, Yves had a little sister. She was named Marie Edma Caroline. Whether Joseph Thomas had a hand in the next move is not clear, but very shortly after this the hoped-for promotion came through. In January 1840 Edme Tiburce Morisot heard that he had been nominated as Prefect of the middle-ranking Department of Cher. He was to start immediately for Bourges.

As Prefect he faced many new responsibilities. The regional capital was a market town where local routes converged; iron and charcoal fed small-scale industrial works. Yet Bourges was primarily an episcopal and administrative centre, the seat of a cardinal-archbishop, a regional inspector-general of police and all the judges of the court of appeal. In addition, it was the site of a divisional army barracks, together with its officer corps and three generals, and lastly the temporary but guarded residence of Don Carlos, the bigoted Carlist pretender to the Spanish throne. There were many interests to oversee and potential conflicts to dispel.

The citizens were uneasy that summer. Business was in recession; bad weather and poor harvests affected the provinces. None the less orders went out to the Prefects from Paris not to do anything hasty in the event of public disorder, but to steer a moderate course. Cornélie Morisot held her breath: this was the moment that she had to tell her husband she was pregnant once again. *Madame la préfète* would have to cut down on the number of public functions she could attend in the prefecture that autumn and possibly well into the following spring.

The arrival of Berthe on 14 January 1841 posed something of a dilemma. Cornélie Morisot had given birth to a trio of daughters in under two and a half

years. If there was a hint of disappointment in Tiburce Morisot at the new baby's sex, it would hardly have been surprising. For according to a popular French saying, '*Une fille, ce n'est rien, deux, c'est assez, trois c'est trop* . . .'[27] The third child of the same sex, be it boy or girl, is frequently at a disadvantage in a family, if the parents have reason to prefer the other sex. The male ego, however, is more easily bruised by the absence of a son and heir. So, too, are family resources, when a husband and father is faced with the combined demands of four females. And this latest child might be a worrying portent: would Cornélie continue to produce daughters? Where was the son to perpetuate the name? Even mothers in this situation were known to regard several daughters as a penance. Such prejudices are not always articulated. They run deep, however, and frequently affect relationships between parents and children.

So too did the crisis which threatened the family when Berthe was less than a fortnight old. We have to deduce what happened from the cathedral records. Devout Catholic parents would have ensured that their baby was given a public baptism within two days of her birth. The fact that Tiburce Morisot ignored this procedure suggests that his inclinations were anti-clerical. It is also possible that he was away on prefectoral business when little Berthe's health gave cause for alarm. A sick nurse named Solonge Lavrat was called in, but Cornélie Morisot may have feared that her baby would die in a state of original sin. On 27 January, when she was thirteen days old, Berthe was hastily taken by her nurse to the cathedral, where, with the archbishop's permission, a private service of *ondoiement* was held. The record shows that it was taken by the vicar, Père Rouault, in the presence of only two witnesses, Solonge Lavrat and Jean Baptiste Martial, the cathedral sacristan. In the confusion, the nurse gave the baby's name as Marie Pauline Berth (*sic*), while the curé's assistant forgot to record her surname in the official tome.[28] Yet the Prefect must have been satisfied. The baby lived, and after her emergency baptism the Morisots saw no need to request a public ceremony. But the crisis convinced them that Berthe was the most delicate of their daughters. Cornélie Morisot was constantly anxious and she fussed over Berthe for the rest of her life.

However, whatever his private emotions, Tiburce Morisot's more pressing concern was the political scene in Paris. Adolphe Thiers was out of office but his father-in-law's patron, François Guizot, was the new prime minister. As the two politicians in Paris played musical chairs for political power, the Morisots heard that Edme Tiburce was to be moved for a third time. He had been nominated for the Department of Haute-Vienne. They were to leave the prefecture of Bourges for Limoges that August. Berthe Morisot was just over six months old.[29]

The Prefect's Daughter

CHAPTER TWO

A Very Political Childhood

1841–52

Berthe Morisot's first recollections were set against the backcloth of Limoges, in the confined surroundings of the prefecture where she passed her early life in the company of her mother, sisters, nursemaids and governess. There is scant evidence of the child growing up in those first seven years, except through personal recollections, which were inevitably idealized over time. But in adult life, through their friends, especially Charles and Louise Haviland, who owned the town's leading porcelain manufacturing business, Yves and Berthe retained an attachment to the distant blue mountains of the Limousin.[1]

Cornélie Morisot's model of motherhood was of the progressive school, tinged with the enlightenment of Rousseau and the practical example of Louis Philippe and his queen, Marie-Amélie.[2] Kindness, they believed, made for loving and obedient children. Cornélie showered hers with affection, with pet-names and with kisses and caresses. So it is not difficult to visualize Berthe happily enjoying children's pastimes, drawing, colouring with pastels, listening to stories from Aesop's *Fables* and Perrault's *Tales of Past Time*, playing with her dolls – as she later lovingly portrayed her own child.[3] From the windows of the prefecture, hemmed into the ancient château quarter of the town, there would be passing views of municipal ceremonies; and inside the foyer stolen glimpses of the local big-wigs, dressed in their finery, arriving for one of her father's receptions. In 1845 and 1847, for instance, the king's second son, the Duc de Nemours, paid a formal visit to the town. It was the kind of occasion that tested the diplomatic skills of the Prefect and his wife. But for their children it was the stuff of fairy-tales.[4]

Religious festivals also played an important part in Limousin life. Berthe and her sisters would watch the ritual procession of the white penitents of Limoges for which the town was famous. On these occasions a young child, dressed in a simple sheepskin to represent St John the Baptist, led the way through the narrow streets from one church to another. Did the mental picture bury itself deep in her psyche, only to emerge very much later in three studies, the simple charcoal sketch, pastel and painting of a solemn-faced *Little St John*?[5]

In view of their father's position the Prefect's children lived restricted lives, although in the dense complex of streets people of all walks of life

lived cheek by jowl, the workers in their wooden dwellings alongside the stone houses of the bourgeoisie. And so, ironically, within walking distance of the prefecture, a boy just six weeks younger than Berthe, was living in crowded premises in the Boulevard Sainte-Cathérine which had been built on the line of the old town walls. He was the sixth child of a tailor and his seamstress wife. The boy's name was Pierre-Auguste Renoir.[6] Later, when mature adults, they were to meet as avant-garde artists of Impressionism. Later still they became devoted friends. But for the present, he was an artisan's son, she the Prefect's daughter, a social gulf wide enough to keep them irrevocably apart. Then, it seems, in the summer of 1845, when Pierre-Auguste and Berthe were both four, his parents decided to move to Paris in search of a better life.

Life was circumscribed, even for the children of the wealthy. There would be occasional excursions into the countryside but otherwise the family was expected to be in residence all year round, except when they were on official leave. Then, if all went well, it was off to Brittany for the annual holiday. Berthe grew to love the wild, rugged scenery of western Finistère. When she was five, in 1846, they stayed at Sainte-Barbe close to the Elorn estuary: she remembered clearly being butted by what she took to be a cow! Another time she stayed with an eccentric Madame de Trobriant in Brest.[7] Sometimes they faced the tedious journey back to Paris by road, since Limoges was not yet linked by railway. Although travel in the prefectoral carriage would not be as exhausting as the two-week stage-coach journey endured by the Renoirs (who had to put up with 'unbearable heat in that rolling box . . . ventilated only by a small window'),[8] it would still be very uncomfortable. But at the end Berthe and her sisters could look forward to seeing their grandparents again.[9]

For Monsieur Morisot it was important to use the time to show his face in the rue de Grenelle, to ingratiate himself with his superiors in the Ministry of the Interior and to confer with his father-in-law in the Finance Ministry.[10] He needed to be sure that his fortnightly or monthly reports on the Haute-Vienne were receiving ministerial approval. Prefects were judged on the contents of these reports and sometimes even on the manner of their presentation. An inefficient, complacent, or indecisive Prefect was likely to lose his job. An over-ambitious or partisan one could be transferred, demoted, or, *in extremis*, dismissed. Morisot was in no doubt as to what was expected of him.

Apart from the exceptional circumstances of a general election, when it was his responsibility to ensure an outcome favourable to the government, he had to keep a watching brief on a range of matters, from popular opinion and the activities of the press to the behaviour of industrial workers, the police and his own sub-prefects. Commerce, industry, agriculture, strikes, droughts, epidemics and a host of social issues came within his brief. And

besides, he was expected to contribute handsomely to local charities and maintain good relations with the notables, the judiciary and the Church. Prefectoral receptions and soirées were a regular feature of the calendar and admission much sought after by the town's social climbers. But they also gave the Prefect the opportunity to demonstrate his departmental loyalty and commitment to the department to those who mattered: the municipal councillors, magistrates, military, tax officials and so forth – and their wives.[11]

To some extent Prefects were also judged by their wives and families. Back in the rue de Grenelle their private lives as well as their opinions were kept under review.[12] It is fairly clear that on a personal level Tiburce and Cornélie Morisot had nothing to worry about. An attractive, loyal and accomplished wife (a reasonable description of Cornélie), together with a few, well-brought-up children (three or four were a sign of stability in a marriage), were regarded as a credit to the husband, just as a difficult, ugly or domineering spouse was considered a disability. Fortunately, the Morisots presented a united front. From all accounts they performed their social duties with grace and tact, managing not to offend. The proof that Morisot had satisfied his superiors came on 29 April 1846, when Berthe was turned five. Her father was promoted to an *officier* of the *Légion d'Honneur*, the rank a Prefect could normally expect to achieve by the height of his career. But there is a family anecdote which underlines her mother's popularity too. The offices in the prefecture employed two elderly brothers, inappropriately named Lajeunesse. When Louisa, the children's English governess, politely asked after the health of one of them, he replied that he had felt quite ill that morning until he saw *Madame la préfète* go past, after which he felt much better! Years later, Berthe Morisot confirmed that her mother was 'the picture of youth and happiness' when they were living there. They had been made very welcome in Limoges.[13]

Meanwhile, Limoges was associated with another important family event. On the morning of 11 December 1845, a month before Berthe's fifth birthday, her mother gave birth to the much-awaited son and heir. The baby was registered by his father that afternoon as Marie Charles Tiburce Morisot in the presence of the first president of the royal court of Limoges, Tixier Lachassagne, and Pierre Mazard, the mayor of the town. He was always called Tiburce after his father.[14] We can guess the effect of the infant's arrival on Berthe. For almost five years the petted baby of the family, she found herself displaced by a little brother. She felt uncherished and unloved for the first time in her life. It was the oldest syndrome in the world. Inevitably she was left more and more in the care of her governess. Louisa is a shadowy figure who comes over as a decidedly plain, pious, no-nonsense English girl, who instilled a love of Shakespeare in her charges. Doubtless life had taught her to be hard: she appears to have equated sensitivity with weakness, in the worst Victorian tradition. She was

competent but not the most compassionate of carers for an impressionable child. Berthe recalled that she 'gave me courage to suffer alone and in silence. When I was quite small, I used to cry sometimes in bed, but she pretended not to hear, never consoling me.'[15] Yet in recalling her days in Limoges, Berthe never directly linked the town with these unhappy memories.

That the Morisots felt comfortable in Limoges may seem surprising in view of the town's reputation. It had been called the '*ville rouge*' – the Red City – originally because of the maze of red-tiled roofs inside its walls. Later the term acquired a more sinister meaning: it became a radical, revolutionary city.[16] Either way, it was considered a dirty, somewhat squalid place. As a rapidly growing, manufacturing town – the chief industry was porcelain – Limoges lacked fine buildings and monuments. Its cathedral was no match for that of Bourges and it was turned down twice for the title of '*bonne ville*', giving the citizens a distinct sense of inferiority. In fact, Limoges was a city of simmering divisions, between rich and poor, church and state, middle class and workers, and since 1833 a republican 'tendency' had developed, stirred up by an articulate young lawyer, Theodore Bac. In that year, when a new but unpopular prefect arrived to take up residence, his carriage was pelted with rocks, then almost overturned by angry crowds.[17]

But if Morisot knew this was a difficult department, he came with a reputation for being a tough Prefect who could keep control. All the same his reports indicated his deep concern over the existence of radical groups in the area. They needed careful monitoring, he believed. In 1846 a major economic crisis hit France. By 1847 the price of basic foods like bread soared; and there was widespread unemployment. In Limoges bitterness among the working class was stirred by the class structure of the town's National Guard. It was not Morisot's fault but it was to weaken his power of defence, particularly when the town's mayor and deputies resigned. That autumn he warned the Interior Ministry that there were rumours of hordes of socialists gathering secretly at night in the forests around the city. Yet the police and judicial authorities were not encouraged to do anything about them. Limoges was copying Paris, where there were serious rumblings of opposition to the monarchy and Guizot's government. Early in 1848 – just before Berthe's seventh birthday – a banquet was held in Limoges in honour of the veteran left-winger Pierre Leroux. It was a sign of the times: a thousand radical citizens attended. It seems that Tiburce Morisot, no more or less than the politicians in power, failed to foresee the coming of another French Revolution in February 1848.[18]

By the time news reached Prefect Morisot on 25 February of King Louis Philippe's abdication and the declaration of a republic after three days of rioting in the capital, Limoges was in the throes of its own revolution. He appointed a new mayor but the town council was ineffectual. When the

porcelain factories emptied at noon that day, the workers gathered on the Place de la Liberté, some blocks from the prefecture. The republican ringleaders had declared themselves a provisional committee of administration. A deputation led by Bac came to see Tiburce Morisot demanding information, but he could tell them nothing because crowds had attacked the mail-coach from Châteauroux, and later the courier, arriving from Angoulême with a telegraph message from Paris, was also seized.

Throughout the winter's afternoon and after nightfall, gangs ran around the town chanting slogans and singing revolutionary hymns. The noise must have carried to the bewildered children in the prefecture. While they were in bed, under cover of darkness, people burst past the guards into the prefecture and forced their way into Monsieur Morisot's office. Showing a blend of firmness and moderation, he tried to reason with them, but the die was cast. Without military protection, he feared that he and his family might be manhandled by the mob like aristocrats in the first French Revolution. Louis Philippe and his family had fled to England on 24 February, so as the king's representative, Berthe's father had no choice but to capitulate to the popular demand for his resignation. The next day the Morisots packed up their possessions. On 27 February, while the crowds celebrated an official holiday, Tiburce Morisot, with his wife and four children, hurriedly left for Paris.[19] Soon after, the provisional government in the capital abolished the prefectoral system, replacing it with a series of new official *commissaires*. At a stroke, Morisot's circumstances were transformed. He had lost his Prefect's income, his official residence and his career prospects. His immediate future was very uncertain. And as France embarked on radical political and constitutional change, the country rapidly collapsed in turmoil.

The Morisots found an apartment in the Cité Vindé, a newly built cul-de-sac close to the Madeleine and the Place Vendôme. It was very central, on the edge of the quarter of Paris which included the Louvre and many of the government offices.[20] As such, it was safe from the violent confrontations between the urban crowds and the Republican troops of General Cavaignac in what came to be known as 'the June Days'. The nearest points of conflict were to the east, along the Boulevard Saint-Martin and around the Hôtel de Ville. But the Morisot household may well have heard the gunfire and it was an uneasy time, particularly disturbing for a seven-year-old, uprooted from the only home she had ever known. In response, Berthe clung to Louisa, whom in her helpless innocence she still adored: 'I had loved her as only children can, and I believed her to be perfect, you understand, *perfect*.'[21] Yet with hindsight her governess's limitations were increasingly apparent. Louisa probably added to her heightened sense of insecurity which had brought those tears of self-pity welling into her eyes at bedtime. However, in that summer of political upheaval and vicious street-fighting, Berthe's misery went unheeded.

The events of 1848 which produced the Second Republic and then tested

its foundations were so deeply confused, so riven with economic crisis, bitterness, depravity and bloodshed, that they lie for the most part outside the parameters of this life story. But two psychological strands emerged to affect the thinking and behaviour of people like the Morisots and the Thomases. First, a deep-seated fear and mistrust of the urban working class, whom they regarded as anarchists and 'Reds', dedicated to the destruction of society. And secondly – since it was no good looking back over one's shoulder at Louis Philippe and the Orleanist monarchy, and since one had to live and eat and feed one's family – a pragmatic mentality, an acceptance of the need to come to terms with the existing regime.

Berthe would have been far too young to understand this response at the time, although Louisa apparently took a hand in her political and moral education. On Berthe's own admission, she induced in her 'an absolute faith, even in miracles'. It is not clear how this squared with her other legacy, for in the guise of history lessons she also introduced her young charges to the spirit of the Great Revolution of 1789: Liberty, Equality and Fraternity.[22] It may have been a misplaced regard for her host country, but under the circumstances of 1848, it was not the most tactful thing for Louisa to do. On the other hand, teaching about democracy might have been the kind of act of subtle subversion to which frustrated, foreign governesses were prone.

Of course, it is anybody's guess how much a seven-year-old could take in about political principles. Berthe claimed to have learned something: never to mock the afflicted and to be fair and tolerant towards others. But in the medium term, at least, the political lessons of Louisa could only have stored up trouble for her and her sisters. In the cultivated but conventional circles in which Yves, Edma and Berthe grew up, family discussions reflected a different viewpoint. A complex mind-set operated: bourgeois mistrust for equality, deep-seated cynicism for fraternity with the labouring classes and a longing for social order, only modified by rare flashes of utopian idealism. So much for the political views of her parents' generation.[23]

In the meantime, Monsieur Morisot's main concern was to secure another position. Much petitioning went on from the Thomases to the powers-that-be, particularly after May 1848 when the Republicans decided to bring back the Prefectoral Corps. The Morisot–Thomas persistence paid off, thanks again to Joseph Thomas's friendship with François Guizot. Although as Louis Philippe's chief minister, Guizot had been dismissed at the Revolution, he was a long-standing deputy for Calvados in Normandy and still had a network of personal connections there. It was the custom for ministries to take local petitions seriously, especially when they were choosing personnel. Then, just as Tiburce Morisot's future was being decided, a new figure appeared on the political stage. In December 1848 Prince Louis Napoleon, nephew of the Emperor Napoleon Bonaparte, was elected as President of the Second French Republic.

At first people underestimated the man. In a moment of political aberration, even Thiers, Morisot's old patron, dismissed Louis Napoleon as a cretin, but fortunately this misjudgement was overlooked in the scurry of political activity. Happily, too, the new administration dismissed some zealous Republican Prefects and re-employed experienced Orleanists. On 10 January 1849 Tiburce Morisot was nominated to the Department of Calvados. The reorganization of the prefectoral system, including the salaries and allowances, put Calvados in Class 4 (like Haute-Vienne) with a salary of 16,000 francs a year and an expense allowance of 57,000 francs, considerably more than he would have received at Limoges or Bourges. His personal fortune had also risen to 10,000 francs. The Morisots were back in business. . . .[24]

If Cornélie had plans to link the celebration of Berthe's eighth birthday with a general family festivity, they would have gone by the board because there was just a week before Monsieur Morisot's installation at Caen. The prefecture was to be enlarged and improved a few years later during the Second Empire, so in 1849 it may have disappointed Madame Morisot. And there was the children's education to sort out. About this time Louisa left their employment, so Yves, Edma and Berthe had to adjust to a new governess, who came from the town. Years later, Berthe Morisot chatted in fond terms to her daughter about Mademoiselle Félicie. But for all that, when retracing the footsteps of her mother and aunts, Berthe's daughter described Caen as a sad, rather grim-looking place.[25]

The truth is that Calvados was a conservative region. Its citizens were known to be more interested in making money than indulging in politics. In this sense it was a safe department to be sent to: unlike the Haute-Vienne, it had not been active in the 1848 Revolution and there was no great difficulty in ensuring the return of conservative deputies. As an experienced Prefect, Morisot quickly resumed the customary round of social duties. His main tasks were to ensure law and order and demonstrate his loyalty to the new regime of the prince-president by cultivating the support of the solid bourgeois of Normandy. Morisot spent a good deal of time doing this, and doing it reasonably successfully. He earned quite a reputation for being tough on potential troublemakers and social riff-raff. Itinerant tinkers and pedlars were his *bêtes noires*. He made speeches, attended functions and, in October 1851, presided over the inauguration of the equestrian statue of William the Conqueror at Falaise, in the company of François Guizot.[26]

After his escape from the hands of the Limoges radicals, Tiburce shared Louis Napoleon's abhorrence of left-wingers and the declared policy of firm government. It is just conceivable that like Thiers, his patron of the Orleanist years, he suspected the prince-president had designs on becoming emperor. But he was far too experienced a political hand, far too much of a

public relations expert, to rock the departmental boat. Besides, he had little quarrel with the policies being introduced in 1850 and 1851: the new laws to hand over the appointment of primary school teachers to the Prefects, to curb the press and reduce the electorate so that it reflected bourgeois opinion and cut out the dangerous classes.

Then in September 1850 Tiburce Morisot had the opportunity to demonstrate his unswerving loyalty. It was also a prized opportunity for Cornélie Morisot to display her social graces, while the children's excitement must have reached fever pitch when the announcement came that the President of the French Republic himself was to visit Calvados and to stay overnight at the prefecture in Caen. The visit was part of a series of presidential tours to woo popular support for his re-election. But for the young Morisots, it would be a tale to tell and retell, a rare chance to see the most important man in France. Meanwhile, it involved their father in a great deal of preparation and wheeler-dealing with the municipal council, before Wednesday 4 September, when he drove in his dress uniform to the village of Hôtellerie, on the border of Calvados and Eure, to greet the presidential retinue.

Caen gave Louis Napoleon a flattering reception. After a stage-managed passage through Lisieux, the president's carriage, accompanied by Prefect Morisot and ministerial officials, reached the departmental capital late in the day. A magnificent triumphal arch had been erected at the entrance to the town. All the houses along the main roads were decorated with flags and bouquets. The tree-lined streets were draped with garlands of flowers. Clean, fine sand had been sprinkled along the route, which was lined with troops and National Guardsmen. Cannon fired a salute as the procession made its way towards the prefecture and a huge crowd was there to greet the president with cries of '*Vive Napoleon!*'[27]

That night the president responded formally to his welcome by hosting a reception and banquet at the Hôtel de Ville to which the Morisots and some 300 guests had been invited. In replying to the speeches, the president promised firm government and indicated his intention to stand as a candidate for the presidential election in 1852. His words were received enthusiastically, although the constitutional implications did not escape the more astute members of his audience. As was customary, the president then rounded off the evening by attending a grand ball held in the town's theatre. The following morning, after reviewing the troops and National Guards, escorted by Prefect Morisot, his cavalcade left the town for its next destination, Cherbourg, in the neighbouring Department of Manche.

After this successful mustering of public support Tiburce Morisot, like most of his fellow Prefects, worked energetically for the revision of the Republican constitution to allow the re-election of Louis Napoleon for a further term in office. So it was like a bolt from the blue when he received a

communication from the Minister of the Interior at the end of 1851. Accusations had reached ministerial ears of Morisot's equivocation on the question of changes to the constitution. The fact that Louis Napoleon and his inner circle were engaged in schemes to overthrow that constitution was immaterial. The Duc de Morny, the president's half-brother and his new interior minister, could not take any risks on prefectoral loyalty. The government swooped on fourteen unfortunates, including Tiburce Morisot. A decree of 26 November singled them out for dismissal or transfer.[28]

Five days later, on 2 December 1851, a pre-emptive military *coup d'état* gave Louis Napoleon sole authority in France. Even so, the loyal Prefect Morisot continued to do his duty. On 6 December the people of Calvados awoke to see patriotic placards plastered in public squares signed by their Prefect.[29] They announced his gratitude for their calm devotion to duty in supporting the Napoleonic coup. The timing of Morny's response was cruel. On the same day Morisot's appointment was formally revoked, four days after Thiers and others had been arrested and thrown in prison. Now, for a second time, the world of the Morisot family was falling apart. . . .

The coup had been accompanied by violence in the streets of Paris in which 30,000 troops shot or bayoneted the resisters, killing over 300 'Red' Republicans. Inevitably innocent bystanders were also caught up in the fighting, including a young bourgeois artist, Edouard Manet. He and a friend, Antonin Proust, were saved from a cavalry charge by the prompt action of a picture dealer in the rue Laffitte. Believing art was nothing if it did not capture real life, Manet went on to sketch the corpses at the Montmartre cemetery, though he was repelled by the carnage. So, too, was his brother, Eugène, who subsequently wrote a novel around the brutal sequel to the coup.[30] This was not the last time that the two brothers witnessed such bloody scenes.

Meanwhile, the Morisots were shocked for a different reason. News of his suspension stunned and affronted Tiburce Morisot. His father-in-law was equally appalled, as were the notable citizens of Calvados. A concerted protest at the slur on Morisot's loyalty was launched by officials, mayors, judges and councillors, who had found him an admirable figure. After all, hadn't Monsieur Morisot's uncle served as a general in Napoleon's army? And hadn't Madame Morisot's great-uncle fought and died for France? One angry veteran of Austerlitz, a retired colonel who had been decorated at the age of twenty-two by the great Napoleon, and was still serving his country as Mayor of Airan and a general councillor of Calvados, wrote passionately to the Ministry of the Interior on Prefect Morisot's behalf. 'I declare that the government of Louis Napoleon goes contrary to its own interests in removing from this Department the man who by his sheer ability and noble conduct thoroughly deserves popular esteem, the man who more than any other, can encourage popular enthusiasm for a plebiscite and draw the sting from the opposition.'[31]

It was probably the reference to Morisot's potential role in the plebiscite which jerked the government back to its senses. A national referendum on Louis Napoleon's position was due on 20 December. The malicious and unsubstantiated accusations against Prefect Morisot were dropped. The revocation was not confirmed, implying that (as everybody had said in the first place) it had been a mistake. But despite this vindication, the traumatic effect of those critical days on Cornélie Morisot and on her three girls, Yves, Edma and Berthe, must have been considerable: sufficient enough for Prefect Morisot's granddaughter to remember her mother's sorry recollections and to remark wistfully over forty years later, 'I know Mother [i.e. Berthe Morisot] always spoke of her childhood years in this prefecture in the saddest terms.'[32]

However, for the time being, all was not lost. On 9 December 1851, Tiburce Morisot was reinstated and nominated for another northern department, that of Ille-et-Vilaine in Brittany. Financially he was still secure. There was no difference in the status or salary (that had risen to 30,000 francs in line with another government review); merely a slight reduction in his allowance, reflecting the different social environment. A couple of days before the plebiscite and a week before the celebration of Christmas, Berthe's father was installed in the prefecture of Rennes.[33]

On the face of it, this should have been a happy time. But much as the Morisots liked the Breton landscape, Tiburce Morisot sensed from the start that there was an element of exile in his transfer to Brittany. Rennes was a western outpost. Largely rebuilt after a disastrous fire in 1720, it boasted some fine architectural features. However, the atmosphere in the city was one of cold, isolated dignity. The turbulence that had soured his family's life in Caen still haunted him. His predecessor in Rennes had also been turned out and had left a great deal of undone business. Morisot discussed the problem with Berthe's grandfather back in Paris. With a protective eye always on his son-in-law's career, Joseph Thomas learned that there was a sudden vacancy in the nearby prefecture of Seine-et-Oise. He wrote courteously but expectantly to Persigny, the new interior minister, reminding him that the Calvados incident had been a regrettable error on the government's part and also pleading the convenience to the Morisot family in view of the advanced age of Monsieur Morisot's mother. (She was over eighty.) But his request was clear, not to say blunt: '*Je désire pour mon gendre* [son-in-law] *la Préfecture de Seine et Oise.*'[34]

Then a number of crucial developments occurred, even before Berthe and her sisters – with Tiburce junior – had started to settle into their new home. At the beginning of January 1852 the government banished their father's mentor, Thiers, from France because of his political opposition. On 23 January Louis Napoleon announced his intention to confiscate all the property belonging to the Orleanist royal family in the name of the state.

This was a provocative act, designed to stake his imperial claims and to flush out Orleanist supporters. But it angered and alarmed the propertied classes. One of Tiburce Morisot's responsibilities was to carry out a survey of local reactions. He himself deplored such an attack on property, but since he had been in charge only a month, it was difficult to anticipate the views of his Rennes constituents. Two reports, written on 25 and 27 January and hastily signed, were sent to Paris, detailing the objections of the people of Ille-et-Vilaine.[35] Just as the second unwelcome report dropped into the minister's hands, Joseph Thomas's forthright request of 30 January also landed there. Suddenly everything had miscued. Persigny was a ruthless and authoritarian man. It proved a horribly inept political miscalculation.

Once again the Morisot children would be shielded from the dark realities, but their father's future was now uncertain. Tiburce Morisot's superiors considered that he had overstepped the mark in showing insufficient loyalty and zeal towards the regime. If there was any consolation, it was that he was not alone. On 9 May 1852, with five other Prefects and nineteen sub-prefects, he was dismissed from office. But this time there was no public outcry in his defence. The common factor was that all the dismissed men had dared to express some resistance to the will of the government. Or, to put it more cynically, they had lost their political antennae.

There was time for the shock to sink in before they moved. Time for Tiburce Morisot to make urgent appeals to Joseph and Caroline Thomas. Time to organize the packing of the china, the crystal, the household linen, the silver plate and the personal items of furniture, not to mention the portmanteaux of clothes which a family of six normally acquired. Morisot's replacement, Prefect Chévillard, did not arrive until the high summer.[36]

By then it was clear that Louisa had been wrong to rely on miracles. There would be little prospect of an official residence again, no more grand balls and receptions, no more private coachmen and liveried servants . . . and for Berthe no more stolen hours peeping through the balustrade at the arrival of the notables of the department. Monsieur Morisot's fine dress uniform was folded away in mothballs. Life in the prefecture was over for ever. But there may have been a *frisson* of anticipation as Berthe left Brittany with her parents, sisters and brother at the beginning of July 1852. A bright, observant child, with nut-brown hair, she was now in her twelfth year. She looked at the world with a powerfully dark gaze.

The Education of a Genteel Revolutionary

1852–8

The next twelve months were in the nature of a transition for Berthe. She became an outsider. The close companionship with Yves and Edma, which she had always taken for granted, came to a halt and for the first time a gulf opened up between them. It was neither her fault nor theirs, and the gap did close again. But in October 1852 Yves had her fourteenth birthday, and two months later Edma turned thirteen, passing the age of their first communion. (The Morisots, like most of their class, were occasional conformists, so they would observe such religious milestones in the proper manner.) In point of fact Yves and Edma had reached the age of puberty, when little girls became women: the time to finish with pigtails, put up the hair and lengthen the skirts, as well as to adopt a whole new regimen that had the effect of changing a lively child into a modest, silent virgin sometime after the age of thirteen. Berthe, meanwhile, was still a happy-go-lucky youngster.

The Morisots' new home was in Passy, a pleasant village that was already taking on a suburban character. Tiburce Morisot had decided against installing his family in central Paris; perhaps the violence of 1848 and 1851 was fresh in his mind. Besides, the inner city – even parts of the First Arrondissement – was hopelessly overcrowded, cholera-haunted, insanitary and unsafe, with pockets of unspeakable squalor like the half-cleared Place du Carrousel, a 'cut-throat den', according to Balzac, which housed young Pierre-Auguste Renoir, along with countless other poor provincial migrants.[1] The Morisots were not poor, but with a pension of only 2,819 francs a year after Tiburce's dismissal, they needed to be sensible.[2] The fashionable districts, the Faubourg Saint-Germain, the Chaussée d'Antin, or the Faubourg Saint-Honoré would have been out of the question.

Fortunately, with the benefit of his connections Tiburce was able to secure another post. It was a financial appointment (this was not unusual for an ex-Prefect) but he was lucky that the government was anxious to stimulate the economy and sponsor some commercial initiatives in 1852. A new mortgage bank, the Crédit Foncier, was formed early that year with a

subvention from the Finance Ministry of some 60 million francs. Tiburce Morisot became its secretary-general. The move was not popular with the traditional world of high finance which had flourished under Louis Philippe, but the post would tide him over until something more to his liking became available. With his growing family he looked to the more salubrious area to the west of the capital, instead of taking a city apartment. Passy fitted the bill perfectly.

It was accessible to the city, but there was still a rural atmosphere that recalled the days when Voltaire came to take the waters. Then, it was a sprawling settlement of old pavilions with just a hint of Marie Antoinette's *hameau* at Versailles: mostly unpretentious houses with white walls and tiled roofs, lining the rue Raynouard or the rue de Passy. One cluster of seventeenth-century villas, known as Beauséjour, was becoming popular as the summer retreat for wealthy Parisians. But allusions to an aristocratic past still lingered: the Duchesse de Berry at the Château de la Muette, the hôtels of Madame de Pompadour and the Princesse de Lamballe. La Muette was but a name since its destruction in 1825, and from 1847 Dr Emile Blanche lived at the Lamballe residence, which was also his medical clinic, while Berthe was soon to become friendly with the Carré sisters at the Villa Fedor on the Grande Rue where Pompadour had lived. Monsieur Morisot, in the meantime, arranged to take a house in the rue des Moulins, at the corner of the rue Vineuse, which he furnished with family heirlooms, some fine First Empire pieces belonging to *Grandpère* Morisot.

Both the rue des Moulins and the rue Vineuse were old country roads which had only recently been improved. When the Morisots came, the incline near the Trocadéro was lined with trees set in alternate rows; a trio of windmills had once turned on these slopes. A short distance away, by the city walls, stood the Convent of the Bonhommes de Chaillot, where Louis XIII had often stopped for a drink of wine on his way back from hunting wolves in the Bois de Boulogne. As late as the 1830s when Lamartine, the Republican poet-politician, visited the popular song-writer, Béranger, in his little house in the rue Vineuse, the built-up area gave way there to ploughed fields stretching all the way to the Bois.[3]

In many ways change was in the air. Louis Napoleon, who skilfully elevated himself by plebiscite from president to emperor in December 1852, was determined that Paris should be a worthy capital for the newly established Second French Empire. One of his first projects was the transformation of the old state forest of the Bois de Boulogne, famous then for duelling and for suicides, into a superior version of London's Hyde Park, a massive municipal leisure centre for the people of Paris, with lakes and waterfalls, trees and shrubberies and curving carriage drives. And on its western flank, once marked by a hideous wall that shut off the Bois from a view of the Seine and the plains beyond, the new race-course of Longchamp

was to be built. All this, together with the necessary approach roads, like the avenue de l'Impératrice, took some five years of planning and construction. But the outcome, for the residents of Passy, was a magnificent playground where they could stroll or take a ride, go boating, feed the swans and skate in winter. No wonder a contemporary journalist remarked, 'There are Parisian ladies who would certainly die every evening if they could not take a drive around the lake each day. For them it is no longer a mere habit, it is a necessity.'[4]

For Berthe, too, it became a kind of emotional necessity. (Much later her friend, Mallarmé, would tease her about it.) The renovation of the Bois happened before her eyes while she was growing up: she was sixteen when it was finished. Her fascination for the parkland paradise stayed with her from those teenage years through to middle age, when it inspired some of her most evocative open air drawings and paintings, such as *Walk in the Bois* (1873–4), *Summer's Day* (1879), *avenue of the Bois under Snow* (1884) and *Effect of the Sun Setting in the Bois de Boulogne* (1894).

In the meantime, Madame Morisot wanted to see her children settle down and find their social feet quickly. In the buoyant capital dancing of every kind was all the rage. Public balls had crept in during Louis Philippe's reign but now they escalated as if Parisians were seized with uncontrollable frivolity. Balls for the masses drew the crowds, along with the café-concerts and the circus of Les Franconi, to the rue de la Chaussée d'Antin, the Champs Elysées, and the Salle Valentino in the rue Saint-Honoré, where in 1852 a student-artist, Edgar Degas dared to venture to a masked costume ball.[5] On the other hand, these were not the kinds of places for respectable *jeunes filles.* And even a decade later Berthe and her friends were ordered to keep clear of the streets beyond the avenue Bugeaud, a newly developed area of Passy frequented by acrobats and other performers from the Hippodrome. Shades of the beggars and pedlars of Caen![6]

Ballet, however, was a different matter. Aesthetically, it was respectable. The great stars of the 1840s – Elssler, Grisi and Taglioni – had waned, but the golden phase was still burnished bright in the persons of the radiant sixteen-year-old, Emma Livry, and Fanny Cerrito, the blue-eyed prima ballerina of the Opera, whose marble skin and gleaming hair set the standards for feminine beauty throughout Berthe's adolescent years. Three months after the Morisots came back from Rennes, Fanny Cerrito, dancing with her famous husband, Saint-Léon, gave a scintillating gala performance before Louis Napoleon and his guests. Shortly afterwards, on 29 December, she danced the title role in a glittering new ballet, *Orfa,* in honour of his elevation as emperor. In the following year Louis Napoleon's consort, the titian-haired beauty, Empress Eugénie, confirmed the imperial patronage of the Opera ballets.[7]

Ballet, with its themes of antique bacchanals, myths and legends, gripped the public imagination in the 1850s. So, too, did any excuse for dressing up.

In the drab winter days of 1853 Cornélie Morisot decided to hold a fancy dress ball for her daughters. Mardi Gras or Lenten Eve was the traditional time for such revelries, but the mid-Lenten break in March – *Mi-Carême* – was a favoured alternative for those with a full social diary. Indulgent parents took pride and pleasure from introducing their young to the carnival, and balls for ten- to fifteen-year-olds were part of the social calendar in wealthy bourgeois circles. The young copied their elders, dancing cotillons, quadrilles and polkas to the accompaniment of a trio of musicians or even a small orchestra. On this occasion Madame Morisot sent out invitations for *Mi-Carême*, and, as was the custom, she went to considerable trouble over her daughters' gowns, which were classical in style, both flattering and modest. Yves wore a costume of the elegant Directoire period. Edma went as a Greek priestess of the god Bacchus, and Berthe, who had just turned twelve, wore the simple dress of a young Greek girl. In terms of design, all three might have stepped off the bas-relief of a Greek vase. The occasion went down in family annals as a great success and happily the three Morisots were a 'sensation'.[8]

Vivid recollections of this ball remained with Berthe for years. In 1885 she went so far as to re-create the occasion by throwing a ball and dressing her daughter in a similar classical Greek gown.[9] And Berthe's love of dancing was confirmed by a chance remark made by Julie Manet when holidaying in Brittany ten years on. 'In the evening a young English girl and her sister dressed in Breton costume danced a very pretty Scottish dance . . . I was thinking of Maman who very much loved dancing ("ballets") and would have watched (this little girl) with pleasure perform her neat and delicate steps.'[10] What better proof that Berthe had retained a love of ballet, a joy in traditional dancing and dressing up, which she had imbibed in her youthful days in Passy.

Pleasure apart, however, Madame Morisot's other preoccupation was her daughters' education. Here she faced three choices. She could continue to raise them at home, with or without the help of a governess and some private coaching. She could send them to boarding school to finish their education, to a select convent like the Ladies of the Sacred Heart in the rue de Varennes; or to one of the 183 secular establishments available in Paris itself – and there were a further 70 in the Department of the Seine. Or she could send her daughters to one of the private and secular day schools, the *cours* for young ladies.

The Morisots, it should be remembered, had some experience of governesses. Louisa had encouraged her young charges to read, as well as introducing them to Shakespeare, whose plays were enjoying a vogue in Paris during the late 1840s while she was in the Morisot household. She had also taught them some basic English. Mademoiselle Félicie had built on the literary foundation and added some French history. Berthe had also learned

the rudiments of pottery-making from Louisa, who by chance implanted a tactile seed in the child's experience which was later to come to fruition. Whether the two governesses fully met the requirements of the Morisots is a moot point. It was still fashionable for young girls to be taught by a governess and there was a certain cachet in having an English 'Miss' or a Swiss or German 'Fraülein'.

It is impossible to know what guided Cornélie Morisot's decision. Her own lasting love of music, embroidery and reading might suggest a convent influence, but her early learning was at home, where she was taught to spell and read by her determined mother, before being sent to a boarding school.[11] Evidently Cornélie's education differed from her mother's at the secular imperial establishment – later Maison Royale – founded in 1809 in the former Benedictine abbey of Saint-Denis. There the curriculum had been quite formal and demanding. Berthe's grandmother, Marie-Caroline Mayniel, had learned some science and modern languages as well as the three 'R's, history and geography, on lines laid down by the celebrated headmistress, Madame Jeanne Campan. However, since the passing of the so-called Law Falloux in 1850, pressure had mounted in favour of religious education and many secular boarding schools were reduced to primary institutions. Whether it was the prospect of losing her daughters' company, or whether there was a financial problem, remains a matter of conjecture. (No amount of pleading on Tiburce Morisot's or his father-in-law's part could persuade the authorities to raise his pension.)[12] It may even be that Cornélie Morisot had a positive motive: she approved of the *cours*. Mothers who accompanied their daughters daily to and fro could attend the classes and feel actively involved in their children's learning; they could make sure that the day school harmonized with their own personal instruction at home.

Berthe, like her sisters, was chaperoned to a select private establishment known as the Cours Adeline Désir, which had been opened in 1850 at 33 rue de Verneuil, on the Left Bank. The proprietor, Mademoiselle Désir, was the daughter of a tanner from Arras, who had realized that there was a market for a meatier form of education than the finishing school offered and a gentler, less intimidating, altogether more useful experience than many boarding schools provided. Her philosophy was based on the bourgeois model of womanhood. It was down-to-earth and serious: she believed, quite simply, that the best heads are those which it is least easy to turn. Her methods gave her students a general culture which was based on Catholic values. There were lessons in social etiquette and academic teaching on arithmetic to help with household accounts, grammar and syntax, reading, a little history, geography and natural science. There was also a practical side to the curriculum. Handwork lessons in knitting, sewing, crochet, pastel drawing and painting were taught, while music was

strongly encouraged, especially piano-playing. Such was the *Cours d'enseignement moderne*, as Mademoiselle called her educational programme. It prepared young ladies to be reasonably well read and well informed, accomplished and socially at ease rather than simply modest and demure.[13]

At some point between 1853 and 1856 Berthe also attended another *cours*, the well-established institution of Monsieur Daniel Lévi-Alvares at 17 rue de Lille, the street running parallel to the rue de Verneuil. It is unclear whether this was before or after the Cours Désir, but their brother Tiburce could recall the three girls in their short capes, long skirts and bonnets with strings tied under their chins, making their way to and from the rue de Lille.[14] The *Cours d'éducation maternelle* was the last word on 'cultured motherhood'. Encyclopaedic enough to meet the needs of rich young things, it was also superficial in scope. But the establishment was run on civilized lines and was geared to genteel practicalities. The education was unthreatening in its academic demands and of short duration so there was no clash with summer holidays when there was a general exit of the bourgeoisie from the city. The Cours Lévi enjoyed considerable kudos and, like the Cours Désir, was elitist but positive, even progressive at the time. Both, however, assumed a conventional role for women.[15]

The assumption underlying all female education was that it should prepare girls for marriage and motherhood. Women, even intelligent women, by and large accepted this in the mid-nineteenth century, along with the inequality of their status, so it would be pointless to refute or fulminate against the social constraints implied in their education. Sixty years later it was a different story for Simone de Beauvoir, who also attended the Institut Adeline Désir. Despite her academic prowess, with hindsight she found the Cours Désir a sterile experience and she was to react robustly to its philosophy.[16] In fact, Cornélie Morisot's generation were perpetuating something with which they could see little wrong; they revelled in a day school system which allowed the presence of mothers and reinforced the family unit. Nor was there much sign of their daughters rebelling against the model of cultured motherhood. Berthe Morisot and her sisters were essentially conformists.

To take a small example of sex discrimination which was practised and tolerated: the best schools for girls employed artists to teach their pupils the basic skills of drawing and painting. However, females were invariably limited to certain media – pastels and watercolours. Oil painting, by its very appearance, smell and technical difficulty, was considered impractical and harmful to health. They were also limited to certain subjects. Myth and history were considered male genres. Girls were thought to excel at miniatures and small-scale works, particularly still life, a familiar domestic artefact, a single specimen of fruit, a bloom, or a nosegay of flowers.[17] The test of a young girl's artistic talent lay in scrupulous copying (of Redouté's

roses, for instance), just as the more academic forms of study at the Cours Désir emphasized rote-learning and accurate memorization.

There were dissentient voices, to be sure, particularly as the century progressed. In the 1840s socialist sympathizers had pressed for special secondary education for girls but these feminists had been routed in the mood of reaction after the collapse of the Second Republic. In the 1850s the social analysis of which Balzac was a master, and the kind of questions raised by Gustav Flaubert's *Madame Bovary*, with its exposure of the hollowness of bourgeois life, had little impact on public opinion. Although Cornélie Morisot wanted to see her daughters developing their talents, she was not thinking of a serious intellectual education. Their studies would be in the context of a prescribed moral formula, and *that*, as the Comtesse de Bassanville had proclaimed in 1850 in her novel *Hope and Charity*, could be summed up in a simple rule, that happiness existed for women only in the performance of duty and the joys of a family.[18]

However, this stage of life was still some time away for the Morisot girls. Their immediate concern was to polish up a range of social accomplishments: deportment, etiquette, music, dancing, drawing, painting, tapestry work and embroidery, which was somewhat euphemistically called 'painting with a needle'.[19] In actual fact, only Yves showed genuine interest in needlework, one of her mother's favourite pastimes, which left Cornélie free for conversation as she worked. And beside these specific accomplishments there were the repetitive and time-consuming tasks of dressing, perfecting one's toilette, choosing the right gown or accessory. This priority grew in significance after 1853 when the Empress Eugénie set the national tone. She became the fashion model of the age, the creator of the crinoline (which was first evolved to disguise her pregnancy), the patron of the House of Worth and the inspiration for a whole class who struggled to ape her elegance, namely the wealthy bourgeoisie. So day after day, year after year, shopping and dressing would be much discussed, and the house in the rue des Moulins rang with feminine voices, as one by one, three fledglings (dwarfing their little brother) grew into elegant young women.

The mental pictures stayed with Berthe: the impression of days so similar that there was no definition; the constant rising in the morning and going to bed at night, the chattering, the sharing of confidences, the little worries they had in common; the sudden panics, the hopes and dreams, the anxieties, the repeated, unconscious gestures, the bending, stooping, squatting, reaching, tiptoeing – the female arm and body movements as they washed and dried and changed – staring in the mirror, brushing and combing hair, fixing ribbons, dabbing the skin with a powder puff, turning curling tongs, fastening buttons, tying laces, smoothing folds, tightening waistbands, straightening a bonnet, fixing a flower . . . These endless

vignettes of a boudoir smelling sweetly of Parma violets, scattered with pretty objects, caskets, hand-mirrors and ring-boxes of tortoiseshell, pearl, crystal, or ivory, integral parts of each day in these formative years: these were the source of her artistic insight.

Here, in the brief and simple routines of a young girl's life in Passy, a well of memory was sunk, a reserve on which she drew in later life to re-create with tender empathy female adolescence and womanhood in its dreamiest, most apprehensive, introspective, semi-naked and vulnerable state. Here, in these recollections, is the explanation for her genius for portraying the half-awakened sexuality of the young female form, a sensuousness that was essentially feminine, irrespective of class, which she saw in her daughter and in her sisters' and cousins' daughters, in the concierge's daughter or the daughter of a village peasant. Here, too, in the company of her sisters, gazing into a private world through the cheval mirror or the looking-glass, was the germ of an idea: love still dormant but stirring, fleeting pangs of jealousy and vanity, a frightened questioning, sweet *frissons* of passion and compassion.

> Tête-à-tête sombre et limpide,
> Qu'un coeur devenu son miroir
> (Baudelaire)

> [Dim and limpid tête-à-tête,
> When a heart is mirrored in itself]

Staring at a reflected image, she saw the world of Venus and Psyche, later translating it into one of her most beautiful paintings. Here, more than in the services of any carefully chosen professional model, was the source of her inspiration for countless sketches, pastels and paintings in oil and watercolour. The sequence began around 1875 with *Young Girl before a Mirror* and continued for another twenty years with pictures such as *The Young Woman Powdering her Face* (1877), *Woman at her Toilette* (1879), *Bare Back* (1885), *The Bath* (1885–6), *Rising* (1886), *Woman Drying Herself* (1886–7), *Young Woman Dressing* (1887) and *Before the Mirror* (1890). But nowhere was the dreamy eroticism of adolescence more sensitively portrayed, with hints of Fragonard, than in *The Cheval Mirror (La Psyché)* (1876).[20]

In the same way, Berthe's musical education etched indelible scenes on her mind. Music was Cornélie Morisot's passion. She was an accomplished singer and pianist and enjoyed performing. So not unnaturally she was delighted to detect some musical aptitude in Yves, and doubly so when Berthe showed signs of considerable musical ability. The pair needed a first-rate teacher to develop their talents, not in order to pursue a career in music so much as to give themselves and others pleasure. With her usual

resourcefulness, Cornélie set about finding someone suitable, and it was a measure of her persuasive powers that in 1855 Yves and Berthe started piano lessons with Camille Stamaty, one of the most eminent music teachers of the day. Was it a coincidence he had once held a position in the Prefecture of the Seine? No matter: he could count among his pupils the composer Saint-Saëns (whose First Symphony appeared that same year) and Louis Gottschalk, the first American pianist to acquire an international reputation.[21]

Berthe cherished a lifelong love of classical music which is reflected in her artistic output. Her vivid studies of children practising at the piano, playing the violin, mandolin and flageolet, the glimpses of intense childlike concentration – the expressive bent of ear, eye and hand, the occasional pause to linger on a note, to listen for a cadence – re-created her musical experience as an adolescent. They drew on her flawlessly precise observations of Yves and others, performing and practising the piano in the rue des Moulins and the rue de Verneuil, beside her own efforts to prepare for her next lesson with the maestro. Even though she was apt to daydream (if Yves is to be believed), and her eye kept roving to a picture on the wall beyond, a drawing of the Stamaty family by the great master, Ingres, the atmosphere of that earlier age is alive in the various exquisite sanguine and charcoal sketches and the oils of Jeannie Gobillard, Lucie Léon and Julie Manet practising their pieces in the 1890s.[22] But to revert in time to the winter of 1855–6 Berthe and Edma had become excited by another artistic accomplishment. They had developed a true talent for, and a growing interest in, drawing and painting.

With hindsight, 1855 was a landmark in the history of French art, although the reason was not altogether apparent when the emperor announced his scheme for a great World Fair. This universal exhibition, his brain child, was to celebrate France's material and cultural progress, and to emphasize its international role, putting into the shade memories of London's Great Exhibition of 1851. A huge glass and iron palace was built midway down the Champs Elysées to house the industrial and scientific exhibits of over thirty nations which were on display from May to November 1855.

As part of the emperor's ambitious plan the Fine Arts exhibits were displayed in a separate palace on the avenue Montaigne. From early 1854 when the construction programme was started, Parisians were agog with expectation. Despite the outbreak of the Crimean War, when the Universal Exhibition opened there were 5,000 works of art from over 2,000 artists assembled in the Palais des Beaux Arts, two thirds of the exhibits being French. The dominant feature was the presentation of major retrospectives for France's two greatest living artists, Jean-Dominique Ingres, the doyen of the Neo-classical school, and the heroic leader of Romanticism, Eugène

Delacroix. Almost 500 French artists received an award of some sort from the hands of the emperor. A woman painter, Rosa Bonheur, took a first-class medal, and among the male artists Camille Corot and Alfred Stevens received second-class awards. Berthe Morisot may, conceivably, have noticed.[23]

The exhibition dominated the social calendar. We can be sure that the Morisots would be counted among the five million visitors to the World Fair and the hundreds of thousands who came to look at the works of art in the Palais des Beaux Arts. In view of Tiburce Morisot's background in the arts and engineering, and Cornélie's concern for the cultural education of their daughters, they would not have missed the chance to see and be seen there. And for Edma and Berthe, it was a unique opportunity to see the diversity of art on view and to ponder on what appealed to their taste. Whether they were allowed to see the separate 'Fringe' exhibition of Gustav Courbet is another matter. Excluded from the official exhibition, in the middle of that sweltering summer, Courbet proclaimed a new school of art, which he called Realism. He set up his display in a pavilion beside the Palais de l'Industrie and charged the public one franc each to view his work. It was a brave, some might say rash, thing to do, but among the artistic novices who went along were Edouard Manet, Fantin-Latour, Edgar Degas and Claude Monet. By flouting the art establishment's monopoly of the creative media, Courbet provocatively taught two lessons which the young and avant-gardes did not forget. All publicity is good publicity. And self-help and self-promotion are natural human rights. Without them Liberty is a sham.[24]

It is easy, given the cultural precocity of the Morisots' upbringing, to imagine that by the year 1855 they had grown into mature young women. This was probably true of Yves, who was in any case the most conformist of the three and had the greatest rapport with her father. But Berthe was then only fourteen and was showing some of the rebelliousness and introspection of a modern teenager, even though nineteenth-century society did not recognize the adolescent condition. She was at the uncommunicative stage. Her father found it somewhat trying and questioned Yves as to whether Berthe had something to hide. One evening Berthe set her heart on staying outside in the garden all night: Monsieur Morisot had great trouble persuading her to come back into the house. Inevitably things ended with a tearful scene. Her Papa was bemused by the fact that Berthe always reacted with expressions of surprise; but he couldn't decide if she was surprised by others or by herself. Edma could be equally difficult. Even when she was seventeen she would poke fun at her mother and quarrel with her brother, a boisterous extrovert, the complete antithesis of his sisters.[25]

From 1855 the Morisot girls began to take drawing and colouring more seriously. In December of that year Tiburce Morisot had moved a few blocks

from the Crédit Foncier to the Cour des Comptes. He had been offered a government position as a judicial counsellor at the national Audit Office (*conseiller référendaire à la Cour des Comptes*). Then some time in 1856 Cornélie Morisot had the idea of letting the girls take drawing lessons so that, as a little celebration, they could each present their Papa with the gift of their own work for his birthday on 11 March 1857. It seemed natural to ask for advice from their former teachers in the rue de Lille, who were able to oblige. There was an artist's studio close by in the same street (where, incidentally, the celebrated Monsieur Ingres also lived). Geoffroy-Alphonse Chocarne, who had been trained in the Neo-classical school and had exhibited seven times in the Salon, agreed to take the Morisot ladies as his pupils. His teaching regime proved a bit excessive: they were to come three times a week for four hours a day for intensive instruction.[26]

As usual, Madame Morisot accompanied them. They were all familiar with the route, having travelled it daily while attending their *cours*. They went on foot to the old turnpike des Bonshommes at the foot of the Trocadéro hill, then by horse-drawn tram to the Place de la Concorde, and finally on foot, crossing the river to the rue de Lille, where *Maître* Chocarne had his low-ceilinged, third floor studio. If the lessons dragged – and family legend says they did – it was because Geoffroy-Alphonse Chocarne was an indifferent artist and a mediocre teacher, pompous and opinionated, boring his pupils to distraction with monologues on cross-hatch. At the end of four months Edma and Berthe begged to stop, while Yves, always the most amenable, said she would prefer to spend the time on needlework. The Morisots agreed. But they recognized that beneath Berthe's and Edma's hostility was a genuine commitment to learn. Another teacher had to be found.

It was about this time, when Berthe was sixteen, that the Morisots came to know a summer resident of Passy, the sculptor-painter Aimé Millet. His father, Frédéric Millet, an elderly but much respected artist, had agreed to paint a portrait of young Tiburce Morisot. Aimé Millet had an apartment in the Boulevard de Batignolles, on the northern edge of the smart Elysée quarter where the better-off artist fraternity was starting to congregate. In 1857 his name was widely known as the winner of a first-class medal in the Salon. He had been a pupil of the legendary David and of the eminent architect Viollet-le-Duc. The Morisots became close friends of Aimé Millet, partly because he was a neighbour and a cultivated man with interests in music as well as art, but also because his niece, Nélie Jacquemart, was exactly Berthe's age and was beginning to have aspirations as an artist.[27]

Through Millet they were introduced to another neighbour, whose wife had set up a private school in the rue des Moulins, the artist Joseph Guichard. A perceptive teacher, with a kindly, pock-marked face, Guichard came from Lyons and had lived on the Left Bank before moving to Passy. Like another, more famous pupil of Ingres, Théodore Chassériau, he had

shown his artistic independence by leaving Ingres's studio in favour of Delacroix, creating a minor storm. His experiences, however, gave him deep insight into the techniques of the two artistic schools. He had been a regular exhibitor in the Salon since the 1830s and he lived by taking commissions for churches and other public buildings as well as by teaching. Among his works was a painting of *Christ in the Tomb* in the church of Saint-Germain-l'Auxerrois in the Place du Louvre, and a mural, *Our Lord on the Cross*, which hung in the Morisots' parish church, Notre-Dame-de-Grâce, in the rue de l'Annonciation.

Guichard took Berthe and Edma under his wing. From the start they liked him; and in the end they revered him. He wanted them to *understand* what they were doing intuitively. In his opening lesson held at their home, he patiently went over the first principles of drawing, painting and composition which Chocarne's teaching had managed to kill. Guichard's Neo-classical apprenticeship and his admiration for the Romantic Delacroix meant that he could explain from the heart the importance of both line and colour. He was also concerned to develop powers of accurate observation and a sharp visual memory, so he set them specific exercises. When Berthe produced a little landscape highlighted by grazing sheep, he saw that she had grasped the gist of his teaching; he was delighted. By that autumn of 1857 he felt it was time to show his pupils the Louvre, where the finest examples of European art were housed.[28]

There he introduced them to the great Venetian colourists of the sixteenth century and under his close guidance they studied techniques of composition, palette and brushstroke. Then when the weather was bad they stayed at the rue des Moulins, learning from an edition of Paul Gavarni's engravings which were among Tiburce Morisot's personal books. These provided excellent models for practising the skills of draughtsmanship; in this, as in his subtle caricatures of Parisian society, Gavarni was second only to Honoré Daumier. But by way of contrast, Guichard insisted they should also copy classical plaster casts and sections of reliefs. By the end of the year Guichard informed Madame Morisot that her daughters were ready to start serious copying at the Louvre.

However, 1858 started disastrously. On the night of Berthe's seventeenth birthday an assassination attempt was made on the lives of the emperor and empress outside the Opera in the rue Le Peletier. A gang of Italian revolutionaries threw bombs at the imperial berlin, killing 8 Parisians and injuring as many as 156 bystanders. Miraculously the imperial couple emerged unscathed from their coach, but Paris was thrown into uproar. The interior minister was summarily dismissed and there was angry talk of war – war, that is, with Britain for having given political asylum to terrorists. It was a while before the horror died down, with the dramatic trial and execution of the ringleader, Felice Orsini. Six days after that, on 19 March, Berthe

received some coveted news. She and Edma had been given formal permission to copy at the Louvre.[29] They were classified now as serious artists. Their lives took on a new routine.

With Guichard as their mentor and their mother as chaperone, Berthe and Edma went regularly to copy the old masters. They drew and painted alongside scores of other students and artists in the Grande Galerie and the Salon Carré while Cornélie Morisot discreetly occupied herself with a book or a piece of embroidery. Encouraged by Guichard, who knew how much Delacroix owed to the tradition of Titian, Veronese and Rubens, Edma and Berthe took these great colourists as their models. Although most of their juvenilia of the 1850s failed to survive, two copies of Veronese made by Berthe in 1860–1 were recorded and testified to this phase of her artistic career.[30]

As he watched their progress with oils, Guichard saw that Berthe and Edma Morisot were two exceptional young artists. He observed at first hand Berthe's quick eye, her grasp of technique and her gritty determination to succeed at a task. She was, as Théodore Duret was later to observe, a *born* artist.[31] Edma was more patient and painstaking, but she, too, had considerable natural talent. Guichard was an honest man. He suspected that once the potential of the Morisot sisters was fully developed, they would rise to great heights and take the art world by storm. But so unusual was it for two women – particularly two sisters – to be acclaimed by the Salon, the implications for their family could be momentous. He felt he owed it to the Morisot parents, who, after all, were paying him for his expertise, to spell out the truth. To clear his conscience Guichard alerted Madame Morisot at the end of 1857 to her daughters' potential. 'They will become painters. Are you fully aware of what that means? It will be revolutionary – I would almost say catastrophic – in your bourgeois society. Are you sure you won't curse Art, because once it is allowed into such a respectable and serene household, it will surely end by dictating the destinies of your two children?'[32]

Madame Morisot listened courteously, but she was unmoved. A catastrophe? A revolution? She knew all about revolutions and revolutionaries. And nothing was more ridiculous than to suggest her two daughters would ever belong to those 'dangerous classes'. . . . She smiled and thanked *Maître* Guichard, asking him to continue his lessons. And in 1858 she put her mind to something more immediate and much more important. In that year the Morisots decided to move to a new address. They left the rue des Moulins in favour of a better house in what was once the old Passy high street, number 12 rue Franklin.

Young Men, Old Men

1859–63

A new aesthetic medium took hold in France in the 1850s, symbolized by the formation in 1864 of the Société Française de Photographie. Photography had novelty, speed and realism. It soon became a vogue, an alternative to engravings or oil paintings. The two leading exponents of the art, Etienne Carjat and Félix Tournachon – better known as Nadar – had been caricaturists before turning their hands to photographic portraiture. But they quickly discovered that their portraits were in demand from the acquisitive bourgeoisie.

When Berthe was about eighteen, the Morisots arranged for her to have a photographic portrait. It reveals an attractive young woman with neat, regular features, whose full face still has the rounded cheeks of youth. A halo of dark hair and two chubby ringlets frame her face and neck. She stands nonchalantly by an armchair, gazing ahead, confidently eyeing the viewer who eyes her. Her day dress is a chic gown, mid-toned in a heavy, shot fabric, with softly sloping shoulders and a crinoline skirt, nipped at the waist. The buttoned bodice fits snugly to her well-rounded bust. The sleeves are generous, sheered below the elbow. White cambric cuffs and collar soften the wrist and neckline, while a black lace jabot picks up the striking braided chevrons of the sleeves.[1]

The Morisot sisters were lucky in their looks. They were dainty but shapely in build, with a number of appealing features. Yves was a natural blonde, a colouring that had become fashionable since the arrival of Empress Eugénie. Despite her stubborn jawline, Yves Morisot was compellingly pretty and capable of turning heads. Her slightly wistful, finely moulded face was perfectly offset by her golden curls. In colouring, as in age, Edma was between her sisters. She had blonde tints to her light brown hair, delicate features and a small, oval face, with a strong look of her father, especially across the eyes. Berthe, who claimed to resemble her grandmother Thomas in appearance, was the darkest of the three. Her eyes 'were almost too large, and so powerfully dark' with 'a deep magnetic force . . . black instead of green which they really were'. Being critical, Théodore Duret observed that her features lacked regularity and her complexion brilliance, but he conceded her grace and distinction and agreed she had the typical colouring and vibrancy of a French beauty.[2]

So in terms of manners and appearance, Edma and Berthe were not in the least like dedicated conspirators. However, they were forced into the role, colluding in private about their vocation for art. Their love of painting was a precious bond between them. Knowing how absurd it might seem to the rest of the family, they swore each other to secrecy. Even Yves could not be told in case she divulged the truth. She felt increasingly excluded from their tête-à-têtes, though by and large she was too good-natured to complain. Just once she let slip her desire to eavesdrop on those whispered conversations held in the quiet of their bedrooms.[3]

Guichard was an unwitting accomplice to the plot. Apart from watching over their artistic development, he did them an important service. Some time in the winter of 1858–9, during one of their copying sessions, he introduced them to a young etcher-engraver called Félix Bracquemond. As a result of this meeting, Bracquemond presented Berthe and Edma to his friend Henri Fantin-Latour on another occasion when they were working in the Louvre. It was as if a door had opened. Beyond lay an expanse of fertile conversations and stimulating relationships. In the months to come, Berthe and Edma found themselves latching on to the ideas floated by a group of artists of their own generation. And it was all very proper. Even Cornélie Morisot's watchful eye and ear detected nothing untoward in these polite discussions on the subject of art.

Félix Bracquemond was twenty-six years old at the time, darkly bearded, a stocky man with honest, wide-set eyes. He was a complex personality: he could be arrogant, dogmatic, fiery, yet extremely charming. He was also multi-talented and became a central figure in the Parisian art scene. From his youth, when he was an assistant to a professional lithographer, he developed into a first-rate draughtsman, a talent he put to use as both a print-maker and a ceramist. While Berthe and Edma were still at school he had worked alongside Charles Méryon, a brilliant but much undervalued etcher, who was trying to resurrect this neglected art form. Bracquemond's interest in etchings grew into an ambition to exploit the market with fine prints (*belles épreuves*) and he was to be co-founder of the Society of Etchers. Later his career took a different direction when he became artistic director of the Haviland Porcelain Works. But at this time – the late 1850s – he lived by taking small commissions, such as the frontispieces of books. He decorated some works of the novelist Champfleury, and through him came to know a number of the pro-Realist critics and writers in Paris. At this time his friends included the Goncourt brothers, Gavarni, Alphonse Legros, Millet, Corot and Edouard Manet, as well as Fantin-Latour, who remained a close friend all his life and through whom he would shortly meet Edgar Degas.[4]

Although he was a working artist, Bracquemond still found time to visit the Louvre. He shared with Fantin (who was three years his junior) a love of Delacroix, Courbet and the seventeenth-century Spanish and Dutch

masters. But he was one of the first artists in France to be seduced by oriental art. From the moment in 1856 when he came across some Hokusai rejects in Delâtre's bookshop in the rue Saint-Jacques, he was inspired by the fine draughtsmanship and unusual composition of Japanese prints and woodcuts. He admired the landscape design and colour of Hokusai and Hiroshige, and the realism of earlier masters like Utamaro, whose prints of everyday life were 'mirrors of the passing world'.[5] Suggestiveness, the lack of irrelevant detail, the fresh combination of colour, eye appeal – all these qualities anticipated the future direction of French art: Impressionism.

Japonisme grew in popularity after 1862 with the opening of a specialist business in the rue de Rivoli. Bracquemond, Fantin and their friends, Whistler, Manet, Degas, Stevens and James Tissot, became voluble exponents of the compositional techniques of oriental art. With certain literary critics – Baudelaire, Zacharie Astruc, Philippe Burty, Emile Zola and the Goncourts – they were patrons of the shop known paradoxically as *La Porte Chinoise*. Berthe caught hints of this new exotica. She learned about the artistic implications in the course of the 1860s, noting that 'only Manet and the Japanese can indicate a mouth, eyes, a nose with a single stroke of the brush, so concisely that the rest of the face models itself'.[6] However, similar remarks were to be made of her work, suggesting that she too had these eclectic tendencies.[7]

Berthe and Edma were naturally curious about Fantin-Latour and Bracquemond. Up to this time their experience of the male sex was confined to father figures: to their Papa and *Grandpère* Thomas, to Aimé Millet, who was their mother's age, Guichard, who was precisely their father's contemporary, and the dreaded Chocarne, who had been born in the eighteenth century! Their interest was aroused partly because these two men were *young* – not unimportant when two young women had reached a marriageable age. Fantin was fascinated by the two attractive female artists, and over time he developed a secret passion for Edma, whose quiet personality did not intimidate him. And for Berthe and Edma it was intriguing to meet a pair of dedicated male artists, struggling to establish themselves in a hard commercial world. The sisters knew as well as the men that the best route to a successful career lay through the Salon, organized by the Institut de France. For the first time, Fantin was preparing to submit three paintings to the Salon jury, a self-portrait and two domestic scenes figuring his sisters. On these might depend his whole future. It was a sensitive time.

Neither he nor Bracquemond was born into privilege. In Fantin's case, he might have seemed favoured: his mother was the adopted daughter of a Russian countess. But his father was a plain drawing teacher and portrait painter in Grenoble, and in 1854 Fantin had fallen at the first hurdle of the

race for artistic success by failing in the Ecole des Beaux Arts. Normally a student moved from the école to the studio of an eminent academician and success came partly by flattering the *maître* to use his influence in respect to the prestigious Prix de Rome. After triumphing in the competition, it was a matter of submitting works to the Salon, winning a medal and waiting for the commissions to flow. Wealth, fame, recognition would surely follow . . . But not for Fantin or Bracquemond, who were already outside this mainstream of the art establishment. Nor necessarily for Berthe and Edma Morisot. They were hampered (if not excluded) by their sex. Without a prestigious studio behind them (or even the humbler Académie Suisse),[8] their only resources were the copying facilities at the Louvre.

But the two men had one advantage over the two women. Convention made it easier for them to strike up friendships with other artists whom they met casually in the great gallery. One of Fantin's companions was the poverty-stricken Burgundian, Alphonse Legros, but he befriended others, such as an ebullient northerner calling himself Carolus Duran. Then in 1857 Fantin met Edouard Manet. They quickly became firm friends. And in the following autumn, when a figure in a large, wide-brimmed Rembrandt hat stopped to admire Fantin's copy of a Veronese, he soon struck up another warm friendship, with the American-born etcher and painter, James Whistler (who – and this point must have interested Fantin – had spent his childhood in St Petersburg). This casual association of artists with varied credentials intrigued Berthe and Edma, coming as they did from a closed and cosseted background. In addition to this, there was an unexpected link between Berthe Morisot and Fantin-Latour. By a remarkable coincidence (which they may not have realized immediately), they actually shared a birthday, 14 January.

Fantin's self-portraits show a pale face, stubby nose and a shock of wiry dark hair brushed back off his low forehead. Often there was an apprehensive expression in his eyes; 'timid' and 'introspective' were the adjectives most often applied to him. But for all that, he was a bit of an enigma. Behind the shy and serious exterior was a likeable man to whom people gravitated and in whom they seemed willing to confide. He was a mine of personal information and for a few years he was the go-between, the inveterate gossip of his circle.[9]

Fantin bent the ear of many a Louvrist with his enthusiasms. He and Whistler sat in bars like the Café Molière talking endlessly about art. Some of this percolated through to Berthe and Edma. Whistler learned from Fantin the technique of using the bottom of a picture frame or a mirror as background for a genre painting, to give it a sense of structure.[10] Berthe picked up the same device, using it, for instance, in her well-known double portrait of *The Artist's Mother and Sister*.

Fantin also seems to have told Berthe and Edma about the radical concepts of his former teacher, Lecoq de Boisbaudran. Only a few months

earlier he had introduced these theories to Whistler; and in 1858 they had received fresh praise and publicity with the publication of an article in *L'Artiste* by the architect Viollet-le-Duc. Lecoq de Boisbaudran was a professor at the Ecole Impériale et Spéciale de Dessin – some say the greatest teacher of draughtsmanship of the century. He had evolved a method of systematic memorization which made it possible to combine traditional, classical subject matter and the modernity of present-day settings. His theories were widely disseminated after 1847 through his book, *Training in Visual Memory*. He acquired a number of enthusiastic pupils and advocates, including Rodin, Tissot, Legros and Fantin.

Edgar Degas picked up his ideas when a student-artist in the mid-1850s, and Manet is also thought to have been influenced by them in producing his *Déjeuner sur l'herbe*. The similarity between Boisbaudran's theories and the instruction given to them by Guichard on technique of memorization must have struck the Morisot sisters, and it would undoubtedly have come into their conversation with Fantin, who enjoyed nothing better than artistic chat.[10] If, as seems likely, he repeated to Berthe and Edma much of what he told Whistler, they had food for thought. For Boisbaudran's students were taught to cultivate the memory by looking at real street scenes out of the window before reproducing them in the studio. And in the summer they were taken into the countryside on clear nights to observe the effects of moonlight: from a white cloth spread out on the grass they could study the different values of white in varying intensities of light.[11]

The hypothesis that Berthe was impressed by Boisbaudran's concepts is perfectly plausible.[12] For all Guichard's lessons, it was Fantin in his quiet way who acted as an artistic informant and set the sisters' collaboration in motion. With his friend Legros, he set an example of an indefatigable artist, working in his cramped room in the rue Ferou. He reinforced all that Guichard had said about the Louvre. He gave hours to copying and recopying the Masters: before 1858 he had sold four of his copies of Veronese's *Marriage Feast at Cana*. For him the Louvre was a kind of community of learning. Like the best kind of university, it offered stimulus, motivation, the ambience and opportunity for improvement, leading ultimately to perfection.

What the Louvre did *not* do, any more than the Salon of 1859, was encourage innovation. Opening on 15 April in the Palais de l'Industrie, the Salon was broadly dismissed by the critics as a dull affair. But it was not without incident. Disappointed artists reacted fiercely to the jury's choice. An angry demonstration was staged on the quai near the Institut des Beaux Arts. Nieuwerkerke, the government's director of the arts, was loudly booed. Fantin's three canvases were rejected, along with a graceful domestic scene by Whistler, and Manet's realist canvas, *The Absinthe Drinker*. In disgust, a sympathetic painter, François Bonvin, opened his Flemish Studio at 189 rue

Saint-Jacques to a public display of the rejected works. Whether Berthe made the pilgrimage across the city to the Left Bank to see the exhibition is uncertain, but Gustave Courbet did. Vain and arrogant though he was, Courbet the Realist was the god of the young artistic generation, and the fact that he came to view the works rejected by the Salon marked them out as avant-garde.[13]

Meanwhile, the central room of the Salon was hung with heroic depictions of war, a sad irony that cannot have been lost on the viewing public. Throughout the summer of 1859 French troops were thrown into possibly the bloodiest conflict of the century, a war against the Austrians fought over Italy, the country considered sacred to art. Inside the Salon, however, academic values still prevailed, exemplified in two arch-conservatives, Bouguereau and Gérôme; and Aimé Millet, the friend of the Morisot family, displayed a sculpture of Mercury which was destined for the Louvre.

Yet the growing interest in landscapes was also striking. There were seven on display by Camille Corot, for instance; a seascape by Eugène Boudin and a picture by Charles-François Daubigny entitled *Bords de l'Oise*. Whereas most landscapists made their initial studies outside, then reworked them in the studio, Daubigny and Boudin worked directly from nature. There was an air of improvisation about their painting which the Morisot sisters surely noticed. Here were signs of the new influences among the painters of the Barbizon school. In 1860 they were to receive a further boost when Louis Martinet, a dealer, set up a permanent exhibition of their works in a prime location at 26 Boulevard des Italiens.[14]

Fantin was sadly preoccupied for much of 1859. One of his sisters had suffered a mental breakdown and his mother died that year. With the influx of summer residents, the Morisots stayed in Passy, knowing that the relative peace and seclusion were coming to an end. At midnight on 31 December 1859 the last remnants of the old walls and customs barriers came down; on 1 January 1860 Passy became absorbed into Paris. By that time Berthe and Edma had resumed their copying sessions at the Louvre with Guichard in attendance. They continued to work at their favourite Venetians. It was in the period 1860–1 that Berthe made her copies of Veronese's *Calvary* and *The Feast at the House of Simon*, which already carried hints of her freer interpretation.

Among the other copyists to be found in the Louvre at this time was a former student of the academic painter, Thomas Couture. A debonair, buckish 28-year-old, who had found the constraints of an academic studio too repressive for his taste, he worked with an obvious intensity and panache. While Berthe was copying her Veroneses in Guichard's presence, he was copying a Titian, *The Virgin and the White Rabbit*, and a Tintoretto self-portrait. She couldn't help but notice him. Nobody could. With his

exquisite manners, well-cut clothes and fair, wavy hair and beard, he stood out from the crowd. They exchanged glances and a few polite remarks. This was Fantin's friend, Edouard Manet.

Manet attacked his brushwork with an air of independence which had immediately fascinated Berthe. Since the summer of 1859 the two sisters had aired their doubts in private as to where this endless copying might lead. It stultified the imagination. Art, they were beginning to believe, should be more about expressing life and nature. By now they were familiar with the atmospheric effects in Corot's work. There was nothing seditious about working from nature. Women artists often took some pastels or a box of watercolours, sometimes an easel too, to paint outdoor scenes. Natural scenery left the artist free to devise her own composition. A fresh approach to composition and colour was one of the talking points between Fantin and Berthe. She and Edma had no preconceived ideas about the routines of formal studio painting. They improvised, painting in the drawing-room of their home. With these thoughts milling in their heads, they were encouraged to think about the genre of small, figured landscapes, and about adopting the practice of working directly out of doors.[15]

They raised the question with Guichard in 1860. To him the whole idea was anathema. But he was astute enough to realize that the two of them meant what they said. He continued to act as chaperone for their copying sessions until 1862, when he returned to his native Lyons as Professor of Painting at the Ecole des Beaux Arts. In the meantime he agreed to put them in touch with Camille Corot, the undisputed master of *plein air* painting.

Corot, with his venerable mane of grey hair, was a veteran: a year older than Chocarne. His reputation, long in the making, was established by 1846 – the year he received the *Légion d'Honneur* – and sealed when the emperor bought *Souvenir de Marcoussis* for his private collection in 1855. Corot, however, was also a free spirit, difficult to pin down. Although he had a studio at 58 rue Paradis-Poissonière, he was frequently out of town, at Ville d'Avray, or staying with friends in the provinces. Guichard reached him via one of his disciples and former pupils, a gentle giant of a man, the artist Achille Oudinot. It was Oudinot who in turn presented Berthe and Edma to Camille Corot.[16]

It is not clear where the first meeting took place: whether at his Paris studio or in Ville d'Avray. What is known is that Corot spent much of 1860 away from both these places, working with fellow painters. He was in Douai, in various towns in Brittany and at the home of Daubigny at Auvers-sur-Oise; but since he never enjoyed giving lessons and rarely taught pupils at the rue Paradis-Poissonière, it is possible that he came to the rue Franklin to meet the Morisots. In any case, Corot's practice was to offer advice rather than to teach in a didactic sense, to quote his personal maxims on the importance

of form and values. Then he would lend his pupils some of his paintings to copy at home and afterwards gave them an honest assessment.[17]

'Papa' Corot quickly became a family favourite, although at first Madame Morisot had to twist his arm to visit socially. A shy, middle-aged bachelor, he was unused to their sort of household, but by agreeing to let him smoke his pipe during dessert Cornélie managed to persuade him to come. Happily he and Tiburce Morisot discovered a mutual love of Italy, so conversation flowed. Corot was much flattered by the family's attention, while they were honoured to have one of France's greatest living painters as a guest.[18] What was remarkable about him was his innate modesty, coupled with his generosity and warmth. He seemed to epitomize Tennyson's couplet:

> Kind hearts are more than coronets
> And simple faith than Norman blood.

Berthe's descendants are clear about what she gained from Corot. The subtle transparency of his painting was the source of her pale palette and her vision of light. The view has gained ground that 'It was Corot who taught her to bathe in air her landscapes, her figures, her still life compositions; it was he who taught her the difficult lesson of understanding values'.[19] Corot's influence was observed in the background to several of her landscapes up to the mid-1870s. His *Port of La Rochelle* is recalled in her *Harbour at Lorient*; her *Hide and Seek* brings back his *Village of Marcoussis*. Berthe's liking for small landscapes with figures is derived from his, just as some of her later nudes reflect his sylvan nymphs, souvenirs of her student days. But he made one overriding contribution. A critic had written of him in the 1840s, 'Do not look too closely at Corot's figures. . . . His half-finished manner has at least the merit of producing a harmonious ensemble and a striking impression. Instead of analysing a feature, one feels an impression.'[20] Corot was a precursor of Impressionism.

However, he was never an authoritarian presence. He allowed the girls to imbibe what they wished, inviting them to Ville d'Avray, a pond-studded hamlet surrounded by woods in the Ile de Paris, which inspired his best-known work. The Morisots went as a family and spent some time there in the summer of 1861. Corot afterwards visited Douai and Fontainebleau, returning to Paris in November to resume attending Madame Morisot's homely soirées. Since Berthe and Edma were in Passy at the time of the 1861 Salon, we may assume they made a point of viewing his six exhibits. Fantin and Manet were both making their debuts too. Manet's *Spanish Guitarist* went so far as to win him an honourable mention and critical acclaim.

Neither Berthe nor Edma was ready to submit her work yet to the scrutiny of the Salon jury, but by the spring of 1862 they were eager for new stimulus. They were determined to copy Corot and work from scenes of

natural beauty. He was to be away on a prolonged painting trip from April to September. For reasons that may be guessed rather than proved (largely of family convenience), the Morisots decided to make for the Pyrenees.

The imperial family had already made Biarritz their summer residence and Europe's pleasure seekers were drawn there like magnets, although Pau was more popular with the British. The landscape also appealed to artists. Gavarni, for one, had made many sketches of the Hautes Pyrenees from his base at Tarbes. When Joseph Thomas finally retired in 1862 after fifty-three years in the civil service, it seemed an appropriate time to revisit Toulouse, where his wife – Berthe's grandmother – had been born, and to take a summer holiday in the Pyrenean foothills. Madame Morisot was probably in the party too, but whether willingly or not, Yves remained in Passy with her father. Berthe and Edma made the most of their outdoor holiday, trekking on horses and mules, sketching and painting in the bright light of Languedoc. Yves wrote to tell them that she and Papa feared they would never catch up on all the incidents of their holiday. It was no wonder that her tone was faintly envious.[21]

The interlude in the south was welcome. In 1863 Passy was being transformed. The Place du Trocadéro, close by the rue Franklin, had been completed five years earlier under Baron Haussmann's first development phase. But now the old roads were being widened and extended, others renamed – the rue des Moulins became the rue Scheffer – and new apartment blocks and streets, like the rue Guichard, were appearing. Residents found the disruption highly irritating. There was constant inconvenience caused by 'this abrupt efflorescence of bricks and slate, this profusion of building timbers . . . this exuberant vegetation of casement windows . . . *this fever, this mania*'.[22] Many locals were aroused to fury when municipal contractors working on the building of the avenue Victor Hugo left it on two levels, divided down the middle by a retaining wall, interspersed with wooden stairways.[23]

It was easy to shut one's eyes to the benefits of a new reservoir and fine boulevards radiating across the Chaillot quarter. However, a few observant artists – Méryon, Gavarni and Constantin Guys – painstakingly drew what they saw around them: the streets, buildings, quays, bridges and inhabitants of Paris. Before the end of the decade the urban landscape inspired younger artists caught up in the Realist trend. Perhaps it was because Berthe was so used to walking to the Trocadéro hill from which she instinctively absorbed the sight of the Paris skyline that she was encouraged to try her hand at some gentle cityscapes in the 1860s. They were genuinely modern pictures, a far cry from the classical subjects she had copied in the Louvre. But we are looking slightly ahead.

For the moment, early 1863 that is, Corot explained to the Morisots he would be off again in mid-April on a protracted tour. He suggested that in

his absence his friend and fellow painter, Achille Oudinot, whom Berthe and Edma had already met, would be the ideal person to tutor and escort them on their painting excursions. He brought Oudinot to the rue Franklin and the arrangement was finalized. It was hard not to be impressed by Oudinot. He was handsome, tall and strong, with enormous biceps and powerful fingers. In addition, he could be relied on to follow Corot's methods to the letter. Berthe and Edma insinuated that they were aiming at making their Salon debut in the near future. Oudinot responded with a suggestion: it would be ideal if their parents were to rent a house in the vicinity of Auvers-sur-Oise where he proposed to spend that summer. He could then supervise their work closely.[24]

The Oise valley was another favourite haunt of artists. The Morisots agreed to rent a cottage at Le Chou, beside the river between Pontoise and Auvers, though again it seems that Yves remained in Passy to run the household for her father. For Berthe and Edma, however, the arrangement worked well. By the end of their stay the sisters had made a clutch of improvised studies in the spirit of Corot. Even so, Berthe was becoming increasingly self-critical, and despite Oudinot's praise and encouragement, she kept only two of her works, a wooded scene in which the line of the *Old Road to Auvers* is strangely obscured, and a *Souvenir of the Banks of the Oise*.

Corot may have told the Morisots about Daubigny, who also lived in Auvers and kept open house for his friends. Daubigny's house was in the centre of the village, a solid-looking property with a colourful, rambling garden at the rear. (Van Gogh painted it in 1890, by which time Daubigny was dead.) He was living there with his artist son, Karl-Pierre, known as Charlot, but he liked to work at pastoral scenes from on board his boat: in 1860 Corot had depicted him working there on the River Oise.

Alerted to the presence of the wealthy Parisian family at Le Chou, Daubigny organized a luncheon party to which he invited the Morisot ladies. The guests were a strange mix, but the common denominator was the absent Corot. Oudinot apart, Berthe and Edma had not met the rest before. There was Madame Daumier and her husband, the famous radical lithographer, Honoré Daumier, a seasoned draughtsman who had taken to painting but whose scathing caricatures had once undermined the July Monarchy of Louis Philippe (for which, had he been there, Tiburce Morisot would not have easily forgiven him); Charlot Daubigny, and a wealthy young landscapist from the Grande Rue, Antoine Guillemet, who knew Manet.[25]

And so to Manet. Everyone knew Manet, it seemed. He was the inspiration of the young avant-gardes. Some critics even spoke of a new school of painters emerging little by little since 1860, headed by him. Following their meeting in the Louvre Berthe had identified who exactly he was, and after that she found his name kept cropping up in conversation. Especially this year – 1863 – when three of his canvases were on display at

Martinet's gallery, including *Music in the Tuileries Gardens*, his masterly testimony to Parisian bourgeois society and *yes, especially this summer*, when he had been the centre of attention at the *Salon des Refusés*.

It was an exceptional year. The Salon had provoked loud protests against the prejudices of officialdom. Berthe had followed the exhibition with interest. A new sculptress had made her debut; her name was Marcello. Then Louis Napoleon had intervened to instigate a rival Salon of the rejected works of 1,200 artists, one of whom was Edouard Manet. He was in good company with Fantin, Whistler, Jongkind, Bracquemond, Legros, all of whom failed to satisfy the official jury. But this time it was Manet's *Déjeuner sur l'herbe* which provoked the fiercest storm of outrage with his 'scandalous' portrayal of nude femininity juxtaposed with clothed manhood: a wench from the Batignolles flaunting herself on the grass beside gentlemen of the Chausée d'Antin. The artistic concept – the skilful translation of Giorgione and Raphael into the modern idiom – was misrepresented or ignored. Instead, the critics vied furiously with each other in execration of Manet's vulgar Realism.[26]

Berthe was aware of his daring and her curiosity was aroused. She had spent her time copying the works of other artists, and it was frustrating that Edma sometimes surpassed her at this task with her meticulous reproductions of Corot. On one occasion Berthe resisted making a slavish likeness by missing out a little staircase which existed in Corot's painting. She was duly chastised when he insisted that she did it again. But there was another occasion when Corot was so pleased with Edma's work that he asked if they might exchange paintings. It was the ultimate compliment.

Berthe was all too conscious of the flaws in her copies of Corot's work, which probably explains why she destroyed them. Only two were recorded, a woodland scene entitled *Forest Clearing*, and a landscape of *The Villa d'Este* at Tivoli. She accepted Corot's criticism and benefited from it.[27] But her intuition was excited by what Manet was doing, although his mode was very different from Corot's luminous landscapes. She made the connection in Manet's case with the traditions of Goya, Ribera and Velázquez: his bold colours and banishment of shade and half-tones. She sensed the uncompromising contemporaneity of the man. For her, the appearance of *Déjeuner sur l'herbe* was more significant than any other notable event of that year, even the much-publicized death of Delacroix in August and the public spectacle of Nadar, the photographer-turned-hot-air-balloonist, launching his 'Giant' into the sky from the Champs de Mars while gaping crowds watched below.

Edma painted a portrait of Berthe the Artist about this time.[28] It is not only a sisterly dedication, it is an important statement. Berthe stands before her easel, her right hand central to the picture, poised to touch her palette with a brush. The pretty, round-faced girl had vanished. The features have

become firmly chiselled, the neck and ears strongly moulded in the manner of a classical figurine. Her femininity comes from long ropes of curls, swept off her face by a bandeau and falling to the shoulders of her black jacket, suggesting an assured pre-Raphaelite beauty or a Tissot model, calm and statuesque. Perhaps that was how others saw her.

But in fact she was neither of these. She was far from calm or assured. She was often frustrated and over-anxious. She was depressed by her own efforts, of which she was unduly critical. Her gaze is searching in the picture for her individual perception of art. Edma tried to give her moral support by surrounding her with the symbols of her vocation, portraying her as a serious painter. Both sisters were mentally preparing themselves for the test of the Salon. For seven years they had studied, listened, watched and practised. One by one the influences were assembling like pieces on a chessboard. Guichard, who introduced them to Gavarni and the Venetian colourists in the Louvre. Bracquemond, with his penchant for Japanese prints and careful draughtsmanship. Henri Fantin-Latour and his mentor, Lecoq de Boisbaudran. The emerging urban scene of Passy, the evanescent greenery of the Ile de France. Achille Oudinot. And presiding over all, Papa Corot.

However, there was one more authority at work on Berthe: the magnetism of Manet. So far as we know they had not yet been formally introduced, even though they had spoken informally at the Louvre. This meant, so far as polite society was concerned, they were not yet on visiting terms. But since that first meeting in the presence of the Venetian masters, they had exchanged pleasantries in the great gallery on various occasions. Berthe's awareness of him had been growing all the time.[29] The strident press condemnation of Manet's *Déjeuner* appalled her. She must have scoured and devoured what was being said that spring, for one column in the *Gazette de France* (allegedly dictated by Delacroix) left an indelible impression on her:

> His acid colours pierce the eye like a steel saw . . . with a crudeness that no compromise of any kind can soften. *He has all the sourness of green fruit that can never ripen.*[30]

The metaphor stung, as it was meant to do. It was as if she took it personally; it was obvious that she cared. The words – and the indignation – lodged in her mind and remained there until they became part of her vocabulary. Somewhat later, she wrote to Edma of Manet, '*His paintings, as they always do, produce the impression of a wild or even a somewhat unripe fruit*'; adding, with deliberate understatement, 'I do not in the least dislike them.'[31]

Then suddenly, in the autumn of 1863, Berthe's life, like Nadar's great balloon, was thrown completely off course – and without her even knowing

it. On 28 October Manet quietly took a trip to marry his Dutch mistress, Suzanne Leenhoff, at Zalt-Bommel in her native Holland. The news trickled out haphazardly to his friends, but not to Berthe, for she was not yet part of the magic circle. So far as she was concerned, Edouard Manet was the most exciting artist she had encountered, a gentleman of her own class, a man of infinite charm and personal interest. To this extent he already filled her thoughts; he was already part of her life.

Expanding Circles

1864–6

As the winter of 1863–4 approached Berthe felt a certain disenchantment with life. Autumn put an end to working out of doors and she felt trapped by the resumption of routine copying. Corot, she felt intuitively, had a greater regard for Edma's work than for hers.[1] Yet she didn't blame her sister. She blamed herself. Uncertain as to her best means of self-expression, she decided to try a different medium: sculpture.

Aimé Millet came to the rescue. After all, he was an old family friend. He was busy with commissions at the time, after enjoying further success at the 1863 Salon. His current project was the decoration of the façade of a Parisian town house on the riverside past the Louvre. However, when Berthe plucked up courage to ask if he would give her lessons, he could not refuse. Though small in stature, Millet was a bundle of energy. He gave her lessons in his studio during the winter months, instruction that was to give her the basic skill and confidence to model a child's head in plaster many years later. In return he asked Berthe for an artistic favour. His sculptor's eye had recognized in her chiselled profile the perfect model for a bas-relief medallion that could form part of his current project. She agreed to his request to pose. And so she remains in stone on Millet's decorated frontage of 14 Quai de la Mégisserie to this day.[2]

As spring arrived, the year 1864 brought fresh hope to Berthe, new interest, new friends. To begin with, she and Edma had already made the momentous decision to try for their Salon debuts. From the riverside scenes they had painted the year before, they each submitted two, describing themselves as pupils of Guichard and Oudinot. The Salon jury accepted all four. It was a moment of great family excitement and Berthe savoured the triumph. She hoped this was a sign that she had found her individuality; that it was a step towards public recognition of her vocation. The truth was probably more complex. This was the Salon which acclaimed Corot's figured landscape, *Souvenir de Mortefontaine.* Corot had never been in higher public esteem. So, in this of all years, there was an evident advantage in being associated with him. It was an irony, for despite her respect for him, the last thing Berthe wanted for herself was to be labelled 'after Corot'.

Unfortunately neither of the pictures she exhibited, *Souvenir of the Banks*

of the Oise and *Old Road to Auvers*, appears to have survived. The latter was a figured landscape more reminiscent of Corot than she cared to admit – a little wooded scene, with flashes of light playing through the trees and a dark figure seated at the foot of a willow tree. Oudinot apparently advised them over their titles, which were derivative of the Barbizon school and Oudinot's own Salon submissions, past and present.[3] Among the many reviews of the Salon, two, the *Revue nationale et étrangère* and *Le Courrier artistique*, noted the Morisots. But the critics were patronizing towards the newcomers. The novelty of two sisters exhibiting together was not lost on them, but Corot's hand was clearly observed in both. So much for their artistic independence![4]

If Berthe was frustrated by the critics' remarks, she put them behind her as the prospect of summer holidays loomed. It was to be a good summer for the Morisots: one they wouldn't forget. Early in the year, before her daughters' Salon debuts, Madame Morisot had answered an advertisement to take a furnished windmill in Beuzeval, between Caen and Trouville, an area of the Normandy coast that had recently been opened up to holiday-makers. It was owned by Léon Riesener, an artist of means who sported a fashionable address in the Elysée, 18 Cours-La-Reine, a point which was not lost on Madame Morisot. She was delighted to make his acquaintance.[5]

A charming man whose white hair belied his youthfulness, Riesener was a pastellist who came from a distinguished line. He was a grandson of Jean-Henri Riesener, the finest cabinet-maker of the *ancien régime* and also a first cousin of the legendary Delacroix, whose estate had been sold amid much publicity that February. The Rieseners were anxious to spend some time at Champrosay in a property they had recently inherited from Delacroix. Since this took them to the picturesque Essonne valley, south of Paris, they were happy to let their country home in Calvados to the Morisots.

The two families struck up an instant rapport. Riesener's wife, Laure, was Cornélie Morisot's type: a refined, beautiful, demure mother of three daughters. It transpired that Léon Riesener was on good terms with Berthe's confidant, Henri Fantin-Latour. Fantin was planning a group portrait for the next Salon which he intended to call *Homage to Delacroix* in honour of the great Romantic master. It also turned out that the Rieseners' eldest daughter Rosalie was Berthe's age and shared her passion for art, while the youngest, Louise, a blue-eyed, golden-haired girl in her teens, soon latched adoringly on to Berthe. At Madame Morisot's invitation the Rieseners visited them at Beuzeval. Only then did Léon Riesener appreciate the sisters' true gifts. With his own light palette and interest in landscapes – in particular, the changing patterns of northern skies – he was sympathetic to the effects they were trying to achieve.[6]

Corot was also invited to Beuzeval but his summer schedule was full and he had to decline. Instead he sent his honest advice to Berthe and Edma, to

reproduce the images they saw in nature rather than be influenced by the words of their teachers. Berthe's brother confirmed that she found Beuzeval a novel experience. The atmosphere of the Côte Fleurie presented endless challenges. From dawn to dusk she was content to wander among the fields and clifftops with Edma, knapsack on her back, stick and artist's apparatus in hand, choosing the right spot, the right subject to sketch and paint, revelling in the freedom and clear light. By the time they were due to leave, Berthe had finished 'a fine harvest of studies'.[7] They included two tiny watercolours, a pastel of cows grazing and another pastel of boats at sunrise; possibly, too, an oil painting of a cottage in Normandy which was exhibited two years later. If there were other studies, Berthe must have felt they were not worth keeping. The assumption is that she destroyed them during one of her introspective, self-critical moods. She kept only what satisfied her own standards of perfection: anything less went the way of almost all her juvenilia. Oudinot, however, was delighted with her progress and showed off her work to a fellow artist, who was equally fulsome.[8]

There was another reason why the summer of 1864 was memorable. After being upgraded once in 1858, on 22 July Tiburce Morisot was given a significant promotion to the rank of chief judicial counsellor (*conseiller maître*) in the national Audit Office. Consequently the Morisots decided to move house again in the autumn. They took over the tenancy of a desirable family-sized property across the way at 16 rue Franklin; as it happened, the Thomas grandparents lived at number 15. The new house was large and simple, with traditional wrought iron balconies. Inside it was spacious and elegant. Rear ground-floor doors opened on to the garden and well-established trees shaded the far end of the lawn. From this rear aspect there were vistas across to the Left Bank of the Seine.[9]

Cornélie Morisot now had more scope to indulge in her favourite pastimes – company, conversation and music. As the nights drew in she resumed her Tuesday soirées, partly for her own enjoyment, but also, she would have admitted, to make sure her three daughters had every chance to meet as many eligible bachelors as possible. Berthe and Edma welcomed the move for other reasons. In theory at least, they would now have room to spread their equipment and paint without disturbing the rest of the family, although in practice they still had to take up Achille Oudinot's offer to store their pictures at his studio: until the turn of the New Year of 1865, that is, when they managed to persuade their father to invest in the building of an annexe. With a studio of their own, Berthe and Edma felt they would be seen as bona fide artists.[10]

On their return from Normandy the two had renewed their sessions with Oudinot. Perhaps because they pressed him out of curiosity, he took them to the area around Fontainebleau. Its forests and shaded villages were a haven for travellers on their way to Paris from the south. They were also the

inspirational haunt of the Barbizon painters and disciples like Oudinot, who was working on a picture of a gypsy encampment for the next Salon. This may have given Berthe the idea for a picture of an Italian girl – *L'Italienne* – while Edma did two paintings at Fontainebleau, one of which was a still life, *Pot de Fleurs*.[11]

At this same time – 1864–5 – the sisters also resumed their trips to the Louvre. Sometimes they went in a threesome with Rosalie Riesener, who was preparing for her Salon debut. Sometimes Berthe and Rosalie went together; the records show that early in 1865 the pair received permission to copy from the series of massive scenes by Rubens painted for his royal patron, Marie de Medici.[12] In Léon Riesener's opinion, Rubens was the Shakespeare of painting. Berthe was very impressed with Riesener's artistic judgement, especially his views on colour. She asked if she might study his unpublished writings and copied 135 pages into her own notebooks, a common auto-didactic practice at the time. Riesener's technique also interested her: his use of pastel mixed with watercolour and his rapid notations, which he was kind enough to demonstrate. What she saw was to influence her own technique.[13]

With the next Salon in mind, Berthe painted a still life and a figured landscape late in 1864. The latter, *Study at the Water's Edge*, showed a recumbent, bare-footed girl gazing into a stream. The setting was more reminiscent of Fontainebleau or Auvers than of Beuzeval. The figure is a standard classic beauty rather than a readily identifiable person. In fact, the whole rendering bore a strong resemblance to the work of her teachers or to an etching by her friend Félix Bracquemond, finished at much the same time. So it is quite likely that Berthe's path crossed Bracquemond's that autumn – perhaps at Fontainebleau – and she was inspired by his composition to produce her own version. It may seem surprising that Corot then decided to pay her the compliment of developing the theme himself the next year. However, artists frequently took each other's subject matter: why else spend time copying the old masters at the Louvre?[14]

But Berthe found it hard to accept that others were doing what she was trying to do. She found it annoying that people continued to label her work with Corot's style. She craved the cachet of originality which she saw in Manet's work. No one except Edma appreciated how deeply she felt about this. And it was bitterly frustrating at times that her mother, and experienced artists like Oudinot and Aimé Millet, failed to appreciate the depth of her *angst*. In an avuncular letter of December 1864 to 'my dear young ladies', Millet reminded them that 'It takes years to gain one's individuality'.[15] This was not what Berthe wanted to hear.

Millet meant well, however, and through him Berthe's social horizons were certainly extended. All the family, Cornélie in particular, had an unerring sense of who mattered in French society, a subconscious gift, if you

will, for building friendships with famous people or people who one day would be famous. Yet compared with many of their class they were not excessively snobbish; nor indefatigable social climbers like some of their acquaintances. They had no pretensions, for instance, to the élite sets of Princesse Julie Bonaparte in the rue de Grenelle, or her aunt, the Princess Mathilde, the emperor's cousin, whose Wednesday and Friday salons in the rue Saint-Dominique would frequently include Tiburce Morisot's patron, Adolphe Thiers.[16] The Morisots were realistic in their expectations. They did not expect to be invited, least of all to the Friday evenings which were graced by artists of the Establishment, many of whom – with few exceptions, like Carpeaux – were second-raters, forgotten names today.

On the other hand, they had no designs on the lesser cultural circles of the Ninth Arrondissement. There, at 6 rue Trudaine, up-and-coming artists were entertained by Madame Lejosne, wife of Hippolyte Lejosne, a Commander of the Imperial Guard, but a man of radical tastes in politics and the arts, an admirer of Baudelaire. The Lejosnes enjoyed amateur dramatics and threw theatrical evenings, cajoling their acquaintances, and even their relative, the painter Frédéric Bazille, to take on dramatic roles from Victor Hugo's plays. Many of the Lejosne set – former students of the Académie Suisse or Gleyre's studio, who would become painting associates of Berthe – also frequented the home of Madame Loubens, wife of a well-known headmaster, in the rue du Rocher. She was *La Loubens* to the Morisots when they were feeling particularly catty. Both Madame Lejosne and Madame Loubens were friends of the ubiquitous Manet; both figured prominently in his painting, *Music in the Tuileries Gardens*.[17]

Yet for all these apparently missed opportunities, the truth is that Cornélie Morisot was a natural networker, a compulsive socializer, a salonist by instinct. All her energies in these years, the 1860s, were spent on cultural opportunism both for pleasure and for the sake of her daughters' futures. In their interests she was quite prepared to overlook the fact that Olympe Pélissier – who as Madame Rossini presided over the most prestigious soirées in Passy – was a retired *demi-mondaine*, formerly the maestro's mistress. And she was quite prepared to treat Madame Rossini with considerable courtesy and deference, as the great composer insisted.

Passy was the Morisots' usual orbit. As Jacques-Emile Blanche testified, the Morisot sisters belonged to a self-contained social set, centring on the Villa Fedor where the Carrés lived, a world bounded by the Ranelagh, La Muette and the Trocadéro.[18] But not everybody with an artistic temperament could take the hothouse atmosphere of the Grande Rue. Renoir, for instance, hated it. 'I'd rather die than live in Passy', he once said. 'In the first place it isn't Paris. It's nothing but a big cemetery at the gates of Paris.'[19] Yet Cornélie Morisot revelled in it and she was a skilled hostess, avoiding the prim and pretentious manners peculiar to the place.

What is more, she transmitted her sincere, unaffected mode of hospitality to her daughters.

The Morisots' connections with the Millets and the Rieseners were crucial to their success in broadening their circle of acquaintances. It was in Millet's studio that Berthe and her mother were introduced to two notable women who in their different ways represented living legends of their time.[20] It happened on separate occasions when each was modelling for Millet's commissions. The women were Madame Viollet-le-Duc, wife of the leading exponent of the Gothic Revival in France, then an architect of great eminence, and Madame Pauline Viardot – composer, pianist, actress, linguist and, most of all, international opera star. Viardot, a superb mezzo-soprano, was a remarkable woman in her own right, but she had the advantage of coming from an extraordinary musical dynasty. Her sister, Maria Malibran, had been one of the great sopranos of her day (until tragically, her life was cut short); her brother Manuel, a baritone of distinction, was perhaps the greatest singing teacher of the age.

Pauline Viardot knew everyone who counted in cultivated circles. She studied with Franz Liszt, was praised by Gounod and Berlioz, and was worshipped by Turgenev for thirty years. She helped to launch Gounod, Massenet and Fauré on their musical careers. George Sand and Robert Schumann were her close friends. Her salon in the Ninth Arrondissement drew as heterogeneous a group as it is possible to imagine. Her guests ranged from writers such as Flaubert, Charles Dickens and Daniel Stern (the pseudonym for another salonist, the Comtesse d'Agoult), and musicians such as Saint-Saëns and Ambroise Thomas, to *émigré* princes, Adam Czartoryski and Trubetskoi, and social upstarts like the young Carolus-Duran.[21]

When Madame Viardot retired from public life in 1863 she moved from the rue de Douai in the Opera quarter to the peace of Passy. Through Aimé Millet the Morisots were invited several times to her home. Either she or Millet was responsible for introducing Cornélie and Berthe to another famous Passy resident, Rossini. Viardot had known him since she sang the major roles in his operas, including *The Barber of Seville*. By 1864 Rossini was an old man. For years he and Olympe, like the Millets, had been summer visitors to Passy. Finally, in the spring of 1861, they moved into a grand villa built specially for them in the select Beauséjour area, with views over the Bois. The whole of Passy knew when the Rossinis were in residence because a golden lyre was placed over the entrance gate.

At their famous Saturday evenings, the maestro and his wife threw lavish dinner parties for between eight and sixteen guests. Conversation sparkled at these '*samedi soirs*'. Farce and burlesque were sometimes performed by amusing *habitués* like Gustave Doré. But the highlight was the musical entertainment, often played by the host himself. Rossini's music *was* the

Second Empire: vivacious and racy, 'the musical embodiment', according to Stendhal, 'not so much of France, as of Paris . . . vain . . . excitable . . . always witty . . . but rarely sublime'.[22]

However, if in public Rossini was a showman, in private he was very kind and generous as well as being an amusing mimic. He was apparently charmed by the Morisot ladies – who wasn't? It seems they entertained him in their new house in the rue Franklin and were in turn invited as guests to his soirées. He also thought well of the Morisots' musical abilities and insisted on giving advice over the purchase of a Pleyel piano for Berthe, to the point of autographing it. Experts believe that it was this instrument which appears in the background of several of her paintings.[23]

So often music and painting went together. Pauline Viardot was an accomplished artist and again it might have been she who introduced Carolus-Duran to the Morisots, for in addition to being a painter he was also a good amateur musician. (On the other hand, it could have been Fantin, who had known Carolus for years and was, like him, a devotee of Schumann and Wagner.) Although he was still struggling to establish himself at this time, Carolus-Duran was a flamboyant and self-confident character, with dark, unruly hair that was noticeably long. He was given to dramatic gestures: Tiburce, Berthe's brother, remembered how he wrapped himself in a Spanish-style, red-lined cloak.[24] When Manet painted his portrait over a decade later, he still cut a dashing figure and sported a thick, curly beard.

In 1864 Carolus was in his late twenties. He came from French Flanders and had been born only a matter of months before Yves Morisot, but in Lille rather than Valenciennes, when old Rousseau de Saint-Aignan was Prefect of the Department of the Nord. (The Morisots appreciated such nice coincidences. On such minor points conversations were started and connections made.) So he was invited to the Tuesday soirées ostensibly to give Edma and Berthe advice on their painting and in no time was a regular visitor. Through Carolus, the Morisots were to meet a well-connected husband-and-wife team, Auguste de Châtillon, sculptor and poet of the Romantic school and portraitist of the Bourbon and Orleanist royal families, and Zoë-Laure de Châtillon, whose numerous commissions included a portrait of the Princess Mathilde.[25]

Madame Morisot had already made a decision that since two of her three daughters were artists, it was her clear duty to welcome promising artistic talent to the house. And there was plenty about. Again, Aimé Millet proved a useful contact. His niece, Nélie Jacquemart, has been mentioned: she belonged to another artistic family of the professional classes.[26] Nélie was related to a high official at the Ministry of Finance, a gifted draughtsman called Albert Jacquemart, who had brought out a *History of Porcelain* in 1862, for which his son, Jules-Ferdinand, had done some excellent engravings. The father went on to play an important part in the development of

decorative art in France, while Jules-Ferdinand was set on a career as an engraver and watercolourist. He knew Félix Bracquemond and had exhibited at the 1861 Salon. The friendship between the Millets and the Morisots encouraged Cornélie's interest in Jules-Ferdinand as a potential husband for one of her daughters. He was about the right age: twenty-eight years old. And he came from the right milieu. It fell to Berthe to be the object of his interest. But she showed no enthusiasm for his advances and they both retreated with a certain lingering sense of embarrassment.[27]

In fact, she was distracted at this time by a different sort of emotional relationship, her friendship with the sculptress Marcello, whose debut had created such a stir in 1863. It was the Rieseners whom Berthe had to thank for an introduction to Marcello. Through Thiers, Marcello had met Léon's cousin, Eugène Delacroix, and their mutual admiration added spice to the last two years of the master's life. Rosalie also befriended the sculptress when she took the tenancy on a rented studio at 1 rue Bayard, adjacent to the Rieseners' house, and Rosalie painted her portrait for the Salon of 1866.

Marcello was the pseudonym of Adèle d'Affry.[28] A member of Europe's aristocracy, the child of an illustrious dynasty of counts and officers of the Swiss Guards, she had met and married an Italian duke, Carlo di Castiglione-Colonna, and was then widowed, all within the space of the year 1856, at the age of twenty. There was a magnetic, feline quality to Adèle's personality. Born in 1836, she was still young enough to captivate, old enough to impress and seduce. And with a combination of a title, money, brains, artistic talent and more than her share of beauty and influence behind her, she appeared to hold all the trump cards as she pursued her chosen career of sculpture.

It was her habit to play them brazenly. Her subjects were from the cream of European society: Franz Liszt, the Empress Eugénie, the Habsburg Empress Elizabeth of Austria-Hungary and the Bonaparte Princesses Julie and Mathilde. The young widow attended all the elegant salons of Paris. She knew Pauline Viardot well. Adolphe Thiers received her with open arms at his home, the Hôtel Saint-Georges, and they corresponded regularly for seventeen years. But he was only one of a number of leading public figures whom she assiduously cultivated. Through the Duchess of Galliera she met François Guizot, while at the salon of the Count and Countess de Circourt she was introduced to Manzoni, Cavour, Bismarck, von Humboldt, and the philosopher, Victor Cousin, who, like the musician Charles Gounod, and Hébert, director of the French Academy in Rome, became her devoted admirer. The painter Régnault proposed to her; Prince Louis Windisgraatz was another suitor, the Count de Kergolay served as her companion. After her salon success in 1863, however, she was presented to the empress and gained an entrée to the imperial court. Invited to Eugénie's *lundi*

gatherings at the Tuileries, she became one of the empress's favoured guests at the palaces of Compiègne and Fontainebleau. It was at one of these visits some time in 1864 that she met Prosper Merimée, the eminent *littérateur* and longtime friend of the Countess of Montijo, the empress's mother. For the next five years, until Merimée's death, he became another intimate correspondent. But she caught the attention of Napoleon too: a dangerous advantage, which annoyed Thiers. Yet playing the situation was half the fun. 'The emperor is fascinating', wrote Adèle, 'it is impossible to be more charming and attractive.'[29]

It was little wonder, then, that Berthe Morisot was fascinated by this woman: by her sphinx-like expression, by her worldliness and sophistication, by her dedication to her chosen medium, by her cool, blonde elegance and her shrewd, unsentimental exploitation of the world, which became apparent in the course of their long conversations. The impact of her personality suggests that Berthe was still striving at this time for emotional as well as artistic independence. Adèle warned her from the heart that the path of true love never ran smoothly and the dream of perfect happiness in marriage was chimerical. Berthe listened respectfully. Adèle seemed the perfect role-model and her presence stirred something of an adolescent passion for a fairy princess. Vestiges of this admiration remained the basis of their relationship.

But admiring friends are often blind to unpalatable truths. Adèle seems to have suffered elements of the same split feminine identity and narcissistic syndrome that afflicted the Russian painter, Marie Bashkirtseff, whose final resting place was Passy. Both were foreign-born aristocrats and their responses were similarly moulded by acute consciousness of social status. Their inner and outward selves were caught in conflict. Both found it difficult to reconcile their physical beauty, which inevitably made them the passive objects of male desire, with their ambition for professional independence and success, then considered to be a male attribute, empowering them to be active subjects of their own fate.[30] Berthe was too discreet to comment on the destructive nature of Adèle's inner turmoil and if she was aware of the selfishness and empty snobbery, she let them wash over her. But she understood the dilemma of conflicting purpose and self-worth. It was a common predicament for women artists. Berthe had already sensed it.

On the other hand Adèle was an exciting confidante for a young woman of twenty-three. After all, she had her finger on the pulse of the imperial court; and she had very different perspectives on art and life from Edma or the Rieseners and the Carrés. Throughout the winter and spring of 1864–5, her friendship pointed up Berthe's ambition. Presumably Berthe's adulation also satisfied a need in the thwarted duchess, a need not satisfied by her countless male admirers. She and Berthe remained fond friends. Not

surprisingly in view of her experience of a strongly female household, all her life Berthe clung with impassioned belief to the strength of friendship between women. For her it was a rock of salvation against the storms of life. In one of her later diaries Berthe paid tribute to her relationship with Adèle. She considered it to be uniquely precious.[31]

Someone else who frequented the rue Franklin in the 1860s and seemed to have been blessed with all the talents was the Belgian painter, Alfred-Emile Stevens. He and his young wife, Marie, were, in Tiburce Morisot's words, 'a young couple of striking beauty, radiant with happiness and joie de vivre', while Stevens 'had a dazzling cleverness' and a worldly wit that won respect in all quarters, including from Whistler, Manet and Degas, all independent-minded men.[32] Although he had painted seascapes, since 1860 Stevens had been building a reputation for his modish genre pictures, portraits of young ladies in plush drawing-rooms, displaying their sumptuous Worth gowns. The Stevenses were wealthy and held regular Wednesday soirées in the Ninth Arrondissement, which the Morisots often attended, and where, among other growing celebrities, they first met Jacques-Joseph Tissot and Pierre Puvis de Chavannes.

Corot, Oudinot and Fantin were still occasional visitors to the rue Franklin, but not all their regular guests were professional artists. Dr Emile Blanche, who had attended the same *lycée* as Tiburce Morisot when it was still known as the Collège Bourbon, was a specialist in nervous and mental disorders. A compassionate man, he was proprietor of the nearby Passy Clinic for the mentally ill (the château and park once belonging to the Princesse de Lamballe), and father of the aesthete and man-about-town, Jacques-Emile Blanche, who became an advocate of the Impressionists.[33] And there were the Ferry brothers, sons of a provincial lawyer, who came originally from Saint-Dié in the Meurthe, Grandpa Thomas's old stamping ground. They were 'bourgeois, brought up correctly in the bourgeois manner'.[34]

Jules and Charles Ferry, who were then touching thirty, attended the soirées over several years. Berthe's brother Tiburce remembered them as two strapping and somewhat burly fellows. Jules was a keen artist, and his expertise gave them a common interest with the Morisots. Before becoming a political journalist he had thought of painting as a career, having studied art for four years while preparing for the bar. His brother was already in business and banking. Both brothers were ambitious to make their way in Parisian society. Charles's aim was to become rich, Jules's to forge a successful political career – which by any standards he was to do. Jules Ferry belonged to a rising generation of politicians opposed to the autocratic structures of the Second Empire. His humanity and secular instincts, his belief in sociability as a growing force in modern society, and his determination that women should be educated on level terms with men, all

these features of his thinking were arguably reinforced by observing the Morisot circle.[35]

Conversation at these soirées generally turned on the subject of people. The human angle was Madame Morisot's specialism: her interest was never-ending, though her wit could be barbed. There were always people to discuss. In 1864–5 the emperor was dallying with a blonde *grisette*, a circus-rider-turned-actress called Marguerite Bellanger, whom he blatantly installed in Passy, at the rue des Vignes, just down the road from the rue Franklin. Bellanger was there when the enraged empress stormed her apartment in the hope of ending the affair. All Paris was agog. Apart from episodes such as this, music, theatre, art and artists, sales, exhibitions and Passy – all featured prominently, as one might expect, in the evening's conversation. Rossini's Little Solemn Mass, composed in Passy during the summer of 1863, was given its first performance there in March 1864. At the other end of the musical spectrum, it was the year of *La Belle Hélène*. Paris loved it. Six years earlier Offenbach had introduced the can-can. Now Parisians went crazy over this new spectacular. His melodies became the hit-tunes of the day.

Politics, too, were much discussed. Although the Second Empire appeared to be on course, it was acceptable in the Morisot house to be discreetly critical of the emperor. Mexico was high on the agenda. In 1862, while the United States was distracted by its Civil War, Louis Napoleon, goaded by his Spanish consort, had inveigled the Archduke Maximilian of Austria into a hare-brained scheme to make himself Emperor of Mexico. His real purpose was to establish a Catholic, satellite state to promote French geopolitical interests in Latin America. Parisians watched with indifference when Maximilian and his wife, Charlotte, visited their city in February 1864, to be seduced by the charms of the imperial pair. France was committed to keeping 40,000 troops in Mexico to support the archduke, much more than the economy could afford. But some bitter campaigning against the Mexican guerrillas produced unexpectedly high casualties, as the Morisots would soon find out. Already in 1865 the Mexican Adventure was being talked of as a monstrous disaster.

At home, too, there was a whiff of scandal brewing, as doubts were cast on Baron Haussmann's financial methods. Yet political talk was not the only reason for the Ferrys' regular attendance at the Morisot soirées. They were quite perceptive enough to sense Madame Morisot's expectations; so they did their best to dance attendance on the young ladies of the house.[36]

Berthe and Edma, however, were more preoccupied with painting. Their new studio was completed in 1865 and before leaving for a spring visit to their uncle Octave in Chartres, they submitted two paintings apiece to the Salon. Cornélie Morisot dutifully went along to the Palais de l'Industrie to check how her daughters' pictures looked in their official hanging place.

She also gave them a suitably expurgated account of the rest of the exhibition. She had hoped, but failed, to make contact with Oudinot there so they could discuss the exhibits. Fortunately she met a friend of Corot instead, the engraver Jean-Eugène Ducasse, who gave her a professional opinion. When he praised Berthe's figure by the stream, Cornélie had the confidence to say it did not look at all bad. Unfortunately, however, Berthe's still life and Edma's flower study were not well placed for viewing. But the same was true of one of Oudinot's pictures. That was one of the hazards of the Salon. Completing her survey, while she liked the Daubignys' paintings, father and son, and said so, she frankly found Fantin's group portrait of his friends, *The Toast*, just plain 'bad'. On reflection Fantin was also unhappy with the work and he destroyed it shortly afterwards.[37]

The press comments on the Salon began to come out as Madame Morisot wrote hers. Edma received a notice in *Le Temps* and Berthe's still life was singled out by the critic, Paul Mantz, in the *Gazette des Beaux-Arts*. Perhaps they were pleased to be mentioned at all. But in tones which seem outrageously condescending today, Mantz concluded, 'Since it is not necessary to have had a long training in draughtsmanship at the Academy to paint a copper pot, a candlestick and a bunch of radishes, women succeed quite well in this domestic type of painting. *Mlle Berthe Morisot* brings to the task really a great deal of frankness with a delicate feeling for light and colour.'[38] No doubt Berthe seized on the last words. Delicate feeling . . . light and colour. The values of Corot and Riesener. She was now more certain of her own artistic priorities.

Madame Morisot's relentless efforts to shield her daughters and organize their lives were becoming increasingly evident. She had purposely made no mention to Berthe and Edma of the furore caused at the Salon by Manet's picture *Olympia*, even though she must have seen the painting in Room 'M' where their pictures were hanging. And she would be well aware of the uproar inside and outside the Palais de l'Industrie, which made the outcry over the *Déjeuner* seem like a puff of hot air. For *Olympia* – the urban prostitute with her pallid skin, which drew the crowds 'as if they were at the morgue'; her lack of soul, redolent of Zola's *bêtes humaines* – almost caused a riot. The authorities were forced to post guards to protect the painting. Then in desperation they moved it to a height beyond the people's reach. Before long the reviewers were again trading insults at Manet's expense. Jules Clarétie in *L'Artiste* asked, 'What on earth might this yellow-bellied concubine be . . .?' 'A female gorilla', replied a fellow critic, while a third lectured Manet on his 'near-childlike ignorance of the elementary principles of drawing . . . and a complete inability to paint'.[39] Did Cornélie Morisot convey any of this to her daughters in Chartres? And did she imagine that she could shelter them from this storm?

Of course not. But her answer was wrapped in her suspicion and

disapproval of this man, Manet. She apparently ignored his exhibits. She had no concept (nor, to be fair, had many others) that *Olympia* would be seen as one of the key paintings of the nineteenth century. But Manet could not be ignored. By the end of the Salon all Paris knew who he was. Degas told him, 'You're as famous as Garibaldi!' 'Barbarian! Madman!' shouted the man-in-the-street as Manet walked past.[40] He shrugged off the abuse with a teasing smile and iron self-control. Doeskin gloves and polished shoes; high silk hat, silver-topped cane. A gentleman born and bred, that was Manet.

In the meanwhile, in her daughters' absence, Cornélie Morisot set about organizing their summer holiday. Brittany was mooted. A plan for Berthe to go to Italy with her father fell through because of the expense of building the studio. Madame Morisot's personal suggestion was Bagnoles-de-l'Orne, an attractive Normandy spa town overlooking a lake. But in the event they settled for Corot's kind of itinerant holiday which gave Berthe and Edma a variety of subject matter to paint. It was a long, hot, dry summer. When the Rieseners made their Normandy home available again, the Morisots gladly took up the offer, but first they went to Petites Dalles in Fécamp, the old fishing port north of Le Havre, where the high cliffs give spectacular views over the Channel. From there they proceeded to Beuzeval, to be joined by Rosalie Riesener, who picked up her easy friendship with Berthe. After a while they moved on again, perhaps to Bagnoles because at some time Berthe painted a picture set in Orne (*La Bermondière*) for the next Salon. They also visited the Emerald coast of Brittany since Edma painted a view of the Rance estuary which she exhibited in 1866 and Berthe a scene of Dinard. However, it was Berthe's other 1866 exhibit, *Thatched Cottage in Normandy*, painted while they were at Beuzeval, that Charles Stuckey regards as her 'first masterpiece, one of the very earliest harbingers . . . of the Impressionist style of the 1870s'.[41] The artist had found what she was looking for: her individual touch.

That touch seemed to lend itself best to figured landscapes, small and modern. And now she was ready to try an urban scene from vantage points in Passy. In 1865 she did a little pastel view of the *Seine from the rue Franklin*. This was followed early in 1866 by an oil painting, which showed the bridge and the city rooftops that formed a backcloth to the river barges on the Seine, with the tall column of the Phare des Roches-Douvers. While the 'silvery, misty painting', *View of the Seine from below the Pont d'Iena*, could still be said to reflect the values of Corot, it also revealed her sharp powers of observation and a remarkable capacity to express visual sensation; 'that delicate, cold, transparent light so peculiar to Paris, especially . . . when winter is ending and spring is in the air' is so skilfully captured that it dates the painting for us.[42]

At this point, as happens at certain times in Berthe's life, it becomes difficult to penetrate the veil of silence which enclosed the family's activities.

At the Salon of 1866 Berthe exhibited her two paintings of Normandy completed the year before, but no doubt she was equally pleased to see Rosalie Riesener's portrait of Marcello on view; she herself painted a little watercolour portrait of Rosalie that year. It must be likely that during the late spring or early summer of 1866 she and Edma paid a visit to the Batignolles, to Manet's studio in the rue Guyot, for stung by the Salon jury's rejection of his entries, the artist had mounted a private exhibition of his work. (His gesture was more constructive than that of another desperate *refusé*, Jules Holtzapffel, who locked himself in his studio and blew his brains out.) Among the pictures in Manet's private display were two of the model he had made famous with the *Déjeuner* and *Olympia*, Victorine Meurent. She had posed that spring for *Woman with a Parrot* and, more compellingly in profile, for *Woman Playing a Guitar*. But she was soon to disappear to the United States, leaving a certain void in Manet's studio, so Berthe was to discover.

There was a different void in Berthe's life. It was the frustration of wanting to taste the 'freedom without which one can't become a real artist'.[43] Despite their dozens of new acquaintances, she and Edma were excluded from the haunts where Manet and his circle spent countless fascinating hours discussing art, philosophy, the ways of the world, and each other! It was not just that Passy was on the edge of Paris: stifling social convention kept them away from places where male artists gathered. The Café Guerbois was the latest: 11 grande rue de Batignolles (later the avenue de Clichy). They were denied a glimpse of this bold, busy, contemporary world: the gilded mirrors, red banquettes or green baize billiard tables. They could never sit and watch the waiters swerving like sharp-eyed magpies in their black waistcoats and white cheesecloth aprons between the marble-topped tables and the island hat-stands. The place had been discovered by Antoine Guillemet and by 1866 it had become the accepted rendezvous for the legion of Manet's friends; two tables were kept permanently reserved. The Morisots knew a few of the clientèle – Stevens, Fantin, Legros, Guillemet – and heard talk of others – Nadar, Lejosne, Bazille, Whistler, Renoir, Duranty, Astruc, Zola. Some of these figured in Fantin's manifesto portrait, *Homage to Delacroix*, and again in his homage to Manet, *Studio in the Batignolles Quarter*. More would be added to this roll-call – Monet, Pissarro, Sisley, Cézanne – and in due course a few became regulars at 16 rue Franklin. One in particular, much admired by Manet and by Alfred Stevens, whom the critic, Silvestre, recalls every evening 'among the silhouettes . . . in the gaslight of the Café Guerbois and amid the noise of the billiard balls . . . his very original, very Parisian face, and his humorous bantering expression'.[44] Like the two Morisots – though for different reasons – he was a bit of an outsider. Sensitive, knowledgeable and of distinguished ancestry, his name was Edgar Degas.

CHAPTER SIX

Marriage Stakes

1866–9

In the high summer of 1866 Yves, Edma and Berthe took off for Brittany, but not to the north coast: this time it was to South Finistère. The decision may have come about because the Morisots had connections at Quimperlé. The de Lassalles were to keep a protective eye on the young women. It must have been a pleasure because thirty years later the '*demoiselles Morisot*' were still warmly remembered in the household. However, it appears they stayed 20 kilometres away at Rosbras, above the sandy estuary of the River Aven, and again, thirty years later the house where they had lived was still there, hidden among pine trees.[1]

While Berthe and Edma sketched and painted, Yves had other distractions. Whether by a chance presentation or by means of a formal letter of introduction, she met a former military officer who had been invalided out of the army after losing an arm in the controversial Mexican campaign. Théodore Gobillard was fortunate. By 1867 the war deteriorated into a sequence of atrocities. The Mexican victors of Puebla were to execute every officer above the rank of lieutenant; and the Emperor Maximilian, abandoned by Louis Napoleon, was forced to surrender to the forces of President Juarez, only to be executed by firing squad with two of his generals on 19 June.[2] However, well before this shocking news reached France, Théodore was safely serving as a tax official in the ancient town of Quimper, west of Quimperlé. His courtship of Yves was swift, and as was the custom, a short engagement followed.

Marriage for the respectable bourgeoisie was still primarily a private, domestic celebration. Publicity was shunned as vulgar, so however curious posterity might be, the records simply show that on 1 December 1866 Yves Morisot married Théodore Gobillard, her hero and veteran of the Mexican War. The bride was then twenty-eight, the groom thirty-three years old. Everyone was delighted and gratified that Adolphe Thiers, who had been the patron and guiding spirit of the Morisot family for so long, agreed to be witness at the civil ceremony held in the mairie in the rue de Passy. This was followed in the traditional manner by a religious ceremony a short walk away at Notre-Dame-de-Grâce in the rue de l'Annonciation. The newly-weds returned to Brittany soon afterwards. Their home in Quimperlé was an

attractive town house, with roses growing round the entrance in summertime. It stood in a square overlooking the converging streams of the River Laita which winds its way through the little town, then south towards the sea.[3]

Cornélie Morisot was greatly relieved to have Yves off her hands. But her first daughter's departure merely raised the stakes for the other two. Madame Morisot was typically sensitive to social expectations. Now in her late forties, she was still a very pretty woman but she was more outspoken and suffered from the heightened anxieties common at that stage of life. At Berthe's age, she was the Prefect's wife, a married woman with three children. It was her duty not to let Berthe or Edma lose sight of the future by over-indulging their present enthusiasm for art. At first she tried to coax them to be sensible and pragmatic. 'Inspiration is all very well, but . . . the true science of life, whether in small issues or large, is a matter of reducing problems, helping things along and being adaptable rather than trying to make them adjust to you.'[4]

These preoccupations underlined existing tensions in the rue Franklin. While it is often difficult to be precise about what was going on in Berthe's head, her emotions were certainly more complex and volatile than her mother realized. The point has been made before that it was not easy to find her own creative style in a female-dominated ménage. And after being closeted so long with Edma, they were treated almost as twins. It was this dual strand of Berthe's existence – the desire to express her individuality while holding on to the warm rapport with her sister – that certain art historians believe manifests itself in Berthe's picture, *Two Sisters on a Couch*, which she painted in 1869.[5] Edma was her daily confidante, her *alter ego* – fortunately she was not as dominant as their mother – but she was also her close personal rival. This discreetly competitive situation added to the tension in Berthe's nature. Edma's gentleness was more instantly appealing. There were times when Berthe chafed at the way Corot, Oudinot, her mother – soon Manet and Degas also – seemed to prefer Edma's more meticulous style of painting to hers. In 1867 Manet, for instance, made an offer to an art dealer for a painting of Edma's that he had found charming.[6] There was no mention of Berthe's work. As in many intimate relationships, there were moments of unspoken frustration, envy, jealousy. Berthe was certainly not above feeling these emotions towards women, even her nearest and dearest.

Since Yves's marriage there was also increased strain between Berthe and her parents. Cornélie Morisot had limited patience with Berthe's artistic temperament. (Indeed, she had qualified tolerance of the quirks of most artists, whom she considered too mercurial to make stable marriage partners.) Her genuine affection was tempered with a tendency to meddle, boss and badger. For instance, when they were on holiday in 1867 Madame

Morisot took it upon herself to spring-clean the studio and hang up her daughters' canvases. But even as she did so, a warning bell rang in her head. 'I am frightened by what I have done', she confessed. 'Your father says that you'll undo my work the moment you come back, and your brother says that you'll be justified in doing so, because I ought not to interfere in other people's business.' But she did not fully appreciate the trouble she was laying in store for Berthe and Edma. It took another artist, Carolus-Duran, to warn her that they would never be able to find anything after this reorganization.[7]

Berthe found it difficult to take her mother's intrusions and she tended to react in one of two ways. She either retreated into silence, which infuriated Cornélie – on one occasion she was incommunicado for some days – or her disapproval showed quite plainly on her face. While Edma tended to remain passive, Berthe's deep-set, velvety eyes took on a stormy look. Cornélie always recognized the signs. 'I know that you are shrugging your shoulders', she warned Edma, 'and I can see Berthe's sneering and annoyed expression.' As to Berthe's father, he and his youngest daughter shared too much reserve. When their proposed Italian trip fell through in 1865, Cornélie was relieved, knowing they found it difficult to relax in each other's company.[8]

These small examples suggest that there was a great deal more aggravation below the surface. Before 1866 it was Yves who had been in the front line of these family tensions, but happily for Yves, she had proved herself in her parents' eyes. She had run the race, so to speak, and demonstrated her staying power when, a year after her wedding, on 3 December 1867, she gave birth at Quimperlé to a baby daughter, baptized Paule.[9] Now that her zeal was focused firmly on the other two, Cornélie hoped (and perhaps she feared a little) that Berthe and Edma would not put up unnecessary obstacles to the course.

The use of the racing metaphor is deliberate. Coining an observation from the novel *Lélia*, by George Sand – 'We bring them up like saints, then we hand them over like fillies' ('Nous les élevons comme des saintes, puis nous les livrons comme des pouliches'), Isabelle Bricard has highlighted the dilemma of young women at this time as they faced marriage.[10] All education, whether at the hands of well-meaning mothers and governesses, religious orders or even progressive day schools like the Cours Lévi, was geared to the same stereotyped goal: to suppress sexuality in order to produce chaste young virgins. But then, when they had been reared and were at their most marketable, to throw the innocent creatures into the marriage stakes, into the furious breaking ground of male dominance, the marriage bed, and in due course over the most testing hurdles of the course, through the painful experience of childbirth.

Cornélie Morisot had been through this process from the age of sixteen.

Her daughters were unquestionably old enough now to withstand the physical and psychological shock. Berthe and Edma, however, were still inclined to jib at the prospect. They knew that the conventional marriage was a loveless arrangement. By good fortune their parents had proved more compatible than most. But looking objectively at her own situation, Berthe could not see how marriage would reconcile her natural yearnings for personal autonomy, enduring friendship, romantic love and fulfilled passion. Observing Yves leaving for the provinces, Berthe must have pondered what her sister was giving up: a choice of personable companions, the comfortable security of the rue Franklin, the stimulus of Parisian life. And for what?

For status, security and respectability, Madame Morisot would have said. But the Duchess Adèle had revealed that respectability was a poor substitute for self-expression, although she made no bones about the difficulties faced by intelligent women bent on an artistic career in preference to motherhood. While some parents were understanding – Rosalie Riesener's seemed sympathetic to her artistic aspirations, and Nélie Jacquemart pursued a promising career until she was virtually past child-bearing age – convention was a powerful social deterrent. The women who achieved the most tended to be highly unconventional, like Pauline Viardot or George Sand. Viardot enjoyed fame, a dynamic artistic career, marriage to a theatre director and the undying devotion of the most famous Russian writer of the age, Ivan Turgenev, whom she declined to marry but whose illegitimate child by a Russian peasant she agreed to raise. Berthe's innate fastidiousness made her circumspect, but partly through Adèle's influence she was attracted to the idea of greater independence at a time when a new view of womanhood was beginning to emerge. (In this respect the mid-1860s bear some comparison with the mid-1960s.)

Thanks to the example of writers like George Sand, whom the Duchess Colonna counted among her friends, and of Victorien Sardou, whose latest comedy, *La Famille Benoîton*, ridiculed social tradition, the 'new woman' was less self-conscious in the presence of men. She was more positive, lively, irrepressible in conversation, willing to ask questions and adopt the habit of shaking hands, thereby implying a degree of free will. These traits were more in evidence in literary and artistic circles than in conventional bourgeois drawing-rooms and they made Cornélie Morisot nervous. Especially since Berthe, and Edma too, could not hide their admiration for the most notorious painter of the decade, Edouard Manet, who attracted artists like bees to honey.

Yet the legal and social advantage enjoyed by men posed constant difficulties to women; and men of means had every conceivable freedom and privilege. Even Cornélie Morisot, who was such a committed defender of the system, was aware of the inequalities. On a few occasions, she felt

aggrieved enough to take the feminine side, especially when she observed the lifestyle of Berthe's brother, Tiburce. She watched helplessly as the recipient of all her tender loving care turned into the archetypal spoiled only son – lazy, selfish, irresponsible and quixotic. She put it down to the greater opportunities enjoyed by the male sex. 'Men indeed have all the advantages, and make life comfortable for themselves', she wrote to Berthe suddenly venting her annoyance. 'I am not spiteful, but I hope there will be a compensation.'[11] This remark pinpointed absolutely Berthe's inner reservations.

So Yves's departure only increased Berthe's sensitivity to the subject of marriage. But that did not deter her mother, who, despite her outbursts about men, resumed her campaign to see her daughters settled. Edma, as the elder, was more vulnerable, but she tended to follow Berthe in being cautious about trusting her future to anyone. In company both sisters perfected an air of aloof gentility. Jules and Charles Ferry, who were still in the habit of attending the Tuesday soirées, did their best to penetrate the mask. Jules made attempts to interest Berthe, whom he decided was the more intellectual of the two; Charles paid court to Edma. It was probably a blessing in disguise that Berthe did not respond. Jules was a somewhat withdrawn, emotionally repressed figure. Art was his refuge and politics the outlet for his self-expression. Tiburce attributed the brothers' failure to their lack of city smoothness, but neither Berthe nor Edma was attracted by the uncertain life of a political wife.[12]

All the same, the Ferry brothers were an imperturbable pair. They continued to call to talk politics with 'Prefect' Morisot, whose experience had given him valuable inside knowledge. He understood the workings of the Crédit Foncier, which had financed the redevelopment of Paris, and the Cour des Comptes, which had competence over financial misappropriation. As Berthe's father talked, Jules Ferry listened and asked judicious questions. These conversations on the statistics of the municipal debt were put to good use when Jules began to publish a series of articles in *Le Temps* attacking Baron Haussmann's whole Parisian extravaganza. Then in 1868 he cleverly turned his writings into a best-selling pamphlet, *Les Comtes fantastiques d'Haussmann*, parodying government policy. His political ambitions grew as popular disillusionment increased.[13]

High finance and mismanagement, however, were not of great interest to Berthe, whereas art and artists were. Carolus-Duran also appeared periodically, looking for encouragement from Berthe. At some point he floated the idea of marriage but she hesitated to trust herself to a brash extrovert. The suggestion was dropped. None the less, he visited her parents when she was in Brittany in 1867 and Madame Morisot went so far as to return the compliment and was shown over his studio to admire his latest pictures.

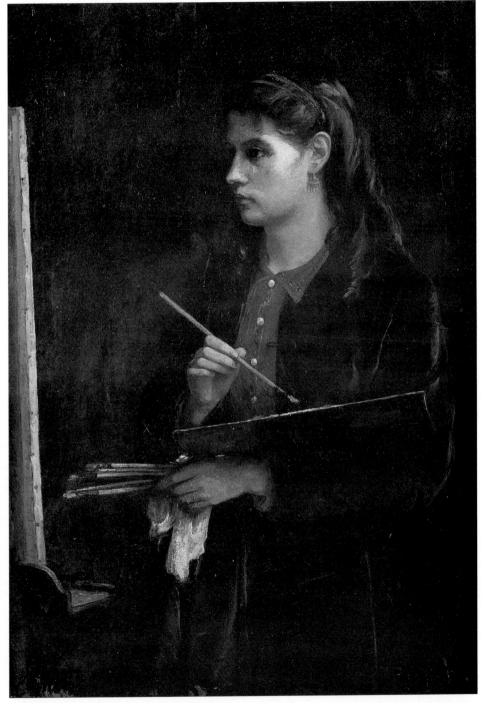

The date of this early portrait is uncertain but it is an interesting sisterly statement about Berthe Morisot's future as an artist.
(Edma Morisot (Pontillon), Berthe Morisot Painting *or* Berthe Morisot the Artist, *c. 1861–6. Oil on canvas. Private Collection. Courtesy Galerie Hapkins-Thomas, Paris.)*

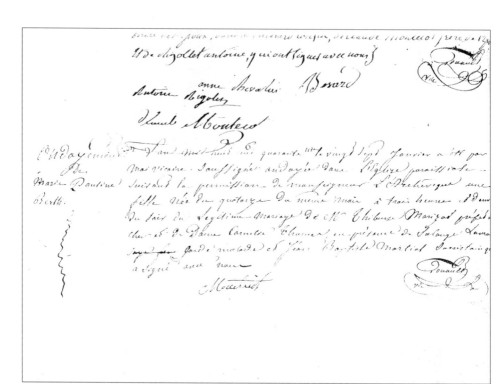

The official record of Berthe Morisot's endoiement or emergency baptism in Bourges cathedral on 27 January 1841.

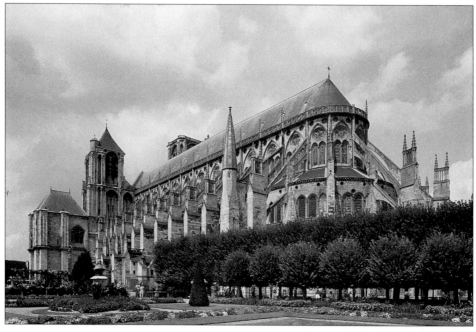

A view of the thirteenth-century cathedral of Saint-Etienne, Bourges, from the Archbishop's garden. (Cathédrale Saint-Étienne, Bourges, le Chanoine Joël Massip. Photograph by Roger Moss.)

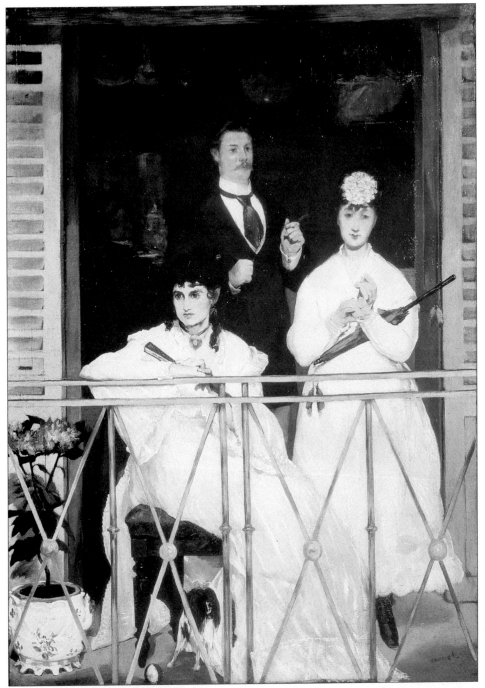

Édouard Manet's first and most notorious representation of Berthe Morisot (seated), with the violinist Fanny Claus, the painter Antoine Guillemot and, in the background, the shadowy figure of Léon Koïlla-Leenhoff.
(The Balcony, *1868–9 by Édouard Manet (1832–83). Oil on canvas. Musée d'Orsay, Paris/Giraudon/Bridgeman Art Library, London.)*

This photograph portrays the intense young woman in her severe day dress. (Photograph of Berthe Morisot, c. 1868. Private Collection. Courtesy of Galerie Hopkins-Thomas, Paris.)

A fine portrait of Édouard Manet, aged thirty-five, at the height of his prowess.
(Henri Fantin-Latour, French, 1836–1904, Édouard Manet, oil on canvas, 1867, 117.5 ×
90 cm, Stickney Fund, 1905.207. Photograph © 1996, The Art Institute of Chicago, All Rights
Reserved.)

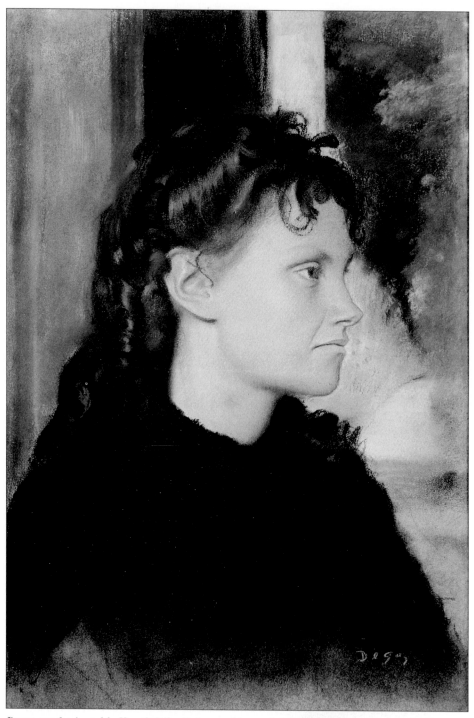

Degas was fascinated by Yves Gobillard's face and persuaded Berthe's elder sister to pose for him. (Edgar Degas, Portrait of Yves Gobillard, *1868. Pastel on paper. The Metropolitan Museum of Art, New York. Bequest of Joan Whitney Payson, 1975. (1976.201.8))*

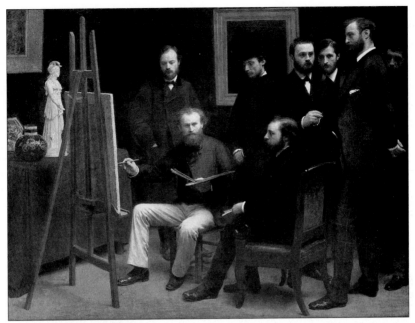

This tribute to Édouard Manet (seated centre) shows some of his admirers: standing left to right: Otto Scholderer, Pierre-Auguste Renoir, Émile Zola, Edmond Maître, Frédéric Bazille, Claude Monet, and (seated) R. Zacharie Astruc.
(Studio at Batignolles, *1870 by Ignace Henri Jean Fantin-Latour (1836–1904). Oil on canvas. Musée d'Orsay, Paris/Lauros-Giraudon/Bridgeman Art Library, London.)*

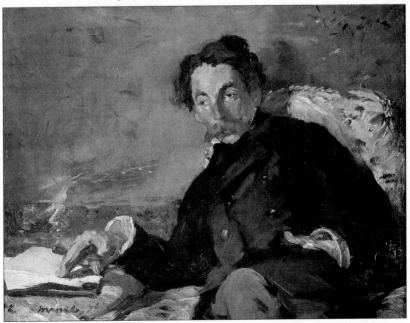

The poet Mallarmé, a close friend of Manet, later became an intimate confidant of Berthe Morisot and her daughter's guardian.
(Portrait of Stéphane Mallarmé, *1876 by Édouard Manet (1832–83). Oil on canvas. Musée d'Orsay, Paris/Bridgeman Art Library, London.)*

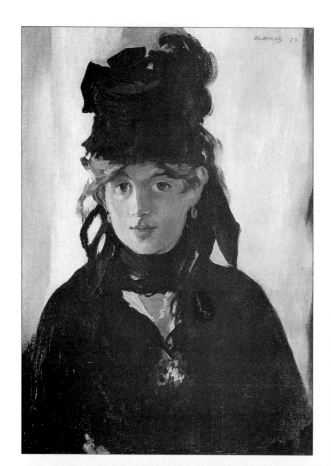

*Paul Valéry observed a tragic
expression in Berthe Morisot's
dark eyes in this portrait by
Manet.*
(Berthe Morisot with a
Bouquet of Violets, *1872 by
Édouard Manet (1832–83). Oil
on canvas. Musée d'Orsay,
Paris/Giraudon/Bridgeman Art
Library, London.)*

On completing the above portrait, Manet painted this still life with a signed dedication to 'Mlle Berthe'.
(Detail: Bouquet of Violets, *1872 by Édouard Manet (1832–83). Oil on canvas. Private
Collection, Paris/Giraudon/Bridgeman Art Library, London.)*

Madame Morisot admitted to Edma that she could never quite make up her mind about him. 'If he were not so pretentious, I think I would find him very appealing.'[14] Cornélie always had a soft spot for a handsome man, but she could be very astute, too, and there was something about Carolus-Duran that told her he would go a long way. In this she was right. Within the next few years his slick portraits became the height of fashion and he was the envy of some of his decriers, such as Madame Loubens and her friends. They may have regretted dismissing him with a joke: 'You don't call yourself Carolus if you were born in Lille!'[15] At any rate, he had his revenge. His career was crowned by the directorship of the French School in Rome, by which time he had attracted students as eminent as the American painter, John Singer Sargent. Yet in high circles he never quite lived down his *petit bourgeois* origins, nor his appeal to popular taste. The Morisots felt intuitively that he was not one of them, so they did not encourage his suit: at best he was kept on the reserve list.[16]

Nevertheless, it has to be said for Carolus that he was determined. He never seemed fazed by Berthe's and Edma's reticence. But the effect on their more timid admirers was devastating. Poor Fantin! After eight years he still found Edma extremely attractive. He had come to the conclusion, however, that she disliked men, so there was no point in proposing to her, as that assiduous matchmaker, Edouard Manet, kept urging him to do. If Cornélie Morisot was exasperated on hearing this bit of news – and she probably was because the anecdote was repeated by that super-gossip, Madame Loubens – she managed to control herself. But she fretted at the uphill task of persuading Edma and Berthe to take the marriage stakes seriously.

It was especially trying when eligible bachelors still presented themselves at the house but failed to fulfil expectations. Pierre Puvis de Chavannes, to whom Berthe was introduced early in 1867 at one of the Stevens's witty soirées, was a case in point. He found her reserve quite appealing. A distinguished and urbane figure (shortly to receive the red ribbon of the *Légion d'Honneur*), he already enjoyed an enviable reputation as an artist of large-scale historical and decorative works in the tradition of Ingres and Chassériau. By the test of wealth and background Puvis de Chavannes would have made an excellent husband for Berthe. He came from a prosperous Burgundian business family; his father, a successful mining engineer, had provided him with a solid, lifelong income. In addition to his apartment in the fashionable Ninth Arrondissement, Puvis was able to afford a large studio in the salubrious suburb of Neuilly, adjacent to the Bois (40 Boulevard du Château). His brother Edouard had political aspirations and lived in some style; his sister also married into a political family.[17]

Puvis, however, was no more involved in politics than any member of the artistic establishment. His early experience of being refused by the Salon

made him sympathetic to aspiring artists, and when Berthe discovered that he admired Corot's work, they had an immediate point of contact. He enjoyed discussing painting with her and was glad to offer his professional advice. In return, she was flattered and a little awed by him.

Although her pictures differed very much in style and subject matter from his, she was the only one in the family to appreciate his work; and typically, she defended it vigorously against her mother's belief that it was uninteresting and cold. Of course, in Puvis's company she reverted to her demure, soft-spoken self. He started to come regularly to the rue Franklin and in return Berthe visited his spacious and well-appointed apartment at 11 Place Pigalle, accompanied by her mother. Her admiration grew. With his erect bearing and round, noble head, and his undoubted presence, he may have reminded the uncharitable Degas of the predatory condor (an American eagle) in the Botanical Gardens, but to most people he looked more like a successful lawyer or statesman.[18]

For a while Berthe nursed romantic hopes of Puvis. She analysed his behaviour in a letter to Edma.

> I bumped headlong into Puvis de Chavannes (at the Salon). He seemed delighted to see me, told me that he had come largely on my account as he was beginning to lose hope of seeing me again . . . and he asked if he might accompany me for a few minutes . . . he implored me so eagerly, 'I beg of you, let us just talk . . .' I almost assented to a rendez-vous there [at the Palais de l'Industrie]. . . . We shook hands, and he promised to come to see me.[19]

Progress, however, was slow. Since she was uncertain of Puvis's intentions, she recoiled from becoming emotionally committed to their friendship. It was easier to concentrate on painting. Private commissions were still sought after (which was probably why Berthe painted at least three portraits, of her cousin Lucien Boursier's wife and her two friends, Rosalie Riesener and Marguerite Carré). But new opportunities had been opening up for artists throughout the 1860s. With the formation of self-help professional groups such as the Société des Aquafortistes in which Félix Bracquemond was involved, and the provincial Sociétés des Amis des Arts, exhibitions and publications were on the increase. Booksellers, publishers, gallery owners, art merchants, including several well-known names – Adolphe Goubil, Louis Martinet, Alfred Cadart, Paul Durand-Ruel – dealt in pictures, but there were scores of small art brokers and retailers of artists' materials who displayed paintings for sale in a window and gave rough-and-ready support, like Tanguy in the rue Clauzel and Latouche and *Père* Martin in the rue Laffitte, the Street of Pictures, as it became known.[20]

Neither Berthe nor Edma wanted to be personally involved in this, the

marketing side of art, any more than they enjoyed the mad bustle of Varnishing Day at the Salon. Madame Morisot did her best to galvanize them into action, with the support of Corot and Oudinot, the latter acting as a kind of business adviser and manager. So by 1867 both Berthe and Edma had pictures on exhibition with the Amis des Arts in Bordeaux. In addition, while they once again holidayed in Brittany, Oudinot came up from Noisy-le-Grand to organize the display of some of their pictures at Versailles, although it was not as lucrative a sale as he had hoped. They received better publicity that summer nearer home, in the rue de Richelieu. It was Jules Ferry who reported enthusiastically that Edma's paintings were attracting attention at Cadart's. He was studying the window display with a friend when he read her name 'at the very moment that people inside the gallery were turning the picture around in order to see it better'.[21]

This good omen, as Ferry described it, confirmed their success a few weeks earlier at the Salon. Berthe's *View of the Seine from below the Pont d'Iena* was accepted, but the hanging committee took two of Edma's pictures, her portrait of Berthe and a scene of the Vaches Noires cliffs at Houlgate painted on their last trip to Calvados. Fantin scored a triumph with his fine portrait of Edouard Manet.[22] It caught the spirit of the man, resplendent with cane and top hat, dark coat and beige trousers. There was even a hint of the swagger. Whistler and Degas, too, were successful, the latter with two family portraits. But most of the Batignolles artists were again ignored: Cézanne, Renoir, Pissarro, Bazille, Guillemet. And Manet was so convinced that he would be rejected that he did not even submit to the Salon. Instead, he borrowed 18,000 francs from his mother and set up his own exhibition in a purpose-built pavilion, opposite to Courbet's, at the corner of the avenue Montaigne and the Place de l'Alma. Here he displayed fifty-three canvases, including his most famous works, which represented eight years' artistic output. The public went to scoff. 'Husbands took their wives . . . wives took their children . . . [and] all the so-called established painters in Paris met at Manet's exhibition. It was a chorus of frenzied ugliness.' Since the Morisots discussed it in their letters it is probable they had seen it too. Despite La Loubens's calculation that Manet lost 150 francs a month on the venture, according to his loyal friend Antonin Proust, it was 'a dazzling sight'.[23]

What forced Manet into taking this costly risk was the much-vaunted 1867 Universal Exhibition which opened a fortnight before the Salon. Louis Napoleon's grand gesture was meant to buy off rising criticism of the imperial regime. To demonstrate that France was still the hub of the civilized world, an international exhibition of fine arts was announced. In addition the emperor presided over a roundelay of balls, feasts, parades and theatrical performances at which a succession of foreign monarchs and dignitaries from all over Europe and as far away as Japan, were lavishly

entertained. However, when it was known that only Salon medal winners qualified as official exhibitors, the majority of artists felt cheated of their commercial rights. For the great exhibition eclipsed everything else in the capital from April to November. Even the Salon had to compete for public attention with displays of Japanese prints and Victorian landscapes, a commemorative presentation of Ingres's works at the Ecole des Beaux Arts and a special exhibition of European masters, headed by officialdom's favourites, Gérôme, Meissonier and Cabanel. Meanwhile, the former royal drill ground of the Champs de Mars, across the Seine from Passy, had been developed as the main site for 'The Greatest Show on Earth'. The focal point was the new Palais de l'Industrie, a colosseum of chocolate-and-gold wrought iron, surrounded by a floral park and a bizarre complex consisting of 101 buildings and towers. Together they offered seven million visitors a kaleidoscope of colours, styles and textures, with a salmagundi of tastes and smells, and the swelling sounds of chorus and orchestra performing Rossini's hymn, specially composed in Passy for the exhibition and dedicated to 'Napoleon III and his Valiant People'.[24]

Excited by all this razzamatazz, Manet decided to capture it in oil as soon as his exhibition finished in June. The idea had been simmering since he saw Berthe's 1866 riverscape at the Salon. Her vision of the Jena bridge and the Left Bank, with the mock lighthouse of Roches-Douvers, part of the exposition effects rising in the far distance, caught his imagination. He must have told her so, and apparently she went to watch him at work on the picture. He chose as his vantage point the meeting of the rue Franklin and the rue Vineuse. His finished *View of the International Exhibition* was markedly different from her *View of the Seine*, and not simply in perspective. It was an action-packed, contemporary panorama of high summer, instead of her gentle river scene on the verge of spring, a vision of a colourful, bustling crowd in place of her somnolent barges at their moorings. But it was significant as the first evidence of artistic interaction between Berthe Morisot and Edouard Manet.[25]

Later that summer, Berthe and Edma visited the Gobillards at Quimperlé before moving on to Rosbras. Berthe still felt bound by professional loyalty to Corot and Oudinot as she worked at *The Pont-Aven River at Rosbras*. Recalling Daubigny's enthusiasm for his *botin*, his floating studio, she and Edma tried painting on board a boat, only to find the tidal motion created problems. At their mother's suggestion they took a trip to the fishing port of Douarnenez. Its beauty left a deep impression on Berthe. Years later she still talked of the early morning views across the bay and the blue fishing nets stretched on gleaming masts, bathed in light.[26] In September, while the two sisters were still in Brittany, Théodore and Yves – now seven months pregnant – came back to Paris and visited familiar sights in the Ile de

France. At Ville d'Avray they met Corot, who warmly pressed Yves's hand as he noted her condition. But in the following months Berthe and Edma found that old friendship ties were loosening. Corot had been hampered by a severe attack of gout in 1866, after which they saw less of him. Around this time they also broke with Achille Oudinot.

Why they quarrelled with Oudinot, whom Berthe had once thought so attractive and with whom, in Edma's words, 'we lived so closely together', will probably never be known.[27] But the crisis prompted a spate of highly emotional letters between the burly, good-looking tutor and his two pupils. And it had such a deeply-wounding effect on Berthe that even in recollection Edma felt angry on her behalf. It is an intriguing episode. Why should Edma 'still feel so much hate for that man'? Why was Berthe so distressed? Did Oudinot take advantage of her as a business adviser? Did he perhaps cut her to the quick with criticism of a painting? Did he make her lose her self-control? Had it anything to do with the rejection of one of her submissions to the Salon of 1867 and again in 1868? If not a professional matter, was it an amorous incident that Berthe wanted to forget? Was Oudinot secretly smitten by her and did he perhaps misinterpret her response? Though with hindsight Berthe felt 'very silly to have cried so much for so little', she became worried about possible repercussions. 'I have never once been to the salon without meeting Oudinot in room M', she confided in Edma. 'Puvis asked me with astonishment if that was not my former teacher. *I think he has heard some gossip in that connection.*' For a while she was haunted by this emotional involvement and veered away from the male sex.[28]

Yet something had to be done about her future. In the absence of any steady admirer, Madame Riesener took a hand. She arranged a formal introduction. Like any blind date, the first meeting was always a tense occasion, and any contender had to win Cornélie Morisot's tacit approval. This time Berthe had gone upstairs to make herself presentable, when her mother appeared outside her room and asked heatedly, 'How long are you going to leave me face to face with that idiot?' As a suitor the man was doomed. Then a similar arrangement in 1869 proved abortive. Berthe admitted (in language reminiscent of Jane Austen's Elizabeth Bennet), 'I have missed my chance, dear Edma, and you may congratulate me . . . I think that I should have become ill if I'd had to decide in favour of Monsieur D—— at that moment. Fortunately this gentleman turned out to be completely ludicrous.'[29]

In present-day circumstances it requires a leap of the imagination to comprehend how intelligent western women accepted this de-personalized mode of courtship (not to mention a marriage system that smacked of horse-trading). The Morisots, to be fair, respected their daughters' choice of partner. The only question was who? If the Millet and Riesener

connections had yielded nothing, there was still the Manet circle. Edouard had two unmarried brothers, both gentlemen-lawyers. Eugène was in his early thirties at this time, Gustave (who had already earned a footnote in art history as a model in the *Déjeuner*), a year younger. But Gustave, outgoing and radical, was into Republican politics, like the Ferry brothers. Eugène, on the other hand, was an inhibited and diffident man, not at his best with women of Berthe's class. Manet, however, had a number of eligible male acquaintances. There was Edmond Maître, for instance, black-haired, with a fine, sensitive face, an amateur artist and son of a rich Bordeaux family. Frédéric Bazille, another *habitué* of the Café Guerbois, might equally have qualified. He was Berthe's age, he was impressively tall and statuesque, had embarked on a career in the medical profession before taking up painting, and came from a wealthy middle-class family in Montpellier. Berthe admired his work and she identified him at the 1869 Salon as 'the tall Bazille'.[30] There was also Bazille's colleague, the landscapist, Alfred Sisley. A comfortably off, Parisian-born Englishman, solidly handsome with dark wavy hair, he was, in Renoir's words, 'a delightful human being'.[31] Sisley, like Berthe, was genteel and reserved and lived outside the hurly-burly of the Batignolles. In 1866, however, he found a wife in the petite Marie Lescouezec.

Here was the nub of the problem. As time went on, one by one the sisters' acquaintances seemed to find partners. Fantin's friend Félix Bracquemond met a lively and intelligent brunette called Marie Quiveron in the Louvre. Marie had worked in Ingres's studio before she and Félix married in 1869. They remained on friendly speaking terms with the Morisots, but their paths crossed less frequently. Another bride of 1869 was the youthful violinist, Fanny Claus. The Morisots had met her at the Manets' and Edouard introduced Fanny to his painter-friend, Pierre Prins. They fell in love: a more shy and gentle pair could not be imagined. Meanwhile, Cornélie Morisot learned too late of Carolus-Duran's impending marriage. His wife, born of French parents in St Petersburg, was one of his former students. Pauline-Marie-Charlotte Croizette, a tall, handsome woman, had made her debut at the Salon the same year as Berthe and Edma. The Morisots' first meeting with the new Madame Carolus-Duran at the Salon inevitably caused a little embarrassment.[32]

Even Fantin deserted Berthe and Edma. In 1866 Degas had painted the portrait of an attractive and serious-minded young painter called Victoria Dubourg. Some time around 1868 she and Fantin met while copying the same picture in the Louvre: it was, appropriately Correggio's *Mystic Marriage of St Catherine*. Soon after they became engaged, although financial constraints prevented them from getting married for several years.

The sight of Fantin with the engaging Mademoiselle Dubourg clearly upset Berthe. Her resentment never matched Degas's venom but her reactions

suggest that deep down she had thought of Fantin as a loyal admirer and a
friend for life. It was her least attractive characteristic that she would give way
to flashes of spite and envy. But that was Berthe as a young woman: prickly,
insecure, over-sensitive and jealous whenever she felt remotely threatened.
She and Edma resented the fact that Fantin was in love with someone else.
They told each other how he had changed; he had become 'more ill-natured
and unattractive', his painting had deteriorated. (In fact, Fantin's flower
paintings were greatly admired, especially in Britain.) Sadly the sisters showed
how privilege could dull their perception of other people's misfortunes:
Fantin was depressed by his frustrating personal circumstances. And yet they
still nursed a liking for his company, even a fondness for him, going back to
their early meetings in the Louvre when he fed them ideas and chatted
knowingly about people. 'Dear Fantin, I don't meet him anywhere!' Berthe
complained. 'Yet I need to talk to him a little to recover my zest for life.'[33]

Degas, who could never pass up an opportunity to score points, gave
Berthe moral support. She murmured with satisfaction when he labelled
Fantin a sour old maid. It was, in fact, a fair description of Degas himself in
certain moods. However, 'Monsieur' Degas could also be very diverting
company, so from 1868 he was a Tuesday night regular at the rue Franklin.
He had a comedian's eyebrows – arched and flexible – and beady eyes above
his flat, pale cheeks and primly curved mouth: questioning, observant, as
Berthe herself observed. He enjoyed teasing, especially those whom he
guessed would stand up to his wicked sense of humour. Yves, being gentle
and good-natured, escaped his barbed tongue, but Madame Morisot was
sometimes gulled by his tall stories and Berthe was vulnerable in a different
way. Perhaps because she took herself and her painting so seriously, he gave
her a hard time and she was easily deflated. Degas, she conceded, 'has a
supreme contempt for anything I do'. It was far from true – witness their
enduring liaison – and if Berthe were being honest, she was well aware of
his tendency to be hyper-critical of his close friends.[34]

In point of fact Degas knew that he was being assessed as a potential
husband. When it came to the mechanics of courtship, Berthe had a
conventional view of gender roles. Not surprisingly she found him a very
elusive suitor. She complained to Edma after one of the Stevens's soirées
that Degas 'came and sat beside me, pretending that he was going to court
me, but this courting was confined to a long commentary on Solomon's
proverb, "Woman is the desolation of the righteous".' Manet, who was
perceptive about relationships and sensed Berthe's confusion, tried to warn
her of Degas's misogyny. Degas wasn't 'capable of loving a woman', he said
in his half-jocular, half-serious way, 'much less telling her that he does, or
doing anything about it'.[35]

This view of Degas prevailed until recent years, supported by his
dismissive remarks (he once said of Berthe that she 'made pictures the way

one would make hats')[36] and his brutally explicit drawings of female nudes. However, antifeminist comments abound in nineteenth-century memoirs. Degas was just a natural bachelor. A cerebral man with no time for fools of either sex; a man who enjoyed his own company, who recognized his own aversion to responsibility and conventional domesticity; who, in the words of Renoir's friend, Georges Rivière, 'was simply not cut out for the annoyances of family life'.[37] He belonged to a type well known in intellectual circles. In time Berthe realized his manner was his personal defence mechanism against emotional involvement, so there was a narrow line between his teasing and his gauche attempts at flirtation. But for a while she was baffled by his behaviour. It seemed to send out confusing signals. What was she expected to think when, on the occasion of the 1869 Salon, he abruptly left her side to go off to talk to the middle-aged Madame Loubens and another hostess, Madame Lisle? She admitted to being affronted, 'when a man whom I consider to be very intelligent deserted me to pay compliments to two silly women'.[38]

In reality, Berthe had something in common with Degas: she was too much of a perfectionist for her own good. She could be just as disdainful of her own efforts as she was of other people's and there was an inner core of naïveté in her which made criticism painful. Yet superficially she conveyed a different impression. Her social superiority and dark, romantic beauty intimidated many men – had undoubtedly intimidated Fantin from the beginning of their friendship. Had she been more conventionally pretty or had she been inclined to exploit her physical attractions like the so-called *ogresses*, the man-eaters of high society, or the *demi-mondaines* of the Parisian boulevards, her life story would have been very different.

But she was far too inhibited to flaunt herself. Instead, she shrank from men with whom she felt incompatible. And given her closely chaperoned existence, her options – like Edma's – were narrowing. In addition, she still nursed a good deal of confusion in her heart about love and marriage. Her admiration for Adèle d'Affry and her fascination for Edouard Manet were two bright lodestars in her life. Yet, while they both directed her instincts to the world of art and artists, they were also counter-attractive forces, tugging her emotions in opposing directions. If one was her ideal heroine, the other was her ideal hero. Whether Edma knew the depth of Berthe's fondness for Adèle is doubtful, but she understood the magnetism of Manet. She and Berthe had spent long hours opening their hearts to each other, keeping their secret faithfully in the privacy of the bedroom confessional. Manet was always extremely attentive and Berthe felt there was a special affinity between them. By 1869 Edma had to concede that she was out of the picture: 'My infatuation with Manet is over', she wrote, warning Berthe to burn the letter. For Berthe it was different. In her own words, Manet 'is associated with all the memories of my youth'.[39] Proof positive of his

importance in her life by that time. She was already twenty-seven by 1868. But there was, of course, one crucial complication to their relationship. Edouard Manet was a married man.

It was ironic that Manet was the link between Berthe and the next event to shatter her life. Manet was immensely loyal to friends of long standing. When in 1848–9 he had temporarily embarked on a naval career, his fellow cadet aboard the ship *Le Havre et Guadeloupe* was a lad called Adolphe Pontillon. They had enjoyed a certain camaraderie on the long voyage to and from Rio de Janeiro, and to record their experiences of the Mardi Gras, Manet drew his friend in the pose of a drunken Pierrot. It was one of his earliest studies.

Now, twenty years after their South American adventure, the paths of Manet and Pontillon chanced to cross again. His former comrade was a naval officer on leave from his base in Cherbourg. His family had an estate at Maurecourt in the Oise valley, from which it was convenient to visit Paris. It seems probable that Manet invited him to his home in the rue Saint-Petersbourg. Can we presume he found the opportunity to introduce him to the Morisot sisters? It seems likely. Manet loved nothing better than a bit of marriage-broking: it appealed to his sentimental nature. At any rate, the meeting certainly took place. And it was the answer to Madame Morisot's prayers. In December 1868 Edma entered her thirtieth year. She was reaching a recognized threshold in her life, a time of decision, sometimes a time of panic; she was loath to contemplate what lay beyond.

A combination of personal, social and even financial urgency was persuasive. Edma succumbed to a whirlwind courtship; preparations were hastily made for the wedding on Monday, 8 March 1869. She and Adolphe were married in Passy. Once again Monsieur Thiers attended and gave his blessing as a witness at the civil ceremony. The couple left immediately for a honeymoon in the Pyrenees.

It was a painful separation for both sisters. 'I am often with you . . . in my thoughts', wrote the new bride. 'I follow you everywhere in your studio and I wish that I could escape, were it only for one quarter of an hour to breathe again that air in which we lived.' Back came Berthe's pathetic reply. 'If we go on like this, my dear Edma, we shan't be good for anything. You cry on receiving my letters and I did just the same thing this morning. . . . You have a serious attachment. . . . Do not revile your fate. Remember it is sad to be alone.' Cornélie Morisot was most concerned. 'I have just found Berthe so touched by Adolphe's letter that she is crying over it with her nose pressed against the wall.'[40] Berthe was distraught. She could not disguise the yawning emptiness in her life now that Edma had gone. Hesitantly she turned to Edouard Manet for consolation.

Manet

Ce riant, ce blond Manet
De qui la grâce émanait,
Gai, subtil, charmant en somme,
Dans sa barbe d'Apollon,
Eut, de la nuque au talon,
Un bel air de gentilhomme.
 (Théodore de Banville)

[Manet, smiling and fair,
full of graciousness and charm,
vivacious and discerning
behind that divine beard,
every inch the epitome
of a handsome gentleman.]

CHAPTER SEVEN

Echoes of Baudelaire

1868–70

The summer of the Universal Exhibition had been oppressive. On the last day of August 1867, the poet and art critic Charles Baudelaire, author of *Les Fleurs du Mal*, died in Paris after a long illness. At the time Berthe and Edma were away in Brittany, and Edouard Manet, still holidaying at Trouville, was called back to the capital by the news. He went to the funeral with a small group of friends, among them Fantin, Bracquemond, Stevens and Nadar. Leaden clouds filled the early September sky, symbolic of the poet's life; a violent deluge of rain and hailstones broke as they laid him to rest in the cemetery of Montparnasse.

Baudelaire was a legend in his lifetime. Manet had met him in 1858 at one of Commander Lejosne's soirées, the year after he and his publisher were prosecuted for the notorious *Flowers of Evil*. The two men, Manet and Baudelaire, distinctive and fastidious in their appearance, quickly recognized the genius in the other. They shared what one biographer has called 'a curiously profound identity of spirit', a doom-laden sense of alienation from both the public and the powers-that-be.[1]

In Manet's case, the feelings of rejection were invariably concealed beneath a layer of charm and bravado, though he was subject to violent swings of mood from elation to despair. The dark side of his spirit surfaced periodically in his preoccupation with death. It was the theme of several of his works: a funeral, a dead toreador, the execution of Emperor Maximilian, corpses in the street. Privately, he was wounded by acts of mindless cruelty and by vicious personal criticism. Stunned by the general condemnation of *Olympia*, he wrote to his friend Baudelaire for comfort: 'Abuse is raining down on me like hail. I have never known anything like it before.'[2]

Baudelaire's problem was chronic. From youth his life was punctuated by phases of acute anxiety and despondency, from which he took refuge in promiscuity and drugs. He attempted suicide. He put his despair into poetic words. 'Today I experienced a peculiar warning. *I felt the wing of madness pass over me.*'[3]

Berthe was fascinated by this *cri de coeur*. Her interest in Baudelaire came through her friendship with Manet: the poet's sharp perceptions of pain and pleasure touched a chord with her. In *The Flowers of Evil* Baudelaire's

lines are suffused with a hopeless nostalgia for unattainable perfection, referred to as *le spleen*, a neurotic depression that was a nineteenth-century obsession. Manet possessed copies of Baudelaire's work in his private library and was in the habit of lending them to his close friends. Since he lent Baudelaire's writings on art criticism to Degas, it is quite probable that Berthe borrowed them too. (Indeed, in 1869 Madame Morisot told her, 'I have taken the books back to Manet.')[4] Later Berthe demonstrated her familiarity with key parts of Baudelaire's *Journaux Intimes* by adapting his words in her own private notebook, as if Baudelaire's sense of the abyss, his analysis of his own private hell, had a special meaning for her.

It was popularly believed that inherited temperament determined much of human action and disease, and little could be done to heal psychic disorders; the importance of Freudian factors, of childhood and environment, were not yet appreciated. In trying to come to terms with his state of mind, Baudelaire believed melancholy was a hallmark of his contemporary world; it was *the* modern affliction. But more significantly, he saw it as a necessary component of beauty and genuine artistry. Other artists – Flaubert, for example – endorsed his view of melancholy as the modern temperament. And the novelist Paul Charpentier went a step further when he concluded that melancholy was part of the French national character, a pervading influence on art and life.[5]

Manet was quick to recognize this acute temperamental condition in Berthe. He saw in his two sensitive friends, Baudelaire and Berthe Morisot, living proof that melancholia was the spiritual cross of all true artists. Berthe spoke of her black days, when she was overwhelmed by a 'mania for lamentation'. It was not something confined to her teens. Her acquaintances always regarded her as a rather melancholy woman. However, the moodiness was fully detectable in her youth, which was why the Morisots found her much the most difficult of their three daughters. Early emotional insecurity, obsessive perfectionism and introspection left their mark. From her twenties the attacks of depression became a regular feature of her life. Edma's marriage merely fanned her feeling of futility. She poured her heart out repeatedly to her sister. 'Remember . . . a woman has an immense need of affection.'[6] Words of infinite pathos, and all the more so because they were written not for public effect but in the privacy of personal correspondence.

Berthe's brooding self-preoccupation baffled the Morisots. They felt powerless to help. Her mother swung between tactlessness and gushing sympathy for her 'dear Bijou', thinking of her 'poor little face bewildered and dissatisfied over a fate about which we can do nothing'. When Berthe's brother, Tiburce, went off to the United States (as if to demonstrate the different opportunities enjoyed by the two sexes), she was left alone with her parents. Her morale nose-dived in this period between 1868 and 1870.

The absence of Edma, the nagging friction with her mother, the inability of Berthe and her father to relate to each other – they scarcely ever talked and tended to avoid each other – and a condition which her mother described as morbid, all seemed to contribute to her general lassitude.[7] Berthe's pallid skin and lack of energy may have signalled anaemia, but her other symptoms fitted a familiar nineteenth-century condition known as neurasthenia: the fatigue, the mood disturbances with bouts of irritability and depression and an eating disorder. Like those with a tendency to anorexia, she was over-preoccupied with weight: the most frequent insult she used about others was to call them 'fat'.

Her low morale went hand in hand with indifferent health. In the spring of 1869 she developed an eye infection. Embarrassed by her appearance, she confined herself to the apartment, staring through the windows at the opening buds of spring. A wet spell in May made her feel wretched. 'I drag myself about aimlessly and I say twenty times a day that I am tired of everything. This is how my life goes.' Even after a summer holiday her face was thin and drawn. By the following spring there were frequent scenes because of her bouts of nervous exhaustion and irrational behaviour. Nausea made eating a major problem. She had lost weight and by the early part of 1870 Madame Morisot was extremely worried by her rejection of food. She reckoned Berthe had barely eaten half a pound of bread since Edma's departure: 'it disgusts her to swallow anything. I have meat juice made for her every day.'[8]

The only solution the family could think of was the distraction of her sisters' company. In May 1869 Yves had arrived with little Paule, now an active toddler. Théodore Gobillard had been transferred from Quimperlé to Mirande, in the south-west, so Yves had seized on the opportunity to come home. Edma presumed that 'to have Bichette [Paule] in one's bed every morning' would cheer Berthe, but the solution was not a success.[9] While Yves was still at the rue Franklin, Madame Morisot packed Berthe off to Brittany to stay with Edma. As it turned out, this was no more effective. Edma was pregnant at the time and did not feel like going out on painting trips. To judge from her letters she was still trying to adapt to provincial life and to marriage. She envied Berthe for being able 'to talk with Monsieur Degas while watching him draw, to laugh with Manet, to philosophize with Puvis' and she bemoaned her own inadequacies. 'I completely ruined a still life on a white canvas and this tired me so that after dinner I lay on my couch and almost fell asleep.'[10]

For a while, painting in the open air was forgotten. Berthe had seen and admired Manet's collection of still lifes in his studio. She discussed them with Edma and, returning home, tried to pull herself together. Fired by these examples, she confessed, 'I too wanted to do my plums and my flowers, the whole thing on a white napkin.' But the result was

'insignificant'. Although she did manage to paint some peonies in a glass vase – they were Manet's favourite flower – her irritability spilled over everything around her. Nothing and nobody pleased her; not even old heroes and masters. 'Landscapes bore me', she said bitingly after viewing the 1869 Salon; even those of Daubigny, father and son. She had been glad not to see any of Oudinot's. And even the Master was not exempt. 'Corot spoiled the *étude* we admired so much when we saw it at his home, by redoing it in the studio.'[11]

In a giveaway comment in one of her letters, Edma put her finger on the source of her problem. Discussing the need for Berthe to have a change of air, she said casually that it was a pity her sister could not join the Manets.[12] The mention of the name was a reminder of Berthe's frustration. The Manets were staying in Gennevilliers. The two families were now on close terms. The Manets sometimes came to the Tuesday soirées at the rue Franklin, and the Morisots were regular guests at Madame Auguste Manet's Thursday musical evenings. Putting aside her former doubts about Manet's artistic and political radicalism, Madame Morisot had struck up a sincere friendship with the widowed Madame Manet.[13] There may have been a little genteel one-upmanship. Madame Morisot could recount how flattering Rossini was about Berthe's piano-playing. In her heyday Madame Manet used to sing to violin accompaniment at the Comtesse de Sparre's intimate musical evenings in the Place Saint-Georges, which Monsieur Thiers attended. But now, at the Manet soirées in the rue Saint-Petersbourg, it was her daughter-in-law, Edouard's wife, who held the attention of the audiences with her piano-playing.

Suzanne played the German composers with great skill: Schumann, Beethoven and, more daringly, Wagner. But she excelled at Chopin, her small, white fingers rippling over the piano keys to produce an effect that brought tears to the eyes of appreciative listeners, particularly Edouard's sentimental friend, Fantin-Latour. To please Suzanne, Madame Manet sometimes invited the Saint Cecilia Quartet, the four Claus sisters, gifted string-players with whom her daughter-in-law played the piano. At other times, she included another of Manet's friends, the petite Madame Camus, wife of a well-known physician, who also happened to be an excellent pianist.

It was ironic that music more than art brought Berthe and Manet into regular contact. Although Edouard had been brought up to listen and play, he had no real ear for music and had a low boredom threshold, if Antonin Proust is to be believed.[14] He attended the family soirées out of conventional respect for his wife and mother, and because many of his friends were music lovers. Zacharie Astruc, Commander and Madame Lejosne, the music critic Edmond Maître, and Fantin and Degas among the painting fraternity, were all genuine enthusiasts. Like Fantin, the Lejosnes were catholic in their tastes and tried to promote Wagner, while still

enjoying *opéra bouffe.* Their friend Offenbach became one of Manet's circle after he met Edouard in the rue Trudaine, and as a testimony to the most popular composer of the age Manet included him in his toast to Paris, *Music in the Tuileries Gardens.*

Manet's political friends also included a keen Wagnerian. Emile Ollivier, the liberal lawyer and deputy who had accompanied Manet on a tour of Italy in 1853, was a noted connoisseur. His first wife, Blandine, was a magnificent pianist, as one might expect of the natural daughter of the renowned Franz Liszt. Another frequent guest with the Morisots was the composer Emmanuel Chabrier, a plump, stocky man who played the piano with great bravura and would mesmerize his audience with his rendering of Saint-Saëns's *Danse macabre.* Manet had also discovered two Spanish musicians and brought them to the rue Saint-Pétersbourg. Jerome Bosc, a composer of charming love songs (one of which Edouard undertook to illustrate with a lithograph), sang for Madame Manet's guests to his own guitar accompaniment; and the tenor Lorenzo Pagans, who had made his Paris debut in 1860 in Rossini's opera *Semiramis,* sang the airs of Rameau with great charm. He was also a fine instrumentalist. In 1869 Edgar Degas painted Pagans strumming his guitar at one of *Père* Auguste Degas's soirées.

Behind the façade of these gracious musical evenings the exchange of banter and cutting gossip hid a deal of polite boredom. Berthe's pleasure came from listening to the conversation and occasionally adding her own swift, soft-spoken comments. Edouard Manet was invariably in good form, a buoyant presence – much more so than his brothers – for allegedly he was the only person who could make Fantin laugh. Edouard was intrigued by literary figures and his guests usually included a writer or two. Zola and Astruc were often there. Manet was grateful to them; their newspaper articles had done a great deal to raise his morale when most journalists were bent on destroying it. Charles Cros was another regular. He was a wonderfully versatile character, inventor, poet, actor and impersonator. And until 1865 one of the most welcome guests was the other Charles, the poet Baudelaire, a man prematurely aged by debauchery and ill-health. Tradition has it that he was sometimes present on the same occasions as the Morisots.[15]

Unfortunately, Baudelaire and the aesthetic school of writers were a cause of family disagreement in the Morisot household. Instinctively Berthe sympathized with their advocacy of 'art for art's sake', whereas Cornélie Morisot scorned it as self-indulgent nonsense. In part she blamed Manet for purveying such trendy arguments to her daughters. Baudelaire had also stated in his famous review of the 1846 Salon that the function of the true artist was to portray the modern world. 'Parisian life is fertile in its provision of marvellous, poetic subject matter. The marvellous envelops and drenches us, like the atmosphere'; and so 'He will be a painter, a real painter who will know how to seize on the epic quality of modern life'. Second to Courbet,

Manet was talked of as the supreme Realist for his objective depiction of contemporary scenes, but his personal vision was more in harmony with Baudelaire's definition of modernity: 'the transitory, the fugitive, the contingent, one half of art, of which the other is eternal and immutable'.[16] Baudelaire's young admirers, Whistler, Renoir and Monet, all tried to find their own way of capturing the instantaneous quality of modern life. Berthe, too, was seeking her individual version of modernity. She was to combine a timeless quality with an immediacy that comes from careful observation of clothes, decor, artefacts and fleeting gestures, set against the transient moods of landscape, sky and water.

Meanwhile, Manet observed Berthe just as closely at his mother's Thursday evenings. Since the sudden and unexpected departure of Victorine Meurent, he had no regular model. In fact, he gave the impression of disliking professional models. He saw Berthe, with her pale olive skin, her almost Spanish beauty and melancholy expression, as an exciting replacement for Victorine. She had all the characteristics of modern womanhood. In his impetuous way he saw her through new eyes. She was highly desirable, and the more he thought about her, the more his senses were teased by her presence. Soon he was obsessed with the idea of persuading Berthe to be his model.

But he was well aware that it would be a delicate request. It was unconventional for an unmarried young woman of her class to pose in an artist's studio for something other than a privately commissioned portrait. Since most models were from the lower classes, it was almost a tradition in Parisian studios that after painting or sculpting a woman's body, an artist had the option of sexual gratification, and it was widely assumed that a regular model was the artist's mistress. In fact, Berthe's situation would be different: her mother's constant presence at the sittings saw to that. And the friendship between Cornélie Morisot and Madame Manet was an additional guarantee of trust. But Manet was still thinking about his tactics when Alfred Stevens intervened. Stevens, who was after all a mutual friend, had persuaded Berthe to pose for an informal portrait in the spring of 1868. When it was finished, Stevens teasingly inscribed the picture 'To Ed. Manet' and handed it to him as a gift. One can imagine the *badinage*. Behind this kind gesture (Stevens was always generous to a fault) was he making a point about Manet's compulsive interest in Berthe?[17]

Manet, of course, always covered his tracks. When Fantin tried to cajole him to reveal his true opinion of Berthe and Edma, he jokingly suggested they should go off and marry academicians.[18] That was in August, but as soon as he returned from holiday in September he eagerly sought Berthe's company at one of the Morisot Tuesday evenings. He wanted to broach an idea for a genre painting which had been simmering in his head while he was away in Boulogne. He had noticed a group of people sitting on a

balcony, silhouetted against a dim interior. The scene had possibilities. Berthe listened encouragingly. There was nothing novel in the setting: Goya, Constantin Guys and Whistler used it. (In fact Manet may have heard the American talking at the Café Guerbois about his portrayal of four women sitting on a balcony drinking tea.) But Manet believed he could develop the idea differently, using two men and two women. He had decided to ask the painter Antoine Guillemet, a colleague of Zola and Cézanne, whom Berthe had met five years before at Auvers, to be one of the male models, and he could always count on Suzanne's young brother, Léon, as the other. If Berthe would do him the honour of posing in his studio, he would ask eighteen-year-old Fanny, the violinist in the Saint Cecilia Quartet, to be her foil. Excited by the prospect, Berthe agreed.

The Balcony was slow to take shape as Manet wanted it. He was always reluctant to waste time on preliminary drawings and studies, but his models found that his spontaneous approach had drawbacks: he was inclined to make repeated revisions. Berthe, however, enjoyed the novelty of watching him at work and observing his routines, regarding this as fair recompense for her time. In the course of these sittings, she became aware that his gaze seldom left her for long. Seated in her flowing gown of striped snow-white silk organza, she felt exhilarated by his enthusiasm. He worked with a manic intensity and for the first time she sensed her power to monopolize Manet's attention. She completely overshadowed the shy and gentle Fanny, 'the little Claus' wearing a ludicrous white posy on her head. Berthe would have been content to attend the studio indefinitely – even allowing for her mother's presence as chaperone. But the others found striking poses tedious and uncomfortable and after fifteen sessions Antoine's patience wore thin. As an artist he judged the painting was getting nowhere. It was no more than an embarrassing study in awkward silences. His rigid, pompous stance and bored look gave him away, and he felt that poor Fanny Claus looked quite atrocious. So to call a halt, they agreed to tell Manet the picture was perfect. Reluctantly Berthe had to go along with their stratagem.[19]

On one of her visits Berthe had noticed a highly flattering portrait of Suzanne which Edouard was working on that autumn, but she was not to know the context. The Manets had earlier been offended by a double portrait by their friend, Degas, which seemed to point to the incompatibility between Edouard and Suzanne. In addition, it had portrayed Suzanne just as she was: a talented, dumpy *hausfrau* approaching forty. Now, looking at Edouard's tribute to his long-suffering wife, Berthe was filled with a brooding anxiety. She was becoming conscious of a certain tacit rivalry with Suzanne. As she looked at Manet's canvas, she couldn't help but admire his use of virginal white and the light, airy effects introduced by his sweeping brushstrokes. Her apprehension showed in the smouldering darkness of her eyes. Manet was delighted. He captured this abstracted expression perfectly

in *The Balcony*, reinforcing it with the Stygian blackness of the background.[20]

His portrayal of Berthe was much more complete and convincing than his depiction of the other figures. Yet nobody dared to speak about the blatant innuendoes in the picture, as spontaneously he began to flirt with Berthe through the medium of his paintbrush. All she could do was to sit there in tense expectation while he touched and stroked the canvas, his face in rapt absorption at the task. At times Manet seemed to be in a trance, as if he was 'discovering the intoxication of love for the first time'[21]; as if, too, he was re-creating the emotional content of a love poem which Baudelaire had written in 1856. The poet had produced this tender, lyrical keepsake in honour of his mistress, Jeanne Duval. The title, appositely, was *The Balcony*.

> Mère des souvenirs, maîtresse des maîtresses
> O toi, tous mes plaisirs! o toi, tous mes devoirs!
> Tu te rappelleras la beauté des caresses
> La douceur du foyer et le charme des soirs
> Mère des souvenirs, maîtresse des maîtresses!
>> (*Fleurs du Mal*)[22]

> [Mother of memories, mistress of my dreams,
> To whom I am in love and duty bound,
> You will recall, as red the firelight gleams,
> What fond embraces, what content we found,
> Mother of memories, mistress of my dreams!]

But would Berthe Morisot ever be his mistress? Subconsciously responding to the despair constantly below the surface of his smile, and inhibited from translating his thoughts into words, Manet poured them into this painting. Berthe's image was symbolically caged behind an impassable barrier of green railings; and she was chaperoned by the presence of other figures. Patrician that he was, Manet could go no further in committing his dreams to canvas, without risk of compromise. Although he finished the painting in October, Berthe continued to call at the rue Guyot, even when Madame Morisot could not accompany her. She told herself that she was visiting for professional reasons, but she cherished these trysts. She felt elated to be in his presence, to be shown his other paintings which were stored in the studio and have the chance to pick up the threads of earlier conversations.

Acting on impulse, one blustery December day she swept into his studio, shivery even in her winter furs and elegant hat, her cheeks flushed with cold. Manet was so excited by this vision that he asked to paint her instantly. The mistress of his dreams was disconcerted and a little nervous, but he caught the moment: the impression of her slim form cloaked in fur, almost in motion, *Berthe Morisot with a Muff*. She came again early in the New Year:

using the excuse perhaps of wanting to break the news of Edma's engagement and to talk over the implications. He was so affable, yet so sympathetic. She revelled in his company. And Manet found her presence irresistible. In a state of breathless excitement, he reached for his palette and brushes. She turned her head; her hair fell in a dark cascade to her left shoulder. This time he caught her likeness in profile, still wearing her jaunty, high-crowned hat, trimmed with a white feather.[23]

For a few weeks after this, Berthe was immersed in the preparations for Edma's wedding and there was no time to visit Edouard. He was, in any case, occupied with finishing a painting; the models were Astruc and an attractive young Parisienne he had met the previous summer in Boulogne. Then in February Alfred Stevens had introduced Manet to a student painter whom he brought to the rue Guyot. She was the daughter of a well-known figure on the Parisian scene, Emmanuel Gonzalès, a popular novelist and president of the Société des Gens de Lettres. His daughter, Eva, was only twenty years old at the time, but she had presence: stunning dark hair which was massed in great loops on the top of her head, a luscious femininity and an aquiline nose suggesting a haughty will. (She was descended from an aristocratic family from Monaco.) Eva had come to persuade Manet to become her teacher. Manet could never resist the flattery of a young woman. With little hesitation he agreed and shortly afterwards they began lessons in the company of her younger sister, Jeanne, who was completely overshadowed by Eva's dominant personality.[24]

When Berthe caught up with Manet in March, he was talking excitedly about his new pupil. She was furious, fearful and frustrated. She had no claim on him, though a few weeks earlier he had been paying court to her with all his sophisticated charm, and this had certainly helped her to face up to Edma's departure. Now, however, in addition to Fat Suzanne, there was the vivacious, 'eternal Mademoiselle Gonzalès' in the frame. Berthe's confidence collapsed. She lost interest in painting for some weeks. If she started a picture, she couldn't finish it. She confided in Edma: 'this is beginning to distress me . . . the sight of all these daubs nauseates me. . . . Yesterday I arranged a bouquet of poppies and snowballs, and could not find the courage to begin it.' She felt isolated. 'Since you left, I haven't seen a single painter.' And when she heard that Eva had agreed to model for Manet, she feared the worst. Gonzalès 'has poise and perseverance; she is able to carry an undertaking to a successful issue, whereas I am not capable of anything.' Significantly, Berthe failed to submit anything to the Salon for the first time in six years.[25]

Someone who had picked up these vibrations was Degas. He had no illusions about Manet's conduct nor about the effect of his casual affairs upon his domestic life. His recent portrait of the Manets implied a hidden agenda of deception, which was why Edouard had taken exception to it.

Degas felt sorry for Berthe. Some time that spring he presented her with a decorative fan, which he had painted in watercolour and brown ink. It portrayed a group of Spanish dancers and musicians, one of the revellers represented being the Romantic poet and writer Alfred de Musset. Degas's choice of subject was full of insinuation. The scenario was a reminder of the Parisian taste for all things Spanish. There were additional hints of illicit romance in the figure of Musset, who had enjoyed a long liaison with George Sand, then at the height of her fame. So what was 'Monsieur' Degas trying to say? That he knew there was a strong affinity between the romantic-minded Manet and Mademoiselle Berthe, the Goyaesque beauty, and probably a secret longing for something more? There is a school of thought that he was making amorous overtures on his own account by presenting Berthe with a token that was usually associated with coquetry or courtship. Could it really be that Degas was setting himself up as a rival to Manet in a tongue-in-cheek way? Unlikely. It is more probable that he was proffering Berthe a thoughtful consolation gift. He was intimating that he understood her predicament: that Manet had always been a fickle lover; he had effectively deserted her just when she was feeling low, when her sister had abandoned her too. Degas's gesture was touching. Berthe always cherished his fan.[26]

There was, of course, the consolation of the Salon, to which Manet had submitted *The Balcony*. This would give her an opportunity to see him, but she was apprehensive about the critics: what would they say about his portrayal of her? In fact she was surprised to discover that he was as nervous as she was about public reaction. He was over-excited, too, believing that he had found a buyer for the picture; he saw it as a sure sign that Berthe was bringing him luck.[27] There was a tenderness as well as a brittle amusement in her tone as she described to Edma what happened.

I don't have to tell you that one of the first things I did was to go to Room M. There I found Manet, with his hat on in bright sunlight, looking dazed. He begged me to go and see his painting . . . I have never seen such an expressive face as his; he was laughing, then had a worried look, assuring everybody that his picture was very bad, and adding in the same breath that it would be a great success. I think he has a decidedly charming temperament. I like it very much.

However, the occasion had some more awkward moments.

For about an hour Manet, in high spirits, was leading his wife, his mother, and me all over the place . . . I wanted to see the pictures . . . I had completely lost sight of Manet and his wife, which further increased my embarrassment. I did not think it proper to walk around all alone. When finally I found Manet again, I reproached him for his behaviour; he

answered that I could count on all his devotion, but nevertheless he would never risk playing the part of a child's nurse.[28]

Her appearance in *The Balcony* was naturally a subject of much comment, although her identity was protected. One journalist, Castagnary, provocatively asked if she and Fanny were sisters; or were they mother and daughter?[29] Berthe bristled, realizing for the first time how personally wounding the critics could be. However, in view of Manet's reputation many people assumed automatically that this dark beauty with a lapdog at her feet, leaning nonchalantly against the balcony railings, must be the artist's mistress. Manet's presentation of her was certainly dramatic, recalling Baudelaire's maxim that the beautiful is always bizarre. Berthe understood the inference. 'I am more *strange* than ugly. It seems that the epithet of *femme fatale* has been circulating among the curious.'[30] While she pretended to be surprised, she secretly revelled in the description. Her ego was temporarily restored, and with it her enthusiasm for the Salon. Excitedly she described to Edma a picture she had seen, Bazille's *View of the Village*, 'something that I find very good'. It depicted a girl wearing a soft, pale dress, seated in the shade of a tree; the village formed the backcloth. Berthe enthused at the 'light and sun'. Bazille, she told her sister, had achieved 'what we have so often attempted – a figure in the outdoor light'.[31]

Suddenly Berthe was eager to paint again. She said goodbye to Yves, who was visiting Passy, and took off in early June for Brittany. (Degas, who, according to Madame Morisot, was wild about Yves's face, was occupied then with painting her portrait.) At Lorient Berthe busied herself, sketching Edma and producing a small but remarkable full-length portrait of her sister sitting by the french window. She also painted the quayside and a brilliant *View of the Harbour at Lorient* in which she pursued Bazille's concept of a light-filled scene. This was one of her early masterpieces, as Manet recognized, but much to Madame Morisot's annoyance, Berthe gave it to him as a present on her return.[32]

Meanwhile her mother wanted to scotch any wild thoughts Berthe might have had of encouraging Manet's attentions. In July Madame Morisot reported unkindly that Manet had forgotten about her. 'Mademoiselle G[onzalès] has all the virtues, all the charms.'[33] Coming by letter, this sort of remark gave Berthe something to brood over and it helped to trigger another bout of depression. On her return home at the beginning of August, Berthe found she had lost her artistic touch. The double portrait she had undertaken of the Delaroche sisters was turning into a nightmare: nothing would come right. Manet thought he was being helpful by lecturing her on what to do. Her only consolation was that he was having acute problems with his portrait of Eva Gonzalès, which he had started months before. Recalling how tiring it was to model, Berthe reported with some

relish, 'She poses every day, and every night the head is washed out with soft soap.' And a month later, 'her portrait does not progress'; Eva was on her fortieth sitting, but Manet was still scrubbing it out.[34]

All the same, Manet was 'the first to laugh about it'. His charm still held Berthe in its grip. When she and her mother went to the next Thursday soirée, 'he was bubbling over with high spirits, spinning a hundred preposterous yarns, one funnier than the other'. She warmed to his compliments about her Lorient paintings. 'To my great surprise and satisfaction I received the highest praise. It seems that what I do is decidedly better than Eva Gonzalès.' Relieved to be back in his favour, she remembered what Fantin had once said, that Manet always approved of the painting of people whom he liked.[35] But her self-esteem, which had taken a severe knock the previous February, was not helped subsequently by Manet's volatile behaviour. One minute he was advising her how to retouch the portrait of Edma to ensure its selection for the coming Salon, the next he was warning her it still might be rejected. She knew she was reading too much meaning into his professional advice. She wished she could just shrug off his comments. But it was no use. She confided in Edma again. 'I am sad . . . I feel alone, disillusioned, and old into the bargain.'[36] She was near to entering her thirtieth year.

It was a measure of her low morale that she wrote in this vein. Manet, in fact, was tired of his portrait of Eva Gonzalès, and by implication (if Fantin's argument was valid) with his protégée too. Suddenly he found Berthe a refreshing change. With some encouragement she resumed her visits. She called on him one September day at the apartment in the rue de Saint-Petersbourg. At his invitation she sat down on the wine-coloured sofa in the drawing room and her white figured organza dress fanned out against the velvet upholstery. He looked keenly at her again, her halo of dark hair and tumbling curls, her neat features and anxious expression: a sensuous woman, appealing, yet so refined and inaccessible. Before she knew what was happening he was sketching her there. He asked her to adjust her position, so that her body was skewed, one leg tucked up, causing her to stretch out her arms for balance, while one black shoe was thrust forward on the floor. It was a bizarre pose. She seemed about to slip off the sofa; her hidden leg caught cramp. Long afterwards she recalled the terrible discomfort. But it was all in a good cause.[37]

Manet was fired, his eyes aglow. He discarded the drawing and turned to oils, working with characteristic intensity to capture the curves of her supple body, her frothy Second Empire gown, and her silent, mournful gaze. It was the absolute modernity of *Repose* which struck the critics, de Banville and Duret, but it has also been seen in highly personal terms, as being both the interpretation of a master and the love-pledge of a man relishing his highly charged emotions.[38]

The subliminal inspiration for *Repose*, as for *The Balcony*, was the eternal power of woman to enchant man. The moment Manet glimpsed Berthe sitting on his sofa, his mind was filled with a sense of *déjà vu*. His memory, though distorted over time, went back seven years to the summer's day when his friend Baudelaire had brought his notorious mulatto mistress, Jeanne Duval, to the rue Guyot. She had appeared in his studio wearing a fashionable white crinoline, a professional seductress, yet Manet could not help but be struck by the contrast between her gown, spreading like a crisp sail in the fresh air, and her raven hair, the black recesses of her gaze which defied the crucifix at her throat. He had painted her in a single sitting while Baudelaire looked on, and the portrait was still stored in his studio. Duval was half reclining, against the softening effects of transparent drapes, her semi-paralysed leg stretched out stiffly from the hem of her gown. It was a weird and ugly pose. But the two compositions are similar, down to details such as their black accessories. And there seems little doubt that Jeanne Duval's posture gave Manet the idea for Berthe's unusual position. Both women looked incurably melancholy in their romantic gowns; both intrigued Manet for that reason. Juxtaposed, the two portraits are unquestionably full of innuendo: the one, Baudelaire's mistress, the Black Venus, wanton and burnt out; the other a Baudelairean heroine in momentary repose, pure, sensuous, expectant, yet inviolate, the mistress of Manet's own dreams.[39]

Repose was not quite finished when Manet put it aside. That winter of 1869–70 Edma came back to Passy for her first confinement. The baby was born at the turn of the year; she was called Jeanne. In the December days leading to the birth Berthe took up an idea from Fantin, among other artists, for a double portrait, of her mother reading to her pregnant sister. It came in for some constructive criticism from Puvis who spotted a fault with the way she had painted her mother's head, but he was too busy with his own Salon entry to answer her plea for help, so in some trepidation she turned to Manet.

The day for submitting to the 1870 Salon was fast approaching, but generously, he reassured her that as soon as he had sent off his pictures, he would come round to see hers. 'I shall tell you what needs to be done.' In fact, Berthe should have known better. He was worried about his prospects for the Salon, and at such times he was always moody and volatile. She was unsure how to respond to him in these circumstances. Besides, having watched him at work, she should have guessed he might go too far with his touching up. Too late she realized her mistake. With rising frustration she recalled what happened next.

He came about one o'clock; he found it very good, except for the lower part of the dress. He took the brushes and put in a few accents . . . mother was in ecstasies. That is where my misfortune began. Once he had

started nothing could stop him; from the skirt he went to the bodice, from the bodice to the head, from the head to the background. He cracked a thousand jokes, laughed like a madman, handed me the palette, then took it back; and finally, by five o'clock in the afternoon, we had made the prettiest caricature that was ever seen.[40]

Since the cart was waiting to deliver the pictures to the Salon jury, Berthe was too embarrassed to intervene. The perfectionist in her was furious both with herself and with Manet for producing what she felt was a pastiche. Her professional pride was at stake; she realized that she should never have given him *carte blanche* to touch her work. Their personal relations were one thing, their professional relations another: she was not his pupil; he was not her teacher. In a fit of pique she told Edma she hoped her picture would be rejected. But Madame Morisot appeared to shrug off the episode as hilarious, confirming what happened next to Edma.

I made matters worse by telling her that the improvements Manet had made on my head seemed atrocious. When I saw her in this state, and when she kept telling me that she would rather be at the bottom of the river than learn that her picture had been accepted, I thought I was doing the right thing to ask for its return. I have got it back, and now we are in a new predicament: won't Manet be offended? . . . you know how the smallest thing here takes on the proportions of a tragedy.[41]

Concerned not to offend Manet – after all, she believed sincerely he was the greatest living artist – Berthe gave in. She recovered her painting and resubmitted it in the nick of time.

In retrospect it was a storm in a teacup. Both her submissions, the picture of Edma (*Young Woman at the Window*) and the double portrait (*Reading* or *Portrait of Mme Morisot and her Daughter, Mme Pontillon*) were accepted for the Salon and she was complimented on her work.[42] With her self-confidence restored, she was magnanimous towards her admirers. Puvis, with whom she spent a day at the Salon, won some acclaim for his two religious paintings. Fantin also had a successful year with his large canvas, *A Studio in the Batignolles*, a powerful tribute to Manet's leadership. He had depicted Manet at his easel, surrounded by some of his artistic disciples. Forgetting her earlier animosity towards Fantin, Berthe remarked with genuine enthusiasm that his portrait of his fiancée, Victoria Dubourg, with her sister Charlotte, was a real gem. And 'Monsieur' Degas had sent 'a very pretty painting' – it was a study in red, a portrait of the pianist, Madame Camus – although emphatically she declared the pastel portrait of Yves to be his masterpiece.[43]

Manet's two submissions, one of which was his portrait of Eva Gonzalès, were also on display. Despite their poor siting, they attracted a lot of

attention. Originally Berthe had been forced to admire his picture of Eva, but after the dance he had led her, she was ready to forget 'the delicate tones and appealing subtleties' and find fault with 'the washed out effect'. It probably gave her some satisfaction to tell Edma, 'The head remains weak and is not pretty at all.'[44] As for Eva's entry for her Salon debut, Berthe was predictably dismissive: it was no more than passable. It was to be a long time before she could find it in her heart to forgive Mademoiselle Gonzalès for having stolen Manet from her.

Meanwhile, Tiburce had returned from America and the spring had arrived. 'The garden has become pretty again; the chestnut trees are in flower', Berthe reported to Edma, who had temporarily rejoined Adolphe.[45] There was a false cheerfulness in Berthe's tone, which in a curious way reflected the national scene. For some while Louis Napoleon had been manoeuvring to save the imperial regime against mounting criticism. On 8 May 1870 a popular plebiscite approved a series of liberal reforms, the basis of a parliamentary regime. The emperor and his chief minister, Emile Ollivier, saw the resounding 'Yes' as a vote of support for the Liberal empire.

At the Salon Manet's roving eye alighted on Berthe's friend, 'that fat Valentine Carré', and to her annoyance he instantly asked her to arrange for Valentine to come to the studio so he could begin work on a study. Swiftly, Berthe hit on a clever ploy to wean him from his studio. Since the weather was glorious, she persuaded him that it would be far better to paint Mademoiselle Carré out of doors in the garden of the rue Franklin, where she could keep him under observation. The idea of Manet as a *plein air* artist amused her. And for good measure they hit on the idea of including Tiburce in the background. However, Madame Carré objected to the fact that her daughter's picture was to contain the lounging figure of a young man. 'Fat' Valentine was forbidden to pose, and in the end Edma, who had returned to Passy, took her place with her baby daughter.[46]

On finishing *The Garden*, Manet went off to Saint-Germain to stay with the artist, De Nittis, a friend of Degas. He had talked at the Morisots' of holidaying again on the Channel coast. Lulled into idleness by the unusual warmth and the presence of familiar faces, Berthe made no definite plans to go away. For months she had been too preoccupied with personal matters to notice the political scene; but France seemed secure enough. That June, however, Adèle d'Affry sensed a certain unease. She decided to give up her apartment in Paris and move south. Later she recalled the eery atmosphere one memorable midsummer evening. Hideous flashes of lightning zigzagged through the cloudy haze, yet strangely there was no thunder; only intense heat. Then the moon appeared between livid clouds, a symbol of coming conflict . . .[47]

Among the rest of Berthe's friends and the members of her family, no one appeared to sense the real truth: that their world was poised on the brink of a Baudelairean abyss.

CHAPTER EIGHT

The Terrible Year

1870–1

The summer of 1870 turned into one of the hottest in living memory. The notion of a trip to England may have flitted through Berthe's mind. Adèle had paid a visit to London four years earlier, Manet had been there in 1869. It would be interesting to see London . . . then a few excursions along the Thames, returning by way of Kent, the Garden of England . . . the cliffs of Dover instead of Les Petites Dalles . . .[1]

She was still musing when without warning, on 3 July, a small diplomatic row suddenly flared into an international crisis. Prince Leopold of Hohenzollern, a cousin of the King of Prussia, was set to mount the throne of Spain, resurrecting historic French fears of encirclement by a hostile power. Some skilful diplomatic manoeuvring almost saved the day, until Gramont, the French foreign secretary, the stupidest man in Europe, according to the Prussian chancellor, Bismarck, proceeded to act like a bull in a china shop and precipitated a full-scale conflict.

Parisians greeted the news with jubilation. War had been on people's lips intermittently since 1867; and the Théâtre des Variétés was still echoing to Offenbach's hit song, '*Ah, que j'aime les militaires!*' sung by the incomparable Hortense Schneider. Now the troops would be marching to the Gare de l'Est to popular cheers of 'A Berlin!' The Empress Eugénie was as belligerent as anyone in Napoleon's Liberal empire, and even his chief minister, Manet's old friend, Emile Ollivier, accepted the inevitability of war with Prussia. On 14 July hundreds marched along the boulevards singing the *Marseillaise* and shouting, '*Vive la guerre!*'

Among the few protesters was a white-haired, bespectacled old gentleman – Adolphe Thiers – who warned the government of ruinous consequences. He was written off as 'an unpatriotic trumpet of disaster',[2] but the charge was grossly unfair considering that back in the 1840s, when he was prime minister and Monsieur Morisot was a Prefect, he was responsible for the erection of the modern fortifications ringing the capital. It was not his fault that France was ill-prepared now, the army badly organized; nor that the troops were inadequately trained to use the improved chassepot rifle and a secret prototype of the machine-gun, the *mitrailleuse*.

On 15 July Emile Ollivier told the Chamber of Deputies that France had

declared war 'with a light heart'. They were ill-chosen words. The French people never forgave him when, later, Thiers's predictions came true. Failure is never pardoned, acknowledged Ollivier ruefully.[3] He was a cultured man, not a warmonger, but the price that he paid for leading his country into military disaster was to be hated, despised and ignored by future generations. 'In this world success is everything', Edma noted about popular ingratitude towards another politician, Gambetta.[4] But even Manet, who was always generous towards his friends, failed to speak up for Ollivier. He was alternately gloomy and indignant. And Berthe, like millions of other citizens with no direct experience of war, was apprehensive, for she had no idea what to expect.

At first people in Passy talked of the possibility of a negotiated settlement to avert bloodshed. *The Times* correspondent noted that 'Here in Paris there is a strong peace party among the bourgeoisie but few people will admit these sentiments in case they are treated as traitors . . . as Monsieur Thiers has been for opposing war'.[5] All parents with sons of military age were bound to be anxious and the Morisots were no exception. Tiburce was twenty-four years old, one of 'the class of 1865' in military terms, so in a national emergency he was bound to be mobilized. Knowing his love of adventure, they were not surprised that he decided to volunteer rather than wait to be compulsorily conscripted or join an amateur ambulance brigade like the *petits crevés* who had no stomach for fighting. Within a few weeks Tiburce had been assigned to the headquarters of the Army of the Rhine under the command of Marshal Bazaine, with whom Yves's husband, Théodore, had served in Mexico. Cornélie Morisot was to bask in her son's fighting spirit. 'This is my idea of the way men should behave in a time of peril', she said proudly, perhaps thinking too of the martial blood that flowed through his veins.[6]

Meanwhile, there was also the safety of Edma's husband to consider. Edma saw no point in going back to Brittany since all naval officers had been recalled on 11 July. On 24 July, the vanguard of the northern squadron, under Vice-Admiral Willaumez aboard his flagship *Surveillante*, sailed out of Cherbourg amid a news blackout. But the ships were observed passing Dover at high speed on their way to the Baltic. Unlike the army, the navy was a formidable force, with 49 ironclads, including 14 fast frigates, and over 400 steamers and sailing ships in reserve, vastly outnumbering the enemy. There were plans to blockade the German coastline and support a military landing on the North German mainland.[7] Edma knew in her bones that it would be some time before she would see Adolphe again.

However, events moved at lightning speed, forcing the Morisots to make some critical decisions. In recent wars the rough-shod separation of civilians has became commonplace: in the nineteenth century it was the exception. But six weeks into the Franco-Prussian War, a two-way human mass began

pouring through the gates of Paris. Some came from the eastern provinces, refugees who had not washed for two days and were looking desperately for shelter. A series of French defeats in the face of the Prussian advance through Alsace-Lorraine meant that by 23 August Bazaine's army, including Tiburce Morisot, was hemmed in at Metz, preparing for a prolonged siege against superior German forces.

In a Paris gloomy under rain-filled skies, spy fever gripped the population, while in the Meuse valley the weary, pain-racked emperor, with Marshal MacMahon, fought to escape the trap into which their army had been manoeuvred. The Marshal was seriously wounded in the battle for Sédan's citadel, and when the French finally capitulated, the emperor was taken prisoner with 83,000 men. Sédan was a catastrophe for French pride. The news reached Paris on 3 September and began to seep through the boulevards. The next day, in scorching sunshine Parisians flooded the streets around the Hôtel de Ville to support the proclamation of a new republic and a government of national defence, while the rest thought of ways of abandoning the capital before it was too late. Shocked by the collapse of the Second Empire, the Empress Eugénie scuttled out of the back door of the Tuileries and escaped to England, just as Louis Philippe had done in 1848. Then the exodus from Paris began in earnest . . .

First to go were the titled and the wealthy, those with most to lose. Tiburce and Cornélie Morisot were uncertain what to do, though they were deeply concerned about the safety of their family, particularly when the government ordered the evacuation of the War and Interior Ministries with all their personnel. The Gobillards were, of course, out of danger in distant Mirande, and thinking of her baby's safety, Edma decided to join them. She knew that Yves would welcome her and 'Bibi' and give them a home. While she accepted its necessity, Berthe dreaded their leaving. The sisters talked anxiously as they sorted out clothes and the baby's paraphernalia. Would Berthe follow if things grew worse? Could they persuade Maman to leave? Would Papa's health hold up? And, of course, *when* would they see each other again? Six months later Edma reminded Berthe that when she left, neither of them anticipated a long separation. 'I remember your packing my trunk and saying to me each time I handed you something, "So you intend to spend the winter there!"'[8] Berthe's observation had the ring of prophecy.

Edma and Jeanne left by train at the beginning of September along with half of Paris. By that time furniture vans were costing twenty livres a day to hire and the railway stations were scarcely able to cope with the indescribable confusion. As Parisians struggled to get out, others arrived 'straggling through the fringes of Passy . . . weary and depressed, seeking asylum in Paris . . . human freight packed together with beds, bedding, chairs, tables, faded tapestry, bird-cages and pet dogs'.[9]

A number of the Morisots' friends and neighbours escaped. On 8 September, at Edouard's insistence the Manet family managed to get away – his mother, that is, with Suzanne, Léon, and Suzanne's nephew and sister, Marthe. They made for Oloron-Sainte-Marie in the Basses-Pyrenees, where they had a contact. 'Manet's crowd' was also dispersing. Pissarro, Sisley and Monet – the last two with their wives – ended up in London, together with Legros, Daubigny, Bonvin and the dealer Paul Durand-Ruel. Cézanne found a haven on the Mediterranean coast. Adèle moved from the south of France to the safety of her native Switzerland. For about a fortnight Cornélie and Berthe prevaricated. Four days after his wife left, Manet called at the rue Franklin with his brother, Eugène. Manet was appalled by their indecision. Seeing Berthe standing there, her delicate eggshell beauty apparently so vulnerable, he begged her to get out while it was still possible. 'What good will it do you if you are wounded in the legs or disfigured?' he asked, imagining the vicious effect of sniper-fire. He had already predicted the worst to Eva Gonzalès, that there would be death, incendiarism, pillage and carnage.[10]

Cornélie Morisot was dismissive. She reminded Berthe that Manet was always prone to exaggerate and see everything in black. She was loath to leave her husband and there were her elderly parents to consider too. But she was curiously fatalistic, believing that events were never as good or bad as anticipated. The Manets' visit, however, did nothing for Berthe's morale and only reopened all the family arguments about what they should do. It fuelled her father's sense of outrage at the plight of his country, his feelings of frustration at the failure of the Liberal empire to protect the public interest. He had more faith in Thiers, who had left Paris to try to whip up support in other European states and persuade them to intervene in the Franco-Prussian conflict. Berthe noted anxiously that her Papa pinned all his hopes on the success of Monsieur Thiers's diplomacy, although she was less sanguine about the outcome. She was right: Thiers's refusal to join the new government of national defence was a black mark against him with the majority of Parisians who were fully behind the Republic at this stage.

All this sparked off some urgent discussion in the Morisot household. While Monsieur Morisot had to remain at his post under the new regime he saw no necessity for the women to stay. He and his wife disagreed on this point and Cornélie complained that he 'would drive an entire regiment crazy', while he accused her 'every minute of being a real doubting *Thomas*'.[11] Berthe, however, was unmoved by puns and by mid-September she had made up her mind. 'My place is with them', she observed, with the voice of a dutiful, unmarried daughter. She knew that if she left, and the worst were to happen, she would be haunted by remorse. In fact, she had fallen into one of those moods of introspective silence which drove her parents to distraction and soured their relations. Berthe had no illusions as

to how they felt. From her point of view duty took precedence over self-interest; from theirs, she was a worrisome burden.[12]

As the Prussians kept up their *Blitzkrieg*, normal life ceased. Men of fighting age – and over – volunteered for the city's defence. Others prepared to shut themselves away. Berthe complained bitterly of her isolation. It was not strictly true, because the Manet brothers, Edouard and Eugène, visited her with Degas, and Léon Riesener came occasionally. But it was only gradually that Berthe learned what was happening to the artistic community, most of whom wanted no part in the conflict but felt a moral obligation to be involved. Few had the natural physique or temperament of soldiers (poor Fantin and Eugène Manet least of all). But Manet was an ardent patriot, and, like Degas, an optimistic supporter of the new Republic: they even found time that September to attend a radical political meeting addressed by General Cluseret, an experienced revolutionary soldier.

Edouard Manet joined the artillery of the National Guard. Degas transferred from the infantry to the artillery in which his schoolmate, Henri Rouart, an amateur painter, was an officer. Tissot volunteered for a company of sharpshooters but was moved to the Seine Skirmishers, a battalion of the National Guard. Bazille joined a regiment of the Zouaves assigned to the Army of the Loire, Suzanne Manet's brother, Rudolph Leenhoff, a horse brigade, and Renoir a regiment of cuirassiers (though he was lucky in being posted first to Bordeaux and then to Tarbes). Oudinot, Bracquemond, Carolus-Duran, Stevens and Puvis de Chavannes all served with the National Guard, the home defence force. Manet tried in vain to exploit his Republican connections to secure government posts for his brothers, but in the administrative chaos during the German advance it was impossible for Leon Gambetta, the new Minister of the Interior, or Charles Ferry, his secretary, to come up with anything suitable. In any case Charles had already volunteered for the army, and Madame Morisot heard that Jules had joined the government – he was running the crucial Department of the Seine and was to become Mayor of Paris a few weeks later – so *faute de mieux* Gustave and Eugène Manet, with Antoine Guillemet, enlisted in the Garde Mobile, a supplementary fighting force of untrained conscripts.[13]

Meanwhile, the Morisots prepared for all eventualities. They had the option to stay in the rue Franklin to keep an eye on the Thomases and to protect their possessions, but this would be feasible only while the forts of Issy and Vanves remained in French hands. Berthe was concerned about her cherished studio, especially her cabinet, mirror and console. Manet had already boarded up most of his unsold canvases in his studio cellar at the rue Guyot and he entrusted the remainder, including *The Balcony* and *Repose*, to Théodore Duret's sturdy, vaulted basement. Monsieur Morisot was more anxious about preserving the family's First Empire furniture. As the

best pieces were removed for storage, Berthe watched their home becoming 'dreary, empty, stripped bare'.[14] However, as the military situation deteriorated, they had to plan for other contingencies. In the end they decided to rent a small repository for the furniture in the rue Argenson (in the Elysée quarter) and Berthe assured Edma they would move in themselves if things became desperate. At the same time their grandfather Thomas would occupy the Mayniel family apartment so that they would be close together in the centre of the city. Aimé Millet also offered the Morisots an apartment in a central district, an offer Berthe thought they might take up if bombs were to land on Passy.[15]

To reassure her parents Berthe tried to be calm and make the most of a magnificent Indian summer. But it was difficult when her precious Bois de Boulogne was being turned over to farm animals to ensure the food supply and the tree stumps were sharpened into sinister stakes to thwart the advance of enemy troops. Besides, she knew that Manet's remarks confirmed the awful stories appearing day after day in the papers: incidents of Prussian brutality, the desecration of a convent, the rape of the young novices, wanton destruction of property, razing of villages and shooting of citizens. What was terrifying, too, was the speed of the Prussian thrust. Nightmares about enemy bestialities plagued her sleep, and it was scarcely reassuring to get a note from Puvis de Chavannes, implying their last hour had come, or to be told calmly by Manet's brother, Eugène, that he did not expect to survive.[16]

While Parisians prepared the defences and transformed their city into a vast armed camp – digging trenches, building ramparts, moving ammunition, preparing gunpowder and oil stores – and while Gustave Courbet was designated custodian of the nation's art treasures by the Government of National Defence, the Morisots could do little but wait. On Sunday 18 September Berthe calmly put pen to paper to her 'dear Edma'. It was a *jour de fête*, technically a public holiday. A false gaiety lit the streets but an unwholesome haze embalmed the city: in Goncourt's analogy, an 'electric brightness' that 'makes the green foliage a glassy blue'.[17] Berthe confessed, 'I want to retain my composure.' The well-brought-up bourgeoise was keeping a tight rein on the nervous young woman. But the roads and villages of the Ile de France were echoing to German boots as von Moltke's forces wheeled into position. Versailles fell without a shot. By the night of 19 September the Prussian investment of the capital was complete. Paris was hemmed in by an impenetrable circle of iron. The siege had begun.[18]

The presence of the enemy was quickly felt. The air was filled with acrid smoke as a scorched earth policy put paid to woods and hayricks around the capital and the sound of heavy guns pounded the eardrums with increasing intensity. With a touch of irony Berthe wrote on 30 September that they

were very well situated to hear the cannon, but very badly placed to hear any news. She had no idea whether her letters would ever reach Edma in Mirande.[19] For inveterate correspondents the news embargo, caused by the cutting of all rail links, post office and telegraphic lines, was one of the most demoralizing aspects of the siege.

Fortunately, substitutes emerged. Pigeons were enlisted as the 'resistance couriers': in a small quill attached to its tail feather a pigeon could carry 500 pages of official communications and up to 1,500 messages on collodion film. But without Manet's inventive friend, Nadar, the news blackout would have been more serious. As head of the Balloon Corps, he set up a system of balloon-post which carried two and a half million letters and enabled escaping VIPs like Gambetta to organize the war effort from Tours.[20] Berthe, however, like Manet, was obsessed by the lack of incoming news. Yet it never discouraged her from writing daily letters, an emotional outlet to fill the interminable monotony. The pages were a litany of hopes and fears for her two sisters and their children, for Adolphe and his squadron, and not least, for her poor brother, Tiburce.[21]

Ordinarily, Parisians would have relied on the newspapers to alert them to what was happening. However, the siege destroyed the credibility of the press as the public was sold a mixture of rumour, repetition and jingoistic comment. Berthe was too annoyed to read the papers and the US Ambassador endorsed her impatience when he said: 'The amount of absolute trash, taken all together, surpasses anything in history!'[22] To find out what was happening, people began to take a look for themselves, even if it meant scrambling to viewpoints like the Point du Jour viaduct or taking a trip on the belt railway to look over the line of the fortifications. Fiacres converged on Passy and Auteuil from all quarters of the city, bringing sightseers who came to stare at the Prussian batteries at Meudon. Any high point served as a lookout. On the windswept heights of the Trocadéro, where Manet had painted his *View of the Universal Exhibition,* young girls congregated with telescopes to view the perimeter forts. 'There is fighting almost every day around Paris', wrote Manet to his wife, 'and we go to the heights to watch the action as though it were a spectacle in a theatre.'[23]

At first Parisians were surprisingly nonchalant. Even Berthe and her mother went out for an exploratory excursion. Cornélie admitted that the pair of them became 'as wet as water spaniels' while searching for a view of the battlefield. But they could make no sense of what was happening. Although the fighting was not far away, it was impossible to tell who was winning. Stories of French successes were greeted with wild enthusiasm, but they were largely false. A rumour that 20,000 Prussians had been taken on the southern sector, where Eugène Manet was serving, was pure wishful thinking. Instead, as Strasbourg and Toul fell to the Prussians, releasing German reinforcements, the noose tightened around Paris.

Tensions ran high for the relatives of those serving in the front-line defences. The Morisots were remarkably self-controlled about Tiburce's fate – Monsieur Morisot took the line that he could look after himself – but the twin sisters who had posed for Berthe, the poor little Delaroches, were constantly in tears because their brothers were at the fort of Vanves, a key point in the French line. Yet scenes of violent death and injury were not confined to the battle zone. Crowds gathered at vantage points, half-scared, half-attracted by the horrible sight of badly wounded men. Cornélie Morisot let slip how by chance she and Berthe had witnessed a corpse being carried away on a stretcher, the victim of a fire near the Point du Jour viaduct where there was a large gun emplacement. They had almost fainted with shock. Such incidents, however, were not uncommon. Cornélie admitted disasters were happening all the time: earlier, two chemical plants across the river had blown up.[24]

From late October luck seemed to desert the French on the battlefield. The Morisots learned from Degas that his friend, the sculptor Cuvelier, had been mown down by enemy guns at Malmaison.[25] Ten days later Thiers's diplomatic mission failed, much to Monsieur Morisot's bitter regret. He was desperately worried about his two favourite daughters, Yves and Edma, and their children, for no letters had been received from Mirande and the fate of the rest of France was unknown. Most Parisians, the Morisots among them, now saw the struggle as a test of national will and accepted Gambetta's plea for a fight to the death. 'Paris will not yield as long as it is possible to hold out', wrote Cornélie in mid-December, confident of the people's courage despite their suffering.[26]

It was brave, reassuring talk, and morale was crucially important, even when it was groundless. Though sortie after sortie collapsed under German firepower, the Morisots, like most Parisians, clung to any shred of hope, even allowing themselves to be hoodwinked by disinformation. Knowing how vital communications were to the French war effort, the Prussians attacked the post-balloons and pigeon-post. The French authorities leaked the news that the Prussians had captured some pigeons and 'turned' them for propaganda purposes. Paris buzzed with contempt and disbelief. Cornélie Morisot related the story which was the talking point of the rue Franklin.

Monsieur de Moltke [Prussian commander-in-chief] has let us know that we were defeated on the Loire – official letter. Three pigeons arrived carrying the most sinister reports. They were identified as birds belonging to a balloon captured by the Prussians, hence the whole thing is regarded as a ruse and a hoax. The answer to Moltke's communications was a proud gesture: the despatches brought by carrier pigeons were made public without any comment, except in regard to their origin.[27]

In fact Field Marshal von Moltke's dispatch was essentially true. The Prussians had recaptured Orleans, Rouen had surrendered, Bourges, Berthe's birthplace, was threatened and the Army of the Loire, on which Paris depended, had almost disintegrated. Berthe was numbed to learn that 'Poor Bazille', conspicuous by his height, had been shot in the head by a sniper on 28 November at Beaune-la-Rolande. The Morisots were satiated with bad news. Information had come from Lorraine. Amid furious wind and unceasing rain, Marshal Bazaine capitulated at Metz. At a stroke no fewer than fifty generals and 173,000 men surrendered to the Prussians. Somewhere in the shuffling lines of prisoners-of-war, waiting his turn to board the train for captivity, stood *Sous-lieutenant* Tiburce Morisot.[28]

For two months Paris braced itself for a Prussian assault that never came, until the more perceptive citizens realized why. Bismarck had given the order to starve the capital into surrender. Throughout the autumn food prices rose steadily, despite the government's attempts at price controls. Like everyone else, the Morisots were forced to tighten their belts. By November a bushel of potatoes was costing 8 francs, by mid-December 15 francs, three times the average daily wage for a French worker. A single cabbage was known to fetch 20, and cheese 30 francs a pound. There was barely sufficient milk for children and the sick. The city's gas supplies were cut off on the last day of November. A week later the first snowfalls brought freezing conditions. People scavenged desperately for wood. When horse meat and donkey became a luxury, butchers sold the carcases of dogs and cats. The zoos were emptied. The rich dined briefly off steaks of kangaroo, elephant, or antelope. But for many the best that could be expected was house-sparrow or broiled sewer rat. By Christmas Day 1870, the hundredth day of the siege, famine stalked every quarter.[29] Between Christmas and the New Year 4,000 citizens died of starvation and hypothermia. In the rue Franklin Berthe's condition was giving cause for alarm.

Her fragile physical and mental health had been shattered by the hideous sights of war. 'I am broken-hearted', she admitted to Edma, too demoralized and ill to write letters any more. In November she had started to have fainting fits. Her old problem of ingesting food revived the symptoms of anaemia and anorexia. Since her natural resistance had been lowered, she developed a persistent chest infection, which Cornélie Morisot was convinced was a sign of consumption. As their dwindling stocks of coal and wood had to be jealously guarded for essential cooking, the Morisots (in common with their friends and neighbours) gave up heating their apartment. Threatened with pneumonia, Berthe reluctantly took the advice of a well-known local physician, Dr Jules Rafinesque, to conserve her body temperature by staying in bed. There she lay, attended by her agitated mother, while the continuous cannonade from Mont Valérian pounded her

brain. Cornélie tried to explain to those who found it hard to understand. 'It is a sound that reverberates in your head night and day; it would make you feverish if you were not already in that state.' In her twilight world of half-sleep, Berthe was tormented by fearful images of Tiburce: she would feel 'a terrible tightening of the heart'. In no time she was too weak to get up and dress. In her mother's mind, she was visibly and progressively deteriorating. The cough, the digestive difficulties, the weight loss and the weakness, all were compounded into a highly neurotic condition that people were referring to as 'siege fever'.[30]

Struggling to keep her dignity, Cornélie felt bitterly that they had been abandoned by the fates. If she was sustained by religious faith she gave no indication. When the Manet brothers called on New Year's Day to offer seasonal greetings, they found the Morisots too undernourished and dejected to raise a smile or return their courtesies. Edouard was shocked. (For most of January he himself reported sick with successive complaints, from piles and a carbuncle to influenza, fatigue and bad food.)[31] Parisians were suffering as never before; some days even Cornélie's fighting spirit deserted her. She wrote to her two absent daughters: 'I have not had the courage to take up my pen for a week. . . . We celebrated the birth of the new year in sadness and in tears.'[32]

The nadir came on 14 January with Berthe's thirtieth birthday. The anniversary was one that she and her mother had been dreading. Yet somehow the conventional cause for commiseration no longer mattered as she lay in a catatonic state. Desperate with worry, Cornélie Morisot turned to another doctor who had been recommended by friends. He gave Berthe a thorough examination and suggested that she should try to get up and take gentle exercise to stimulate her circulation. It was at least reassuring to be told that she was not terminally ill with tuberculosis or pernicious anaemia. Cornélie seized on his words, allowing herself to hope that this could be a turning point for her daughter's health.

It was an act of faith because Berthe was extremely weak and there was little the doctor could do. The capital's food supplies were almost exhausted. People (if they were lucky) were living on coffee, wine and bread, though the stuff that passed for bread was almost impossible to swallow. Jules Ferry, who was responsible for the administration of Paris, carried the blame. 'Pain Ferry' was made of wheat, rice, beans and straw; it was 'black, heavy and miserable', according to US Ambassador Washburne.[33] Then, five days after Berthe's birthday, Ferry was forced to introduce bread rationing. It was an act of desperation which earned him unqualified hatred. In rosier times he had been a popular deputy as well as a welcome guest at the Morisots'. Now he was reviled by the man-in-the-street as the perpetrator of 'Ferry-Famine', the policy of starvation that was bringing Paris to its knees. The Morisots had little to say about him. He

made no attempt to contact them. Nor did they receive any favours from the ambitious lawyer who had once wanted to marry Berthe.

Meanwhile, on 5 January the Germans' long-awaited bombardment of the city was launched. Gunfire raked the landmarks of the Left Bank. Women and children fled under cover of darkness. Some reached the affluent south-western suburbs. Léon Riesener was wounded by a shell which fell on the rue Bayard. But Cornélie Morisot, still defiant, scornfully played down the rumours of massive casualties and destruction. She had been told that the Pantheon and Grenelle quarters had borne the brunt of the damage, although bombs did fall on Auteuil and the Point du Jour and even Passy were hit. However, more critical for morale were the French plans for a last-ditch salient from Mont Valérian towards Versailles. General Trochu, the commander-in-chief, knew in his heart it would be totally futile, but a *coup de grâce* was called for: 'Paris must die on her feet', was the official line.[34]

On Friday 20 January, a day of dense, clinging fog, Berthe's mother wrote with weary cynicism of the great sortie to come. Earlier French offensives had shown that 'we take the honours the first day, then the Prussians come at us in overwhelming numbers and we are compelled to fall back. To be victorious, Paris would have to be capable of holding out for a very long time, and we would have to receive substantial aid. I doubt that either will happen.'[35] The outcome was the appalling débâcle that she feared. A week after Berthe's birthday the whole capital was in mourning, enduring the 'silence, the silence of death, which disaster brings in a great city. Today you can no longer hear Paris live.'[36] Among the dead in the Buzenval sector was a brilliant academic artist, Henri Régnault, toast of the 1870 Salon. Berthe was not told the news immediately lest she should collapse with shock. As the crowds listened to the muted *De Profundis*, the bugles and the drumroll, Goncourt reflected, 'In weeping over the corpse of this talented young man, people are weeping for the burial of France.'[37]

Ironically, while desperate relatives scrutinized the casualty lists after the final salient, the Morisots at last received news of the rest of their family. The emotional strain was too much for Monsieur Morisot. Normally so undemonstrative, he wept openly on hearing that everyone was well, his daughters and granddaughters, and the two combatants, his son and son-in-law. Adolphe was still at sea, and they heard a little later what had happened to Tiburce. Edma wrote in pride and admiration at her brother's bravery on the battlefield and in the aftermath of the surrender of Metz. 'One would never believe that he had gone through such ordeals.'[38]

Tiburce had, in fact, been taken from Metz to one of the massive prisoner-of-war camps at Mainz. There, packed under canvas with over 25,000 fellow nationals, he had to endure cold, damp and gross overcrowding before seizing an opportunity to escape. Taking his chance at the dockside – Mainz is at the confluence of the Rhine and the Main – he

climbed aboard a collier and hid in the hold until it reached the port of Hamburg. There he jumped ship and made his way to Bordeaux, where he reported to the military authorities. For his courage and initiative he was promoted to the rank of lieutenant and posted first to Tarascon near the Rhône estuary, then to Périgueux in the Dordogne. He was there when the siege was officially lifted.[39] On 28 January Paris surrendered and an armistice was agreed between a humiliated France and the new German Empire, proclaimed in the hallowed Hall of Mirrors at Versailles.

February 1871 was a strange, unsettled month. The detritus of the siege lay all around. Spirits revived slowly as consignments of food and fuel began to reach the capital. But Cornélie complained at the beginning of February that supplies were too slow. Meanwhile, her daughter was still losing weight; her cheeks were two hollows. Berthe recognized the same war-weariness in her mother. Lack of nourishment and months of enforced confinement in a bare apartment, echoing to the noise of the cannonade, had taken their toll on bodies, tempers and nerves. Cornélie rued the fact that she and Berthe talked so little to each other, while Berthe and her father seldom had a civil conversation during the siege.[40] Although they avoided a direct confrontation over politics, the matter that most aroused her father, it was impossible to ignore the subject because at Bismarck's insistence there were to be immediate national elections for a legal government.

First, France had to make a life-or-death decision as to whether to accept peace terms. As women they were disenfranchised, but Berthe shared Edma's impatience over the election results. At least the Morisots agreed on one thing, that France desperately needed a peace settlement. However, the elections raised a second issue, the future of the government of national defence and the country itself. Monsieur Morisot was bristling with opinions. He was as dismissive of the Republican regime, a 'gang of loquacious lawyers' who had governed the country since the previous September, as he had once been of Napoleon III's lackeys. And he singled out two for his particular scorn: old Crémieux, the justice minister, who had removed long-serving public servants like himself in favour of lesser fry, and that cold fish, Jules Ferry, who had spurned the very friends he had once used. As a staunch patriot, Berthe's father had no doubt that men of property should vote for the experienced hand of Adolphe Thiers.[41]

If he had not sounded so dogmatic, the rest of the family might have kept quiet. But Berthe warned Edma that a letter was on its way from Papa about the political situation. Though she did not entirely share Yves's view of events, any more than Monsieur Morisot did, Berthe could not accept the paternal line. Much of the family debate revolved around the radical figure of Gambetta as Minister of War and of the Interior. Almost despite themselves, Cornélie and her daughters had come to admire his patriotism and courage, whereas in provincial France he was viewed differently. The problem, as Edma

pointed out, was that everyone's war experiences had been different, so they supported whichever political leader they judged had done best for France. She felt as indignant as her mother at the bitter criticism of Gambetta. 'It was he who did most for the defence', yet he was 'unanimously attacked in the provinces and held responsible for our defeat'.[42]

Writing back a few days later, Berthe mentioned another controversial figure, Garibaldi, the flamboyant Italian leader who had brought a volunteer force to fight against the Prussians. To the Left he was the undefeated hero of the Republican cause. But to many Frenchmen he was associated with the brand of volatile left-wing politics which France had rejected after 1848. Berthe observed a little tartly to Edma how Garibaldi was loathed as much in the provinces as the leaders of the Government of National Defence, Favre, Trochu and others, were hated in the capital, but considering all that Paris had been through, Parisians were more justified in their views. In pointing this out, Berthe was not so much defending Garibaldi's radical politics (for which she had no particular sympathy) as scorning those grey Republicans whose mismanagement, she believed, was responsible for the recent disasters. Her father, however, did not approve of her making mischievous political remarks, and whenever she dared to voice her opinions at home, he threw up his hands and called her 'a madwoman'.[43]

In fact, the elections showed a political split between Paris and the majority of Frenchmen out in the country. France as a whole was conservative, voting for the monarchists or those, like Thiers, who favoured the status quo, whereas most Parisians supported the heroic Republicanism of Gambetta, Victor Hugo and Clemenceau. Monsieur Morisot was delighted when Thiers was appointed head of the executive power by the newly elected National Assembly sitting in Bordeaux, and Cornélie agreed that Thiers was the best spokesman for common sense. By that, she meant that he could be relied on to represent the interests of the French bourgeoisie. But to anyone with the least political sense, it was obvious that there were festering tensions dividing the capital from the country.

Edma Pontillon was concerned about the strength of the right wing in the National Assembly. 'This reactionary Chamber does not inspire me with great confidence. Those who advocate caution and moderation do not seem to be the men of the hour.' Berthe also despaired of the nation's capacity to handle its problems responsibly: 'The French people are so *frivolous*.' She knew that a political polarization was taking place and by the end of February the unrest was apparent. On 26 February, a huge demonstration was held in the Place de la Bastille in the wake of the anniversary of the 1848 Revolution. Without going into details, Berthe told Edma there had been a great commotion and the situation was becoming inflammatory. She was perhaps thinking of a savage lynching incident which occurred the day before. Her mother was more explicit.

Some rowdies with a predilection for noise and rioting . . . began to build a barricade in the Champs Elysées. . . . Feeling ran high everywhere. Some madmen seized this opportunity for perpetrating an act odious and revolting in the last degree. They drowned a . . . policeman, after subjecting him to two hours of torture, and not a soul among the millions who were there did anything to save the unfortunate man, who only begged for the mercy of having his brains blown out. What infamies! What a nation![44]

The atmosphere became even more volatile when the peace terms were made known. They were, in Berthe's opinion, far too harsh. France had to cede Alsace and Lorraine to Germany and pay an unprecedented war idemnity of five milliard francs, while being subject to military occupation. Until the ratification, the German army was to encamp in Paris. The Morisots were justifiably alarmed, anticipating trouble. Berthe had already written to Edma on 27 February that 'The Prussians are to enter on Wednesday, and our arrondissement is . . . to be occupied. . . . This news was circulated in the afternoon. . . . Our Passy, usually so quiet, was animated, the Place de la Mairie and the main street filled with noisy crowds.'[45]

Cornélie Morisot had a hunch that the Germans would billet troops in their apartment. At the mere suggestion her husband exploded, all his hatred for the 'Red' Republicans suddenly overtaken by his loathing for the villainous Prussians. 'God knows what senile or childish idea has got hold of Father', said Madame Morisot. He was prepared to let the Prussians break in his front door rather than open it to them; he would return force by force and sacrifice his life rather than surrender.[46] In the end she and Berthe pacified him by reminding him that it was Monsieur Thiers who had called on the people to forget their bitterness in the interests of order. It was one of the few occasions when Tiburce Morisot found Adolphe Thiers's invocation difficult to swallow. None the less, Berthe held her breath when, on the morning of 1 March, the Prussian troops began their ceremonial triumphal march through Passy towards the Champs Elysées. The streets were deserted. The citizens of Paris, who had had to bear so much, stayed behind their bolted doors and shuttered windows in a display of dumb insolence. The peace preliminaries were duly approved by the National Assembly. Forty-eight hours later the martial display was over and the *pickelhaubes* had gone. The Morisots breathed a sigh of relief. Cornélie observed to Yves that their presence had been like a dreadful nightmare that would be soon forgotten. But it was difficult to preserve harmony in a city where smouldering resentments burned in too many hearts.

'Paris is far from peaceful', Madame Morisot detected in early March. It was a piece of deliberate understatement to stop her daughters in Mirande from worrying too much. In reality, Paris was on the verge of civil war.[47]

CHAPTER NINE

Crisis and Aftermath

1871

All through that March of 1871, politics and the follies of men superseded art and artists as the main topics of conversation in the rue Franklin. Berthe was easily rattled by the discussions. She had no energy and found ordinary tasks, even writing letters, too much of an effort. For the time being, Tiburce and Edma were her parents' first concern. Adolphe had returned to port in Cherbourg (the navy having played a less active and distinguished part in the war than many had hoped), so Edma was anxious to join him as soon as possible. But ever ready with advice, Cornélie warned her it was still too early to travel.[1] The railways had scarcely resumed operations, the Prussians occupied a 25-mile zone around the capital and the peace terms had not yet been signed. She strongly advised Edma to stay in Mirande with Jeanne, at least until the Germans had withdrawn from Paris.

But there was another reason for Cornélie's concern. Although it was natural to blame foreigners for the volatile state of Paris, her instinct told her that the real enemy was within. During the armistice about half a million men were encamped in and around the capital, regulars, conscripts and volunteers. Some of the National Guard battalions (mostly the middle-class, disciplined units) were disbanded in February. The remainder were bored and restless, still smarting with thwarted chauvinism or filled with revolutionary fervour. Bourgeois families like the Morisots and the Rieseners feared and detested these tendencies and were apprehensive about what would happen.

Berthe wondered about her former friends. Puvis de Chavannes, like Degas and the Manets, had been discharged in mid-February from the National Guard; she heard that he had become a monarchist deputy in the new Assembly. (This was not the case, as she later discovered: it was his brother-in-law who was elected.) As soon as he could quit Paris, Edouard Manet left to rejoin his wife and mother in the south-west, Eugène Manet following soon afterwards. Degas, whose wit brought some much-needed light relief to the Morisots when he called to see them after the siege, left in mid-March for Normandy. Meanwhile, it seems that Puvis was in touch with Berthe again, and feeling deserted by Manet, she was grateful for his attention. It may be that discussing politics with Puvis made a change from

listening to her father (though his views, if anything, were further to the right).

Berthe's mother blamed the politicians – in this case, the elected deputies of Paris – for disowning their responsibilities and allowing rampant aggression to develop. She feared that would-be revolutionaries would take advantage of the situation to plunge the capital into chaos. The war and the siege had temporarily united Parisians, but now these were over, she foresaw how the radicals might 'pose as heroes' and manipulate popular feeling, inciting the people to revolution in order to fulfil their own lust for power. 'Paris does not want to be tricked out of its republic – it wants the real thing, the republic of the communists and of disorder . . . I think our poor country is rotten to the core.'[2] The majority of the National Assembly, it seems, shared Cornélie's opinion. They passed a number of reactionary and provocative laws, including the ending of service pay to the National Guards.

The poor discipline of the radical Guards battalions aroused strong emotions in families like the Morisots. They were especially worried about the motives of the 'Red' units, the *Fédérés*. In a number of serious incidents during February and March, cannon and ammunition were seized by left-wing Guards from artillery depots and police posts. 'Nothing is more shameful', Cornélie told Yves, 'than the conduct of the men of Belleville and Ménilmontant, who have the courage only to fight their own countrymen, hoping thus to find an opportunity for plunder and for gratifying all their passions.'[3] Despite these misgivings about the political situation, Edma had made up her mind to rejoin Adolphe. With little Jeanne and Tiburce, she broke her journey at Passy during March. Berthe and her parents were overjoyed by the reunion. Now at last she and Edma could talk to their hearts' content about all that had happened in their months of separation.

Unfortunately, no sooner were they reunited than Paris exploded with fresh drama. The trail had started on 8 March as Edma left Mirande. The army had been ordered to recover the 200 cannon held illegally in various parts of the city by the National Guard. Thiers, returning from Bordeaux on 17 March, insisted that force be used. The next day, the recovery operation in the Montmartre district was stupidly bungled, and despite the personal intervention of the Mayor, Georges Clemenceau, two officers who had been seized by National Guardsmen and irregulars, Generals Clément Thomas and Lecomte, were summarily shot and their bodies mutilated. Elsewhere in Paris the mob took the initiative. Adolphe Thiers decided on a tactical retreat to Versailles. That same night, Jules Ferry, the unpopular mayor and Prefect of the Seine, climbed out of a rear window of the Hôtel de Ville, the building in which he had once administered Paris. He fled to a safe house, and the next morning – 19 March – he hurried in Thiers's footsteps to

Versailles, where soldiers loyal to the Republican government were gathering. In Paris the unfurling of the red flag on the town hall belfry and the erection of barricades heralded another revolution.[4]

As they learned what had happened, the citizens of the respectable suburbs were filled with numb disbelief. Passy was strangely isolated and quiescent, like a little city a hundred miles from Paris, insulated from the upsurge of revolutionary feeling in the capital. Edmond de Goncourt heard the news of the insurrection from the bread woman. He found no traffic in the city. The shops were closed and the talk on the pavements was of the generals' execution.[5] The Morisots, it can be assumed, shared the general stupefaction, but out of curiosity Tiburce, Berthe and Edma joined the thousands of other sightseers who went to have a look at what was happening. They found 'the quay and the two main streets leading to the Hôtel de Ville closed by barricades with cordons of National Guards in front of them . . . a red flag on the Hôtel de Ville tower, the rumble of an armed populace behind three cannons'. Seeing 'the vulgar licentiousness of the National Guards', their faces bathed in 'a kind of radiant swinishness' that disgusted Goncourt, Berthe and Edma returned home in an agitated state. The memory of 'that sad walk on the boulevard that upset us so greatly' lingered with Berthe for some time.[6] It was reinforced by the ringing of the tocsin from Notre Dame, silent since the nervous nights of June 1848. 'A dead fearful calm in the city', reported a foreign observer; 'not a shadow of a legal and responsible city or national government.'[7]

It was a situation which households like the Morisots ignored at their peril. A fresh exodus of the well-to-do to the provinces and the north coast started the following morning. Neighbours in the rue Franklin were departing in droves. Edma decided it was time to go too. Berthe promised to join her in Cherbourg as soon as she could. Meanwhile, their parents were discussing their own position. Since the previous September the whole legal system had been grinding to a halt, but now, with the withdrawal of the Thiers administration to Versailles and the collapse of order, the law courts of the Palais de Justice were officially closed. There were no longer any professional constraints upon Monsieur Morisot: he was free to go. But there were still inhibiting factors, such as the safety of relatives and family properties and possessions; and more importantly, perhaps, the fact that Tiburce was now deeply committed to counter-revolutionary activity. As Cornélie said from the heart, 'How can one leave one's son in the thick of this fighting?' And while her parents were reluctant to leave, Berthe had to answer herself, how could she defy their wishes?[8]

They were still agonizing when Tiburce seized the limelight. On 19 March Thiers had sent Admiral Saisset to Paris with the thankless brief of rallying the remaining bourgeois units of the National Guard. Tiburce Morisot junior found himself immediately on the admiral's staff, where he quickly

took the initiative over his fellow officers in the drive to recruit loyal men. It was not easy, for, as he told his mother, there were no more than 500 such males left in the capital. But in response to the chaos, groups of conservative-minded citizens rallied together, calling themselves the Friends of Order. They were men of property, respectable businessmen, ex-officers and successful shopkeepers.

On 21 March they set out to demonstrate peacefully in the Place Vendôme. Braving armed companies of the radical National Guard, Tiburce led the unarmed marchers. Their show of force raised bourgeois confidence and they decided to repeat the demonstration the following day, when Admiral Saisset joined with the Friends at the Place de l'Opéra. Again Tiburce Morisot stood in the front ranks dressed in uniform, with two acquaintances, a medical student called Gaston Rafinesque, son of the Morisots' physician, Dr Jules Rafinesque, and a doctor, a Monsieur Dally, an ardent admirer of Berthe. Wisely, however, Tiburce decided against repeating his performance of leading the march. It was as well, for the crowds were larger and the temper of the National Guards less restrained.

The demonstrators were converging on the Place Vendôme when they were ordered to disperse. There was confused firing and a dozen marchers fell dead. News of the 'Massacre of the rue de la Paix' spread like wildfire. Dr Dally, who gave medical help at the scene with Gaston Rafinesque, called round at the Morisots' later to tell them what happened. He claimed to have picked up nine dead and nine wounded in the rue des Capucines. Tiburce, meanwhile, had hurried home to reassure his parents that he was unharmed, though among the casualties were some prominent Parisians. On hearing this, Berthe was very upset, certain that her brother was trying to cover up some bad news. She convinced herself that Puvis de Chavannes was among the leading demonstrators and had been wounded at the very least, a false belief which neither the doctor nor Tiburce could counter. Her brother then insisted on returning to the Grand Hotel which, with the Bourse, was a rallying point for the Friends of Order. There he volunteered to negotiate with the insurgent leaders on behalf of the Thiers government.

By a curious coincidence, Tiburce claimed to know two of the revolutionary leaders: Charles Lullier, an ex-naval officer, and General Gustav-Paul Cluseret, the radical military commander whose political meeting Manet and Degas had attended the previous September. It could be that Tiburce had met them both in America; or it is equally possible that he was bluffing since his own politics were distinctly rightist. Be that as it may, Cornélie Morisot could not rest until she found out what was happening and whether Tiburce was safe. It transpired that he was perfectly all right, and Puvis as well.

But the Morisots knew it would be tempting fate to delay. The revolution of 18 March was showing every sign of developing into a Terror.[9] The streets

echoed to marching feet and the beating of the *rappel*. Bourgeois men were being rounded up and tried by revolutionary tribunals for nothing more than wearing a blue ribbon. Puvis decided to leave when he realized that neighbours in the Ninth Arrondissement were informing on each other and it was possible at any moment to be forced to join the rabble or be shot 'by the first escaped convict who wants the fun of doing it'. From the safety of his sister's residence in Versailles, he wrote to Berthe, begging her to get away from Passy to avoid what was bound to be a bloody denouement. He was worried that her parents did not realize just how vulnerable they were in the capital.[10] But Cornélie feared that Tiburce's appearances with the Friends of Order would make him a prime target for the revolutionaries. Berthe and her parents urged him to leave immediately with them.

On Sunday 26 March, municipal elections were due to be held. The outcome was to be a victory for the Reds in the new municipal council, the 'Commune de Paris'. However, the trains were still running and it would be a day of coming-and-going, an opportunity to leave without drawing attention to themselves.[11] Trusting their home to the care of their servant, Louis, the Morisots travelled west to the royal town of Saint-Germain-en-Laye. On 31 March the gates again closed on Paris. The scene was set for the mortal confrontation between the men of the Commune and the Versailles government, which began on Palm Sunday.

To Berthe and her parents, tucked away in Saint-Germain, the raw brutality of life and death in the capital was limited to the sight of drifting smoke and the boom of cannon. With other spectators, they stared towards Mont Valérien and the city beyond from the high terrace of the town. Then Berthe wrote to Edma in her usual low-key vein about the contradictory stories they had heard from last-minute refugees; but on the whole she felt there was no reason to be alarmed about the state of things back home.

In actual fact conditions in Passy were far from good and would soon deteriorate when the Versailles forces attacked Neuilly.[12] By mid-April the bombardment encompassed the whole of the western approaches to the city; ironically it was the elegant, pro-government suburbs which were in the front line. Passy was caught in the crossfire, because to counter the government batteries established on Mont Valérien, General Cluseret set up his naval artillery on the Trocadéro Heights, thereby drawing their salvoes into the surrounding streets: 'they tried to destroy the batteries of the Trocadéro from Mont Valérien', Berthe wrote, knowing that it couldn't be done without 'splattering the neighbourhood', so 'we are philosophically awaiting the outcome'.[13] One effect was an influx of Communards into Passy. 'Bandits', the Morisots' doctor, Jules Rafinesque called them as he watched them arrive, 'a veritable army of unpaid mercenaries, a dirty, sordid, vicious, indisciplined rabble' from the working-class areas of Belleville, La Villette and Ménilmontant.[14] It was feared they would dig

themselves in for a protracted house-to-house slog with the Versailles forces. Desirable properties like the Morisots' in the rue Franklin were likely to go up in flames with their defenders.

Yet for most of May there was little the temporary refugees could do in Saint-Germain except watch and wait as the perimeter forts fell to government forces. The city's fate still hung in the balance. Meanwhile, Cornélie found the German presence in Saint-Germain hard to bear, particularly after the Treaty of Frankfurt was signed in the middle of May. 'These odious Prussians regale the terrace with their music every day', she complained with uninhibited hostility. 'Their arrogance is extreme, I don't like them any better since it has been decided that they are no longer our enemies.' The old enemy and the new – Prussians and Communards – they were equally the objects of the Morisots' loathing.

From the middle of May, however, their immediate foe was the new Jacobin leadership, who had overthrown the original leaders of the Commune and showed every sign of perpetrating the excesses of the Great Revolution. Those outside Paris had no means of knowing about the atrocities taking place. (Berthe learned much later how Pierre-Auguste Renoir was almost lynched, like the policeman, Vincenzini, when he was caught painting by the Seine.) Meanwhile, Berthe became bored by her enforced inactivity in their cramped accommodation. She was depressed, too, at the sight of her father's morose face. Reading the signs, her mother suggested she needed sisterly companionship. Berthe hesitated for a while. She did not want to intrude on Edma's and Adolphe's privacy: after all, they had been apart for nine months. And she had no desire to vegetate in provincial Cherbourg, while Edma was engrossed in domestic matters. Finally she was goaded into action by Edma, who had written asking for painting materials. She packed her things and decided to risk the train journey alone.[15]

Even in Normandy, however, the shadow of the horrors being perpetrated in Paris hung over her, amplified by the steady flow of information from her mother. For instance, on 17 May there was a major explosion on the Avenue Rapp. It wrecked the arsenal near the Champs de Mars and, according to the Morisots' manservant, Louis, the force was such that he thought their house in Passy was collapsing around him. Cornélie sent a hasty and alarmist message to her daughter. If everything had been reduced to rubble Berthe had lost her studio, her canvases, her unfinished sketches, her personal possessions – in fact, all the achievements and memories of her youth. This news came as a crushing blow, especially when her mother added with minimal tact that she had better get back to work and produce some new paintings.[16]

While this and other incidents were reported (such as the terrible hubbub when the manacled figure of Henri de Rochefort, a radical journalist, was

taken under cavalry escort to Versailles by government troops), the civil war was approaching its climax. In the early hours of 21 May the Versailles forces began to pour through the undefended Porte Sainte-Cloud into Auteuil and Passy. Cornélie Morisot was both excited and relieved at the prospect of returning home, but her husband, 'who is always afraid to be happy, did not believe it'. Tiburce, impatient to be in the thick of things, left them on the morning of 22 May, intending to make his way to the rue Franklin. He was uncertain whether he would stay there or return to Saint-Germain later with a progress report.[17]

As it happened, Tiburce came back that evening. He had bumped into Jules Ferry, who was also reconnoitring the situation in Passy, and the politician had commandeered a cab which brought them both back as far as Versailles. Tiburce had felt at home amid the smoke of gunfire and the scent of danger. He reported coolly that shells had been raining all around the house, as they failed to make their full trajectory to the Place de la Concorde. He found that the second and third storeys of his grandfather Thomas's house – number 15 – had been blown apart, and their luckless tenant, Madame Heymonet, had lost everything, while other properties nearby had been damaged or ransacked.

The rue Franklin was under continuous fire from a rebel gunboat on the Seine, for it was marked out as the headquarters of the Versailles forces. General MacMahon, the commander-in-chief, billeted himself in the home of the Guillemets, General Vinoy at the house of other neighbours, the Cosnards, and the military Intendant-General set up in the Morisots' at number 16, despite the absence of glass in the windows. For once, Cornélie Morisot was delighted by her son's boldness and presence of mind. He had two lucky escapes, one when a marksman's shot passed near as he chatted to General Vinoy on the Cosnards' terrace, and the other when bullets whistled all round him as he went on a foray to the Rond Point. Tiburce was not one to let the grass grow under his feet. He invited the high command to dinner, despite the difficulty of getting hold of provisions. Warming to her son's resourcefulness in cultivating the Versailles generals, Cornélie passed on to her daughters how Tiburce had been invited to lunch by the top brass and had duly returned the compliment by putting the family's wine cellar, linen and china at their disposal. In the event, the atmosphere was quite cordial and General Vinoy had been most amicable.[18]

Several more days elapsed, however, before it was safe for the Morisots to return to Paris. In that last week of May, Armageddon descended. Ferocious engagements were fought out, street by street, in the choking smoke of cannon, machine-guns and muskets, as the Versailles forces herded the Communards like cattle into the working-class sectors of the city. Then on the night of 24 May, the struggle entered its short penultimate phase. Cornélie Morisot wrote another hasty and emotional letter to Berthe. 'Paris

is on fire! This is beyond any description. . . . A vast column of smoke . . . and at night a luminous red cloud, horrible to behold, made it all look like a volcanic eruption. There were continual explosions and detonations; we were spared nothing.'[19]

At the burning of Paris, the rage of the Versailles troops broke all bounds. Their savagery towards the civilian population of the city created the bitterest of legends. Madame Morisot listed some of the devastation, but it was only a part of the cost: 'the Tuileries is reduced to ashes . . . the part of the Finance Ministry building [where Grandfather Thomas and Tiburce had once worked] . . . is on fire, the Cour des Comptes is burned down, twelve thousand prisoners, Paris strewn with dead.' And a little later:

What I saw was frightful . . . this great massive building [the Hôtel de Ville] is ripped open from one end to the other! It was smoking in several places, and the firemen were still pouring water on it. It is a complete ruin . . . I saw the remains of the Cour des Comptes, of the Hôtel de la Légion d'Honneur, of the Orsay Barracks, of a part of the Tuileries. The poor Louvre has been nicked by projectiles . . . half the rue Royale is demolished, and there are so many ruined houses, it is unbelievable.[20]

What she did not see, or turned a blind eye to, was the other side of the class struggle that was taking place: the merciless revenge-killings of the Communards by government troops.[21] Later, pitiful convoys of prisoners struggled through the select quarters of Paris on their way to the Porte de la Muette: hundreds of women and girls, ragged, bruised, maimed, goaded by stones and rifle butts or the whips of General Gallifet's escorting cavalry. But Berthe and Edma were apparently unaware of the mindless slaughter on the streets. In later years Berthe blamed Louisa, her childhood governess, for failing to teach her compassion, 'for she made no appeal to my sensitivity'.[22] Yet she and Edma were horrified by the collapse of their parents' morale. While Papa Morisot saw his life's work melting away, he felt marginalized and was filled with helpless rage. Cornélie shared his bitterness and disbelief. Since the Cour des Comptes was burned to the ground and its papers were scattered to the winds, it seemed likely that the court would be abolished. Cornélie confided in Berthe: 'your father would like all this debris to be preserved as a perpetual reminder of the horror of popular revolution. It's incredible, a nation thus destroying itself!' Another Parisian, watching the judicial documents of Monsieur Morisot's office whirl and wrinkle in the sparks, confirmed that 'they were the history of the Second Empire which was passing, page by page, in the smoke and flames'.[23]

By Whit Sunday the 'Bloody Week' was almost at an end. Cornélie Morisot assured Berthe it was as well that she was not a witness to the final scenes. At

midday the last barricade fell in Belleville and later, in the cemetery of Père La Chaise, 147 Communards were penned against the walls and shot by General Vinoy's men. The rising of the working class was over and the long process of expiation was about to begin.

L'année terrible – the phrase was Victor Hugo's – had a profound effect on Berthe. It would be naive to think otherwise. The winter siege, defeat and humiliation by Germany, their flight from the people's revolution, man's inhumanity to man: all these gouged deep scars. Her health had never been robust and remained a permanent source of concern, although she was fortunate compared with Marie Bracquemond and Fanny Claus, both of whom had given birth to baby sons in 1870 and suffered terrible deprivation, as did their husbands. Fanny died at the age of twenty-seven, her strength irreparably undermined by the effects of the siege.[24] However, for Berthe there could be no return to the immaculate innocence of young womanhood. In the past few months she had become extremely withdrawn, introspective, wary and even cynical.

During the siege, she commented on something that Manet also noticed, that stress brought out the worst in people and made them excessively self-centred. Alphonse Daudet, the writer, also had some bitter thoughts about those who fed on other people's misery, 'from the idlers in the suburbs . . . to the majors with seven stripes, contractors for barricades . . . all glowing with good meat gravy, dandified sharpshooters preening themselves in the cafés . . . all the monopolizers, all the exploiters, the dog-stealers, the cat-chasers, the dealers in horses' hooves'.[25] But as the situation deteriorated it was a question of *sauve qui peut*. Berthe was profoundly shocked at the failure of people to behave with a modicum of decency, especially the Parisian *haute bourgeoisie*. Her anger spilled over in the pages of her letters. She had emerged from the siege 'disgusted with my fellow men, even with my best friends. Selfishness, indifference, prejudice – that is what one finds in nearly everyone.'[26] No names were mentioned, but Jules Ferry was almost certainly one she was castigating.

Yet none of her former friends came in for much praise. Berthe had no time for male self-pity. A terrified Fantin, who had no athletic prowess, spent much of his time in hiding in the cellar of his studio-apartment. 'Je suis poltron, moi!' (I chickened out), he admitted to Whistler. Cornélie Morisot heard about it and was disgusted that he had been able to continue working.[27] Monsieur Degas claimed his eyesight had suffered from hours on duty in the icy winds. Manet detested sleeping on straw and complained there was not enough of it. As soon as possible, he pulled what strings he could to be made up to the rank of lieutenant, and was given a staff posting under the command of Colonel Meissonier, the pillar of the art establishment. Berthe was evidently sceptical as to whether he deserved

promotion and observed crisply that he spent the war 'changing his uniform'. Manet was not by choice a man of action, so only later did she discover he had taken part in the bloody sortie to the Marne. But she heard that he got out of Paris at the first opportunity. And from the safety of Bordeaux Eugène let the cat out of the bag by revealing that Edouard was regaling everyone with imaginary wartime exploits. By this time Berthe had grown tired of self-styled heroes. She was in two minds about Manet when in June she received a letter from him. He was back in Paris, trying to bury his nightmare recollections. 'Each lays the blame on his neighbour, but to tell the truth all of us are responsible for what has happened', he said with great feeling.[28]

Berthe may not have quite appreciated Manet's state of mind. He and his brothers had never hidden their long-standing Republican sympathies, but their radicalism was *never* extreme, as Madame Morisot was inclined to believe. She simply could not understand how men of impeccable bourgeois pedigree like the Manets and Degas could be so stupid as to align themselves with the political Left. Gustave Manet, the most radical of the brothers, had enlisted in the Ligue d'Union républicaine des droits de Paris during the Commune, and his friend Arthur Ranc, another Ligueur, was exiled for six years in 1871. Predictably Cornélie made her views known. As Paris burned, she said fiercely to Berthe, 'Should Monsieur Degas have got a bit scorched he will have deserved it'. As for Manet, he 'irritates me with his railings against Monsieur Thiers whom he calls a demented old man'.[29] Her animosity sharpened when Achille Oudinot, who had been her daughters' teacher, was appointed administrator of the Louvre by the Commune.[30] But her disgust was complete when she read the names of the Comité de la Fédération des Artistes – those artists alleged to favour the revolutionary regime – and the list included Gustave Courbet; Corot, who had so often been their dinner guest at the rue Franklin; Daumier, with whom they had taken lunch at Daubigny's in the summer of 1863; *and* Manet . . .

Berthe also found it hard to empathize with their commitment to the left-wing cause. In her opinion artists had little in common with politicians and by April she was utterly sick and tired of the miserable business of politics which absorbed everyone else's attention. Although she found her father's political dogmatism irritating, she was as appalled as both her parents at the excesses of a regime that was apparently responsible for a policy of vandalism; a regime which encouraged the mob to desecrate the mansion of Thiers in the Place Saint-Georges – a treasure house of books and works of art – and to pull down the great Vendôme Column, felling it like a giant tree, an act for which 'Citizen' Courbet was held personally responsible.[31]

However, Berthe understood – even if her parents did not – that Manet's election to the artists' committee was *not* a sign of his socialist sympathies,

but a measure of past artistic notoriety. He did not support the Commune – he had actually left Paris a fortnight before it was formed – and was deeply disturbed by the indiscriminate violence of the Communards. Indeed, when Tiburce bumped into him in Paris at the end of May, Manet was in a highly agitated state. He had been sketching the slaughter in the streets and had found the experience extremely stressful. In addition, his studio in the rue Guyot had been badly damaged and he claimed to be facing financial ruin. But it was a measure of Cornélie Morisot's waspish partiality that she described Manet and Degas as two Communards and blamed them for 'condemning the drastic measures used to repress them [the *Fédérés*]. I think they are insane, don't you?'[32] As it happens, Berthe's reply went unrecorded.

In the aftermath of nine months of disaster and blood-letting, a spate of paintings and engravings appeared, mostly by academic artists. Among the best known were Meissonier's representation of *The Siege of Paris*, and two, *The Balloon* and *The Pigeon Carrier*, by Berthe's friend, Puvis de Chavannes. Manet had kept some painting equipment in his soldier's knapsack, and in late December 1870 he had painted two snowy scenes in Eugène's sector, Petit-Montrouge, and the railway station at Sceaux. Later came the Commune sketches. As for Degas, he drew some Daumier-like caricatures of the war's dramatis personnae and the likenesses of his comrades. Yet of the artists who portrayed this terrible year, there were few who caught the atmosphere or the passing moment as well as those painters-in-words, Théophile Gautier and Edmond de Goncourt. It was they who described the city at war with the vision of *plein air* painters in a style that was redolent of the future Impressionists.

Goncourt was impressed by the variety of colour in wartime Paris. Walking towards the Bois and Saint-Cloud, he caught the impact of 'the marvellous genre pictures brought into being by the felling of the trees . . . rusty coloured underbrush . . . poplars with golden foliage . . . green fir branches . . . branches the colour of dried currants, grey canvas tents with azure smoke over them . . . the red trousers of the soldiers . . . like vermilion pistol shots'. From the foot of the Point du Jour, he had been struck by the variations of light and shade in late September: 'on the other side of the barricade, a whole landscape under a sky and over a river both luminous and grey. . . . Shadows in bluish, violet, lead-coloured tones, flashes of silver . . . like a landscape drawn in molten metal.'[33] Gautier was similarly aroused as he looked from the same viaduct across the Seine: 'the whole horizon . . . was bathed in a white light in which the contours were lost and yet there was no fog, but rather a sort of luminous dust. Nature that day', he concluded, 'seemed to be painted with the palette of Corot.'[34]

However, the colourful feast of reds, russets, brassy gold, grey and silver

provided by the military camped along the Avenue de Neuilly and in the Tuileries Gardens – the modernism of the urban scene recast by war which had caught the writers' imaginations – was seemingly lost on Berthe. For all her painter's eye and artist's soul, she took a prosaic view of the military. The militia, quartered in her studio, prevented her from working. 'There is no way of using it', she told Edma cryptically.[35]

War appalled her. It could never inspire her. She had no desire to make artist's models of the soldiery; they were uninvited guests, obtrusive and undesirable except as guards. Cut off from access to her own premises throughout the hostilities, she viewed her shrinking world with a jaundiced eye. Her only consolation was Degas's fan which was small enough to be kept by her side. When there was nothing else to do, she copied from 'Monsieur' Degas, reproducing his subtle shading and fine detail in watercolour. She remained dedicated to the medium; indeed, in Fourreau's opinion she reached 'a mastery over it which no painter of her generation, save Jongkind, could equal'.[36] So it was an irony that, except for the weeks when she was too ill to care, she constantly brooded as to whether the conditions of war would stifle her creativity for ever.

Her frustration over the wasted months caught up with her at Saint-Germain. It was partly the arrival of spring which made her restless. Walking around the outskirts of the town in the fine April weather, she realized how pretty this part of the Seine valley looked, and how attractive to a landscapist. Unfortunately, she had neither tools nor her favourite models to hand. (Since the Morisots had left Passy in a hurry it had been impossible to load her artist's paraphernalia into the cab.) With limited means she attempted an open air scene in watercolour, ruefully admitting she felt as awkward as a child-novice. Impatience chafed inside her like grit in an oyster shell, so she scratched another letter to Edma, protesting how prolonged idleness would be disastrous for her in every way. It is clear from her messages to her sister that she had been taking stock of herself. She was now a mature woman of thirty, unmarried and alone but for two ageing parents of uncertain health. Her prospects were not particularly good. Perhaps these considerations, taken with the events of the previous nine months had given her a sense of urgency to put her life in order.

Thinking aloud, she found herself rehearsing old arguments. She appealed to Edma for empathy and understanding that painting was now the sole purpose of her existence. To some extent her mother had been right. 'Art for art's sake' was all very well, but a woman who pursued this path would always be labelled an amateur. Perhaps she was indulging in illusions, but she hoped Edma would agree that to work 'just for the sake of working' was unsatisfactory. Recalling her much-admired picture of *The Harbour at Lorient*, which she had presented on an impulse to Manet, Berthe suddenly felt able to articulate her desire to be a professional artist.

'It seems to me a painting like the one I gave Manet could perhaps sell, and that is all I care about.'[37]

It was not the whole truth. In part she was echoing Manet, who had told Fantin-Latour that all he wanted was to make money out of painting. If Berthe believed her own assertion, then she was deceiving herself. She hoped for many things out of life in addition to commercial success. But she was not driven by burning ambition. She did not strive to stake out new ground or be an activist for a good cause. She was not a critic of 'the system' in the manner of Jenny d'Héricourt or Juliette Adam. She was no more a critic than her mother, who tempered her acceptance of the patriarchal society with occasional outbursts. 'Men fill me with disgust: I have a horror of them', Cornélie told Edma in the summer of 1871.[38] In truth, the idea of being a protagonist for the female sex never entered Berthe's perceptions: by temperament she was an individualist and by instinct a conservative, inclined to keep her own counsel, especially after her recent experiences of the war. In any case she lacked the drive for organizing others and felt most comfortable pursuing her own interests or passing time in the company of friends of her own limited set. This was not the stuff of which revolutionaries are made.

Her words, however, showed a new resolution, and interestingly, her confessions to her sister were not about fears of becoming a lonely old maid, but about her intention to break the mould of conventional middle-class behaviour (and so to fulfil Guichard's prediction.) Other women had done this before her, covering their tracks with a degree of double talk. When Berthe's contemporary, Louise d'Alq, an authority on social protocol, said that a bourgeois woman had to be a lady, and by definition a lady did not work, she did so without fear of contradiction, since that was the popular view. Yet, as a working journalist, Madame d'Alq contradicted her own dictum. She practised the same personal code as George Sand, the sculptress Marcello and Nélie Jacquemart, for whom work was the key to female independence.[39] Berthe was now seriously pondering the possibility of joining that small band of professional women. She was ready to put the past behind her and was looking to an active future, while warning her sister of things to come. She was making a clear declaration of independence and of professional intent.

'Steer her ship wisely'

1871–2

Cherbourg was a bracing world away from the Ile de Paris, as Cornélie Morisot sent solicitous messages via Edma: 'Kiss my precious little Berthe for me. Tell her that I wish she would steer her ship wisely and cautiously.'[1] Her choice of metaphor was apt. Berthe enjoyed the breezy, naval atmosphere of the place and found it conducive to painting. She set to work on scenes of masted ships tied up at the quayside or cutting their way through the outer harbour. She also persevered with watercolour, which suited her taste for working on a small scale. *Woman and Child Seated in a Meadow*, for instance, was much admired on her return, evoking with great charm the green countryside and urban clutter of a provincial seaport, combined with vignettes of her sister and niece.

On rejoining her parents in August, Berthe continued with her watercolours. One of her early pieces was a study of a young brunette seated on the red sofa of her restored studio, a pleasant little presentation in profile. Soon afterwards Yves and Paule posed on their first home visit for fifteen months. They served as models for *On the Balcony*, which set the elegant figure of Yves and white-pinnied 'Bichette' against the pictorial skyline of the Left Bank. Berthe was so pleased that she made two versions, in watercolour and oil. Meanwhile, she had taken one of her Cherbourg scenes to be framed by one of the leading dealers – possibly Durand-Ruel – only to be warmly complimented and assured that it had attracted the attention of artists visiting his gallery.[2] In a rush of optimism she assumed that she had found her outlet. Both Manet and Puvis de Chavannes showered her with praise and Berthe's confidence rose in proportion to the generosity of their comments.

Now she was determined to develop the spontaneous effect, which was becoming the hallmark of her painting. She worked with intense concentration, so much so that her mother (who often jumped to the wrong conclusion) saw only her 'anxious, unhappy, almost fierce expression'. Berthe, she was sure, was plagued with uncertainties over technique and felt as desperate as 'a convict in chains'. She put it down to her daughter's whimsical nature. 'Berthe is always sure she could do such wonderful things in any place where she is not at the moment, and hardly

ever makes an effort to use the resources at hand.' However, once she immersed herself in a project she tended to work too hard and make herself ill.[3]

Needless to say, Berthe saw the situation differently. It was not her professional commitment that was a burden but her responsibility to her parents. Her father had developed angina and his deteriorating health, together with her mother's neurotic protectiveness, were preventing her from fulfilling a long-standing urge to go abroad. Her earlier idea of an English trip had come to nothing because of the war. Now she was filled with nervous energy – a reaction to the pent-up months – and a continuing emotional need for change. A number of Manet's circle had already left France. In July Théodore Duret had set off for America on the first stage of a world tour. Claude Monet was in Holland. Degas was to visit London in the autumn. James Tissot, who had managed to get away to England to escape reprisal for having co-operated with the Communards, was achieving enviable success there. French painters as a whole were receiving good publicity in the Second Annual Exhibition held at the newly opened Durand-Ruel gallery in New Bond Street. Daubigny's paintings sold well, and between the armistice and the Commune, Fantin's wealthy patron, a lawyer by the name of Edwin Edwards, had bought up all his paintings and was selling them at good prices. Even little Claus, as Berthe still disparagingly referred to Fanny, 'is delighted with her stay there'. It was galling to have no influential contacts in England, and Berthe felt an understandable pique that 'All these people are stealing my idea.'[4]

As autumn approached, relations between Berthe and her mother had become acrimonious again. Cornélie despaired over her two mavericks. Tiburce, who showed no inclination to work, had developed a penchant for plump, mature women and nymphomaniacs. The perfect hero had become a daredevil. Berthe was little better with her headstrong dreams of being a painter. Cornélie was ambivalent. Unlike Edma, she doubted Berthe's ability to paint for a living but, moved perhaps by guilt, she pledged her support 'to help her reach her goal'.[5] One thing she could and did do was to contact her friend, Madame Chassériau, widow of the eminent painter, who in the New Year wrote on Berthe's behalf to Charles Blanc, director of the Beaux Arts, asking for support, with the assurance that 'this young woman has shown a phenomenal taste for the arts since her youth . . . she is determined to dedicate herself entirely to painting'.[6]

None the less, Cornélie still had difficulty in coming to terms with her daughter's gifts. There was no sound reason to be optimistic. In her judgement, the family genes produced moderate performers rather than high fliers: 'That is how we are, and that is how we'll always be.' So, on that reckoning Berthe was unlikely to win a gold medal in the Salon, nor were her skills and style of painting conducive to commercial success. Compared

with an artist like Alfred Stevens, who was about to purchase a fine mansion with landscaped gardens in the rue des Martyrs on the basis of his very considerable earnings – he stood to make more than 100,000 francs in 1871, Cornélie observed enviously – Berthe would never make it. A confrontation between mother and daughter loomed after Berthe was told politely but firmly that she simply did not have the talent to do 'anything worthwhile'. Stung by this, Berthe came back with a crisp observation, 'I must certainly have as much talent as Nélie Jacquemart.' This startled Cornélie, but neither of them would apologize. 'She thinks me raving mad', said Berthe coolly.[7]

Edma loyally defended Berthe in her letters back home, and to some extent her protests forced her mother to think again. Cornélie was in any case inconsistent. Sometimes she was proud of Berthe's accomplishments – her 'ravishing things' – but more often she was unsure whether Berthe could ever be more than a gifted amateur. She took the compliments of the male fraternity with a large pinch of salt, noting incredulously that 'To believe these great men, she has become an artist!' When Puvis, for instance, told Berthe that her work was highly subtle and distinctive, Cornélie scoffed at the man's insincerity. She also dismissed Manet when he tried to assure her that Berthe would succeed in her own good time. Nor was Degas to be trusted; he 'uttered some compliments' without so much as looking at Berthe's work: just to be sociable, Cornélie contended.[8] The irony is that for once 'these great men' spoke the unvarnished truth. But in the last analysis Madame Morisot wanted Berthe to understand that there was a difference between the compliments of gentlemen and the professional appraisal of male artists. It was a distinction that Germaine Greer took very seriously in her book, *The Obstacle Race*. 'Women painters had more to fear from poisonous praise than destructive criticism', she affirmed. 'When men begin to persecute and exclude women, they acknowledge their own insecurity. When they patronize and flatter them, they assert the unshakeability of their own superiority.'[9]

Yet to suggest that Berthe herself had no inkling of this danger is seriously to underestimate her intelligence. She had listened too often to the barbed tongue of 'Monsieur' Degas, to the opinions of Oudinot and the advice of parental friends, to believe that cultured men were exempt from male arrogance towards women artists. But her ego was still sensitive and her technique had not yet totally discarded its visible debt to Corot and Manet. And again, Greer surveyed the frequency with which women artists had failed to find their authentic voice because of 'egos that have been damaged . . . wills that are defective . . . energy diverted into certain neurotic channels'.[10] So the next two or three years were bound to be a restless striving for her 'authentic voice' and there were to be other obstacles and other blows to her self-image along the way.

One of these was the smouldering, contentious issue of marriage. Contrary to her mother's fears, Berthe was conventional enough to see this as a personal necessity. She was not lacking in admirers – and she knew it. During the siege of Paris she had been fawned on by a Dr Dally, an acquaintance of Dr Rafinesque. The gentleman's ardour exceeded his discretion, but it was his portliness that was his undoing. No more was heard of '*fat* Monsieur Dally' after the spring of 1871. Meanwhile, another former admirer had come back into the picture. Pierre Puvis de Chavannes had always enjoyed philosophizing with Berthe, and she with him. However, during her attack of siege fever Berthe found his company and conversation too exhausting. But he called at the rue Franklin just when she was trying to stave off the persistent Dr Dally: it was a timely reappearance.

Only to Edma did Berthe admit her interest in Puvis. 'Interest' was obviously a considerable understatement, for she had become very agitated when his safety was in question during the street-fighting. And the 'interest' was mutual because Puvis was greatly relieved when Berthe was safely installed in Saint-Germain. He visited her there; and later Berthe wrote to him from Cherbourg. Replying immediately in his wordy way, Puvis told her how much pleasure her letter had given him. After a lengthy peroration on the state of France, he begged to know in great detail 'everything you are doing or thinking . . . what is happening . . . whether you are working, whether you are succeeding – in other words, everything. Boom!'[11]

They corresponded regularly for the next two months: letters full of the personal confidences and tender pleas for understanding which betray a certain intimacy. Berthe accused Puvis of deserting her during the winter of the siege. He answered with a playful rebuke that it was she who had told him to stay away. Then, cultivating the slightly self-deprecating tone of the wronged suitor, he begged her to 'let bygones be bygones' but asked reprovingly, 'Why don't you tell me anything about your life?' In the midst of this exchange, Berthe had an attack of panic, as if aware that she was getting into deep waters. Puvis was a very distinguished and successful artist with a public image to sustain. She drew back instinctively. Again he gently admonished her for letters that were too bland and impersonal. 'It is hard to find even a gleam of light, and I strain my eyes trying to find you in the fog', he wrote with poetical tenderness.[12] She tried to respond, aware of her mother's disapproval.

Parental pressure forced Berthe into bottling up her emotional life. It was invidious enough that her every act should be conveyed in detail to her sisters, but Cornélie Morisot had also confided in friends like Laure Riesener while Berthe was away. Meanwhile, she and Edma had ample opportunity to talk between themselves about marriage. Doubtless Edma had definite views, for while Berthe was staying in Cherbourg, she discovered that she was pregnant again, following her reunion with Adolphe.

Back in Passy, Berthe temporized in her parents' company. The Rieseners had managed to convince Cornélie that there was no point in pushing Berthe towards businessmen or politicians (which ruled out a number of people, including Manet's younger brother, Gustave, who had an eye on a political career). They pointed out that Berthe was most at ease with artists, whether they were amateur gentlemen of private means or professional gentlemen enjoying official recognition. Their opinions left Cornélie feeling distinctly unhappy, for she had repeatedly said that artists were whimsical creatures, if not downright unstable: the worst sort of marriage partner for her daughter.

It was at this point that Berthe's relationship with Puvis was coming to a head. Puvis had no illusions about the uphill task he faced. He knew full well the Morisots did not like him. He felt they were actively discouraging him from visiting Berthe.[13] This was the stark truth and Berthe may have been unaware of the real cause. The Morisots had discovered some compromising facts about Puvis. For the past fifteen years he had enjoyed a steady relationship with the Princess Marie Cantacuzène, a cultured woman married to a Rumanian prince from whom she was estranged. On the face of it, this was a close, romantic attachment: Puvis showered his princess with bouquets of pale pink roses and she returned his generosity with passionate and profound devotion. They exchanged gifts of verse and he received her in the elegant gold and white setting of his Neuilly apartment, with its Aubusson carpets and Topino furniture. Yet several of Puvis's drawings of this period, including his self-portraits, suggest that he was in the throes of a personal crisis. He felt alienated and helpless, caught in the grip of a dominating older woman (Marie Cantacuzène was almost as old as Cornélie Morisot) from whom he was desperate to escape.[14] The connection was probably revealed to Cornélie by Madame Chassériau, whose husband had introduced Puvis to Marie Cantacuzène. And either Degas or Manet may have stirred Cornélie's fears, since both had strong reservations about Puvis; Manet was probably jealous of the man, too.[15] Puvis, meanwhile, was set on courtship. Perhaps pursuing Berthe was a bid for freedom. Or perhaps, at the age of forty-seven, the gentleman had fallen in love? Whatever his motive, the Morisots were satisfied that he was up to no good.

Berthe may have assumed that politics lay at the root of her parents' hostility. The Morisots were feeling politically insecure. As they faced the July by-elections for the National Assembly, Cornélie poured out her fears to Edma. 'France is split between madmen – such as the Manet clique and others – and fools, the party of Chambord and his following. . . . These people gloat over the return of their prince, and flaunt all their old prejudices – it's pathetic!'[16] Unfortunately, Puvis and his family were patricians of the far right, adherents of the Bourbon Comte de Chambord. In Morisot terms he was a decadent reactionary, an object of mistrust by

Berthe's father with his old Orleanist loyalties. Foreseeing the difficulty, Berthe warned Puvis that their relationship would always cause problems. For his part, Puvis was so anxious to win her parents' approval that he was ready to acknowledge his personality defects. He had already confessed pathetically to Berthe that he knew how unpopular he was with those around her.[17]

So matters had reached an impasse by early July, and there they might have rested but for the fact that Puvis suddenly mustered all his manly resolution. He urged her to write another letter and explain 'sweetly about everything that passes through your brain . . . set in such a mysterious and charming head'. She was in a quandary. From the safe distance of Cherbourg she tried to settle the issue by asking his intentions and suggesting he should call formally on her parents. Without hesitating, Puvis dutifully obeyed.[18] By accident or design, only Tiburce was at home that day. So, thwarted in his mission, Puvis wandered around the Bois de Boulogne, returning finally to the house in the rue Franklin, where he stood gazing at Berthe's bolted studio, brooding on her absence – and on his fate. It was perhaps as well the Morisots were not there to meet this man of the world reduced to love-sick impotence, and speaking of secret trysts and indiscretions. 'Your Passy studio was open but dark and sepulchral – the curtains three-quarters drawn. I looked for you in a white peignoir, but had to content myself with my own evocation.' He withdrew to wait for another day.[19]

Discounting the formal language of his letter, the speech of a pompous, middle-aged bourgeois gentleman, he was clearly smitten by Berthe at this time. A second incident puts a similar gloss on his feelings. It concerned his patronage of a prisoner then confined in Cherbourg, whose release he was trying to secure. Puvis let slip confidentially that he had thought of enlisting Berthe's help, but on reflection realized he might compromise her. For the very sight of her beauty would have been a cruel torment to an imprisoned man.[20] In normal circumstances this would have been unwarranted familiarity, offensive to someone of Berthe's background. Obviously their relations had changed. The buoyant courtier wrote teasingly, 'You must admit that you are pretty brazen, with your eight folded pages, and saying "ouf" at the end of a page and a half! Lord, what impudence! . . . write me eight pages at once!'

On her return to Passy, Berthe agreed to an assignation. Puvis was in raptures of expectation. He insisted she should choose the day and time but asked for advanced warning so he could be properly prepared: 'this will be a very, very great pleasure to me . . . I shall be waiting.' Anticipating Berthe's pledge, he reassured her of his goodness and promised in a give-away phrase that she would discover his other virtues '*little by little and in due time*'.[21]

What happened then? If Berthe went to their rendezvous, it was in

carefully contrived secrecy. When the question was put, she demurred. Had she taken the opposition of Manet and her parents to heart? It seems the affair ended there, in tears perhaps, but not in the hurtful recrimination that soured the rupture with Oudinot. On the contrary, Puvis continued to admire her painting and to offer extravagant praise. He paid her social calls occasionally and went on writing to her: his customary, wordy, unctuous epistles. In return he asked only for occasional notes – and she duly obliged – while he plunged himself into a long period of intense activity like many a spurned admirer.

At the 1872 Salon she saw his exhibit entitled *Hope*, epitomizing in a female form the spirit of renewal in France. At times they discussed art, occasionally personal, even intimate matters. In 1887 he painted his self-portrait in oils. It shows a spare, soulful gentleman with white whiskers and a high, noble brow. Two years later, Berthe still found him charming, if somewhat pompous. Over the years their friendship gradually pulled apart like spun thread, yet unbroken to the end. Pierre Puvis de Chavannes was always too academic, too magisterial for an idiosyncratic and feline woman like Berthe Morisot . . .[22]

As Berthe tried to put the Puvis affair out of her mind, it was comforting to be drawn back into the Manet circle. Cornélie Morisot had accepted an invitation to the reopening of the Thursday salons while Berthe was still away. Tiburce was in attendance but she found the occasion nauseating, partly because of the heat in the overcrowded drawing-room – unfortunately, the drinks were not properly chilled – and partly because she was tired of seeing the same old faces. With her usual relish she observed that Eva Gonzalès had become uglier. It was pure bitchiness, for on another occasion it suited her to say that Mademoiselle Gonzalès was 'ravishing' and 'so intelligent'. Then she went on to say how the pianist Madame Camus overdid the smooth talk (though Tiburce found her captivating), the novelist Champfleury was a pain in the neck, and Degas had apparently aged. Only Edouard, the host, was his old sociable self, facetiously enquiring whether Berthe intended to stay in Normandy for ever with a host of new admirers.[23]

Cornélie Morisot's language had grown more outspoken with the passing years. Berthe was used to her tirades against the Manets. Her mother particularly resented Edouard's disparaging remarks about Thiers: Adolphe Thiers, patron and family friend, who was to become President of the French Republic in August of that year! There were times, however, when Edouard Manet could do no wrong – for instance, when he offered to use his influence to land a job in journalism for Tiburce – and he was invariably gracious to Berthe. She was flattered on her return from Cherbourg to be invited to model for him again; she assumed from this that he still found

her attractive.[24] But her timing was wrong: soon afterwards the Manets went off to Boulogne. Edouard was suffering from nervous exhaustion, proving to Cornélie how the males of that family were effete.

They were away until the end of September. Some weeks after this, Edma arrived at the rue Franklin with Jeanne, a toddler of almost two, to prepare for her second confinement. Berthe was delighted to be reunited with her favourite models. Early on she completed a little double portrait in watercolour, *Madame Pontillon and Her Daughter, Jeanne*, seated on Grandfather Morisot's First Empire chaise longue. And she followed this with a pastel *Portrait of Madame Pontillon*, in which Edma sat full-face, her jet black gown reminiscent of Manet's style. By this time Berthe's sister was heavily pregnant. The mature contours of her face and her air of sad resignation project a cryptic message of apprehension to the world.

Edma's second daughter was born just before Christmas, on 23 December 1871. She was christened Blanche. Edma made a slow recovery from the birth and it was agreed she should remain in Passy until she felt well. Berthe worked indoors, producing a pastel, *Little Girl with Hyacinths*. At the approach of spring when Edma was stronger, Berthe completed what subsequently became her most famous painting, *The Cradle (Le Berceau)*. Though she hoped it would have commercial appeal, there is something very personal in this most touching and positive of statements about motherhood. Gone is Edma's apprehension of childbirth: instead the dark maternal figure keeps a patient, watchful gaze over the sleeping infant. The scene is suffused with light, soft, yet penetrating enough to illuminate a wealth of detail. Although it belongs to Berthe Morisot's early phase of independence, *The Cradle* has the master touch and evokes an emotional response of great intensity.[25]

Edma and Yves served as their sister's models intermittently during 1872. The theme of woman-and-child also figures in an enigmatic oil painting simply called *Interior* which belongs to this time. Berthe seems to have used a device of Degas to produce a double portrait of her sisters which is also an unusual domestic genre painting: an interesting piece of social comment in which the figure of Yves – or was it Edma? – seated inside the inner room beside a jardinière, is disconnected from the woman and child looking towards an external world from which they are all excluded.[26]

During her sisters' visits Berthe was thinking ahead to the Salon, the first of the Third Republic. The Palais de l'Industrie had been closed since July 1870, so its reopening was an eagerly awaited event. Berthe decided to submit her pastel portrait of Edma, together with the light-filled oil painting, *Interior*. The jury, who included Manet's former superior officer, Ernest Meissonier, were thought by many to be excessively traditionalist. Several of the artists in Manet's circle – Monet, Pissarro, Sisley and Degas – decided against submitting anything. Renoir's canvas was rejected, as were

two by Courbet, the latter on blatantly political grounds. Berthe was naturally hurt when her unusual oil was turned down. Her hope that Madame Chassériau's appeal to Charles Blanc might bear fruit was not fulfilled. When Puvis heard, he wrote a consoling letter to her about the prejudice of 'old-fashioned conventional eyes'.[27] Fortunately her pastel *Portrait of Mme Pontillon* was accepted. Manet, too, was successful with a painting of a naval battle scene fought off Cherbourg.

But whatever pleasure Berthe had from the Salon was short-lived. There was no one to gossip with after Edma left with her two babies for her husband's country property at Maurecourt. The Gobillards were back in Mirande; Madame Morisot was preoccupied with Tiburce's various unsuitable romances which were causing comment in their Passy circle. Like her husband, she was also fretting about the political state of the nation. Cornélie had observed many times before that France was a sick country. Its constitutional system presented an unedifying spectacle that spring. While costing the country millions of francs a day, the Chamber wasted its time passing useless and repressive laws or arguing about personalities. After the end of the Commune, as a patriotic gesture the Morisots had invested 1,000 francs of their savings in the government's subscription loan. Now they anxiously watched events, as political divisions undermined financial confidence.[28]

For Berthe, however, these preoccupations mattered less than the fact that the Salon had left her no nearer achieving public recognition. Her instinct was to get away from Paris again. But she hesitated because there was talk of a combined Manet–Morisot holiday at Saint-Valéry-en-Caux, just beyond Fécamp on the Channel coast. Edouard, according to Cornélie, had taken a liking to Tiburce: in fact the reverse was probably true, but Edouard was too urbane to dispute it. In any case, Berthe knew that this was a smoke-screen to conceal a cunning little Manet plot to throw her and Eugène together in the hope that they might fall into each other's arms. Cornélie was ambivalent about the idea. Eugène did not really match up to her expectations for Berthe. His lack of initiative sorely tried her. 'If his [Edouard's] brother had any sort of serious intention, it would not require a chance opportunity or an impulsive moment for him to declare himself', she wrote acidly. Certainly, this was not the appropriate way to approach marriage.[29] Since it was clear there was no mutual attraction, Berthe found the hints deeply embarrassing and suspected Eugène did too. As she waited on events, wondering whether Edouard would be one of the holiday party, she was thinking of painting a cityscape, a *View from the Trocadéro*; she would ask her friends the Carré sisters to pose against the backcloth of the river and the Left Bank scene.

Edouard had, of course, painted the same panorama in 1867, and the artistic intimacy between the pair of them was now paralleled by the affinity between the two families. It was not always easy to prove who influenced

whom, and Berthe was much more defensive about her artistic independence, infinitely more sensitive to the charge of influence and plagiarism. As she admitted to Edma, the composition of one of her pictures of Yves and Paule resembled a Manet: 'I realize this and am annoyed.'[30] Yet several of her mother-and-child pictures may have been inspired by Manet's pre-war picture painted in the garden in the rue Franklin and she had already borrowed from Manet's use of fragments to open up pictorial space. He, on the other hand, had responded to her enthusiasm for *plein air* painting and he used the back view of a figure in *The Railway*, a device Berthe had already used, for example, in *Interior*.

By May Berthe was acutely bored, waiting for a decision on plans for the summer. When the Gobillards invited her to join them on the Basque coast, she jumped at the chance. They met up at Saint-Jean-de-Luz, which was not as attractive in Berthe's view as the old Roman town of Bayonne which they visited. The resort was full of Spaniards, and because neither Berthe nor the Gobillards spoke their language, they felt isolated. Their main pleasure came in the evenings when she and her sister sat talking in the square or by the sea. One wonders what the two of them found to discuss: Yves, bored with her isolation and the dullness of her marriage, Berthe, defensive and laconic when things went wrong. In the meantime the weather turned unbearably hot, their accommodation was none too comfortable and they were plagued with fleas. When she tried to paint out of doors, Berthe was distracted by hordes of children roaming the streets, and by the intense sunlight, which eliminated all the nuances of light and shade. The sea, she complained, was either dark and dull or all blue, like a slab of slate. With this catalogue of woes, she felt ashamed of both the quality and quantity of her output during this visit. In the end she left with one pastel.[31]

While they were in Saint-Jean-de-Luz, Berthe became so fractious that out of sisterly concern Yves suggested a change of plan. It was agreed she and Berthe should take a trip to Madrid, leaving Théodore to escort the household back to Mirande.[32] For Berthe a visit to the Spanish capital was a long-held dream. Manet had told her about his Spanish holiday of 1865, which his friend Zacharie Astruc had organized, and she remembered Manet's praise for the Velázquez and the Goyas. Now she wrote quickly to Edouard asking for Astruc's address, in the hope of persuading him to act as their interpretor and guide. In the event he came up trumps. 'The handsome Astruc put himself entirely at our disposal for visiting the city, which he knows well', Berthe crowed. But unfortunately, she was still feeling out-of-sorts and her final judgement was that 'Madrid has no character'. As someone used to the temperate north, she obviously felt no affinity with Spain. So her sight-seeing was limited to the Escorial Palace and Toledo, while her enthusiasm was reserved for the collections in the Prado. For the rest, she was relieved to get back to France, as Manet had been seven years

before. Impatient to pour out her impressions to Edma, she left Yves in the Hautes Pyrenees and hurried on to Maurecourt.[33]

For the next few summers, while the Pontillon children were small, Maurecourt became Berthe's favourite retreat. The little township lay near the confluence of the Seine and the Oise, not far from Auvers, with its youthful memories. A few miles downstream was the ancient town of Pontoise, where Pissarro, Cézanne and Guillaumin were busy painting at this time. The area was rich in meadowland, orchards and copses, surrounded by wide, uninterrupted vistas that Berthe captured in a pastel of 1873; and above was the fluctuating cloud pattern of the Ile de France which produced such varied light effects. The Pontillon property had extensive grounds that were to provide an ideal setting for some of Berthe's most appealing rural genre paintings, *Hide and Seek* (1873), *Catching Butterflies* (1874) and *The Lilacs of Maurecourt* (1874). In that first summer, however, she completed little watercolours of Edma on the grass and sitting on a bench with Jeanne, and pastels of baby Blanche. In fact she spent her time between Maurecourt and Passy, until she was drawn back to the capital by the news that Manet was asking to paint her.

Berthe was excited. Only Manet could arouse such a flurry of emotion. And she was happy that at last he seemed to be acquiring the material rewards he had craved. In January 1872 he had sold over two dozen pictures to Paul Durand-Ruel for the princely sum of 53,000 francs. The dealer was a shrewd and ambitious operator, not afraid to take risks by anticipating trends. To escape the financial ravages of the Franco-Prussian War he had temporarily transferred his stock and himself to London, where he had met Monet and Pissarro. On his return to Paris he was introduced to other painters associated with the two 'exiles': Sisley, Degas, Renoir, and more significantly, through the good offices of Stevens, Edouard Manet. Now it occurred to Berthe that Manet could be useful to her; he could recommend her to the dealer.[34]

Manet agreed and in July he showed Durand-Ruel some of Berthe's work. The dealer's priorities were becoming clear by this time. He was interested in artists of independent mind and talent, as well as those whose work displayed tendencies that suggested a group affinity. To achieve his aims he was sometimes prepared to purchase whole collections or the entire contents of an artist's workshop. In fact Durand-Ruel bought four of her paintings, a Cherbourg seascape and three watercolours, including a vibrant little study in greens and black of Edma sitting on a garden bench at Maurecourt.[35]

Meanwhile, on 1 July Manet had taken over the lease on a vast ground-floor apartment at 4 rue de Saint-Petersbourg. A fortnight later in his inimitable way he held a house-warming party, to show off his airy studio overlooking the rue Mosnier. Berthe was one of the principal guests. He showered her with his attentions. Then, as soon as he had arranged things

to his liking, Manet settled down to work, inviting Berthe to be his model. She could not refuse.

Those weeks between the middle of July and late September were profoundly significant for their relationship. To begin with, Manet was on top of the world after his first taste of artistic success for eleven years. And when Manet was on a high, his happiness touched everyone around him, filling them with a sense of his elation. In her mind's eye Berthe was suddenly aware of the clock turning back to those halcyon days when he had first asked to paint her, when they had felt the surge of mutual physical attraction, which for her had been entirely novel and disturbing in its force. Edma had envied her 'laughing with Manet'. Now Manet's eyes were sparkling again. Manet was glowing with his old enthusiasm, eager to paint the enigmatic and emotional woman behind the immaculate reserve. She still teased his senses and stirred his masculinity. She enjoyed pitching her wits against his. They found they talked easily and intimately together, letting go of some of their reserve.

She came the first day wearing her favourite fashion colour, black. Her rich brown hair was piled high beneath a round black hat trimmed with a short veil. Manet would not let her remove it, for how else would she remain an enigma? She was apprehensive. Hat and veil sat low upon her brow; the net obscured her mouth and chin, leaving visible the natural wistfulness in her eyes. Perhaps this was why Renoir later pronounced it an ugly picture.

When Manet had finished it she came again, dressed in her favourite black gown and rose pink shoes with Louis-Quinze heels. It was to be a full-length portrait this time. Manet placed her before a landscape with a bell-tower and she stood there, a little self-consciously, her dark hair dangling loosely to her shoulders, right foot thrust forward from beneath the dark hemline. It catches the attention by the pretty colour of her shoe and the boldly pointed toe. But in the third portrait she was coquettish, she provoked, and more, she was truly teasing. Reminding her she had once been called a *femme fatale*, he dared her to be so obvious. With a rustling movement Berthe swivelled sideways on his white studio chair and swung a leg over her knee. She thrust it forward from the gleaming fullness of her skirt, exposing her white stocking as far as the middle of her calf. At the same moment she raised the fan with her left hand, to conceal the upper part of her face, denying Manet and the viewer the secret expression in her eyes. The whole effect – fan, exposed leg, arched foot and outstretched toes – was decidedly flirtatious and familiar. Manet had his own explanation. He was to tell the poet, Mallarmé, laughingly, 'one can know all about a woman merely by watching how she places her feet. . . . The amorous ones turn their feet out. You can expect nothing worthwhile from a woman who turns her feet in.'[36]

How many sittings, how many 'trysts' there were, is beyond reckoning. Since their two families were so close, Berthe sometimes arrived

uncharoned and took the opportunity to share confidences with him. Sometimes their talk flowed easily; sometimes he was light-hearted and teasing; from time to time he seemed withdrawn. Manet always lived his life in pigeon-holes amid obsessive secrecy. Berthe was probably unaware of his other projects, and no one could keep count of all his models, such as the unknown brunette who about this time posed nude for *Dark-haired Woman with Bare Breasts*. However, suddenly, during August, he dropped her a note to say he was off to Holland with Suzanne, his broad-hipped matron of a wife. He guessed Berthe would be annoyed and to mollify her he tried to fix her up with commissions from a wealthy client interested in pastels. His tactic seemed to work. She contemplated her future fees with wonderment: could she possibly command as much as 500 francs for a single picture . . . 1,000 for two? Such enormous sums![37]

Then in September Berthe posed for him again. She arrived one Wednesday, as arranged, a picture of elegance. Her deep-crowned black hat had tie-strings and a broad bow of ribbon at the back, a fold of which swept over her left ear and dangled down her neck. Around her shoulders she wore a short black mantle; at her neck a touch of crisp white. Maybe she had stopped to buy a bunch of violets on the way or perhaps it was Manet who thrust them into her hands, asking her to pin them to her dress.

He sat her down before a neutral backcloth and started to paint, working swiftly. On this occasion the painting came 'easily, obediently to the supple brushstroke'. He set out to place on record this uniquely charming, mysterious and intense personality, while faithfully portraying her physical likeness: the nut-brown hair with chestnut lights that fell so readily into long curls, the 'pale or rosy luminosity of the flesh' and 'the great eyes whose vague fixity suggests the profoundest abstraction, a sort of presence in absence'. A smile played around her lips but as his eye searched her features, the artist saw 'something almost tragic in the expression of her face'.[38] In the opinion of Paul Valéry *Berthe Morisot with a Black Hat and Violets* radiates pure poetry: he ranked it among Manet's finest work. For discretion's sake, Valéry could not elaborate on the poignancy bordering on tragedy – a tragedy of thwarted love, of passion circumscribed by time and place and social class. Manet, however, must have known that he was gazing at a young woman whose heart was near to breaking point. He knew only he could help resolve her emotional turmoil.

When the sitting was over, they stayed and went on talking.[39] It was an unexpected opportunity to clear the air. For years Berthe had wrapped up her love for Edouard in praises for his artistry or in facetious remarks about his person. Finally she had been forced to face the stark truth: Edouard Manet was the only man she had ever desired. As a married man, however, he was inaccessible, and as a gentleman, an 'honnête homme', he would never tarnish her respectability by suggesting an illicit liaison. And much as

she wanted to pour out her repressed emotions, the barriers of decorum and delicacy were still inhibiting. So her innermost thoughts had to be transmitted in carefully coded words.

Edouard's response is largely a matter of conjecture. Yet enough is known about his dazzling, warm, but superficial personality to suggest that for him love was akin to infatuation, meeting an obsessive but transitory need in himself. As important a priority was his own self-esteem. So while he had been the focus of so much public denigration as an artist, like all the Manets, Edouard had an intensely private self and an inner compulsion to appear blameless. Baudelaire, who had observed this craving for respectability, commented on his marriage with heavy irony, 'This wife is not only beautiful, but *very good. . . . So many treasures, all combined in one person!'* – though perhaps her greatest gift was to remain silent throughout her husband's frequent infidelities.[40] It was the price Suzanne paid for her own indiscretion years before when she might have dragged the Manet name into disgrace and chose instead an imbroglio of secrecy.[41] And so, as they faced one another, Berthe and Edouard were united by a desire to avoid a breath of serious scandal upon each other's name.

For Manet, the incorrigible and sentimental matchmaker, there was an obvious solution which he pressed fervently on her: a compromise, but one that would be the best solution in the circumstances and to the benefit of all parties. If Berthe were to become a member of the Manet family, the two of them would be united by powerful and respectable bonds. He would be entitled to greet her with a kiss on both cheeks each time they met: a sweet inducement. Edouard pleaded with her to marry his brother, Eugène. Berthe listened for 'a very long time', but her reply was inconclusive.[42] It was an intolerably painful decision. She needed more than a modest interval to think. When she had gone, Edouard gathered up the small mementoes of her fragrant presence in his studio, the fan which she had held in her hand and the bunch of flowers, violets for constancy. Later, he painted a personal picture for her, adding the briefest and simplest of dedications, implying a culmination and a new departure. It was a small canvas, a still life, 'that most charming of visual love letters, depicting a bouquet of violets and a fan, inscribed *To Mlle. Berthe . . . E. Manet*'.[43]

It was impossible to avoid each other. They met the following night at the Manets' for one of the Thursday soirées, and Berthe had another sitting so that Manet could finish the portrait. That autumn she grew more depressed at her inability to make an impact with the dealers and the connoisseurs. Manet's efforts on her behalf came to nothing and she began to lose hope. Her problem was one of confidence to sort out priorities, both personal and professional. She had tried to steer her ship wisely and cautiously but where had it taken her? She was still uncertain of her true direction. 'My situation is impossible from every point of view.'[44]

Turning Points

1873–4

The advent of 1873 brought no apparent change in Berthe's situation. She claimed to be working hard to no avail, turning down invitations to stay in the country, where she could have gone walking and riding. Her father's poor health may have inhibited her from going away. On the other hand the Morisot parents had some reason to be cheerful. The year had opened on a confident note. The Paris Bourse, that important financial barometer, was firm and seldom had the capital 'presented an appearance of greater animation and tranquillity', thanks to Adolphe Thiers. *The Times* congratulated the president for steering France into the calmer waters of political recovery and preparing the ground for everyone's dream, which was the liberation of the country from German occupation.[1] (The final withdrawal took place in the course of 1873.) To judge from the triumphant response to the president's appeal for a second national loan – it was massively oversubscribed – Adolphe Thiers had won the nation's confidence. All seemed well with France.

In addition, Cornélie and Tiburce Morisot were preoccupied by an unexpected piece of family news. Yves was pregnant again and later in the year gave birth to a boy, Marcel. The arrival of their first grandson and a great-grandson for Monsieur Thomas was a cause for celebration. The event, however, would only reinforce Berthe's feelings of inadequacy. She continued to work in her studio at portraits of those friends and relations willing to pose. Her cousin Madame Boursier came, bringing her daughter to sit for a double portrait. The Carré sisters, too, though Berthe's portrayal of Valentine, a dumpy and plain bourgeoise, perhaps reflected her own feelings as well as her friend's appearance. On the other hand, she produced a fine pastel portrait in profile of her mother's young niece, Madeleine Thomas, a blonde-haired beauty in the making. The following year it was the turn of a dear friend of the family, Marie Hubbard, wife of a parliamentary lawyer and economist, Nicholas-Gustave Hubbard. Berthe painted her reclining in a sea of white organdie, her dark eyes filled with a Gallic sparkle.[2]

Meanwhile, the year 1873 held out promise to the artistic community. As one journalist remarked, 'The passion for picture-buying is now as rampant

in Paris as in London.' Three important spring sales attracted considerable attention, and the Laurent Richard auction put a rare and exciting number of nineteenth-century masters on the market: works by Corot, Millet, Delacroix, Géricault, Meissonier and others.[3] Berthe herself had reason to be pleased that in March Durand-Ruel took her *View from the Trocadéro* on consignment. After buying it in April for 500 francs, he sold it the same day to the retail magnate, Hoschedé, for 750 francs. Three months later Durand-Ruel did even better for her, selling the Boursier double portrait to Stevens for 800 francs. The dealer also bought a seascape (*The Breakwater*) from her which she contributed to a benefit sale in April held in his gallery in aid of refugees from the newly annexed German territories of Alsace-Lorraine.[4]

The Richard sale on 7 April marked the beginning of Holy Week. As usual the Parisian calendar was crowded with events: sacred concerts and services, the Stations of the Cross, and special performances such as Massenet's drama, *Marie Madeleine*. It was a time for drawing-room theatricals, too, and charitable bazaars, notably the Grand Sale organized by Madame Thiers at the Opéra in aid of the war orphans; the spring races at Longchamp, brilliant fashion displays, the new spring 'toilette'; and the popular fêtes of the *foire des jambons* and the *foire aux pains d'épices*, when gingerbread cakes in the image of President Thiers were sold in numerous little shops in the Place du Trône and the Faubourg Saint-Antoine. While this was happening, Durand-Ruel was mounting the April Exhibition of French Artists in his London showrooms, where some of his new acquisitions from the Hôtel Drouot sales were displayed, including works by Corot and Fantin-Latour.[5]

Although she hoped for more success through Durand-Ruel, Berthe was still as unsure of the free market world. In mid-March, when the time approached to enter works for that year's Salon, she had opted to try her luck again. The decision as to which of her works to enter was always a problem. But there was a danger of trying too hard to please official taste: Berthe recalled how Fantin had made this mistake in 1869, submitting an oil in the style of Veronese, which in her opinion had lacked conviction. So after careful thought she submitted two works. To her chagrin, however, only one was accepted, her pretty and meticulous pastel of a *Little Girl with Hyacinths* (also known ambiguously as *Blanche*).[6] But she was not the only one to face rejection by an Academic jury headed by arch-conservatives like Gérôme, Meissonier and Bonnat. Eva Gonzalès, the veteran seascapist Jongkind, and Renoir were all turned down.

Manet had asked Durand-Ruel to lend him *Repose* for the Salon – his full-length portrait of Berthe – which the dealer had bought in 1872 for 2,500 francs. Edouard felt it would make a good foil to his portrait of the engraver Emile Bellot, a pot-bellied, rosy-cheeked, pipe-smoking regular at the Café Guerbois. Inspired by Frans Hals, *Le Bon Bock* was a robust (and some said

meretricious) rendering of the subject, but it certainly touched a popular nerve. In the course of May and June it was praised, photographed, reproduced and displayed all over Paris. Manet relished his success that summer, especially after receiving an official medal. The same could not be said of Berthe. She bit back her disappointment but she had gained little from the Salon. Her pastel went unnoticed by the critics amid the welter of small genre pictures.

However, in a different way her presence was much in evidence. Her mother had foreseen the possibility of unwanted publicity if Manet were ever to submit *Repose*. For all that, Berthe could hardly have anticipated the tasteless caricatures of herself in the press, with their none-too-subtle hints at impropriety, the price of being a Manet model. An early review in the *Gaulois* asked the sort of leading question that was soon on everyone's lips. 'Why does Manet exhibit this rather jaded woman, seated in a dishevelled manner on a wine-coloured sofa?' Then, if any of the public were unaware of her identity, Manet's friend, Philippe Burty blurted out in *La République Française*, '*Repose* dates back a few years. . . . It is, we are told, the portrait of Mlle Morisot, one of the most remarkable pupils of M. Manet.'[7] Apart from her inaccurate designation as a 'pupil', Berthe was being presented as one of Edouard Manet's 'has-beens', and any vicarious pleasure she might have felt at the painting's acceptance by the hanging committee quickly evaporated. The hordes of visitors who came to the Palace of Industry to nod or grin at the jovial face of *Le Bon Bock* had the opportunity to stare and ogle over Berthe's image: two thrills for the price of one.

Inevitably the chattering classes were divided, partly along political lines. A few journalists saw its merit. Manet's admirer, the poet Théodore de Banville, considered *Repose* 'an engaging portrait'. Some critics suggested that since the model appeared to be neither standing nor sitting, the picture was misnamed. Thwarted by the success of *Le Bon Bock*, however, the anti-Manet right-wing lobby took up the cry from Marius Chaumelin, who wrote in the conservative paper, *Bien public*, 'Room M. The Woman who squints and the Bon Bock by M. Manet. Quite lifelike monstrosities.' Cham, the cartoonist of *Le Charivari*, referred to her sourly as 'the goddess of slovenliness'; his counterpart in *L'Illustration* labelled the picture 'Seasickness'. In turn, this encouraged Edouard Drumont of the *Petit Journal* to write of 'an abhorrence', and the monarchist *Union* to taunt Manet that 'his woman in the picture *Repose* defies good taste'. Collectively, these remarks must have been hurtful, if not damaging to Berthe's self-esteem. Even an old friend like Alfred Stevens allowed himself a touch of sour grapes.[8]

Paul Alexis blamed popular ignorance for this popular antagonism, but some years later Théodore Duret gave his explanation. He laid the blame on the obsession of critics and of the cultivated public alike with the ideals

of beauty laid down by the great masters of the Italian Renaissance. By casting beauty in traditional forms, artists thereafter were doomed to produce lifeless imitations. This Edouard Manet could not accept. He studied his female models as women of their time and portrayed the qualities of beauty that he perceived as unique to them, in this case the 'bitter elegance' of her image. It saddened him that the critics of *Repose* could not accept that he had painted what he had seen in Berthe Morisot: 'a woman of singular depth and charm of expression, graceful, distinguished'.[9]

No sooner had the 1873 Salon opened than the curtain went up on another act of the country's long-running constitutional drama. The Republic had seemed safe when President Thiers had repudiated a royalist restoration and confirmed his belief in strong republican government, a preference shared by most of the middle classes. However, just as the Salon entries were under consideration in March, a conservative groundswell surfaced with an upsurge of religious piety, a popular, patriotic reaction both to the decadence of the Second Empire and to the disaster of recent years. To reflect the mood of national atonement the foundation stone for a majestic basilica was laid: symbolically, Sacré Coeur was to dominate the most radical *quartier* of Paris, Montmartre.

In common with many urban bourgeois, the Morisots and the Manets frowned on these developments. Though they were firmly patriotic, there was a degree of scepticism and anti-clericalism in both families. But popular Catholicism found natural allies in the monarchical press and the conservative majority in the National Assembly. Right-wing Catholicism was represented in every walk of life, including the world of art. Paul Durand-Ruel, a devout Catholic and monarchist, drew his clientèle from the great conservative body of the well-to-do. He patronized them too. He bought the works of Pierre Puvis de Chavannes, for instance, and filled his Paris gallery that spring with the paintings of the most socially distinguished talent: the Prince de Joinville, the Princesse de Caraman-Chimay and seventy-four other aristocratic amateurs. No wonder *The Times* correspondent noted the political implications of this 'essentially anti-Republican exhibition'.[10]

In the changing political climate, artists of the comfortable social background of Manet, Degas and Berthe Morisot – bourgeois, Republican and inherently anti-clerical – were suddenly fair game for right-wing critics. Events in Spain, where the anarchist wing of the Federalist party known as the Intransigents had just precipitated the new republic into civil war, revived bitter memories of the Commune in France. Republicans were identified with socialism. The monarchist art critic, Dubosc de Pesquidoux, blindly attacked the official Salon in the *Union* as '*un salon républicain*'. He made play with the analogy between art and politics, deriding bourgeois

taste and accusing the Salon exhibitors of harbouring dangerous radicals. A political threat lay behind his art criticism: 'the Palace of Industry is given over to a crowd of artistic serfs and they play at princesses as the crowd in the Republic of '48 once did in the Tuileries, and more recently the Commune.' So when the Royalists were back on top, he warned, 'one will know whom it is one is dealing with. Those who agree to throw their lot in with the riff-raff, who sing the same song as the rabble, will have to stick to it!' The message was understood by people in 1873.[11]

Art had traditionally been a manifestation if not a tool of politics in France.[12] Now the Royalists were on the attack. In March, while Berthe was thinking about the Salon, the monarchists curbed Adolphe Thiers's constitutional powers. Then in the middle of the Salon season, in May, they manoeuvred the 76-year-old president into resignation. With the indefatigable Thiers gone, the country had reached another political turning point. The new head of state, Marshal MacMahon, Duc de Magenta, had been the commander of the Versailles troops against the Commune in 1871. A government dominated by aristocrats set about restoring what was called 'the Moral Order'. France entered a phase of thorough-going conservatism and a restoration of the old monarchy was on the cards.

The Morisots were bound to be worried about these trends in view of Monsieur Morisot's heart condition. He had been Thiers's disciple for forty years, following him from Orleanism by way of ardent nationalism to firm Republicanism. Like a great many, Tiburce Morisot was *against* more than he was *for* in politics. He was *against* the regressive faith of Legitimacy, *against* aristocratic privilege, *against* an erosion of secular power, *against* anything that would upset the ordered rhythm of the status quo. As for Berthe, she was with her parents on these issues. She feared the political turnabout would not help her win Durand-Ruel's patronage. Against a backcloth of traditional values, it would be hard for her innovative artistic style to gain recognition. Facing this and other personal dilemmas, she turned not to priests and pietistic cults, as conventional bourgeoises were increasingly to do, but to reading: Charles Darwin's scientific best-seller, *On the Origin of Species* for one. It was a book that found a natural place in an agnostic household. Yet she found his theories of organic evolution and natural selection heavy going – 'It is scarcely reading for a woman, even less for a girl' – and privately she admitted it did nothing to help her.[13] At the Salon she had been jeered at on canvas by the crowds, mocked as Manet's pupil by the critics. She could see little to cheer about that May and June of 1873.

So Berthe went off to Maurecourt to join Edma and the children: to close her mind to the press and the politicians and enjoy picnics with her nieces, excursions along the riverside, talking shop with her sister. She completed a pastel panorama of the village, and a figure-landscape of Edma with Jeanne.

Hide and Seek (Cache-Cache) captured a moment's harmless fun to perfection, showing her mastery of the art of depicting human beings in the vibrant atmosphere of a natural setting. Manet was delighted and persuaded her to let him have it.

Manet was to paint prolifically out of doors that July at Berck-sur-Mer. Monet had gone to Argenteuil, where he was visited frequently by Renoir. They shared professional ideas, just as Renoir had done while he painted with Sisley a few weeks earlier. Since Edma's defection, Berthe had been forced back on her own resources, discovering for herself how to depict reality. She valued every opportunity to test her sister's opinions. This kind of mutual stimulus which the avant-garde painters derived from each other's company, as they painted together in the suburban countryside around Paris, was significant in the evolution of their artistic concepts. Interaction was more productive at this stage than it was inhibiting, though Théodore Duret could foresee the day when the latter might be true. He warned Pissarro later that year, 'If I had a piece of advice to give you, I should say . . . don't pay attention to what they [Monet and Sisley] are doing, go on your own, *your path of rural nature.*'[14]

Berthe's path of rural nature now led her from Maurecourt to Fécamp with the Pontillons. She took advantage of the continuing fine weather to produce at least five paintings of the shore and cliffs. Fourreau observed two striking characteristics: her use of a 'ringing note' of colour amid the quiet harmony, and the 'gentle radiance', confirming Manet's belief that Berthe was already a painter unusually sensitive to the play of light.[15] When the best of a fine summer was over, she returned to Passy. The Manets followed in September to resume their social round. Edouard was in good form having painted almost thirty pictures in the course of 1873.

His optimism, however, was to be cut short. As he and Berthe settled down in their studios, the economic boom that had enabled Durand-Ruel to ask high prices was grinding to a halt. The failure of one of the biggest American investment companies, Jay Cooke, in late September caused fluctuations in the financial markets, which in turn triggered other bankruptcies. Berthe did not need to be told that the fine arts were the most volatile sector of the investment market. This was the beginning of an economic crash that brought penury to many artists, and a world-wide depression that was to last, with brief remissions, from the end of 1873 to the close of the decade.

Paris was already in the throes of political uncertainty when a great fire gutted the old opera house in the rue le Peletier in October. The following day, the Legitimist Comte de Chambord caused a major sensation by renouncing his claims to the monarchy. The Royalists were shattered, the Republicans jubilant. Some arch-conservatives tried to retrieve the situation. Paul Durand-Ruel published an extraordinary pledge in *Le Figaro*, affirming

the support of the whole business community and the artistic establishment to the monarchy. But the right was forced to climb down and accept an alternative solution, the confirmation of the Republican presidency for seven more years. Nothing, however, could prevent the continuing economic slide. Early in 1874 Durand-Ruel was forced to suspend financial support to his artistic clients.[16] By that time Berthe had thrown her lot in with a group of avant-garde artists in a bold act of self-help. A remarkable set of events was under way.

It was not a new idea, a collective venture by a group of artists. There had been precedents in the 1860s and Bazille had mooted it after he and Monet had been rejected by the 1867 Salon. Monet raised it again with the Batignolles group in April 1873 after failing to submit to the jury. He, Pissarro, Sisley and Renoir were the natural spokesmen. Their notion was of an association of painters outside the official system. It would be a self-sustaining, self-promotional organization, a kind of co-operative, an anti-Salon. The hope was that it would find approval within the nebulous world of dealers, critics, publicists and private connoisseurs. The scheme was discussed intermittently that summer wherever the artists met: at Monet's place in Argenteuil, at Renoir's studio in Montmartre, at the Café Guerbois or at the more sedate Café de la Nouvelle-Athènes in the Place Pigalle. Someone suggested inviting some older artists – Daubigny, Corot – but that fell through. Meanwhile, Paul Alexis lent support to the group in his newspaper, *L'Avenir National*. By the autumn of 1873 the priorities were agreed. The first step was to set up an organization, the second to arrange an exhibition and sale of work in Paris. It was about this time that Berthe heard of the enterprise through Degas. He and Manet had both been invited to join by Claude Monet. Degas saw the logic of the venture and accepted.

Though in some ways he stood apart from this independent group (he thoroughly disliked working out of doors), Degas had his reasons. Opportunism played a part: he wanted an outlet for his work and he disapproved strongly of the artistic stranglehold of a Salon of cronies. But he couched his motives in more idealistic terms to James Tissot, for he believed in the new naturalist tendencies: 'The realist movement is, it exists, it has to show itself separately.' At the same time he argued for tactical precautions. There had to be a wide representation of artists, including some traditionalists, to avoid the charge of being a self-appointed *Salon des Refusés*, a gang of radical no-hopers. The others would have preferred to restrict membership to the original band of half a dozen, but the financial attraction of increasing the number of shareholders enabled Degas to have his way. Monet foresaw a problem. 'It's very difficult to ask people to join who don't know you', he admitted to Pissarro. But Degas had many contacts

and was willing to approach some reputable artists and gentlemen of means – Tissot, Legros, Fantin-Latour, Henri Rouart, Vicomte Lepic, Léopold Levert; and Edouard Manet. He also suggested the name of Mademoiselle Berthe Morisot, whose talent would add a certain cachet to the venture. And, if Manet demurred but she were willing to cooperate, Berthe Morisot might also exercise a little gentle persuasion on that gentleman. So Degas reasoned as he tactfully approached Berthe via her mother . . .[17]

By now it was November. Despite the general economic gloom, Manet was basking in the temporary afterglow of a minor triumph. He had just struck a business deal with Jean-Baptiste Faure, the leading baritone of the Paris Opéra, when Berthe paid him a special call at his studio. She had dressed for the occasion in an elegant black gown, the low-cut neckline softened by a flower and a frothy trim. She wore a matching velvet neckband and bow and her hair was combed into a sedate crown. She arrived with a sense of purpose. Manet was delighted to see her. Possibly out of a desire to make up for the embarrassment he had caused her in the spring by showing *Repose*, he politely insisted on painting her portrait yet again. She was persuaded to settle herself in a semi-reclining position on the couch which stood against a background of muted, flowery wallpaper. She held her head upright, unable to prevent a few loose strands of hair falling across her brow. Edouard worked with his customary *élan*. In the end he was not satisfied with the perspective and impetuously he cut the lower part of the canvas. But *Berthe Morisot Reclining* bears his unique stamp and the effect was to highlight once more her compelling gaze and the special mould of her face, pale and composed.[18]

After the session Berthe had the opportunity to broach the matter of the artists' association. She wanted to discuss the developments frankly with Manet: the practicalities of the proposal, the prospects for the new painting in the changing political and economic climate. (This was not something that she could talk over usefully with her mother at this time.) She knew from Degas that some of Manet's Batignolles associates were hard up and ready to abandon the Salon. She, too, was tired of waiting for official recognition from a prejudiced and unpredictable establishment. Mentally she may have already committed herself to join the group and to adhere to the principle of voluntary exclusion from the Salon. She appealed to Manet's understanding and his judgement, confident that since he had taken a similar initiative, with his one-man exhibition in 1867, he was bound to approve.

Manet was appalled. He remonstrated fiercely with her, pointing out her social vulnerability. Her professional and personal reputation would be ruined by her association with these madmen, as he called them. Was she seriously proposing to link her name with Monet, a provincial grocer's son? With Renoir, whose father had been a humble tailor in Prefect Morisot's

département of the Haute-Vienne, and a penurious gentleman called Sisley, who seemed immured in failure? Worse: had she considered how it would look when it became known that one of the group's leaders, Pissarro, was a Jewish creole, an atheistic socialist with anarchist tendencies, who wanted to involve two undesirable friends from the Académie Suisse, Armand Guillaumin, a tousle-haired street labourer, and Paul Cézanne, a strangely turbulent character who seemed to paint as he behaved, with the air of a country bumpkin?

Berthe stood her ground, pressing Monsieur Degas's intention to recruit gentlemen of substance. Manet refuted the notion. The avant-garde group would be branded as subversives, he argued. Their chances of winning professional recognition would vanish overnight. But he may have had a hunch, too, that as the unofficial leader of the new school of painters, his own reputation would be at stake. Although he had been slighted, ignored and insulted by the art establishment, his psychological need to be part of it forced on him the principle of the Salon, right or wrong. 'Why don't you stay with me?' he challenged Berthe. She countered that she was disillusioned with the official system and would be quite happy to cede that ground to Eva Gonzalès. Manet angrily accused her of disloyalty, a charge which she indignantly denied. Her pride, too, was stung by his questioning of her good sense.[19] Inevitably, Degas was drawn into it, and for some time afterwards his relations with Manet were decidedly strained. Degas fumed over Manet's obstinacy. 'He may well regret it', he predicted with some malice. 'There has to be a Realist Salon. *Manet doesn't understand that. I definitely believe him to be much more vain than intelligent.*' Meanwhile, much to Cornélie Morisot's concern (since it looked like leading to a rift between their two families) Manet and Berthe agreed to differ, each without offering any concessions to the other. Though Berthe played things close to her chest, she intended to lend her support.[20]

As soon as Christmas was over, the first historic step was taken. To avoid controversy the group adopted a bland and somewhat clumsy title. On 27 December 1873 the Anonymous Co-operative Society of Artists, Painters, Sculptors, Engravers, etc., was formally constituted with eleven members: Monet, Renoir, Pissarro, Sisley, Degas, Guillaumin, Lepic, Béliard, Levert, Rouart and Berthe Morisot. It was founded on a company basis with certain regulations governing membership, finance and democratic management and its declared objective was to promote 'independent art'. The news leaked out early in the New Year through the artists' contacts in the press; Pissarro chose to ignore a warning from Théodore Duret that they were making a tactical mistake.[21] The founders' immediate task then was to enlist other members whose participation would swell the funds before their spring exhibition. Later its date was moved forward a fortnight to upstage the official Salon. But that is to anticipate events.

In the New Year Berthe's participation was overshadowed by her father's deteriorating health, which forced him to retire and take the title of *conseiller maître honoraire* three days before Christmas 1873. Nothing could be done to alleviate his heart condition and the recollection of his 'last years that were so agonizing, of his long suffering' remained a distressing memory. Despite her loving care, Madame Morisot was a helpless spectator at his bedside, and Berthe, too, was haunted by feelings of impotence that she 'did not know how to ease his last moments'. He died on 24 January 1874 at the age of sixty-seven years.[22]

Cornélie Morisot was bewildered by bereavement and by the process of adjusting to widowhood. Berthe was naturally her principal support as they went through the ritual of mourning together, accepting the condolences of friends and acquaintances and a much restricted social life. Madame Auguste Manet – Eugénie, now that they were on intimate terms – was a consoling friend to Cornélie, and it was during this period of domestic sadness that Manet completed his penultimate portrait of Berthe. The pronounced use of black emphasized her staring eyes and the luminous rendering of her face. It is an austere picture carrying an element of the dark melancholy and disappointment through which she – and their relationship – had passed.

When the shock of her father's death subsided a little, Berthe went to stay again with the Pontillons at Maurecourt. Spring had not yet arrived; except for the evergreens, the trees were still bare. She captured in pastel and watercolour the gaunt woodland and the clear chill of the open countryside, offset by the figures of Jeanne and Edma. Their mother, meanwhile, was considering her financial position. She decided to give up the large family residence in the rue Franklin in favour of a compact, pleasant apartment in the rue Guichard. It was built in 1858, a quiet and respectable road between the Place de Passy and the Place Possoz, with sculpted stone porticoes and decorative wrought iron in the style of the Second Empire. The artist, Jacques-Emile Blanche, recalled their new home at number 7. 'Imagine a middle-class apartment in which one room is the studio of a great artist. Antimacassars, white curtains, portfolios, rustic straw hats, a green gauze bag for gathering butterflies, a cage with parakeets, a litter of fragile accessories; no bric-à-brac, no *objets d'art*, but on the walls hung with a striped grey moiré paper, a number of studies and in pride of place a silver-flecked Corot landscape.'[23]

These adjustments to her life occupied Berthe until the approach of the society's show and they prevented her from playing any practical part in its organization. Probably to console her mother, she was persuaded to submit to the Salon again that March. Fate, perhaps, intervened. The jury's rejection of her works steeled her resolve to go through with the new strategy, despite a last-minute and rather sanctimonious appeal from Puvis

de Chavannes.[24] Since her father's death she felt less constrained by old-fashioned attitudes, and she also had the means to make a more generous contribution to the society's overheads, although this seemed less pressing as the number of participants had more than doubled.

Degas had suggested Edma's name but she had declined. He also failed to catch Antoine Guillemet or draw out Tissot, Legros and Fantin from their comfortable English lairs. However, he did succeed in enticing Edouard Brandon, a banker's son and both a dealer and painter, the smooth-mannered Neapolitan Joseph de Nittis, a frequenter of Princess Mathilde's salons, and Henri Rouart, an urbane amateur painter, an industrialist who revered Corot. Cézanne and Guillaumin were also admitted, and Zacharie Astruc, who had acted as guide to Berthe and Yves in Madrid. A few older, experienced men, Monet's friends – the landscape and marine artist, Eugène Boudin, Félix Cals, and the sculptor Ottin – agreed to contribute. Philippe Burty prevailed upon Félix Bracquemond to send in some etchings. Not all the artists attended the exhibition, but the catalogue drawn up by Edmond Renoir, the artist's brother, listed some thirty names. The organizing committee was fortunate in securing a fine second-floor suite of rooms at 35 Boulevard des Capucines, premises which had just been vacated by the photographer Nadar: out of sympathy he let them have it rent-free. The opening was fixed for 15 April. Pierre-Auguste Renoir was in charge of the hanging and room arrangement and it was agreed to open ten hours a day, visitors being promised a 10 per cent discount on works purchased during the show.

Excited by the opportunity to display her work in a fashionable commercial district, Berthe showed her commitment by sending some nine pictures, as many as Claude Monet.[25] She chose four oils: her figure-landscape *Hide and Seek*, which she had to borrow from Edouard Manet, along with her cool marinescape, *The Harbour at Lorient*; her 1870 Salon entry, *Reading*, the 'difficult' double portrait of Madame Morisot and Edma; and *The Cradle*, her 'nativity picture' of Edma and Blanche. To these she added two well-contrasting pastels of 1873, the *Portrait of Madeleine Thomas* and the landscape, *The Village of Maurecourt*. As for watercolours, it seems she changed her mind at the last minute, before offering three open air figure-landscapes painted in previous summers at Cherbourg, Maurecourt and Fécamp.

At first the exhibition raised curiosity more than anything else. The press seemed uncertain which way to spring. Emile Cardon of *La Presse* praised the idea in principle before slamming the show: 'the debaucheries of this new school are nauseating and disgusting.'[26] A number of papers, including the *L'Univers Illustre* steadfastly ignored the event, and out of the fifty or so journalists who had something to say, opinion was divided on Berthe Morisot's work. The radical Republican critics, who were all known to

Manet, tended to be sympathetic or complimentary. In his distant provincial paper, Emile Zola found her canvases 'interesting'. But among the favourable reviewers each preferred a different exhibit. Armand Silvestre of *L'Opinion National* (and the Café Guerbois) thought Berthe's masterpiece was the 'vigorous and charming pastel', the *Portrait of Madeleine Thomas*. In *La République Française*, Gambetta's new paper, Burty commended the Maurecourt picture which Manet had so admired: 'An oil painting of a young mother playing hide and seek behind a cherry tree with her little girl, is a work that is perfect in the emotion of its observation, the freshness of its palette, and the composition of its background.' In Burty's view she was 'a gifted artist', whose pastels and watercolours showed 'a touching grace'. *Le Siècle* was equally flattering about *Hide and Seek (Cache-Cache)*. The Realist Castagnary wrote, 'Berthe Morisot has wit to the tips of her fingers, especially at her fingertips. What fine artistic feeling! You cannot find more graceful images handled more deliberately and delicately than *Berceau [The Cradle]* and *Cache-Cache*. I would add that here the execution is in complete accord with the idea to be expressed.'[27]

But unequivocal praise was rare. These mostly male journalists (there were a few women around, like Marie de Quivogne of *L'Artiste*) seemed to find difficulty in coming to terms with a lone female in the ranks of the Independents, so even a favourably disposed reviewer such as Jean Prouvaire of the extreme left-wing *Rappel* tinged his praise with condescension.

Mlle Berthe Morisot brings together the delightful art of the Parisian and the charm of nature; this is one of the characteristics of the new-born school, combining Worth and the good God, though a whimsical Worth, rather unconcerned about fashion-plates and producing vaguely unreal gowns. Mlle Berthe Morisot is certainly not the perfect artist. Yet what happy instincts are present in the way the pink border of this chiffon scarf is arranged alongside a blue or green parasol, and what charming waves in those seascapes, in which little mastheads can be seen dipping. But Mlle Morisot sometimes leaves the meadows and the shores and nothing is more real nor at the same time more tender than the young mother, quite dowdily dressed, it's true, leaning towards a cradle in which a rosy-cheeked baby, visible through a pale cloud of muslin, is sleeping peacefully.[28]

A poor press was hard to counter. Journalists were powerful men and it was easy for critics – and profitable for newspaper proprietors – to let rip with smears and abuse. Jules Clarétie typified the worst kind of conservative bombast when he had the last word: 'Messieurs Monet – a more uncompromising Manet – and Pissarro, Mlle Morisot etc. appear to have

declared war on beauty.'[29] Unfortunately, entrance receipts were affected by this kind of remark. Visitors stared but they did not buy. Berthe was naturally hurt that not one of her pictures had sold by the closing day. When the expenses had been paid, the receipts from shares, sales and catalogues left the society with a hidden deficit of over 3,000 francs. Berthe was committed to paying her share of it which came to 184.50 francs.[30]

Right-wing critics had contributed to this financial disaster. But with nice irony, the hostility of the press was to backfire, leaving its victims with the last laugh. The influential critic of the right-wing *Charivari*, Louis Leroy, taunted each artist in turn. Berthe stood accused of sketchy brushwork and hesitant draughtsmanship. 'Now take Mlle Morisot! That young lady is not interested in reproducing trifling details. When she has a hand to paint, she makes exactly as many brushstrokes lengthwise as there are fingers, and the business is done. Stupid people who are finicky about the drawing of a hand don't understand a thing about Impressionism, and great Manet would chase them out of his republic.'[31] Then summarizing the visual effects he had seen in Monet's portrayal of *Impression, Sunrise*, he dismissed them all as 'Impressionists'. The word stuck. Other terms came and went, but this one provided a rallying point. It became the best-known group label in the history of art.[32]

As it happened, Leroy attributed the whole aberration of Impressionism to Camille Corot. He railed portentously, 'Oh Corot, Corot, what crimes are committed in your name! It was you who brought into fashion this messy composition, these thin washes, these mud-splashes.' But from his retirement at Ville d'Avray, Corot had already distanced himself from the new landscape trends, notably from Monet and Pissarro, telling Guillemet he had 'done very well to escape from that gang'.[33] Cornélie Morisot was mortified. All her old doubts about Berthe's artistic abilities churned inside her. She wanted advice. Perhaps she was too embarrassed to turn to the Rieseners, with their good connections, despite the fact that they were old friends. Understandably she could not call on Corot. So she approached Berthe's other former teacher, Joseph Guichard. He was flattered to be recalled by the gracious lady: 'Madam,' he replied, 'the kind welcome you gave me this morning touched me deeply.' He promised to give his honest opinion after viewing the exhibition, but in giving his reply he indulged in a good deal of unctuous sentiment and conventional rhetoric, as old men are wont to do. His judgement was designed to placate Berthe's mother. Yet, behind this façade his admiration for Berthe showed through, and his concern that she might be so discouraged by criticism as to abandon her vocation or destroy her work, as she had her juvenilia.

When I entered, dear Madam, and saw your daughter's works in this pernicious milieu, my heart sank. I said to myself, 'One does not associate

with madmen except at some peril. . . . If Mlle Berthe must do something violent, she should, rather than burn everything she has done so far, pour some petrol on the new tendencies. . . . to negate all the efforts, all the aspirations, all the past dreams that have filled one's life, is madness. Worse, it is almost a sacrilege.'

Then came his recommendation.

As painter, friend and physician, this is my prescription: she is to go to the Louvre twice a week, stand before Correggio for three hours, and ask for forgiveness for having attempted to say in oil what can only be said in watercolour. To be the first watercolourist of one's time is a pretty enviable position.

I hope, Madam, that you will be kind enough to answer this devoted communication, which comes straight from the heart . . . she must absolutely break with this new school, this so-called school of the future.[34]

Presented with a powerful case – Monsieur Guichard's advice and her mother's pleas – and taking account of Cornélie's emotional state, Berthe found herself in an unenviable position. But she had to balance their stratagem against her own instincts. Some time in May she slipped away to Maurecourt to think. The garden of the Pontillons' estate had that indefinable luxuriance that comes at the transition of spring and summer. Again she took advantage of her sister's patience to complete three evocative scenes with Edma, Jeanne and Blanche, *On the Lawn*, *The Lilacs of Maurecourt* and *Catching Butterflies*.[35] With *Hide and Seek* they are a vivid quartet.

Meanwhile, Berthe must have asked herself what the exhibition of the Anonymous Society had achieved. The worldly de Nittis told an Italian friend that 'had there been only the paintings of Degas, a drawing by Bragmond [*sic*] and a portrait by Mlle Morisot, it would have been enough to justify the entrance fee'.[36] Berthe's boldness in aligning herself openly with a hybrid bunch of male artists set many people wondering. What was her motive for taking such a defiant step and plunging herself into controversy? Was it respect for Monsieur Degas? His involvement was reassuring. Was it a celebration of freedom from parental control? Though officially still in mourning, she was not inhibited by her father's death. Was it a flush of idealism, did she see the venture as a milestone on the road to independence? Was she seized by an unusual wish to be *engagée*, to dabble in a radical cause? It would have been uncharacteristic of her. So, did she, as some have suggested, show a remarkable degree of insight or feminine intuition; was she moved by a sense of destiny, by a belief that this was the right moment for such an undertaking? If the latter, one is bound to

question whether she could possibly have foreseen the outcome of this extraordinary coalescence of creativity, that a new movement was being born, after which contemporary art would never be the same.

To dispute with the visionary is not to minimize the importance of her vision. She had broken completely with the protected world of dilettantism and with Academic formality. From there she had gone on to identify publicly with the freedom and directness of a group of painter-adventurers. In Maurecourt, if not earlier in Manet's studio, she grasped the reality of her decision. There was no turning back.

Madame Manet

1874–5

A sharp-eyed journalist, watching the July exodus of the Parisian middle classes as they made for some comfortable villa in Trouville or Boulogne-sur-Mer, commiserated with certain of the travellers. He was thinking of the middle-aged matrons, bustling along the platform at the Gare Saint-Lazare, looking harassed: 'for mothers who have marriageable daughters – those pitiable victims of civilization for whom the hour of release does not come until their children are married – the summer, like the winter, is a period of struggle and contrivance.'

It was a mother's task to find proper accommodation, preferably with a seaside view, then to ensure tactfully that entertainment was available and company would be on hand. As the same journalist remarked, 'An excursion is the dream of every mother who is looking for a son-in-law. In an excursion the young people spend the whole day together; there is no restraint; they climb rocks, gather wild flowers; everything in nature seems to conspire against bachelors.'[1] When several excursions had been made and the young lady had worn every dress in her wardrobe, the anxious mother awaited the results. A painless courtship, a proposal, the *fiançailles* and finally the wedding – this was the pattern that had worked for Yves and Edma. In her widowhood, Cornélie Morisot was determined it would work equally for Berthe at Fécamp.

To her mother's relief Berthe was more amenable than usual, for Cornélie had taken the precaution of inviting a stream of visitors. For her part, Berthe had insisted on bringing her easel, paints and drawing-block, and since the first arrivals were members of the family, Edma and their cousin Maria Boursier, she put them into pictures of the beach and the chalet terrace, contemplating the elements of nature, the cliffs and waves below. But there were elements of a different order at work in Fécamp. Berthe spent much of the time tussling with her emotions.

In her heart she knew her mother was right to force her towards a decision to marry. As a wise man once said, the dread of loneliness is greater than the fear of bondage: and that was how she was beginning to see it. Almost two years had passed since Edouard had dissolved her girlish fantasies and pressed her to consider his brother. Two years during which

she had prevaricated constantly, indulging in impossible flights of fancy, 'living for quite a long time amid daydreams that gave me very little happiness', she admitted later.[2] Now those romantic dreams were spent, leaving a residue of lasting cynicism. 'People repeat ceaselessly that woman is born to love, but that's what's hardest for her', she reflected subsequently in her private diary. She was no longer able to feel overwhelming emotion towards any man: 'It's the poets who have created the women lovers and ever since we have been playing Juliet for ourselves.'[3] However, to her mother's intense relief she responded calmly that summer to the news that everything had been arranged. Edouard would not accompany his mother and wife to the coast; he would spend some time with Monet at Argenteuil instead. But Madame Eugénie Manet and her son Eugène would be joining the Morisots for part of the holiday.

Eugène Manet was by then a serious man of forty-one, who held himself aloof. Of medium height and slight build, with tidy brown hair and a beard that Edma described as very soft after he had kissed her, his manner betrayed an inner tension, despite the languid tempo of his life. He had suffered more than his brothers at the hands of their stern and unbending father, who had wanted a daughter. While the ebullient Edouard was a disappointment to his papa, he received more attention than his siblings. By comparison Eugène was neglected and grew up withdrawn and excessively shy. Back in 1871, he had called on Berthe at Saint-Germain, uninvited, but finding her out, he had neither the sense nor the confidence to leave a note. His wartime experiences under German shellfire reinforced his tendency to nervous introspection. After the war Madame Morisot noticed how strangely Eugène behaved in company: sometimes he could hardly keep awake. He was also inclined to be unsteady on his feet and suffered intermittently from severe headaches. On the other hand, he was an intelligent man and quite witty, with an eye for the absurd as well as the beautiful. And he was certainly no recluse. He frequented boulevard cafés with his brothers and their friends, and he habitually attended his mother's soirées. There had been a friendship of some sort with Miss Claire Campbell, the good-looking daughter of the director of the *Daily Telegraph*, whose portrait Edouard drew in pastel in 1875.[4]

Though he had none of Edouard's easy gregariousness, Eugène shared his enthusiasm for art and felt comfortable in the company of artists. He found they were less inclined to exhibitionism than the lawyers and politicians with whom his younger brother, Gustave, associated. Despite her earlier reservations, Cornélie Morisot was willing to overlook everything now that Berthe was past the first flush of youth. Besides, Eugène was a property owner with a private income inherited from his father. He had his own apartment near the Parc Monceau, at 87 rue de Monceau, an area of fashionable eighteenth-century houses. His mother was reassuring that her

second son greatly admired Mlle Berthe, and taking everything into account, both widows looked for peace of mind in a providential union of their two families.

The pair behaved impeccably. They did what was expected of them. They made the conventional little excursions – 'charming walks', Eugène described them – giving him a chance of a 'glimpse of the little shoe with a bow that I know so well' and the more erotic sight of Berthe in a bathing costume which, thanks to Edma's initiative in the matter, came to be known in the family as 'Madame Pontillon's triumph'.[5] They drew and painted together in sheltered spots around the harbour. Berthe produced a seascape of the quay, a pastel sketch of the port basin and an oil of the grey houses rising in the distance behind an expanse of ripening corn. Together they also sketched some boats under construction, though the untidy shipyard was hardly an attractive, let alone a romantic, place to set up an easel. But Eugène's blood was stirred, and summoning all his courage he eventually declared his admiration and undying love in a formal proposal of marriage. His 'beautiful artist' intimated her acceptance, and when she had finished her dockyard scene she gave it to him as a memento of the day. A courtly correspondence followed Eugène's departure for Paris and Berthe's to her sister's. Brimming with joy, Eugène vowed to make his goddess 'the most adulated, most cherished woman in the world'.[6]

The impending marriage brought satisfaction to both families and activated their friends. Degas expressed his pleasure and asked to be allowed to paint a portrait of Eugène to celebrate the event. The husband-to-be was half-sitting, half-reclining, his face obscured by a black hat. (Eugène was always too reticent to look directly at his portraitist.) Degas worked at it during the autumn in Berthe's studio, which gave Eugène the excuse he wanted to visit her; but to remind the pair of Fécamp, Degas added a background of turf and dunes. Later he presented it to them as a wedding present. In the meantime, Berthe's friend, Adèle – the sculptress Marcello – expressed a desire to paint the bride-to-be. She had already made two drawings of her in the course of the year in preparation for a substantial portrait in oils, which she worked on in late 1874 and early 1875. Adèle painted with a knowing eye. The pink décolleté evening gown makes no pretence to hide Berthe's full breasts and the burgeoning thirties' plumpness round the upper arms: overall a luscious, comely figure.[7] A formal studio photograph taken at much the same time was more sedate, as if the ruched black gown was chosen to emphasize her elegance and sobriety.[8]

Meanwhile, Edouard felt compelled to make his own gesture. The spring exhibition was not mentioned. Manet wanted to paint a personal portrait – his last – of 'Mademoiselle Berthe'. Some familiar features of past compositions were present – the fan, the dark day gown, neckband, strands

of hair breaking loose from her coiffure, and the palette heavily dependent on Manetian blacks and browns. Her left hand was raised, the long, artistic fingers as prominent as the band upon her ring-finger. Her face, composed and confident, was turned as if looking, symbolically, in a new direction. *Berthe Morisot with a Fan* was Edouard Manet's personal, complimentary way of saying au revoir.

Arrangements proceeded for a quiet family marriage since less than a year had intervened since Monsieur Morisot's death. In other circumstances there might have been a grand celebration, increasingly the fashion for wealthy families. But Eugène was preoccupied with the possibility of a position in Constantinople. The wedding was therefore brought forward to three days before Christmas, the ceremony to be conducted by the Abbé Hurel, an old family friend of the Manets. Monsieur Thiers, the former president, now seventy-seven years old, was not present. The witnesses were Adolphe Pontillon and Octave Thomas.[9]

In mid-December Renoir had called a meeting of the members of the Anonymous Society of Painters at his Montmartre studio. It was fixed for Thursday 17 December, but this was too close for Berthe to be able to attend. In addition, five days before her wedding day northern France was hit by exceptionally heavy falls of snow. 'The city woke up as white as a bride at the Opéra Comique. The large trees in the promenade shook their snow flowers on the passers-by and the entire city, usually so noisy, became at once dumb under the thick bed of snow which enveloped it.'[10] Movement was difficult, so it was perhaps as well that they had planned a quiet event. At nine o'clock on Tuesday 22 December 1874, following the deposition of their marriage contract, the civil ceremony took place at the *mairie* of the Sixteenth Arrondissement. The bride was modestly dressed in black. There followed a short religious service in a side-chapel at the church of Notre-Dame-de-Grâce, Passy. Berthe summed up the occasion later in a letter to Tiburce who was abroad. 'I went through that great ceremony without the least pomp, in a dress and a hat, like the old woman that I am, and without guests.'[11] It hardly seemed propitious. A lugubrious reporter, gazing at the streets of Paris, was moved to say, 'The snow hardens, the cold continues and a thick fog hangs over the city.'[12]

In terms of heritage and upbringing, Eugène Manet and Berthe Morisot were well suited. Their families were steeped in the same traditions of high government service, and by coincidence Eugène's father and Berthe's grandfather Thomas served simultaneously as heads of personnel in their respective ministries. One of Madame Manet's brothers had been an officer in the dragoons; another – Edouard's favourite uncle, Edmond Fournier, who first showed the boys how to draw – was a colonel in the artillery and had been aide-de-camp to one of Louis Philippe's sons. A third brother

became Prefect of Cantal and the Basses Pyrenees. Indeed, he and Monsieur Morisot may have met, for Adolphe Fournier was sub-prefect at Cherbourg when Tiburce was Prefect in neighbouring Caen. And a nephew of Madame Manet, Jules de Jouy, made a name for himself as an able advocate in the Court of Appeal. The cultural affinity between the two women, as we have seen, was instrumental in bringing their families together. On a personal level, both Madame Manet and Madame Morisot were exemplary wives and mothers, the one with her trio of daughters, the other with her three sons.

The Manets originated in the Ile de France, where for two centuries the name appears in records of local officials. Eugène's grandfather, Clément Manet, was a lawyer and an energetic mayor of the Seine township of Gennevilliers, just north-west of the capital. Here the family possessed properties and 150 acres of land. His son, Auguste, also a lawyer, entered the Justice Ministry and rose rapidly in the reign of Charles X, until in 1829 he was promoted to *Chef du Personnel.* Under Louis Philippe he was appointed to the political post of principal private secretary to the Ministry of Justice, ending his career in a magisterial role as Judge of the Tribunal of the Seine. Berthe never knew the man who would have been her father-in-law, but Judge Manet had the reputation of being severe, sober and immensely self-righteous; a person of puritanical integrity and diligence. His Republican roots were bequeathed to all three sons, but little else to Edouard. The other two inherited their father's physique; Eugène, being timid, stood in certain fear and awe of him.

By comparison, the Fourniers were imaginative, volatile and monarchist by inclination. The reckless streak perhaps explains their fluctuating fortunes.[13] Madame Manet's eldest brother acquired the Château de Vassé at Sillé-le-Guillaume in the Sarthe: the Manets holidayed there as family guests on numerous occasions. However, Eugénie-Desirée Fournier had married Auguste Manet when she was twenty, not for love, but because he seemed a good catch. Security was all-important to her. Her father and grandfather had both lost fortunes, though by diplomatic sleight-of-hand her father, Joseph Fournier, had retrieved his position in the service of Prince Bernadotte, later king Charles XIV of Sweden, godfather to the baby Eugénie. This was how the king came to present the Manets (among other things) with a drawing-room clock on their marriage in 1831. Berthe would have seen the latter gracing the drawing room at 49 rue de Saint-Petersbourg.

Eugène Manet regarded his marriage as his supreme triumph. He was besotted by his bride. Yet it would be naive to call it a love-match. Berthe had no illusions that becoming Madame Eugène Manet would bring her complete happiness. She had watched Edma's creative talent drain away as

the result of domestic responsibility and the demands of a traditionally minded, autocratic husband. (Marie Quiveron suffered similarly after she married Félix Bracquemond.) And she had seen at first hand how uncommunicative and dull Théodore Gobillard was and how bored Yves had become with her lot in life. 'I am facing the realities of life', she told Tiburce a month after the wedding, without a hint of bridal bliss.[14] To Berthe marriage was a compromise. It was not a great romance, a heady, dream-fulfilling experience, nor a step in social advancement. Her husband was a mere shadow of his brilliant brother. It was an acceptable arrangement because he was 'an honest and excellent man', modest and kind, who would not make excessive demands upon her, but would offer companionship while allowing her to be herself.

Inevitably marriage affected her other relationships. 'Fat' Suzanne had warmed good-naturedly to her new sister-in-law and for the sake of family solidarity, Berthe tried to respond with a veneer of politeness. All her snobbish instincts, however, were reinforced by her mother, who told her that she was 'so superior to Suzanne' that she should not take any notice of her. Berthe also had difficulty establishing new bonds of affection with her mother-in-law, as women who have been very close to their own mothers often do. On the other hand, when it came to her own flesh and blood she was highly protective. She had to defend Tiburce: Eugène considered him a good-for-nothing who indulged his selfish wanderlust at the family's expense.

Most of all, however, Berthe agonized about deserting her mother, wondering if she, too, had behaved irresponsibly. Her anxiety was understandable, but Cornélie Morisot had a clear sense of the natural order. Having reached widowhood, she knew what to expect. She was more concerned for Berthe. Would she adapt to her changed role, 'now he [Eugène] has become part of you and must come first in your affections'? Whether Berthe wanted it or not, she received advice on all kinds of personal matters, on her wardrobe and on how to run her social life now that she had taken over as hostess at family gatherings. Although Cornélie had been an advocate of the marriage, she suspected Eugène was a gauche and tense lover, and that Berthe was not blameless in an age which expected wives to yield tactfully to their husbands only after they had aroused them sexually. Whether she suspected Berthe would be frigid, or at best too passive in physical love-making, Cornélie gave her a gentle homily about duty and the fleeting nature of happiness, warning her that 'we must fight against that part of ourselves which disposes us to excessive sensibility and melancholy'.[15]

Cornélie Morisot positively willed the marriage to succeed. On a practical level, she did everything convention expected of her. When it was decided Eugène's apartment was not suitable, she tactfully disappeared to Cambrai

to see Yves and Théodore, who had just been transferred to the *département* of the Nord. It was an area full of memories from the time Tiburce Morisot was sub-prefect. The newly-weds were left to settle down like comfortable cuckoos in the nest at 7 rue Guichard. Beneath her fussy manner, Cornélie worried a great deal about the pair of them. She had little faith in their common sense.

Eugène had studied law, but gave his occupation as property owner for the marriage register. With Edouard's encouragement and support from the family's Republican connections, he had nursed ideas at one time of a career in the prefectoral service. In 1870 he had approached Charles Ferry, then secretary to the interior minister, Gambetta: he knew Gambetta had at one time been secretary to his cousin, Jules de Jouy. Ferry offered Eugène the *sous-prefecture* of Saint-Dié – it was a kind of compliment since the town was the Ferrys' birthplace – but sensibly he turned it down as the Prussians were about to occupy the Vosges. His request for Le Havre instead fell on deaf ears, so Edouard tried to secure him a junior post in the Ministry of National Defence, where Gustave Manet's friend, Eugène Spüller, held a senior position.[16] However, the war overtook events and in the aftermath of the Commune, when the rightist reaction monopolized the administrative system, both Eugène and Gustave Manet were considered too radical to be placed in government service. They were still waiting for their entrée into the bureaucracy.

Cornélie was sure her son-in-law would make a conscientious civil servant, and she was convinced of the value of a government salary when the stock market was turbulent. After all, a household with children and servants called for a good income. What worried her was Eugène's lack of tactical instinct in a constantly changing political situation. In the January of 1875 the debate on the constitution was the main subject of conversation. A week after the first anniversary of her husband's death, the Third Republic was confirmed, almost furtively, by a majority of one vote on an amendment. The right, however, was by no means reconciled to a permanent republic. Even so, a clever bureaucrat would survive; he made his own luck, in Cornélie Morisot's experience, by being a skilful servant of different regimes. Her fear was that Eugène had neither the force of character nor the prescience. If he missed the boat, he and Berthe would be stranded with the turning of the political tide. As the weeks went by without news of the foreign posting they had hoped for, she offered to use her residual influence.

When family interests were at stake Cornélie placed her hopes in personal recommendation: never mind newfangled systems like entrance examinations. She took herself off purposefully to see her brother Octave in Grenoble. He held a senior position in the Ministry of Finance and claimed to have influence with Gambetta. After discussing Eugène's position fully

with him, Cornélie contacted Berthe in the mid-May. 'Octave advises Eugène to apply for the position of tax collector in Grenoble. It pays 17,000 francs.' However, the political situation was ambiguous. Although he had been told that the post had already been abolished, Octave was prepared to demand the decision be reversed: under Thiers such intervention was not uncommon. Cornélie believed the post would be a valuable step on the ladder for Eugène; Grenoble was 'superb', 'a prosperous city' and 'not so far away as Constantinople'.[17]

If Eugène applied for this tax-collectorship (as he implied he would), nothing came of it, confirming Cornélie's view that he was one of nature's losers.[18] Eugène would not have agreed with her: he felt the year was proving memorable. In April, with the smell of blossoms in the air, he had the pleasure of taking his new wife to the Manet ancestral home. Gennevilliers lay in the loop of the Seine beyond Asnières. The river frontage was still crammed with boats, boathouses and repair yards. The hinterland, an arable plain, looked up to the low wooded hills between Argenteuil and Sannois. It was a patchwork of farms, green pastureland and brown scrubby waste, dotted with golden haystacks after harvest time. Berthe captured the terrain perfectly on her canvas *Landscape at Gennevilliers*. To Eugène it was an idyllic place. He cherished the soft hazy light enveloping the fields, forgetting that in winter the same low, misty ground produced a mordant cold. He had loved Gennevilliers from the time that he and his brothers used to spend the summer holidays at their grandfather Manet's house. (Their cousin Jules de Jouy still had a property at 2 rue Croix-des-Vignes, a solid bourgeois house with a walled orchard and garden, once owned by Eugénie Manet's sister.) As youths the three rambled over the whole peninsula from the Ile de la Grande Jatte to Chatou. They enjoyed picnics, bathing, or boating on the river. But changes were now under way. The railways were turning these pretty riverside spots into cheap day resorts, and at this time – the mid-1870s – the area was the focus of a furious row over the desire of the Parisian authorities to extend the great collector sewage farm to Argenteuil and beyond. Around the periphery there were signs, too, of industrialization, trails of smoke rising from distant factory chimneys, a horizon of red tile and grey slate roofs.[19]

Eugène and Berthe stayed there for several weeks, missing the 1875 Salon, in which Edouard had entered a vivid painting of Argenteuil. They also left it to Edma to report on the exhibition and auction of Corot's works held at the Hôtel Drouot in May. They were still there in June when the Pontillons went back to Maurecourt. Edma teased her sister for not writing to her and for being so secretive and anti-social.[20] But Berthe had thrown herself into a creative phase, with Eugène's active encouragement. She finished a watercolour and four oil landscapes in ten weeks, which made interesting social and environmental statements. Like her *Landscape*, the

Child in the Cornfield cast a broad-lensed sweep across the plain with its ripening grain. A third, *Washerwomen's Lines (Perches de Blanchisseuses)* was pure modern realism, reminiscent of a popular monologue of Monsieur Bartavel, a star of the *Opéra Bouffe*. He complained about the contemporary world: 'Instead of cornflowers and poppies, great prairies covered with old clothes and detachable collars . . . laundresses everywhere and not a single shepherdess . . . factories instead of cottages . . . great red brick chimneys giving out black smoke.'[21] So Berthe depicted life as it was lived in the 1870s: a world of toil and modest reward, evinced by scraps of linen hanging on the fence of the allotments for weekenders on the plain of Gennevilliers.

To complement their stay in the Ile-de-Paris, Berthe wanted to make a trip to Beuzeval, with its memories of her early painting days. Eugène was happy to oblige. He even agreed to pose for a summery, open air scene. Bearded and bowler-hatted, Eugène lay on the grass beside a young female model dressed in blue, in a colourful picnic scene.[22] On their return to Paris, Berthe took her canvases to a dealer, a Monsieur Poussin. She hated the business of negotiating with such people. The man procrastinated over price, muttering about the poor market and his overheads. His response revived a long-time dream in Berthe, to visit England, a haven for those French artists who found the Salon-regulated society of Paris too inhibiting. Later that year, Puvis teased her for having English blood in her veins; at least, she looked upon the world with English eyes, he said, a compliment on her feel for the essentially English medium of watercolour. But others had found inspiration through oils. Claude Monet, for instance, had found the mist and fog of London took on 'a light-filled radiance', and Pissarro had also produced some graphic scenes of Upper and Lower Norwood.[23] Edma's former admirer, Henri Fantin-Latour, was now exhibiting regularly at the Royal Academy. And of Edouard's circle, Alphonse Legros had become a successful art master in Kensington, while Tissot's meticulous realism and theatrical style appealed greatly to the English well-to-do. The English connection had certainly transformed these artists' careers.

While no one pretended that London was as beautiful as Paris, it was the metropolis of the world. With something of these thoughts in her head (and possibly of Turner too) Berthe put the idea to Eugène of a trip to England. He agreed, on one condition. They should treat it as a professional venture and go armed with the appropriate documentation. Berthe had no objection. She turned for help to Adèle, who prided herself on her knowledge of the English scene. In 1866 the Duchess Colonna had profited from the connections of the Comte de Circourt to exhibit at Kensington Museum, so she was quite happy to provide letters of introduction on her friend's behalf to aristocratic and well-connected members of London society.[24] Armed with these, and with all their artistic equipment in their baggage, the Eugène Manets took a boat to Southampton early in July 1875.

Their first stopping place was the Isle of Wight. Although it had not been on their original itinerary, like Turner and Tissot they were attracted by the landscape and the ambience. 'It is not too expensive here, and it is the prettiest place for painting. . . . Nothing is nicer than the children in the streets, bare-armed, in their English clothes.'[25] The island's coastline of inlets and cliffs and the thatched cottages and manor houses of the interior appealed to Berthe and reminded her of parts of Normandy and of some photographs of South Devon which Tiburce had sent her. Eugène rented a furnished property called Globe Cottage in West Cowes, then a small township of seamen's cottages, family businesses and retired naval officers' villas. She could never resist the lure of water. 'The little river here is full of boats', she wrote, enthusing over the Medina estuary, and 'adds a lot of charm to the place.' She was soon trying her hand at watercolour seascapes. But painting on the water was another matter. Having experimented in Brittany, she should have known the breezy conditions would make it difficult. 'Everything sways; there is an infernal lapping of water . . . the boats change position every minute.' All the same, Berthe decided Cowes was very pretty, with its narrow winding high street. The coming and going of people and craft by the landing stage also caught her imagination. 'The beach is like an English park with the addition of the sea.'[26]

By contrast, Ryde appeared less scenic. Despite the fact that it boasted shops, an excellent new theatre, a pier half a mile long and even a picture dealer, she was not impressed by the facilities and the resort was too exposed for her liking. The high winds grated on Eugène's nerves; he was annoyed because her hat blew off, leaving her somewhat dishevelled. And they had scarcely settled down in their cottage than the island was struck by a spell of atrocious weather which put paid to her plans to paint outdoors. (It was a bad summer in France too.) Enforced idleness threatened Berthe's concentration. There was nothing to do but stay indoors and make the most of her husband's company. Cajoling him into being a model was not easy, but she embarked on an ambitious oil. He sat awkwardly by the open window, staring towards the harbour like a trapped tourist, past the billowing voile curtains and the terracotta plant pots on the sill, through the green picket-fence. The viewer follows his gaze out of curiosity, to the yachts and steamers riding the swell, to a woman and her child passing by, to the glinty sunshine and the sea breezes stirring the clouds. *Eugène Manet on the Isle of Wight* is the very essence of the south coast of England on a July day, yet equally it is her personal vision: a busy, intricate, light-washed impression.[27]

As the weather improved, Berthe was distracted by other events. At the end of July, the queen and her entourage arrived to take up residence at Osborne House and made public appearances at Cowes and Newport. At the same time the Prince and Princess of Wales joined the Duke of

Richmond's sumptuous house party for the four days of racing at Goodwood on the Sussex Downs. Cheered by the idea of something different, Berthe allowed Eugène to escort her to see the glories of English flat-racing. She had none of Degas's nor Edouard's interest in horses as artistic subjects: she went merely as a curious observer of the English at play. 'Never in my life have I seen anything as picturesque as these outdoor luncheons', she remarked, while her quick eye noticed that the illustrator Gustave Doré was there with a group of fashionable ladies. Her conventional treatment of the picnic, painted a few weeks before at Beuzeval, was in no way like this picture of moneyed and titled gourmandizing in the open air; but neither was Edouard's infamous *Déjeuner sur l'herbe* which had inspired both Monet and Tissot.

Watching the English scene, Berthe decided that the upper class was as dull as it was wealthy. 'At Goodwood races I was struck by the elegance and the bored air of the women. On the other hand, the populace seemed very jolly – there was a liveliness that contradicts the notions we have about the people of the north.' The noise and commotion surprised her, for special trains brought hordes of townspeople from the coast and the capital. In the glorious sunshine the crowds were joined by the royal party, aristocrats and their ladies and foreign visitors, including the exiled Louis Napoleon and the Prince Imperial. For Edma's interest, Berthe sent her sister an article on the Goodwood Cup. She concluded, 'I was enchanted by my day there, but it was rather costly . . . and horribly tiring.'[28]

No sooner was Goodwood over than the bank holiday was upon them and once again the English people took to their favourite resorts. Berthe found 'Cowes has become extremely animated: a few days ago the whole of the smart set landed from a yacht.' This transformation was due to Cowes Week, the great annual festival of the Royal Yacht squadron, which began on 3 August. Berthe noted with interest that the Yacht Club garden was full of ladies of fashion. There were fireworks in the evening; the shore and Parade were packed with visitors all week, but on the last day of Cowes Regatta, the Saturday, festivities reached their climax to coincide with the Duke of Edinburgh's birthday. After this Ryde became the focus of attraction until the eve of the royal family's departure for their annual holiday at Balmoral on 19 August.[29] Early that morning Berthe and Eugène left the Isle of Wight themselves, heading for London.

They departed 'very hurriedly', in Berthe's words. The holiday had been in danger of turning sour: with hindsight they had stayed too long. With their indifferent English, the strain of trying to communicate was beginning to tell, but national differences played a part.[30] She had tried painting one of her pastoral genre scenes using two local children as models, but unfortunately had overlooked how possessive the English are about landownership. A swarm of kids pounced on her and 'All this ended in a

pitched battle and the owners of the field came to tell me rudely that I should have asked for permission to work there'. In fact the locals were too parochial for a pair of highly-cultivated Parisians, and Berthe was not amused when a group of sailors in Ryde laughed at her black hat with a lace bow. On the other hand the smart set in Cowes was more obnoxious. Though she professed indifference to their vulgar extravagance, both she and Eugène felt like Republican pariahs. They could not afford to spend too freely and they did not know anyone important on the island. 'We are only humble folk,' Berthe wrote with heavy irony, 'too insignificant to mingle with this fashionable society. Moreover, I do not know how one would go about it, unless one had a fortune of several millions and a yacht, and were a member of the club.'[31]

Personal matters were also getting her down. Seven months had passed since her marriage without any sign of pregnancy: she was beginning to doubt her ability to conceive. Suffering the debility and embarrassment associated with menstruation, she felt 'horribly depressed, tired, on edge, out of sorts'. She also knew it was only a matter of time before there would be family speculation about her sterility, first in hushed whispers, then in open talk. Anxiety affected her concentration and self-belief. It was the old story. 'My work is going badly, and this is no consolation . . . I don't know where to start . . . I am not doing much, and the little I am doing seems dreadful to me.'[32] And she realized starkly that Eugène was not always capable of being supportive. He had his own problems, prime among them hypochondria. He found modelling a stressful chore and he had not been able to make progress with his own painting. When he was twitchy and depressed, Berthe became snappy. They had their first big row and decided on an impulse they had had enough of Cowes.

In their hasty departure they missed a sensational incident which happened only hours later. As the royal yacht *Alberta* was taking Queen Victoria and her party to Gosport, it collided in the Solent with a small pleasure craft, the *Mistletoe.* The master, mate and a young woman passenger from the smaller vessel lost their lives. The tragedy was headline news in all the papers the day after the Eugène Manets reached London. Berthe seized on the story as a colourful tit-bit for her mother, only to be immediately diverted by an item of equal melodrama originating in Paris. On the afternoon of 19 August a violent domestic fracas took place publicly outside the Bourse, involving the banker Achille Degas, brother of 'Monsieur' Degas, and another man, named Legrand, whose wife had formerly been the banker's mistress. A letter from Berthe's mother-in-law confirmed the scandal, a full account of which appeared in the London *Times,* along with the Solent tragedy.[33] Berthe and Eugène were upset to learn that Achille Degas had been arrested by the police for shooting and wounding his rival. On their return to Paris, Eugène dropped in to express his and Berthe's

sympathy. The Manets sensed the distress felt by the banker's family, especially by Edgar Degas, who suffered throughout his life as the result of carrying family burdens.

Meanwhile, arriving in London, Berthe and Eugène found accommodation in Marylebone. Manchester Street was part of London's Georgian development, but in that part of the West End better-class lodgings and hotels had taken over from private residences. Number 51, where they were staying, had been the home of Admiral Sir Francis Beaufort, inventor of the wind scale half a century before, but by 1875 it had been converted into a boarding house. Berthe found the whole area dreary. In addition, London in August was as hot as Paris, so she complained to her mother. However, the urge to make up for lost time drove them to begin the exploration of the city's architectural splendours, the parks and public buildings, and the shops and *haut ton* developments of Kensington, until rapidly Berthe became exhausted. 'We race about like lost souls' was her cry.[34] They promptly changed tack.

Having visited the National Gallery in the first few days and seen the eighteenth-century English masters, Berthe decided she wanted to paint in the open air again. The cooler atmosphere and shimmering water drew them to the Embankment. As she imbibed the riverscape, Berthe's emotions broke through their crust of reserve. London, she conceded to her mother, was 'a kind of fantastic Babylon, as one sees it from the Thames on a foggy day'. And to Edma, 'This Thames is really beautiful. I often think of how much pleasure you would have in seeing this forest of yellow masts, through which one can catch a glimpse of the dome of St Paul's, the whole thing bathed in a golden haze.'[35] As Monet and Sisley had done before her, Berthe took to the river by boat to explore the artistic possibilities. The Thames was alive with shipping of all kinds. She painted a shimmering canvas of boats at anchor, masts and rigging blending with haze and steam, and another of a little steamboat ploughing along the river, which Eugène particularly liked. In fact, once they adjusted to the congestion of the capital, they began to enjoy themselves. They took several river trips, including excursions to Greenwich and Kew, and later Berthe regretted they had not made it as far as Windsor. They also discovered that cheap steamboats plied between Hampton Court and the Kent coast, enabling them to visit Ramsgate and Margate. These fishing ports reminded her of Fécamp and they inspired her to paint three marinescapes, encapsulating the enduring fascination that boats and the swell of waves hold for so many of the people of northern Europe.

The Manets, however, had come to England with the intention of making contacts as well as painting. What neither seemed to realize was that in late August the English aristocracy would be in the throes of the hunting, shooting and fishing season. Even Durand-Ruel's knowledgeable secretary,

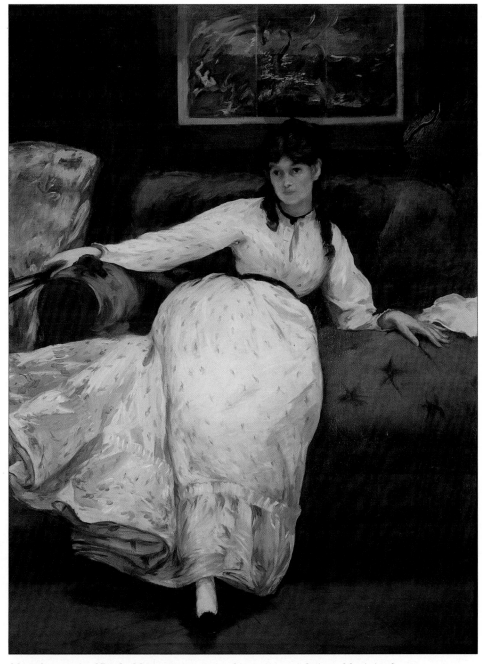

Manet's portrait of Berthe Morisot, representing his controversial view of feminine beauty. (Édouard Manet, Repose, 1870. Oil on canvas. Museum of Art, Rhode Island School of Design, Providence, R.I. Bequest of the estate of Mrs Edith Stuyvesant Vanderbilt Gerry.)

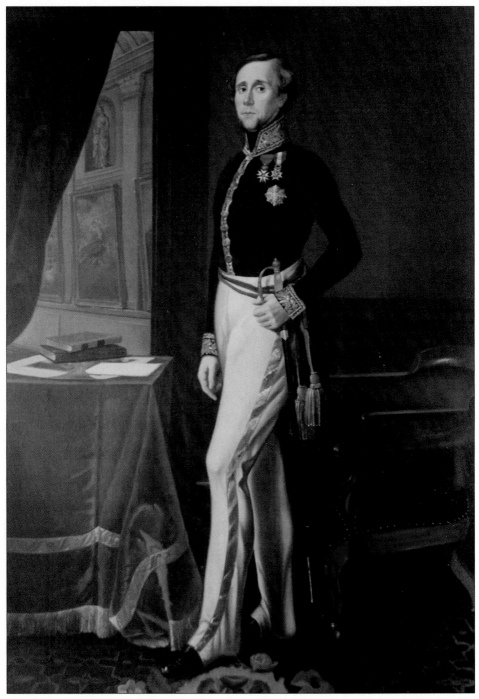

A portrait of the artist's father, Prefect Morisot, in his official dress.
(Georges Ardant du Masjambost, Portrait of Edmé Tiburce Morisot, *1848. Oil on canvas.*
Préfecture de la Région Limousin et de la Haute-Vienne, Limoges. Photograph by José Cerdá,
Limoges.)

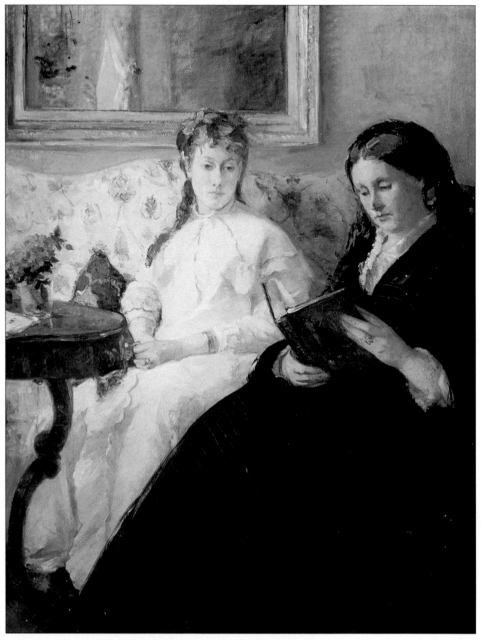

Morisot's double portrait of her mother and sister Edma reading was a subject of a misunderstanding between the artist and Édouard Manet.

(Portrait of the Artist's Mother and Sister, *1869–70 by Berthe Morisot (1841–95). Oil on canvas. National Gallery of Art, Washington DC/Bridgeman Art Library, London.)*

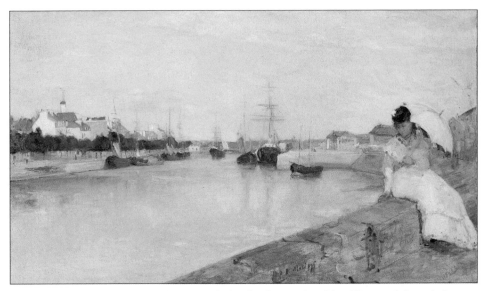

Manet admired this early masterpiece so much that Berthe gave it to him. The seated figure is her sister Edma.
(Berthe Morisot, The Harbour at Lorient, *1869. Oil on canvas. National Gallery of Art, Washington, DC, Ailsa Mellon Bruce Collection, 1970.*)

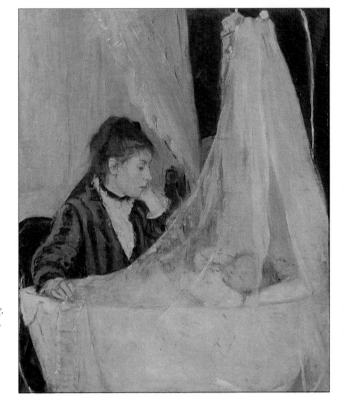

This portrait of Mme. Edma Pontillon with her baby daughter Blanche is probably Morisot's best known painting.
(The Cradle, *1872 by Berthe Morisot (1841–95). Oil on canvas. Musée d'Orsay, Paris/Giraudon/Bridgeman Art Library, London.*)

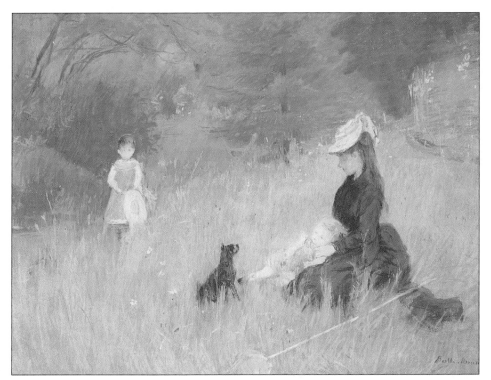

One of several charming open air scenes portraying Edma with her children in the garden at Maurecourt.

(Detail: In a Park *by Berthe Morisot (1841–95), (also known as* On the Grass *or* On the Lawn*). Pastel. Musée du Petit Palais, Paris/Giraudon/Bridgeman Art Library, London.)*

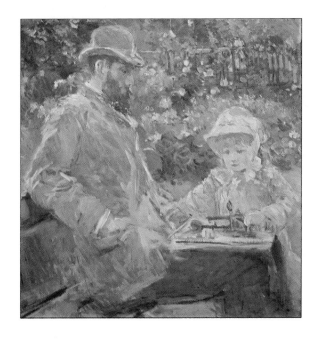

Little Julie Manet playing with her toy village, watched over by her father, in the garden at Bougival. (Detail: Eugène Manet with his daughter at Bougival, *c. 1881 by Berthe Morisot (1841–95). Oil on canvas. Private Collection, Paris/Giraudon/Bridgeman Art Library, London.)*

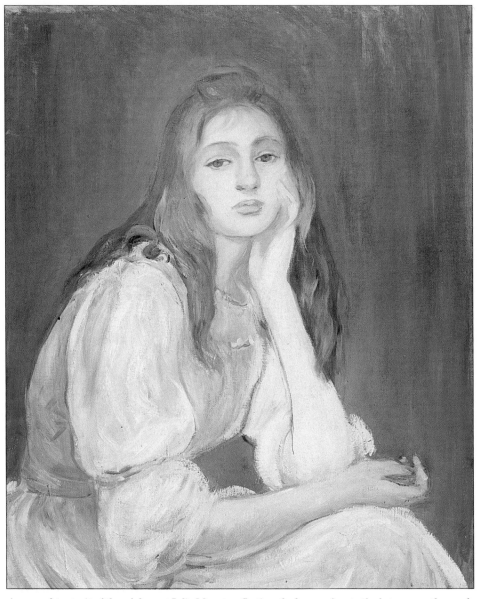

A sensual portrait of the adolescent Julie Manet, reflecting the love and empathy between mother and daughter.
(Berthe Morisot, Julie Daydreaming, *1894. Oil on canvas. Private Collection. Courtesy Galerie Hopkins-Thomas, Paris.)*

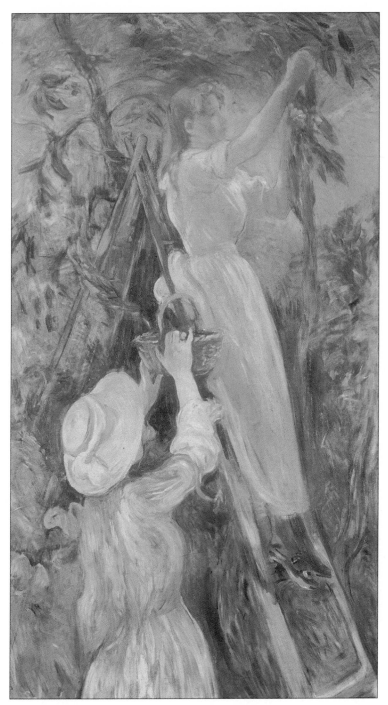

Berthe Morisot produced numerous studies for this decorative work for which Julie Manet and Jeannie Gobillard posed at Mézy. In this version the model Jeanne Fourmanoir replaces Julie on the ladder.
(The Cherry Picker by Berthe Morisot (1841–95) (also known as The Cherry Tree). Oil on canvas. Private Collection, Paris/Giraudon/Bridgeman Art Library, London.)

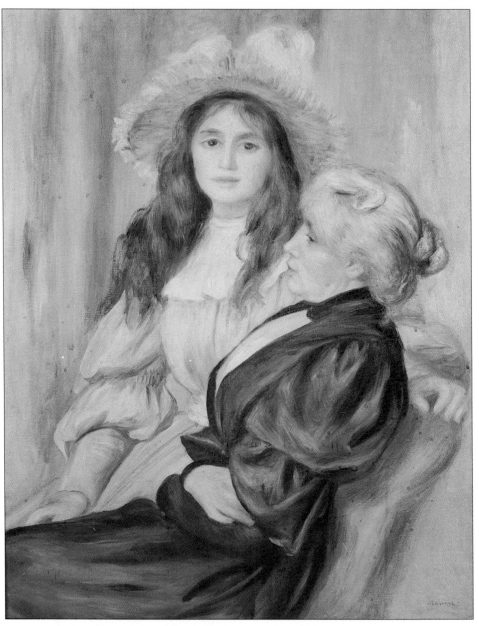

This touching double portrait, painted at Renoir's request, reflects the close friendship between the two Impressionists in Berthe Morisot's later years.
(Pierre-Auguste Renoir, Berthe Morisot and her Daughter, Julie Manet, *1894. Oil on canvas. Private Collection. Courtesy Galerie Hopkins-Thomas, Paris.)*

Charles Deschamps, was out of town the day they called at the New Bond Street Gallery. It was a phrase that became all too familiar. Berthe made several attempts to pay her respects, but the doors of most London mansions were closed to callers from France, no matter how socially respectable. She found that the philanthropic and liberal Duke of Westminster (she knew him as the 3rd Marquess, which he had been until 1874) and his brother-in-law, the 3rd Duke of Sutherland, a keen traveller with many European connections, were both away in the country. Ultimately Berthe pinned her hopes on another much-travelled gentleman, whom she was assured by Tissot was 'a very important personage, who can open all doors to us'.[36] This was the Reverend Arthur Penrhyn Stanley, the Dean of Westminster, whose wife, Lady Augusta Bruce (a daughter of the Earl of Elgin of the 'Elgin Marbles' fame), had been a francophile since living in Paris during the Second Empire. Berthe learned that the dean was not far away: he was staying in his so-called country residence among the salubrious villas of the Norwood–Crystal Palace area. All she hoped for was a chance for Eugène and herself to make themselves known, in case the influential cleric could prove a useful contact on any subsequent visit to London. Berthe was not to know that poor Lady Augusta was indisposed, and that the illness from which she was suffering would finally kill her the following March.

In the end their only successful contact was with their compatriot, James Tissot, who invited them to dinner at his home in St John's Wood. Tissot knew the Manets well and in fact was to go on a painting trip to Venice with Edouard and Suzanne the following month, September 1875. His star had risen significantly since he fled from the defeated Commune. In 1873 he had moved into a fine villa with a large garden at 17 Grove End Road. Within no time Paris was awash with rumour that Tissot employed liveried servants to offer iced champagne to his guests and to polish the leaves of the shrubs around his colonnaded garden pool.[37] Berthe's letters confirmed the spirit rather than the substance of these tales. Tissot 'lives like a king', she assured Edma, though he retained enough of the common touch to be polite to them. The Eugène Manets were impressed. They saw that he had found a receptive market for his paintings of social occasions, such as his *Ball on Shipboard* (1874), which portrayed an officers' gala during Cowes Week. Berthe was mollified when Tissot told her that they had seen the cream of English fashionable society in Regatta Week. They exchanged compliments about each other's work, but the evening strained her charity as she and Eugène listened to the mounting evidence of Tissot's triumphs. His 'very pretty things' were each fetching as much as 300,000 francs. Envy gnawed at Berthe as she concluded, 'He is very nice, a very good fellow, *though a little vulgar.*'[38]

Berthe's experiences in England proved a mixed blessing. Her

confidence had its ups and downs and she was disappointed that Edma and the children were unable to join them in the Isle of Wight. After talking to the picture dealer in Ryde, she came to the conclusion that her style of watercolour painting was so different from the English that there was little hope of success in that market. Madame Morisot, a conventional nationalist, was not in the least surprised. While English connoisseurs, she conceded, gave credit to originality, 'the English clientèle would not suit you at all.' Better to stick to 'one's own little corner' was her advice.[39]

Her mother's words struck a disheartening note on which to pack up and return home. But some seventeen pictures – oils, watercolours and pastels – was no mean record for two months' work. And there were some high points. Berthe's boat trips on the Thames left happy memories, and thirteen years later she still recalled the 'extremely beautiful Gainsboroughs and Reynolds' she had seen in London. Even the memory of the Isle of Wight grew rosier with time.[40] For the moment, however, the end of summer approached, and Eugène was concerned to sort out his finances and his prospects. Though Edouard had greatly approved of Berthe's Gennevilliers paintings, and they had had attracted some interest in Poussin's shop while she and Eugène had been away, the dealer had failed to sell any. As soon as they got back home, Berthe had to rush off to see her sisters, first 'Mame' in Maurecourt, then Yves at Cambrai. She made the most of the chance to paint her elder sister and the children, eight-year-old Paule and Marcel, already a curly-headed toddler. One of her watercolours, of Yves and her son, was quintessentially Morisot: a delicate and finely detailed Flanders setting, meadows and distant windmills, soft colours spiced with touches of black, specks of gold and smears of sky-blue, walnut and wine-red.

Eugène was lonely in her absence, missing her 'lovely chatter' and 'pretty plumage' a great deal.[41] He spent the time catching up with the family news. Edouard had not been well, but he was experimenting on Impressionist lines with his latest picture; and the two mothers were keen to see Berthe's English paintings and offer their compliments. Eugène also had some business to do. He paid a visit to Gennevilliers to collect his rents, only to face a barrage of questions about his wife. She had impressed the villagers, he was happy to report. He began touching up his own paintings from Cowes, at the same time dealing with the framing and placing of Berthe's pictures. And all the while he waited like a patient and devoted dog for the next letter from his wife.

She was quite attuned to writing him affectionate letters. But it was a measure of their relationship that Berthe was eager to escape so soon to the company of her sisters. By the conventions of the time, this was an acceptable custom. While marriage was in law a business arrangement and wives had to accept severe restrictions on their legal freedom, in civilized circles, common decency gave the wife a discretionary loophole. As a relief

from the tedium of domestic life or from an an over-zealous husband, a wife was allowed to escape from the marital home periodically to visit her relations. Berthe had watched her sisters exercising this right for some years, and she was eager to stake her claim, despite the fact that she and Eugène had scarcely been in one place for more than a few weeks. In an interesting way her relationship with Eugène was a mirror-image of Edouard's with Suzanne. It would be rash to say how far Berthe had calculated on her husband's tolerance, but she and Edouard Manet definitely enjoyed considerable latitude and independence from their marriage partners. Their spouses seemed content to give in to their (quite different) private needs, providing unselfish support and unqualified love. In return, Edouard and Berthe gave respect and measured loyalty. The mutual compact within each of the Manet marriages may have never been articulated, but independence was clearly implied in the pattern of their lives.

Meanwhile, Eugène's professional future remained uncertain. The Middle Eastern post had remained on the table throughout the summer but Cornélie Morisot had written to them in England at the end of August to remind them of the need for a decision. Obviously she did not relish the thought of Berthe's departure for foreign parts, not least because Tiburce was still abroad. By now she had also serious reservations about Eugène's entrepreneurial capabilities. 'If only Eugène could find employment here, it would be better to scrape along than to go far away and be forgotten, for the sole purpose of earning one's bread. I am not at all sure that Eugène would know how to make his fortune; I think he is too honest, for one thing . . . and too carefree for another.'[42] Besides, since Tiburce had picked up a debilitating ailment overseas, she had the gravest doubts about their capacities to stand the physical rigours of living abroad.

As it turned out, Eugène had lost his enthusiasm for a career which required him to travel to the Middle East. When he turned it down, unquestionably everyone around him breathed a sigh of relief. Adèle, speaking for all Berthe's friends and relatives, was openly relieved that they were opting to remain in Paris, which she felt was their true environment.[43] There would be a price to pay, of course, as Cornélie Morisot had foreseen. They would not have the security of a steady supplementary income. It meant that Eugène and Berthe would have to 'scrape along' a little longer on their inherited assets.

Solidarity

1875-7

By nature Berthe was neither a spendthrift nor a hedonist like her brother-in-law Edouard and her brother Tiburce. But the cultivated environment of her youth, where the talk was of balls, receptions, ballets and operas, is reflected in the subject matter of a group of paintings dating from the winter of 1875–6. *Before the Theatre (Devant le Théâtre)* and *At the Ball (Au Bal)* were of the same black-haired, dark-eyed model, known as Mademoiselle M. The year had been given a fillip by the inauguration of the new opera house, a fortnight after Berthe's marriage, an event that would certainly not have escaped her notice. The evening's performance of popular works by Delibes, Meyerbeer, Halévy and the overture from Rossini's *William Tell*, was just the sort of dazzling occasion to set the Morisots talking in times gone by. 'All the persons who have made their mark in France and abroad in Politics, Science, Art, Literature or Finances, were there': a glittering audience, proudly displaying their *Légion d'Honneur* ribbons before crowned heads and princes. 'It was a real page of modern history placed before the people's eyes', acknowledged *The Times* correspondent in Paris.[1]

The celebrations were in stark contrast to another page, a sorry page of recent history. The failure of their exhibition dealt a body blow to several of the Impressionist artists. Monet, Renoir and Pissarro, all were in dire financial straits. Renoir had had to beg a loan of 100 francs to pay his father's funeral bill. (He had died on Berthe's and Eugène's wedding day.) From Argenteuil Monet wrote in desperation to Edouard Manet. 'Once again, I haven't a penny. If without embarrassing yourself you could lend me fifty francs, you would be doing me a great service.'[2]

Through Edouard, Eugène and Berthe heard about the plight of her co-exhibitors. Her sensitive financial situation was nothing compared with theirs, and neither she nor Eugène could have contemplated the daily hardships of these artists. Edouard felt sorry for Renoir and Monet in particular, but he was also brooding about his own prospects for the coming Salon. In the previous summer he had painted half a dozen scenes on the River Seine at Argenteuil, adopting Impressionist techniques: contemporary scenes, full of summer light on water. In his depressed mood he half-expected rejection. He took it as a bad omen when his woodcut illustrations

for Stéphane Mallarmé's *L'Après-midi d'un Faune* were turned down by the publisher Lemerre in that spring of 1875. Berthe, meanwhile, was worried about Edma, who had been ill in the New Year with a prolonged post-natal condition. She was saddened, too, by the news of Camille Corot's death on 22 February. Eugène represented her at the artist's funeral.

With her mother tactfully out of Paris, Berthe and Eugène were trying to settle into their own social routine. Berthe had picked up with Adèle d'Affry again. The duchess visited the house, along with Degas and Manet. Both men found the sculptress attractive company. Degas had presented her with one of his hand-painted fans, and she had started to visit Manet in 1872, with encouragement from Durand-Ruel, who greatly admired Edouard. Early in 1875 Manet paid her a compliment (as he thought), by asking her to paint his portrait for exhibition. Adèle firmly declined and Manet felt rebuffed. But Adèle had no desire to face the adverse publicity that anyone publicly associated with Manet would endure. However, they remained on civil terms.[3] Another mutual friend of the Manets and the duchess was Marcellin Desboutin, an eccentric poet, dramatist and painter, who, like Manet, Puvis and Fantin, had been a student of Thomas Couture. Despite aristocratic roots (shared with his cousin, the rebel, Henri de Rochefort), Desboutin looked for all the world like a tramp when he turned up in the Café Guerbois around 1872. He had squandered his inheritance in Florentine real estate and on the *dolce vita*, although he still managed to retain his dignity and a gift for easy conversation. Degas and Manet used him as a model in the mid-1870s: a clay pipe-smoker with a red face and curly black hair beneath his squashed felt hat. Their friendship brought him closer to the Eugène Manets in 1875, for Desboutin was to ask Berthe to pose for a homely little etching, *Portrait of Berthe Morisot*, in the coming year.[4]

About the same time, 1875, on one of her visits to the rue de Saint-Pétersbourg, Berthe was introduced to another relative newcomer to Edouard's circle, an impoverished teacher of English at her father's old school and a poet of the new Symbolist generation. Stéphane Mallarmé had developed the habit of calling almost daily at Manet's studio on his way home to the rue de Rome. He hated the boring routine of a schoolteacher's life, and he looked up to Manet with awe, fascinated by the artist's relationship with Baudelaire, his own poetic guru. Berthe quickly came to appreciate the qualities which drew the pair together: Mallarmé's admiration for Edouard's sartorial elegance and his artistic virtuosity; the poet's refined speech, exquisite manners and reserved, rather melancholic nature – qualities Berthe may have recognized in herself. In conversation, she warmed to his finesse and cultivated mind, and she found him sympathetic to the aesthetic notions of the new painting.

Berthe never had any intention of giving up her vocation. Nor had

Eugène of persuading her to do so. It was understood before their marriage that she was a serious and talented artist. It had also been agreed privately within the family that to retain her artistic identity and avoid the confusion of there being another Manet in the profession, as a painter she should continue to use her own name. So when Renoir approached her in early March with a new initiative, she could not resist being drawn back into artistic politics. He had already put the idea to Sisley and Monet: as a means of raising money they would hold an auction of their works that month. They hoped she would join in the venture, not least since Manet was holding back in favour of the Salon.[5]

Berthe and Eugène both admired their dedication and the quality of their art, so she agreed without hesitation. Renoir negotiated with Durand-Ruel and the auctioneer Charles Pillet to hold the event in the Hôtel Drouot on Wednesday 24 March. Altogether, the four artists – Renoir, Monet, Sisley and Morisot – could put up over seventy works, of which Berthe would contribute a dozen. Philippe Burty did his best to arouse favourable interest with his well-chosen remarks in the sale catalogue.

We are extremely grateful to these painters for achieving with their palettes what the poets of their time have been able to present with an entirely new emphasis: the intensity of the summer sky, the poplar leaves transformed into golden coins by the first hoarfrosts; the long shadows cast on the fields by the trees in winter; the Seine at Bougival, or the sea along the coast, quivering in the morning breeze; children rolling over in the grass dotted with tiny flowers . . . they are like small fragments of the mirror of universal life.[6]

Edouard Manet also wanted to be as helpful as he could. As a supportive gesture to needy fellow artists, he offered to put in a word with the influential critic, Albert Wolff. Since Eugène would never have forgiven him if he omitted Berthe, he wrote a brisk note, 'My friends, Monet, Sisley, Renoir and Madame Berthe Morisot are going to hold an exhibition and sale at the Salle Drouot. . . . Maybe you do not appreciate this sort of painting yet, but you will come to like it. In the meantime it would be kind of you to say a word or two about it in *Le Figaro*. . . . Yours ever, Ed. Manet.'[7] Yet if ever an attempt at exercising a little harmless influence misfired, it was this. No one, least of all Manet, foresaw the outcome. Wolff, a German immigrant with countless personal hang-ups, took perverse pleasure in denigrating the display. Since *Le Figaro* was a high circulation paper, he plainly warned off potential buyers on the eve of the sale. 'All these pictures have somewhat the effect . . . of a painting that you must look at from fifteen paces while squinting your eyes', he wrote. 'The impression produced by the Impressionists is that of a cat walking on the keys of a

piano, or a monkey that has got hold of a box of paints.'[8] His sarcasm did not deter the crowds; but they came to pour scorn on the quartet and intimidate the officials and the few brave bidders. The atmosphere in the Hôtel Drouot had all the animosity of a political rally infiltrated by a gang of extremists. A shout of 'harlot' was directed at Berthe. In fury, Pissarro punched the face of the vilifier. In desperation Pillet called in the police.[9]

There was no doubt that the hostility was orchestrated by a reactionary section of the press. Gyges in *Paris-Journal* used heavy irony. 'We derived a certain amusement from the purple-coloured landscapes, red flowers, black streams, yellow or green women and blue children which the pundits of the new school had presented for public admiration.'[10] Some detractors – Girard of *Le Charivari*, for one – were brazenly political. All the country's economic and constitutional ills were attributed to the influence of a handful of "Intransigent" radicals . . . "schismatics" and "hard-faced individuals" (one of them is a woman)'. He rammed home the conservative line. 'They call this new group the School of Impressionism, although it has made no impression on the public. Their style of painting, which is both coarse and ill-defined, seems to us to be the confirmation of ignorance and the negation of beauty and truth.'[11]

The auction was a disaster for the artists' pride as well as their pockets. Individual prices were lower than the previous year, and in all the seventy works fetched a mere 11,496 francs. Berthe's twelve works averaged 250 francs, thereby making hers the best prices in relative terms. The critic of the *Echo Universel* had singled out two of her oils, *Reading* (her portrait of Madame Morisot and Edma Pontillon) and *Interior*, as attracting attention at the preview, and at the auction the latter was sold to Ernest Hoschedé for the highest bid of the whole afternoon at 480 francs. Later Eugène used this minor triumph to soothe his mother-in-law, who had plainly been desolated by the débâcle.[12] A trio of Maurecourt figure-landscapes had mixed luck. The pastel *On the Lawn* reached 320 francs, the canvas *Catching Butterflies* (also known as *The Butterfly Hunt*), made 245 francs, and the little watercolour, *On the Edge of the Woods*, went for a mere 45 francs.[13] Yet half of Renoir's paintings did not even reach 100 francs and a proportion of their works were bought back by the artists themselves.

Berthe was fortunate in having family solidarity behind her. Eugène stepped in, along with Gustave Manet, and Berthe's cousin, Gabriel Thomas (who bought the *Little Girl with the Hyacinths* for 320 francs) to raise the bids on her behalf. Some far-sighted investors braved the catcalls to acquire canvases at knock-down prices. Friends of Degas and Théodore Duret were tipped off to a golden opportunity: Rouart, Caillebotte, a generous and talented amateur artist, the industrialist Dollfuss and the bankers Henri Hecht and Charles Ephrussi all came. But mingling with established figures like the writer Emile Blémont and the publisher Georges Charpentier were

some unknown faces: a modest customs officer, Victor Choquet, with a private love of eighteenth-century *objets d'art*, and two youths, Georges Seurat, the future Pointillist painter, and twelve-year-old Paul Signac, who became a leading Neo-Impressionist. If it had achieved little else, the auction had stimulated some aspiring artists and opened the eyes of other wealthy connoisseurs.

To the quartet, however, the episode left a bitter taste in the mouth. Eugène was mortified by the reception given to Berthe's work. He was worried about the effect on her morale and even her health. But the press did not give up. On Good Friday, two days after the auction, Burty tried to redress the balance in *La République Française*, ending with a final epitaph: 'The sale of pictures, watercolours and pastels by Mlle Berthe Morisot and Messieurs Monet, Renoir and Sisley has had to triumph over ill-will which found expression in a ludicrous uproar.'[14] The artists' mood was reflected in the Easter weather; the sky was Lenten. Biting back their disappointment, Berthe and Eugène agreed with the other three that it would be foolish to hold another exhibition that year. Sisley retreated to Marly, Renoir stayed in Montmartre, Monet lay low in Argenteuil. And with the auction behind them, Eugène whisked Berthe off to Gennevilliers, prior to their embarking for the Isle of Wight. Before the year was out, Monet was again writing begging letters to Manet. 'It's getting more and more difficult . . . not a cent left and no more credit.'[15]

On the first anniversary of their father's death, Berthe had written to Tiburce abroad, enquiring whether he was still interested in national politics. It was too much to hope that he and Eugène would have agreed on the subject, for the political in-fighting between monarchists and Republicans intensified during the year. But the laws to ensure the effective working of the constitution were passed while Berthe and Eugène were in England. At the end of the year 1875, after interminable delays, the National Assembly met for the last time. To rally Republican spirits for the forthcoming general election, Gambetta spelled out its importance. 'On this choice are about to depend the repose, the security, internal and external peace, the greatness even of France.'[16]

Winter brought back the short, dark days, forcing Berthe to work indoors. Even though her mother had moved out to the other side of the rue de Passy, to 2 rue Jean Bologne, the apartment in the rue Guichard was small compared with the rue Franklin, so Berthe worked in her studio-bedroom. She was totally at ease with a boudoir setting, where young women *en déshabillé* busied themselves with their toilette, ball gowns were fitted, coiffures arranged and bourgeois dreams woven. Her familiarity was based on personal experience. And on another level these scenes suggest a quest for a female sanctuary, an element of escapism from a male-dominated

society, possibly from the concealed tensions of her marriage. But whatever its precise psychological roots, *At the Ball* resumed a search for distilled womanhood which she had started in 1869 with *The Artist's Sister at the Window*. She pursued it in earnest in the early part of 1876 with two works, *Young Woman with the Looking Glass (Jeune Femme au Miroir)* and an outstanding oil, *The Cheval Mirror (La Psyché)*, employing an age-old device to produce a double vision of a private, enclosed, feminine world, where male partners were forbidden to appear.[17] This became Berthe Morisot's particular hallmark, as opposed to the boldly sexual messages of Manet's and Degas's treatment of bedroom scenes. Nothing points the contrast with hers more graphically than the stays and bloomers of Manet's woman *In front of the Mirror* or his blue-corseted *Nana*, provocatively making up her face while she keeps her top-hatted escort waiting.

The boudoir scene continued to inspire Berthe for the rest of her life, but she was not blind to the outside world. To her relief, Eugène took on some of the burden of trying to market her work, although his attempt to place her English portfolio with the Dudley Gallery's Winter Exhibition in London came to nothing. On the other hand, Hoschedé was showing sufficient interest in her pictures to buy another of her boudoir scenes, *Woman at her Toilette*, from Durand-Ruel. This, coupled with the fact that he would show three of her paintings in his New Bond Street Gallery in London in the course of the coming spring, suggests Berthe had succeeded in carving out a small niche with this discerning dealer.[18] Hoschedé's purchase was made in January, just when the tension between art and politics was surfacing again. It was the eve of her thirty-fifth birthday. Although President MacMahon called for all moderate citizens to vote for 'Order and Peace', the majority of Frenchmen took this to signal his right-wing inclinations. They turned down his appeal. Thanks to the forcefulness of Gambetta, the elections of February and March produced a sweeping victory for Republicanism in the Chamber of Deputies. But a political polarization was again inevitable with the indirect selection of a conservative Senate.

Berthe had a dual interest in these events. Her brother-in-law, Gustave Manet, was on the point of making his political debut. His mentor was the left-wing politician, Georges Clemenceau, who had made his name in the Franco-Prussian War as a radical supporter of Gambetta. He had been Mayor of Montmartre and deputy for the Seine prior to the Commune, and afterwards he had returned to local politics in Paris. For five years Clemenceau had been a municipal councillor for the Eighteenth Arrondissement. Now, with the present Republican revival, he was elected as deputy, leaving it open for Gustave Manet to succeed him as councillor in the Montmartre *quartier*. And if Gustave's political career were to take off, Eugène's professional future would be more secure.[19]

In addition, Berthe was concerned in her own right with the political trends she observed. In February 1876, before the election results were known, the Eugène Manets were notified by Renoir that preparations were in train for another Impressionist exhibition in April. Renoir's intention was to reconvene the participants of 1874 – the 'Capucines' as Degas liked to call them, after the name of their venue. Berthe's solidarity was unreserved. She accepted his invitation with alacrity. If she noticed what was happening in the newspapers in March and April, she was undeterred. The right-wing press continued to hurl invective against radical Republicanism (with which Berthe's brother-in-law, Gustave, was associated). Their tactic was to link the new trends in the fine arts with political extremism and instability, knowing that in cultural terms the middle classes who had voted Republican were conservative, and that bourgeois taste favoured the restrained modernity of Bastien-Lepage, Besnard, Carolus-Duran and Puvis de Chavannes. It was clearly a risky time to be launching radical artistic initiatives.[20]

Renoir and his group did not have time to consider all these factors. They may also have been lulled by Durand-Ruel's generosity. The dealer was an extraordinary man. A traditionalist in religion and politics, he was remarkably catholic in his aesthetic vision.[21] Although his business was going through difficult times, he offered Renoir the use of his premises for one month: three large rooms at 11 rue le Peletier from 30 March. But Renoir had disappointments to face. Several Capucines had been syphoned off to a rival organization known as the Union, formed the previous autumn by Pissarro and a disgruntled painter, Alfred Meyer. In fact, half the original participants developed cold feet and would not risk their reputations by exhibiting with the notorious quartet of 1875.

Cézanne, Astruc, Bracquemond, Boudin and de Nittis, all friends of Manet, abstained. On the other hand, Desboutin and Legros (the Anglophile from Kensington) agreed to join Renoir, and to swell the numbers an eager new recruit was introduced, Gustave Caillebotte. Also at Monet's and Renoir's initiative two pictures by Frédéric Bazille were to be shown posthumously. Degas suggested to Berthe that Eugène would be welcome to take part but he declined, not from Edouard's touchy adherence to convention but from modesty or deep-seated feelings of inadequacy. In the event, Pissarro deserted the Union and came in with Renoir. Finally invitations went out to two old stalwarts of the Batignolles days, Fantin-Latour and Edouard Manet. With their sights set on the Salon, however, they both refused. 'My brother-in-law is not with us', Berthe reported succinctly to one of her aunts, but this time, since she was married and had her husband's support, Edouard made no attempt to interfere and dissuade her.[22]

Renoir was greatly encouraged by Victor Choquet who had become his patron and did his best to publicize the forthcoming exhibition. It was no

easy task to coordinate arrangements and ensure the cooperation of such brilliant talents and disparate temperaments, a fact that Eugène appreciated. There were too many visionaries, eccentrics and dunces, in Edmond Duranty's opinion.[23] Degas, for one, was as prickly as ever and infuriated the organizers by presuming to contact friends, Berthe included, to convey the arrangements. 'Dear Madame', he wrote officiously over Renoir's head:

I do not know whether you have been notified that this is the moment for sending your pictures. The opening will be Thursday morning, the 30th of this month. It is therefore necessary that you send in your work on Monday or Tuesday, and that you come if possible to take care of the placing. We are planning to hang the works of each painter in the group together, separating them from any others as much as possible. . . . I beg of you, do come to direct this.[24]

It was hardly surprising that Renoir and Monet were angry. Rumours were already circulating that Degas was the guiding hand behind Duranty's publication of a pamphlet, *The New Painting: Concerning the Group of Artists who are Exhibiting in Durand-Ruel's Gallery*; in it Degas was singled out as a man of the rarest talent and intellect. But Berthe knew the *grand seigneur* too well by then to be surprised. Whatever she thought about the incipient rivalry between her colleagues, she never had a taste for public disagreement and kept aloof from the wrangling. Besides, Degas had reason to be courteous to her. He particularly wanted her permission to exhibit two family portraits, an old sketch of his 1869 portrait of Yves and his wedding portrait of Eugène. Naturally, Degas assured her, he would not exhibit them without her consent, but she saw no reason to withhold it.

Again Berthe Morisot was the only woman to exhibit. Of the 252 works by nineteen contributors in the Second Exhibition of 1876, she contributed 16 paintings and 3 pastels. She went back to her two holidays at Fécamp to find an 1873 cliff landscape figuring Edma and Jeanne, and the little scene of boats under construction which she and Eugène had painted side by side during the summer of their engagement. She also included the *Washerwomen's Lines*, the *Picnic*, and some of her recent indoor portraits, such as *At the Ball*, *Rising (Le Lever)* and *Dressing (La Toilette)*. But the largest group of her exhibits were the oils and the watercolours completed on her English trip, which were to attract some favourable comment.[25]

Waiting for the press reaction provided some anxious moments, but the initial response was quite heartening. Among the first critics into print were certain drinking companions of Manet and Degas, regulars at the Nouvelle-Athènes. Alexandre Pothey of *La Presse* was eager to congratulate the artists for a more interesting exhibition than that of 1874. Armand Silvestre

echoed this approval in the Republican *Opinion*, praising their extension of colour tones, their 'new statements', especially in the *plein air*. 'The panel of little canvases by Mlle Morisot', he remarked, 'is particularly pleasing to the eye.' A week later Emile Blémont commended their innovative quality of 'rendering with absolute sincerity . . . by means of simple, sweeping strokes, the impression aroused by their vision of reality'.[26] However, in the historiography of Impressionism, the weightiest analyses came from the pens of two novelists, Duranty and Zola, and the poet Mallarmé. Duranty's *New Painting* refrained from personal references but in his review of 'The Impressionists and Edouard Manet' in an English periodical, the *Art Monthly Review*, Mallarmé complimented Berthe on her 'new charm . . . infused by feminine vision': 'Mademoiselle Berthe Morizot [*sic*] seizes wonderfully the familiar presence of a woman of the world, or a child in the pure atmosphere of the sea-shore, or green lawn.' And saluting the new movement, with Monet as its head, for the benefit of a wider European readership, notably the Russian intelligentsia, Emile Zola summarized her contribution in *Le Messager de l'Europe*: 'Mlle Berthe Morisot paints little pictures which are extremely accurate and sensitive. I would highlight in particular two or three seascapes executed with an amazing delicacy.'[27]

Flattering words, but short notices. Berthe kept a low profile, knowing perhaps that praise in radical newspapers from a group of Batignolles critics was a double-edged form of publicity. In the charged atmosphere of that spring of 1876 it was no time before the press politicized the whole affair, even though the occasional journalist, like Emile Blavet of *Le Gaulois*, tried to defend the exhibitors against charges of political extremism. Once the rightist press found they could use a fringe exhibition to make anti-Republican propaganda, they set to with a will, charging the exhibitors with bringing anarchy to the country. The social dangers of the new art was the theme of Charles Bigot in a long article in the *Revue Bleue*, in which he tried to undermine the Impressionists' credibility as artists. 'Here we have a revolutionary school', he wrote, 'and France, which is quite wrongly accused of favouring revolutionaries, seems to me to favour them today less than ever in art as well as politics.' The *Moniteur Universel* took up the cry. 'The intransigents of art holding hands with the intransigents of politics, what could be more natural?'[28] But when all else failed, the critics resorted to vicious personal abuse.

The worst offender was Albert Wolff, critic of *Le Figaro*. A recent biographer of Degas (whose draughtsmanship Wolff dared to attack) described him as 'a very minor draughtsman . . . a grotesquely ugly dandy notorious in the cafés of the Grands Boulevards for his mincing manners, tight corsets, and heavy use of cosmetics'.[29] His stock-in-trade was the poison-pen review.

The rue le Peletier is ill-fated. Following the burning of the Opéra, a new disaster has fallen upon the quarter. In Durand-Ruel's gallery a so-called exhibition of painting has just opened. The innocent passerby enters, and a cruel spectacle meets his terrified gaze. Here five or six maniacs, one of whom is a woman, and a group of unfortunates deranged by ambition have got together to show their work. . . . These self-styled artists call themselves Intransigents, Impressionists; they take some canvases, paint, and brushes, they throw a few colours on at random, and then sign the lot. . . . In the same way the inmates of a madhouse pluck up the stones in the road and believe they have found diamonds. It is an appalling spectacle of human vanity gone astray to the point of complete dementia.

Then, a few sentences on, came the *coup de grâce*, so far as the Manets were concerned. 'There is also a woman in the group, as is the case with all famous gangs. Her name is Berthe Morisot. She is interesting to behold. With her, feminine grace manages to preserve itself in the midst of the ravings of a frenzied mind.'[30]

Unforgivably, Wolff stabbed the Manets in the soft underbelly of bourgeois respectability. In the case of the male members of the Manet family – Auguste, Edouard and Eugène – inviolability amounted to an obsession, so the analogy between Berthe Morisot and a gangster's moll roused Eugène to paroxysms of fury. Brushing aside the emollient remark about his wife's femininity, he challenged Wolff to a duel.[31] Berthe was privately aghast, first at the insult, then at her husband's violent reaction. But worse might be the outcome: at forty-two and with poor physical co-ordination, no one was less suited to a physical confrontation. She did what she could to calm those around her, but the gauntlet was down. *Le Figaro* added insult to injury by maliciously reporting, 'It seems that art does not always soothe the mind. Yesterday the policeman who was offended by the colour of the [Impressionist] paintings, was seized by an epileptic fit in front of them. . . . It was quite a job to bring him back to his senses.'[32]

Happily, Wolff's nerve cracked first. He made his apologies to the Manets and Berthe urged Eugène to accept an *amende honorable*. He did so, in a state of nervous exhaustion. A fortnight later the critic effected a truce, if not a partial reconciliation with Edouard: '*For us who greatly love Monsieur Manet* . . .'[33] On this occasion the family felt vindicated but had it been Berthe's principal desire to become a Manet, she now began to learn the price to be paid. Wolff's scurrilous review rallied all the petty-minded and spiteful within the ranks of Parisian journalists. Until that time they had been concentrating on political matters but from Easter they had a field day at the expense of the Manet family. Edouard's submissions to the Salon had been turned down by the jury. He had been furious, and hit back by holding another personal exhibition in his studio during the second half of

April. Berthe exercised self-restraint. 'He has just been rejected by the Salon; he takes his defeat with as great good humour as possible', she assured her aunt.[34] But the critics continued to be offensive. Bertall in *Le Soir* echoed Wolff: 'There is a young woman, Mlle Berthe Morisot, who threatens to turn herself into a considerable celebrity; her *Beach at Fécamp* and her *Toilette* alone would be enough to win her some full-blooded notoriety.'[35] At the final reckoning of the second Impressionist Exhibition, the total attendance was lower than in 1874. The poor receipts were a deep disappointment to the artists.

Berthe retained her composure as she waited for the rumpus to die down. Eugène felt her frustration keenly, while Cornélie Morisot grieved at her daughter's inability to win success. She had craved two things for Berthe: a respectable marriage and public recognition. 'I should like to enjoy greater peace of mind in my old age', she had confided to Edma.[36] The first she had achieved. The second seemed as elusive as ever to Cornélie. In case other members of the family should be shocked by reading *Le Figaro* and other papers, thereby adding to her mother's distress, Berthe wrote a soothing letter to her aunt in the provinces. But her calm exterior belied her anger. For the Manets, the spring of 1876 went down in family history as a silly season, the year when the work of the master, Edouard Manet, was rejected in favour of that of his pupil, Eva Gonzalès. It was another bitter pill for Berthe to swallow. Her elemental resentment towards Eva had never totally gone. In the intimacy of her home, Berthe poured scorn on the Salon and on popular taste, fuming that 'burgeoning talents are stifled by the indifference of a conventional public without any artistic pedigree'.[37]

In the spring of 1876 Yves, who was almost forty, discovered that she was pregnant again. Coming after Edma's struggle to regain her health after her last confinement, the news caused as much worry as pleasure in the family. Not unnaturally they closed ranks. Berthe spent less time painting because her mother was unwell. Madame Morisot had, alas, lost her zeal for life and was plagued by memories of her husband's suffering. At some point Edma came to stay, for Berthe painted her watering a shrub on the terrace at the rue Guichard. Then while Berthe took a break at Maurecourt (where she painted two tiny watercolour scenes of the river), Edma apparently stayed behind in Passy to take her turn at looking after their mother.

Eugène also remained in the capital for financial reasons. He discussed the Bourse with Berthe's grandfather Thomas, who still had a remarkably lively mind and a keen interest in public affairs despite his advanced age. Eugène wrote frequently to Berthe with news of the art world. The annual Exhibition of the Industrial Fine Arts was opened by President MacMahon in early August. Eugène met one of the exhibitors at Sèvres whom Berthe had known for years, Félix Bracquemond. His business of decorative china

was more certain than the sluggish market for modern art. Eugène knew the Impressionist artists were finding it impossible to raise loans from their dealers because the latter were overstocked. He saw no point in mincing words with Berthe. 'The entire tribe of painters is in distress', he warned, and even Edouard was talking of cutting down on expenses and giving up his studio in the rue de Saint-Pétersbourg.[38] From every angle the situation was depressing when Berthe returned to Passy in September to take over the care of her ailing mother.

In reality there was little she could do to ease her suffering. Cornélie Morisot died on 15 December 1876, after a long and painful illness, the accepted euphemism for cancer. She was fifty-six. Berthe's grief was a private torment. Although condolences poured in, including from loyal friends like Degas and Puvis de Chavannes, Berthe felt crushed by the loss of such a vivid, maternal personality with indomitable spirit.

In the aftermath, Berthe and Eugène left the rue Guichard, with its unhappy associations. Once the estate was settled, there was the prospect of an enhanced lifestyle. They moved to a rented apartment at 9 Avenue d'Eylau (now Avenue Victor Hugo) in the prestigious area near the Arc de Triomphe. Yves's child was due early in 1877; Berthe had already made up her mind to take her mother's place in caring for mother and baby. It seems that Yves, Paule and Marcel joined the Manets before the end of the year, because Berthe painted a portrait of Marcel – *Little Boy* – at this time. Then two days after Berthe's birthday, on 16 January, Yves gave birth to another girl at the Avenue d'Eylau. The baby was called Jeannie, though in the family she was nicknamed Nini. Coming soon after her mother's death, her birth deeply affected Berthe. The child was fair-haired and fair-skinned like Yves. Her placid temperament and sweet nature made her a pleasure to raise, and from babyhood she became a willing model for her aunt. Although she loved all her nieces and nephews, Jeannie Gobillard had a particular place in Berthe's heart.[39]

These preoccupations severed Berthe from the artistic community over the winter of 1876–7. Renoir, however, acquired a new patron, a bachelor with whom he struck up a warm friendship. Gustave Caillebotte, a man of boundless enthusiasm, had been toying with ideas of how best to demonstrate his commitment to the New Painting. In his will, drawn up somewhat prematurely in November 1876, he bequeathed his art collection to the nation. He also stipulated that there should be an exhibition of works by the painters he admired, and in his testament he explicitly identified the seminal figures of Impressionism. 'The painters to take part in this exhibition', he directed, 'are Degas, Monet, Pissarro, Renoir, Cézanne, Sisley and Berthe Morisot. I name these . . .'[40]

More immediately, Caillebotte injected fresh determination into these artists. Since Berthe had not been involved in the planning of the earlier

exhibitions and she was, in any case, immersed in domestic matters, she and Eugène did not attend a preliminary private dinner party held at Caillebotte's in late January or early February 1877. But Edouard Manet was there to represent the Manet interests, together with Renoir, Degas, Monet, Sisley and Pissarro.[41] Caillebotte was determined on another spring exhibition, partly to counter their rivals in the Union, who tried to steal a march with their own somewhat ineffective exposition held at the Grand Hotel in mid-February. There was firm support except from Manet, who was still intent on showing at the Salon. Despite the disappointment at his decision, Berthe in due course received a letter from Renoir and Caillebotte indicating 'We are happy to think that you will participate as usual'.[42] It had been an unhappy, frustrating and somewhat unproductive year. For obvious reasons her artistic equipment had languished almost untouched since they moved house and some of her unsold work hung in the new apartment – *At the Ball*, for instance, adorned the dining-room. But her commitment was not in doubt and now her enthusiasm would be rekindled. She was kept informed about developments as Caillebotte forged ahead with the preparations.

Durand-Ruel's cautious refusal to let his premises again caused a temporary problem, but a third-floor apartment at 6 rue le Peletier (just across from Durand-Ruel's gallery) was made available by a friend of Caillebotte, who bore the cost of the rent in advance. He and Renoir hoped that any additional expenses might be met by the other 'capitalists of the group' – like Madame Eugène Manet – on the understanding that they would be refunded from the proceeds of the entrance fees.[43] Apart from the sordid matter of finance, there were other issues of principle to be agreed, in which Degas, for one, had a burning interest. When Berthe was invited to another meeting at the home of a friendly dealer, she received an unctuous note from Monsieur Degas. 'Dear Madame', he wrote:

Caillebotte and Renoir must have already written to you that the premises are rented and that on Monday (tomorrow) there will be a general meeting at the home of M. Legrand, at No. 20 or 22 rue Laffitte (next door to an optician). But I am writing this anyway, just for the pleasure of doing so and of sending you my very best wishes. I do not know whether your husband remembers that last year he promised to exhibit with us.

Your very devoted,

E. Degas

The meeting is at five o'clock. A momentous question is to be discussed: is it permitted to exhibit at the Salon as well as with us? Very important![44]

One issue to be decided was the designation under which the artists would exhibit. To pre-empt the critics' inventing new terms of insult, Berthe voted with the majority in favour of adopting the name 'Impressionist'. The two

dissident voices of Renoir and Degas were outvoted, the latter being assuaged by the acceptance of a ruling against submitting work to the official Salon. Berthe saw this as a cardinal condition of solidarity within the Impressionist group. But it was never possible to satisfy everyone. Before arrangements were completed several of the 1876 participants withdrew, though they were counterbalanced by Cézanne, Armand Guillaumin and three newcomers, Frédéric Cordey, Franc Lamy and Ludovic Piette (on whose farm in Brittany Pissarro had taken refuge in the Franco-Prussian War). There were eighteen exhibitors and 231 works were on view. Of these, Berthe Morisot showed five oils: *Head of a Girl (Tête de Jeune Fille)*, though this portrait of a brown-eyed blonde in a black gown is now known as *Woman with Fan*; *The Cheval Mirror (La Psyché)*; *On the Terrace*, Maria Boursier at Fécamp; *Young Woman Getting Dressed* (or simply *La Toilette*); *The Horsewoman*; in addition, three watercolours, her 1876 production, two drawings and two pastels, a view of the Thames and a young woman *Dreaming (Rêveuse)*.[45]

The exhibition of April 1877 was significant in promoting what for posterity has come to be known as the Impressionist School. Berthe Morisot's intimate oil paintings hung with more dominant works by Renoir, Pissarro and Cézanne; her watercolours and drawings shared a gallery with Degas. In time it would be appreciated that her dreamy, shimmering picture of a young woman fingering her coiffure, and another, surveying herself full-length in the looking-glass, appeared together and by right with some of the greatest vignettes and modern life subjects ever painted – Degas's *Café-Concert at Les Ambassadeurs*, Monet's series of the *Gare Saint-Lazare*, Sisley's *Flood at Marly* and Renoir's *Swing* and *Bal du Moulin de la Galette*. In Duret's judgement some of her colleagues had achieved their complete development. This was less true of Berthe Morisot, for despite the qualities of her early pictures of distinction – from *The Harbour at Lorient*, *The Cradle*, *Hide and Seek* and *Eugène Manet on the Isle of Wight* to *At the Ball* and *The Cheval Mirror* – these were mostly precursors for the 'feasts of light' which were yet to come.[46]

However, what perceptive observers noticed on viewing this third exhibition was the consistency on display. It caused Zola to portray the artists as a homogeneous group in a review in the *Sémaphore de Marseilles*. He wrote of their 'common vision of nature conceived in tones that were both light and bright . . . by their commitment to painting out-of-doors, to the creamy colours and a harmony of extraordinary tints, a remarkable originality of appearance'. Zola dealt sparingly with Berthe's work, but she was used to that. 'I can only give a few lines to Mlle Berthe Morisot, whose canvases possess such subtle and true colouration. This year, *The Cheval Mirror [La Psyché]* and *The Young Woman at her Toilette* are two veritable pearls, in which the greys and whites of the fabrics make an extremely delicate symphony.'[47] But already, in *Le Méssager de l'Europe* the year before, he had picked out her name as among the half-dozen most influential

members of the new school. Now Burty, too, likening Berthe's pastels to the work of the eighteenth-century Venetian, Rosalba Carriera, confirmed her great talents.

Charles Flor O'Squarr in the *Courrier de France* was equally positive. But of all the reviewers the least inhibited was a young civil servant-turned-journalist, Georges Rivière, a friend of Renoir and founder of a weekly art magazine, *L'Impressioniste*, which he ran to coincide with the exhibition. On 6 April he threw down the gauntlet to the seasoned critics with passionate praise for the masterpieces he so admired.[48] With tedious predictability the established journalists responded.

Hostile or negative comments rained down upon the artists. Louis Leroy and the cartoonist Cham in *Le Charivari*, Georges Maillard in *Le Pays*, Roger Ballu in *La Chronique des arts*, the anonymous reviewer in *L'Evénement*, all relished the chance to mock. Writing under the pseudonym of Baron Grimm, Albert Wolff dismissed the exhibition as a museum of horrors and 'a collection of freshly painted canvases spread with blobs of pistachios, vanilla and red-currant cream'.[49] On the whole the work of Monet, Pissarro and Cézanne bore the brunt of their derision. The skilled hand of Paul Mantz, however, singled out Berthe for attention in *Le Temps*. His words revealed both frustration and admiration.

> The truth is that there is only one real Impressionist in the group in the rue le Peletier and that is Madame Berthe Morisot. She has already been praised and she should be praised again. She will never complete a picture, a pastel, or a water-colour. She produces in effect prefaces for books that she will simply not write; but when she toys with the gamut of clear shades she finds utmost delicacy in the greys and the most refined pale tones among the pinks. Mlle Morisot also has boldness at her disposal. . . . Her painting, which is not sullied by a single black shadow, has all the frankness of improvisation. It does truly give the idea of an 'impression'.[50]

Berthe sensed a breakthrough. Unjustified criticism repeated too often had become counter-productive. As for Edouard, although he had chosen to remain with the Salon, what good had it done him? In July Berthe had cause to smile wryly at an article in *L'Artiste* entitled 'Impressionism at the Salon', in which Manet was dubbed a fully fledged impressionist. What Chevalier and others saw as their weakness, Rivière took to be the Impressionists' strength, namely the uncompromising modernity of the works on display. The third exhibition had turned into a notable Parisian event. The public came to view in a way they had not done the year before, nor in 1874. As a result, Théodore Duret was to maintain, in 1877 the Impressionists were 'talked about in cafés, clubs and drawing-rooms as a remarkable phenomenon'.[51] Solidarity was at last beginning to pay off.

'The positive stage of life'

1877–80

The publicity surrounding the first three Impressionist exhibitions and the quartet's auction at the Hôtel Drouot meant that the name of Berthe Morisot was becoming well known in critical circles, especially to a number of discriminating collectors. The banker Charles Ephrussi, who had been present at the 1874 exhibition and the Drouot auction, possessed at least one of her works by this time, a Maurecourt watercolour. Ernest Hoschédé, patron of both Monet and Manet, who expressed his appreciation of her Gennevilliers landscapes, had also acquired two of her boudoir oils by 1876, *Interior* or *Young Woman with a Mirror* and *Woman at her Toilette*. Another admirer of her work was Renoir's sponsor, Victor Chocquet, who became a fervent collector of Cézanne as well. Unlike public auctions and dealers' records, private purchases are difficult to trace, so her popularity cannot be charted with total certainty. But it is known that the Rumanian-born homeopath, Dr Georges de Bellio, who had a sophisticated taste for contemporary art and had attended both the second and third group exhibitions with Chocquet, bought three of her works at the rue le Peletier. And during the continuing recession, in February 1878, when Hoschédé was forced to put part of his collection up for auction, Chocquet saw a bargain in Berthe's dressing-room scene, *Interior*. A year later he added one of her English seascapes of 1875 to his collection.[1]

Another amateur of Impressionism from the entrepreneurial world was the banker and diplomat, Paul Bérard. In addition to their Paris house, the Bérards owned a château near Dieppe, where they were on friendly terms with their neighbours, Dr and Madame Blanche, the Passy psychiatrist and his wife who had shared in the Morisots' musical circle before the war. Their son, an enthusiastic young artist, who visited Berthe and her mother in the rue Guichard, acquired one of her early watercolours. Through the Blanche–Bérard connection, Berthe and Eugène met Paul Bérard, whose art collection was to include two Morisots, the airy indoor pastel of a young woman daydreaming, exhibited in 1877, and the *Lady by the Screen (Dame à l'ecran)*, showing a semi-reclining figure in a filmy, light-washed atmosphere, painted in that year.[2]

However, of all the businessmen-collectors of the 1870s, none was closer

in background and interest to Berthe than Degas's former schoolfriend and comrade-in-arms, Henri Rouart. A handsome man, whose dark good looks were captured in profile by Degas in a fine portrait of 1875, he was a contemporary of the Manet brothers and a veritable Renaissance man. Rouart had built up a fortune through his unusual combination of gifts as a scientific inventor and practical engineer; he pioneered the refrigerating process on which he founded a successful industrial enterprise. Yet his real love was always art, and as an accomplished landscapist he was closely associated with the Impressionists from the formation of the Anonymous Society of Painters in 1874. Paul Valéry testified to his aesthetic judgement in addition to his personal qualities. 'He was untroubled by ambition, by envy, by any thirst for appearances. The value was all he cared for, and he could appreciate it in several kinds.'[3] He had acquired two of Berthe's Fécamp works as a result of the Quartet's sale, *In a Villa at the Seaside*, and a little watercolour, *By the Seashore*. Then at the 1877 exhibition, in which he and Renoir were jointly reponsible for the sale of the paintings on display, he bought a third Fécamp painting, *On the Terrace*. Subsequently he added others to his Impressionist collection, and his brother Alexis, another keen collector, also possessed one of the earliest of Berthe's watercolour landscapes.[4]

The respect with which affluent amateurs like the Rouarts and Gustave Caillebotte treated Berthe's pictures may have taken the edge off her original ambition to sell at all costs and risk her reputation by dubious public exposure. Certainly, she cannot have felt the pressure that persuaded some of the other participants in the third exhibition to submit to another auction in the Hôtel Drouot at the end of May 1877. Berthe declined to take part, a decision which proved wise in view of the abysmal prices achieved by the works of Renoir, Pissarro and Sisley. But the auctioneer could hardly be blamed for this latest humiliation. Events veered out of control when, out of the blue, Paris was caught up in fresh political excitement. Even interest in the Salon was overshadowed by President MacMahon's transparent bid for personal power in the *coup d'état* on 16 May.

In essence '*seize mai*' was yet another stage in the prolonged constitutional struggle to rally Conservative forces and roll back the progress of the Republic. To cut down the power of the radical Chamber of Deputies, the president effectively dismissed the moderate prime minister and instituted wholesale changes in the administration. Many of the prefects, their deputies and members of municipal councils were among the victims as the stage was set for one of the most vigorous electoral campaigns in modern French history. To the radical Manets, concerned about Gustave's aspirations as councillor for Montmartre and the political careers of friends and deputies like Antonin Proust and Eugène Spüller, these were

challenging times. But typically, Edouard Manet, who was close to his brother Gustave and sympathized with his anti-clerical views, opened his studio to Republican electoral meetings on behalf of a left-wing candidate, Anatole de la Forge. Though Berthe was not directly involved in the politics of her brothers-in-law, the prefectoral purges must have once more brought back recollections of her own feelings of insecurity at her father's sudden dismissal.[5]

In retrospect, the summer and autumn of 1877 were seasons of vociferous political campaigning, culminating in a comfortable Republican victory over the Conservatives. The one blight for Berthe was the sudden death in September of eighty-year-old Adolphe Thiers. For all her life he had been the most talked-about politician in the Morisot household, as well as a family patron. It was 'Monsieur' Thiers who had made the Republic respectable. Fifty thousand citizens paid their last respects and signed the book of condolence in his home in the Place Saint-Georges; and despite heavy rain and biting winds at his state funeral, 'the day was, from beginning to end, a solemn, dignified calm homage, magnificent beyond description'.[6]

As an epitaph to Thiers's life, in the closing weeks of 1877 Marshal MacMahon realized the constitutional limitations of presidential power. He appointed a moderate Republican ministry, acceptable to the Chamber of Deputies. Gustave Manet stood again for municipal office in 1878 on an anti-clerical ticket, pledging also to restore municipal liberties and fight for an amnesty for the exiled Communards. That he could openly espouse these causes was a measure of political change. As the result of public clamour for an official celebration of the Republic and an exorcism of the horrors of 1870–1, the Fête de la Paix was established on 30 June 1878. And some six months later, in January 1879, President MacMahon resigned, to be replaced by a moderate bourgeois Republican named Jules Grévy. Eight years of Conservative government came to an end. Parliamentary democracy was safeguarded, for the time being at least.

In February the husband of Berthe's friend, Madame Hubbard, was promoted to be chef du cabinet of Léon Gambetta, the new leader of the Assembly and the object of much Manet admiration. Edouard, who had got to know him through Antonin Proust after the siege, had dearly wanted to paint the intrepid politician's portrait. The swing of the pendulum also brought back to power Berthe's former admirer, Jules Ferry, as the minister for public instruction and fine arts. It was a strange irony that the man reviled in 1871 for his rotten bread should now control French culture! However, the Manets had friends in high places, as high as the Palais Bourbon itself. In the wake of these developments, in May 1880, Eugène's brother was at last rewarded by Gambetta with a job in the Ministry of the Interior. As inspector-general of prisons, 5th class, with a salary of 6,000

francs (raised in 1882 to 7,000), Gustave did not exactly achieve the bureaucratic heights Cornélie Morisot coveted for her son-in-law, Eugène. But Gustave was an *avocat* and a member of the Municipal Council of Paris, so that he gave the name of Manet some modest prestige, of a kind that was less contentious than Edouard's.[7]

Throughout much of this time, from the early summer of 1877 to the beginning of 1879, Eugène and Berthe effectively shielded their private lives from the prying eyes of potential biographers. One could hypothesize endlessly on this apparent secrecy, on possible distractions, on their state of health, and also on Berthe's artistic activity. Were the Eugène Manets regulars at the parties thrown at this time by Edouard Manet, sparkling occasions held in his studio and attended by the world and his wife? Did they converse with Mallarmé and listen to Emmanuel Chabrier playing and singing from his latest *opéra bouffe* success? We can't be sure. Circumstantial evidence suggests that they remained in Paris throughout this period and abstained from a seaside holiday. (At the invitation of the Hoschédés, the Edouard Manets stayed in Montgéron in Seine-et-Oise in 1877; Edouard claimed to be bored with the sea.) Perhaps having committed themselves financially to an expensive new apartment in the Avenue d'Eylau, Eugène felt they should make the most of it. It was also possible that, like his brother, he was waiting on political developments with the intention of picking up a government post. Perhaps . . . perhaps . . . Certainly Eugène was willing for Yves and Edma to visit with their children and they probably found Paris was a pleasant alternative to provincial life. And as Berthe's domestic commitments increased, she contented herself with quick essays in pencil, sanguine and pastel, perhaps intending these as preliminary studies, which, for want of opportunity or inclination, were never completed in oil.

The themes of her output from this period are personal and domestic, which suggests that her way of life was settled but confined. Her work consisted of a series of pastel portraits of her two Pontillon nieces, dating from 1877, and revealing the contrasting features of dark-haired Jeanne and her blonde five-year-old sister, Blanche. There is, too, an exquisite little watercolour of Edma with her younger daughter; in addition, a couple of still lifes, entitled *Tureen and Apple* and *Roses in a Glass Vase*; two oils of boudoir scenes, almost certainly using the same model, a young woman of Mediterranean extraction. Then in 1878 came another still life and two more female-figure paintings, indicating that Berthe had found a new professional model, another dark-haired girl called Milly, whom she painted wearing a dark *décolleté* ball gown with a black neck band. And picking up the silvery-grey and white palette at which as a *luministe* she excelled, and which she had demonstrated in *The Cheval Mirror* and *Woman at her Toilette*, she produced a possible self-portrait in the shimmering picture *Summer* or *Young Woman by a Window*.[8]

Finally, dating from 1878, probably from the beginning of the year, were some pastel studies of Berthe's youngest niece, Jeannie Gobillard, who had grown by now into a chubby toddler. Of *Baby in White*, an expert has this to say:

> in this extraordinary portrait of a young child, one has the feeling of an impression instantly conveyed, completely transmitted by means as simple and secret as those of a coded message. The calm, unwavering eyes of childhood – two sharp vertical strokes of blue crayon; the impatient feet, held still for once: a few heavy brown strokes, a scribble of white; a few more – how marvellously few – strokes across the paper, quickly, before the small creature begins to squirm; the outline of the solid body is securely blocked in. Little Jeannie Gobillard, wrapped in her whole finery, stares at us solemnly, bemused, ready for her outing.[9]

These particular drawings can be seen as the first in a new series of spontaneous studies of the child form. Berthe's sensitive eye picked out the unique expressions of each infant with the tenderness of a mother. To choose young children as her models, to observe so closely their individual movements and personalities, was a self-imposed test of love and charity as much as of artistic skill. In the summer after her marriage she had admitted to Edma her fears of being unable to conceive and the sense of bitterness at the prospect of a childless marriage. Her nervousness on this subject had grown as the months and years passed, knowing as she did that the problem was outside the scope of scientific medical remedy. The injustice of fate was all the greater when Berthe learned, early in 1878, that Edma was pregnant for a third time. Her sisters' fertility seemed to mock her choice of a different vocation: art as opposed to motherhood. Despite their genuine affection for each other, providence, it seemed, had set her apart.

In addition to this, her life in the busy and fashionable Avenue d'Eylau drove an embarrassing wedge between Berthe and her fellow Impressionists who were still struggling, in Pissarro's words, against 'a hungry belly, and empty purse'. 'We are living through a very troubled time', Cézanne wrote to Zola in August 1877, and he sensed then that the group spirit, which had once flourished on mutual admiration as well as mutual need, was in danger of dissipating. 'A profound desolation seems to reign in the Impressionist camp', he confessed sadly, echoing more intensely Eugène's concerns in 1876. Even the bourgeois Monsieur Degas would be 'overwhelmed' on his own admission in the coming months by his family's banking failures.[10] The battle for survival forced each of the artists to go his own way. Neither Monet, now living outside Paris at Vétheuil and nursing his invalid wife, nor Renoir, anxious to make a good living by distancing himself from his 'revolutionary' associates, was willing to take the initiative in organizing

another group exhibition in the spring of 1878. The Salon that year was dominated by the memory of Thiers: Vibert's portrait of the lying-in-state and Jules Garnier's massive picture of the triumphant liberator of France portrayed in the National Assembly. Manet had sulkily avoided the event. Historical paintings were much in evidence. Gustave Doré and Carolus-Duran jockeyed for attention, but the prizes went to sculptors. It was not a favourable year for Impressionism.[11]

For Berthe another cause of sadness was the death at the end of May 1878 of the elderly Léon Riesener, the father of her friends Louise and Rosalie. Nine months later it was the turn of the engraver Daumier, by now old and blind but remembered as the delightful man who had entertained the Morisots at lunch in 1863. After the loss of her parents, it seemed to Berthe that except for her indomitable grandfather, the older generation was slipping away. Again Berthe meditated on the fleeting nature of existence and the irreversible passage of time. But she was also losing touch with valued friends. Since 1875 ill health had driven Adèle d'Affry away from Paris. She spent most of her time in Italy, Switzerland and Provence, maintaining a voluminous correspondence despite her consumptive condition. Yet when Berthe heard in July 1879 that her 'dear duchess' had died suddenly at Castellamare on the Bay of Naples, she was inconsolable. The sculptress was forty-two and at the height of her artistic powers. For all Adèle's empty snobbery, Berthe had never ceased to regard her with a special warmth and admiration.[12]

The disappearance of familiar faces from the Parisian scene weighed upon her. The melancholy days returned with a vengeance. Like her friend Degas, Berthe found death increasingly hard to come to terms with, particularly when it seemed untimely. She was reminded of Fanny Claus's premature death in April 1877, a cruel blow to her husband Pierre Prins. Despite the high incidence of childhood deaths, she could never reconcile herself to their occurrence. She grieved for the Mallarmés who lost their only son, Anatole, in October 1879 at the age of eight. Her artistic colleagues were suffering too. In February 1879, Renoir lost his favourite model, a young and beautiful girl, Margot Legrand: she died of smallpox. And by July, Claude Monet's wife, Camille, was terminally ill with cancer. He was racked by remorse and personal doubt, hinting at suicide. Sisley spoke bitterly of vegetating, Pissarro was bordering on despair.[13] The world was a brutish place.

Yet all was not gloom. For others Paris was still a city of hope and promise. In the spring of 1878 the capital buzzed with activity as another Great Universal Exhibition was opened to the world. Flags and bunting everywhere greeted the twelve million visitors who flooded the city until October to see the artistic and industrial achievements of France and the rest of the civilized world. Then soon after Easter Berthe found herself

facing a situation that she had come to believe was outside the bounds of possibility. Like Edma two months earlier, she was startled to find herself pregnant. To be *enceinte* for the first time at the age of thirty-seven was daunting; but to have her 39-year-old sister Edma in the same condition gave her much-needed moral support. Taking the best advice available, Berthe discreetly withdrew into a life of quiet solitude. She avoided physical activity, even painting. And like every expectant mother with time on her hands, she was preoccupied with the sex of her unborn child. She longed openly for a boy in order to 'perpetuate a famous name', but mostly, as she admitted to Yves, 'for the simple reason that each and every one of us, men and women, are in love with the male sex'.[14] Thus at the lips of this supremely gifted woman came the strongest confirmation of her conventional maternal impulses and the clearest denial of any feminist antiversion.

On 13 September Edma gave birth to a son. He was named Edme after Papa Morisot and herself. Berthe had another eight weeks to wait for her confinement in the apartment at the Avenue d'Eylau. Then on Thursday 14 November she was delivered of a healthy baby daughter. They called her Julie.[15]

Marriage had given Berthe status and had satisfied the social prerequisites of the Morisot family. Motherhood gave her unalloyed joy and a depth of personal fulfilment beyond her wildest dreams. Like many first-time mothers, she was overwhelmed by a sense of achievement. Yet she struggled to control the surging pride in having borne a Manet. Being naturally modest, she felt bound to control her elation by wrapping it up in a touch of self-mockery. 'Well, I am just like everybody else!' she told Yves. 'I regret that Bibi is not a boy. In the first place she looks like a boy . . .' But to contain her emotions she had to add, 'Your Bibi [Jeannie] is a darling; you'll find mine ugly in comparison, with her head as flat as a paving stone. . . . All poor Julie has to offer is her fat cheeks and her pretty complexion.' To Edma also she was sheepish in boasting about her baby's progress. 'Julie or Rose is like a big inflated balloon.' Berthe was never ill-at-ease with children and she wrote with warmth in a note to her niece Jeanne: 'I should not mind showing you my little Bibi who in reality is not as ugly as in her photograph, and is sweet as an angel . . . she is like a kitten, always happy.'[16]

If she made no mention of Eugène in all this, it could be quite a significant omission. In her heightened emotional state, what mattered most of all to Berthe was something which came out in a Freudian slip. 'My daughter is a Manet to the tips of her fingers; even at this early date she is like her uncles, she has nothing of me.' And by the following summer, 1879, when she resumed painting pictures and produced some intricate little watercolours, such as *Luncheon in the Country*, figuring Julie with her

nursemaid and young Marcel Gobillard, she observed in her daughter the fair skin, the candid open gaze, quick smile, sparkling eyes and good facial bone structure, all of which were associated in her mind with Edouard Manet: and she was thoroughly content.[17]

Berthe had one other cause for satisfaction. During the tedious time when she was waiting for her baby's birth, in 1878, Manet's friend, Théodore Duret, had published *The Impressionist Painters*. It was the most spirited and articulate defence of the avant-garde school that had yet appeared, and in it he classed Berthe Morisot, in the Quintet with Monet, Renoir, Sisley and Pissarro, as a true 'painter of light'.[18] So reflecting on her priorities in 1879, Berthe could congratulate herself on a rare triad of achievements: marriage, maternity and the first indications of professional acclaim. Now, without a shadow of doubt, she had entered 'the positive stage of life', to use a phrase she subconsciously borrowed from those early well-learned lessons at the Cours Lévi or the Cours Désir.[19]

Tradition has it that Berthe had a difficult confinement and regained her energy only slowly during the spring of 1879. Given the practice of keeping middle-class mothers (especially those of mature years) confined to bed for some weeks, a slow recovery was probably to be expected. Her situation must have reminded her of the terrible year when she was denied access to her studio. It is also said that a lack of energy and willpower accounts for her failure to take part in the fourth Impressionist exhibition in April 1879. The truth was rather different. Despite her physical weakness, she was extremely anxious to return to work. 'I have always had a need for activity', she admitted later.[20] So in the midst of her new domestic role, it seems she turned to Degas's medium of delicate, hand-painted fans, in which she was quickly perceived by her artistic colleagues to have expertise.

Abortive attempts had been made to hold a fourth exhibition, first in June and then in the autumn of 1878, while Berthe was expecting her baby. The June date would have been acceptable to her, so she told Degas in March (when she may not have known she was pregnant), but the later date would have been too risky for her pregnancy. In fact, any initiative would have been doomed to fail because of competition from the Universal Exhibition. So it was in January or early February 1879 before serious plans were afoot for a new exhibition. Degas and Caillebotte, the leading instigators, once more presumed to count on Berthe's support. During February, when Julie was three months old, they let her know discussions were under way and that the dealer, Alphonse Portier, had agreed to act as business manager. At this stage, Berthe was keen to keep her options open, and must have said so. Degas was too much of a gentleman to appear to be putting pressure on her, so he asked his new protégée, the American artist Mary Cassatt, as respectable a *grande dame* as Madame Eugène Manet

herself, if she would call at the Avenue d'Eylau and try to seal Berthe's agreement, particularly to the specific condition of non-submission to the Salon. Degas, it seems, was confident when he wrote to Caillebotte in the middle of March: "Mlle Cassatt is seeing Mlle Morisot tomorrow and will know her decision. We are therefore almost certainly: Caillebotte, Pissarro, Mlle Cassatt, Mlle Morisot, Monet, Cézanne, Guillaumin, Rouart . . .'[21]; and he went on to enumerate another nine artists, including Bracquemond and himself. Berthe Morisot was obviously considered a likely participant.

Degas had also discussed with Mary Cassatt the possibility of several 'desertions' from the ranks of the original Independents in favour of the official Salon – and as it turned out there were some, including Renoir, Sisley and Cézanne. But there was never any suggestion that Berthe Morisot was a possible defector. It is true that there is no record of the conversation which took place in the Manet apartment between the two ladies. It must have been a difficult meeting; it was certainly a critical one. Berthe always spoke softly and hurriedly in low tones; Mary Cassatt's voice was loud and harsh. Berthe's spoken English had never been fluent and Mary Cassatt's French was the object of some polite ridicule on the part of her Parisian friends. In such situations nuances are lost and misunderstandings arise. However, a fortnight later the news in Paris was that the exhibition would open on 10 April within recently completed premises in the prestigious new Avenue de l'Opéra with *three* women artists listed as exhibitors: Mary Cassatt, Marie Bracquemond *and* Berthe Morisot. There is no doubt that even in early April Degas was expecting Berthe to take part, and that she would be displaying some decorated fans: a special room was set aside for this particular genre, since he, Forain and Pissarro also proposed to show some.[22] However, when the official catalogue was printed and the Fourth Exhibition opened its doors on 10 April, Berthe's name and exhibits were nowhere to be seen. Sometime during the first week in April Berthe gave word that she would not be contributing. And her absence, confirmed by several critics, was considered to be a sad loss to the quality of the exhibition.

This public retreat from her former solidarity with the Impressionists (a volte-face was the term used by one expert)[23], has never been adequately explained. Had Berthe been suddenly taken ill, it would not have prevented Eugène from arranging for her exhibits to be conveyed to the Avenue de l'Opéra, for he took on the organization of her exhibits in 1882 when she was out of Paris. And there is a curious twist to the mystery. The Irish writer, George Moore, later made a curious observation in his *Confessions of a Young Man*. Telescoping his memories into one brief description, he said of 'Madame Morisot': 'Take note, too, of the stand of fans; what delicious fancies are there – willows, balconies, gardens and terraces . . . distant tendresses.'[24] So where were the 'delicate fancies' of 1879? Was Moore

totally confused or does this suggest some precipitate action on Berthe's part? The key to the conundrum must lie in her state of mind.

She had always been fastidious, her own severest critic and counsellor of perfection, and these characteristics intensified in times of emotional stress. She had won respect with her vibrant oils and delicate watercolours but as the opening day approached, she felt unprepared and probably convinced herself that she had nothing worthwhile to contribute. Monet shared the same crisis of confidence. 'I am completely disgusted and demoralized', he told his patron, Dr de Bellio, in March. 'I hear that my friends prepare a new exhibition this year; I renounce taking part in it, not having done anything that's worth being shown.'[25] Berthe's sentiments precisely. Yet, was that the case when Mary Cassatt called at the Avenue d'Eylau? Or more to the point, was Berthe's change of heart something to do with Miss Cassatt's sudden dynamic entrance into the Impressionist circle? She had first appeared actively on the scene during Berthe's pregnancy. In June 1878 she had also bought one of Berthe's pictures from the Hoschédé collection – *Woman at her Toilette* – at the knock-down price of 95 francs. All that is known about Berthe Morisot's reactions to younger female rivals – and there were the obvious precedents of Victoria Dubourg and Eva Gonzalès – suggests a powerful connection between events. She sensed serious competition.

Mary Cassatt was an impressive personality. She had the advantage of being wealthy and intelligent and also of being three years younger than Berthe: not so young as to be inexperienced, but old enough, at thirty-five, to know her own mind. In appearance she was tall, elegant and refined, 'a true aristocrat', according to Paul Durand-Ruel, 'A real American lady', in the words of Jean de Sailly. In character, Miss Cassatt was forceful and opinionated.[26] She displayed the self-confidence of belonging to a powerful, new nation, proud of its republicanism, which enabled her to be a friend of someone as radical as Clemenceau. To Berthe Morisot, another 'real lady', equally determined and the only woman in the Impressionist school, Mary Cassatt presented a formidable threat – a threat which Marie Bracquemond could never pose. And Berthe's instincts served her well in this respect. It is significant that a quarter of a century later, in 1904, Mary Cassatt was to write, 'I was one of the original "Independents" who founded a society on principles, which were, there was to be no jury, no medals, no awards . . . and amongst the artists were Monet, Degas, Pissarro, Mme. Morisot, Sisley, and I. Our first exhibition was held in 1879, and since then we . . . have stuck to the original tenets.'[27]

Time plays tricks on the memory, but Mary Cassatt's was highly selective on this occasion. It was as if in her mind the Anonymous Society of 1874, the famous auction of 1875 and the original three exhibitions had never happened. Yet these events were crucial stages in the evolution of

Impressionism. Berthe Morisot had participated in all these initiatives. She remembered the arguments and faced the criticism. She knew the artists. Duret had identified the seminal figures for posterity as a quintet – Monet, Renoir, Sisley, Pissarro and Morisot. Berthe also knew instinctively that the American artist might be temperamentally inclined, as well as being sufficiently talented, to oust her from the leading female role. Berthe Morisot, Madame Manet, was proud and sensitive enough to resent her intrusion.

In addition another emotion compounded the situation, jealousy. Degas had been an intimate friend of Berthe for over a decade, an admirer, possibly even a suitor. As with Fantin-Latour many years before, theirs was a special relationship in Berthe's eyes, forged by years in each other's company and sealed with a particular loyalty. It was a relationship enmeshed in a network of bourgeois friends and family and it had given her valued psychological support at difficult times. While he had never been her teacher, Degas was a strong influence in her professional life: he had encouraged her to join the 'Independents' five years before when Manet derided them. Now this rapport seemed threatened by the emergence of his gifted pupil. It looked like an act of betrayal on Degas's part to encourage this newcomer, Miss Cassatt, with whom he had another 'special' relationship, to exhibit with the group, though it was significant that Berthe did not blame the man. But she could not tolerate such rivalry, any more than she could endure the prospect of comparisons being drawn that spring in the reviews between her small-scale *éventaux d'art* and Mary Cassatt's portraits of young women, her 'exquisite symphonies of colour' (as they were described by Arsène Houssaye in *L'Artiste*).[28]

Years later, when time had softened the contours of this rivalry between two upper-class women, one the daughter of a Pittsburgh stockbroker, the other of a Prefect of France, Denis Rouart, Berthe's grandson, recalled how in their correspondence Berthe always addressed the American artist as 'Chère Madame', whereas Mary's letters began 'Chère Berthe'. This may have been partly a matter of cultural difference, but with meaningful understatement he admitted they were never great friends.[29] In 1879 friendship was not a relevant word: they were professional rivals. As the opening of the fourth exhibition drew near, Berthe pondered her position astutely. She decided to play safe and withdraw altogether, using the pretext of her health. She needed the rest of the year to shake off her lethargy, regain her self-assurance, assert herself – and paint.

It was not easy. The attacks of mild depression came and went. On one occasion Madame Carré tried to tease her out of a dark mood. 'I think you have lived too long', she told Berthe laughingly.[30] The joke fell flat. In the meantime, Eugène continued to be stricken periodically by his severe migraines and there were adjustments to be made: stricter household

budgeting and a changing domestic routine. The apartment had to make room for a nursery with a resident nurse for Bibi. Berthe was afflicted by a nagging bourgeois problem: 'Life is largely a question of money, which is not at all to my liking', she admitted to Yves.[31] Then the family doctor caused a commotion by recommending that they should spend the whole of the summer by the sea. Julie, a plump infant by all accounts, had a slight tendency to chestiness which was aggravated by the humid, overheated conditions of the capital. Berthe complained that they were too poor to consider a traditional summer retreat, though in the end the money was raised for a short stay in Beuzeval by Houlgate, where she had once spent long holidays *en famille* in the Rieseners' converted windmill. The rest of the time, however, was spent quietly in Paris, except for the occasional outing into the Ile de Paris, such as a trip to the Meudon heights. It was a productive time, however: from it came the elegant, summery portrait of a *Young Woman Dressed for the Ball (Jeune Femme au Bal)* and other indoor figure-paintings, *Young Woman Seated, Woman Sewing* and *Behind the Venetian Blinds*, an unusual composition set on the terrace of the Avenue d'Eylau, in which a plump young woman in profile (was she the housemaid, perhaps?) is seated on one of the Morisot heirlooms, an ebony spindle-backed chair used in Berthe's *Interior* scene seven years earlier.

From her birth Julie became the centre of her mother's passionate attention. Thinking of her spiritual welfare as well as her physical needs, Berthe had the child formally baptized Eugénie Julie (much to the surprise of all their anti-clerical, Republican friends) and vaccinated against smallpox. 'Two necessary chores are thus behind me', she confided in Edma.[32] Berthe was in the habit of accompanying Julie and her nurse, Angèle, on their daily walks in the Bois de Boulogne. The exercise was therapeutic, but Berthe saw the Bois in summer as an inspiration for working out of doors. The park had so much to offer, woodland and water, bird and animal life, plenty of secluded cover and spacious *allées*, and above all, humanity ever on the move. Using watercolour, she painted the lake in *At the Water's Edge* and a sketch of *Summer's Day*. But most of all, with her little daughter as a new model, she portrayed Julie in her cradle, in her pram, being breast-fed by the wet-nurse, sitting on Angèle's knee. So she began to find a compromise between the practical demands of her new way of life and her own perfectionism. Her oil versions of *Women Gathering Flowers (In the Garden)* and *Summer's Day (The Lake in the Bois de Boulogne)* – for English art-lovers, Berthe Morisot's most famous boating scene – show how far she was succeeding.

Autumn gave way to a winter that was memorable for its severity. The first snowfalls came at the beginning of December. Before Christmas the Seine was frozen over for the first time since 1861, and the freezing weather continued well into 1880. She worked indoors: from this time came her

romantic, opaline picture of a young woman viewed from behind as she touched up her hair (*Jeune Femme de Dos à sa Toilette*) and pastels and oils of young Marcel Gobillard in his formal grey suit, painted while he was staying with his aunt. From a pastel study, she also produced another sombre seasonal portrait – *Winter* – of a young woman, her hands tucked into a brown muff. However, on an outing to the Bois Berthe was suddenly struck by the transmutant effect of frost and ice upon the cold air and in that moment she realized the wintry daylight offered her a new artistic challenge. In the course of this bitter spell, she produced some atmospheric vignettes, working quickly and in loose strokes, sometimes in pastel, and, in the case of *Young Woman Retying her Skate*, with sensationally novel effects.

It was about this time, the end of January 1880, that a mischievous notice appeared in *Le Gaulois*, indicating that Claude Monet would be deserting his Independent colleagues to exhibit in the official Salon. Some saw this as a sign of Impressionism's impending demise. In view of the decision of Renoir, Sisley and Berthe Morisot – the other three of the original quartet – not to take part in the fourth exhibition, and with the defection for personal reasons of Cézanne, it had been left to the stalwart and prolific Pissarro to provide the largest group of pictures for that show. The 1879 exhibition had proved to be a rather improvised affair, even though it attracted bigger crowds. In truth, Impressionism no longer shocked. The fire had gone from the bellies of the critics. They seemed more concerned to harp on the lack of innovation, while former supporters, like Mantz, Zola, Ernest Chesneau and Georges Rivière, had grown tired of upholding a group that appeared to be dissipating its clear identity. It was as well that by the beginning of 1880 Berthe had rediscovered her inspiration and commitment because Degas was counting on her support. He was not a born organizer, and there were inevitable disagreements – notably with Caillebotte – over practical matters such as the posters, the noise and the lighting, after premises had been found near the Louvre, in an unfinished building at 10 rue des Pyramides. Of the original 1874 exhibitors, only Degas, Pissarro, Caillebotte, Guillaumin and Rouart were willing to be involved, and it was seen as an unfortunate omen that Duranty, author of *The New Painting*, died on 10 April, just a week into the exhibition.[33]

After three years' abstinence, however, Berthe felt ready to test her work again in public. The works she decided to show typified her evolving, original style. Her return was generally welcomed, and her exhibits, ten oils, four watercolours and a fan, received considerable publicity, more than either Degas or Mary Cassatt.[34] Paradoxically Albert Wolff exonerated Berthe from his general criticisms of the exhibition, as he made clear, whereas past supporters of the Impressionists, Mantz, Ephrussi and Silvestre, tempered their praise for her work with the old, familiar complaints about her daubing and lack of finish. But given the contradictions of the fifth exhibition (in

which the meretricious newcomer, Raffaelli, was overly praised and Paul Gauguin was dismissed by one journalist as 'of no consequence'),[35] it was not surprising that Berthe Morisot's most hostile critic was Duranty's fellow Naturalist writer, Joris-Karl Huysmans of *L'Art Moderne*, who echoed the late novelist's liking for Degas, and with him his protégée Mary Cassatt. Not only did Huysmans refer to Berthe inaccurately as Manet's pupil, but he concluded with tedious lack of originality, 'These lifeless sketches exude a wilful, mundane elegance and perhaps the epithet "hysterical" would not be inappropriate to describe such astonishing improvisations.'[36]

However, on balance the publicity she received left her satisfied. The young banker, *boulevardier* and reviewer of the *Gazette des Beaux-Arts*, Charles Ephrussi, declared aptly that 'Berthe Morisot is French in her distinction, elegance, gaiety and nonchalance'. On balance, he thought well enough of her work to buy the portrait *Winter*, while the *Young Woman Dressed for the Ball* went to another banker, de Nittis, who had taken part in the first exhibition in the Boulevard des Capucines. And there was no lack of compliments. 'I have been seduced and charmed by Morisot's talent', admitted Arthur d'Echerac of *La Justice*. 'I have seen nothing more delicate in painting. Her works, *Summer, The Lake in the Bois de Boulogne, The Avenue of the Bois*, and a *Portrait*, have been painted with extraordinarily subtle tones.' And both Philippe Burty and Paul Mantz paid homage to her distinguished lineage. Burty purred: 'Berthe Morisot handles the palette and brush with a truly astonishing delicacy. Since the eighteenth century, since Fragonard, no one at all has used clearer tones with such intelligent assurance.'[37]

With the wisdom of hindsight it is easier to perceive the effects of the emotional intensity experienced by Berthe Morisot after the birth of her daughter Julie. She 'became, in the period between 1878 and 1879, an artistic personality in her own right, striking out new paths for herself which she steadily followed from then on'.[38] This was the judgement of her grandson three-quarters of a century later, but it was the voice of a considerable expert rather than the sentiment of an heir. In the coming decade she retained the primary purpose of the true *luministe*, to render the sensation of colour and light as directly and truly as possible. She worked in an idiom that was 'free and nervous, characterized by bold brushstrokes as though the brush, jabbing at the canvas, left dabs of pigment behind, irregular, disjointed, corresponding only to the play of the coloured light as it struck her dazzled eyesight'. For George Moore it was her gift for creating light that marked her out: 'Look how wonderfully she always handled the white in her pictures; no one ever made such a fine use of white.' She was, Jules Clarétie observed in *Le Temps*, 'a thoroughgoing, unrepentant Impressionist'.[39]

Edouard

1880–3

'My dear Berthe, do not be surprised to receive this latest style easel, very handy for pastel; it is my modest New Year's gift.' Edouard's little note was dated 28 December 1880. Although this was a traditional time for family festivities and the exchange of gifts, its message was revealing. This was a peace-offering. He was sorry that circumstances seemed to keep them apart. Sometimes he felt guilty about Berthe, helpless too, as he did with Eva Gonzalès: 'I see that you get along perfectly well without me. . . . It's a long time since you asked for my advice. Has my lack of success earned me your contempt?' He might have used the same words to Berthe. It was a matter of genuine regret to him that they had both gone their own way.[1]

The events of 1880 underlined his point. In April, while Berthe had been exhibiting with the Independents at the rue des Pyramides, Edouard had been showing a selection of his latest works in a one-man exhibition at *La Vie Moderne*, Charpentier's gallery in the Boulevard des Italiens. But Manet would not abandon the Salon and when two of his canvases were accepted, he took fresh heart. He needed cheering. Exhausted by overwork and worried about his health, he had escaped thankfully for the summer of 1880 to a friend's villa in Bellevue, overlooking the Seine, where he was prescribed daily massage and plenty of rest. But his new regime of taking short walks in the grounds and listening to Suzanne playing the piano, quickly palled. He still craved company, so he took to writing copious letters. To fend off boredom he resumed painting, too, but had to confine himself to small still lifes. Meanwhile Eugène and his family went off once more to Beuzeval in Normandy, where Berthe produced some pastoral landscapes in watercolour, in contrast to her urban and family scenes painted that year. One of these, worked with exceptionally free brushstrokes, of Julie full-face on her nurse's knee, revealed clearly how the chubby child with blue eyes and golden hair resembled her Uncle Edouard.

When the weather finally broke in mid-autumn, Suzanne and Edouard returned to Paris (they had moved apartments to no. 39 rue de Saint-Pétersbourg). The city was awash. 'Rain, rain, rain, and umbrellas', Degas complained to Henri Rouart.[2] In October Berthe's grandfather Thomas collapsed running after an omnibus and died at the ripe old age of ninety-

two. It seems that against her wishes his house in the rue Franklin was sold. The tempo of life was now dictated by family considerations. Eugène and Berthe lived quietly over the winter months of 1880–1. They even kept away from the Manets' Thursday receptions and Tuesday musical evenings.

Edouard's New Year gift to Berthe, then, was intended to mend fences – and to draw her attention to their new common interest, the use of pastels. It was a medium which had grown in popularity, especially since the foundation of the Société des Pastellistes in 1870. Privately Berthe was full of praise for Manet's beautiful pastel portraits of fashionable women like Mme Dupaty and Mme de Valtesse. Conversely, Manet had admired Berthe's handling of pastel for some years, but he had been specially taken with a profile of Julie, which she had drawn that winter of 1880 and which she was to show in the next Independent exhibition. In fact, he had been working regularly in pastels since 1878, colouring enthusiastically 'with broad and even brutal strokes'.[3] He found them less exhausting than oils, and the result was some forty pictures in the three years up to the end of 1880. Sometimes he and Berthe focused on the same subject in different ways. In 1877 Edouard had produced a pastel sketch of a woman skating – not, as in Berthe's exploitation of the theme, on the frozen lake of the Bois de Boulogne, but amid the crowds at the skating rink in the rue Blanche which he loved to frequent.

Edouard had no intention of interfering in Berthe's work. It was just his nature to make spontaneous comments when the opportunity arose, if only out of admiration. And although marriage and motherhood had given Berthe emotional maturity, she never had the heart to ignore his opinions. This came out time and time again. Debating with herself whether to exhibit a particular genre painting in 1882, the litmus test was that 'Pissarro and Edouard saw it and neither of them seemed to be lost in admiration'. In the case of an unfinished picture, *Lady with the Parrots*, Berthe agonized over the composition, wondering all the time what Edouard would have made of it. On the other hand, she was more confident of another – a small picture of Julie and her new nurse – for the simple reason that Edouard had taken the trouble to write and say that he liked it. Beneath her polished manner, this full-fledged artist would never shake off her deference to Edouard Manet so long as he lived.[4]

Although Eugène would have vigorously denied it, the myth of Berthe's dependency on Manet kept surfacing. It had reappeared in 1877 in *L'Artiste*: 'Mlle Morisot is a pupil of M. Manet, that is to say she sees nature in terms of separate touches of colour rather than through an iridescence of colours, as does M. Renoir. She copies M. Manet but her delicate nature has caused her to transform the masculine idiom which made the master a great painter, into the delicate and sensitive techniques of the feminine idiom, and despite being derivative, has produced a certain originality in her

work.'[5] And after being repeated by Huysmans in *L'Art Moderne*, it was difficult for Berthe to contest such publicly stated views.

A careful study of the evidence suggests that the two-way interaction, which has been touched on before, continued between Manet and Berthe Morisot. After her marriage their give-and-take probably never amounted to collaboration in the studio. But it would be naive to deny that Manet's now-famous picture *Boating*, which was exhibited in the Salon of 1879, gave her the idea for the composition of *Summer's Day*. We could go further. Was Manet's picture *Before the Mirror* (1876), with its deliberate off-beat back view of the model, the inspiration for Berthe's poetic *Woman at her Toilette* (1879)? No more, one suspects, than the compelling effrontery of *Nana* (1877) owes something to the feminine grace of Berthe's *Cheval Mirror* (1876). Not surprisingly, their spasmodic cooperation – if that was what it was – took other forms. In 1877 Manet had found a new model for his genre painting, *The Plum*, a young woman who frequented the brasserie Nouvelle-Athènes. He must have suggested the woman to Berthe, who used her at least twice in 1879 with another titian-haired woman, for *Summer's Day* and *Women Gathering Flowers*. Whether one of them also posed for Berthe's *Winter* is impossible to be sure. But Manet was obviously so struck by Berthe's skilful blending of atmosphere and figure in this picture, and in her earlier putative self-portrait, *Summer*, when they appeared in the 1880 fifth exhibition, that in the course of 1881 he was moved to produce two paintings entitled *Spring* and *Autumn* (figuring two of his favourite models, Jeanne de Marsy and Méry Laurent) which rank among his most admired pictures. Was it his intention to complete the series? If so, he never did. So these four works by Berthe Morisot and Edouard Manet, associated by title with the seasons, remain an extraordinarily apposite and beautiful complement to each other.[6]

Manet was never inhibited. Whether he acknowledged it to himself or not, much of his late work shows his artistic affinity with Berthe and her Impressionist colleagues. He was concerned with the transient. Beauty is always changing, he told Antonin Proust; and 'one doesn't just paint a landscape or a marine or figure study but the impressions of a moment in time'. Neither Berthe nor Monet could have expressed it more cogently. Proust recalled that in 1879 Edouard's obsession was to paint a picture 'entirely out of doors, in which the features of persons would melt . . . in the vibrations of the atmosphere'.[7] In the three summers of 1880–2 he completed a number of *plein air* paintings in the grounds of the Bellevue establishment where Berthe and Eugène visited him. He found the air invigorating and 'the sight of flowers and the contemplation of woods' enchanting and conducive to work.[8] These outdoor scenes were reminiscent of Renoir and Monet, but his inclination towards pure Impressionism went back more than a decade to half-remembered conversations with Berthe during the 1860s and early 1870s.

In January 1881 Gustave Caillebotte made the first moves towards another avant-garde exhibition. The auguries were not good, for Monet, Sisley and Renoir, Berthe's former colleagues, disqualified themselves by deciding to submit to the Salon, and Caillebotte accused Degas of introducing disunity into their midst. Pissarro the conciliator tried his best to push the idea of tolerance and communality, but it was no use. Caillebotte withdrew, leaving Degas to organize the sixth exhibition for April 1881 in Nadar's former premises in the Boulevard des Capucines. Berthe agreed to take part, but the exhibition came at an inconvenient time. Her friend, Louise Riesener, had come to sit for her portrait, but more than that, taking stock of their improved financial situation, Eugène was in the throes of making important decisions on their behalf. From the late 1870s, the French economy was overheating as the bourgeoisie rushed to buy investment stocks and indulge in capital projects. At some point – it is not clear precisely when – Eugène at last acquired a government position in the Finance Ministry. With the promise of a regular income and inherited investments as sureties, he and Berthe decided to buy and develop a plot of land in the rue de Villejust. The western fringe of the city was being rapidly developed at this time; the Cassatts were another family inspecting new properties in the area, though as the exhibition approached they gave up the idea of moving. The Eugène Manets, however, decided to leave the Avenue d'Eylau and move temporarily to the country. The fact that Berthe sent a small mixture of works to the exhibition (including a gauche garden scene of Angèle breast-feeding Julie) which were not hung in time for the opening day, 2 April, suggests their schedule was confused.[9]

As things turned out, the sixth exhibition was conspicuous for the work of Degas (his sculpture of the fourteen-year-old dancer) and for the involvement of artists like Raffaelli, Zandomeneghi and Bracquemond, whom he persuaded to come in, though they could hardly be described as Impressionists. In fact, only Berthe and Camille Pissarro represented the original group. The emphasis was on modern realism rather than light-touched landscapes and figures. The critics were not unkind to Berthe, although Huysmans was more complimentary to Mary Cassatt; like Gauguin, he felt the American's painting was 'more poised, more calm, more able than that of Mme Morisot', remarks not calculated to endear her to Berthe. On balance, however, the reviewers accepted Berthe's sketchy forms as the price for her 'luminous effects, for harmonious combinations'; and Gustave Geffroy confirmed that 'No one represents Impressionism with more refined talent or with more authority than Morisot'.[10] And far from being daunted, she was to develop these in the next few years in the subtle light of the Ile-de-France.

In the late spring or early summer of 1881 the Eugène Manets moved into

a rented house with a large, enclosed garden at 4 rue de la Princesse in the picturesque township of Bougival. It was the fashionable thing to do. Once a popular bathing spot like Gennevilliers, Bougival was linked by railway with Paris and was becoming a riverside commuter town. Renoir was there that summer and chose it as the setting for his *Luncheon at Bougival* (more popularly known as *The Luncheon of the Boating Party*). The Cassatts meanwhile were staying in a villa nearby at Marly-le-Roi. Like Bougival it was close to Versailles, where Edouard, Suzanne and Maman Manet had taken a furnished house in the Avenue de Villeneuve-d'Etang from the end of June. Berthe found her holiday productive, for out of it came some twenty drawings and paintings. Her former model, Milly, posed on the grass with a sunshade, wearing a pale blue gown. But most of her Bougival pictures were intimate family pictures, painted in the sunlit garden: golden-haired Julie pulling a toy or playing a game at her father's knee while Eugène, pensive, hands in pockets, absent-mindedly watched over her; the new nurse, Pasie, with pale face and auburn hair, sitting in a shady corner by the house, quietly sewing. They are pictures full of colour, a gamut of greens, hot, earthy pinks and cool blues; mature trees filtering the sun's rays; a cobalt garden bench here, a sandy path, a straw hat there; a quiet conservatory; shuttered windows; bushes ablaze with roses, and clumps of hollyhocks.[11]

When the summer was over, and without a town house of their own to return to, Berthe wanted to escape the rigours of a Parisian winter and try an experiment. Her intention was a long-term stay in Nice, broken perhaps by a trip to Italy, which had been one of her dreams for many years. Recalling her father's homilies on classical art, she was curious to see the Mediterranean and experience its warmth, encouraged perhaps by Marcellin Desboutin's decision to retire to Nice in 1880. Or possibly she had Eugène's delicate health in mind, for according to the English eighteenth-century novelist, Tobias Smollett, who came there to cure his consumption, the air had a reputation for being 'agreeable to the constitution of those who labour under disorders arising from weak nerves, obstructed perspiration . . . and a languid circulation'.[12] On the strength of this, climatotherapy had become an important local industry. The crucial fact, however, is that they were now part of a privileged élite who could contemplate living *en villégiature*. And Nice was at this time a city at the very peak of fashion, reflecting the country's booming economy.

Nestling at the foot of the Maritime Alps and prized for its mild climate and long hours of sunshine, Nice had grown rapidly since its days as a medieval port peopled by seafarers of Italian stock. It had become a sophisticated resort beloved by the French upper crust, and by rich English *hivernants* (not least by Queen Victoria) who gave rise to the magnificent coastal Promenade des Anglais. Cosmopolitan, too: a haven for émigrés from different regimes. Both Adèle d'Affry and Marie Bashkirtseff had lived

there with their mothers, and Bashkirtseff, with her painter's eye, found the beauty 'quite maddening'; 'the sky of Nice enraptures me. . . . The sea is slightly silvered by the sun, veiled under clouds of a soft and warm grey. The verdure is dazzling.'[13] The new fashionable area was Cimiez, and about this time, the early 1880s, a clutch of large hotels, airy, luxurious palaces, were under construction. With good railway connections, an impressive seafront, an opera house, an annual winter carnival – the famous Battle of Flowers – a brand new municipal casino as well as the Jetée-Promenade, a cast-iron and glass pier and casino built on the model of Brighton, a choice of rural villas and solid hotels, Nice, it seemed, had everything its wealthy visitors could want.

The Eugène Manets stayed in the Hotel Richmond, Avenue Delphine.[14] Berthe became friendly with her French neighbours, also some young American ladies, but there is no evidence that she met up with Desboutin or with Eugène Pertuiset, a big game hunter, art collector and acquaintance of Manet, who was reputedly staying at the Grand Hotel and whose portrait by Edouard had been shown at the previous Salon. She also just missed one of Carolus-Duran's former pupils, the rising American portraitist, John Singer Sargent. Julie, on the other hand, befriended a little Russian girl; 'they adore each other; they never stop hugging', Berthe reported with amusement.[15]

In the course of the winter of 1881 and the spring of 1882 Berthe painted at least eighteen landscapes, watercolours and oils, of the surrounding scene, the houses, harbour, the ships in port and the beach where Julie played. She paid a visit to Monaco and attended the theatre to see the latest Sardou play. The winter in Nice was drawing to a close as they set off for Italy, in February. It would seem they had an open-ended itinerary. Edouard instructed them to include Venice, but after making stops to take in the artistic heritage of Genoa and Pisa, they moved on to Florence. To judge from many later remarks, the Botticellis in the Uffizi filled Berthe with wonder and admiration, but her pleasure was soon overtaken by events: Julie developed a chest infection. They decided it would be foolish to carry on. Instead, they returned to Nice, whence Eugène was hurriedly recalled to Paris.

Since leaving Paris in the autumn the Manets had been in touch with their relatives by letter. It was once more a time of political flux both in France and abroad. Tiburce Morisot, still a confirmed adventurer, had been angling for some while for another overseas posting, where he hoped to find his Eldorado. These were years when colonizing the African continent stirred the imagination of many Frenchmen. Tunisia had recently become a French protectorate, and with his eye to the main chance Tiburce conceivably saw Egypt as the next target. Jules Ferry's presence in the ministry must have proved valuable, for although he was not yet responsible

for colonial affairs, Ferry had been ambassador in Athens and knew whom to approach. At any rate, it was announced early in 1882 that Tiburce Morisot had been appointed as secretary to the minister for Sudan by the Egyptian government. He was due to leave in March, at a time when anti-European feeling and Anglo-French rivalry were on the increase, though it is questionable whether the family appreciated how volatile a situation existed out there.[16]

In the meantime, other more promising developments had taken place. Soon after their arrival in Nice – it happened to be Julie's third birthday – there was a change of government and the president appointed Edouard's favourite politician, Léon Gambetta, as premier of a new administration. Manet was additionally pleased by the news that his old friend, Antonin Proust, had been appointed Minister of Fine Arts. In 1880 he had painted Proust's portrait yet again, a lucky coincidence in Renoir's opinion. 'So there *is* a minister who has at least some idea that painting is carried on in France', Renoir said with satisfaction.[17] Those close to Edouard realized the moment had come when the official recognition he so richly deserved, but had been repeatedly denied by the artistic establishment, would at last be his.

And so it was. In the 1882 New Year's Honours, Edouard's name appeared as *Chevalier de la Légion d'Honneur*. He was unashamedly delighted as he contemplated his famous red ribbon. The day before the announcement was made public in *L'Officiel* he penned a letter to Berthe in Nice. 'My dear Berthe, since I should rather send you nothing than a shabby present, I shall content myself for the time being with my best wishes. . . . Today I had a visit from the good Fantin who came to congratulate me, and then one from Faure, who was radiant because he is included in the New Year's promotion and has even commissioned me to do his portrait.'[18]

Berthe's reply must have pleased him, even though in her opinion Manet's greatness was self-evident and did not depend on recognition by the state. Others expressed their delight in his hour of triumph. The Café de la Nouvelle-Athènes flowed with champagne. Renoir wrote affectionately from Capri. Some came in person to express their good wishes. Even the former imperial superintendent-general of the Beaux-Arts, Count Nieuwerkerke, sent his congratulations. Edouard was extremely flattered by the fuss. But inevitably there were some who were puzzled or disapproving of his desire for fame. While Pissarro, a committed radical, greatly admired Manet's painting, he considered it a failing that his friend was so wedded to the idea of recognition by the establishment. Degas had been openly disparaging when Manet admitted his ambition. 'I've always known how thoroughly bourgeois you are!' he said in a scornful tone. There is even a suggestion that Eugène, the most self-effacing of men, considered that his brother wore his heart too ingenuously upon his sleeve.[19]

In reality, recognition had come none too soon. Shortly after the publication of the list the political scene shifted again. The Gambetta ministry lasted only eleven weeks, and by 26 January 1882 Proust was out of office again. Yet the ex-minister reiterated the opinion of a section of the artistic community, that Edouard Manet had the right to enjoy the nation's homage. All the same, the sour grapes Manet encountered were hurtful. He never sought notoriety, but he had acquired it in abundance. True fame, on the other hand, had been elusive, and he knew that for many artists it came posthumously. His bitterness lay close to the surface. 'It means one begins to live only after one's dead', he told Proust.[20]

There was pathos in his remark because by the beginning of 1882 Edouard Manet was a sick man. His family had been aware since the time of Julie's birth that he was suffering from periodic attacks of severe muscular pain which hindered movement. Eugène had pressed him to try his own favourite health treatment, homeopathy, which had given him some remission from persistent headaches. Eventually Edouard consulted a homeopath called Simon Vincent who practised near the Gare Saint-Lazare, but he wavered between scepticism and emotional dependence upon his medical advisers. For a while he was convinced of the efficacy of hydrotherapy, another form of alternative medicine. In 1879 he agreed to a course of treatment with a Dr Béni-Barde who practised in the rue de Miromesnil, in the fashionable Elysée quarter, and then in 1880 at another well-known hydrotherapeutic institution in Bellevue, near Sèvres, where he was prescribed prolonged bathing, massage and mild exercise. Cumulatively the treatment gave him some relief, but his condition fluctuated. He wrote to Berthe at Nice, 'This year [1881] is not ending very well for me as regards my health.'[21] However, three months later things had improved. During this remission, he was able to abandon his cane.

With hindsight it was clear that Manet had been struggling for about five years. For most of that time he remained full of bravado. He joked about his limp and various bodily discomforts, although he spent more and more time immobile in the studio in the rue d'Amsterdam. In the course of 1879 the family physician, Dr Siredey, privately diagnosed locomotor ataxia, a degenerative disease of the posterior spinal cord. While he did not spell it out, in order to spare Manet and his family from the tragic implications, the doctor recognized the symptoms of the tertiary phase of syphilis.

It seems possible that Manet had contracted it as a youth during his first sexual experiences with the dusky slave-prostitutes of Rio de Janeiro. The infection then remained benign for over twenty years, although Edouard's penchant for the *demi-mondaines* of the cafés and popular theatres of Paris always left him vulnerable to venereal disease, which as late as 1900 allegedly killed a sixth of the French population. More than Aids, to which it has been likened by doctors today, syphilis was a national scourge. It was

an irreversible illness, marked, in the terminal stages, by paralysis, delusion and insanity. Manet had watched Baudelaire dying of the disease, in mere oblivion, *sans* teeth, *sans* eyes, *sans* taste, *sans* everything. The Chabriers, Emmanuel and his wife, the poet Guy de Maupassant, whom Dr Blanche tended unsuccessfully, and Nina de Callias, exotic mistress of Manet's favourite bohemian salon, all went the same way. When there was no sustained improvement in his condition, Manet consulted other doctors, then turned to charlatans – the walls of public lavatories in Paris were littered with the names of quacks offering cures for the disease – until in 1880 he was evidently told the bleak facts of his condition.

From 1881 Manet was steadily more dependent on palliatives. Sometimes he steeled himself to join his friends in the Place Pigalle. De Nittis marvelled how it was that 'He exudes gaiety which he imparts to others. That is how I always visualize him – a man of sunny disposition, whom I love.'[22] Only his immediate household knew the truth: how he returned home exhausted, bitter and morose. In reflective moods and in the dead of night he came close to complete despair. Yet at other times he threw himself into his work, and despite everything continued to paint and draw. Amazingly, in this period he produced his *chef-d'oeuvre*, the *Bar at the Folies-Bergère*, which his great-nephew, Denis Rouart, considered the most perfect and complete of his works. Together with *Spring* ('a delicious jewel of a picture', in Jacques-Emile Blanche's phrase) he was to display it at the Salon of 1882 the following May. Indeed, work seemed to act as a spur. To Méry Laurent he confessed his longing to paint women 'in the middle of greenery and among flowers . . . where everything is enveloped in light, because, believe me, I'm not done for yet'.[23] So long as he could keep going, a contrary, puritanical streak prevented him from sharing the truth with his nearest and dearest. These included the Eugène Manets, wintering in Provence and Italy. They were virtually inaccessible and would have been the last to be told the prognosis by Edouard. In his letters he contrived to sound his usual self.

It was a letter from Edouard which alerted Berthe and Eugène to the prospects for another, the seventh, Independents' exhibition. Henri Rouart had offered to put up rent for the premises, but Pissarro, who had taken on the role of organizer, had tried and failed to contact Berthe because she was then in Italy. He went to Edouard to enlist his help and took the opportunity to press him to take part too. The artists were once more having trouble agreeing with one another, but, as Manet's letter to Berthe made clear, Pissarro was being pushed by Gauguin to contact all the original Impressionists and to bring them back into the fold – if necessary, at the expense of Degas and his Realist friends. Berthe hesitated at first, largely for practical reasons. She was not intending to return imminently to Paris and she was preoccupied with Julie, who was still recovering from bronchitis.

(Renoir was suffering from pneumonia at the same time in the South of France.) And like Sisley among others, she was worried that Monet, whom she regarded as incontestably the leader of the group, would perhaps pull out again at the last minute. Renoir also had reservations and, while recuperating, laid down his conditions. 'With Monet, Sisley, Mademoiselle Morisot, Pissarro, I will accept, but only with them.'[24]

After some discussion, Berthe relented. Since Eugène had to return to the capital for other reasons (work called, but he also had to check what was happening to their new apartment block in the rue de Villejust) he and Berthe agreed that he should act for her and organize her contribution to the exhibition. Caillebotte came back as an active participant, but only because Degas had withdrawn, followed by his disciples, Rouart and Mary Cassatt. It probably came as no surprise that Pissarro's plea to Manet fell on deaf ears. After his award, Edouard felt bound to the Salon, though he was happy to advise Eugène on the hanging of Berthe's pictures in the premises at 251 rue Saint-Honoré, and in due course he went along to view the results and pass judgement.

Edouard's letter to Berthe had indicated a sense of urgency behind this exhibition. The instigator was Paul Durand-Ruel, who had invested heavily in the Impressionists again since 1880 with the backing of the Union Générale Bank. In January of 1882 the bank had failed, and the frenzied stock market bubble was on the point of bursting. As Manet warned Berthe in February, 'Business is bad. Everyone is penniless as a result of the recent financial events, and painting is feeling the effect.' At the same time Pissarro had written to Monet, 'For Durand and for us the exhibition is a necessity.'[25] The fact was, to repay his loans Durand-Ruel urgently needed the Impressionists' paintings to win public acclaim and fetch good prices, so he gave the event all the support he could, even to the extent of influencing the press.

Eugène's main thought was for the practical arrangements. He travelled up from Nice on the hanging day itself and stayed in Gustave's flat in the rue Trudaine. The exhibition was due to open on 1 March. Eugène did his best for Berthe, keeping her fully informed of what was happening. On his arrival in Paris he went straight to the Salle des Panoramas in the rue Saint-Honoré, where 'he found all the brilliant group of the Impressionists busy hanging quantities of canvases in an enormous hall. Everyone was delighted to see me, especially because I have come for the purpose of exhibiting your works.'[26] But he had a great deal to do: he had to pick up one of Berthe's figure-paintings from her dealer, Alphonse Portier, and select and collect her other canvases from Bougival, then arrange for their framing and display. Berthe was content with half a dozen exhibits, one or two from Nice, the rest from Bougival. Seemingly she did not feel the urgency to maximize her opportunity, or perhaps she was too preoccupied with other

things. At any rate, not only had she the fewest exhibits this year (the catalogue listed nine, though Eugène rustled up twelve), but they were a week overdue. Consequently some critics failed to review her work. Eugène was anxious to rectify the situation. He urged her to paint more pictures quickly. 'Your landscape of the Villa Arnulfi is charming', he said encouragingly, 'and you did it in no time.'[27] But he must have known it was far too late.

The notices Berthe received were mixed. But she was forty-one now: publicly she took criticism with a dignified reserve, while privately swallowing the opinions of 'that Philistine Clarétie' and Wolff, the baleful critic of *Le Figaro*, who was in her view 'unbearably arrogant'. She was sceptical of Huysmans too, but by now she was used to fault-finding couched in a *placet*: 'Always the same – the hurried sketches, subtle in tone, charming even, but so what? No certainty, no single work entire and complete: always substantial vanilla snow-eggs served as a painting feast.'[28] Eugène gave her the benefit of his own evaluation of the artists' work after reassuring her that 'Your pictures at Portier's seemed very good to me.' But it was Manet's opinion she awaited. 'What does Edouard say of the exhibition as a whole?' she pressed Eugène anxiously. 'Edouard . . . says that your pictures are among the best', her husband reported back to Nice. Edouard also wrote directly to press her not to undervalue her paintings, while loyal Gustave sent the message, 'It is your pictures that interest the public most.' This might have been an exaggeration but Théodore Duret, who thought this seventh exhibition was the best the group had ever held, congratulated Eugène on Berthe's paintings. 'I have no doubt about your future success', her husband wrote confidently. 'I have asked 500 francs for each of your small pictures, 1,000 for *La Blanchisseuse [The Washerwoman]* and for *Pasie et Bibi* and 1,200 for *Marie*.'[29]

What mattered in the long run was the opinion of the dealers. Eugène reported with restrained delight, 'Portier, who reflects the general opinion, seems to have made a complete volte-face. He says he will sell more of your pictures.' And Durand-Ruel liked her work sufficiently to buy a painting of Julie and take two more Bougival scenes on consignment for an exhibition in London in July 1882. Subsequently, she lent him three more works for an Impressionist exhibition held in New Bond Street the following April. The homogeneity of the seventh exhibition was its strength. It reunited Monet, Renoir, Sisley, Pissarro and Berthe Morisot, and proclaimed that Impressionism, far from being consigned to the cultural side-lines, was now in the centre stage of contemporary art. It was his brother's opinion that Edouard bitterly regretted not taking part. 'I have the impression that he hesitated a great deal', Eugène told Berthe in one of the many letters he wrote to her in Nice.[30] In the light of hindsight there can be no doubt of Edouard Manet's misjudgement: his work should have been represented there.

Manet entered. . . . That figure! those square shoulders that swaggered as he went across a room and the thin waist; and that face, the beard and nose, satyr-like . . .[31]

Although Berthe's view of Edouard had changed inexorably over the years, George Moore's admiring words would bring instant recall to anyone who knew Manet. He was, and always would be, the most stylish and handsome of men, with a certain carnal appeal to both sexes. Even in 1880, when his illness had a fatal hold on him, Manet never lost his gift for making engaging conversation with a woman. His contemporaries found his natural charm and generosity irresistible, and mostly they forgave his failings. Curiously, Berthe shared some of these: his feminine irritability, the disdain for stupidity and the intense dislike for everything banal and conventional. She could even act in the way Faure observed Edouard behave – like an angry cat![32] But she retained an awe at and a pride in his incomparable gifts which mingled with her deep fondness for him. At her marriage all feelings of sensual attraction were deliberately buried. As Madame Eugène Manet, her love for Edouard was smothered in decorum. They were allowed terms of endearment – 'My dear Edouard' and 'My dear Berthe' – and even the exchange of kisses which Edouard had promised as a greeting, but the intimate meeting of minds at artistic trysts and the unalloyed pleasure of snatching hours *à deux*, went by mutual consent and with the relentless passage of time. They accepted the social prescriptions on their lives.

As their paths diverged, there was also an imperceptible shift in the relations between Eugène and Edouard, a matter of degree rather than of kind, for they had never been as close as Edouard and Gustave. Occasional glimpses of trouble show up in the family correspondence. Edouard had always played on his position as favourite and his messages to his mother during the Franco-Prussian War were full of self-righteous complaints of how he had tried to persuade his brothers to write to her. He enjoyed manipulating others. Hence Madame Morisot had reported to Edma in June 1871, 'Manet told us at lunch his two brothers had almost come to blows, and everywhere one hears talk about their quarrels.'[33] Family loyalty usually prevailed, but sometimes Eugène let the mask slip, as he did twice in 1882 when he observed smugly to Berthe that 'financial success does not seem to come to the rue Saint-Pétersbourg any more'; and that the singer Faure had just cheated his brother by beating him down on the price of two paintings.[34] Edouard, a tormented figure now, stood on his dignity as head of the family. (Once he even rebuked Berthe, warning her not to 'frighten my mother too much about Bibi's health; it puts her in a fearful state'.)[35] The temperamental gulf between Edouard and Eugène accounts to a degree for their disagreements, but jealousy also played a part. Both men had coveted Berthe Morisot.

The severing of Edouard's emotional relationship with Berthe, unleashed his lascivious instincts. 'Since Berthe Morisot had become Madame Eugène Manet, an increasing number of elegant women had been coming to the studio in the rue de Saint-Pétersbourg. And Manet drifted from one casual affair to another.' So said one of his biographers.[36] It was a sad paradox that Berthe's sobriety drove Edouard further into the arms of other women. He had always enjoyed female company and had rarely been without it, but his appetite appeared to grow as he reached middle age. These were the years of the models Marguerite, Marie and Amélie-Jeanne; of his liaisons with the divas Emilie Ambre and Louise Valtesse de la Bigne, and the young actresses Ellen Andrée and Jeanne de Marsy. It was the time he met up with Henriette Hauser, a golden-haired *cocotte* who posed for *Nana*. As the mistress of the Prince of Orange, she was nicknamed Citron. Then just after Julie's birth he painted a series of portraits of Isabelle Lemonnier, sister of Madame Charpentier, whom he met at the latter's dazzling salon in the rue de Grenelle. While confined to the garden of Bellevue he wrote her pretty letters which he illustrated with watercolour motifs of fruit and flowers. 'I would kiss you, had I the courage', he told Isabelle poignantly.[37] But it was never courage that Manet lacked: by that stage it was sheer physical vigour.

Some of his visitors passed quickly in and out of his life, as ephemeral as the company he had kept at Tortoni's or the Folies-Bergère. Through his old friend Madame Loubens, he made the acquaintance of a Madame Gamby, a dark-haired beauty with an hourglass figure, who posed for a picture entitled *The Promenade*, set in the gardens of the Bellevue Clinic. And lastly there was Méry Laurent, the sophisticated mistress of Louis Napoleon's dentist, whose apartment in the rue de Rome became Edouard's love-nest until infirmity chained him to his studio. Even then Méry tended him with discreet and loving care. And all the while there was Suzanne, with her 'gift for good nature, simplicity and candour', whose love for her 'charming *enfant terrible* of a husband' – de Nittis's words – never faltered.[38] It was a barren and humdrum marriage, but by turning a blind eye and avoiding confrontations, she appeared to retain his affection and he her respect.

The family kept mum. Social convention was tolerant of married men, but only once did Berthe show her resigned amusement. In a light-hearted letter to a friend, she recounted a casual exchange between her daughter and a couple of local hustlers at Bougival. Little Julie was not yet three. 'When she is asked her name', Berthe explained, 'she answers very politely, "Bibi Manet". This made two *cocottes* walking along the bank laugh till they cried. They no doubt thought that she was the daughter of the famous Manet put out to nurse in this village of boating girls.'[39] All told, however, Julie was a natural reconciler in the ups and downs of the Manets. Later in life she always spoke and wrote affectionately of her Uncle Edouard.

Though he had little experience of children, he painted a miniature portrait of his niece just after her first birthday. And during a visit to Bougival in the summer of 1882 he made a sketch of Julie in a brown straw bonnet, sitting on a watering can in the garden. A few yards away, Berthe worked at her own canvas of the child squatting beside the same blue can, making sandpies. The occasion must have held happy memories: Berthe had a soft spot for this picture.

Eugène and Berthe, reunited in Paris before the end of March 1882, took furnished accommodation near the Tuileries, at 3 rue de Mont-Thabor. Eugène had kept her posted about progress on their new apartment, but it was still a long way off completion. Berthe had urged him to find them a temporary home, clean and convenient to his ministry. In May Edouard had the satisfaction of seeing his two brilliant paintings, *Spring* and the *Bar at the Folies-Bergère*, hanging *hors concours* in the Palais de l'Industrie, where the public at last treated them with respect. But the remission he had enjoyed in the spring was fading. He took a three-month lease on the furnished villa of a Monsieur Labiche in Rueil. Despite Suzanne's attentions, he knew he was painting for the last time out of doors. The drab, shuttered exterior of the house and sombre, shaded patches in the garden, reflected his state of mind. Eugène and Berthe, in Bougival for the summer, visited him frequently.

Berthe threw herself into artistic activity in the rue de la Princesse, partly as a distraction. She had finished half a dozen pastels and the same number of watercolours and oils by the end of the summer, warm domestic scenes, aglow with colour and life, full of air and gentle movement, and strewn with generous brushstrokes. Julie with Pasie on the balcony; Julie playing in the garden, seated on a bench, sitting on the grass; Julie asleep; Julie's blonde head; mother and daughter together; an auburn-haired model in blue, drinking tea.

With their new property still far from ready, the Eugène Manets remained in Bougival throughout the autumn and winter to avoid the expense of renting another apartment in the city centre. Edouard had had enough of the country and, having made his will on the last day of September, he went back to Paris in October, accompanied by Suzanne and Maman Manet. For the next few months he continued to work in his studio as and when he could. He fell back on still lifes, the least physically demanding genre: roses, tulips, lilacs and pinks, which kind friends and well-wishers brought as gifts.

Sadly, the advent of 1883 dealt Edouard another blow. On New Year's Eve the death of Léon Gambetta was announced. Berthe and Eugène were back in Paris at the time for the New Year family reunion. Edouard could not forget that it was Gambetta who had nominated him for the *Légion d'Honneur*. So on 4 January, four-year-old Julie was taken along to the Palais

Bourbon to see the official lying-in-state. The sight of the great Republican's body, surrounded by wreaths and black crepe, made a deep impression on the child.[40] And the state funeral of the man whom the Manets had revered cast a long shadow over the dark winter days ahead.

Edouard no longer dissembled to his visitors, though he was willing to try any remedy offered to him. On 9 March Berthe wrote to tell Tiburce, 'Poor Edouard is very ill; his famous vegetarian has very nearly dispatched him into the next world.'[41] According to Degas, this Dr Hureau de Villeneuve, the latest in a long series of medical consultants, inadvertently poisoned him with doses of ergotized rye. By Easter Manet was too ill to remain in his studio. He returned home to 39 rue de Saint-Pétersbourg and took to his bed. 'Manet is done for', Degas warned his friend, Bartholomé, at the beginning of April.[42] A fortnight after this, Edouard's left foot was found to be gangrenous. His leg was amputated five days later, but blood poisoning set in, accompanied by a high fever. His close friends and relatives gathered for the end, Eugène and Berthe among those who scarcely left his bedside. The horror of the experience racked her visibly. 'These last days were very painful', she admitted afterwards; 'poor Edouard suffered atrociously. His agony was terrible. In a word, it was death in one of its most appalling forms that I once again witnessed at very close range.'[43]

Edouard Manet died on 30 April at the age of fifty-one. The next day, the 1883 Salon opened its doors to the general public. 'The expressions of sympathy have been intense and universal', Berthe wrote to Edma. Tributes to his genius poured from the lips of friends but also from the press. In *La Vie Moderne* Gustave Goetschy spoke of him as 'one of those innovators who leave behind them a trail of glory'. Degas acknowledged that 'he was greater than we realized'. The sense of loss was felt by all, yet to each one it was uniquely intimate. As Berthe acknowledged, 'Edouard also had . . . something indefinable, so that on the day of his funeral, all the people who came to attend . . . seemed to me like one big family mourning one of their own.'[44]

There was a brief and simple funeral service on 3 May at the church of Saint-Louis-d'Antin in the Opéra district. Gustave, Eugène and their cousin, Jules de Jouy, were the chief mourners. The pallbearers were Edouard's old friends, the politician Antonin Proust, the writer Emile Zola, the critics, Philippe Burty and Théodore Duret, and the artists Alfred Stevens, Claude Monet and Henri Fantin-Latour. A crowd of 500 followed the hearse to the graveside in the cemetery at Passy. They were not to know that a tragic coda would ensue. That morning, Eva Gonzalès, who had just given birth to a baby boy and was distraught to hear of Manet's death, insisted on making a wreath for him. Two days later, at the age of thirty-three, she collapsed with an embolism and died instantly.[45]

In her grief, however, Berthe thought only in private and personal terms

about Edouard. Her heart was filled with memories of their former 'intimacy' and of his 'attractive personality' which had held her in its spell for so long. To Edma she confessed to the extreme intensity of her emotion. As 'the long-standing friendship that united me with Edouard, an entire past of youth and work [was] suddenly ending', 'you will understand that I am crushed.' And to another friend she repeated the same dread realization that Edouard was 'associated with all the memories of my youth'. But more disturbing was her inability to conceive of a world without Manet. While everyone had their allotted span – and Berthe herself had for some while been conscious of ageing visibly – Manet was not as other mortals. George Moore remarked, 'There is a vision in his eyes.' And Berthe had come to believe that he was so alert in mind, so inimitable in spirit, that somehow he was beyond the power of death.[46]

Alas, her guru was not immortal. Edouard Manet had gone. And with him passed the ideals and fading recollections of young womanhood, ever more difficult to recall.

PART FOUR

The Deepening Years

Je suis comme un homme lasse dont l'oeil ne voit
en arrière, dans les années profondes.

(Baudelaire)

The rue de Villejust

1883–5

Without the magnetism of Edouard Manet's presence, the sense of common purpose among the avant-garde artists effectively ceased. It had been weakening since 1879; in 1880 Monet had admitted that he very rarely saw the men and women who were his colleagues. After 1883, however, the Impressionist artists went their own way. For some of them the year was a point of crisis, not merely in their personal lives but in their professional careers. Berthe's associates, Monet, Pissarro and Sisley, were still short of money and even Degas had to pester Durand-Ruel for advances. Immured in his studio in the Ninth Arrondissement, he grew increasingly lugubrious and testy. Meanwhile, in the spring of 1883, Monet rented a house at Giverny, halfway to Rouen. The move was permanent and symbolic of his decision to distance himself from the Parisian art world.

Since 1877 Paul Cézanne had declined to take part in the group exhibitions, spending his time in the south, between Aix and l'Estaque. In 1882 Sisley had moved to Moret, on the south-eastern edge of the Forest of Fontainebleau. Strained finances rendered him increasingly immobile. Two years later Pissarro settled in the hamlet of Eragny-sur-Epte, near Gisors; he began to reject his early Impressionist techniques as being wildly romantic and undisciplined, and was drawn instead to the divisionist methods of Georges Seurat and Paul Signac.

Berthe, Degas and Mary Cassatt were fortunate in being able to decamp from Paris for holidays. Degas was regularly entertained both in and out of town by rich and tolerant friends, the Rouarts, the Halévys and the Valpinçons. Of the painters of humbler origin, Renoir was the only one to retain a base in the capital. With wealthy patrons behind him, he had earned the means to travel, but around the time of Edouard Manet's death, he had reached an impasse in his life. A sensitive man, he confessed that 'About 1883 a kind of rupture occurred in my work. I had reached the end of Impressionism and came to the realization that I did not know how to paint or draw. In short, I had come to a dead stop.'[1]

Renoir's self-doubts were shared by some of his former friends. In the unchanging, sun-drenched scenery of Provence, Cézanne began to question the Impressionists' quest for fleeting atmospheric effects. Claude Monet, on

the other hand, was pondering how best to reproduce the harmonies, the ephemeral colours and qualities of the natural world with an even greater intensity.[2] He was finding it a difficult, if not an impossible, challenge, as he confessed to friends like Duret and Geffroy. On reaching forty, Monet had been plunged, like Renoir, into something of a mid-life crisis, and for much of the 1880s he was subject to emotional cycles of despair and elation of the kind familiar to Berthe. Strangely, on approaching her mid-forties she seemed to present a more positive, serene face to the outside world. Only occasionally did the mask slip.

Her equanimity was partly an illusion, partly a factor of age. Melancholy was inherent in her makeup, but so was courage. She steeled herself to face reality and present the image of a dignified *grande dame*, hiding her sensitivity under a veil of irony that was imperceptible to most people. She cultivated composure. Only in private did she reveal the emotions which were invariably focused on Julie, a voluble and inquisitive child with communicable needs. (It was in 1883 that she started to paint a children's primer, of which only fragments remain: the *Alphabet of Bibi*.) Unlike the majority of mothers on the verge of middle age and facing the syndrome of the empty nest, Berthe was blessed with a joyful, sustaining *raison d'être*, her daughter's welfare.

But she still had a compelling need to be creative. Over the coming decade, painting provided her principal means of coming to terms with disappointments and bereavements, just as Stéphane Mallarmé found an escape via poetry. Through her art, and only through her art, she learned to suppress her emotions and sublimate reality. The more depressing the external world, the more gentle, fragile, feminine and exquisite became her pictures. Few could see behind the mask, but the novelist, Octave Mirbeau, whom she came to know through Mallarmé, commented in 1886 that 'Berthe Morisot is disturbing. In her exquisite works there is a morbid curiosity that astonishes and charms. Morisot seems to paint with her nerves on edge, providing a few scanty traces to create complete, disquieting evocations.'[3]

Her poignancy, however, never slipped into banality or sentimental affectation, both of which she abhorred. Her advice to Edma on the question of her daughter's reading was 'No silliness, no sentimentality, no pretentiousness'.[4] She disapproved of public displays of feeling. How far she was aware of the eighteenth-century cult of sentiment and motherhood in art and literature, and was reacting against it, is a moot point. For instance, could she have been familiar with Fragonard's exuberant yet tender mother-and-child paintings (such as *Mother's Kisses* or *The Joys of Motherhood*)? If so, they were almost certainly too explicit for her liking. But to the best of our knowledge Berthe never responded to the assertion of certain reviewers that her work was strongly reminiscent of Fragonard's. If she resented the

distinction frequently drawn between male and female artists, she also acknowledged that 'The truth is that our value lies in feeling, in intuition, in our vision that is subtler than that of men, *and we can accomplish a great deal provided that affectation, pedantry and sentimentalism do not come to spoil everything'*.[5]

Her dislike of affectation explains the detached quality in her parent-and-child works. It is noticeable that her figures avoid touching or fondling. The emotion, though intense, is restrained, even implicit. She can never be accused of mawkishness. This is as true of *The Cradle*, which depicts Edma and her baby, as it is of the scenes of Julie with her father or her self-portraits with Julie (though one must concede the impossibility of painting the latter while clasping a child). But it is interesting to compare her with Mary Cassatt, who though childless herself could pour love and affection into her pictures as she did with *Mother and Baby* (1880). Julie later wrote that her mother loved children, *all* children, and Louise Riesener confirmed that 'She loved life and youth, she was lenient towards their shortcomings; she found all the graces there'.[6] Berthe's portrayals of children and artless adolescent girls have an ethereal quality lacking in Mary Cassatt's work. Together with swans and ducks, she saw them as among nature's Elysian creatures. Perhaps, as has been suggested, as she quietly sketched the swans in the Bois de Boulogne, she was struck by the opening lines of Sully Prudhomme's poem, 'Le Cygne':

> Sans bruit, sous le miroir des lacs profonds et calmes,
> Le Cygne chasse l'onde avec ses larges palmes,
> Et glisse.[7]

> [Silently beneath the deep, calm mirror of the lakes
> The swan sheers through the wave with its webbed feet
> And glides.]

As subject matter these ideal forms were *not* so much a reflection of a serene and harmonious life, but a means of purifying and elevating what was arbitrary, unjust, sad, tedious and drab in her existence. For, as she concluded after her Italian visit of 1882, 'life is a dream, and that dream is truer than reality. It's about being ourselves, our true self. If we have a soul, that's where it is to be found.'[8]

During much of the 1880s Eugène Manet seemed more active and fulfilled. For two years his energies were absorbed in overseeing the construction of their new town house, an elegant apartment block at 40 rue de Villejust, between the Etoile and the Bois de Boulogne. They had commissioned the Parisian architect Julien Morize, who had worked on many of the elevations

on the Boulevard de l'Impératrice (now the avenue Foch). Perhaps to counter Morize's predilection for curves, Eugène insisted that Berthe's preferences in design and decor should be taken into account. 'Follow freely your architectural taste and come to the rescue of your architect', he urged her as the builders pressed ahead. (None the less, at some point work must have slowed down because they were not able to move in for another year.) He wrote to her in Nice for ideas and suggestions. 'What is to be done in the courtyard? Where shall the fountain be placed?' And at the request of Morize, he begged her to send a detailed drawing for a feature-window based on a design she had seen in the Church of Jesus in Old Nice.[9] In the end Berthe was satisfied with the classical simplicity of the interior. Eugène, too, felt pleased with a number of features: the balconies and roof terrace, the well-lit stairway and the large courtyard. He saw the house as both a financial and architectural challenge in which he contributed the financial expertise and Berthe the artistic flair. Their new home provided the pair of them with a common interest which strengthened their marriage. It also whetted Eugène's appetite for real estate. Periodically he went in search of a country house of their dreams that would complement their town apartment in the rue de Villejust.

In addition to this project, Eugène had secured a post in the civil service, although little has emerged about his career in the Ministry of Finance. Since numerous family acquaintances were in high office, any one of them could have had a hand in it: Ferry, Gambetta, Clemenceau, Eugène Spüller, Antonin Proust or Gustave Hubbard, the husband of Berthe's dear friend, Marie, with his contacts in the Chamber of Deputies. Octave Thomas was an obvious inside connection, and Baron Barbier was another useful acquaintance. Known in Parisian bohemian circles, he had posed for Edouard Manet; but his closest friend, Daniel Wilson, was under-secretary of state for finance. Equally, Renoir's patron and confidant, Georges Rivière, was well placed to help. He was a highly placed career bureaucrat in the Ministry of Finance but combined this responsibility with the roles of connoisseur and art critic of the journal *L'Impressioniste*; and as such he was a warm admirer of Berthe's painting. At all events Eugène was lucky to work under a sympathetic *chef du bureau* like Rivière, who allowed him a flexible routine, time to manage his wife's artistic career and enjoy periods of creative leisure. Just once, it seems, Eugène overtaxed his superior's tolerance. 'I came back in the nick of time [from Nice]', he admitted to Berthe, '. . . my chief had written to Florence insisting that I return.'[10] However, the fact that Eugène managed to combine a civil service post with greater family responsibilities suggests he had exceeded Cornélie Morisot's modest expectations.

After Edouard's death, Eugène was head of the Manet family. The day after Edouard's funeral, Suzanne and Léon Leenhoff, who were both

physically and emotionally exhausted, left to stay with relatives in Holland, so it fell to Eugène to undertake the unpleasant task of arranging the final interment of Edouard's body from a temporary grave. Berthe accompanied him. She wrote to Suzanne, 'This morning I have been to the cemetery with Eugène, the definitive plot not yet having been chosen. We have found one on one of the main pathways, surrounded by fine trees. But it's so small! Only two metres by one metre. Ask your brother [Léon] if that seems to him to be large enough. Eugène has to go back tomorrow.'[11] In the end they bought two adjacent plots in the family name.

Meanwhile, following Edouard's lead, Eugène insisted that his mother came to live with them at 40 rue de Villejust. Madame Manet was very grateful. It was not the most convenient of times: the workmen were still putting the finishing touches to the place. They had been rectifying minor defects during Edouard's final illness, which was why she had first moved to Gustave's apartment. The job of transferring the household into the new premises had been a major undertaking. After the distress of Edouard's death, it was a while before life returned to normality. In that time Berthe's mother-in-law was only partially aware of the stresses around her, though she hinted to Suzanne of problems: 'There is not much room except in her [Berthe's] studio. This troubles me greatly.' In fact, there were still things to be done, and, as Berthe explained to her friend, Sophie Canat, 'I have no furniture yet to seat visitors.' None the less, Madame Manet suggested to Suzanne that they might consider jointly renting one of the upstairs apartments in the house. 'Berthe says to tell you how very pleased she would be to have you', she assured her daughter-in-law.[12] Duty and decorum gave Berthe no alternative but to go along with this idea, and at the end of May Suzanne and Léon came to stay on a temporary basis. But her sister-in-law may have felt uncomfortable there. In June she moved back to the Boulevard des Batignolles where she and Edouard had lived when they were first married.

The family's main preoccupation was to settle Edouard's affairs. There were outstanding debts; the apartment in the rue de Saint-Petersbourg had to be cleared and an inventory taken. For a while the Manet possessions were stored in the rue de Villejust. In his will Edouard had laid down that all the paintings in his studio should be sold for the benefit of Suzanne, the arrangements being entrusted to Théodore Duret, his executor. However, Berthe was among those who felt strongly that there should be a major exhibition of Manet's work before it was sold, so that the public and the art establishment, who had reviled and neglected him so unjustly, would at last come to appreciate Manet's greatness. 'It will be a revenge for so many rebuffs', she told Edma, adding poignantly, 'but a revenge that the poor boy obtains only in his grave.'[13]

There had been a recent precedent in the Courbet sale at the Ecole des

Beaux-Arts, but prejudice against Manet still lingered in official quarters. Gérôme, the great academic master, caustically observed that the Folies-Bergère was a more appropriate venue. To pre-empt opposition to the idea, Antonin Proust and Duret took the precaution of applying to Jules Ferry, who was now the head of the French government. Berthe remembered his pale face and mutton-chop whiskers from the days of his perfunctory courtship. She had long lost respect or liking for the man, but she recognized reluctantly that as a prime minister he would have the last word. To their relief, Ferry granted the request.[14] The date, however, had to be agreed with the authorities, so in June, Berthe and Eugène, with Julie and her nurse, went off to Bougival for their usual working vacation.

At the time Berthe had three works showing in Durand-Ruel's Impressionist exhibition at Dowdeswell's Galleries in New Bond Street. The artists were hoping they were poised for a breakthrough into the English market. Were this to happen, Berthe's asking prices would rise significantly above the current range of 500–1200 francs. Unfortunately, *The Times* chose to ignore the event; the press was lukewarm. Only the *Standard* conceded the Impressionists were 'individual, brilliant, engaging' and 'a force to be reckoned with'.[15] It was still necessary to be patient. But it was a productive summer, against all the odds. As a result of excursions around Bougival, Berthe painted a satisfying number of watercolours and oils: the quay, boats on the Seine, local farmers making haystacks, Julie and her nurse in the forest of Marly, and the garden at Malmaison, associated with the Empress Josephine, but also more painfully, with the house at Rueil where Edouard had spent the previous summer, which had been his last. *Little Girl in Mourning in the Garden* is a reminder of the formalities of bereavement. But the masterpieces of the summer were two garden scenes. *The Fable*, as Mallarmé called it, was a heart-warming portrayal of Julie with her nurse. *Eugène Manet and His Daughter* epitomized Berthe's handling of the parent-and-child theme: Julie utterly absorbed in her red boat sailing on the garden pool, the kindly father-figure sitting close by, but emotionally detached.[16]

In July, the family returned briefly to Paris. Eugène met with Jules de Jouy, Proust and Duret, to discuss Edouard's exhibition and sale: there had been no word from the Ecole des Beaux-Arts. Berthe was preoccupied with Julie, who had developed whooping cough, and at the first opportunity she returned to Bougival. Her brother, too, was on her mind. The abortive Egyptian venture behind him, Tiburce had set up as an art impresario in America, but had characteristically run into difficulties. A little peeved that he had consulted Edma but not herself, Berthe offered all the same to introduce him to Antonin Proust; and later she wrote with the names of several artists – Fantin, Renoir, Monet, Sisley, Degas, Degas's friend, Henri Lerolle, and the fashionable Salonist, Jean-Charles Cazin – who might be

willing to exhibit or propose some helpful contacts. And lastly, since they were bound to know more about artistic taste in the USA, she suggested, 'If you talk with Mlle Cassatt, she might be helpful to you; her address is 13 avenue Trudaine' and 'Have you sent anything to Sargent [John Singer Sargent], the American? . . . He is supposed to have spoken of me in the most flattering way. He is very successful and a pupil of Carolus-Duran.'[17]

This brief contact between brother and sister was over all too quickly, for Tiburce was shortly off to North America again. Berthe felt both aggrieved and saddened by their deteriorating relations. She was growing apart from her sisters, too. There had been snappy ripostes in letters to Yves, though the fact that Jeannie and Paule continued to visit suggests that they had not lost touch. But a mutual sourness had crept into her relations with Edma, based, one suspects, on jealousy of Berthe's achievements and wealth on Edma's part and on creative self-absorption on Berthe's. However, on one of her quick visits back to Paris that summer, she and Tiburce had met to say their farewells. Defensively, she rejected his accusations of neglect: 'why do you say that I never write, while actually it is you who never write?' But deep down, Berthe was anxious in case she was responsible for estrangements in the family. She had confessed to Sophie Canat that work kept her extremely busy, and that since the trauma of moving house that spring 'time has passed leaving a surface of indifference and forgetfulness in its wake'. At any rate, unhappy about leaving things as they were, she dropped Tiburce a nostalgic note asking for his photograph and sending him one of Julie with a gentle rebuke. 'I do not want you to forget that you have a niece.'[18]

Worries seemed to be accumulating. Earlier that month – August 1883 – Eugène's mother had a bad stroke which left her paralysed. Eugène and Gustave shared the supervision of her care. Berthe was concerned, however, not only for the old lady whose condition was so distressing, but for the effect on Eugène, who resumed his commuting but remained overnight with his mother now that she could not be left alone. The prognosis was not good. Her life now assumed an interminable uncertainty.[19]

The dates of Edouard's sale and exhibition seemed equally uncertain. Official delaying tactics over the exhibition irritated the family, who were in any case divided against Duret over the choice of dealer to manage the auction. The Manets favoured Durand-Ruel. Despite his mounting debt, he had been supportive of avant-garde art, but Duret took it upon himself to approach the rival firm, Georges Petit. By October, after Berthe and Julie had rejoined Eugène in the rue de Villejust, Petit's had agreed somewhat grudgingly to share the sale at the Hôtel Drouot with Durand-Ruel. While Madame Manet remained unable to speak or move, and the indecision over the Beaux-Arts continued, the autumn was a sad season. For the most part Berthe painted at the back of their house where she was on call. She hired the professional model, Milly, for a picture called simply *The Garden*. The

woman's haunted face, expressed in chalky white strokes, projects, as no words could, the bleakness in Berthe's heart.

On the day before Julie's fifth birthday, the Manets heard at last that the Ecole des Beaux-Arts would be available during the month of January 1884 for Edouard's exhibition. So the auction sale would follow in early February. In the seven weeks to the opening, a cumbersome committee, which included Eugène and Gustave, began to assemble Manet's pictures, while Berthe worked actively behind the scenes. She greeted the inauguration on 5 January with a mixture of buoyant optimism and understandable bitterness. Even as the opening approached, the Republican president, Jules Grévy, a natural compromiser, declined to open the exhibition in case he upset the art establishment, although he had inaugurated the retrospective of the Communard, Courbet. This was yet another insult. But in a letter to Edma, Berthe hit back defiantly, certain 'that it will be a great success, that all this painting so fresh, so vital, will electrify the Palais des Beaux-Arts'. When Edma let her down by declining to view the collection, Berthe took it badly. Even so, she tried to patch things up with her sister at New Year. But each stood on her dignity and Berthe could not resist raising some sore points. They remained in touch, but only because Berthe kept her posted with the news.[20]

The Eugène Manets lent two of Edouard's paintings to the exhibition, the early *Boy with the Cherries*, and the last of his portraits of Berthe. On his mother's behalf Eugène also contributed the double portrait of his parents. De Bellio lent the enigmatic portrait, *Berthe Morisot behind a Fan*, and countless other friends offered their works, almost 200 in all. For Berthe, joining the thousands of visitors at the Beaux-Arts, it was 'a great success', the educated public showing their admiration for Manet's brilliant execution, and major artists like Stevens, Duez and Puvis de Chavannes saying openly that they had not seen such good work since the master, Ingres. But the past kept coming back to haunt Berthe as the mixed reviews rolled in. Some critics – Gustave Goetschy, for one – were supportive yet somewhat imperceptive; some, like Albert Wolff compulsively sneery; a couple downright abusive. And as for the comparison with Ingres, in a moment of searing pride she wrote, 'but we, the truly faithful, we say, "It is far greater".'[21]

Berthe was over-confident about the outcome of the auction on 4–5 February. Julie's godfather, the sober lawyer Jules de Jouy, knew that she was being unrealistic in anticipating a general rush to buy that would send prices soaring. Mary Cassatt, too, had picked up other vibes. Her brother, a collector of modern pictures, was alerted, that 'as the executors have managed the whole thing badly it is thought some things may be picked up cheap'.[22] All the same, Berthe wrote jocularly to the Pontillons on the eve of the sale, suggesting that they could do a lot worse than invest in a few small

Manets, and admitting that she herself had every intention of buying a number of his pictures. On the first day she paid 1,700 francs for a little garden scene, 'a jewel, one of the prettiest things he ever did', a 'magnificent sketch' of Manet's mother sitting in the garden at Bellevue, and *Departure of the Steamboat*, 'a very attractive work' painted at Boulogne and one of Manet's earliest to show her own Impressionist influence, which she bought with the Pontillons in mind.[23] However, a few days later her optimism had plummeted. Money, particularly spending it, always worried Berthe: this was one reason why she was so grateful to Eugène, who shouldered their finances. He was forced to invest in a total of eight of his brother's pictures in the course of the two days.

Berthe fumed:

It's all over. It was a fiasco. Following on the victory at the Beaux-Arts, it was a complete failure . . . in this rout the brothers thought that they had better step in and we spent 20,000 francs. In fact I have some of the big paintings, *The Washing*, *Madame de Callias* and *Girl in a Garden*, as well as some of the smaller ones – a singer at a *café-concert*, two pastels, a torso of a woman and some oysters . . . I am broken-hearted. . . . In all the auction brought in 110,000 francs, whereas we had been counting on a minimum of 200,000. . . . Anyway here I am with a whole gallery of pictures; our future inheritance from Madame Manet has been eaten into, but no matter; one can only laugh.[24]

In saying this, Berthe was not laughing at all. In reality she was deeply upset by the public's response. But outside the family the results were thought to be good, considering that France was in the middle of a stubborn recession. Proust called it a considerable success and Renoir wrote to Monet in a similar vein. However, it was noticed that apart from family and private collectors, many of whom were friends of Manet, there were few wealthy buyers. Chabrier (whose wife had just come into a fortune) was in a position to buy *Bar at the Folies-Bergère* for 5,850 francs and Caillebotte had the means to pay 3,000 francs for *The Balcony*. But there was no sign of rich Americans, and with the exception of Durand-Ruel, no galleries or museums. The only consolation was that Manet's work had gone to genuine admirers, fellow artists and connoisseurs.

By 1884 the Manets felt settled in their town house. Eugène had lovingly created a little 'country garden' at the rear where Julie could play and Berthe could work in peace. He planted shrubs and climbers to ensure plenty of natural greenery as a backdrop to her paintings. The upper floors were let as apartments and studios. Their own suite was on the ground and first floors, the drawing-room doubling up as Berthe's studio. She had

rejected the customary north-facing room in favour of light: light reflected from the universal white stucco work and creamy blinds, which made sure there was not a single dull corner. Flowers contrasted with the sheen of the parquet floor: her favourites, daffodils, tulips and peonies. Some inherited possessions – the treasured Empire *chaise-longue*, the Louis-Quatorze mantel-mirror – and Japanese screens completed the decor. Everything was in the best possible taste.

The room was unaffectedly dedicated to Edouard Manet's memory. A bowl which he had personally given to Berthe, and a fruitbowl that figured in several of his paintings, were on display. The walls were lined with his pictures. *The Washing* and *Woman with the Fans* took pride of place. Clustered around the first were two portraits of Berthe herself and two sketches of Julie, along with *The Café-Concert*, a *Nude*, *Boy with the Cherries*, a portrait of Isabelle Lemmonier and several studies of Bellevue. The portrait of Nina de Callias was one of her favourite Manets, and it was her intention that it would go to the Louvre. The only sign of her own work was a fragment of Boucher's *Venus at Vulcan's Forge*, which she had copied in the Louvre, to fill the space above the mirror in the drawing-room until Monet's promised work appeared.[25] Here, surrounded by Edouard's art, Berthe worked during the day, stowing away her equipment and canvases into a cupboard and pulling round the screens to transform it into a salon fit to entertain their friends during the evening.

Besides working in her new garden, Berthe spent time in the spring of 1884 in the Bois de Boulogne, where she painted Julie and her English teacher, a Miss Reynolds. Summer saw the family back in their beloved Bougival. August was a month of heavy thunderstorms. Eugène continued with his commuting regime. His mother was in gradual decline and could not be left for long, but Gustave was not well enough to share the burden. For Julie's sake Berthe stayed in the rue de la Princesse, and despite the unhappiness which hung over them, she completed a dozen oils, set in the garden or the veranda of the house. At some point they took a trip to Maurecourt, perhaps to patch up relations with the Pontillons, which had nose-dived after the auction in February. Adolphe had tactlessly rejected the marinescape Berthe had reserved for him (he took exception to the fact that Edouard had prominently depicted the captain on the bridge). The Manets were privately outraged and promptly gave it to a grateful Degas instead. After some weeks Edma made a gesture of reconciliation by sending her adolescent daughter's diary for Berthe to pass comment on her talent. Berthe allowed herself to be mollified and subsequently painted her sister with a young girl in the garden at Maurecourt.[26] But the summer was a watershed. It marked the end of Berthe's visits to both Maurecourt and Bougival and the close of a long series of atmospheric rural scenes, of which one of her last, *Garden at Bougival* (1884), was also one of her most radiant.

At the onset of autumn Berthe and Julie returned to Passy. Eugène was deeply worried by Gustave's state of health, which showed all the symptoms of tuberculosis. He was anxious to accompany his brother to the sunshine of the Riviera. One of her Uncle Gustave's last gestures before leaving Paris was to give little Julie a blue enamel watch and chain and a turquoise ring which she cherished. Berthe would have liked to have gone with the brothers – 'I envy you the scent of the mimosas' – but she had no choice but to stay with her failing mother-in-law. Occasionally she escaped to the Bois to complete a few scenes of the lake and the zoo while Julie played in the autumn sunshine. Indoors, she captured her golden-haired daughter sitting in a buttoned chair nursing her doll. But the winter brought great sadness. Shortly before Christmas, on 18 December, Gustave, aged forty-nine, died at the resort of Menton. Eugène could not bring himself to tell their mother, who followed her youngest son to the grave three weeks later, on 8 January 1885. Among the letters of condolence to Eugène was one from Claude Monet. He was deeply shocked. He had known Gustave well for two decades.[27]

The severe winter brought its share of other difficulties. The Bois was veiled in white, but it was impossible for Berthe to take her pastels and catch the skaters on the lake because Julie had succumbed to scarlet fever. The disease carried the danger of crippling complications so they endured weeks of isolation. By March, however, Julie was back to normal, so Berthe threw a mid-Lent children's ball to celebrate her recovery. Unhappily, it revived Edma's jealousy because her son Edme was not invited.[28]

Family discord was never far below the surface. Another instance had occurred earlier, at the turn of the year. Eugène and Berthe had been horrified to learn that Suzanne Manet and Léon had given their approval to an idea of Antonin Proust's to hold a banquet at the restaurant of Père Lathuille to celebrate the first anniversary of Edouard's exhibition. Not only did it seem bizarre, given the mixed financial outcome of the auction sale, but it was undoubtedly in bad taste, since Gustave Manet and his mother were desperately ill at the time. Eugène protested furiously to Proust, encouraged by Berthe and his cousin, Jules. However, Proust decided to go ahead on 5 January, since scores of Edouard's friends, including Mallarmé, Zola, Degas, Renoir, Monet, Stevens and Fantin-Latour, had accepted the invitation and the press had been informed. 'It is not simply Manet, but modern art in general that we celebrate today', wrote Georges Duval of *L'Evénement*.[29] But Berthe turned her face away in disgust. For her and Eugène it was an utterly insensitive and empty gesture that had come far too late.

The public world seemed no better than the private scene. At the turn of the year the Italian Opera company went bankrupt. In the bitter February cold a deputation of unemployed protested to deputies at the Palais

Bourbon about the plight of the poor. And as if to underline the cynical injustice of life, the last trainload of Frenchmen taken prisoner in the Franco-Prussian War finally returned home. There were still many in France who nursed hopes of revenge on Germany. There were many on the right who opposed Jules Ferry's far-sweeping reforms of education and local government. Free, universal, secular education, however laudable, was irrelevant to people of the Manets' class; they had decided that Julie should be educated privately at home by her father. And while Berthe had been brought up to share Ferry's anti-clericalism, she disapproved of political extremes. But Ferry's critics came as much from the left as from the right. His policy of colonial expansion, directed towards Madagascar, the Congo and Indo-China, was attacked as gross opportunism, just as the Mexican War had been a generation before. And there were some, Berthe included, who disliked Ferry for his cold manner and skilful manipulation of power. 'Tell me what your husband thinks of the situation in China', she scribbled to Edma, knowing that Adolphe would agree: 'It seems to me that Jules Ferry who has so far been merely ridiculous is becoming insufferable.'[30]

However, a minority of Frenchmen, like Berthe's brother Tiburce, aspired to overseas adventure and the extension of French influence in the world, spiced with material gain. To them foreign wars were an acceptable hazard. Later that year China was to recognize French control of Tonkin (northern Vietnam today), but not before a minor reverse had given Ferry's political enemies the chance they were looking for. At the end of March Ferry lost Republican support as the Radical Clemenceau savaged him in the Chamber. He was forced to resign, while delighted crowds shouted death to 'Ferry-Tonkin' as they had attacked him with the slogan 'Ferry-Famine' fourteen years before. Ferry's political extinction (for that is what it almost proved to be) unquestionably gave Berthe some grim satisfaction. It was not a matter for boasting that at one time she might have married the now fallen prime minister.

But before the country had stabilized, another blow fell. On 22 May 1885 the last great figure of the Romantic movement, Victor Hugo, died in Passy. He had been a seminal figure in literature and radical politics for sixty years. Eulogies flowed: 'A hero of humanity, the champion of the poor, the weak, the humble, the woman and the child'. *The Times* correspondent reported how popular fever raged for the next ten days.[31] The area around the poet's home in the avenue Victor Hugo (it had been known as the avenue d'Eylau when Berthe and Eugène lived there but was changed in honour of the poet's eightieth birthday) swarmed chaotically with people pressing to sign the book of condolence. Adjacent streets such as the rue de Villejust were caught up in the bedlam. The fever climaxed with the lying-in-state beneath the Arc de Triomphe two blocks away and subsided only after his massive state funeral on 1 June.

These were not happy months for Berthe. On a personal note, there was more family sadness when Yves Gobillard lost her husband, Théodore. While she was tied to the house in the winter Berthe produced three self-portraits, one a double portrait of herself with Julie.[32] In personal terms they represent the three facets of her life: mother, mature professional artist and private person. Self-control emanates from the first two in oils: head upright, shoulders straight, not a blink of hesitation on her face. But the third, a pastel, tells a different tale. It is by any standards a remarkable work of self-analysis. We see what the mirror told her: the greying hair, tense lips, bony, elongated nose, staring eyes, a face shrunken, haunted by despair. It is the corollary to the gliding swans and happy children. And it is the image Berthe Morisot normally took pains to hide.[33]

Nothing, however, assuaged her taste for work. Around this time she also made a pencil study of Louise Riesener as the basis of another portrait of her friend. Berthe had already done two portraits in 1881, and after watching her at work, Louise recalled with admiration her professional qualities. She always took her time, studying her subject with a fierce intensity, her hand poised ready to dab the canvas; there was nothing whatsoever of the dilettante about her.[34]

Berthe confined herself to Paris that summer, taking in Saint-Cloud, where she painted a pair of watercolours. But she worked largely at home, in the apartment or in Eugène's garden. Sometimes, it is true, she was drawn to the Bois (which inspired a series of sketches, pastels and watercolours, including a large decorative picture entitled *The Goose*). Sometimes she took Julie down to the Tuileries and the Louvre. Her output was considerable. Julie, Pasie – and Jeannie Gobillard when she came to stay – were willing subjects. But Berthe also found a sixteen-year-old with brown hair, rose-petal skin and the fragility of Dresden china, and for a year or so, until her tragic death at seventeen, Isabelle Lambert became her favourite model. Among the pictures for which she posed were two light-filled boudoir scenes, *The Bath* or *Girl Arranging her Hair* (1885–6) and *Getting out of Bed* (1886). The latter showed off another family possession, the Louis-Seize bedhead which Berthe had inherited. Puvis de Chavannes was highly complimentary; he found the picture 'a marvel of tones . . . subtle, very subtle, and inimitable, too'.[35]

Eventually Paris palled. 'There are a thousand things to see', she admitted, 'but if you live here you do reach saturation point.'[36] She had a compulsive desire for the sunshine of the south and the treasures of Europe's other galleries and palaces. So she persuaded Eugène that they ought to visit Venice, which they had been cheated of seeing in 1881. However, cholera had been rampant on the Mediterranean seaboard for two summers; the authorities were forced to put Venice under quarantine. The news came as a blow. They were forced to stay in the north. In August

they took off instead for Compiègne to see Yves, who was now living in Vieux-Moulin. Berthe painted an airy, impulsive landscape as a memento, *The Forest of Compiègne.* And from there it seemed logical to go on to Holland and Belgium, to see for themselves the treasures of the Flemish and Dutch schools, starting with the Rijksmuseum.

For Eugène the pleasures of anticipation probably exceeded the reality. He was always difficult to satisfy. He became bored in Amsterdam and as keeper of the family purse he was worried by the extravagance of staying in a grand hotel. Berthe, on the other hand, found the city enchanting. She warmed to its patrician architecture and, observing the changing light of the sky, felt her hand itch to take up a pencil. She confessed privately, however, to being disappointed with the works of the Dutch school, and even Rembrandt's *Night Watch* smacked too much of 'the most disagreeable blackish brown'. She was equally dismissive of the lowering landscapes of Ruysdael and Meindert Hobbema, and the slick portraits of Frans Hals at Haarlem. In Rotterdam, which was cheaper but less interesting, Berthe found time to paint a couple of landscapes before they moved on to The Hague and Antwerp.

But it was hard to keep a whining seven-year-old happy. Julie wanted fresh air and toys rather than works of art. They headed home, leaving Berthe with golden memories of Rubens. 'It seems to me he is the only painter to have totally succeeded in rendering beauty', she observed. She had not studied the great Flemish colourist since her early days in the Louvre. But now she was filled with admiration for those works she had seen in the Museum of Antwerp, for his little painting of *Jesus tended by the Holy Women* and another of the *Virgin and Her Mother.* And she would never forget the impact of his decorative genius, the 'dazzling impression' of light made by the Assumption on the altarpiece of Antwerp's cathedral church of Notre Dame. Seen from afar, every outline is bathed in light, elevating the Virgin to radiant glory.[37]

Back in Paris, Berthe felt compelled to return to the Louvre. She had not worked there since her student days. But now she viewed its treasures with the experienced eye of a mature artist. She looked again at the works of artists like Ingres, finding to her surprise that 'there is undeniably always something new to be seen'.[38]

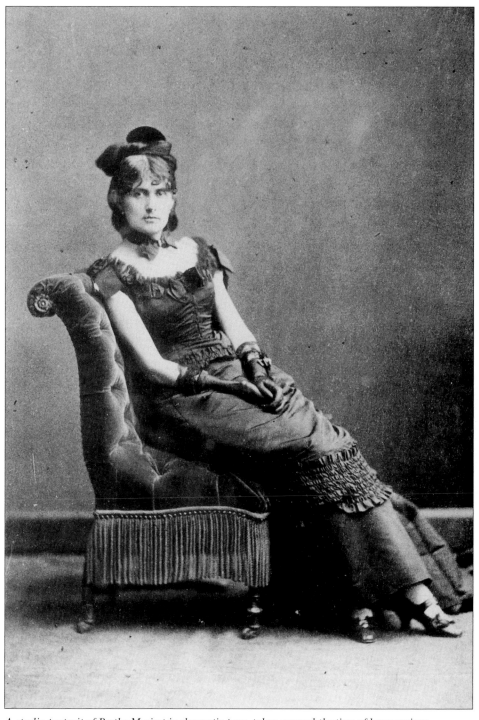

A studio portrait of Berthe Morisot in dramatic pose, taken around the time of her marriage.
(Photograph of Berthe Morisot, c. 1874. Private Collection. Courtesy of Galerie Hopkins-Thomas,
Paris.)

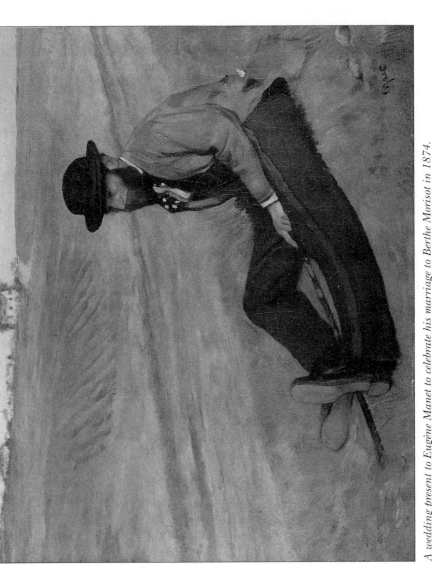

A wedding present to Eugène Manet to celebrate his marriage to Berthe Morisot in 1874. (Eugène Manet by Edgar Degas (1834–1917). Oil on canvas. Christie's Images/Bridgeman Art Library, London.)

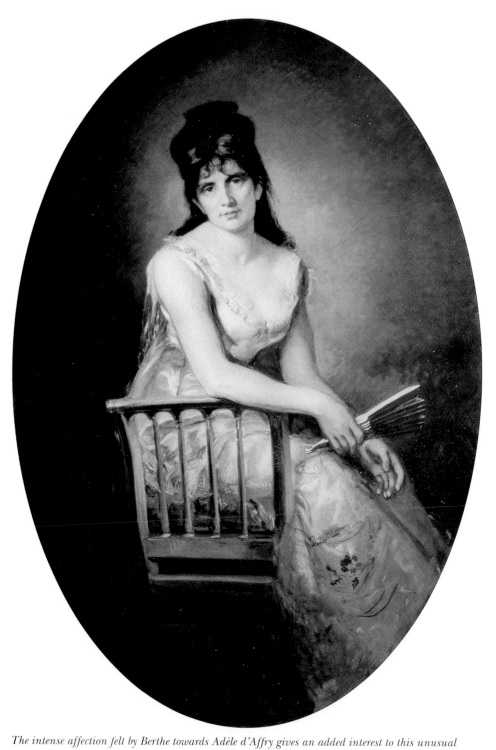

The intense affection felt by Berthe towards Adèle d'Affry gives an added interest to this unusual likeness, painted for Morisot's approaching marriage.
(Marcello (Adèle d'Affry), Portrait of Berthe Morisot, c. 1874. Oil on canvas. © Musée d'Art et d'Histoire, Fribourg, Switzerland.)

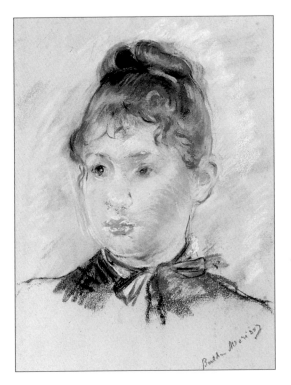

*This revealing self-portrait exposes
Berthe Morisot's inner torment,
usually controlled and sublimated in
her art.
(Berthe Morisot, French, 1841–95,
Self-Portrait, pastel, with stumping,
on grey laid paper with blue fibres,
c. 1885, 48 × 38 cm, Regenstein
Collection, 1965.685 recto.
Photograph © 1996, The Art Institute
of Chicago, All Rights Reserved.)*

*Isabelle Lambert, one of Berthe Morisot's
favourite models, died tragically at the
age of seventeen in about 1886.
(Berthe Morisot, Isabelle, c. 1885.
Pastel on paper. Sainsbury Centre for
Visual Arts, University of East Anglia,
The Robert and Lisa Sainsbury
Collection. Photograph by James
Austin.)*

On the doorstep of her Passy home, the Bois de Boulogne presented Berthe Morisot with endless artistic stimulus.
(Berthe Morisot, The Lake at the Bois de Boulogne, 1888. Drypoint. British Museum, London.)

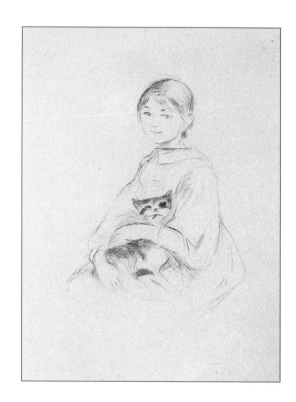

This engraving was inspired by Renoir's 1887 portrait of Julie Manet with a cat. (Berthe Morisot, Julie Manet with a Cat, c. 1889. Drypoint. British Museum, London.)

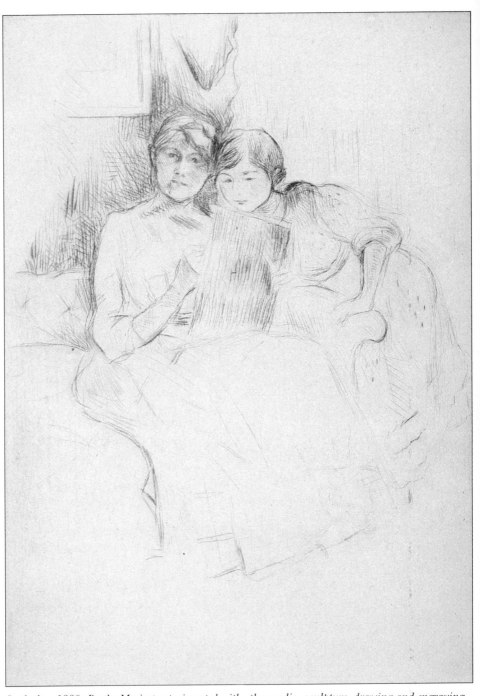

*In the late 1880s Berthe Morisot experimented with other media, sculpture, drawing and engraving,
as this drypoint aptly indicates.*
(Berthe Morisot, Berthe Morisot drawing with her daughter, *1889. Drypoint. British Museum,
London.)*

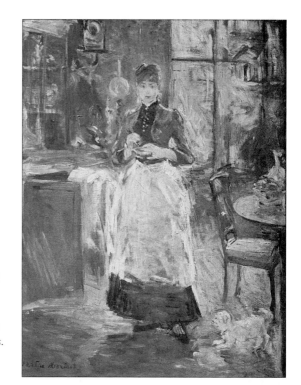

The maid, Pasie, in the dining room at
Rue de Villejust, Passy.
(In The Dining Room, *1886 by*
Berthe Morisot (1841–95) (also known
as The Little Servant*). Oil on canvas.*
National Gallery of Art, Washington
DC/Bridgeman Art Library, London.)

A modern view of the village of Mézy, where the Manets lived in 1890–1. Today a street plaque
commemorates her name. (Author.)

The Chateau of Le Menil, near Juziers, in the Seine valley, bought by Eugène Manet and Berthe Morisot in 1891. (Author.)

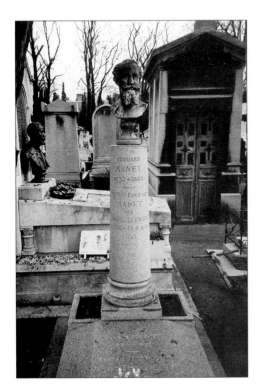

The Manet family tomb, Passy cemetery, in which Berthe Morisot is buried. (Author.)

The Thursday Faithful

1885–9

'Would you do us the great favour, you and Mademoiselle Geneviève, of coming to dine next Thursday? Monet will be there, Renoir also . . .'[1]

Berthe's invitation was addressed to Stéphane Mallarmé, and it was in this disarming way that she persuaded friends of many years, artists, poets, writers, to come regularly to her home in the rue de Villejust. Seeing this circle of eminent people together under the Manet roof gave her great pleasure and went some way towards filling the gaping void created by Edouard's death. It was at her *jeudis* that Degas's enthusiasm for poetry was enriched by talking to Mallarmé, and Puvis at last met Monet. The Thursday dinners gave her the satisfaction of maintaining a hallowed Manet tradition. In an indefinable way, this act of continuity projected to the outside world the stable face of her marriage to Eugène, a face she needed to present for her self-esteem.

Since the beginning of 1884 she was aware of being closer to her Impressionist colleagues, Renoir and Monet; and they, with Degas and Mallarmé, were to become the inner core of her circle.[2] As a matter of honour they attended her Thursdays unless they were too far from Paris. Increasingly she looked to them for stimulus and affection; Monet and Renoir, in particular, replaced Edouard as her professional confidants. They were superb artists in her judgement. Some years before she had encouraged Mary Cassatt to buy Monets as an investment, and marvelling at Renoir's output from his visit to Venice and Algiers, she concluded that he was a born artist, a brilliant draughtsman with a refined, acute sense of colour.

Monet and Degas were among the first visitors to the rue de Villejust. Degas, of course, needed no excuse to call on Berthe, and Monet had an entrée through his friendship with Gustave. Monet was a tough, bluff ambitious man of Norman stock; his relationship with the Manets was based on the attraction of opposites. However, the *grande bourgeoisie* never rushed into familiarity. Berthe and Eugène were cautious about discussing his unconventional private life, although it was no secret that Alice Hoschedé, wife of the Parisian store magnate and art collector, had set up home with him before the death of his first wife, Camille, and it was not until 1892 that

the two were married. In fact, while the situation required tact, it presented no obstacle to the Manet–Monet friendship. Alice would sometimes write on Monet's behalf or Berthe would send her 'best regards'. In 1889 Berthe felt able to ask teasingly, 'My dear Monet, may I drop the "dear Sir" and treat you as a friend?'[3] By that time they were genuinely close. In truth, Monet knew them well enough by 1884 to offer to paint a picture for their drawing-room in the rue de Villejust before he left for the Riviera. They were touched and honoured by his gesture, and not a little amused when this great artist later ran into difficulties and had to write repeatedly with profuse apologies. (He confessed later that he felt his natural style and personality might be too 'brutal' for the delicate handling of Mediterranean colours.) In fact, Claude Monet was quite apprehensive about Berthe's reaction to his picture. But when *Villas at Bordighera* was at last finished, she was delighted to hang it in her home. There were hints of her last Bougival scene in the enriched palette; in addition, the sparkle and enchanted light unique to the Riviera coast could only have been painted by a master.[4]

Her rapport with Renoir was somewhat different. Temperamentally poles apart from Monet, he was a gentle, secretive person, a dreamy sensualist, yet sociable too. He had charm and a knack of building connections with influential friends; his personal acquaintances read like a list from *Who's Who*. However, Berthe knew less of his private life than she knew of Monet's – that in 1884 he was settling into his love-nest in the rue Houdon with a buxom young seamstress and model called Aline Charigot – but their artistic interests were remarkably similar; through these their friendship was cemented in the course of 1885–6. And it happened at a time when Berthe was much in need of encouragement.

After Edouard's death she had started to look again at the old masters in the Louvre which he had loved so much. She found herself drawn to the great artist of the Rococo, François Boucher, whose decorative painting adorned the châteaux of Versailles, Fontainebleau, Marly and Bellevue. During her early years, Boucher along with Watteau, Chardin and Fragonard, had been neglected as representatives of a decadent, aristocratic age. (For this reason, Berthe may have been ignorant as a young woman of her family connection with the Fragonards.) However, thanks to the revisionary work of Edmond de Goncourt, the art of the eighteenth century was rediscovered in the years after 1875.[5] And it was because she was excited by Boucher's colours, his rose and blues and the living quality of his portrayal of human flesh, that she decided to make a copy of a fragment of his *Venus at Vulcan's Forge*, which was so reminiscent of his pupil Fragonard's *Venus and Cupid*.

While examining the vaporous background to Boucher's *Venus*, Berthe couldn't help noticing the artist's voluptuous lines, which made him the master of the erotic. They whetted her interest in the nude form, something

she had instinctively suppressed hitherto. She also looked again at the great classical painter, Ingres. After all, Guichard, her own teacher, had been his pupil. Her mind went back to the picture which used to intrigue her as a young girl when she went to Monsieur Stamaty for her music lessons. But much as she admired Ingres's work, she now looked critically. 'Ingres often produced beauty in the early stages of his work', she recorded in one of her notebooks, 'in portraits of Madame de Vaucay, Madame de Senonnes, and Mademoiselle Robillard which are in the Louvre, in black lead sketches, Madame Varcolin at the piano and the drawing of the Stamaty family, but more often it is harsh and loses charm and grace as much as it gains in strength and character.'[6]

After these visits to the Louvre, Berthe set out to try her hand at nudes. In the past it would have been unthinkable for a woman of her class. Social and cultural taboos had bedevilled women artists from the Renaissance to the Third Republic. Now, in her maturity, she cared less what bourgeois society thought. And however painful it might be to acknowledge it, another inhibiting factor had been removed by Edouard's death. Whether she could ever have brought herself to submit a nude painting to his scrutiny is questionable. He had, after all, produced two of the most controversial nudes of the century in *Déjeuner sur l'herbe* and *Olympia*. But the stimulus of Edouard's work was always there. And for their pleasure Eugène had bought his brother's *Nude Combing her Hair* at the auction of his work in February 1884. The painting hung in the drawing-room/studio where Berthe could study it daily: an inspiration to her as she made a series of nude drawings in the years after 1885, especially after she had found a new professional model, the red-haired Carmen Gaudin. With her drawing of *Nude from the Back*, Berthe broke new ground, while coyly protecting her reputation, and her model's, by working in the privacy of her bathroom in the rue de Villejust.

Renoir had a hand in encouraging her new interest. He was then going through his so-called *aigre* or harsh period, turning away from the delicate effects of light on people, to concentrate on the discipline of line and form. His stimulus came from classical art and by the work of Ingres and Corot. In the course of 1885 Renoir and Berthe became aware of their artistic rapport. On 11 January 1886 Berthe felt sufficiently at ease to call on him in his new studio in the rue Laval. For some time now, he had cultivated the habit (which Degas had practised from the beginning of his career) of making detailed sketches and drawings prior to studies in oil. By 1886 Berthe was also making quick sketches in her notebooks and following these with preparatory drawings in sanguine, charcoal, graphite – and at the end of the decade she was even experimenting with coloured pencils – prior to pastel, watercolour or oils.

On that winter's day, Berthe was amazed to find so many drawings stored

in Renoir's studio. Her gaze alighted in particular on a pencil and chalk drawing of a young peasant-mother nursing her baby. There was a reminder of Boucher in the infant's high kick and the woman's fleshy breast and she found it 'charming in its subtlety and gracefulness'.[7] Her words were carefully chosen. Renoir regarded the female figure as the apogee of beauty. He had a certain reputation with those who knew him for feasting his eyes on the sensuous contours and soft skin tones of women's breasts. (One of his models, the captivating Polish aristocrat, Misia Godebska, who posed for Renoir as a young bride in the 1890s, disappointed him by refusing to expose hers, despite his repeated pleading.)[8]

Meanwhile, Berthe had turned her attention elsewhere, to some studies for a project on which Renoir had been working for three years. It was to be a large canvas of a group of nude bathers, based on a bas-relief of cavorting nymphs at Versailles by the seventeenth-century artist François Giraudon. Berthe was so impressed that at the first opportunity she went to Versailles herself to see the originals. She made light sketches in her green *carnet* after studying Giraudon's ornamental pond in the Allée des Marmousets. Prior to this she had recorded her reactions to the studio visit. 'He is a subtle and brilliant draughtsman', and an artist of the first order, she wrote of Renoir, basking in a mixture of pleasure and surprise that their artistic inclinations were so much in tune. 'All these preliminary drawings would astonish the public who obviously imagine the "Impressionists" work at tremendous speed. I don't believe one can go further than this in the study of form in a drawing. I am charmed by his *Nude Bathers* quite as much as by those of Ingres. He [Renoir] tells me that he thinks the nude is absolutely indispensable as an art form.'[9]

Degas, the only survivor of the pre-war soirées, would have agreed. No one was a better draughtsman of the nude than he. Like Guichard, Degas had been influenced by Ingres, ever since at the age of twenty he had visited the great man's studio and been advised by him to 'Draw line, young man, many lines . . .'[10] Berthe must have heard this story many times. She had never lost touch with Degas. Though he was still a bundle of contradictions, what had intimidated Berthe in her youth now seemed amusing or irrelevant. 'Degas is always the same, witty and paradoxical', she dropped to Edma. In no way did he look intimidating, this 'round-shouldered man in a pepper-and-salt suit and blue necktie'. They exchanged mild insults. He was 'that fierce Degas'. She was 'that terrible wife' of Eugène's.[11] She was sceptical of his new interest: 'Are Degas's four sonnets really poetic or mere variations on the tub?' she asked the expert, Mallarmé.[12] But Degas's bark remained worse than his bite, and for a man who chose to spend his days hermetically sealed in his studio, his evening engagement diary was remarkably full. He was still an opera buff, but could equally be found at the Théâtre des Variétés, the Cirque Fernando or Les Ambassadeurs. On Tuesdays he dined with Alexis Rouart, on Fridays

with his elder brother, Henri, in his spacious town house on the rue de Lisbonne. Then Thursday evenings were shared between the Eugène Manets and the Halévys, for somehow Degas had no difficulty in juggling the invitations between the two. He admired Ludovic Halévy as the librettist of Offenbach's operas, Bizet's *Carmen* and Strauss's *Die Fledermaus*. He equally admired his consummate hostess in the rue de Villejust, though despite a lifetime of knowing her, it was not until 1892 that he got round to praising her artistry to her face.[13]

At her select little dinners Berthe listened respectfully to what Degas had to say. Some of his aphorisms ('orange gives colour, green neutralizes, violet is for shade') became part of the Manet family lore. Sometimes she found his opinions intolerable, especially when they were critical of Edouard. On one occasion when Mallarmé was dining with them, Degas was deliberately provocative. 'Art is deception', he announced. 'An artist is only an artist at certain times, by an effort of will . . . the study of nature is a cliché: isn't Manet the living proof? For although he prided himself on slavishly copying nature, he was the most inadequate painter in the world, not making a single brushstroke without reference to the old masters; for instance, he refrained from drawing fingernails because Frans Hals did not draw them.'[14] Berthe was too proper to betray her disapproval and she had a gift for defusing situations. 'Even Degas became more civil with her', Renoir confided to his son.[15] So Degas was outrageous, Degas was impossible, but he was still one of her oldest friends . . .

By comparison, Berthe and the poet Stéphane Mallarmé were two of a kind. They shrank from vulgarity and self-indulgence, they delighted in their shared sensitivity to art, music and poetry. Experts point to a certain similarity between the simplicity and economy of Berthe's paintings and Mallarmé's Symbolist prose-poems. Some go further and imply that Mallarmé's controlled eroticism is reflected in the suggestive sexuality of some of Berthe's later drawings and paintings of young women.

Mallarmé had recently jumped to literary renown with the publication in 1884 of the novel *A Rebours* by Huysmans, in which his poetry was praised and publicized; and also by the appearance the next year of his own love poems in a volume entitled *Prose pour des Esseintes*. He had aged since Berthe first met him. The shock of unruly dark hair painted by Manet in 1876 was now plastered down over his pointed ears; the sandy moustache drooped into grizzled whiskers. Tobacco was still his opium, but he was more at ease with himself now that he was a celebrity. He marked his rise to fame by holding 'at homes' for writers, critics, poets on Tuesday evenings. It was an honour to be invited but they were nearly always male occasions (Marie and Geneviève dutifully brought in a tray of rum grog before tactfully disappearing). Eugène, who had literary aspirations, went along sometimes to the cramped apartment in the rue de Rome to hear the master give his

monologue in measured, elegant speech. Manet's precious portrait hung on the wall, to be joined later by one of Berthe's marinescapes.

Although it was a reverence for Edouard Manet which brought them together in the first place, the relationship between Berthe and Mallarmé grew more complex with the years. It was framed by family friendship, by Mallarmé's perplexing personal life and by Eugène's dogged devotion to the poet: a curious emotional triangle. Berthe was captivated by Mallarmé's grace; for Manet he was half-priest, half-dancer. She was intrigued, too, by the enigmatic refinement of his poetry which, in her heart, she did not fully understand. Eugène, perhaps, saw him as the man he himself wished to be: a poet of originality, one whose allusive verse lost none of its magic with literary acclaim. In turn Mallarmé respected Eugène Manet. He recognized a highly intelligent but over-sensitive and seriously neurotic man, always searching for health and happiness. But it was Berthe, his 'Dear Lady', who ensnared Mallarmé. Without knowing it, she reduced men to the semblance of 'a peasant or an animal'. Mallarmé worshipped her with the shy secrecy of a young man afraid to declare his love.[16]

This is not to infer any explicit sexual involvement between the poet and the artist. However, there was an intellectual intimacy, a profound mutual admiration and compassionate concern, an intense sociability of the kind found in artistic rather than respectable bourgeois circles.[17] With unimpeachable tact, Berthe sometimes included Mallarmé's daughter Geneviève in her invitations. At the same time she firmly refrained from prying into Mallarmé's marriage and his relationship with Geneviève whose companionship gave him immense satisfaction. It was not her place to cast judgement on the way he treated his silent, half-estranged wife, Marie, who had never recovered from the death of their young son and who shrank from the high-profile social life which was balm to the poet's phenomenal ego. As to his other liaisons, Berthe made no comment so it is impossible to tell how much she knew about his dependence on other women. His deep, seven-year liaison with Edouard Manet's former mistress, Méry Laurent, was a turning point in his life. Her radiant personality and luxuriant hair inspired his poetry and gave him confidence at a time when he was emerging from relative obscurity. Mallarmé had a decided streak of vanity, and he revelled in the intimate company of women so long as they were beautiful, intelligent and highly gifted. Within many of his poems, perhaps nearly a half, women have a central place. He captivated the opposite sex with his little poetical gifts, which elevated everyday events into the most memorable occasions. He was both artless and sophisticated. Berthe was by no means the only woman to feel 'united' to him 'by a fragile, emotional communion': these were the words of the beautiful Misia Godebska, Madame Thadée Natanson, the Mallarmés' neighbour at Valvins.[18] Berthe, however, had learned through her unrequited love for Manet never to open

her heart; so she remained on her guard, sometimes playing the coquette in letters. 'Mallarmé finds more beauty in men than women', she concluded, after listening to one of his monologues at her dinner table. As a statement it seems highly questionable. And although Berthe professed indifference, it suggests a certain brooding ambiguity in her feelings.[19]

The Thursday dinners were an accepted ritual until the high summer when the friends tended to disperse. Monet had become attached to his house at Giverny and Mallarmé to his riverside retreat of Valvins, where he stayed each school holiday to recuperate, meditate and write. In June 1886, with the end of the last Impressionist exhibition in sight, Berthe, Eugène and Julie left the rue de Villejust for the island of Jersey, where Victor Hugo had spent four years of exile. It was a choppy crossing to Gorey, where they took a furnished house, the Villa Montorgeuil. Ignoring the indifferent weather, Berthe went out on foot, making copious sketches in her notebook of everything she saw: the coast, the hinterland, orchards, haymaking, St Helier, Gorey. *Interior of a Cottage* was her biggest challenge. Pastel and watercolour studies preceded the finished oil, another celebration of her triumphant use of white. But she wrote to Monet with a hint of wistfulness. 'I am far from Paris . . . I have a bay overlooking the sea, and a garden which is a mass of flowers. You could do marvellous things with it.'[20]

The holiday had unfortunate repercussions. Eugène had been in a state of acute nervous exhaustion before coming to Jersey and the island was not particularly to his liking. In this state he was always a difficult model. After sketching him, Berthe decided to paint him out of the picture, *Interior of a Cottage*. No sooner had they returned to Paris in August than he fell prey to an unidentifiable illness. His recovery was slow, and caring for him took much of Berthe's time into the autumn. He was reluctant to go far, preferring to spend his time at home, tutoring Julie, reading, writing, toying with a paintbrush. Berthe resumed the ritual of the Thursday dinners as a way of trying to shake her husband out of his lethargy. Otherwise, they lived a somewhat secluded life in their grand *quartier*, only straying to the Bois.

Sometime that autumn Berthe's favourite nieces, the Gobillards, came to stay. She felt protective towards 19-year-old Paule, and produced two portraits of her in 1887. She was a talented girl but very young for her age; on the other hand, too mature to be counted in with the youngsters, Jeannie and Julie. As a matter of course Berthe helped her improve her skills as a painter, but she had also noticed her niece's facility with words, which touched a chord in her own lifelong interest in literature. (Family letters were spattered with references to novels or plays, Molière, Sardou, Zola, Sand, Constant, Flaubert.) After all, if artistic flair ran in the family, then why not literary ability as well? She had similar hopes for Julie, who already showed signs of possessing precocious talents.

Julie's education was of a highly individualist kind. Mother and child went for walks together through the streets and squares of central Paris, observing, talking, imagining, everywhere they went. 'Julie and I went out together down the rue Bonaparte', Berthe recorded in her notebook. 'We saw some reproductions of Botticelli's *Primavera* in the window of a photographer at the corner of the rue de Beaune.' It was a June day, 1887; Julie was eight. 'Another stroll along the quais with Julie asking questions all the time. We stood for a long time examining the sun and the planets at a mapmaker's.'[21] They looked at some eighteenth-century prints of figures in period costume, including one of the *Departure from the Opera*. The child's fertile imagination was suddenly fired. She panicked, recollecting the reddish glow of the Parisian night sky after the Dante's Inferno that engulfed the Opéra Comique at the end of May. People had been talking about the disaster ever since.[22] Berthe comforted and distracted her by chatting about the costumes. They walked on. 'Then in the Tuileries Gardens she recited to me from Théophile Gautier. We were looking for Coysevox's nymphs, and I think these are all by Coustou; sitting down I began to ponder over my painting of the garden, watching the shadows on the sand and on the roof of the Louvre, and trying to find the relationship between light and shade. Julie saw pink in the light and purple in the shadows.'[23]

Both Julie and Jeannie had also inherited their mothers' musical gifts. They spent endless hours together making music. Inseparable companions, all they looked for was the run of the place, afternoons in the Bois and the occasional treat like a visit to the Hippodrome. After that, Berthe was free to draw and paint them as she wished. She treated them as a duo, like the Delaroche sisters years before: *Jeannie with a Doll, Julie with a Dog*, and several studies of *Julie Manet and Jeannie Gobillard at the Piano*, collectively a series on the theme of two children, their lives in unison, each a perfect foil for the other.

Though she was confined to the house by Eugène's reluctance to go far, Berthe had no lack of ideas. It was about this time – 1885–6 – that she made her first attempts at drypoint, a method of engraving in which the subject or design to be printed is scratched on to a copperplate. But she was also intent on another project. She was keen to make a portrait in plaster, as she called it, of Julie's head. On her own admission, she became obsessed with sculpting to the exclusion of her other interests, as she paused only to record, 'I am a slave to this idea of white plaster.' It was only when she had finished it that her nerve went, and she was terrified that her critics would lambaste her efforts. 'I very much wanted to try my hand at sculpture and now I haven't the nerve any more', she confessed.[24] However, Monet was reassuring, and in the spring, at her request, he contacted Auguste Rodin, whom he knew well, to advise on casting it in bronze.

Monet had had to miss one or two of Berthe's Thursdays that autumn because he was painting off the Breton coast. He sent a thousand thanks and apologies, promising to visit her as soon as he returned. But her sister Yves, Degas, Mallarmé and Renoir were about, and *Maître* Jules de Jouy was always willing to make up a depleted dinner table even if the hospitality was sometimes a little too exotic for his taste. (Berthe could be surprisingly unconventional: she had acquired a repertoire of foreign dishes, including Mexican saffron rice and chicken with dates.)[25] Puvis was an occasional guest; Fantin too. Then the table talk turned between art and music, to Alfred Stevens's musical soirées, the recitals at Henri Lerolle's where Ernest Chausson played violin to Claude Debussy's piano (through Julie, Madame Lerolle and her daughters became family friends). The Lamoureux concerts were another topic of conversation. Mallarmé was a devotee, and it was his habit to call at the rue de Villejust on his way home. The poet was not a performer like Renoir, who could have been a professional singer. Indeed, Charles Gounod had once tried to persuade the gifted chorister to abandon art in favour of music.[26]

At one of their dinners in the spring of 1887 the Eugène Manets persuaded Renoir to do a different kind of favour. They commissioned him to paint a portrait of Julie. She was eight years old by that time. Her plait had disappeared and her sweet, heart-shaped face was enclosed in straight, short, floppy hair. Renoir came over to the rue de Villejust for the sittings, working morning and afternoon with a break for lunch. Three-quarters of a century later, Julie could still recall those days when she posed in her embroidered frock, nursing her cat: they sealed the Manets' fondness for Renoir. He had done five preparatory drawings which he later gave to Berthe and she was to make her own drypoint of the figure.[27] Finally, he painted in the tracing on the canvas bit by bit, 'one day my head and a little of the background, another day my dress and the cat'.[28] The finished version was treasured. Always the centre of attention, Julie was still everyone's favourite, even Puvis's (despite the fact that she once called him 'the Gingerbread Man' because of his florid complexion). To Renoir, who had no daughters, she was 'the sweet and lovable Julie'. Mallarmé tended to use her pet name, 'Mademoiselle Bibi'. And someone else who found the child appealing and would send kisses to 'Miss Julie' in her letters was the formidable Mary Cassatt.

In March that year the Cassatts had moved house to the rue de Marignan, just off the Champs Elysées. Mary Cassatt was a keen equestrian and it was her habit to ride in the Bois de Boulogne. The sight of riders in the Bois, on horseback and in carriages, was familiar to the inhabitants of Passy, and in 1888–9 Berthe was to capture the feel of movement through the trees in frenetic strokes of watercolour. Occasionally Mary Cassatt stopped at the rue de Villejust, since it lay on her route home, simply to pay her respects. If

Julie was about, she would lean down from her mount to have a personal word with the child. Mary Cassatt was sufficiently impressed by the Manets to hope that they might be friends. It was certainly she who had made all the running. 'I am so happy that you have done so much work', she wrote to Berthe with fulsome assurances, adding, 'I am very envious of your talent.' And while Cassatt failed to take part in the 1882 exhibition, she still went along to view. While there she had nobbled Eugène, who alerted Berthe that Miss Cassatt 'seems to wish to be more intimate with us'.[29] The American was bold enough to broach the possibility of painting portraits of Berthe and Julie. At that stage (Berthe was away in Nice) it was not practicable, but so far as one can tell, the favour was never granted. Berthe may have regarded the request as presumptuous. She always jealously guarded the rites of friendship.

Over the years, however, she learned to appreciate that Mary Cassatt was an influential and beneficent contact for Impressionist art. She certainly respected the American's intelligence and artistry, and recognized her dedication. They corresponded in friendly terms and exchanged visits; they had mutual friends and mutual interests. Beneath the skin the two women were always rivals, but Berthe reciprocated Mary Cassatt's hospitality with occasional invitations to the Thursday dinners.

The summer of 1887 was spent in Paris, except for two short trips. As a measure of the Manets' friendship with Mallarmé, he invited them to Valvins on the edge of the Forest of Fontainebleau. It was a haven of woods and water, ideal for Julie. Mallarmé loved boats – they were Berthe's private passion too – and he spent hours sailing on this stretch of the Seine. At Valvins he was 'the Captain' (Edouard's nickname for him), the proud owner of a yawl.

That August was sizzling. The Manets were also due to stay with Eugène's cousin, Madame de Vaissières, who lived at the Château of Vassé, in the Sarthe region. A love of architecture and a fascination with the past persuaded Berthe and Eugène to combine the visit with a tour of the châteaux of the Loire. From Orleans they travelled by carriage through a dull landscape of vineyards until Chambord emerged like an apparition through a thin veil of trees, its lilac-tinted roof slates heralding the gleaming white façade. Their guide was little more than Julie's age, dressed in sixteenth-century costume. She knew the château's history off by heart and crooned it mechanically as she led them through the courtyard to the double-spiral staircase, and past the guardroom to the upper terrace. Here the visual impact was inspirational. Berthe was deeply impressed by this masterpiece of Renaissance architecture, so graceful and elegant. But the setting played its part, conjuring images of courtly life, tournaments, pageants, the excitement of the royal hunt. 'A magnificent tapestry of days

gone by,' she remarked, 'exhilarating, yet a place to contemplate and work.'[30]

The next day, 12 August, they reached Blois and crossed the Loire, where again Berthe applied her knowledgeable mind and eye to everything around her. Blois had had a gruesome history during its transition from a feudal stronghold to a royal palace, but she focused on the 'admirable' additions of Francis I's wing, which included the king's famous staircase in flamboyant Italian style, and Mansart's classical range. Again it was the panoramic view from the terraced gardens which lingered; and the sharp contours of the rooftops below the skyline 'flooded with pearly tints', reminding her of Florence. But afterwards it was the wisdom of Michelet, which struck her. Surprised by 'the dead air of the town' and by the dirt in their hotel, she put a new construction on the great historian's description of the Touraine as the 'sweet land of idleness'. Rashly, perhaps, she let Julie go bathing in the river, while she herself sat amid tubs of oleander in the hotel grounds, gazing at the river and the changing patterns of light playing on the sandbanks; thinking, too, of the blood-letting of the sixteenth-century Wars of Religion, which brought ruin to the area and extinction to the royal house of Valois.

So they moved on to Chenonceaux, another jewel of the French Renaissance, its arcaded foundations rising from the waters of the Cher. The story of the château read like a Balzac novel. Six prominent women ruled its fate, including the legendary Diane de Poitiers. Yet strangely, Berthe was more impressed with Amboise, the picturesque little town dominated by the château, its round tower giving more superb views across the Loire valley. They stayed at a hostelry on the river bank, the Lion d'Or. It was possibly here that Berthe painted two little riverscapes in watercolour, before a southward detour along the Indre took them to the old fortress town of Loches, cresting a spectacular rocky spur. But they did not dally long. It was back towards the Loire and on to Tours, capital of the châteaux country, which housed a fine art collection in the former archiepiscopal palace. They lingered for a while on the heights of Saint-Symphorien, on the north side of the river, while Berthe worked on a pastel of *A View of Tours* below. Then finally it was on, northwards, to the River Sarthe and Vassé, where Eugène's cousin and her family were waiting to greet them.

Madame de Vaissière was a Fournier by birth. Her husband was a gentleman of substance and they had three children, two daughters, Marie and Julie, and the baby of the family, Georges. After Judge Manet's death, the Manet brothers had renewed contact with this side of the family and had stayed at Vassé, and their cousin had attended some of Edouard's Thursday soirées when visiting Paris. The country seat was a fine mansion flanked by towers, one of which housed the music room. It was approached by the traditional driveway of poplars, and the parterre was laid out with

yews in the formal style of Le Nôtre. But there were ample grounds besides, dotted with ancient trees, and a dovecot. The visit was apparently a success because the Eugène Manets went back twice in the next five years. While they were there Berthe completed a portrait of Marie de Vaissière in pastel as a token of gratitude for their hospitality.[31]

With the renewal of their Thursday evenings that autumn, Eugène invited some long-standing friends whom they had rarely seen since Edouard's death. Zacharie Astruc brought his wife and their daughter Isabelle; and Napoleon III's prime minister, Emile Ollivier, was accompanied by his second wife, Marie-Thérèse, to whom Degas took a fancy. Old memories drew them all together. Fifteen years had passed since Astruc had escorted Yves and Berthe around Madrid, and thirty since the Manet brothers enjoyed Ollivier's company (then a rising radical lawyer) on holiday in Italy. A love of art drew the three together. During the pressured years of the Napoleonic Empire when Ollivier had been one of only five Republicans in the legislative body, they had seen him intermittently: it was a time when Gustave and Eugène were becoming interested in politics. However, after the disastrous collapse of his political career at the outbreak of the Franco-Prussian War, Ollivier had lived mostly in Saint-Tropez. He gave up the law and immersed himself in the arts. He had spent years preparing his *apologia pro vita sua*, a massive history of the Liberal empire, but found time to indulge his knowledge of sculpture and painting in a book on Michelangelo. And as it happens he was also the author of one novel.

It may have been a coincidence that Eugène, a frustrated, romantic Republican, was also working on a novel at this time. But it was doubly coincidental that his story was set in the chaotic aftermath of the 1848 Revolution, the very time when Emile Ollivier had been dismissed from office for socialist activities. Berthe's dinner parties may have been a useful sounding board for Eugène. The hero of his story, like so many Republicans after 1848, was condemned to a slow and brutalizing death on a French penal colony: in real life, Emile's father, Demosthenes Ollivier, had also suffered for his Republican zeal.[32] At any rate, *Victimes!* was a political novel. It was a tale of derring-do and official skulduggery, vaguely reminiscent also of Gustave Flaubert. The setting was authentic and provincial, like *Madame Bovary*; the events, bound up in class warfare and repression, had the flavour of Flaubert's other masterpiece, *Sentimental Education*. It was perhaps through this work of fiction that Eugène found he could articulate, or sublimate, his political convictions.[33]

While Eugène was writing, Berthe committed herself to an equally difficult project at Mallarmé's request. He was keen to bring out a collaborative limited edition of a number of his prose poems under the title of *The Lacquered Drawer (Le Tiroir de laque)*. He hoped very much that she, together with Renoir, Monet, Degas and John Lewis-Brown, could be

persuaded to illustrate a poem each in lithograph. Since Lewis-Brown was experienced in this genre, he was asked to do the cover, while Berthe was entrusted to illustrate the 'White Water-Lily' ('Le Nénuphar Blanc'). Modesty made her hesitate because she had only experimented briefly with drypoint. She agreed with some misgiving, a feeling shared by Renoir. Finding it impossible to start without guidance, she wrote to Mallarmé in December 1887, 'It would be kind of you to come to dinner on Thursday. Renoir and I are very confused; we need some clarification on the illustrations.'[34] Mallarmé was clearly baffled by their self-doubt, but he came willingly enough. Berthe was to struggle to fulfil this commitment. She hated missing deadlines or giving up on challenges, but this was to prove a tough assignment because it called for a new set of skills. In the course of the next nine months she worked on preparatory drawings using three coloured pencils, pale red, yellow and blue, to achieve the tinted effect she was seeking; she had also made two etchings in drypoint of scenes on the lake in the Bois de Boulogne. But her three-pencil drawing of a white water-lily, which excited the attention of Monet, has not survived and she was never able to complete her illustrated page.[35] In actual fact, the project was dogged with delays and problems from the start, symbolized by the death of Lewis-Brown on Julie's twelfth birthday.

The winter of 1887–8 was long and exceptionally cold, an endless series of dark days. Renoir and Monet escaped to the south, the one to Martigues, the other to Antibes. In the rue de Villejust, Berthe worked with two new models, a young woman called Jeanne-Marie who modelled *Woman in a Hat*, and another named Jeanne Bonnet, whose rounded rosy cheeks and long plait made her uncannily like Julie before her hair was cut. Early in 1888 Jeanne posed for several studies for oils, including *Little Girl with the Parakeet* and *Little Girl Reading*. Berthe's work was cut short, however, when she developed bronchitis and influenza. She was out of action for some weeks for she had not been so ill since the terrible days of the Siege of Paris. Though she was back on her feet by the middle of March, she had little energy for work. She struggled with her canvases. Monet had written to enquire solicitously after her health and she admitted sadly that she was becoming a bronchial old lady.[36]

As a cold spring turned into a poor summer, Berthe returned to work in her studio. She and Eugène stayed in Passy over the next few months, having decided already, for the sake of their health, to winter in the Riviera. By July most of her friends had disappeared, except for Mary Cassatt, who welcomed her courtesy calls because she was laid up with a broken leg. Monet was anxious that Berthe should visit him in Giverny – he wanted to show off his latest figured landscapes – and Mallarmé pressed them to come to Valvins, but Eugène resisted firmly. By the time September came, bringing some glorious days, Berthe was already looking ahead to a change

of scene. In October she said goodbye in person to Renoir and as a goodbye gesture she sent a bouquet of roses to the Mallarmés on the eve of their departure.

For a while Berthe was in heaven. It was gloriously sunny, she was 'in the midst of real country', they had a lovely roomy white house, the living was cheap. And it was all so deliciously familiar. 'Here is our address', she wrote to Mallarmé: 'Villa Ratti, Cimiez Rise.' From their hilltop site the world was at their feet. They gazed over a vast garden, an avenue of orange trees, olive and aloe groves, Roman ruins and a Capuchin monastery, 'very picturesque' and 'very Italian'. Then below and beyond the tree-tops, they could glimpse the city of Nice and the blue Mediterranean Sea. It was so warm in November that they took lunch in the garden. Shopping was a delight. Mother and daughter went down to the market together to buy fresh fish. 'Julie is like a rose in bloom', she cooed to Edma, '. . . her cheerful little face, as she trotted in the narrow streets of the old town, was a pleasure to see.' The only thing missing was friendly company. Eugène was always there, but he could be moody and introverted. 'We have no one to talk to', Berthe suddenly realized.[37] So she wrote to all her friends in turn, assuring them that the guest bedrooms were prepared.

Renoir had already promised to come; he threatened to cycle all the way! She tried to tempt Mallarmé for a December break with promises that the oranges would be turning yellow; but he should come by sleeper-train as they had done. She sent a warm invitation to Monet, hoping that he might be persuaded to make another painting tour of the Riviera coast. She asked Yves to come down, and also Puvis, who was planning a trip to Italy. She urged him to break his journey with them, so it was disappointing to be told, 'Alas, my lovely trip is off for this year.'[38] Renoir, on the other hand, held out hope of arriving in January to paint the Manets sitting under the orange trees. But the best-laid plans fell through: he caught cold on a visit to Champagne and the Côte d'Or and developed paralysis of the facial muscles. With regret there was nothing Berthe could do but send a box of lemons to the invalid with the frozen face and flowers to all the rest (Mary Cassatt and her mother as well), 'a method of correspondence customary in this region', she explained. Mallarmé wrote back, sending his own gift of thanks with a specially composed quatrain, but he too had to break the news of 'an unexpected deluge of work' which detained him in Paris.[39]

Despite these setbacks, it was a pleasant way of life. Berthe basked in the endless opportunities to draw and in 'an unchanging weather that makes possible the most careful studies'. She found her touch. 'I am doing . . . a whole exotic vegetation . . . I am working myself to death', she wrote enthusiastically to Edma.[40] The Mediterranean scenery reminded her of Corot and she understood his penchant for the title *Souvenir of Italy*. She

produced a spate of drawings, pastels, watercolours, preliminaries for oils; landscapes – such as *Nice Seen from Cimiez, Surroundings of Nice Seen from the Garden at Cimiez, Under the Orange Tree, Olive Trees* – and figure paintings of the orange pickers, girls in local peasant costume, figures from the carnival and Julie as *Little Girl with Mandoline*. In the absence of her piano, Julie was learning to play this instrument, as well as taking drawing and painting lessons with her mother. Berthe was also working hard on an album of drawings depicting Julie's progress. Apart from these occupations, it was fun to follow goat trails in the hills above their villa or ramble among the ruins of the Roman amphitheatre, discussing art and philosophy while Julie galloped around like a young fawn.

There were few social distractions. They saw the Olliviers, for through Berthe Madame Ollivier sent her warmest regards to Monsieur Degas. They took a trip to the museum in Grasse to see Fragonard's works. As enthusiastic as ever, Julie persuaded her mother to let her be involved in the Nice Carnival, the high point of the winter season. The Battle of the Flowers was a major tourist attraction. A parade of elaborate floral floats and decorated carriages would stream along the stylish Promenade des Anglais, followed by the indiscriminate tossing of bouquets. Berthe was mildly disapproving of such hedonism, but she could not refuse her child's eager request, and it was only the rain which inhibited events.[41]

Visitors were more than welcome in Nice, which had suffered badly in the economic recession of the 1880s. The arrival in port of the flagship of the European Squadron of the American fleet was another major event. Under the command of Rear-Admiral Baldwin, the sloop was on an eighteen-month tour of duty in the Mediterranean. Its purpose was partly to promote international goodwill. Typically, Julie did her bit to foster harmony by befriending the captain's daughter, just as in 1882 she had befriended the little Russian *émigrée* in Nice. One outcome was an invitation to Monsieur and Madame Manet to attend a reception aboard the USS *Lancaster*. No one was more adept than Julie at the exercise of political skills.[42]

Politics, however, were rocking the country again. Since the fall of Ferry's ministry in 1885, instability and mediocrity had reigned, confirmed by the election of Sadi Carnot to succeed President Grévy, who had resigned over a family scandal in 1887. By 1889 it was widely expected that France would shortly have a new, charismatic head of state to supersede President Carnot. Renoir, though still unwell, scribbled a note to Berthe, 'We shall talk about General Boulanger when I can write without tears falling on my paper.'[43] He was referring to a handsome, blond-bearded populist, who had taken Parisians by storm as he rode his black charger in the Bastille Day celebrations of 1886. Boulanger was soon the hero of stage and song. But two years on, he had become a dangerous focal point for government critics and troublemakers on both political extremes, right and left. Spurred on by

nationalist fervour, Boulanger went from strength to strength. On 27 January he stood for a parliamentary by-election in a Paris seat, traditionally a Republican stronghold, winning an astonishing victory. Even Mallarmé was seduced. 'Well, Manet, I voted for the General, in obedience to my daughter', he remarked to Eugène, perhaps unsure how Berthe would react. He need not have worried. Although the Manets were detached from events, the radical Eugène shared Emile Ollivier's private sympathies for Boulanger and hostility towards the Republicans in power. 'My husband thanks Miss Geneviève for having made a Boulangist of you', Berthe replied by letter. Meanwhile, excited mobs called for Boulanger to be president, while extremists tried to persuade him to stage a *coup d'état*. The situation was tense in mid-February when Monet wrote to Berthe from Giverny, dissociating himself from the political fever which was gripping the capital. But the general delayed – reluctant to play the role of Bonapartist demagogue – and, as the old saying goes, he who hesitates is lost. Fearing arrest, he fled the country on April Fool's Day. Later he was to compound his débâcle by committing suicide on his Belgian mistress's grave.[44]

The irony was not lost on Eugène, whose political novel about a *coup d'état* and a Bonapartist dictatorship was to be published that year. But by the time Boulanger fled to Brussels, he and Berthe had decided it was time to return to Paris. They travelled by train and were back in the rue de Villejust by the last weekend in April. Berthe had enjoyed the Riviera greatly, but she admitted to Mallarmé that she had missed her 'Thursday faithful'. No sooner was she back than she asked him to dine with them *en famille*.[45]

The Republican government was again firmly in control. The French people had other things to distract them. The country was set to celebrate the centenary of the 1789 Revolution with an ever more ambitious Universal Exposition which attracted 32 million visitors. Despite protests from influential artists and writers, the Paris skyline was permanently altered. The panoramic view of the Left Bank from the Trocadéro, which both Manet and Berthe had painted, was now dominated by the colossal iron structure of the Eiffel Tower standing four-square on the Champs de Mars. It was a bold monument to the 1889 Exhibition, but it was also meant to signify the narrowing gap between the social classes in France.

By the time the venture closed in the autumn and Paris returned to normality, the Manets' Thursday dinners were back in full swing.

Bitter-sweet Fruits of Success

1886–94

The art world was changing. The official Salon system had been reformed in 1881. In theory at least, French artists were now in control of their own destinies. Innovation, however, always has its opponents, and an influential core of successful painters still dictated standards. It was only a matter of time before there was another rebellion by rejected artists, who broke away and founded the Société des Artistes Indépendants in 1884. But in any case, another element had to be reckoned with in the 1880s, the economic power of the market and the influence and control exercised by entrepreneurs, which became unassailable.[1] Dealers were as subject to it as artists, but the most hard-headed members of the business fraternity, such as Georges Petit, could anticipate trends and tastes. They could make – or break – an artist's chances of success. On the other hand, shrewd and determined artists like Claude Monet learned to do their share of bargaining and manipulating. In the mid-1880s he and Renoir were on the brink of breaking through the crucial barrier from notoriety to fame. Berthe watched their progress with admiration, aware that neither she nor Eugène had Monet's brazen self-belief; but knowing too that if Impressionism caught the popular imagination, success for Monet's less assertive colleagues, such as Sisley and herself, would surely follow. Ironically it was Monet himself who put the same point to Berthe in the summer of 1887. 'Do work hard so that this time success may be decisive for all of us.'[2]

However, Berthe's aims were less explicit than Monet's or Renoir's: they were breadwinners. In 1886 she was in her mid-forties. Yet she had no intention of settling back into a leisurely retirement. On the contrary, over the next six or seven years she laboured to produce a stream of pictures. It was a measure of her dedication and versatility that as an artist she changed with the times. She adopted new working methods, experimented with different media. Her ambitions were discreetly veiled, but an inner driving force made these her most prolific years. She knew from long experience that although success was harder to achieve for a woman than a male artist, it could be measured in several ways apart from material wealth: that there was such a thing as public recognition, the esteem of colleagues, contentment, self-fulfilment, and in the last resort, that it was 'the warmth

of the heart which makes our friends remember'. It is difficult to estimate her sense of achievement because her letters continued to be peppered with the kind of self-deprecating remarks her fellow artists, even Monet, commonly made: 'I am distressed' and 'I am working badly'.[3] A side of her was frightened of success; she could only cope by disparaging her own efforts. Yet she felt the responsibility of being born with great talent; she recalled the words of St Matthew: 'Many are called, but few are chosen'.[4]

On her return from the Low Countries in the autumn of 1885, Berthe heard that Durand-Ruel had been invited by the American Art Association to present an exhibition of their works in New York the following spring. In March 1886, when the dealer left for the United States, he went armed with nine of Berthe's paintings, along with large numbers by Manet, Renoir, Monet, Degas, Sisley, Pissarro and others. Coincidentally, however, there had been talk among the artists of another co-operative group exhibition.[5] Pissarro was the first to float the suggestion, for he was unhappy about his dependence on Durand-Ruel. Among those he approached were Monet and Mary Cassatt. Independently, Berthe would appear to have been mulling over the same idea. She and Eugène certainly approved of the proposal and did some canvassing behind the scenes and it is likely that Berthe discussed it with Renoir in January. Since they had not been involved in the organization of the 1882 exhibition, Berthe and Eugène seemed determined to play their part this time. Her husband joined Henri Rouart and Armand Guillaumin in drawing up the admission rules, which again precluded Salon exhibitors. But more pertinently, the Manets were prepared to put up 3,000 francs towards the rent of rooms. Not surprisingly Eugène took a certain proprietorial interest in the event.

However, like the earlier exhibitions the negotiations were fraught with disagreement. At the outset their crusty friend Degas seemed to be the stumbling block. In 1885 Berthe had written to her sister Edma in tones of scarcely veiled irritation. 'I am working with some prospect of having an exhibition this year. . . . This project is very much up in the air. Degas's perversity makes it almost impossible of realization; there are clashes of vanity in this little group that make any understanding difficult. It seems to me that I am about the only one without any pettiness of character.'[6] To have become directly involved in these arguments was beneath Berthe's dignity: she was content to leave the in-fighting to the men.

But in December 1885 an anguished Pissarro appealed to Monet. 'For some time there has been much talk about a show. . . . Can't we come to an understanding about it? All of us, Degas, Caillebotte, Guillaumin, Berthe Morisot, Miss Cassatt and two or three others would make an excellent nucleus for a show. The difficulty is coming to an agreement.'[7] Three months later he was at his wits' end. 'The exhibition is completely blocked.

. . . We shall try to get Degas to agree to show in April, if not we will show without him. . . . Degas doesn't care. . . . I shall find out what Madame Manet [Berthe Morisot] thinks, but I am afraid she will not want to appear with us if Degas does not. In that case the whole thing will be off – there won't be any exhibition.'[8]

By early 1886 it was clear that the problem was not simply one of personality: each of the Impressionist artists had their own agenda. Four of them, Monet, Renoir, Sisley and Caillebotte, had decided it was not in their best interests to be involved in an independent exhibition. It must have seemed a sad situation to Berthe, who felt such a kindred admiration for both Monet and Renoir. As a matter of principle, Degas insisted on a direct challenge to the official Salon to be held in May–June, a tactic that Pissarro, with an eye to sales, considered to be ludicrous, although Edgar finally got his way. But it was really the old conciliator, Pissarro, who pushed matters to a crisis. He insisted that three newcomers should be included: Georges Seurat and Paul Signac, exponents of the new mode of Pointillism, and Odilon Redon, who was a founder member of the rival Société des Artistes Indépendants. It was Berthe's role in the preparation to vet a selection of works by potential exhibitors, and it seems to have been understood that in the previous autumn she had accepted both Seurat and Signac. But as the date of opening drew near, the Manets seemingly realized that Seurat proposed to submit his giant canvas, *A Sunday Afternoon on the Island of La Grande Jatte*. If Berthe had had earlier reservations but suppressed them, her anxieties may have resurfaced or been reactivated by discussion with colleagues – Henri Rouart perhaps, almost certainly Renoir, and conceivably Monet as well. At any rate, Eugène decided, even though it might jeopardize the exhibition, he would have to confront Pissarro. The latter took up one side of the story.

Yesterday I had a violent set-to with M. Eugène Manet on the subject of Seurat and Signac. The latter was present, as well as Guillaumin. You may be sure I rated Manet roundly – which will not please Renoir. . . . I explained to M. Manet, who probably didn't understand anything I said, that Seurat has something new to contribute which these gentlemen, despite their talent, are unable to appreciate. . . . I do not accept the snobbish judgements of 'romantic impressionists' to whose interest it is to combat new tendencies. . . . But before anything else is done they want to stack the cards and ruin the exhibition. Monsieur Manet was beside himself! I didn't calm down. They are all underhanded, but I won't give in. . . . Monsieur Manet would have liked to prevent Seurat from showing his figure painting [*La Grande Jatte*]. I protested against this, telling Manet that in such a case we would make no concessions, that we were willing, if space were lacking, to limit our paintings ourselves, but that we would fight anyone who tried to impose his choice on us.[9]

Unfortunately we have no version of the Manets' side of the argument. But Eugène was known to have an uncontrollable temper, and, as he had demonstrated to Albert Wolff, he could be ferocious in protecting Berthe's interests. His opposition to the new 'Scientific Impressionism' was almost certainly couched in aesthetic terms. But tactical considerations may have been at the back of his mind. A group exhibition needed identity. The Pointillists' work seemed to him to be out of harmony with true Impressionism and there was the real danger that they would draw the critics' attention away from the original Impressionists, including Berthe. And Redon's inclusion was an added embarrassment. Unable to describe the show as 'Impressionist', the organizers were also deprived of the right to call it 'Independent'. They had to settle for the meaningless title of 'The Eighth Exhibition of Painting'. Finally, the sheer size of *La Grande Jatte* made it an inappropriate exhibit for an intimate group show. As one of the financial sponsors, Eugène probably felt he had the right to protest.

In the event, after all the bickering, they kept to Degas's schedule. He found prime premises on the corner of the rue Laffitte and the Boulevard des Italiens, a suite of rooms above a restaurant, La Maison Dorée, famous for its ornate gilded balcony. There were seventeen contributors and it was clear from the outset that they scarcely constituted a homogeneous group. Berthe chose eleven pictures and a series of drawings, watercolours and fans. A representative selection, they included two of her translucent garden scenes, *Hollyhocks* and *The Garden at Bougival*, and three recently completed interiors, *Getting out of Bed*, *The Bath* or *Girl Arranging her Hair* (Mary Cassatt exhibited *Study*, a picture of the same theme) and *The Little Servant* (a complex figure painting of Pasie in the dining-room at the rue de Villejust).[10] To these she added some portraits, including one of her niece Paule Gobillard, a placid adolescent then verging on young womanhood.

According to Mary Cassatt's father, none of the sponsors – his daughter, Degas and an acquaintance, and the Eugène Manets – expected any profits from the venture.[11] But if they wanted the public's attention, they must have hoped the exhibition would attract more visitors than it did. In fact, the weather was atrocious and after reaching a few hundred a day, the numbers dwindled. The organizers were left with a memory of Alfred Stevens, playing fast and loose with his fortune as he shuttled between La Maison Dorée and Edouard Manet's old haunt, the Café Tortoni, enticing the *boulevardiers* across the road to see the show by throwing gold pieces around with gay abandon. Sadly it was not so much Berthe's painting that brought the people in as Seurat's, as Eugène had feared. George Moore, who went on the first day, had been told to look out for 'a lady with a ring-tailed monkey'. He found 'these scientifically-painted pictures . . . strange, absurd, ridiculous'.[12] The stiff images of Seurat's people in *La Grande Jatte* were

equally a subject of disdain, and Degas's shockingly unflattering nudes were another talking point.

The critics had less to say about Berthe's 'charming and wittily inspired art', and there was something familiar, almost inevitable, about their condescension. *La République Française*: 'It is necessary to view the submissions of Berthe Morisot, essentially white on white, from some distance, to avoid being halted by their initial quaintness; in this way a young woman getting out of bed is interesting.' *Le XIXe Siècle*: 'I am bound to report that in the case of the canvas entitled *The Bath* – the face of the bather does not come out very well – the colours are in turn transient, jumbled and careless; but the ensemble has a certain charm, as Diderot would have said.' Fortunately, Alfred Paulet of *Paris* observed her sensitivity, her gift for raising the prosaic to a poetic level. The poet Jean Ajalbert, Mallarmé's protégé, resorted to analogy in his critique for *La Revue Moderne*, comparing Berthe's brevity of idiom with a Symbolist poem. And in due course Félix Fénéon had these complimentary words for her in *Les Impressionistes en 1886*: 'Madame Berthe Morisot is elegance personified: her treatment is bold, clear, quick; feminine charm without affectation; and despite an appearance of improvisation, her values are strictly accurate. Her paintings of young girls on the grass, rising, doing their hair, are exquisite works; in addition to the joy of her economical drawings and swiftly-executed watercolours.' However, it was his conclusion that mattered. '*Madame Morisot and Messieurs Gauguin and Guillaumin represent Impressionism such as it has been in past exhibitions.*' Or as Maurice Hermel put it – more pointedly – in *La France Libre*, 'Her style remains *too purely Impressionist.*'[13]

It was a label Degas had never liked. He and his associates, Mary Cassatt, Rouart, Marie Bracquemond, Forain, Tillot and Zandomeneghi, formed a large côterie in the main room where Berthe's work was hung. But on a practical level the disparity was underlined by the organizers who insisted on putting the works of Seurat, Signac and the two Pissarros, father and son, in a separate and inferior room. As for Odilon Redon, whose style the critic Paul Adam decided bore 'no immediate relation to Impressionism', his compositions were hung in a corridor on their own. The critics had grown used to traditional Impressionism, with its transient effects and 'irregularity dear to Renoir'. Far from shocking, it had a certain appeal, the appeal of familiarity. 'For my part, I would trade all of Redon and his future work for one simple watercolour by Berthe Morisot – three strokes of the brush and a bit of blue and green', wrote Georges Auriol of *Le Chat Noir*. Fénéon confirmed that Berthe was, in Pissarro's phrase, a 'Romantic Impressionist'. Seurat and his followers were a new breed; they were 'Scientific Impressionists'. Félix Fénéon produced his own terminology: Neo-Impressionism.[14]

The full implications of the eighth exhibition dawned more quickly on

some than on others. Gauguin was pleased with the response of other artists there to his work and optimistically told his Danish wife Mette, 'Our exhibition has reopened – and favourably – the whole question of impressionism.' In fact his style was taking him beyond Impressionism, though he demonstrated his individualism by declining to exhibit with the Society of Independent Artists in August.[15] But Eugène Manet had had his fingers burned. Organizing a complex event in competition with a traditional counter-attraction, was a fool's game (and independence from the Salon was no longer an issue). There was no future in the privately sponsored, self-help type of initiative. More than that, the eighth would be the last exhibition because, having stamped their mark on the history of modern art, the Impressionists found the management structure of the art world had changed; at the same time Post-Impressionism had become the new avant-garde.

In future Berthe would have to consider seriously whether to try to follow the example of her friends, Monet and Renoir, who had exhibited in Brussels earlier that year and joined Petit's circle. They demonstrated their independence on 15 June, the same day as the Impressionist exhibition closed, when they took part in the fifth international exhibition in Georges Petit's sumptuous gallery in the rue de Sèze. It may have touched a raw nerve with the Manets, but Berthe would never have raised the matter. Quite the reverse, she apologized handsomely to Monet for being unable to attend. She knew they were reaching a crucial stage in their careers and wished them well. 'This time will you conquer the public once and for all?' she asked Monet pointedly.[16] The reply was a qualified yes. The prices had yet to rocket but he sold twelve of his thirteen paintings on show for a total of 15,000 francs.

A few days after Petit's exhibition opened, Durand-Ruel returned from America with the news that the exhibition of 'Works in Oil and Pastel by the Impressionists of Paris' had also been a fair success. 'Don't think that the Americans are savages', was his message. 'On the contrary, they are less ignorant, less bound by routine than our French collectors.'[17] The American press was not especially discerning but the Art Association was supportive and the show ran for an extra month. Durand-Ruel sold about a fifth of the works on show, sufficient for him to be confident of future sales. In the long run his optimism was justified, though it would take more time, buoyed by the opening of his New York branch in 1888. But again, the year 1886 pointed the way to change. Impressionism had reached America.

The next few years chart the artistic consummation of Berthe Morisot. It was a fertile yet fraught period of her life, as she took her part in the growing adulation of Impressionism. The eighth exhibition had some unexpected repercussions. One of the critics and author of a review of the

show in *L'Art Moderne* was Octave Maus, a Belgian lawyer active in the leadership of an ultra-modern group of painters and musicians in Brussels, the Circle of Twenty (*Cercle des Vingt*). Their aim was to promote avant-garde art through annual exhibitions and to bring together artists from other European countries. Early in 1886 Berthe had declined an approach to exhibit because of the coming Impressionist exhibition. However, in the course of his review article, Maus had praised her picture *The Little Servant*, observing in Berthe 'a temperament . . . that bears the stamp of real aristocracy of feeling and taste'.[18] A few months later he repeated his invitation to her and to a number of other foreign artists – the landscapist Albert Lebourg, Degas's bombastic friend, Raffaelli, and her recent co-exhibitors, Seurat and Pissarro. This time she accepted, sending some of her pictures shown at the last Impressionist show together with the interior scene painted at Gorey. The exhibition of *Les Vingt* ran from 5 February to 5 March 1887. Her 'feasts of light', painted both indoors and *en plein air*, were favourably received, even by some of the Pointillists. Pissarro let slip in a letter to his son that 'Seurat, Signac, Fénéon, all our young friends like only my works *and Mme Morisot's a little*'.[19] Under the circumstances, this was fair praise. Although Pissarro encouraged the rising generation of Neo-Impressionists to reject Impressionist techniques, he could not bring himself to criticize Berthe Morisot.

That same spring Berthe received further gratifying recognition when she was asked to take part in the next international exposition at Georges Petit's gallery near the Madeleine. She joined a list of outstanding artists. Renoir was showing the large canvas of *The Bathers*, which he had at last finished. Monet exhibited a set of Breton landscapes from his recent visit. Sisley and Pissarro were also represented and others who had made their names outside mainstream Impressionism: John Lewis-Brown, the engraver; Jean-Charles Cazin, a fashionable establishment artist; the indefatigable Raffaelli; the American, James Whistler; and Rodin, who had already attracted major civic commissions. Petit struck a hard bargain for the honour of exhibiting with him. As her contribution to overheads Berthe sacrificed her shimmering figure of Isabelle Lambert in *Getting out of Bed*. She had finally plucked up courage to put forward her sculpture of Julie's head; and besides this a pastel and five other pictures, among them the recently completed portrait of Paule Gobillard.[20] Her 'delicious fantasies' and charming transparency of style were noted in reviews. Berthe's own verdict on the show was a characteristic piece of understatement. 'Exhibition not as bad as I had thought.'[21] In her modest way she was gratified to exhibit with a prestigious dealer. It would have been demeaning to point out that Petit failed to sell any of her works.

In the next twelve months the competition between the major dealers and art galleries intensified as it became clear that a market was opening up

in Paris for Impressionist works. Mary Cassatt still resolutely supported Durand-Ruel. He was keen to hold another Impressionist exhibition, but at the time Georges Petit was also planning an exhibition of modern artists. Berthe had no objection to exhibiting in Petit's fine gallery again, but she was warned off by Monet. In a letter to her, he wrote darkly of 'all the trouble we had with Petit', a reference to the dealer's excessive demands.[22] But at the same time Monet had found a new contact, a young Dutch dealer, Theo van Gogh, who managed the well-established Gallery of Boussod & Valadon in the Boulevard Montmartre, and in June 1888 showed a number of his landscapes there. This was the reason why he turned his back on both Petit and Durand-Ruel that year. Berthe and Eugène went to see his exhibits. She knew how important it was to an artist's self-esteem to receive praise: 'the picture I liked best is the one with the little russet tree in the foreground; my husband and I stood in ecstasy before it for an hour', she wrote generously.[23] Her subconscious mind may have absorbed the impression, for she produced a tiny watercolour and drypoint entitled *Russet Tree*, possibly intending to use the latter for her illustration of Mallarmé's poetry volume.

In the meantime Berthe had to make a decision about where to place her work. Having been unwell, she felt uncertain, until Renoir encouraged her to send what she could to Durand-Ruel's exhibition in the rue Laffitte, since – as he sensibly reminded her – there would be no expenses so there was nothing to lose. (Among her five exhibits was an early version of *Bathers*, for which Carmen Gaudin had posed in the nude.) With her usual tendency to knock any venture in which she was involved, she wrote it off afterwards as 'a complete fiasco' – except for the work of Renoir and Whistler! But she was quite mistaken. One viewer who was both impressed and intrigued by her work was the talented young aristocrat recently arrived in Montmartre, Henri de Toulouse-Lautrec, who was also using Carmen as a model at the time. And another, who wrote with his sincere congratulations, was Claude Monet.[24]

Berthe was aware that her friends were going from strength to strength. Renoir, she knew, would grace any exhibition. She found Monet's landscapes simply dazzling, and watched as the following year he and Rodin jointly mounted a major retrospective. In February 1888, Puvis won an important commission from the town of Rouen. Even her cousin, Gabriel Thomas, a serious collector of modern art, had in a different way found a niche in history by heading the consortium of financiers behind the building of the Eiffel Tower for the Universal Exhibition of 1889. But most gratifying of all was Edouard Manet's place at this great centennial celebration of the French Revolution. Antonin Proust, who was in charge of organizing the exhibition of French art at the Palace of Fine Arts in the Champs de Mars, ensured that fourteen of his pictures (including his

portrait of Proust) were prominently displayed. (And with them three Monet landscapes and one Cézanne.) Among Edouard's paintings in the Champs de Mars was *Olympia*, for which he had once asked the princely sum of 10,000 francs. The enemies of modern art stared aghast. But there were some, like Monet and John Singer Sargent, who endorsed Berthe's certainty that *Olympia* was part of the cultural heritage of France.

The future of this painting by Manet was almost certainly discussed between friends at one of Berthe's Thursdays. At any rate, acting with the utmost discretion she and Monet collaborated to take soundings on the possibility of a public subscription to buy *Olympia* from Suzanne Manet and present it to the Louvre. Berthe approached Puvis de Chavannes, whose only reservation was that the idea might not be acceptable to the government. Her response was touchingly optimistic: only in matters relating to Edouard could Berthe be accused of being quixotic or naive. 'He [Puvis] would like you first of all to ascertain the administration's goodwill. I told him that neither you nor I thought this necessary.' Unfortunately Puvis also urged that someone should talk to the egotistical Antonin Proust. Berthe's instinct was to withdraw immediately from any involvement. 'I have no way of influencing the authorities, and even if I had, I should think that an intervention by the family would change the character of the subscription.' She knew success depended on pulling the right strings. So she pleaded with Monet to take on the initiative. 'You alone, with your name, your authority, can prise open the doors of government, if they can be opened at all.' The project assumed a greater urgency when rumour stirred that an American collector was interested in buying the painting. By 13 November, Monet reported buoyantly to Berthe on progress. 'The subscription is successful beyond my hopes. . . . All the important painters have contributed.'[25]

However, nothing concerning Edouard Manet was ever plain sailing. Monet had got wind of trouble in November. Emile Zola refused to subscribe: hardly surprising since he had fallen out with all the Impressionists in 1886 over the publication of his novel, *L'Oeuvre*. Then in January 1890 at the instigation of Proust, articles in two newspapers suggested that the subscription was a form of charity for Manet's widow (and therefore the Manet family). Proust's preference was for the painting of *Argenteuil*. Monet was furious, Berthe was mortified, Eugène outraged at the public slur. 'Now that war is declared we shall fight on to the end', Monet, pugnacious as ever, assured them. But Eugène also took up the cudgels, or, more accurately, the pen. An exchange of letters followed. Eugène, as 'protector of the honour of the family' – his own words – demanded a retraction and public apology. No matter: in the New Year the subscription reached 19,415 francs, only a few hundred short of the target figure. After much effort and perseverance, on 7 February Monet tried to

conclude the affair by writing to the minister for fine arts, confirming the offer of *Olympia* to the state. Even then, over nine months elapsed before a ministerial decree decided Manet's most famous painting should go to the Luxembourg Museum rather than the Louvre. It was the great Republican, Clemenceau, whose portrait Edouard had also painted, who ordered the transfer of *Olympia* to the Louvre in 1907.[26]

Such bruising encounters were emotionally exhausting for Berthe and her husband, and neither was constitutionally strong. In the following two years, 1891 and 1892, Berthe turned down invitations to exhibit with *Les Vingt* in Brussels on genuine grounds of ill-health. For much of that time she was working as hard as ever, and yet she felt that worldly success – money, fame, acclaim – was passing her by. She spoke from the heart to her sister Edma. 'It looks as though I am coming to the end of my life without having achieved anything and only selling my work at bargain prices.'[27] Then in April 1891, three months after she had turned fifty, she was tempted back to Durand-Ruel's by news from Monet that he had gone back to the rue Laffitte. The dealer was a great survivor and his business had rallied considerably since his financial difficulties of the early to mid-1880s. His Paris gallery was doing well and the New York branch was established. Furthermore, to support his activities and promote his artists' work, Durand-Ruel founded a new review at the end of 1890, *L'Art dans les Deux Mondes*. The 6 December edition featured an article on Renoir by a critic-friend of Mallarmé, Théodor de Wyzewa, and the following weeks saw valuable publicity for the work of Degas, Pissarro, Monet, Sisley, Lépine and Seurat.

Berthe was sufficiently encouraged by these initiatives to agree to take part in Durand-Ruel's spring exhibition alongside her old colleagues. She was introduced to Wyzewa, who had accompanied Renoir on a trip to Toulon at the beginning of the year. Any friend of Renoir was welcome at the rue de Villejust. She was gratified by his lengthy, illustrated critique of her work in the 28 March issue of Durand-Ruel's journal. After long years at the receiving end of condescending or critical reviews, she no longer took exception to the assumption, which Wyzewa made, that hers was a particularly feminine style of painting. She took it for what it was: a form of compliment for someone whose work was, in his judgement 'perfection itself'.[28]

He was also gracious enough to suggest that her work was influential in its impact on contemporary artists. Conscious of her distinguished background and refined nature, Wyzewa was wary of sounding condescending. After he came to know her, he opened his heart. 'I have always sensed, Madam, that your feelings were so exalted and your disinterestedness so unalloyed that I have always feared to offend you by telling you how much I admire your talent. But I believe more and more firmly that after the death of Manet

only Renoir and you have preserved the qualities of the painters of past times; that you alone, with Renoir, are an artist among pupils or teachers; and each time I see your works I am so deeply enchanted.'[29] Allowing for a touch of sycophancy on the part of a young man making his way, she must have been deeply touched.

For all his involvement with Durand-Ruel, however, the exhibition in the rue Laffitte was badly handled. Berthe was 'horribly disappointed' by the fact that her work was relegated to the corridor.[30] In addition, she was annoyed by her perfunctory treatment at the hands of one of the Durand-Ruel sons, who told her tactlessly that they had tried her paintings in the exhibition room and they looked *even worse*. At that moment Puvis arrived. Berthe was virtually ignored by the staff, for, being one of the princes of the art world, Monsieur Puvis de Chavannes had to be escorted round in style. Even then Berthe took it philosophically. She had nothing against Puvis who was charm itself, but if it had not been for the presence of her bearded friend, Pissarro, the day would have seemed a disaster. They stood and talked in ironic tones about what it meant to be successful. Had Edouard been right after all? Was real renown only attainable through the Salon system? Puvis had triumphed through that route. Not for the first time, he took her to task by letter. 'I regret that you are not regularly exhibiting at the Salon. . . . But I am convinced that in the end you will return there.'[31]

Berthe did learn one lesson from the episode, but not that particular one. She was sufficiently disillusioned with Durand-Ruel's to vow that next time she would exhibit at a different gallery. Meanwhile, Eugène was already brooding about how to ensure that her work received proper public attention. She had amassed a considerable output in the last few years. He came to the conclusion that the time was ripe for her to take a leaf out of another artist's book and hold an individual exhibition. Mary Cassatt had already shown her determination by holding a personal exhibition at Durand's. Pissarro also held his own show and Renoir was to hold a triumphant solo exposition in the rue Laffitte the following year, 1892. Berthe decided to follow Monet's example: she turned to Durand's rivals. Whether it was Eugène who initiated the negotiations with Maurice Joyant of Boussod & Valadon and put him up to approaching Berthe – the dealer certainly wrote inviting her – or whether Joyant approached her on his own initiative, is obscure, but what is certain is that Berthe was left to complete the arrangements with Joyant in the spring of 1892. The event was a major task and a landmark in her life.

Friends, collectors and dealers had agreed to lend her works to supplement her own for this, her first personal exhibition. Out of her customary decorum Berthe declined to attend the opening on 25 May and left Paris the following day. Forty oils and innumerable watercolours, pastels and drawings besides had been assembled in two small rooms. The preface

to her catalogue, composed by Gustave Geffroy, an experienced journalist, paid a delicately worded tribute which pleased her. 'This display here confirms her art of creating delicious illusion with a vaguely uncanny truth; truth which evokes translucent shadows in the forest light, in the depths of water and in pure crystal, satisfying to this woman, who is an exceptional artist and who achieves something extraordinarily rare, delicate, fleeting yet instantaneous, painting which is essentially feminine.' He concluded, 'This is an unique feast of painting.'[32]

His gentle panegyric was echoed by reviewers. Albert Aurier of *Le Mercure de France*, for instance, highlighted

> this young girl sitting, so exquisitely doll-like that one thinks of Renoir, this picnic, these aloes, these haymakers, this shepherdess lying down, this youngster with a basket, this little girl with a bird, these swans, all these visions of rosy urchins, laughing babies rising into the blue and green beyond in clear flight, in this crystalline and so delicate art . . . oh, and above all, all these delicious watercolours, all these charming, light sketches of children, just and so accented with blue and pale vermilion.[33]

Berthe was gratified to hear that 'there were many visitors'. She was also grateful for the letters and compliments of friends: it was a special delight to be told by Monsieur Degas that he saw infallible draughtsmanship in her subtle painting. Naturally Renoir sent his compliments, Puvis was charmed, Mary Cassatt used the same word to Pissarro, while apparently omitting to tell Berthe.[34] At the sale Monet paid 1,500 francs for *The Bowl of Milk*, Gallimard the same for the *Swans* and the composer, Ernest Chausson, double that for golden-haired Julie *On the Verandah* at Bougival. *The Haymakers* and *View of the Bois de Boulogne* fetched more modest sums, and a pair of watercolours and two drawings little more than they would have brought twenty years before. Since Berthe rarely aired her views on money, it is hard to gauge her response. Judged alongside the masters of grand murals or meticulous portraits – Puvis, Carolus-Duran, Stevens, or Tissot – this exhibition would have been classed a financial disaster. However, if aesthetic considerations were the benchmark, she had scored a personal success. Even Berthe herself was pleasantly surprised that, in her own eyes at least, her early work had stood up to the test of time. 'Let us hope that in twenty years from now the new ones will have the same effect on me', she confided to Louise Riesener. All in all, the experience 'seemed to me less bad than I had expected'.[35]

As it turned out, this was Berthe's only personal exhibition in her lifetime. In May 1893 she sent two paintings to the annual group exhibition of the Association pour l'Art in Antwerp, and that same spring one of her early Fécamp scenes was shown in London at an exhibition organized by the

New English Art Club. In 1894 Octave Maus again contacted her, inviting her to take part in a large exhibition of modern art which he was organizing in March under the auspices of *Libre Esthétique* in Brussels. She agreed, and decided to take Julie, now fifteen years old, to show her the city. Berthe had four items on show, including *On the Verandah*, borrowed from Ernest Chausson, and *Nude Shepherdess Resting* (sometimes known as *The Reclining Shepherdess*), one of her most erotic and beautiful works. The Pissarros, father and son, Gauguin and Maurice Denis, were among the contributors, but it pleased her to discover that Renoir had two pictures hanging in the same gallery.

Of all the facets of success, Berthe would have said, the most prized and rare is the high opinion and affection of colleagues. She had noted carefully that Mallarmé once said it made him happy to be living in the same age as Monet: she took his words to be the highest compliment the poet could pay the great Impressionist painter. In his 1891 review, the critic de Wyzewa had bluntly (though with sincere regret) pointed out that 'Madame Morizot' (*sic*) was not, in truth, a celebrity: the public scarcely knew her name, and only the cognoscenti appreciated her work. Pissarro was to say much the same in a letter to his son.[36] The high walls of a bourgeois household, which gave her privacy – much-needed by her ailing husband and her growing child, as well as by her fastidious self – were also an impenetrable barrier to public scrutiny and approval. However, as it turned out, she would still be honoured in her time, thanks to those who believed fervently in her gifts.

In February 1894, before leaving for Brussels, Berthe learned of the death of Gustave Caillebotte. He had offered his considerable Impressionist collection to the nation for display in the Luxembourg Museum. It included Manets, some Degas pastels, paintings by Monet, Sisley, Pissarro and Cézanne. The bequest caused a furore among the art establishment, led once more by Gérôme, but when the dust had settled, two Manets, six Renoirs, eight Monets and all but seven of Degas's pastels were accepted by the Luxembourg. It was the highest honour France could pay a living artist. If greatness is judged in terms of popular appeal and public esteem, then Renoir, Monet and Degas triumphed in their lifetime. Since Edouard's death, however, and even more since the traumatic events of his posthumous sale and the *Olympia* controversy, Berthe felt that only posterity could judge an artist's originality. 'Is it possible to create a new painting? The future alone will tell.'[37]

But not all her friends agreed with such declared modesty. Mallarmé felt strongly that an Impressionist collection was incomplete without at least one Morisot painting, for she had been a central figure in the movement. When an opportunity occurred to rectify the situation he acted promptly. He used his personal influence with Henri Roujon, minister for fine arts, to

intervene at the sale of Théodore Duret's collection to purchase, at the price of 4,500 francs, one of Berthe's paintings, *Young Woman in a Ball Gown*, on behalf of the state. By a twist of fate, while protracted negotiations delayed the implementation of the Caillebotte bequest, this classic example of Berthe Morisot's work entered the Luxembourg Museum as part of the national heritage.[38] It was poetic justice. As George Moore observed, she was 'perhaps the best of all women painters' and 'Her pictures are the only pictures painted by a woman that could not be destroyed without leaving a blank, a hiatus in the history of art'.[39]

In all likelihood, this posthumous verdict would have raised a wry smile, but otherwise have left Berthe Morisot unmoved. In private she confessed to having thought about immortality, the symbolic trace of our material existence, but as age took its toll she coveted very little and envied no one. Today, when the trappings of success – luxury, kudos, hype – are greatly prized, it may be difficult to appreciate her mind-set. Yet with acclaim and fame within her grasp, her appetite for worldly triumph diminished. She was content with small satisfactions. In her own words, 'For a long time now I have had no expectations, and the desire for posthumous glory seems to me an inordinate aspiration. My ambition is limited to trying to record something fleeting, anything, the least of things. Yet even this ambition is excessive. A pose struck by Julie, a smile, a flower, a fruit, the branch of a tree, one of these would be enough.'[40]

Valediction

1890–5

General de Gaulle once likened the decade of the 1890s in France to a Spanish Infanta, weeping with melancholy while enjoying all the material benefits of life. He might have been describing Berthe Morisot. The new decade opened unhappily, so far as she and Eugène were concerned, with the distasteful wrangling over *Olympia*. Mallarmé also had his problems. He was still grieving for his friend, Villiers de L'Isle-Adam, one of the Symbolists who had died the previous August. The Manets knew that Mallarmé had been invited to make a lecture tour in February 1890, taking in Brussels, Ghent, Antwerp, Liège and Bruges, where he delivered an elegaic *tour de force* on Villiers, the man and his work. Eugène was deeply interested, as he was in all Mallarmé's literary pursuits. Villiers had been an intriguing figure. A penniless aristocrat with a penchant for symbolism, sensuality and the occult, he had hated the materialism and morality of bourgeois society. Eugène could identify with his romantic idealism. Anxious to please both her husband and her friend, Berthe encouraged them to hold a special Thursday soirée at the rue de Villejust at which Mallarmé would deliver his lecture before a specially invited audience of their mutual friends. It was arranged for the evening of 27 February 1890.

The complete guest list has not survived but some forty people were invited to Berthe's drawing-room/studio. Eugène took charge of the organization, but as hostess Berthe presided with solemnity over the events in her studio. She wore her traditional black which made her look taller and slimmer than she was. A number of Mallarmé's literary friends came, Edouard Dujardin, editor of the *Revue indépendante*, Francis Viele-Griffin, the critic Théodor de Wyzewa and the poet Henri de Régnier, who sat next to Degas and observed everyone in his orbit with a penetrating eye. He noted in particular Eugène, who appeared neurotic and ill-at-ease, and Degas, whom he alleged became bored and behaved with a certain arrogant discourtesy. Dr Cazalis and the Belgian-born artist Henry de Groux came at Mallarmé's invitation, but Théodore Duret, Pierre Franc-Lamy and Joris-Karl Huysmans could not make it: Mallarmé bemoaned to Eugène that everyone seemed to have the flu, although Octave Mirbeau declined because he was in Menton. However, in view of the numbers who did

attend, some other *habitués* of Mallarmé's Tuesday soirées must have been there: Odilon Redon, Jean Ajalbert, Saint-Pol-Roux, Charles Morice, Georges Rodenbach, Jean Marras, Arthur Symons, Fontainas, and from among his new devotees, the composer Debussy and the painters Gauguin and Edouard Vuillard. The Emile Olliviers were present as guests of Berthe and Eugène, and it is possible that Desboutin, Henri Lerolle and Mary Cassatt received invitations: the latter was on her most cordial terms with Berthe at this time, largely because they were both involved in experimenting with etching and drypoint and adding colour to their prints. And there was a female presence: Berthe's sister-in-law, Suzanne Manet, and the young trio, Julie, Jeannie and Paule Gobillard, who sat between Renoir and Monet. However, observing the chauvinist code laid down by the master, Madame Mallarmé and her daughter, Geneviève, were positioned where they could catch a glimpse of what was going on without being seen themselves.

Mallarmé, pale and grave, stood to open the evening with moving eloquence and then sat down to give his talk. Berthe listened with intense application to every word, and for Régnier one memorable aspect (as distinct from Degas's behaviour) was her mesmerizing presence. Dressed with studied austerity, her hair, now almost pure white, drawn back to show the melancholy set of her face, he caught the lofty reserve which made her at the same time intriguing, enigmatic, distant and intimidating to a young man. In gratitude, afterwards, Mallarmé wrote a quatrain in her honour.

> Vous me prêtates une ouie
> Fameuse et le temple; si du
> Soir la pompe s'est avanouie
> En voici l'humble résidu.[1]

> [You have lent me both audience and oratory
> While the glory of the evening has departed
> Here are its humble remains.]

With her encouragement, Mallarmé was always prominent at Berthe's table talk. In fact even Degas felt warmly towards him as a person and would come to the rue de Villejust in anticipation of seeing him: this was certainly true after Edgar took up writing poetry. 'My whole day has gone on a blasted sonnet, without advancing a step', he once complained to Mallarmé over dinner at the Manets. 'And yet I'm not short of ideas. I'm full of them. I've got too many.' 'But, Degas, you can't make a poem with ideas. You make it with words', Mallarmé replied. The two had very different concepts of the use of words but it did not lessen their mutual respect.[2]

Through their friendship with Mallarmé, Berthe and Eugène became

acquainted not only with Symbolist ideas and the group of younger poets who sat at the master's feet, but also with the Aesthetic movement in England, which had distinct affinities with French Symbolism. Mallarmé danced attendance on Berthe and they maintained a regular correspondence when either was out of town. In this way he gave Berthe a sense of being directly involved in the contemporary intellectual debate about the relationship between art and life. By the mid-1880s the issues at stake were whether there was a consonance between the arts and whether art had an ethical function. The discussion centred on the cult of 'art for art's sake', a doctrine which had originated in France with the poets Gautier and Baudelaire and the philosopher, Victor Cousin. Now, however, it was being freshly promoted across the Channel.

The leading publicist of the Aesthetic movement was the Irish writer and wit, Oscar Wilde, but James Whistler was another major proponent. In 1885 he had presented his artistic philosophy in the 'Ten O'Clock Lecture' at London, Cambridge and Oxford. Degas had heard him repeat it at a house party in Dieppe in 1886 and almost certainly mentioned it at one of the Manets' dinners. Mallarmé had lent Berthe Morisot his English copy of the published lecture in March 1888. Although she had barely recovered from acute bronchitis, out of regard for the poet she struggled through the book. It was hard going for someone who did not feel comfortable with abstract theory written in the English language, and she admitted candidly to Monet that she did not gain much from Whistler's aesthetics (any more than she had profited years before from reading Charles Darwin).[3] None the less, her curiosity was satisfied.

Shortly afterwards, Claude Monet introduced Mallarmé to Whistler and persuaded him to translate the work into French. Then during Whistler's stay in Paris, in the late May of 1888, Mallarmé had brought the American round to the rue de Villejust at the Manets' invitation.[4] Eugène recalled Whistler from the distant days of the Café Guerbois when he was on good terms with his brother Edouard. Berthe thought highly of his work and knew that he was now enjoying real artistic success. But he had a litigious nature and a tempestuous history of broken friendships. Berthe did not find him particularly congenial company, although he was an admirer of her artistry. However, she was to invite him occasionally to her Thursday dinners, and at least once he brought the Irishman, Oscar Wilde, whose witticisms were legendary, to the Manets' house.[5]

Like most of her class, Berthe had been trained to hoard *bons mots* and personal impressions in scrapbooks and diaries. So for years she had been garnering her thoughts, and those of others, in her *carnets* – Lecoq de Boisbaudran, Léon Riesener, Charles Baudelaire, Théophile Gautier, Manet, Mallarmé, Colonna, Paul Bourget – theories, opinions, art criticism, besides the anecdotes of Degas, Astruc and others. The outcome was not so

much a coherent philosophy as a pot-pourri of ideas. Sometimes she looked back on her efforts with disgust, the old self-critical side of her nature exerting itself – 'so many good ideas . . . and to end up writing nonsense!' At other times she found it stimulating to record hypotheses which might enliven conversation. Over the years she had honed her intellect. Certainly, she felt obliged to keep abreast of the ideas in circulation, even if she was unimpressed by what she perceived to be novelty for its own sake: Pissarro's conversion to Pointillism was a case in point. Seeing the influence of Paul Gauguin, and even more of her friend Puvis, upon the 'modern' painters, she kept an open mind about the new aesthetics expounded by the stripling Maurice Denis in his key article, 'Definition of Neo-Traditionalism', which appeared in 1890. He, on the other hand, knew her painting, admired it and, as Charles Stuckey has pointed out, borrowed the concept of her picture *The Cherry Tree* (1891–2), for one of his own commissions in 1892.[6] By 1893 she had come to appreciate his work. There seems no doubt that through her Thursday faithful and, critically, through Mallarmé's leadership of the whole Symbolist movement, Berthe came into contact with a younger, wider artistic community. For example, in September 1889 he brought two visiting Dutch artists, François Erens and Isaac Israels, to the rue de Villejust, and it was through his friendship with Octave Maus that Berthe received invitations to exhibit in Brussels. The remarkable cultural breadth of her youth was played back, as it were, in her middle age.

Meanwhile, Berthe was worried about Eugène's health. He had given his all to setting up the Villiers lecture, while he was still feeling the strain of the *Olympia* row. Before winter was through they had made a decision to look for a country residence not too far from Paris which they would take on a long lease. After several disappointments, they found a house at Mézy-sur-Seine, a village halfway between Meulan and Mantes. It had the advantage of being on the train route from the Gare Saint-Lazare; yet it was a peaceful place, perfect for Eugène's recuperation. The Maison Blotière was built on high ground with an ample garden and open aspect to fields and orchards. Unlike Bougival, which had become suburban, the ambience of Mézy was still rural. It encouraged Berthe to go back to landscapes: she painted the view from the terrace, morning on the banks of the Seine, moonrise over the valley. To her artistic senses this was a place belonging to an idealized past, a land of milk and honey and mellow fruitfulness, of pretty peasant girls, graceful milkmaids and gentle shepherdesses. It was a vision far removed from the reality of French agriculture, but these were the themes for a plethora of studies over the two summers of 1890 and 1891 and some of her most graceful decorative work: *Under the Apple Tree, The Flute, The Little Flute Players, The Haymaker, The Little Goat, The Cherry Tree, Young Girl Picking Cherries, Nude Shepherdess Resting, The Girl with the Goat, The Bather* and so forth.[7]

Mézy was also convenient for reunions, and she had promised Mallarmé that there would be many. No sooner had they arrived than she invited Mary Cassatt for lunch. Berthe had offered to help the Cassatts find a similar country retreat, though in fact they had decided on Septeuil, a township some 25 kilometres south-west of Mézy, across the Seine. The two women had discovered a mutual interest in oriental art forms. (Berthe had been in raptures over the graceful Javanese dancers performing at the Universal Exposition the year before.) Mary Cassatt wrote, and was insistent that Berthe should return to Paris for the day so they could go along together to the Ecole des Beaux-Arts where an exhibition of Japanese prints was on view. There was no arguing with her. 'You *must* see the Japanese – *come as soon as you can*.'[8] Berthe went. And she must have been enthused by what she saw, for shortly afterwards she parted with two of her own paintings to the dealer Hayashi in exchange for some Japanese prints. Another friend, who shared this interest and was himself a brilliant etcher, was Marcellin Desboutin. With Renoir, Monet and Mallarmé, he became a welcome house-guest at Mézy.[9]

Mallarmé had been invited to stay for a traditional *jeudi* as soon as the guest room was made up: 'spend Thursday with us . . . if the fresh air of the country tempts you.'[10] He was indeed tempted several times that summer, but the wet weather brought on a severe rheumatic condition which made his life a misery. Berthe, however, had met up with Monet and they planned a get-together on Bastille Day. Monet was feeling more secure, having decided to buy the property at Giverny which he had grown to love. With his stepdaughter, Blanche Hoschedé, as his assistant, he spent as much time as he could painting in the surrounding fields, concentrating on features such as the haystacks and poplar trees. Berthe, meanwhile, alerted Mallarmé about the reunion at Giverny. On Sunday 13 July, the day before the official holiday, the three Manets and Mallarmé took a horse-drawn cart to Mantes, then the train to Vernon, the next town on the line, where they were picked up. It was a happy occasion and a big houseful with the Monets' extended family. When Monet offered Mallarmé one of his pictures, Berthe encouraged him to take a landscape of Giverny with the smoke-trail from a distant train. The poet felt deeply honoured.[11]

Berthe also felt as if she had an extended family at the Maison Blotière. Jeannie Gobillard came to keep her cousin company, knowing that she and Julie would, as usual, be required as models. They were joined for a while by a new member of the family. Alice Gamby was Berthe's step-niece, the daughter of Tiburce's wife, the former Madame Gamby, who had been a friend and model of Edouard Manet. Alice was about twenty at this time. Julie was delighted when she had stayed with them at the rue de Villejust the previous winter: Berthe had drawn and painted them together. Alice was a poised, lissom young woman with brown eyes and a striking profile, who

drew effusive compliments from Desboutin. While she was at Mézy, Alice happily posed for both Berthe and Renoir. Sitting on the grass away from the world, she was the subject for Berthe's pastel, *Young Girl Seated in the Meadow*, and Renoir's *In the Meadow* or *Gathering Flowers*. But to free the three girls from constant modelling, Berthe looked around for other subjects. She had decided to take over a barn in the grounds as a makeshift studio. Here she drew and painted some of the local children: Gaston, a little village boy, who made a perfect St John the Baptist, and the Dufour sisters, Gabrielle and Julia, a pair of obliging, shapely peasant girls. Gabrielle posed for one of Berthe's most natural figure pictures, *The Bowl of Milk*, which Monet greatly admired.

Renoir and Desboutin came in August. In fact, Renoir was to stay several weeks. A guest room was always ready for him. As their devoted friend, he was so much at home at Mézy that he no longer needed to write in advance. It was an arrangement which worked perfectly until the following summer when he turned up out of the blue with his new wife Aline and six-year-old son, Pierre. Berthe may have recognized them as the subjects of the drawing that she had admired in Renoir's studio on the winter's day back in 1886. There were a few awkward moments as Berthe took in the sight of this ungainly woman: she confessed this later to Mallarmé.[12] Renoir had remained silent about his common-law wife in case his apparent immorality offended his sophisticated bourgeois friends. But almost immediately Berthe's fondness for Renoir and Aline's naturalness broke the ice. Thereafter Madame Renoir and her family were entirely accepted by the Eugène Manets.[13]

The mutual artistic influences between Berthe and Renoir at this point in their lives was quite marked. Privately Berthe was excited by the sexuality of Renoir's work. As they worked together, talking about the music which they both passionately loved, discussing their ideas on decorative effects, sharing subject matter and the same models – Alice, Julie, Jeannie, Gabrielle – a special affinity developed.[14] But it was not a sudden process. For two years or so Berthe had been moving away from her long-established technique of painting in short, rapid, nervous brushstrokes, to a more flowing and sinuous style, combined with clarity of line and form. But she never lost her fascination for light, for portraying the radiance of summer skies. And, coincidentally, in 1889 Renoir was leaving behind his preoccupation with precise line in favour of achieving an iridescent effect, characteristic of his so-called 'pearly (*nacrée*) period'. So there was no question of Berthe following slavishly in Renoir's footsteps. They reinforced each other's perceptions.

In fact, while Berthe absorbed what her artist-friends offered, she retained her special individuality and gave back to them something of herself in these 'deepening years'. Monet, for instance, started on his

haystack series in 1884, the summer *after* Berthe painted *The Haystack* at Bougival. And Mallarmé confided to her that Monet had been charmed by her 'white water-lily done with the famous three crayons' and had said he intended to follow her example.[15] So it is possible that his famous water-lily series, the *Nympheas* murals, was inspired by her. Mary Cassatt was working on the theme of Berthe's largest and most complex work, *The Cherry Tree* (1891) in her *Young Women Picking Fruit* (1892).[16] But in view of their camaraderie it was no coincidence that Berthe shared subject matter with Renoir, Monet and Mary Cassatt; nor is it surprising that she mastered Mallarmé's art of distilling the poetic quality out of the inherently everyday and ordinary.

After enjoying an Indian summer, Berthe and Eugène returned to Passy at the end of October 1890. As the nights drew in, they had spent their time reading before log fires. Berthe was moved by the journal of Marie Bashkirtseff, the 24-year-old artist who had died of tuberculosis in 1884. She found it hard to reconcile the awareness and vigour of her mind with the banal naturalism of her art. It was only a few weeks after this that Berthe herself was struck down with rheumatic fever. She was seriously ill and 'felt the embrace of death'. As she fought to survive, she told herself, 'I am approaching the end of my life.'[17]

Eugène's morale was crushed and the experience brought home to Berthe the terrifying implications for Julie's future. Given Eugène's declining health, she made provision in her will for Mallarmé to assume her daughter's guardianship. But she knew that Julie needed more. She wrote poignantly to Edma, 'Would you undertake to care for the child?' And on receiving Edma's answer, 'Thank you for answering "Yes" so sweetly.'[18] With this crucial reassurance, she improved. But on 14 January 1891 Berthe reached the rubicon of fifty. She hoped that there was nothing prophetic in the fact that Aimé Millet died that day. He was an old man: she refused to indulge in lamentation or self-pity. She wrote: 'I saw the passers-by on the avenue clearly and simply, in the way they are in Japanese prints. I was thrilled, I knew definitely why I had been painting badly and why I would never paint that way again. I mean to say, I am fifty years old and once a year at least I have the same joy and the same hope.'[19] She found that new inspiration in her concierge's children, little Marthe Givaudan and her baby brother, Louis, who acted as her models.

In company with Mallarmé, new faces also appeared at her Thursday dinners that winter. Henri de Régnier, Octave Mirbeau and Théodor de Wyzewa increased the literary representation, but the stalwarts still came. In between she pressed on with her series of studies of Julie in various poses, drawing, reading, writing. It had occupied her for many months but she hoped dearly that it would be published in book form one day. Yet it was

hard to be optimistic in view of the shocks which passed along the artistic grapevine. First in January came the death of Theo van Gogh, who had proved such a sympathetic friend to the Impressionist painters – he followed his brother, Vincent, who shot himself at Auvers the previous July – and then in March, Georges Seurat, whose *Grande Jatte* had dominated the last Impressionist Exhibition, succumbed to diphtheria. And the next year, Paul Durand-Ruel was to lose his son, Charles; Berthe attended the funeral with Renoir. The pity of it was that all were young men, barely in their prime.

Spring saw the Manets back at the Maison Blotière, though to please Puvis, Berthe went back to Paris briefly for the opening of the Salon. Another wet season was upon them. When the rain held off Berthe worked on pastels in the garden and she also started on a number of preliminary drawings as variations for the motif of *The Cherry Tree*. Eugène and she had already grown to love the area. When she put her pencils away they went out rambling with Julie. They enjoyed the peace. Berthe hoped to keep in touch with Edma by seeing her at Maurecourt which was no great distance from Mézy: but she did not come and the two sisters grudgingly put pen to paper. Berthe had cut herself off from Tiburce. Eugène had always been suspicious of his intentions since he borrowed 2,000 francs from Adolphe Pontillon in 1882.[20] After her brother's marriage, Berthe felt no moral obligation to be supportive any longer. So they had few visitors. Monet was too busy working to budge himself, Mary Cassatt and her elderly parents had rented a château in the Oise valley, and Mallarmé, ensconced in Valvins, was unable to come over for the usual 14 July celebrations. He was flattered that Berthe had been reading his latest book, *Pages*, which contained Renoir's illustration, all that came of his project for *The Lacquered Drawer*. As usual, the two of them indulged in an intense and slightly coquettish correspondence. Meanwhile, Renoir came twice to spend a little time beside Berthe at the easel.

It was Renoir who drew their attention to an interesting property at Juziers, the next village to Mézy, which was up for sale. They glimpsed it through a cluster of pines one summer's afternoon, a substantial seventeenth-century country mansion, a long, white, classical building with a Mansart roof of grey slate, set in wooded parkland. With instinctive certainty, the Manets decided the Château du Mesnil was for them. Understandably, Eugène had envied his relatives their fine château in Touraine. He had already toyed with buying a country house. Seven years earlier he had looked over a villa at Cimiez which had stunning views and olive and orange groves, but at a conservative estimate it had needed a third again of the asking price spending on restoration work. He had not pursued it. This time however – in Berthe's words – he was 'crazy about it'. In July Berthe let Mallarmé know that they were negotiating to buy Le Mesnil,

'carried away by the desire to be in a beautiful setting before we die'.[21] Then suddenly in August the sale was off. Berthe got cold feet and must have talked Eugène out of it. Despite the reasonable asking price, it was a daunting commitment, and they had invested a great deal in the rue de Villejust. The château was duly put up for auction but failed to find a buyer. So by the end of September, the deal was on again after the owner succeeded in rekindling Eugène's interest. That autumn they embarked on the protracted legal negotiations for purchase. As they entered winter Le Mesnil took up all Eugène's thoughts. He set his heart on creating a gracious aristocratic home, a lasting memorial to the Manet name.

For Eugène, however, it was a cruel illusion. Driven to bed by weakness and a persistent cough, he had not the strength to participate in the future of the château when it became theirs early in 1892. It had been obvious to Berthe for some time that her husband was seriously ill. Even so, he was preoccupied with persuading Boussod & Valadon to hold an exhibition of her work the following summer. She, on the other hand, was inhibited from spending too much time in the studio. It was only when her model arrived that she slipped away to work on *Little Girl with a Basket*: Cocotte in a white chiffon picture hat. Otherwise she felt compelled to be at Eugène's side, reading to him, silently willing him to fight back, while Julie hovered apprehensively out of earshot. In fact, there was nothing Berthe hated more than a sick room. And they had another cause to worry. About this time Julie's godfather, Jules de Jouy, suffered a paralysing stroke.

After her own illness the year before, the introspective side of Berthe's nature had taken over and her mind was filled with great unanswerable questions. 'We have to be accepting as we reach the end of life, resigned to all the disappointments of this world, and all the uncertainties of the next.'[22] From this time the horror and fear of death were always with her. It seems she adhered, or was won back, to the occasional conformity of her upbringing, for she concurred with Julie's first communion at the village church of Mézy. But familiar as she was with the rubrics of Catholicism, a familiarity passed on to Julie, it would appear that Berthe took no personal consolation from religious observance or from the ministry of priests. Her art, her palliative, took the place of religion.[23]

In the New Year Eugène rallied briefly. But to Berthe's distress he had become piteously thin, so that he scarcely took up his place at the dining table. She watched his irreversible decline during those first three bleak months of 1892. When he died on 13 April, her courage failed. 'I have descended to the depths of suffering . . . I have spent the last three nights weeping. Pity! Pity!'[24]

Julie, who loved her father sincerely, wept too, but she wept alone in the silence of the night, shut up in her bedroom. Some years later she admitted to herself that she had inherited a fatal flaw from both her parents, an

impediment of deep inhibition. 'I recognized it . . . I was often confined with Papa and Mama, and I wanted to speak to them but daren't. Now I regret it. When I think that I never dared to speak about Papa to Mama since his death; I never pronounced his name, it's extraordinary. We both of us wept but I never let my tears mingle with Mama's.'[25]

The grief tearing at Berthe was genuine and spontaneous. She looked for catharsis by writing down her thoughts, but her memory-book centred on herself. 'I have sinned, I have suffered, I have atoned for it.'[26] In her bereavement there were no expressions of lost love, no paeans of praise for Eugène. She had never loved him. Over the years she had become accepting, tolerant of his tantrums, his moods, his sanctimonious side; grateful for his considerable kindness, admiring of his decency and intelligence and concerned about his frailties. She had grown fond of him because he brought her some happiness, despite himself. But too often theirs was a dialogue of silence. And so now the suffering she spoke of was the agony of remorse. Deep anguish that she had never been able to love Eugène, show him the affection that she had seen her mother lavishing on her father; guilt that she had been perfectly content away from his presence, remorse that she had been neglectful, putting her work ahead of him, while he always put her first; remorse, too, because it was Eugène who had gratified her wish to be a Manet. The torment etched upon her face would never go away.[27]

There were even trivial matters that she came to regret. In the last years she had been carping about his faults in her letters to Mallarmé. She told tales about his idiosyncrasies and prejudices: 'Eugène refuses to admit that he was wrong'; 'Eugène . . . always accuses me of boring my friends' (to which Mallarmé could only reply defensively, 'No, Eugène is not dictatorial, any more than I am').[28] In her defence, marriage to Eugène had sometimes been painfully difficult, but if she had been less self-centred and had recognized her failings, would it have been better? That was the hell of it. In her initial despair she had no wish to live. Then she wished that she could reverse time, live her life again, recapture her energy and the crystal vision of her youth. . . . It was the oldest wish in the world. But instead of miracles, there were only memories. And memories began to gather like dust.

Berthe's next reaction was entirely natural. She wanted to hide, and she did so by escaping with Julie to the seclusion of Le Mesnil, even though it grieved her to think that Eugène had not lived to enjoy it. In her refuge she relied on three sources of comfort: her daughter, her work and her friends. (Her sisters were preoccupied: Yves had not been well.) She knew that if there was any way she could pay homage to the memory of Eugène it was to cherish Julie, still a child at thirteen years old. More than ever, the two became inseparable companions: theirs was the ultimate mother-and-

daughter relationship. Berthe also asked Mallarmé to act as Julie's tutor as well as her guardian, and later Renoir, too, who became additionally a family adviser.

For feminine support she called on old loyalties, Louise Riesener and Marie Hubbard. Madame Hubbard had lost her husband four years earlier, so better than anyone understood the overwhelming sense of loss. She enlisted her son, Gustave-Adolphe Hubbard, on Berthe's behalf. It was a great relief to have this rising barrister and radical deputy behind her. He sorted out Eugène's affairs and dispatched the 'wretched notary' and 'horrible businessmen' who had been plaguing her.[29] His intervention gave her the opportunity to throw herself into work in preparation for her personal exhibition which was due to open at Boussod's in the last week of May. Since it was not proper to ask Julie to pose, she found two interesting new models, two red-headed sisters, Jeanne and Emma Bodeau, who lived nearby. Then in an amazing burst of creative energy she produced a score of pictures in pastel, watercolour and oil, including *Young Girl with her Hat, Young Girl at Mesnil, Little Girls at the Window, Little Girl Sitting on the Grass,* and others variously called *The Woods, The Dovecot, Trees, On a Bench, The Bath* and *Bathers at Mesnil.* She had hoped to finish *The Cherry Tree,* regarded as one of her masterpieces, but it needed more work in the studio. None the less, Mallarmé summed up her achievement. 'So, with bravura, an existence was to go on, undisturbed, victorious now, and surrounded by homage.'[30]

She returned briefly to Passy before the opening of her personal exhibition, long enough to question whether she could ever live happily in her apartment in the rue de Villejust or at Le Mesnil, both of which in their different ways had too many reminders of Eugène. She brought in workmen to carry out some cosmetic changes and then let the château to an aristocratic family for three years at what she considered a modest rent. With this problem disposed of, she and Julie spent the summer on their own in Passy, though they visited Le Mesnil in September in company with a young musician, André Rossignol, whom Berthe had befriended. She felt unable to face the public's reaction to her exhibition, despite the warm reception it received, particularly from friends. The only one who failed to communicate (though she attended it) was Mary Cassatt. Berthe was stung by this: 'as you can imagine, Miss Cassatt is not one to write to me about an exhibition of mine', she told Louise Riesener.[31] The old rivalry had blown up again. Somehow the American achieved a higher public profile in France: she had two individual exhibitions in Paris in 1891 and 1893, and following the second the French government requested one of her works for the Luxembourg. Berthe shared Lois Cassatt's view that Mary was pushy, arrogant and self-centred. It was not how the true *grande bourgeoisie* behaved.

That summer Jeannie Gobillard came for a short stay because her mother was still ill. As well as the children of the concierge, Berthe was to paint a

portrait of Lucie Léon at the piano in her drawing-room/studio, a study in blue like Gainsborough's *Blue Boy*. Berthe also found distraction working with a new model recommended by the artist Zandomeneghi, a decorous blonde who was strikingly like some of Renoir's past models. She used the girl, whose name was Jeanne Fourmanoir, to complete *The Cherry Tree*, and painted her in several other poses.[32] It was as if Berthe's reticence fell away at the sight of her voluptuous beauty. The constraints upon her freedom to represent sexuality had finally gone with Eugène's death. At the age of fifty-one she felt relieved of the external pressure exerted by family and friends, free from those opinions, pieces of advice and class conventions pressed upon her by her mother, by Guichard, Oudinot, Corot, Edouard Manet, and even by her husband: all those who had tried to shape the parameters of her art. So now she depicted Jeanne's graceful, rounded form with the unalloyed sexual pleasure of Renoir, or as Mallarmé might have celebrated her beauty in a sonnet, by highlighting her long, glorious, golden hair.

However, at the approach of autumn Berthe was again depressed but clutching at straws that Yves's cancer had shown signs of remission. She and Julie took themselves off to Touraine for a break. They went back to Saint-Symphorien, by Tours, where they had stayed with Eugène in 1887; and together they indulged their compulsion to copy fragments of the collection of old masters in the museum. After a few days at Vassé with the Vaissières, they returned to face what Berthe had been dreading: the wrench of packing up and moving house. She had already found accommodation at 10 rue Weber, on the doorstep of the Bois de Boulogne; the rue de Villejust would be let. It was merely a question of convincing herself that it was a wise step to take. 'I was silly to think for a moment that such external things have any importance, that my happiness was somehow built into the walls', she rationalized. 'I have become used to the idea of leaving this place, where Julie has grown up and I have grown old.' And speaking from the heart, 'Gradually one is consoled and healed . . . suddenly one has forgotten; the loved ones are gone.'[33]

The new apartment had an attic floor which Berthe had converted to a studio. As soon as everything was in place she began to work. Here, and in the Bois, she drew and painted indefatigably with a number of models, including Julie and her niece Jeanne Pontillon, who had grown into a serious, dark-haired girl with a delicate, oval face, the image of her mother at the same age. Another who fitted this description, though she was older, was Geneviève Mallarmé. Berthe felt there was something sad about this young woman. As a gesture of sympathy she sent her a personal New Year's gift for 1893 with the message, 'Would you give me pleasure by wearing this pin brooch which I used to wear myself?'[34] From time to time they visited Julie's invalid godfather in his house off the rue Saint-Honoré, and also Berthe's sister-in-law, Suzanne Manet, at the family house in Gennevilliers.

Renoir came to see them when he could but he was often away. He tried, but failed, to tempt them on another trip to the Midi where he spent the winter of 1892–3.

The political scene was building up to one of its periodic *frissons* in the face of another industrial slump. The Republican Old Guard were blamed for the country's ills by anarchists believing in the efficacy of violence. Jules Ferry's death in March 1893 was attributed indirectly to an assassin's gun. But Berthe had other things on her mind: she was desperately concerned about Yves's condition. Three months later, in June, her elder sister finally succumbed to cancer. She had suffered terribly. Berthe was appalled and took the news badly. All she could do was to install the three orphaned Gobillards in the third-floor apartment of the rue de Villejust where she could keep an eye on them. She had intended visiting Yves's close friends, the Havilands, the porcelain manufacturers, at Limoges, partly to paint their daughter's portrait, but she could not find the heart to go. Instead, she spent a lot of time close to home, painting copiously in the Bois, escaping in her imagination from the accumulating miseries of life. Her output was remarkable: thirty-seven oils, thirty-two watercolours and thirteen pastels. Among these were some tender family portraits showing a deeper palette: a solemn-faced Julie, stroking her new pet dog; her cousin's little girl, Jeannine Thomas, whom she painted with her brother in 1894; and figure-paintings, such as *On the Sofa* and *Young Woman Reclining*, which bore the influence of Renoir as well as being modelled by one of his golden-haired girls (though she bore an uncanny likeness to Jeannie Gobillard, who had posed for Renoir at Mézy).

The summer was broken by a pleasant interlude at Valvins. They took the train from the Gare de Lyon on the afternoon of Thursday 24 August and stayed for ten days at the Valvins Hotel, a rustic riverside inn across the bridge from the Mallarmés' modest farmhouse. They knew it of old. The family lived on the second floor. Fading cretonne curtains hung at the windows and the rooms were furnished sparsely but in good taste; a Persian rug adorned the red-tiled floor and one of Berthe's paintings the whitewashed wall. It was a humble home compared with La Grangette, the house of their wealthy but hospitable neighbours, Thadée and Misia Natanson, who had drawn Mallarmé into their brilliant circle. Valvins was frequented then by the writer Octave Mirbeau and the artists Redon, Vuillard, Bonnard and Toulouse-Lautrec. Mallarmé knew them all. Natanson had been at the Lycée Condorcet, where the poet had taught and Berthe's father had also been a student. He was the founder of a celebrated journal, the *Revue Blanche*. His incomparable wife was a gifted virtuoso pianist, immensely attractive to both sexes. Julie was enchanted by her, and Berthe admitted her admiration.[35]

The time was spent taking carriage drives in the neighbourhood, walking

in the woods of Fontainebleau, chatting, boating, drawing and painting. Mother and daughter both depicted *Mallarmé's Sailboat* in oils. Julie had the company of her greyhound Laertes, a gift from her guardian. She boasted that he was a graceful dog, truly aristocratic compared with other breeds, but not, as Hamlet said, 'good Laertes'; in fact, he was very badly brought up, putting his paws on the table and begging for food from everyone. She shared Mallarmé's love of animals.[36] (In his apartment in the rue de Rome he kept a pair of green parakeets – 'the academicians', he called them – besides Lilith, the black cat, and at Valvins a circus pony named Gobemouche and a succession of other horses for Geneviève.)

Berthe found Valvins so relaxing that a fortnight later they came again, and Mallarmé escorted her and Julie on a pleasant day's outing to Moret to see Sisley. Back home for October, Julie resumed her lessons. Mallarmé must have arranged her literature teaching: her tutor was the Symbolist poet and critic, Camille Mauclair. Her music teacher was a brilliant young violinist, Jules Boucherit, who had carried off the first prize at the Paris Conservatoire in 1892 and now played with the Colonne orchestra. But all her classes, including history and science, fitted into a flexible regime which allowed time for other priorities, such as visits to the Louvre. Then at the end of October Berthe took Julie to Giverny. Despite the rain Monet proudly showed them over the house and grounds which he was in process of renovating. He wanted Berthe's opinion on his latest work, his famous series of paintings of Rouen cathedral, with their extraordinary colour effects. Julie was amazed and found them 'an excellent painting lesson', and she was pleased to see two pastels by her mother and her uncle Edouard hanging in his newly built bedroom, alongside an attractive nude by Renoir.[37]

Monet rarely appeared in Paris now except for the monthly all-male Impressionist dinners held at the Café Riche, but Degas, who apparently boycotted these, did come occasionally to dinner at the rue Weber, with Mallarmé and Renoir. It was no longer the grand social ritual of the past, but a quiet evening among friends. From time to time she dined with the Renoirs – Madame Renoir was an excellent cook – and from time to time Degas returned her compliment (Pissarro noted how kind-hearted he was to sorrowing friends). As a result, Berthe established new friendships from among Degas's old circle. There was Forain, a gifted artist who had contributed to four of the Impressionist exhibitions, Paul-Albert Bartholomé, a pastellist and a gentle, infinitely kind widower, who sublimated his sorrow by becoming a celebrated sculptor in the 1890s; and Henri Rouart, whom she knew already to be an upright, discriminating gentleman through his involvement with the Impressionists. Mallarmé also added to her acquaintances at this time. He introduced her to one of his most ardent admirers, the young poet Paul Valéry, who like Régnier was

quickly captivated by Berthe's elusive but charming personality.[38] Mallarmé returned her hospitality by inviting her to his Tuesday gatherings, but on the whole she preferred to meet him at the Sunday Lamoureux concerts with Julie. And so another winter passed.

But the depressing train of events seemed never-ending. Early in March Berthe lost two of her most dependable and affectionate friends, Marie Hubbard and Jules de Jouy. 'My dear old Uncle Godfather, the last of the Manets', Julie wrote later. 'Now I really am the only descendant of the three Manet brothers.' Maître de Jouy was buried with his family at Gennevilliers after a funeral at the Madeleine.[39] That night, 13 March, Berthe and Julie took the train to Brussels on a prearranged trip. They stayed at the Sweden Hotel which had been recommended by Suzanne Manet since the owner, Van Cutsem, owned Edouard Manet's *Argenteuil*. Their purpose was to visit the exhibition of the Libre Esthétique, but they took the opportunity to do some architectural sight-seeing and to attend an inaugural concert by the distinguished Belgian violinist-conductor, Eugène Ysaÿe, a pioneer of new music. His vibrato style interested both mother and daughter, since it was markedly different from the delicate playing of Boucherit; and afterwards they were introduced to Ysaÿe backstage by Octave Maus, the director of the Libre Esthétique.[40]

Tired and exhilarated by their break, the pair arrived back in Paris just in time for the exhibition and sale of Théodore Duret's art collection on 19 March. Berthe was extremely anxious to buy two of Manet's works, both portraits of herself, *Repose* and *Berthe Morisot with a Black Hat and Violets*. She acquired the second through a dealer for over 5,000 francs: it gave her much happiness. For Julie the exhibition was a chance to admire her uncle's palette and brushwork, but for Berthe it was an occasion charged with emotion. Innocently Julie was to touch on it in her diary: 'three Manet brothers; there remain only one unhappy young girl and two widows to mourn them . . .'.[41]

Renoir asked that spring if he could paint a double portrait of Berthe and Julie. They came to his studio for their sittings and stayed to lunch. It was the last oil painting of the two of them together. Berthe in profile, elegant as ever in her black gown, her white hair caught in a loose chignon; Julie, full-face, 'a wild child' Régnier had once called her, but beneath her wide-brimmed hat she looked anything but: rather, demure and wistful.[42] She was growing up into an attractive young woman like her cousin Jeanne Pontillon, whom Berthe painted in June, wearing a striking flame-coloured gown. The picture was to adorn the white walls of Edma's apartment.

Sparked by a poster she saw in the Gare Saint-Lazare that summer, Berthe felt an urge to see Brittany again. She invited Yves's daughters, Paule and Jeannie, ostensibly to keep Julie happy but in fact partly to enable her to

indulge a reawakened wish to paint landscapes in the wake of Monet and Renoir. Berthe asked Renoir to join them but he had other plans. His wife, Aline, was to give birth to their second son, Jean, in September. Renoir wished her well, however, anticipating 'those lovely sea views . . . and white-clad Julies against a background of golden isles'.[43] A letter from Mallarmé contained a cheerful quatrain to the Manet ladies at Roche Plate, the granite house in Portrieux, Côte du Nord, which was their base for six weeks from early August. Replying to her poet-friend, Berthe admitted she was painting but then 'despair sets in'.[44] The first September mists warned them of autumn's approach; and news from Paris came that Adolphe Pontillon had died. By a sad coincidence it was Edme Pontillon's sixteenth birthday the day after his father's interment at Maurecourt. Paule and Jeannie left first. Berthe made her way back with Julie in a gentle arc by Morlaix, Brest, Quimperlé, Lorient, Vannes, and Nantes, reliving her memories. They were home on 24 September.

The only cause for celebration that autumn was Julie's sixteenth birthday. Paule and Jeannie brought her flowers. They went to dinner with some friends, the Rouaults, then to enjoy Molière at the Comédie Française. Otherwise Berthe was painfully conscious of passing time and the madness that had seized France. Corruption, conspiracy, terrorism, anti-Semitism, death. . . There was no reason to be optimistic. She had no faith in politicians or grand administrators, even though she had come from their ranks. Nor even in the benevolence of a God. Her instincts told her that the much-vaunted alliance with Tsarist Russia would bring no good to France. Clemenceau, so admired by the Manets, had been disgraced in the Panama Canal scandal. Sadi Carnot, the president of France, had been shot dead in June by an anarchist. Edouard's friend Chabrier died hideously of syphilis in September. A Jewish army officer, Alfred Dreyfus, condemned in December to deportation for life, was sent in the New Year to Devil's Island. It seemed like the plot of Eugène's novel come alive. But the sentence marked the beginning of something that would divide friend from friend and rock France for the rest of the century: namely, the Dreyfus Affair.

Berthe threw herself into her work to avoid sinking into depression. She had prodigious energy. Her output soared even above that of the year before. *Fifty-six* oils. She chose her old themes – her fascinating daughter, other people's children, bathing, dressing, swans, the garden, the Bois – and always young models – Julie, Jeannie, Charley and Jeannine Thomas, Marthe, Jeanne-Marie, and little Marcelle (the concierge's child). In New Year 1895 she painted Julie in a wide-brimmed Liberty hat. Mallarmé celebrated it with a quatrain.[45]

Then in January Julie caught flu. It was a bad strain. Berthe turned down a theatre invitation from Mallarmé. Julie's temperature soared. She became delirious. Berthe feared the worst, that it was typhoid fever. She nursed her

daughter night and day, while outside it was – in Renoir's phrase – 'snow all the way from Paris to Tarascon'.[46] Occasionally she slipped out of Julie's bedroom to draw some preparatory studies of little Marcelle. But when Renoir wrote twice to entice them down to the Midi, Berthe could not think of going. She had caught Julie's flu. The doctor was called. On 28 February she wrote to Mallarmé, 'I am ill, my dear friend. I won't ask you to come because I can't speak.'[47] Edma, Paule and Blanche arrived. Berthe was extremely ill: pneumonia had set in, but she expressed the wish that Renoir should help take care of Julie and the Gobillard girls. On Friday 1 March she felt her strength slipping away. She steeled herself to write down her last wishes, emotional words which speak for themselves.

My little Julie, I love you as I die; I will still love you even when I am dead; I beg you not to cry, this parting was inevitable. I hoped to live until you were married. . . . Work and be good as you have always been; you have not caused me one sorrow in your little life. You have beauty, money; make good use of them. I think it would be best for you to live with your cousins, rue de Villejust, but I do not wish to force you to do anything. Please give a remembrance from me to your aunt Edma and to your cousins; and to your cousin Gabriel give Monet's *Ships under Repair*. Tell M. Degas that if he founds a museum he should select a Manet. A souvenir to Monet, to Renoir, and one of my drawings to Bartholomé. Give something to the two concierges. Do not cry; I love you more than I can tell you. Jeannie, take care of Julie.[48]

At three o'clock the following afternoon Julie plucked up courage to speak to her mother, who was having considerable difficulty in breathing. Two doctors were in attendance during the evening. Julie could not bear to watch and left her room for the last time at seven o'clock. At half past ten on the night of Saturday 2 March, Berthe Morisot drew her last breath.

Postscript

The news of Berthe's death was passed swiftly round the family and her circle of close associates and admirers. Stéphane Mallarmé, mortified by the speed of her decline, notified some friends by telegram, including Degas, Henri de Régnier and Octave Mirbeau. 'I am the bearer of appalling news. Our poor friend, Madame Eugène Manet, Berthe Morisot, is dead. With her customary discretion she requested no announcements; merely that those known to her should be told personally. There is no way I could have failed to inform you.'[1] Others – friends and acquaintances of many years, artists, dealers, poets, critics, politicians – he contacted by letter or told in person. However, contrary to her wishes, the news was also given to the press, which was predictably restrained. On Monday 4 March a notice appeared in *Le Figaro*. 'We hear the death has taken place of the painter Madame Berthe Morisot, who was with Renoir and Monet one of the first Impressionists.' The following day in London *The Times* also carried a short obituary.[2]

Renoir was away in Aix, sharing the company of Cézanne when he heard what had happened. Loyal to the last, he closed his box of paints and folded his easel. Then he took the first train back to Paris. From there he dropped a note to his friend Alphonse Portier, who had known Berthe for years. 'We are taking her to her last resting place, friends only, Tuesday morning at 10', he told the dealer.[3] But his first thought had been to comfort Julie. Much later she could still recall his kindness. 'I have never forgotten the way he came into my room at the rue Weber and took me in his arms – I can still see his white flowing necktie with its red polka dots.'[4]

The funeral ceremony at the church of Saint-Honoré-d'Eylau was intended to be as private as Berthe Morisot's baptism in the great cathedral of Bourges fifty-four years before. Reserve and modesty were her abiding attributes: her death certificate, like her marriage certificate, described her illogically as a woman of 'no profession'.[5] Afterwards she was laid to rest in the cemetery of Passy. Julie recorded in her diary that the day was cold and bleak, in tune with the mourners' hearts: nothing more.[6] But the warmth of those friendships which had sustained Berthe in the deepening years after Edouard Manet's death now extended to her bereaved daughter.

Renoir was the painter with whom she had forged the closest personal links in later life. Despite their different social origins which had divided

them in childhood in Limoges, they enjoyed in middle age a strong personal respect for each other and a shared passion for light, colour, space and form, as they are expressed in art. In historical terms their friendship was a testimony to the growing egalitarianism of French bourgeois society under the Third Republic. Renoir was to survive Berthe by two dozen years: time to reflect upon his dear friend. 'What a curious thing is destiny!' he exclaimed. 'A painter of such pronounced temperament, born in the most severely middle-class surroundings which have ever existed and at a period when a child who wanted to be a painter was almost considered the dishonour of the family! And what an anomaly to see the appearance in our age of realism of a painter so impregnated with the grace and finesse of the eighteenth century: in a word, the last elegant and "feminine" artist that we have had since Fragonard, with the additional something of the "virginal" that Madame Morisot had to such a high degree in all her painting.'[7]

Perhaps of all her colleagues Renoir felt her loss most keenly. However, for Degas, who suffered a form of physical pain as he came to terms with bereavement, it was an utterly desolate year, marked by the further diminution of Edouard Manet's circle, the loss of the actress Ellen Andrée in addition to Berthe, and the death of his own sister, Marguerite Fèvre. Claude Monet, too, was shocked when he heard from his wife what had happened in his absence. He had been in Norway visiting his stepson since the beginning of 1895 and hence he was out of touch with events back home. 'I have just learned of the death of Madame Manet', he wrote to Paul Durand-Ruel on 9 March. 'I'm very distressed.' Meanwhile, Camille Pissarro had notified his son, Lucien, an etcher in London, and included his own sincere tribute to 'this distinguished woman'. He received a solemn reply: 'Poor Madame Morisot! I was very sorry to hear of her death and greatly admired her wonderful talent.' Antipathetic though he was towards the bourgeoisie, the veteran anarchist Pissarro was determined to pay his respects at the graveside of 'our old comrade, Berthe Morisot'.[8] As to Mallarmé and Renoir, each in his way was to do the utmost to honour his reponsibilities as Julie Manet's guardian.

Inevitably the first year without both her parents was a lonely and often heartbreaking experience for Julie. She was sustained by her faith and by hallowed recollections of her mother's presence.

> . . . Et dans le soir, tu m'es en riant apparue
> Et j'ai cru voir le fée au chapeau de clarté
> Qui jadis sur mes beaux sommeils d'enfant gâté
> Passait, laissant toujours de ses mains mal fermées
> Neiger de blancs bouquets d'étoiles parfumées.
> [Mallarmé, 'Apparition', *Premiers Poèmes*][9]

[. . . And in the evening you appeared to me, laughing
And I thought I saw the fairy with the cap of knowledge
Who once passed through my sweet slumbers of a spoiled child
Letting fall eternally from half-closed hands
Snow-white bouquets of perfumed stars.]

Julie returned to the rue de Villejust, as her mother had suggested, to share the third-floor apartment with her cousins Paule and Jeannie Gobillard. As soon as decency allowed, she was encouraged to follow precedent and, with those who had known her parents well, to participate in arranging a retrospective exhibition to coincide with the first anniversary of her mother's death. It was a major undertaking for someone youthful and inexperienced; she rose admirably to the challenge and Berthe's former colleagues rallied to a man. Mallarmé agreed to compose the preface to the catalogue of over 400 works – oils, watercolours, pastels, drawings and sculptures – while Renoir, Monet and Degas assisted with the organization and installation over a period of three days, leaving Julie to label the works with the catalogue numbers. The exhibition was to last for almost three weeks, beginning on Thursday 5 March, in the gallery of Durand-Ruel on the rue Laffitte.

On the Monday prior to the opening, before making her way to the gallery where the organizers were assembling, Julie Manet retraced her steps to the high-walled cemetery by the Trocadéro to pay her own private tribute to her adored mother. A year on, it was a clear spring day. The yews stood sentinel against the blue sky and light drifting clouds; wreaths sparkled against the headstones. She paused beside the tree overhanging the family vault. The pure white petals of an azalea mingled cheerfully with airy meadowsweet. Her thoughts were all of her mother, so brilliantly gifted, and her famous uncle, Edouard Manet, who had lain there for thirteen of her seventeen years. And as she gazed at the tomb, she sensed a pervading atmosphere of gentleness, a certain welcome reassurance that at last her mother was happy.[10]

In life, at the height of her beauty, circumstances had forced Berthe Morisot to renounce her instincts and rein in her deepest emotions. 'She could be unaffectedly and dangerously silent', Valéry observed, and as if to verify that there were personal matters she had always consciously concealed, she had written in her private notebook, 'We shall die everyone with our secrets untold.'[11] In death, she lay for ever beside her husband, Eugène Manet, the only man she ever portrayed in her painting, and Edouard Manet, whose genius was her inspiration, the only man whom she had ever passionately loved.

Locations and Public Collections with Examples of Berthe Morisot's Work

Existing catalogues of Berthe Morisot's artistic output underline its concentration in private collections, which has limited public awareness of her work. The preliminary catalogue by Monique Angoulvent in her monograph (1933) lists 655 works, in the private and the public domain. The catalogue by Bataille and Wildenstein is more comprehensive, listing 847 oils, watercolours and pastels (but not other media or preliminary studies), indicating the exhibitions in which they were shown and their known whereabouts in 1961. Currently a new *catalogue raisonné* of all her works is in preparation by Alain Clairet, Yves Rouart and Delphine Montalant, which will be an important addition to knowledge of her work.

This short survey is therefore *not* intended as a definitive statement but as a brief guide to the whereabouts of some of Berthe Morisot's paintings and drawings, which are held in public collections and are easily accessible to interested viewers.

EUROPE

France

The national collection of Impressionist works, formerly housed in the Jeu de Paume Museum in the Louvre and now in the **Musée d'Orsay**, Paris, contains a number of Morisot's paintings, including the best-known of her oil paintings, *The Cradle* (1872), a portrait of Edma Pontillon with her baby daughter, Blanche; *Catching Butterflies* or *The Butterfly Hunt* at Maurecourt (1874); *In the Wheatfield* (1875), a landscape of Gennevilliers; *Young Woman in a Ball Gown* (1876), purchased by the state in 1894 to hang in the Luxembourg and then the Louvre; a boudoir scene, *The Young Woman Powdering her Face* (1877); *The Hydrangea* or *The Two Sisters* (1894); and the

double portrait of *The Children of Gabriel Thomas* (1894), bequeathed by the latter to the Louvre. The Cabinet des Dessins in the Louvre also holds the pastel *Portrait of Mme Pontillon* (1871); a pencil drawing of *Before the Mirror* (1890); a portrait in watercolour of *Rosalie Riesener* (1866); and genre scenes of Edma Pontillon with her daughter Jeanne in *Young Woman and Child on a Seat* (1872); *On the Cliff at Fécamp* (1873); and a watercolour *On the Lawn* (1874–5).

The **Musée Marmottan** in Passy has a fine Impressionist collection, including Morisot's *At the Ball* (1875); *Girl with a Greyhound* or *Julie Manet with Laertes* (1893); and a pastel, *Young Girl with a Basket* (1891), which were among the Donop de Monchy and Claude Monet bequests. Examples of Morisot's work are located at the **Musée des Palais des Beaux-Arts de la ville de Paris**, in the Petit Palais: such as the pastel *On the Lawn* (1874); a lead pencil drawing of Alice Gamby, *Embroidery* (1890); and the oil, *Young Woman with a Flower in her Hair* (1893). A set of eight drypoints (1887–9) are to be found in the **Bibliothèque Nationale**.

Outside the capital, Berthe Morisot's work can be seen in a number of regional galleries: the **Musée d'Art et d'Histoire de Provence, Grasse** (the pastel, *Picking Oranges*, 1889); the **Musée des Beaux-Arts, Lyon** (*The Little Girl from Nice*, 1889); the **Musée des Beaux-Arts, Pau** (*Pasie Sewing in the Garden at Bougival*, 1881); the **Musée des Beaux-Arts, Toulouse** (*Young Woman on a Bench*, 1893); the **Musée de Berri, Bourges** (*Young Woman in a White Gown*, c. 1893); the **Musée Calvet, Avignon** (*Bathers*, 1888); the **Musée Fabre, Montpellier** (*Summer* or *Young Woman by a Window*, 1878); the **Musée Léon-Alègre, Bagnols-sur-Cèze** (*Entry to the Port*, Fécamp, 1874); and the **Musée Municipal, Sète** (*Portrait of Jeannie Gobillard*, 1890).

United Kingdom

In England, the **National Gallery, London**, currently holds *Summer's Day* or *The Lake in the Bois de Boulogne* (1879) in the Lane Collection. The *Portrait of the Artist's Sister, Mme Edma Pontillon* (c. 1875) is to be found in the **Courtauld Institute** and *Young Woman* or *Girl on a Divan* (1885) in the **Tate Gallery**. **The British Museum** (Department of Prints and Drawings) contains two late watercolours, *Young Girl in the Wood* (1893) and *Tree in the Wood* (1894). It is one of several institutions world-wide holding impressions of Morisot's drypoints (see Janine Bailly-Herzberg, 'Les Estampes de Berthe Morisot', *Gazette des Beaux-Arts*, 6, 93, May–June 1979). The collection of the **Ashmolean, Oxford**, includes examples of Morisot's watercolours: *Landscape, Jersey* (1886) and *Carriage in the Bois de Boulogne* (1887–8). **The Sainsbury Centre for Visual Arts, Norwich**, University of East Anglia, contains a pastel portrait of Isabelle (Lambert) (c. 1886).

The National Gallery of Scotland, Edinburgh, has *Young Woman Sewing in*

the Garden or *Woman and Child in a Garden* (1884), while the collection of the **National Museum of Wales, Cardiff**, includes *At Bougival* (1882).

Belgium

In the **Musée d'Ixelles, Brussels** (Collection of F. Toussaint) is *Interior at Jersey* (or *Girl with a Doll*) (1886).

Denmark

In Copenhagen, the **Ordrupgaardsamlingen** collection (A.M.W. Hansen Bequest) includes two oil paintings, the *Portrait of Mme Marie Hubbard* (1874) and *Young Girl in a Red Bodice* (1885).

The **Ny Carlsberg Glyptotek, Copenhagen**, contains the watercolour *In the Tuileries Gardens* (1885) and three oil paintings: *Nurse and Baby,* an early painting in oils of Julie Manet and her nurse *Angèle* (1880); *Peasant Women Hanging out the Washing* (1881); and *Young Girl Arranging her Hair* (1893).

Ireland

The **National Gallery of Art, Dublin**, contains an oil painting, *The Black Bodice* (1878).

Netherlands

The **Rijksmuseum, Amsterdam**, has an impression of the drypoint *Berthe Morisot Drawing with her Daughter* (1889).

Norway

The **National Gallery, Oslo**, contains an oil painting, *The Quay at Bougival* (1883).

Sweden

The **National Museum, Stockholm**, includes three watercolours, *On the Sofa* (1871) and two studies of *The Beach at Nice* (1882), and the oil painting, *In the Garden* or *Women Gathering Flowers* (1879).

NORTH AMERICA

USA

Thanks to a number of assiduous collectors and generous patrons of Impressionist works, the USA has the largest number of Morisot works in the public domain.

The **National Gallery of Art, Washington**, has been generously endowed with a number of works by Morisot, including some of her masterpieces. They include *Portrait of the Artist's Mother and Sister* or *Portrait of Mme Morisot and her Daughter, Mme Pontillon* (1869–70), also known as *Reading*; *In the Dining-Room* or *The Little Servant* (1886); and *The Artist's Daughter with a Parakeet* (1890), all in the Chester Dale Collection. *The Artist's Sister at the Window* or *Young Woman at the Window* (1869), a portrait of Mme Edma Pontillon; *The Harbour at Lorient* (1869); *View of the Bois de Boulogne* or *Island in the Bois de Boulogne* (1889); and two watercolours of her sister Edma, *Mme Pontillon and her Daughter, Jeanne* (1871); and *Young Woman on a Bench* (1872), are in the Ailsa Mellon Bruce Collection; the Paul Mellon Collection contains the *Laundresses Hanging out the Washing* (1875), painted at Gennevilliers. *Two Women Seated* (1869–75) was a gift of Mrs Charles S. Carstairs. The Rosenwald Collection 1953 includes the Morisot drypoint *Julie Manet with a Cat* (1887).

The **Phillips Memorial Gallery, Washington**, contains *Young Women at their Toilette* (1894) and the **National Museum of Women in the Arts** (Holladay Collection) includes an oil painting, *The Cage* (1885) and a watercolour, *The Lake, Bois de Boulogne* (*c.* 1887).

In **New York, the Metropolitan Museum**, Harris Brisbane Dick Collection, contains a Morisot watercolour known variously as *Woman Seated in the avenue du Bois* or *Lady with a Parasol Seated in a Park* or *Woman with a Straw Hat* (1885); also a pencil study for *Girl in a Green Coat* (n.d.), Robert Lehman Collection. The **Brooklyn Museum** has a double portrait of *Mme Boursier and her Daughter* (1874).

The **Museum of Art, Cleveland, Ohio**, has three works by Morisot: *The Artist's Sister, Madame Pontillon Seated on the Grass* (1867 or 1873), a gift of the Hanna Fund; a charcoal and pastel portrait of *Louise Riesener in a Hat* (1888) from the Leonard C. Hanna Bequest and *Child with Shirt*.

The **Art Institute of Chicago, Illinois**, has a variety of Morisot's works: the well-known oil painting, *Young Woman at her Toilette from Behind* (1879–80) from the Stickney Fund, and a landscape in oils, *Forest of Compiègne* (1885), the bequest of Estelle McCormick; three watercolours, *Woman and Child on the Balcony* (1872), gift of Mrs Charles Netcher, *Young Woman Seated* (1894) and *Young Woman in a Green Coat* (1894); also three pastels, *Head of the Little Brunette* (1877), *The Plait* (1894) and a *Self-Portrait* (1885) in the Helen Regenstein Collection; and drypoints 1887–9.

Of the smaller institutions with important Impressionist collections, which include works by Berthe Morisot, the **Sterling and Francine Clark Institute, Williamstown**, Massachusetts, has a watercolour, *Bow of a Yacht* (1875), and in oils, a still life, *The Dahlias* (1876) and *The Bath* or *Girl Arranging her Hair* (1885–6), modelled by Isabelle Lambert.

Other US galleries and museums of art with collections in which Berthe Morisot's work is represented:

Albright Art Gallery, Buffalo, New York
Art Centre, La Jolla, California
Baltimore Museum of Art, Maryland
Boston Museum of Fine Arts, Massachusetts
California Palace of the Legion of Honor, San Francisco, California
Dallas Museum of Art, Texas
Fogg Museum of Art, Harvard University, Cambridge, Massachusetts
Houston Museum of Fine Arts, Texas
Minneapolis Institute of Art, Minnesota
Mount Holyoke Museum of Art, South Hadley, Massachusetts
Nelson-Atkins Museum of Art, Kansas City, Missouri
Newark Museum, New Jersey
Norton Simon Inc. Museum of Art, Los Angeles, California
Philadelphia Museum of Art, Pennsylvania
Phoenix Art Museum, Arizona
Santa Barbara Museum of Art, California
Smith College, Museum of Art, Northampton, Massachusetts
St Petersburg Museum of Fine Arts, Florida
Toledo Museum of Art, Ohio
Worcester Art Museum, Massachusetts
Virginia Museum of Fine Arts, Richmond, Virginia

Canada

The **National Gallery of Canada, Ottowa**, has a Morisot sculpture in bronze, entitled *Julie* (1886), and a drawing in red and black chalk of *Julie Manet* (*c.* 1889).

SOUTH AMERICA

Argentina

The **National Museum of Fine Arts, Buenos Aires**, holds a late oil painting, *The Coiffure* (1894).

The Missing Link? A Tentative Hypothesis

The Fragonard–Morisot connection remains the elusive factor in Berthe's ancestry, despite repeated affirmations by family friends and art historians. In his 1896 preface to the catalogue of Berthe Morisot's memorial exhibition, Stéphane Mallarmé described her as '*une arrière-petite-nièce . . . de Fragonard*'. This was repeated by Jacques-Emile Blanche in 'Les Dames de la grande rue' (p. 19). The general assumption seems to have been that the link was between the Fragonard family and the male side of the Morisots. There is one dissentient voice, however. Whether with the benefit of inside knowledge, or mistakenly, in *L'Impressionisme et Son Epoque* (vol. 1, p. 595), Sophie Monneret states that Cornélie Thomas, Madame Morisot, was a '*petite-nièce de Fragonard*', which would make Berthe Morisot the artist's great-grand-niece. However, there is no supportive evidence given for this statement. Moreover, all other authorities assume the link was through Monsieur Morisot, although that seems to be the limit of agreement on the subject.

To illustrate the point, albeit briefly, a family friend, Monique Angoulvent, *Berthe Morisot* (p. 72) tells us that '*elle descendait puisque par sa famille paternelle, elle était cousine de Fragonard*'. Bataille and Wildenstein made plain in their *Catalogue des peintures* (p. 13), for which Denis Rouart wrote the introduction, that '*La famille Morisot était alliée à la famille Fragonard*'; in the Introduction to *Berthe Morisot, Drawings, Pastels, Watercolours, Paintings*, Elizabeth Mongan referred to her as 'great-niece of Fragonard' on her father's side, thus repeating Fourreau (p. 57). Huisman blurs the picture (p. 5) by saying that 'there had been one or two cultured artists and eccentrics among the family. Her paternal grandfather, Edme Tiburce Morisot, a distant cousin of Fragonard, had been an architect who died in Italy'. However, the uncertainty about the identity of Berthe's paternal grandfather (Fourreau, p. 9, Bataille and Wildenstein, p. 13, Huisman, p. 5, André-Jean Tudesq, p. 400, and Stuckey, p. 177 offer different identities) serves only to obscure hopes of establishing the precise relationship. In the

main, later writers (e.g. Lowe, p. 9 and Petersen and Wilson, p. 90) describe her as a 'great-granddaughter', though in their bibliography (p. 187) Bachmann and Piland call her 'the granddaughter of Fragonard'. The point does not need to be laboured.

Jean-Honoré Fragonard himself was an only (surviving) child, and his direct, legitimate descendants (including their spouses) are documented up to the death of his great-grandson, Antonin, in 1887. There is scant information about the parents of the artist, François and Françoise Fragonard, or other relatives in the Grasse area, and even less about Morisot ancestors living there. So the question remains: when and how did the tradition of a Fragonard–Morisot link arise? Charles F. Stuckey is sceptical of its validity. 'Many biographers now claim, perhaps incorrectly, that Fragonard was in fact her great-great-uncle on her father's side' (p. 81). Stuckey points out (p. 183) that Mary Cassatt was also sceptical, and claimed that Berthe's surviving sister, Edma Pontillon, knew nothing of the alleged relationship. Unfortunately, Berthe herself never placed the connection on record. It was not mentioned in the Morisot *Correspondence*, nor in her private notebooks. Apparently, the first mention in print was Stéphane Mallarmé's remark.

It is tempting to ask, did Mallarmé first learn of some affinity from Julie Manet after her mother's death? As her guardian, he was very close to this vulnerable adolescent, approaching womanhood. Could it be that Julie Manet, recalling family discussions which had taken place in her hearing, was the person who first conveyed the notion of a *paternal* connection? If so, it must have been with the best of intentions. In her long life – as Madame Ernest Rouart, she lived until 1964 – Julie Manet was, as Armand Fourreau respectfully put it in his dedication, a 'pious warden of a glorious and beloved memory'. In the confusion of family lore, the paternal connection may have been *hers* – and only very indirectly her mother's.

To return to the Fragonard family tree: Jean-Honoré's only daughter, Rosalie, died at the age of nineteen, unmarried and childless. His only son, Alexandre-Evariste Fragonard, a pupil of David, enjoyed brooding good looks as a young man, and, according to the Baron Portalis, enjoyed '*une grande notoriété*' as a painter and sculptor throughout his life. (It was he who painted the portrait of Claudine Elisabeth Duchesne, the wife of M. Morisot, Berthe's grandfather.) Alexandre-Evariste had one (legitimate) son, Théophile-Evariste Fragonard, born in 1806 (the same year as Berthe Morisot's father). The Archives de la Ville de Paris contain the record of this child's birth; his mother, Alexandre-Evariste's wife, is named as Julie Félicite *Fournier*. Is this pure coincidence? Is it possible that the daughter-in-law of Fragonard was related to the Eugénie Desirée Fournier, who in 1831 became Madame Auguste Manet? Does this woman personify the flimsy link between the Fragonards and Berthe Morisot? After all, it was Madame

Manet's brother, Edmond-Edouard Fournier, who had such a keen interest in art that he encouraged his young nephew, Edouard Manet, to take up drawing, even against *Père* Manet's wishes. Eugénie Fournier became the mother-in-law of Berthe Morisot and the grandmother of Julie Manet. The child was named Eugénie, so bearing the name of her Fournier grandmother. But was she also named Julie after another Fournier ancestor? Or rather, Julie Eugénie, after the two Fourniers in her paternal line? In these circumstances, Julie could have been a great-great-grand-niece of Fragonard by marriage on *her* paternal side.

As to her mother, Berthe Morisot – Madame Eugène Manet – were this link proved, she would in effect be Fragonard's great-grand-niece-in-law through two successive marriages. A highly tenuous connection indeed, and certainly not a blood relationship; but in view of the publicized artistic affinity between the paintings of Fragonard and those of Berthe Morisot, a connection which young Julie Manet, the recipient of so much artistic gossip and family legend, may have been only too happy to convey to posterity.

When did Berthe Morisot and Edouard Manet Become Close Friends?

There is a commonly held view, still constantly repeated, that Berthe and Edouard Manet were not introduced until sometime in 1868, although it is generally conceded that the friendship between the two artists and their families developed very rapidly from that point. Henri Fantin-Latour is invariably credited with having made the crucial introduction in the summer of 1868. A letter from Manet to Fantin, dated 26 August 1868 and sent from Boulogne-sur-Mer, where he was holidaying, is often cited as the first evidence of this new friendship. In a tone of light-hearted bantering, Manet famously remarked: 'I quite agree with you, the Mademoiselles Morisot are charming. What a pity they're not men. All the same, they could serve the cause of painting, in their capacity as women, by each marrying an academician and bringing trouble to those old fogeys in the enemy camp. Or perhaps that's asking too much self-sacrifice! In the meantime, do present my compliments to them' (Moreau-Nélaton, *Manet Raconté par Lui-même*, vol. 1, p. 103).

If this letter is interpreted as pointing to their recent introduction, the timing runs counter to other sources, as well as to the strong circumstantial evidence putting the date of Berthe's friendship with Manet significantly earlier. First, there are Berthe's own words, associating Manet with '*all* her youth'. Is it likely, given that the average lifespan was somewhere around forty-five years, that she should consider her twenty-eighth year as the outset of her 'youth'?

Some experts on Manet (Daix, Jamot, Curtiss) place the origin of their friendship around 1865 when Berthe was twenty-four years old. In his edition of the Morisot correspondence, Denis Rouart noted that Fantin introduced them while Berthe and Rosalie Riesener were copying a series of paintings by Rubens on the subject of Marie de Medici. According to Reff

this was in February 1865, the date of the last entry in the Louvre of permission to copy. Fourreau, her first biographer, states that 'it was . . . *towards 1865* that the two families became really friendly' (emphasis added).

Rouart also notes that when the Manets and the Morisots became close friends, the latter attended the Manet soirées where other visitors included Baudelaire. This is repeated in the 1990 monograph on Morisot by Anne Higonnet, who writes that 'At her [Mme Manet's] receptions, Berthe, Edma and their parents met a new group of intellectuals, including musicians, art critics, and writers like Baudelaire'. In his biography of Baudelaire, F.W.J. Hemmings confirms the Manet–Baudelaire–Morisot association, and as already indicated (Chap. 7, n. 15) he was of the opinion that Berthe played Wagner to Baudelaire in his last illness. However, the chronology of Baudelaire's movements is important. He left Paris to live in Belgium in April 1865 and remained there until July 1866; after that, he returned to Paris but the long, debilitating illness from which he suffered until his death in September 1867, precluded any normal socializing. So if Berthe met Baudelaire at the Manet soirées, she must have been friendly with the Manets before the spring of 1865.

It was 'a certain day' in 1867 that Jacques-Emile Blanche, then a young boy, first heard the name of Edouard Manet at the Morisots' house; he had just been introduced to 'Mademoiselle Berthe' by her friend, Marguerite Carré. According to his recollection, Manet had been there in the rue Franklin, the implication being that Berthe was definitely on close, friendly terms with the artist by that time. More to the point, Madame Morisot's letters to Edma and Berthe written in the summer of 1867 referred in very personal terms to Edouard Manet. It is inherently unlikely that she would have written in that vein had they not known Manet well by that time.

Denis Rouart also states: 'The introduction [i.e. of Manet and Berthe Morisot] was made by Fantin-Latour and Manet asked Berthe to pose . . . for *Le Balcon*' (although, as already indicated, he links 'this time' with Berthe and Rosalie Riesener's visits to the Louvre prior to February 1865). It would be very surprising, and in their situation unlikely, if a woman of her class were to agree to pose for an artist for a commercial painting unless she had known him for a reasonable length of time, and had her parents' approval, particularly an artist as controversial as Manet. His request to her to sit was allegedly made on his return from Boulogne in 1868.

Opinions contrary to Rouart's have been expressed, but in the main they have been overlooked by subsequent commentators. For instance, Tabarant, Manet's biographer, says that the pair first met in the Louvre in 1860. Fourreau agrees that Berthe and Edma first noticed Manet there in that year, and if Théodore Duret is to be believed, it was impossible not to notice Manet, who was 'essentially a man of the world, refined, courteous, polished, taking pleasure in society'. It was Duret (p. 118), one of Manet's

many friends, who said Berthe and Manet came to know each other around 1861, when she was twenty years old, and that Berthe was one of the first artists to borrow his method of painting in bright colours. By 1865, when Berthe's Salon exhibits were praised in the *Gazette des Beaux-Arts*, Manet was aware of her interest in *plein air* painting. Already, over two or three years, their friendship had assumed 'a character of frank cordiality', according to Tabarant. This was confirmed by Duret: 'when he [Manet] became famous, especially after 1865, they [Berthe and Edma] . . . visited him in his studio to renew their acquaintance.'

If Berthe's friendship with Manet is regarded as the seminal relationship of her life, there is a compelling reason to accept, with Duret and Tabarant, that it developed in the course of the whole decade of the 1860s, starting from the mutual attraction felt at their first meeting in 1860. We can then assume that before 1865 they had a number of acquaintances in common and were in the habit of meeting, albeit by chance rather than by pre-arrangement, as the result of their shared interests. By the winter of 1864–5 Berthe (just turned twenty-four) and Edma were almost certainly attending Manet soirées (where they would have encountered Baudelaire) while the two mothers, Madame Manet and Madame Morisot, were on regular visiting terms. What this underlines is that there is reputable support for dating the friendship between Berthe Morisot and Edouard Manet at several years before the usually stated time.

Notes

PREFACE

1. See Appendix 1 on location of Morisot's works.

2. Louis Rouart, 'Berthe Morisot (Mme Eugène Manet) 1841–1895', *Art et Décoration* (May 1908), p. 176, reiterated in *Berthe Morisot* (Paris, 1941).

3. The most impressive celebrations of her work in recent times were the retrospective exhibitions held in the USA at the National Gallery of Art, Washington, DC, Mount Holyoke College Art Museum, Mass. and the Kimbell Art Museum, Fort Worth, Texas, in 1987–8. Simultaneously, viewers in western Europe were treated to the first exhibition in over a quarter of a century, held at the Galerie Hopkins-Thomas in Paris (April–June 1987); and later, in association with that gallery, at JPL Fine Arts, London (1990–1). The decision to embark on these undertakings was a measure of the growing interest in women artists like Morisot. It was Linda Nochlin's landmark essay, 'Why Have There Been No Great Women Artists?' in E. Baker and T. Hess (eds), *Art and Sexual Politics* (New York, Collier, 1973), which posed a fundamental question to art historians, first mooted by Frank Rutter in the context of Impressionism in 1905. Many entered the debate, but two other works proved significant for this study: Germaine Greer's *The Obstacle Race: The Fortunes of Women Painters and Their Work* (London, Secker & Warburg, 1979) and Rozsika Parker and Griselda Pollock's *Old Mistresses: Women, Art and Ideology* (London, Routledge & Kegan Paul, 1981). Subsequently, a résumé of the development of feminist art history in relation to Morisot appeared in Kathleen Adler and Tamar Garb's Introduction to a new edition of *The Correspondence of Berthe Morisot with her family and friends*, ed. Denis Rouart, tr. B. Hubbard (London, Camden Press, 1986). To these, Charles F. Stuckey and William P. Scott, with the assistance of Suzanne G. Lindsay, in *Berthe Morisot – Impressionist* (New York, Hudson Hills Press, 1987) have added an impressive account of her artistic development, style and technique.

4. See the bibliography. M.-L. Bataille and G. Wildenstein, *Berthe Morisot: Catalogue des peintures, pastels et aquarelles de Berthe Morisot* (Paris, Editions d'Etudes et des Documents, 1961) is of prime importance. Two recent monographs are well illustrated: Stuckey and Scott, *Berthe Morisot*, and K. Adler and T. Garb, *Berthe Morisot* (Oxford, Phaidon Press, 1987). Reproductions of a number of watercolours and drawings can be found in two exhibition publications, entitled *Berthe Morisot*, produced in association with the Galerie Hopkins-Thomas, Paris, in 1987 and 1990.

5. P. Valéry, 'Pièces sur l'Art: Berthe Morisot', *Oeuvres*, ed. Jean Hytier (4 vols, Paris, Gallimard, Bibliothèque de la Pléiade, 1962), vol. 2, p. 1302.

6. P. Valéry, 'Berthe Morisot', exhibition catalogue, Musée de l'Orangerie, 1941, repr. in English in 'Degas Manet Morisot', *Collected Works*, ed. Jackson Matthews, tr. David Paul, Bollingen Series (New York, Pantheon Books, 1960), vol. 12, p. 119.

7. Armand Fourreau, *Berthe Morisot* (Paris, F. Rieder, 1925), p. 7.

8. Jean Dominique Rey, *Berthe Morisot*, tr. Shirley Jennings (Naefels, Switzerland, Bonfini Press, 1982), p. 10.

9. Anne Higonnet, *Berthe Morisot* (New York, Harper & Row, 1990), p. xi.

10. *The Correspondence of Berthe Morisot with her family and friends . . .*, ed. Denis Rouart, tr. Betty W. Hubbard (London, Lund Humphries, 1959), Preface, p. 9 (hereafter cited as *Morisot Correspondence*); see Fourreau, *Morisot*; Monique Angoulvent, *Berthe Morisot*

(Paris, Morancé, 1933); Christine Havice, 'The Artist in Her Own Words', *Woman's Art Journal*, 2, Pt 2 (1981–2), also questions this statement.

11. Valéry, 'Berthe Morisot', exh. cat. 1941; repr. in 'Degas Manet Morisot', p. 115.

12. Paul Mantz, 'L'Exposition des Peintres Impressionistes', *Le Temps*, 22 April 1877.

13. Valéry, 'Berthe Morisot', p. 1302.

14. Preface to the catalogue of Morisot's posthumous retrospective, Durand-Ruel Galleries, 5–23 March 1896, Stéphane Mallarmé, *Divagations* (Paris, Bibliothèque Charpentier, 1943), pp. 147–8.

15. *The Journal of Marie Bashkirtseff*, tr. Mathilde Blind (2 vols, London, Cassell, 1890, repr. London, Virago Press, 1985), vol. 1, p. 166.

16. Edmond and Jules de Goncourt, *French Eighteenth-Century Painters*, rev. edn (London, Phaidon, 1948), pp. 289–91.

17. George Moore, *Confessions of a Young Man*, ed. Susan Dick (Montreal and London, McGill-Queen's University Press, 1972), pp. 68–9; Louis Rouart echoed this in 'Berthe Morisot', p. 168: 'she belonged to the same artistic family as Watteau, Boucher, Hubert Robert and Fragonard.'

18. For a fuller discussion, see Appendix 2.

19. Philippe Huisman, *Morisot: Enchantment*, tr. Diane Imber (New York and Lausanne, French and European Publications, 1962), p. 64.

20. J.H. Plumb (ed.), *Studies in Social History: a Tribute to G.M. Trevelyan* (London, Longman, Green, 1955), Introduction, p. xiii.

CHAPTER 1. LINEAGE

1. Angoulvent, *Berthe Morisot*, appendix, *Pièces justificatives, Extraits des Registres de l'état civil de la ville de Bourges, Actes de Naissance, Berthe Morisot*, no page nos.

2. Fourreau, *Berthe Morisot*, p. 9, n. 2; E. Bellier de la Chavignerie and Louis Auvray, Dictionnaire Générale des Artistes (5 vols, Paris, 1882–5, repr. New York and London, Garland Publishing, 1979), vol. 3, p. 130; Firmin Didot Frères, Nouvelle Biographie Générale (Paris, 1861), vol. 35, c.v. Morisot; cf. Bataille and Wildenstein, *Catalogue des peintures*, p. 13.

3. Bataille and Wildenstein, *Catalogue des*

peintures, p. 13; Stuckey and Scott, *Berthe Morisot*, p. 177, n. 10.

4. André-Jean Tudesq, *Les Grands Notables en France 1840–1849: Etude historique d'une psychologie sociale* (2 vols, Paris, Presses Universitaires de France, 1964), vol. 1, p. 400.

5. J.M. and B. Chapman, *The Life and Times of Baron Haussmann* (London, Weidenfeld & Nicolson, 1957), pp. 162–4.

6. cf. Sophie Monneret, *l'Impressionisme et Son Epoque. Dictionnaire International* (2 vols, Paris, Robert Laffont, Editions Denoël, 1978, repr. 1979), vol. 1, p. 595.

7. Bataille and Wildenstein, *Catalogue des peintures*, p. 13; see Appendix 2 on the Fragonard connection.

8. Massengale, Jean Montagne, *Jean-Honoré Fragonard* (London, Thames & Hudson, 1993), pp. 7, 46.

9. Huisman, *Enchantment*, p. 63.

10. Jean-Paul Bertaud, 'Napoleon's Officers', *Past and Present*, August 1986, pp. 91–111.

11. Claude Roger-Marx, 'Les Femmes Peintres et l'Impressionisme: Berthe Morisot', *Gazette des Beaux-Arts*, 3rd series, 38, December 1907, p. 491.

12. G. Vapereau, *Dictionnaire Universel des Contemporains*, revd edn (Paris, 1858, 4th edn repr. 1870), c.v. T. Morisot, pp. 1307–8.

13. Archives Nationales, Paris (hereafter cited as A.N.) Flb I 167 (31) *Dossier Morisot: Détails personnels; bulletin des renseignements.*

14. Frederick B. Artz, *The Development of Technical Education in France 1500–1850* (Cambridge, Mass., Cambridge University Press, 1966), p. 161.

15. Chapman, *Baron Haussmann*, p. 58.

16. The most recent biography of Thiers in English is J.P.T. Bury and R.P. Tombs, *Thiers 1797–1877: A Political Life* (London, Allen & Unwin, 1986), but see also Henri Malo's tome, *Thiers 1797–1877* (Paris, Payot, 1932) and Pierre Guiral, *Adolphe Thiers* (Paris, Fayard, 1986).

17. A.N. Flb I 167 (31) *Dossier Morisot: Détails personnels au fonctionnaire; Morisot Correspondence*, p. 12.

18. Malo, *Thiers*, p. 150; A.N. Flb I 167 (31) *Dossier Morisot.*

19. Vapereau, *Dictionnaire Universel*, c.v. Thomas, Jean-Simon-Joseph, p. 1748.

20. D. Johnson, 'A Reconsideration of Guizot', *History*, XLVII, 161 (1962) p. 240.

21. *Morisot Correspondence*, p. 12; Higonnet, *Berthe Morisot*, p. 4.

22. Angoulvent, *Berthe Morisot*, p. 41.

23. Chapman, *Baron Haussmann*, p. 26.

24. Jean-Pierre Aguet, *Les Grèves sous la Monarchie de Juillet (1830–1847)* (Geneva, Droz, 1954), pp. 55–62, 159–63.

25. Vapereau, *Dictionnaire Universel*, pp. 1307–8. Morisot's promotion was most unusual: Tudesq points out (p. 400) that, except for Morisot, the prefectoral corps came from families of the *notable* class.

26. A.N. Flb I 167/31, *Dossier Morisot: Renseignements*, 26 July 1839.

27. Laura S. Struminger, *What Were Little Girls and Boys Made of?* (Albany, NY, State University of New York Press, 1983), p. 7. The whole saying goes thus: *Une fille, ce n'est rien, deux, c'est assez, trois c'est trop, mais quatre filles et la mère font cinq diables contre le père.* ('One daughter is no problem, two is enough, three is too many but four daughters with Mother makes five devils against Father!')

28. Archives de la cathédrale de Bourges, Registres, 1841.

29. A.N. Flb I 167/31, *Dossier Morisot: bulletin des renseignements*. Berthe Morisot never returned to Bourges according to her daughter. The baptismal record and an *esquisse* on wood of a young woman in a white gown, thought to be a late example of her work, which was acquired by the Musée de Berry in 1935, are the only memorabilia in her birthplace.

CHAPTER 2. A VERY POLITICAL CHILDHOOD

The social and political background to Berthe Morisot's earliest years is covered by J.M. Merriman's works on Limoges; the period 1848–52 by a number of histories of the Second Republic and the establishment of the Second Empire, e.g. Adrien Dansette, *Louis Napoleon à la Conquête du Pouvoir* (Paris, Librarie Hachette, 1961), Roger Price, *The French Second Republic: A Social History* (London, Batsford, 1972) and Roger Magraw, *France 1815–1914: The Bourgeois Century*, gen. ed. Douglas Johnson, Fontana History of Modern France, 3rd impress. (London, Fontana Books, 1988), Pt I, chap. 2, 'The Triumph of the Grande Bourgeoisie 1830–48', pp. 51–88; Bernard Le Clère and

Vincent Wright, *Les Préfets du Second Empire* (Paris, Fondation National des Sciences Politiques, Armand Colin, 1973), though specialized, is also useful.

1. Julie Manet, *Journal 1893–1899* (Paris, C. Klinksieck, 1979), 27 August 1897, p. 130; *Morisot Correspondence*, pp. 36, 118, 175–6.

2. Isabelle Bricard, *Saintes ou Pouliches: L'Education des Jeunes Filles au XIXe Siècle* (Paris, Albin Michel, 1985), Part I: *L'éducation en famille: la manière 'douce'*, pp. 15–21.

3. *Eugène Manet and His Daughter at Bougival* 1881 (see Plates); *The Fable (Julie and Her Nurse Pasie)* 1883; *Julie with a Doll* 1884; a pastel, *Little Girl with her Doll (Julie Manet)* 1884; *Interior at Jersey* 1886, all in a private collection.

4. J.M. Merriman, *The Red City: Limoges and the French in the 19th Century* (New York, Oxford University Press, 1985), p. 94.

5. Ibid., pp. 9–12; the sketch, *Little St John* 1890, in a private collection, Paris, is reproduced in Rey, *Berthe Morisot*, p. 53.

6. Jean Renoir, *Renoir, My Father*, tr. Randolph and Dorothy Weaver (London, Reprint Society, 1962), pp. 17–18; Merriman, *The Red City*, pp. 5–8.

7. Julie Manet, *Journal*, 24 August 1898, p. 176.

8. Renoir, *Renoir, My Father*, pp. 20–1.

9. The Thomas grandparents and the widowed Madame Morisot all lived in the capital: A.N. Flb I 167 (31), M. Joseph Thomas to the minister of the interior, 30 January 1852.

10. Chapman, *Baron Haussmann*, p. 26. A shrewd Prefect like Haussmann knew that it was wise periodically to 'take the air in the offices of the Ministry of the Interior'.

11. See B. Chapman, *The Prefects and Provincial France* (London, Allen & Unwin, 1955) for the role of the Prefect in French society; also Le Clère and Wright, *Le Préfets du Second Empire*, p. 59 ff.

12. Chapman, *The Prefects and Provincial France*, p. 34.

13. *Morisot Correspondence*, p. 12.

14. Archives départementales de la Haute-Vienne, tables décennales 1843–52, 3E.85, 180: Acte no. 1475, states that the baby was born on 11 December 1845 and was named Marie Charles Tiburce Morisot, the witnesses being the mayor and the first president of the royal court of Limoges; cf. Bataille and

Wildenstein, *Catalogue des peintures*, p. 13, which gives the date as 1848, repeated in many secondary sources.

15. Huisman, *Morisot: Enchantment*, pp. 63–4.

16. Merriman, *The Red City*, pp. xiii, 5.

17. J.M. Merriman (ed.) *French Cities in the Nineteenth Century* (London, Hutchinson, 1982), pp. 42–72, 68–9; Merriman, *The Red City*, pp. 43, 69.

18. Alain Corbin, *Archaïsme et Modernité en Limousin au XIXe siècle 1845–1880* (2 vols, Paris, Marcel Rivière, 1975), vol. 1, p. 709 ff.; A.B. Cobban, *A History of Modern France* (2 vols, Harmondsworth, Middlesex, Penguin Books, 1961), vol. 2, p. 134.

19. The events of the revolutionary crisis in Limoges are detailed in a little-known work, Victor Chazelas, 'Un Episode de la Lutte de Classes à Limoges, 1848', *Bulletin de la Société d'Histoire de la Révolution de 1848*, vol. 7 (novembre–décembre 1910), pp. 168–80, 240–56.

20. Bataille and Wildenstein, *Catalogue Morisot*, p. 13; J. Hillairet, *Dictionnaire Historique des Rues de Paris* (2 vols, Paris, Editions Minuit, 1961), vol. 2, p. 649: the cul-de-sac was developed in 1844.

21. Huisman, *Morisot: Enchantment*, p. 63.

22. Ibid., p. 64; Higonnet, *Morisot*, p. 8, offers this more explicit translation.

23. Middle-class interests have been analysed in depth in Adeline Daumard, *La Bourgeoisie Parisienne de 1815 à 1848* (Paris, Centre de Recherches Historiques, Démographie et sociétés VIII, Flammarion, 1963, repr. 1970).

24. A.N. Flb I 167 (31) *Dossier Morisot*; Le Clère and Wright, *Les Préfets du Second Empire*, pp. 338–40.

25. Julie Manet, *Journal*, 1 October 1896, p. 109.

26. Howard Machlin, 'The Prefects and Political Repression: February 1848 to December 1851', in Roger Price (ed.), *Revolution and Reaction* (London, Croom Helm, 1975), p. 292; *The Times*, 29 October 1851.

27. *The Times*, 2, 3, 4, 7 and 9 September 1850.

28. Le Clère and Wright, *Les Préfets du Second Empire*, passim.; V. Wright, 'The Coup d'Etat of December 1851', in Price (ed.), *Revolution and Reaction*, pp. 303–33.

29. A.N. Flb I 167 (31) *Dossier Morisot*, placard: *Habitants du Calvados*.

30. Pierre Courthion and Pierre Cailler (eds) *Portrait of Manet by Himself and his Contemporaries*, tr. Michael Ross (London, Cassell, 1953), 'Memories of Antonin Proust', p. 40.

31. A.N. Flb I 167 (31) *Dossier Morisot*, Colonel Borgarelli d'Ison to the minister of the interior, 8 December; members of the council of the *arrondissement* and the municipal administration of Caen to the minister of the interior, 9 December 1851.

32. Julie Manet, *Journal*, 1 October 1896, p. 109.

33. A.N. Fib I 167 (31) *Dossier Morisot, Notice Individuelle*.

34. Ibid., M.J. Thomas to the Minister of the Interior, 30 January 1852.

35. Ibid.; Wright, 'The Coup d'Etat of December 1851', in Price (ed.), *Revolution and Reaction*, p. 320.

36. M. Morisot remained in place until 3 July 1852. It was a normal requirement that prefects should supply at their own expense the furniture and social necessities for official entertaining.

CHAPTER 3. THE EDUCATION OF A GENTEEL REVOLUTIONARY

Albert Boime, *The Academy and French Painting in the Nineteenth Century* (London, Phaidon, 1971), illuminates the artistic generation of Chocarne and Guichard. The role of women which forms the background to this and following chapters, is treated by James F. McMillan, *Housewife or Harlot: The Place of Women in French Society 1870–1940* (Brighton, Sussex, Harvester Press, 1981), by Claire Goldberg Moses, *French Feminism in the Nineteenth Century* (Albany, NY, State University of New York Press, 1984), and by Bonnie G. Smith, *Ladies of the Leisure Class: the Bourgeoises of Northern France in the Nineteenth Century* (Princeton, NJ, Princeton University Press, 1981). Linda L. Clark, *Schooling the Daughters of Marianne* (Albany, NY, State University of New York Press, 1984) throws light on the development of girls' education, while Isabelle Bricard, *Saintes ou Pouliches: L'Education des Jeunes Filles au XIXe Siècle*, provides an excellent analysis of the educational theory and practice in France in this period.

Notes

1. Chapman, *Baron Haussmann*, pp. 1, 79–80; David Pinkney, *Napoleon III and the Rebuilding of Paris* (Princeton, NJ, Princeton University Press, 1958, repr. 1972), pp. 3–24; Renoir, *Renoir, My Father*, p. 19.

2. R. Bargeton, P. Bougard, B. Le Clère and P.-F. Pinaud, *Les préfets du 11 ventôse an VIII au 4 septembre 1870: répertoire nominatif et territorial* (Paris, A.N., 1981), 'Morisot', p. 225.

3. Hillairet, *Dictionnaire Historique*, vol. 2, p. 649. For an interesting historical vignette of Passy, see Musées de la Ville de Paris, *Chaillot–Passy–Auteuil, Promenade historique dans la 16e arrondissement* (Paris, Les Musées de la Ville de Paris, 1982).

4. Pinkney, *Napoleon III*, p. 99.

5. Roy MacMullen, *Degas: His Life, Times and Work* (London, Secker & Warburg, 1985), p. 29.

6. Jacques-Emile Blanche, 'Les Dames de la grande rue, Berthe Morisot', *Les Ecrits nouveaux* (Paris, 1920), p. 17.

7. Ivor Guest, *The Ballet of the Second Empire, 1847–1858* (London, A. & C. Black, 1955), passim; by an imperial decree of 29 June 1854 the Opera became a department of the imperial household.

8. *Morisot Correspondence*, p. 127.

9. Ibid.

10. Julie Manet, *Journal*, 18 August 1895, p. 60.

11. *Morisot Correspondence*, p. 12; Huisman, *Enchantment*, p. 6.

12. A.N. Flb I 167 (31), *Dossier Morisot*, M. Joseph Thomas to the Ministry of the Interior, 17 August 1854; M. Tiburce Morisot to the Ministry of the Interior, 14 January 1855.

13. Bricard, *Saintes ou Pouliches*, pp. 20, 32–7, 56–63, 79, 128–35, 328. As a type of day school, the *cours* dated from 1786 and *les Cours d'éducation à l'usage des jeunes filles du monde*, founded by Abbé Gaultier: see Simone de Beauvoir, *Memoirs of a Dutiful Daughter*, tr. James Kirkup (London, André Deutsch, 1963), p. 621, n. 29; Sandra Horvath-Peterson, *Victor Duruy and French Education: Liberal Reform in the Second Empire* (Baton Rouge, LA and London, Louisiana State University Press, 1984), p. 150.

14. Fourreau, *Morisot*, p. 12; *Morisot Correspondence*, p. 13. It seems Tiburce Morisot's memory played tricks on him. His recollections must date from 1853–5 rather than 1857 if they were, as he maintained, still 'little girls'. Fourreau's word that they were accompanied by their father is repeated by D. Rouart and most later writers, but Angoulvent makes clear that it was Madame Morisot who acted as chaperone: *Berthe Morisot*, p. 2.

15. Bricard, *Saintes ou Pouliches*, p. 34; Horvath-Petersen, *Victor Duruy and French Education*, p. 151; Frances I. Clark, *The Position of Women in Contemporary France* (Westport, Conn., Hyperion Press, 1981), pp. 126 ff.

16. Simone de Beauvoir, *Memoirs*, passim. In the author's day, Adeline Désir was a legend in the institution. 'From the rarified heights of her gilded frame, Adeline Désir, our foundress, a stony-faced lady with slightly hunched shoulders, who was in the process of beatification, gazed down at us. . .', p. 23.

17. Parker and Pollock, *Old Mistresses*, p. 13, cite Léon Legrange, 'Du Rang des femmes dans l'art', *Gazette des Beaux-Arts*, 1860.

18. The Comtesse de Bassanville was a prolific author of works on social conduct and etiquette as well as being a writer of fiction.

19. Bricard, *Saintes ou Pouliches*, pp. 108–15.

20. Parker and Pollock, *Old Mistresses*, p. 38.

21. Fourreau, *Berthe Morisot*, p. 12; for Stamaty, see *The New Grove Dictionary of Music and Musicians*, ed. Stanley Sadie (20 vols, London, Macmillan, 1980), Vol. 18, p. 59.

22. Elizabeth Mongan (ed.), *Berthe Morisot, Drawings, Pastels, Watercolours, Paintings* (London, Thames & Hudson, 1961), passim.

23. Accounts of the 1855 Universal Exhibition may be found in many sources, e.g. C. Baudelaire, *Oeuvres Complètes*, ed. Claude Pichois (Paris, Editions Gallimard, Pléiade, 1961), 'Exposition universelle de 1855', pp. 953 ff.; A. Tabarant, *La vie artistique au temps de Baudelaire* (Paris, Mercure de France, 1963), pp. 203 ff.; Chapman, *Baron Haussmann*, Chapter 6, pp. 96–103; F.A. Trapp, 'The Universal Exhibition of 1855', *Burlington Magazine*, 107 (1965), pp. 300–5.

24. Tabarant, *La vie artistique*, pp. 217–18; F.W.J. Hemmings and R.J. Neiss (eds) *Culture and Society in France 1848–1898: Dissidents and Philistines* (London, Batsford, 1971), pp. 93–107; John Rewald, *The History of Impressionism*, 4th edn, rev. (London, Secker & Warburg, 1985), pp. 13 ff.

25. Julie Manet, *Journal*, 3 October 1896, p. 110.

26. Fourreau, *Berthe Morisot*, pp. 11–12; *Morisot Correspondence*, p. 13; Bellier de la Chavignerie and Auvray, *Dictionnaire Générale des Artistes*, vol. 1, p. 256; Dr Ulrich Thieme and Dr Felix Becker, *Allgemeines Lexicon der Bildenden Künstler* (37 vols, Leipzig, E.A. Seeman, 1907–), Vol. 6, p. 519.

27. Fourreau, *Berthe Morisot*, pp. 27, 29.

28. Bellier de la Chavignerie and Auvray, *Dictionnaire Générale des Artistes*, Vol. 2, p. 720; Thieme and Becker, *Allgemeines Lexicon*, Vol. 15, pp. 270–1; E. Bénézit, *Dictionnaire Critique et Documentaire des Peintres, Sculpteurs, Dessinateurs et Graveurs* (10 vols, Paris, Librarie Grund, nouvelle édition, 1976), Vol. 5, p. 284; Henri Dérieux, 'Joseph Guichard, peintre lyonnais (1806–1880)', *Gazette des Beaux-Arts*, 5th series, 5 (March 1922), pp. 181–94; Fourreau, *Berthe Morisot*, p. 14.

29. *Morisot Correspondence*, p. 14; T. Duret, *Manet and the French Impressionists, Pissarro, Claude Monet, Sisley, Renoir, Berthe Morisot, Cézanne, Guillaumin*, tr. J.E. Crawford Flitch (London and Philadelphia, Pa, Grant Richards and J.B. Lippincott, 2nd edn 1912), p. 183; Theodore Reff, 'Copyists in the Louvre 1850–1870', *Art Bulletin*, 46 (December 1964), pp. 552–9.

30. The Veronese copies, *Calvary* and the *Feast at the House of Simon*, are attributed to 1860 by Reff, 'Copyists in the Louvre', p. 553, cf. Fourreau, *Berthe Morisot*, p. 17.

31. Duret, *Manet and the French Impressionists*, p. 185.

32. This frequently repeated anecdote originated with Tiburce Morisot, Berthe's brother: Fourreau, *Berthe Morisot*, pp. 13–14; Angoulvent, *Berthe Morisot*, p. 5.

CHAPTER 4. YOUNG MEN, OLD MEN

Art education and training are discussed in general terms by Charlotte Yeldham, *Women Artists in Nineteenth-Century France and England* (New York and London, Garland, 1984), and by Jacques Lethève, *The Daily Life of French Artists in the Nineteenth Century*, tr. Hilary E. Paddon (London, Allen & Unwin, 1972). The articles by Théodore Reff, 'Copyists in the Louvre', and Paul Duro, 'The "Demoiselles à copier" in the Second Empire', *Woman's Art Journal*, 7, 1 (Spring–Summer 1986), are also illuminating.

1. Photograph in a private collection.

2. Edma served as a model for a number of Berthe Morisot's paintings and drawings, but she produced fewer of her sister Yves. However, the latter sat for Degas in 1868; for his portrait in pastel in the Metropolitan Museum of Art, New York, see Plates. For the remarks on Berthe's appearance, Valéry, *Oeuvres*, 'Berthe Morisot', p. 1303; Duret, *Manet and the French Impressionists*, pp. 78, 184.

3. *Morisot Correspondence*, p. 15.

4. Fourreau, *Berthe Morisot*, pp. 16–17; Monneret, *L'Impressionisme et Son Epoque*, vol. 1, pp. 74–6; McMullen, *Degas*, pp. 96–7, 108–9.

5. Approx. meaning of 'Ukiyo-e', Japanese genre painting: *Encyclopaedia of World Art* (16 vols, New York, Toronto, London, McGraw Hill, 1963–83), Vol. 8, p. 886.

6. *Carnet vert c.* 1885, in Angoulvent, *Berthe Morisot*, pp. 69–70.

7. See Louis Leroy, *Le Charivari*, 25 April 1874, and *infra*, chap. 11, p. 151.

8. The Académie Suisse was an open studio on the Quai des Orfèvres, where for a small fee artists could work from a model without tuition. Here Pissarro and Monet met in 1859, and Pissarro also met Cézanne in 1861 and Guillaumin in 1863.

9. Fantin-Latour's self-portrait 1859 shows how he must have appeared to Berthe and Edma at that time. His friends were also portrayed in his two great manifesto paintings, *Homage to Delacroix* and *Studio in the Batignolles*: see Plates. For Fantin's tendency to gossip, Lawrence and Elisabeth Hanson, *Golden Decade: The Story of Impressionism* (London, Secker & Warburg, 1961), p. 64; *Morisot Correspondence*, p. 34.

10. S. Weintraub, *Whistler: A Biography* (London, Collins, 1974), p. 57.

11. Ibid., p. 56; Judith Wechsler, 'An Aperitif to Manet's "Déjeuner sur l'herbe"', *Gazette des Beaux-Arts*, 6th series, 91 (January 1978), pp. 32–4.

12. Fourreau, *Berthe Morisot*, pp. 16–19; Louis Rouart, 'Berthe Morisot', pp. 173–4; Angoulvent, *Berthe Morisot*, p. 9.

13. Tabarant, *La vie artistique*, pp. 255–60, for the 1859 Salon.

14. Louis Martinet began as an artist, studying with Baron Gros, before changing to an impresario in 1860. He went on to found a magazine, *Le Courrier Artistique*, and in 1862 he organized the Société Nationale

des Beaux-Arts with Gautier as president. After his exhibition of the Barbizon landscapes, he showed the works of Manet, Legros, Whistler, Jongkind and Bracquemond, but by 1870 he was in financial straits: Tabarant, *La vie artistique*, passim; Rewald, *History of Impressionism*, pp. 76–81, 84.

15. Fourreau, *Berthe Morisot*, p. 18.

16. Louis Rouart, 'Berthe Morisot', p. 174, cf. Fourreau, *Berthe Morisot*, pp. 18–19, implying it was Guichard who introduced the Morisots to Corot.

17. G. Bazin, *Corot* (Paris, Pierre Tisne, 2nd edn, n.d.), pp. 111–13 details the artist's movements; Fourreau, *Berthe Morisot*, p. 20; Duret, *Manet and the French Impressionists*, p. 182.

18. Fourreau, *Berthe Morisot*, pp. 20–1; Angoulvent, *Berthe Morisot*, p. 12.

19. Mongan, *Berthe Morisot, Drawings*, p. 48.

20. The critic, Thoré-Bürger, *Salons de Théophile Thoré* (Paris, 1868), p. 35 in Boime, *The Academy and French Painting*, p. 96.

21. *Morisot Correspondence*, pp. 14–15.

22. T.J. Clark, *The Painting of Modern Life: Paris in the Art of Manet and His Followers* (London, Thames & Hudson, 1985), pp. 32–3.

23. Pinkney, *Napoleon III*, pp. 62–3.

24. Fourreau, *Berthe Morisot*, p. 23; Angoulvent, *Berthe Morisot*, p. 13.

25. *Morisot Correspondence*, p. 15; W.E. Echard, *Historical Dictionary of the French Second Empire 1852–1870* (London, Aldwych Press, 1985), pp. 168–9 on Daubigny, pp. 169–71 on Daumier; Hemmings and Neiss, *Culture and Society*, pp. 82–8.

26. Duret, *Manet and the French Impressionists*, pp. 30–4; Tabarant, *Manet et ses Oeuvres* (Paris, Librairie Gallimard, 1947), pp. 60–74.

27. Fourreau, *Berthe Morisot*, pp. 20, 22–3; Huisman, *Enchantment*, p. 10.

28. The painting is in a private collection: see Plates. Higonnet, *Berthe Morisot*, facing p. 114, attributes it to 1865–8, Stuckey and Scott, *Berthe Morisot*, p. 22, to *c*. 1865, Bataille and Wildenstein, *Catalogue des peintures*, to 1863, but Monneret, *L'Impressionisme et Son Epoque*, Vol. 1, p. 696, refers to it as 'Berthe Morisot à vingt ans', so attributing the portrait to 1861.

29. See Appendix 3 for a discussion of the mystery surrounding the meeting of Berthe Morisot and Edouard Manet.

30. 'Lettres d'un Bourgeois de Paris' (Delacroix), *Gazette de France*, May 1863, in Tabarant, *La vie artistique*, p. 314.

31. *Morisot Correspondence*, May 1869, p. 31.

CHAPTER 5. EXPANDING CIRCLES

1. Fourreau, *Berthe Morisot*, p. 20.

2. For Millet, see Stanislas Lami, *Dictionnaire des sculpteurs de l'école français au dix-neuvième siècle* (4 vols, Paris, repr. 1970 [1914–21]), vol. 3, pp. 451–9; *Morisot Correspondence*, p. 16; Angoulvent, *Berthe Morisot*, p. 17.

3. Bellier de la Chavignerie and Auvray, *Dictionnaire Générale des Artistes*, Vol. 3, p. 183 for Oudinot's works.

4. *Morisot Correspondence*, pp. 16–17; Fourreau, *Berthe Morisot*, pp. 24, 27–8; Angoulvent, *Berthe Morisot*, pp. 18–19.

5. Fourreau, *Berthe Morisot*, pp. 24–5; Geneviève Viallefond, *Le Peintre Léon Riesener (1808–1878): Sa vie, son oeuvre avec des extraits d'un manuscrit inédit de l'artiste, de David à Berthe Morisot* (Paris, Edition Morancé, 1955), pp. 14, 16–17.

6. Fourreau, *Berthe Morisot*, p. 25.

7. Ibid., p. 27.

8. *Morisot Correspondence*, p. 16; Fourreau, *Berthe Morisot*, p. 27.

9. *Morisot Correspondence*, p. 17.

10. Ibid., pp. 18, 20.

11. Ibid., pp. 20–1.

12. Reff, 'Copyists in the Louvre', p. 553.

13. Viallefond, *Le Peintre Léon Riesener*, pp. 18, 29, 32, 39, 63 ff., 72, 93.

14. Stuckey and Scott, *Berthe Morisot*, pp. 21–3.

15. Fourreau, *Berthe Morisot*, pp. 27–8.

16. M. Castillon du Perron, *Princess Mathilde*, tr. M. McLean (London, Heinemann, 1956), pp. 185–6.

17. *Morisot Correspondence*, p. 21; Henri Perruchot, *Manet*, tr. H. Hare (London, Perpetua Books, 1962), p. 71. Mesdames Lejosne and Loubens are the two figures seated in the forefront, wearing cream cloaks and blue bonnets. Madame Loubens is on the left, Madame Lejosne is the veiled figure on the right.

18. Blanche, 'Les Dames de la grande rue', p. 18. Monsieur Carré was a judge of the Court of Appeal. See K. Adler, 'The Suburban, the Modern and "une Dame de

Passy"', *Oxford Art Journal*, 12, 1 (1989) pp. 3–13 for a discussion of Passy society.

19. Renoir, *Renoir, My Father*, p. 20. The artist's son also testified to the fact that Renoir 'avoided artistic and literary sets like the plague', ibid., p. 268.

20. Fourreau, *Berthe Morisot*, p. 29.

21. Angoulvent, *Berthe Morisot*, p. 15. For an outline of Pauline Viardot's career, Echard, *Historical Dictionary of the French Second Empire*, pp. 269–70, 687–9.

22. Stendhal, *Life of Rossini* (London, John Calder, repr. 1956), p. 408; Francis Toye, *Rossini: A Study in Tragi-Comedy* (London, Heinemann, 1934), passim; Herbert Weinstock, *Rossini: A Biography* (London, Oxford University Press, 1968).

23. Angoulvent, *Berthe Morisot*, p. 14.

24. *Morisot Correspondence*, p. 18.

25. Ibid., pp. 21, 24.

26. Her name was to be perpetuated in the Musée Jacquemart-André on the Boulevard Haussmann.

27. *Morisot Correspondence*, p. 30.

28. She was born Adelaïde Nathalie Marie Hedwige Philippine d'Affry. See Odette d'Alcantara, *Marcello, Adèle d'Affry, Duchesse Castiglione Calonna 1836–1879. Sa vie, son oeuvre, sa pensée et ses amis* (Geneva, 1961). The daughter of Comte Louis d'Affry and Lucie de Maillardoz, she belonged to one of the most celebrated families in Switzerland. Adèle's childhood alternated between long stays in Italy or the Midi and the family château near Fribourg. After her husband's death, she stayed at the Convent of the Trinità dei Monti in Rome, and allegedly it was the sight of the antique statues in the gardens of the Villa Medici nearby that stimulated her passion for sculpture. She founded the Musée Marcello in Fribourg, which contains examples of her work.

29. Ibid., p. 67.

30. The ambitions, frustrations and choices facing such women are cogently documented in Bashkirtseff's diaries; for a discussion of this issue, see Parker and Pollock, *Old Mistresses*, pp. 106–10.

31. Stuckey and Scott, *Berthe Morisot*, p. 178, n. 40.

32. *Morisot Correspondence*, p. 18; Fourreau, *Berthe Morisot*, p. 23; for the life of the artist, see Peter Mitchell, *Alfred-Emile Leopold Stevens, 1823–1906* (London, John Mitchell, 1973). Stevens was a friend of many in high society, including Princess Mathilde, Rossini

and Sarah Bernhardt. As the granddaughter of General Sausset, Madame Stevens (Marie Blanc) came from the upper bourgeoisie.

33. Jacques-Emile Blanche, *Portraits of a Lifetime 1870–1914*, tr. W. Clement (London, Dent, 1937), passim.

34. Theodore Zeldin, *France 1848–1945* (2 vols, Oxford, Clarendon Press, 1973–77), Vol. 1, p. 615.

35. *Morisot Correspondence*, pp. 17–18; Zeldin, *France*, vol. 1, p. 625.

36. *Morisot Correspondence*, p. 17.

37. Ibid., p. 19; Rewald, *History of Impressionism*, p. 125.

38. Fourreau, *Berthe Morisot*, p. 30; Angoulvent, *Berthe Morisot*, pp. 19–20.

39. Jules Clarétie, *L'Artiste*, June 1865, in Jacques Lethève, *Impressionistes et Symbolistes devant la Presse* (Paris, Armand Colin, 1959), p. 33; Paul Mantz, 'Salon de 1865: IV', *Gazette des Beaux-Arts*, 19, 1 July 1865, in ibid., p. 30.

40. F. Fénéon, 'Souvenirs sur Manet', *Bulletin de la Vie Artistique*, 15 October 1920, p. 609.

41. Stuckey and Scott, *Berthe Morisot*, p. 22.

42. Fourreau, *Berthe Morisot*, pp. 30–1.

43. Bashkirtseff, *Journal of Marie Bashkirtseff*, p. 347. Although the words were those of the Russian artist, not Berthe Morisot, they aptly expressed the dilemma of both women.

44. A. Silvestre, *Au pays des souvenirs*, 1892, p. 179, in McMullen, *Degas*, p. 154.

CHAPTER 6. MARRIAGE STAKES

1. Julie Manet, *Journal*, 16 August 1895, p. 59.

2. Edouard Manet produced four versions of the subject of Maximilian's execution but they were considered too politically sensitive to exhibit at the 1867 Salon.

3. Julie Manet, *Journal*, 23 August 1895, p. 61.

4. *Morisot Correspondence*, p. 22.

5. This painting, now in the National Gallery of Art, Washington, DC, has become a focus of academic debate. Matthew Rohn, 'Berthe Morisot's *Two Sisters on a Couch*', *Berkshire Review* (Fall 1986), pp. 80–90, and John T. Paoletti's 'Comments on Rohn', ibid., pp. 91–4, attempted a psychoanalytical interpretation, suggesting that Berthe was undergoing a crisis of identity and

confidence at the time. Higonnet discusses it with gusto in *Berthe Morisot's Images of Women* (Cambridge, Mass., Harvard University Press, 1992), pp. 142–245. In Stuckey and Scott, *Berthe Morisot*, pp. 31–3, Charles F. Stuckey questions the models' identity and the circumstances under which the work was completed, and raises the question of whether they were twins. Bataille and Wildenstein, *Catalogue des peintures*, p. 24, confirm that the models were the Delaroches, who, according to the *Morisot Correspondence*, lived in Passy and were middle-class acquaintances of Berthe's family. They had brothers of military age, on whom they were fondly dependent. The Morisot women, who were in the habit of referring to people in overtly physical terms – fat, tall, small – described the pair as 'petite', implying they were shorter than average, and the painting indicates they were short-waisted and small-boned. In the event, Berthe had great difficulty in motivating herself to complete the picture because her loneliness had induced depression. In addition, the Delaroches were possibly difficult models: many people find the business of posing a considerable physical strain. So the portrait may not have been completed in 1869 but put aside for an indefinite period until Berthe found the heart to finish it.

6. *Morisot Correspondence*, p. 21.

7. Ibid., pp. 21, 23.

8. Ibid., p. 22.

9. Julie Manet, *Journal*, 3 December 1895, p. 74; cf. *Morisot Correspondence*, p. 20, which states Yves became engaged only in 1867.

10. Bricard, *Saintes ou Pouliches*, Pt II, 'La Débutante', pp. 179–319.

11. *Morisot Correspondence*, p. 24.

12. Ibid., p. 18.

13. Ibid., p. 21; Chapman, *Baron Haussmann*, pp. 133–4, 225 ff.; Pinkney, *Napoleon III*, pp. 198–201.

14. *Morisot Correspondence*, p. 23.

15. Ibid., p. 21.

16. Julie Manet, *Journal*, 11 October 1897, p. 135.

17. Richard J. Wattenmaker, *Puvis de Chavannes and the Modern Tradition* (Toronto, Art Gallery of Ontario, 1975).

18. *Morisot Correspondence*, p. 35; Rodin was greatly impressed by his aristocratic bearing: F.V. Grunfeld, *Rodin. A Biography* (London, Hutchinson, 1987), pp. 300–1.

19. *Morisot Correspondence*, pp. 31–2.

20. In 1861 there were 104 dealers operating in Paris: Zeldin, *France*, vol. II, p. 464; see Albert Boime on dealers and entrepreneurs in Edward C. Carter II, Robert Forster and Joseph N. Moody (eds), *Enterprise and Entrepreneurs in Nineteenth- and Twentieth-Century France* (Baltimore, MD and London, Johns Hopkins University Press, 1976).

21. *Morisot Correspondence*, pp. 22–3.

22. See Plates.

23. For the Salon of 1867, Tabarant, *La vie artistique*, pp. 400–16; Manet's exhibition, Duret, *Manet and the French Impressionists*, pp. 45–56; Tabarant, *Manet et ses Oeuvres*, pp. 135–7; *Morisot Correspondence*, p. 21; on the reaction of the press and public, Denis Rouart, *Manet*, tr. Marion Shapiro (London, Oldbourne Press, 1960), p. 51.

24. Chapman, *Baron Haussmann*, chap. 11, pp. 199–212; F.A. Trapp, '"Expo" 1867 Revisited', *Apollo*, 89, February 1969.

25. cf. Patricia Mainardi, 'Edouard Manet's "View of the Universal Exposition of 1867"', *Arts Magazine*, 54, 5, January 1980, pp. 108–15.

26. Julie Manet, *Journal*, 4 September 1895, p. 64.

27. *Morisot Correspondence*, pp. 34–5.

28. Ibid.

29. Ibid., pp. 33, 37.

30. Ibid., p. 32.

31. Renoir, *Renoir, My Father*, p. 109.

32. *Morisot Correspondence*, p. 30.

33. Ibid., pp. 31–4, 39.

34. Ibid., pp. 35, 39; Degas's personality and attitudes to both sexes have been much analysed, e.g. McMullen, *Degas*, pp. 262–83; Norma Broude, 'Degas's "Misogyny"', *Art Bulletin*, 159, March 1977, pp. 95–107; Théodore Reff, *Degas: The Artist's Mind* (New York, Metropolitan Museum of Art/Harper & Row, 1976); B. Nicolson, 'Degas as a Human Being', *Burlington Magazine*, 105 (June 1963), p. 239.

35. *Morisot Correspondence*, p. 35; Reff, *Degas: The Artist's Mind*, pp. 156–7.

36. F.A. Sweet, *Miss Mary Cassatt, Impressionist from Pennsylvania* (Norman, OK, University of Oklahoma Press, 1967), p. 18.

37. McMullen, *Degas*, p. 262.

38. *Morisot Correspondence*, p. 31.

39. Ibid., p. 117.

40. Ibid., pp. 27–8.

CHAPTER 7. ECHOES OF BAUDELAIRE

1. Perruchot, *Manet*, p. 72.

2. Pierre Schneider, *The World of Manet 1832–1883*, 4th Eng. edn (London, Time Life Books, 1978), p. 64.

3. Baudelaire, *Oeuvres Complètes*, 'Journaux Intimes, Hygiène, I', p. 1265: '*Maintenant, j'ai toujours le vertige, et aujourd'hui, 23 janvier 1862, j'ai subi un singulier avertissement, j'ai senti passer sur moi le vent de l'aîle de l'imbécillité.*' Ironically, 23 January was the thirtieth birthday of his friend, Edouard Manet.

4. *Morisot Correspondence*, p. 36.

5. Amy M. Fine, 'Portrait of Berthe Morisot; Manet's Modern Images of Melancholy', *Gazette des Beaux-Arts*, 6th series, 110 (1987), p. 17; also cites Paul Charpentier, *Une Malade Morale*, *Le Mal du Siècle* (1880).

6. *Morisot Correspondence*, p. 33.

7. Ibid., pp. 20, 36; Karen Petersen and J.J. Wilson, *Women Artists: Recognition and Reappraisal from the Early Middle Ages to the Twentieth Century* (New York, Harper & Row, 1976, repr. London, 1978), p. 92, suggest Berthe's listlessness was akin to artist's block, a classic condition known as 'accidie', or Chaucer's 'sin of sloth'.

8. *Morisot Correspondence*, pp. 29, 33, 38–40.

9. Ibid., p. 35.

10. Ibid., p. 38.

11. Ibid., p. 32.

12. Ibid., p. 38.

13. The two women also shared Orléanist sentiments: Prefect Morisot's career was cut short because of his Orléanist affiliations, while Madame Manet's brother, Edmond Fournier, had resigned his commission out of loyalty to the house of Orléans and dislike of the Bonapartist regime.

14. Courthion and Cailler, *Portrait of Manet*, 'Memories of Antonin Proust', p. 38.

15. e.g. *Morisot Correspondence*, pp. 25–6; Higonnet, *Berthe Morisot*, p. 44; Monneret, *L'Impressionisme et Son Epoque*, vol. 1, p. 596; F.W.J. Hemmings, *Baudelaire the Damned: a biography* (London, Hamish Hamilton, 1982), p. 215. The evidence is confused. If Berthe Morisot met Baudelaire at the Manets', it must have been before the poet went to Belgium where he lived for most of 1864–5, for he was a very sick man when he was admitted to a Paris nursing home in February 1866. Hemmings asserts that during Baudelaire's last illness, 'one of his principal delights was when . . . Berthe Morisot found time to come and play his favourite airs from Wagner on the piano', but there seems to be no corroboration and he may have been confusing her with Mme Paul Meurice.

16. Baudelaire, *Oeuvres Complètes*, 'Salon de 1846', pp. 949–50, 952; G. Poulet, *Who Was Baudelaire?*, tr. Robert Allen and James Emmons (Geneva, Albert Skira, 1969), p. 100.

17. Mitchell, *Stevens*, p. 17.

18. Courthion and Cailler, *Portrait of Manet*, p. 17, Manet to Fantin-Latour, Boulogne-sur-Mer, 26 August 1868.

19. Perruchot, *Manet*, pp. 164–5; *Morisot Correspondence*, p. 29.

20. See Plates.

21. Perruchot, *Manet*, p. 164; Pierre Daix, *La Vie du peintre d'Edouard Manet* (Paris, Fayard, 1983), p. 191.

22. Baudelaire, *Oeuvres Complètes*, pp. 34–5; Hemmings, *Baudelaire*, p. 138.

23. Tabarant, *Manet*, p. 157; Perruchot, *Manet*, p. 165; Daix, *Manet*, p. 191; see front jacket.

24. Perruchot, *Manet*, pp. 166–7.

25. *Morisot Correspondence*, p. 38.

26. Reff, *Degas: The Artist's Mind*, pp. 156–7; Marc Gerstein, 'Degas's Fans', *Art Bulletin*, 64 (March 1982), pp. 105 ff.

27. Angoulvent, *Berthe Morisot*, p. 33.

28. Ibid., p. 30; *Morisot Correspondence*, pp. 30–1; Daix, *Manet*, p. 198.

29. Tabarant, *Manet*, p. 161; Daix, *Manet*, p. 199.

30. Angoulvent, *Berthe Morisot*, p. 31; *Morisot Correspondence*, p. 31; Daix, *Manet*, p. 198; Anne Coffin Hanson, *Edouard Manet 1832–1883*, exhibition catalogue (Philadelphia Museum of Art, 1966), p. 121.

31. *Morisot Correspondence*, p. 32; Angoulvent, *Berthe Morisot*, p. 32.

32. Ibid., pp. 36, 37, 39.

33. Ibid., p. 37.

34. Ibid., p. 39.

35. Ibid.; Perruchot, *Manet*, p. 171.

36. *Morisot Correspondence*, p. 40.

37. Tabarant, *Manet et ses Oeuvres*, pp. 168–9; Hanson, *Edouard Manet*, p. 123; Bernice Davidson, '"Le Repos": A Portrait of Berthe Morisot by Manet', *Rhode Island School of Design Bulletin*, 46 (December 1959).

38. Fine, 'Portraits of Morisot', p. 17, on Théodore de Banville's remarks; Duret, *Manet and the French Impressionists*, p. 78.
39. See Plates. Manet's *Repose* is in the Rhode Island School of Design in Providence, Rhode Island, USA; his *Portrait of Jeanne Duval* is in the Szepmuveszeti Muzeum, Budapest, Hungary. Bearing in mind the Baudelairean symbiosis of melancholy and modernity, *Repose* has a more obvious affinity in terms of inspiration, and indeed of composition, with Jeanne Duval's portrait than with Eva Gonzalès's; cf. Fine, 'Portraits of Morisot', p. 18.
40. *Morisot Correspondence*, p. 41.
41. Ibid., p. 42.
42. Ibid., p. 43; Angoulvent, *Berthe Morisot*, p. 36.
43. *Morisot Correspondence*, p. 43.
44. Ibid., p. 44.
45. Ibid.
46. For the controversy over this painting, see Tabarant, *Manet*, pp. 180–1; Julie Manet, *Journal*, 29 March 1898, p. 160.
47. Alcantara, *Marcello, Adèle d'Affry*, p. 175.

CHAPTER 8. THE TERRIBLE YEAR

There are many eye-witness accounts of the events of 1870–1 in print. In addition to *The Correspondence of Berthe Morisot with her family and friends*, *The Times* newspaper, *Journal Officiel*, Robert Henrey (ed.), *Letters from Paris 1870–1875*, written by C. de B., a political informant, to the head of the London house of Rothschild (London, Dent, 1942); Joanna Richardson *Paris under Siege: A Journal of the Events of 1870–1871 Kept by Contemporaries*, (ed. and tr.) (London, the Folio Society, 1982); Rev. W. Gibson, *Paris during the Commune* (New York, Haskell House Publishers, 1974); E. and J. de Goncourt, *Journal, Mémoires de la vie littéraire 1864–1878* (4 vols, Paris, Fasquelle and Flammarion, 1956); Robert Baldick, *The Siege of Paris* (London, Batsford, 1964); and E.B. Washburne, *Recollections of a Minister to France 1867–1877* (2 vols, New York, Charles Scribner's Sons, 1887) were all useful for this and the following chapter.

1. *Morisot Correspondence*, p. 71; Alcantara, *Marcello, Adèle d'Affry*, pp. 87–9; Tabarant, *Manet et ses Oeuvres*, p. 163.

2. Henrey, *Letters from Paris*, Marquis de Pire to Thiers, 15 July 1870, p. 25.
3. J.P.T. Bury, *France 1814–1940* (London, Methuen, University Paperbacks, 1969), p. 113; Theodore Zeldin, *Emile Ollivier and the Liberal Empire of Napoleon III* (Oxford, Clarendon Press, 1963), p. 186.
4. *Morisot Correspondence*, p. 51.
5. *The Times*, 26 July 1870.
6. *Morisot Correspondence*, p. 57.
7. *The Times*, 22 July, 26 July, 16 August, 19 August 1870; the reports continued intermittently until 1 October, when the paper reported the withdrawal of the blockade; Michael Howard, *The Franco-Prussian War* (London and New York, Methuen University Paperbacks, repr. 1985 [1961]), pp. 74–6.
8. *Morisot Correspondence*, p. 51.
9. Richardson, *Paris under Siege*, Mrs Griffin, 8 September 1870, pp. 18–19.
10. McMullen, *Degas*, pp. 186–7; *Morisot Correspondence*, p. 48; on atrocities, *The Times*, 8 October 1870.
11. *Morisot Correspondence*, p. 48.
12. Ibid., pp. 46, 51.
13. Mina Curtiss (ed. and tr.) 'Letters of Edouard Manet to his Wife during the Siege of Paris, 1870–71', *Apollo*, 113 (June 1981), 13 September (3), p. 380; n.d. (13), p. 382; 7 November (20), p. 384; *Morisot Correspondence*, p. 48; McMullen, *Degas*, pp. 186–7.
14. Tabarant, *Manet*, pp. 182–3; *Morisot Correspondence*, p. 46; Manet also complained that his empty home was 'sad': Curtiss, 'Letters of Edouard Manet', 15 September 1870 (4), p. 380.
15. *Morisot Correspondence*, p. 47.
16. Ibid., p. 46.
17. Goncourt, *Journal*, vol. 2, p. 109.
18. Richardson, *Paris under Siege*, anon. chronicler, 19 September 1870, p. 37.
19. *Morisot Correspondence*, pp. 45, 47.
20. Alistair Horne, *The Fall of Paris: The Siege and the Commune 1870–71* (Harmondsworth, Mx, Penguin Books, 1981), pp. 158–73; Baldick, *Siege of Paris*, pp. 51–2, 111–13; Richardson, *Paris under Siege*, p. 48; Curtiss, 'Letters of Edouard Manet', 23 November 1870 (24), p. 384.
21. *Morisot Correspondence*, p. 46; Curtiss, 'Letters of Edouard Manet', 5 October (12), p. 382; 16 October (15), p. 382; 19 November 1870 (23), p. 384; 1 January 1871 (35), p. 386.

22. Washburne, *Recollections*, 19 October 1870, vol. 1, p. 197; despite the war, twenty-three daily papers were still being published in Paris: ibid.

23. Curtiss, 'Letters of Edouard Manet', 16 October (15), p. 382; Richardson, *Paris under Siege*, Henry Labouchère, Paris correspondent of the *Daily News*, 25 September, 7 October 1870, pp. 52 ff.; Goncourt, *Journal*, 22 September, vol. 2, p. 613.

24. *Morisot Correspondence*, p. 48.

25. McMullen, *Degas*, p. 191.

26. *Morisot Correspondence*, p. 49.

27. Ibid.; Henrey, *Letters from Paris*, p. 107.

28. Richardson, *Paris under Siege*, Théophile Gautier to Carlotta Grisi, 31 October 1870, pp. 77–8; *The Times*, 27 October; *Morisot Correspondence*, p. 53; Howard, *The Franco-Prussian War*, chap. 7, pp. 257–83.

29. Baldick, *The Siege of Paris*, pp. 128–31, 186–8, 190, 204–5, 222; Horne, *The Fall of Paris*, pp. 220–31; Richardson, *Paris under Siege*, Henry Labouchère, 5 December, pp. 94–5; Goncourt, *Journal*, 6 and 8 December, Vol. 2, pp. 690–1.

30. *Morisot Correspondence*, p. 49; in her wartime journal, Juliette Adam, the wife of the Prefect of Police, likened the symptoms to a feeling that all the centipedes in the world were crawling over the brain.

31. Curtiss, 'Letters of Edouard Manet', 16 January 1871 (41), 17 January (42), p. 388; 30 January (46), p. 389.

32. *Morisot Correspondence*, p. 49; Washburne, *Recollections*, vol. 1, p. 286, echoed these sentiments: 'What a New Year's day! . . . with sadness I welcome the new year 1871.'

33. Ibid., p. 321; Horne, *The Fall of Paris*, p. 272.

34. Baldick, *The Siege of Paris*, p. 209; Horne, *The Fall of Paris*, pp. 274–5; the sang-froid of the Parisians, as shown by Madame Morisot, was widely observed: Henrey, *Letters from Paris*, p. 115; Richardson, *Paris under Siege*, pp. 108–9; *Morisot Correspondence*, p. 49.

35. Ibid., p. 50.

36. Goncourt, *Journal*, 21 January 1871, vol. 2, p. 723.

37. Ibid., 27 January 1871, vol. 2, p. 730.

38. *Morisot Correspondence*, p. 51.

39. Ibid., pp. 50–1.

40. Ibid.

41. Ibid., pp. 51, 52, 54.

42. Ibid., p. 51.

43. Ibid., p. 52.

44. Ibid., p. 53. The victim was a plain-clothes policeman, Sous-Brigadier Vincenzoni, whom the crowd caught allegedly spying on them in the Place de la Bastille. After a summary 'trial', he was bound, thrown into the Seine, pelted with stones and submerged with boat-hooks until finally he drowned. Watching soldiers failed to intervene, indicating the growing lawlessness in Paris. Horne, *The Fall of Paris*, p. 324; Robert Tombs, *The War against Paris 1871* (Cambridge, Cambridge University Press, 1981), p. 27.

45. *Morisot Correspondence*, p. 52; Goncourt, *Journal*, Vol. 2, pp. 740–2.

46. Ibid., p. 53.

47. Ibid., p. 54.

CHAPTER 9. CRISIS AND AFTERMATH

1. *Morisot Correspondence*, pp. 54, 57.

2. Ibid., p. 54; a similar opinion was expressed by C. de B., the political informant to the Rothschilds: Henrey, *Letters from Paris*, p. 126.

3. Ibid. Belleville and Ménilmontant, as working-class districts of Paris, were seats of radical Republicanism: Henrey, *Letters from Paris*, p. 129; *Morisot Correspondence*, p. 54.

4. Henrey, *Letters from Paris*, pp. 133–4; Horne, *The Fall of Paris*, pp. 322–41.

5. Goncourt, *Journal*, 18 March 1871, vol. 2, pp. 745–6.

6. Ibid., 19 March, vol. 2, pp. 747–8; *Morisot Correspondence*, p. 54.

7. Washburne, *Recollections*, Tuesday 21 March, vol. 2, p. 44.

8. *Morisot Correspondence*, p. 56.

9. Ibid., pp. 56–7. Also for the events of 21–2 March 1871, Washburne, *Recollections*, vol. 2, pp. 44–50; Gibson, *Paris during the Commune*, pp. 121–6, 164.

10. *Morisot Correspondence*, p. 55.

11. Washburne, *Recollections*, vol. 2, pp. 56 ff.; Gibson, *Paris during the Commune*, p. 154.

12. For an account of life in 'Paris under the Red Flag', Gibson, *Paris during the Commune*, pp. 141 ff.

13. *Morisot Correspondence*, p. 57; Horne, *The Fall of Paris*, pp. 387–8.

14. Ibid., p. 388.

15. *Morisot Correspondence*, pp. 58, 60–1.

16. Ibid., p. 58; Gibson, *Paris during the Commune*, pp. 241–2; Washburne, *Recollections*, vol. 2, pp. 121–2.

17. *Morisot Correspondence*, p. 60; Washburne, *Recollections*, vol. 2, 21 May, pp. 148–50.

18. *Morisot Correspondence*, pp. 61–2.

19. Ibid., pp. 62–3; Horne, *The Fall of Paris*, pp. 437 ff.

20. *Morisot Correspondence*, p. 63; Washburne, *Recollections*, vol. 2, 24–5 May, pp. 151–6; Horne, *The Fall of Paris*, pp. 459, 464–7; Richardson, *Paris under Siege*, pp. 187–9.

21. An estimated 10,000–25,000 prisoners were shot in cold blood by the Versaillese army: see Tombs, *The War against Paris*, p. 191.

22. Huisman, *Enchantment*, p. 64.

23. Richardson, *Paris under Siege*, Marie Colombiers, p. 189.

24. For personal information about the Bracquemonds, Elizabeth Kane, 'Marie Bracquemond: The Artist Time Forgot', *Apollo*, 117 (February 1983), p. 121; Goncourt, *Journal*, 24 January 1871, vol. 2, p. 726; and on Pierre and Fanny Prins (Claus), see D. Wildenstein, *Pierre Prins 1855–1913*, exhibition catalogue, 5–20 June 1975, London, Wildenstein, 1975.

25. Richardson, *Paris under Siege*, A. Daudet, 6 February 1871, p. 128; Curtiss, 'Letters to Edouard Manet', 23 October 1870, p. 383.

26. *Morisot Correspondence*, p. 51.

27. James Laver, *Whistler* (London, White Lion Publishers, repr. 1976 [1930]) p. 108; *Morisot Correspondence*, p. 68.

28. Curtiss, 'Letters of Edouard Manet', 30 September (10), 2 December (28), 7 December 1870 (29), 11 February 1871, pp. 381–2, 385, 389; *Morisot Correspondence*, p. 64.

29. Philip Nord, 'Manet and Radical Politics', *Journal of Interdisciplinary History*, 3 (Winter 1989), pp. 447–8, 450, 459–60; *Morisot Correspondence*, pp. 63, 68.

30. Ibid., p. 58.

31. Washburne, *Recollections*, vol. 2, pp. 89, 119, 207–8; Hemmings and Neiss, *Culture and Society*, pp. 188–94.

32. *Morisot Correspondence*, p. 63.

33. Goncourt, *Journal*, 27 September, 16 October 1870, vol. 2, pp. 619, 640.

34. Richardson, *Paris under Siege*, T. Gautier, *Le Journal Officiel*, 20 September 1870, p. 42.

35. *Morisot Correspondence*, p. 46.

36. Fourreau, *Berthe Morisot*, p. 37.

37. *Morisot Correspondence*, p. 57.

38. Ibid., p. 66.

39. McMillan, *Housewife or Harlot*, pp. 12–13; Zeldin, *France*, vol. 2, pp. 669–71. According to the *Gazette des Femmes*, the number of women artists was reckoned to be 2,150 in 1879 and 3,000 by 1883: Higonnet, *Berthe Morisot*, p. 99.

CHAPTER 10. 'STEER HER SHIP WISELY'

1. *Morisot Correspondence*, 22 June 1871, p. 66.

2. Ibid., p. 71.

3. Ibid., p. 72.

4. Ibid., p. 71.

5. Ibid., p. 72.

6. Janine Bailly-Herzberg, 'Les Estampes de Berthe Morisot', *Gazette des Beaux-Arts*, 6th series, 93 (May–June 1979), p. 217.

7. Perruchot, *Manet*, p. 187; *Morisot Correspondence*, p. 72.

8. Ibid., pp. 72–3.

9. Greer, *The Obstacle Race*, p. 68.

10. Ibid., p. 327.

11. *Morisot Correspondence*, pp. 58–60.

12. Ibid., p. 68.

13. Ibid., pp. 67, 69.

14. Aimée Brown Price, 'Puvis de Chavanne's Caricatures: Manifestoes, Commentary, Expressions', *Art Bulletin*, 73, 1 (March 1991), pp. 137–9; John Storm, *The Valadon Story* (London, Longman, 1958), pp. 58–9.

15. Brown Price, 'Puvis de Chavannes', p. 137, quotes from the French edition of *Morisot Correspondence*, p. 63: 'All the trouble comes from the antipathy I sow in my path as others sow flowers, for that there is no remedy.'

16. *Morisot Correspondence*, p. 68.

17. Ibid., p. 67.

18. Ibid., pp. 68–9. That Puvis was serious in his intentions can be construed from his words: 'You end your letter with a question, which you could easily answer yourself if you stopped to think a little. Among many proofs I shall offer only this one that shows my perfect docility; for without losing a day, I went to see your parents . . .'

19. Ibid., p. 69.

20. Ibid.

21. Ibid.

22. Puvis de Chavannes was the foremost mural painter of the nineteenth century, who carried out grand commissions on both sides of the Atlantic. His work decorates many public buildings in France, including the Panthéon, the Sorbonne and the Hôtel de Ville; and the public library in Boston, Massachusetts. His personal life was somewhat strange. He met Princess Marie Cantacuzène in 1856 in the studio of Théodore Chassérieu, whose allegorical scenes of Peace and War had decorated Monsieur Morisot's workplace, the Cour des Comptes, until May 1871. Puvis and the princess continued their apparently platonic relationship for forty years. However, his celibate lifestyle changed dramatically in 1882 when he was fifty-seven: the tempestuous seventeen-year-old artist Suzanne Valadon became his model and his mistress. In 1883 she gave birth to an illegitimate son, the future painter, Maurice Utrillo. Joking about the child's paternity, she implied mischievously that the father could have been either Puvis or Renoir, for whom she also modelled. Finally, in 1896, at the age of seventy-two Puvis de Chavannes married his loyal confidante, Marie Cantacuzène, dying two months after her in 1898: Storm, *The Valadon Story*.

23. *Morisot Correspondence*, p. 70.

24. Ibid., p. 71; Daix, *Manet*, p. 225.

25. The widespread appeal of *The Cradle* is due to both its universal theme and its familiarity through commercial reproduction. It hangs in the Musée d'Orsay, Paris.

26. Manet had already painted an indoor domestic scene in the spring of 1871, entitled *Interior at Arachon*, figuring Suzanne Manet and Léon Koella: Tabarant, *Manet*, p. 189; Stuckey and Scott, *Berthe Morisot*, pp. 45, 48; Rey, *Berthe Morisot*, pp. 16, 21, who uses Morisot's *Interior* on the front cover of his monograph.

27. Stuckey and Scott, *Berthe Morisot*, pp. 49, 180, n. 115. However, among the critics, Jules Castagnary and Jules Clarétie dismissed the 1872 Salon as very disappointing and lacking talent: Paul Tucker, 'The First Impressionist Exhibition and Monet's Impressionism: Sunrise: a Tale of Timing, Commerce and Patriotism', *Art History*, 7, 4, December 1984, pp. 466–7.

28. *Morisot Correspondence*, p. 69.

29. Ibid., p. 66; Perruchot, *Manet*, p. 191.

30. *Morisot Correspondence*, p. 71; Stuckey and Scott, *Berthe Morisot*, pp. 41, 44, n. 4.

31. *Morisot Correspondence*, p. 75.

32. Ibid., p. 76. Curiously, Berthe speaks of Théodore returning with the children, yet there is no other evidence that the Gobillards had more than one child, Paule, at this stage.

33. *Morisot Correspondence*, p. 77.

34. Tabarant, *Manet*, pp. 195–6; Perruchot, *Manet*, pp. 187–8; *Morisot Correspondence*, p. 77.

35. Stuckey and Scott, *Berthe Morisot*, p. 50.

36. Perruchot, *Manet*, p. 198, citing Thadée Natanson.

37. Ibid., p. 191; Tabarant, *Manet*, pp. 198–9; Daix, *Manet*, pp. 228–9; *Morisot Correspondence*, p. 77.

38. Valéry, 'Triomphe de Manet', 'Pièces sur l'Art', in *Oeuvres*, vol. 2, pp. 1332–3; Manet also made a drawing and an etching of the portrait, which emphasized Berthe's gloomy, melancholy image: Duret, *Manet and the French Impressionists*, p. 49; Amy M. Fine, 'Portraits of Berthe Morisot', p. 19; Tabarant, *Manet*, p. 200.

39. Julie Manet, *Journal*, 3 December 1895, pp. 74–5.

40. Courthion and Cailler, *Portrait of Manet*, Baudelaire to Carjat, 6 October 1863, p. 48. It seems that Suzanne Manet may have had a miscarriage in the summer of 1871, following her post-war reconciliation with her husband: *Morisot Correspondence*, p. 71.

41. In 1852 Suzanne Leenhoff had a son, registered as Léon Edouard Koella, who was treated publicly as Suzanne's younger brother and for many years was known by her surname, Leenhoff. Rumours at the time suggested Edouard Manet was the father, and that the child was born after an affair between the twenty-year-old art student and his 22-year-old music teacher, but against that, his marriage to Suzanne in 1863 surprised most of Manet's friends, who certainly did not regard it as a love match. Their marriage had allegedly been opposed by Judge Manet on social grounds and took place only after the judge's death in 1862. Much later, however, a distinguished relation by marriage revealed that Judge Auguste Manet was Léon's true father. Family solidarity succeeded in suppressing the truth to prevent a double scandal of Judge Manet's adultery and Edouard's relationship with his

half-brother's mother. Edouard Manet's
marriage to Suzanne was a form of insurance
against the truth ever breaking. It seems to
have been approved by Madame Manet, the
artist's mother. But his illegitimate origins
troubled Léon Koella-Leenhoff even into the
twentieth century: little wonder that the
whole family was sworn to secrecy fifty years
earlier. Curtiss, 'Letters of Edouard Manet',
p. 379.
42. Julie Manet, *Journal*, 3 December 1895,
pp. 74–5.
43. Curtiss, 'Letters of Edouard Manet',
p. 382; Tabarant, *Manet*, p. 200.
44. *Morisot Correspondence*, p. 78.

CHAPTER 11. TURNING POINTS

For artistic developments in the years
1873–86 covered in this chapter and in
Chapters 13–17, see Lionello Venturi, *Les
Archives de l'Impressionisme: Lettres de Renoir,
Monet, Pissarro, Sisley et Autres. Mémoires de
Paul Durand-Ruel. Documents* (2 vols, Paris,
Durand-Ruel, 1939), Rewald, *The History of
Impressionism*, and Charles S. Moffett (ed.) *et
al.*, *The New Painting: Impressionism
1874–1886* (Oxford, Phaidon Press, 1986).
Lethève, *Impressionistes et Symbolistes* is a
useful source of press opinion. Of the many
social and political histories of the period,
Magraw, *France 1815–1914: The Bourgeois
Century*, Part IV, chap. 6, pp. 209–54, Sanford
Elwitt, *The Making of the Third Republic: Class
and Politics in France, 1868–1884* (Baton
Rouge, Louisiana State University Press,
1975) and Cobban, *A History of Modern
France*, proved helpful, in addition to the
regular reports of social and political events
in *The Times*.

1. *The Times*, 31 December, review of the
year 1872; 12 March 1873.
2. Marie Hubbard was originally a friend
of Cornélie Morisot but she became close to
Berthe after Yves and Edma left home, partly
as a result of their shared interest in
drawing. She was the daughter of Achille
Guillard, a chemist, statistician and inventor
of the word 'demography', as well as being
related by marriage to the Bertillons, also
eminent statisticians. Marie Guillard married
Nicholas-Gustave Hubbard (1828–88), a
journalist and historian who entered the

political world, becoming Treasurer
(*questeur*) to the Chamber of Deputies and
chef du cabinet to Gambetta's ministry (1879).
Their son Gustave Adolphe Hubbard
(1858–1927) was deputy for Seine-et-Oise.
The portrait of Marie Hubbard is now in the
Ordrupgaadsamlingen, Copenhagen.
3. *The Times*, 22 April 1873.
4. Stuckey and Scott, *Berthe Morisot*, pp. 50,
54; *The Times*, 25 March 1873.
5. *The Times*, 16 April 1873.
6. The model could not have been
Blanche Pontillon, who was only a baby in
1872.
7. Tabarant, *Manet et ses Oeuvres*, p. 206.
8. G.H. Hamilton, *Manet and his Critics*
(New Haven, Conn., Yale University Press,
repr. 1986 [1954]), pp. 163–5; Tabarant,
Manet et ses Oeuvres, pp. 208–9.
9. Duret, *Manet and the French
Impressionists*, pp. 78–9. After Manet's death,
Berthe recorded in her private notebook:
'Edouard often said that beauty could not be
rendered in painting'; *Carnet vert, c.* 1885, in
Angoulvent, *Berthe Morisot*, p. 75.
10. *The Times*, 24 March 1873; 1 July 1873,
the correspondent observed that 'the
incessant obtrusion of politics into the social
existence of France constitutes one of its
misfortunes'.
11. Stephen F. Eisenman, 'The Intransigent
Artist or How the Impressionists Got Their
Name', in Moffett, *The New Painting*, pp. 52–3;
Tabarant, *Manet et ses Oeuvres*, pp. 208–9.
12. Bury, *France*, pp. 70, 118; Cobban,
History of Modern France, vol. 2, pp. 112–14,
168–9; and for the interaction at this critical
juncture of the 1870s, Tucker, 'The First
Impressionist Exhibition', p. 466.
13. *Morisot Correspondence*, p. 78.
14. Duret to Pissarro, 6 December 1873, in
Rewald, *History of Impressionism*, p. 294;
Duret, *Manet and the French Impressionists*,
p. 141.
15. Fourreau, *Berthe Morisot*, p. 39.
16. Venturi, *Archives de l'Impressionisme*, vol.
1, pp. 34, 37; *The Times*, 20 October,
29 October, 30 October 1873; for the shock
to opera lovers caused by the fire, McMullen,
Degas, p. 240.
17. Rewald, *History of Impressionism*, chap.
IX, pp. 309 ff.; Venturi, *Archives de
l'Impressionisme*, vol. 1, pp. 36–7; vol. 2,
pp. 199–200, 255–6; Duret, *Manet and the
French Impressionists*, pp. 124–6; Tucker, 'The
First Impressionist Exhibition in Context', in

Moffett, *The New Painting*, pp. 93–117; Stuckey and Scott, *Berthe Morisot*, p. 54.

18. This portrait by Manet was deemed by Julie Manet, Mallarmé and Degas to be the truest likeness of the artist and after Edouard's death it remained in the Morisot–Rouart collection. It was also chosen for the frontispiece of the catalogue for her first retrospective in 1896: Higonnet, *Berthe Morisot*, pp. 107–8.

19. Madame Morisot must have made public Manet's hostility to Berthe's participation: *Morisot Correspondence*, p. 80.

20. McMullen, *Degas*, p. 245.

21. It was reported in the *Chronique des Arts* and in *L'Opinion Nationale*; Duret to Pissarro, 15 February 1874, in Rewald, *History of Impressionism*, p. 310.

22. *Morisot Correspondence*, p. 84.

23. Blanche, 'Les Dames de la grande rue', p. 21.

24. This unpublished letter is referred to in Stuckey and Scott, *Berthe Morisot*, p. 54.

25. There may have been more than nine exhibits: the pastel portrait of Edma in black (1871), not listed in the catalogue, was mentioned in a review.

26. Contemporary reviews are listed in appendix, Moffett, *The New Painting*, p. 490; Lethève, *Impressionistes et Symbolistes*, p. 61.

27. Moffett, *The New Painting*, pp. 131–6.

28. Jean Prouvaire, *Le Rappel*, 20 April 1974, in Angoulvent, *Berthe Morisot*, p. 47.

29. Jules Clarétie, *l'Indépendance belge*, 13 June 1874, in Lethève, *Impressionistes et Symbolistes*, p. 72.

30. For the exhibition's finances, see Rewald, *History of Impressionism*, pp. 334, 336.

31. Louis Leroy, *Le Charivari*, 25 April 1874, in Rewald, *History of Impressionism*, p. 322.

32. For a reappraisal of the terminology of Impressionism, see Eisenman, 'The Intransigent Artist', pp. 51–60.

33. Rewald, *History of Impressionism*, pp. 316, 320.

34. *Morisot Correspondence*, p. 80.

35. *On the Lawn*, see Plates.

36. De Nittis to a friend, April–May 1874, in Rewald, *History of Impressionism*, p. 324.

CHAPTER 12. MADAME MANET

1. *The Times*, 'A Parisian Summer', 22 June 1873.

2. *Morisot Correspondence*, p. 84.

3. *Carnet noir*; Higonnet, *Berthe Morisot*, p. 204.

4. Berthe was aware of the friendship: *Morisot Correspondence*, p. 81; Tabarant, *Manet et ses Oeuvres*, p. 277.

5. *Morisot Correspondence*, pp. 81–2.

6. Ibid., p. 82.

7. See Plates for both portraits.

8. See Plates.

9. Angoulvent, *Berthe Morisot*, appendix, *Pièces justificatives*, no page nos.; the Abbé Hurel was priest at the Madeleine.

10. *The Times*, 17 December 1874.

11. *Morisot Correspondence*, p. 84.

12. *The Times*, 23 December 1874.

13. Berthe Morisot's mother-in-law, Madame Manet (née Eugénie Fournier), had an interesting background. One side of her family, the Delanoues, came from the western province of Poitou. Beginning as valets, they had progressed in royal service from the time of the sixteenth-century Wars of Religion. Her grandfather Delanoue had built up a fortune during the French Revolution, only to lose it again. The Fourniers, meanwhile, made strides as businessmen, diplomats, army officers and civil servants. Her father, Joseph Fournier, was in business in Hanover and Göteborg, Sweden, where he must have made some useful connections before he also went bankrupt during Napoleon's ascendancy over Europe. In circumstances shrouded in uncertainty, Joseph Fournier assumed the authority of the French *chargé d'affaires* in Sweden. He persuaded the Swedish Estates to declare the disgraced French marshal, Jean Baptiste Jules Bernadotte, brother-in-law of Napoleon's brother Joseph Bonaparte, to be the hereditary Crown Prince of Sweden. In 1818 Bernadotte became King Charles XIV of Sweden; he reigned until 1844. As a reward for services rendered, Bernadotte stood godfather at the baptism of the Fourniers' baby daughter. She was named Eugénie-Desirée after the Crown Princess Eugénie Bernardine Desiree – later the Queen of Sweden – who had started life as the daughter of a rich Marseilles merchant, named Clancy. On the marriage of Eugénie-Desirée Fournier to Auguste Manet, the bride received 6,000 francs and some state bonds from the King of Sweden, as well as a fine classical clock. The Fourniers, however, were said to have

expected a great deal more from their royal patron, though in this they were disappointed.

14. *Morisot Correspondence*, p. 84.
15. Ibid., p. 83.
16. Curtiss, 'Letters of Edouard Manet', 13 September 1870 (3), p. 380.
17. *Morisot Correspondence*, pp. 85–6.
18. Ibid., p. 88.
19. Eugène's view of Gennevilliers was probably idealized: T.J. Clark, *The Painting of Modern Life*, pp. 161–2.
20. *Morisot Correspondence*, p. 88; the Corot exhibition was reported in *The Times*, 26 May 1875.
21. Clark, *The Painting of Modern Life*, p. 153.
22. Julie Manet, *Journal*, p. 80.
23. Raymond Cogniat, *Monet and His World* (London, Thames & Hudson, 1966), p. 47; K. Adler, *Camille Pissarro: A Biography* (London, Batsford, 1978), p. 43–6; *Morisot Correspondence*, pp. 93, 95. During the Franco-Prussian War Monet and Pissarro met up in London, thanks to the good offices of Paul Durand-Ruel. From his base in Kensington, Monet painted London's parks and the Thames; Pissarro worked on suburban scenes; he was living at 2 Chatham Terrace, Palace Road, Upper Norwood, at the time. London received great publicity in art circles following the publication in 1872 of *London, a pilgrimage*, by the eminent engraver, Gustave Doré, and his friend Blanchard Gerrold.
24. *Morisot Correspondence*, p. 92; Alcantara, *Marcello, Adèle d'Affry*, pp. 87–9.
25. *Morisot Correspondence*, p. 89.
26. Ibid., pp. 89, 91.
27. *The Times*, 17 July, 21 July 1875; see Plates.
28. *Morisot Correspondence*, p. 91; *The Times*, 26 July, 29 July, 2 August 1875.
29. *Morisot Correspondence*, p. 90; *The Times*, 4 August, 7 August, 14 August 1875.
30. *Morisot Correspondence*, p. 89.
31. Ibid., pp. 90–1.
32. Ibid., p. 91.
33. *The Times*, 19 August, 20 August 1875; *Morisot Correspondence*, p. 93.
34. Ibid., p. 93.
35. Ibid., p. 92.
36. Ibid.
37. Goncourt, *Journal*, vol. 2, pp. 1001–2.
38. *Morisot Correspondence*, p. 92.
39. Ibid., p. 94. In April 1876 Durand-Ruel

held an exhibition of 'French and Other Foreign Painters' at his Bond Street Gallery, which included works by Berthe Morisot; and in 1883 three of her works were on show in Dowdeswell's Galleries, New Bond Street, but the Impressionists were slow to win approval: Kate Flint (ed.), *Impressionists in England: The Critical Reception* (London, Routledge & Kegan Paul, 1984), pp. 4–6. Théodore Duret told Pissarro that the English were slow to accept Impressionism because they were twenty-five years behind the French in their tastes: Adler, *Pissarro*, p. 48.

40. *Morisot Correspondence*, p. 138.
41. Ibid., p. 96.
42. Ibid., p. 94.
43. Duchess Colonna to Berthe Morisot, 19 January 1876, unpublished letter in private collection, Stuckey and Scott, *Berthe Morisot*, p. 181, n. 183.

CHAPTER 13. SOLIDARITY

1. *The Times*, 5 January 1875.
2. Perruchot, *Manet*, p. 207.
3. Gerstein, 'Degas's Fans', pp. 105 ff.; Alcantara, *Marcello, Adèle d'Affry*, p. 167: '*Manet m'a demandé de faire son portrait pour l'exposer. Je lui ai répondu qu'ayant déjà bien assez d'ennemis, je craignais d'y ajouter les siens.*'
4. Janine Bailly-Herzberg, 'Marcellin Desboutin and his World', *Apollo*, new series, 95 (June 1972), pp. 496–500.
5. Venturi, *Archives de l'Impressionisme*, vol. 2, p. 201; *Morisot Correspondence*, p. 87.
6. P. Burty, introduction to the catalogue: *Vente du 24 mars 1875 – Tableaux et aquarelles par Cl. Monet, B. Morisot, A. Renoir, A. Sisley*: Venturi, *Archives de l'Impressionisme*, vol. 2, p. 290.
7. Courthion and Cailler, *Portrait of Manet*, p. 29.
8. Wolff, 'Masque de Fer', *Le Figaro*, March 1875, in Rewald, *History of Impressionism*, p. 351 and Angoulvent, *Berthe Morisot*, p. 51.
9. Venturi, *Archives de l'Impressionisme*, vol. 2, p. 201; Renoir, *Renoir, My Father*, p. 141.
10. Lethève, *Impressionistes et Symbolistes*, p. 75.
11. Angoulvent, *Berthe Morisot*, pp. 50–1; *Morisot Correspondence*, p. 88.
12. Rewald, *History of Impressionism*, p. 354; *Morisot Correspondence*, p. 89.

13. M. Bodelsen, 'Early Impressionist Sales 1874–94 in the Light of Some Unpublished "Procès-verbaux"', *Burlington Magazine*, 110, 783 (June 1968), pp. 333–6; Monneret, *L'Impressionisme et Son Epoque*, also gives details of Berthe Morisot's sales from the 1875 auction, vol. 1, p. 598.

14. Lethève, *Impressionistes et Symbolistes*, p. 75.

15. Monet to Manet, 28 June 1875, in Rewald, *History of Impressionism*, p. 363.

16. *The Times*, 6 January 1876, reporting Gambetta, 31 December 1875.

17. Angoulvent, *Berthe Morisot*, pp. 49–50. *Young Woman with the Looking Glass* is in a private collection; *The Cheval Mirror* (*La Psyché*) is in the Thyssen-Bornemisza Collection, Madrid, Spain.

18. Stuckey and Scott, *Berthe Morisot*, pp. 68, 182 n. 162.

19. Nord, 'Manet and Radical Politics', p. 448.

20. For an English account of the 1876 Salon, *The Times*, 30 April 1876.

21. Venturi, *Archives de l'Impressionisme*, contains much about Durand-Ruel, including extracts from his letters (vol. 1) and *Mémoires* (vol. 2), pp. 143–220; also Monneret, *L'Impressionisme et Son Epoque*, vol. 1, pp.209–13.

22. *Morisot Correspondence*, p. 98.

23. Louis Emile Edmond Duranty, *The New Painting: Concerning the Group of Artists Exhibiting at the Durand-Ruel Galleries*, 1876, reprinted in Moffett, *The New Painting*, p. 46.

24. *Morisot Correspondence*, p. 97.

25. Moffett, *The New Painting*, p. 163, gives a facsimile of the exhibition catalogue listing Berthe Morisot's exhibits, pp. 16–17.

26. Lethève, *Impressionistes et Symbolistes*, pp. 76–8.

27. Moffett, *The New Painting*, pp. 27–34; in particular p. 33; Emile Zola, *Le Bon Combat de Courbet aux Impressionistes* (Paris, Collection Savoir, 1974), p. 185.

28. Lethève, *Impressionistes et Symbolistes*, pp. 76, 79; Hollis and Clayson, 'A Failed Attempt: the Second Exhibition 1876', Moffett, *The New Painting*, pp. 145–59, esp. p. 152; Maria and Godfrey Blunden, *Impressionists and Impressionism*, 2nd edn (London, Macmillan, and Geneva, Skira, 1980), pp. 110–12, 154, 162–3, 181, 192.

29. McMullen, *Degas*, p. 253.

30. Lethève, *Impressionistes et Symbolistes*, pp. 76–7; *Morisot Correspondence*, p. 98.

31. Rewald, *History of Impressionism*, p. 370; Blunden, *Impressionists and Impressionism*, pp. 110–12; *Morisot Correspondence*, p. 98. In 1870 Edouard Manet had challenged Duranty, one of the Guerbois circle, to a duel over some malicious remarks. An appalled Zola had to stop the fight midway after Duranty was slightly wounded.

32. Blunden, *Impressionists and Impressionism*, p. 111.

33. Tabarant, *Manet et ses Oeuvres*, p. 284.

34. *Morisot Correspondence*, p. 98.

35. Angoulvent, *Berthe Morisot*, p. 55.

36. *Morisot Correspondence*, p. 73.

37. Angoulvent, *Berthe Morisot*, p. 54.

38. *Morisot Correspondence*, p. 98.

39. Julie Manet, *Journal*, 16 January 1898, p. 148; Mongan, *Berthe Morisot*, pp. 14 and passim.

40. Rewald, *History of Impressionism*, pp. 388–90.

41. For the genesis of the 1877 exhibition, see Richard R. Bretell, 'The "First" Exhibition of the Impressionist Painters', in Moffett, *The New Painting*, pp. 189–202; Monneret, *L'Impressionisme et Son Epoque*, vol. 1, pp. 90–4 on Caillebotte.

42. *Morisot Correspondence*, p. 100.

43. Guillaumin to Dr Gachet, 24 February 1877, in Rewald, *History of Impressionism*, p. 390.

44. *Morisot Correspondence*, p. 100.

45. Moffett, *The New Painting*, p. 205, for the catalogue of the exhibition.

46. Fourreau, *Berthe Morisot*, pp. 48–50.

47. Zola, *Le Bon Combat*, pp. 187–8.

48. Venturi, *Archives de l'Impressionisme*, vol. 1, pp. 51–2; vol. 2, pp. 292, 306–29; Lethève, *Impressionistes et Symbolistes*, pp. 83–4, 88–91.

49. Ibid., pp. 82, 84–5, 86–7; Venturi, *Archives de l'Impressionisme*, vol. 2, pp. 291–3, 303–4, 330.

50. Fourreau, *Berthe Morisot*, p. 48; Angoulvent, *Berthe Morisot*, p. 56; 'Exhibition of the Impressionist Painters', *Le Temps*, 22 April 1877, in Lethève, *Impressionistes et Symbolistes*, pp. 84–5.

51. Duret, *Manet and the French Impressionists*, p. 128.

CHAPTER 14. 'THE POSITIVE STAGE OF LIFE'

1. Bataille and Wildenstein, *Catalogue des peintures*, pp. 26–7; Rewald, *History of Impressionism*, p. 413; Stuckey and Scott, *Berthe Morisot*, p. 76.
2. Bataille and Wildenstein, *Catalogue des peintures*, pp. 28, 52.
3. Valéry, *Oeuvres*, vol. 2, pp. 1165–6.
4. Bataille and Wildenstein, *Catalogue des peintures*, pp. 26, 61–2.
5. Nord, 'Manet and Radical Politics', pp. 447 ff.
6. *The Times*, 8 September 1877.
7. A.N. F1b I 273 I Min. of Int. 24 May, 27 May 1880, Registre matricale IV, no. 268.
8. Bataille and Wildenstein, *Catalogue des peintures*, pp. 28, 52, 63; Fourreau, *Berthe Morisot*, p. 50; the last picture, *Summer* or *Young Woman by the Window*, is in the Musée Fabre, Montpellier.
9. Mongan, *Berthe Morisot, Drawings*, p. 134.
10. Cézanne to Zola, 24 August 1877, in Rewald, *History of Impressionism*, p. 410.
11. *The Times*, 2 May, 30 May 1877.
12. *Morisot Correspondence*, pp. 101, 103.
13. Pissarro to Mürer and Duret, 1878, Sisley to Duret, March 1879, in Rewald, *History of Impressionism*, pp. 414, 421.
14. *Morisot Correspondence*, p. 101.
15. The child's full name was Eugénie Julie Manet; Julie Manet, *Journal*, p. 82, confirms she was born in the same apartment in the rue d'Eylau as her cousin, Jeannie Gobillard.
16. *Morisot Correspondence*, pp. 101–2.
17. Ibid.
18. Duret, *Les Peintres Impressionistes* (Paris, Librairie Parisienne, 1878) was later greatly expanded into his *Histoire des Peintres Impressionistes* (Paris, Floury, 1906) and the English edition, *Manet and the French Impressionists* (London, Grant Richards, 1910).
19. *Morisot Correspondence*, p. 84, gives a slightly different translation from the original French edition, p. 81.
20. *Morisot Correspondence*, p. 103.
21. Degas to Caillebotte, 16 March 1879, in Ronald Pickvance, 'Contemporary Popularity and Posthumous Neglect', on the fourth exhibition, 1879, in Moffett, *The New Painting*, p. 247.
22. Ibid., pp. 249, 263 n. 32, n. 33.
23. Ibid. Ronald Pickvance rightly questions the conventional explanations for Berthe's absence and points to the ambiguities in her actions.
24. Moore, *Confessions of a Young Man*, p. 70.
25. Monet to de Bellio, 10 March 1879, in Rewald, *History of Impressionism*, p. 421.
26. Nancy Hale, *Mary Cassatt* (New York, Doubleday, 1975), p. 181. It is interesting that according to Cassatt's biographer, F.A. Sweet, Lois Cassatt, Mary's sister-in-law and another strong character, found her 'utterly obnoxious', p. 56. In a letter of 1880 to her sister, Lois said accusingly of Cassatt, 'I have never yet heard her criticize any human being in any but the most disagreeable ways. She is too self-important and I can't put up with it.'
27. Hale, *Mary Cassatt*, p. 203.
28. Arsène Houssaye (F.-C. de Syène), *L'Artiste*, May 1879, in Moffett, *The New Painting*, p. 277.
29. Hale, *Mary Cassatt*, p. 131.
30. *Morisot Correspondence*, p. 101.
31. Ibid.
32. Ibid.
33. As a tribute to the novelist and critic, Degas re-exhibited his portrait of Duranty seated at his desk, surrounded by papers and books.
34. There is some discrepancy in the sources as to which of her works were shown in the fifth exhibition. There seems no doubt about *Summer, Winter, Summer's Day* or *The Lake in the Bois de Boulogne; Snow* or *L'avenue de Bois, effet de neige, In the Garden* or *Women Picking Flowers; Portrait* or *Young Woman Dressed for the Ball*. However, there is some confusion between *Woman at her Toilette*, listed in Bataille and Wildenstein, *Catalogue des peintures*, p. 28 under the year 1877, and *Back of Young Woman at her Toilette*, listed ibid., p. 29, 1880, and the version *c*. 1875 in Moffett, *The New Painting*, p. 327 and the same cited as *c*. 1879 in Stuckey and Scott, *Berthe Morisot*, p. 81. In addition, two unidentified landscapes and four watercolours are listed in the official catalogue. The fan may have been *Jeune Femme en Barque*, 1880, Bataille and Wildenstein, *Catalogue des peintures*, p. 63.
35. Wolff, *Le Figaro*, 9 April, in Lethève, *Impressionistes et Symbolistes*, p. 110; Gustave Goetschy, *Le Voltaire*, 6 April 1880, in Moffett, *The New Painting*, pp. 304, 325.

36. J.-K. Huysmans, *L'Art Moderne* (Paris, G. Charpentier, 1883), 'L'Exposition des Independants 1880', pp. 110–11. On the other hand, her work attracted quite a lot of attention: Charles S. Moffett, 'Disarray and Disappointment', on the fifth exhibition, 1880, in Moffett, *The New Painting*, p. 297.

37. Charles Ephrussi, *Gazette des Beaux-Arts*, 1 May 1880, in Moffett, *The New Painting*, p. 327; A.E., *La Justice*, 5 April 1880; P. Burty, *La République Française*, 10 April 1880, in Moffett, *The New Painting*, p. 326.

38. Mongan, *Berthe Morisot, Drawings*, p. 20.

39. Nancy Cunard, *G.M.: Memories of George Moore* (London, Rupert Hart-Davis, 1956), p. 162; Jules Clarétie, *Le Temps*, 6 April 1880.

CHAPTER 15. EDOUARD

1. *Morisot Correspondence*, p. 102; Tabarant, *Manet et ses Oeuvres*, p. 365; Perruchot, *Manet*, p. 221.

2. Degas to Henri Rouart, 26 October 1880 (XXXI), in Marcel Guérin (ed.), *Lettres de Degas* (Paris, Bernard Grasset, 1945), p. 61.

3. *Carnet vert*, in Angoulvent, *Berthe Morisot*, p. 75; Courthion and Cailler, *Portrait of Manet*, Edmond Bazire, 1884, p. 91; Duret, *Manet and the French Impressionists*, p. 103; Tabarant, *Manet et ses Oeuvres*, pp. 546–7.

4. *Morisot Correspondence*, pp. 96, 107, 110.

5. Frédéric Chevalier, 'Les Impressionistes', *L'Artiste*, 1 May 1877, pp. 329–33, in Angoulvent, *Berthe Morisot*, pp. 56–7. The perception of Berthe as Manet's pupil was dismissed by her family. Julie Manet, *Journal*, p. 83: 'Maman only ever watched my uncle Edouard painting; she was not his pupil.'

6. Stuckey and Scott, *Berthe Morisot*, pp. 31, 33, 41, 44–5. However, Julie Manet played down the influence: *Journal*, p. 83: '*Villa at the Seaside*, Aunt Edma and Jeanne on the chalet terrace at Fécamp, overlooking the green sea. The blacks are noticeable in this picture and the sea has a certain resemblance to my uncle Edouard's painting; it's the only thing, one might say, in which I can see his influence.'

7. Courthion and Cailler, *Portrait of Manet*, 'Memories of Antonin Proust', pp. 5, 8, 87.

8. Ibid., p. 96.

9. *Morisot Correspondence*, p. 102; catalogue

of the sixth exhibition, in Moffett, *The New Painting*, p. 354.

10. Gustave Geffroy, *La Justice*, 19 April 1881; Huysmans, *L'Art Moderne*, pp. 110, 231–2; Fronia Wissman, 'Realists among the Impressionists', on the sixth exhibition, 1881, in Moffett, *The New Painting*, pp. 337–52, especially 347–8.

11. *Morisot Correspondence*, pp. 102–3; Julie Manet, *Journal*, p. 81; see Plates.

12. C. James Haug, *Leisure and Urbanism in Nineteenth-Century Nice* (Kansas, Regents Press, 1982), pp. 6–8.

13. Bashkirtseff, *Journal of Marie Bashkirtseff*, vol. 1, pp. 160, 314.

14. Bibliothèque Nationale (B.N.) f.NAF 24839, Marcel Guérin Collection, letter 10 December 1881 returned with address.

15. *Morisot Correspondence*, p. 110.

16. Ibid., pp. 113–14. Tiburce could not have left for Africa at a more unstable and potentially dangerous time, and Berthe had already expressed her grave concern about his willingness to flirt with danger in foreign parts. French and British investment in industrial and engineering projects such as the Suez Canal, opened in 1869, had brought many Europeans to Egypt seeking fame and fortune. Under the Khedive some Europeans were employed in high civil and military office (such as the English soldier, Charles George Gordon, governor-general of the Sudan 1877–80). But by 1881 a growing power vacuum, coupled with nationalist feeling, produced simultaneous popular risings under Arabi Pasha in Egypt and Al Mahdi in the Sudan. Egyptian government forces were defeated twice, in August 1881 and May 1882, before and after Tiburce Morisot's appointment. The revolt continued until 1885 when the Mahdi's forces took Khartoum and killed General Gordon. How long Tiburce stayed in Africa is unclear, but he was back in France by March 1883.

17. Renoir to Manet, 28 December 1881, E. Moreau-Nélaton, *Manet Raconté par Lui-même* (2 vols, Paris, Henri Laurens, 1926), vol. 2, p. 88.

18. *Morisot Correspondence*, pp. 103–4.

19. Courthion and Cailler, *Portrait of Manet*, Joseph de Nittis, 'Notes et Souvenirs', p. 85; *Morisot Correspondence*, pp. 105, 109.

20. Perruchot, *Manet*, p. 245.

21. *Morisot Correspondence*, p. 103.

22. Courthion and Cailler, *Portrait of Manet*,

de Nittis, 'Notes et Souvenirs', pp. 85–6.

23. Courthion and Cailler, *Portrait of Manet*, 'Memories of Antonin Proust', p. 7.

24. *Morisot Correspondence*, p. 104; Venturi, *Archives de l'Impressionisme*, vol. 1, p. 120, Renoir to Durand-Ruel, 24 February 1882.

25. *Morisot Correspondence*, p. 104; Joel Isaacson, 'The Painters Called Impressionists', in Moffett, *The New Painting*, p. 377.

26. *Morisot Correspondence*, p. 105.

27. Ibid., p. 107.

28. Ibid., pp. 109, 111; Huysmans, *L'Art Moderne*, pp. 264–5.

29. *Morisot Correspondence*, pp. 105, 106, 110, 112. The painting referred to as *Marie* illustrates the problem of identifying Berthe's exhibits at the 1882 exhibition. It appears from letters to have been borrowed from Portier and displayed the first day, priced by Eugène at 1,200 francs. Moffett, *The New Painting*, says the only painting of hers on show the first day was *A la Campagne*, listed as such in the catalogue of the seventh exhibition, priced at 1,200 francs. Stuckey, however, identifies the picture *Marie* as *Young Woman in a Conservatory* and the size of the canvas as 80 x 100 cm. The only canvas of this size listed by Bataille and Wildenstein as having been exhibited in 1882 is *Après le Déjeuner*.

30. *Morisot Correspondence*, pp. 108, 112.

31. Moore, *Confessions of a Young Man*, p. 104.

32. Courthion and Cailler, *Portrait of Manet*, p. 86.

33. *Morisot Correspondence*, p. 68.

34. Ibid., pp. 105, 109.

35. Ibid., p. 104.

36. Perruchot, *Manet*, p. 215.

37. In 1880 Manet wrote some seventeen letters, charmingly illustrated with watercolour sketches, to Mlle Isabelle Lemonnier, who was little more than half his age: Tabarant, *Manet et ses Oeuvres*, pp. 392–3; Schneider, *The World of Manet*, pp. 170–1.

38. Courthion and Cailler, *Portrait of Manet*, de Nittis, 'Notes et Souvenirs', p. 86.

39. *Morisot Correspondence*, pp. 102–3.

40. Julie Manet, *Journal*, 28 October 1897, p. 138.

41. *Morisot Correspondence*, p. 116.

42. McMullen, *Degas*, p. 365.

43. *Morisot Correspondence*, p. 116.

44. Ibid.

45. Courthion and Cailler, *Portrait of Manet*, Jules-Camille de Polignac, 5 May 1883,

pp. 103–6; Tabarant, *Manet et ses Oeuvres*, pp. 477–9.

46. Moore, *Confessions of a Young Man*, p. 105; *Morisot Correspondence*, pp. 116–17.

CHAPTER 16. THE RUE DE VILLEJUST

In addition to the contemporary reports of *The Times* on political events in France for 1883–95, from the second premiership of Jules Ferry to the Dreyfus Affair, there are copious secondary sources providing background information to Part IV of this book, e.g. Magraw, *The Bourgeois Century*, Pt IV, chaps 7–8, and two political biographies, Maurice Reclus, *Jules Ferry* (Paris, Flammarion, 1947) and the more recent Jean-Michel Gaillard, *Jules Ferry* (Paris, Fayard, 1989).

1. A. Vollard, *Renoir*, chap. 3, in Rewald, *History of Impressionism*, p. 486.

2. Joel Isaacson, *Claude Monet: Observation and Reflection* (Oxford, Phaidon, 1978), Monet to Gustave Geffroy, pp. 38, 40.

3. Octave Mirbeau, *La France*, 21 May 1886, in Moffett, *The New Painting*, p. 460.

4. *Morisot Correspondence*, p. 124.

5. *Carnet intime*, in ibid., p. 158.

6. Julie Manet, *Journal*, p. 89; Angoulvent, *Berthe Morisot*, p. 95, Mme Léouzon-le-Duc to Paule Gobillard, 14 January 1932, the anniversary of Berthe Morisot's birthday.

7. Quoted in Mongan, *Berthe Morisot, Drawings*, p. 90.

8. *Carnet intime*, in Angoulvent, *Berthe Morisot*, p. 61.

9. *Morisot Correspondence*, pp. 108–9, 111, 112.

10. Ibid., p. 109.

11. Tabarant, *Manet et ses Oeuvres*, p. 485.

12. *Morisot Correspondence*, pp. 116–17.

13. Tabarant, *Manet et ses Oeuvres*, p. 480; *Morisot Correspondence*, p. 120.

14. Tabarant, *Manet et ses Oeuvres*, pp. 487–8, 494.

15. D. Cooper, *The Courtauld Collection* (London, Athlone Press, 1954), pp. 23–7; Rewald, *History of Impressionism*, pp. 482, 485.

16. Bataille and Wildenstein, *Catalogue des peintures*, p. 32; both these paintings are in a private collection.

17. *Morisot Correspondence*, pp. 117–19.

18. Ibid.
19. Ibid., p. 118.
20. Ibid., pp. 119–20.
21. Ibid., p. 120; for the retrospective and its reviews, Tabarant, *Manet et ses Oeuvres*, pp. 490–7.
22. Nancy Mowll Mathews (ed.), *Cassatt and Her Circle, Selected Letters* (New York, Abbeville Press, 1984), Katherine Cassatt to Alexander Cassatt, 30 November 1883, pp. 174–6.
23. *Morisot Correspondence*, p. 121.
24. Ibid., pp. 121–2; Tabarant, *Manet et ses Oeuvres*, pp. 498–502; Bodelsen, 'Early Impressionist Sales'; Courthion and Cailler, *Portrait of Manet*, pp. 178–82, Paul Eudel, 'La vente Manet', *Le Figaro*, 5 February 1884.
25. Angoulvent, *Berthe Morisot*, p. 68; Edouard Manet's exotic portrait of Nina de Callias remained in Manet hands until 1930 when Julie Manet, Madame Rouart, donated it to the Louvre in accordance with her mother's wish.
26. *Morisot Correspondence*, pp. 122–4.
27. Julie Manet, *Journal*, 25 October 1899, p. 269; *Morisot Correspondence*, p. 125.
28. Ibid., pp. 127–8.
29. Tabarant, *Manet et ses Oeuvres*, pp. 506, 503–7; Courthion and Cailler, *Portrait of Manet*, pp. 198–9 for Proust's Address on this occasion.
30. *Morisot Correspondence*, p. 125.
31. *The Times*, 27 May, 30 May, 2 June 1885.
32. *Self-Portrait with Julie* (1885) and *Self-Portrait* (1885), oil on canvas, are in a private collection. For the smaller *Self-Portrait*, in pastel on paper, which is in the Art Institute of Chicago, Helen Regenstein Collection, see Plates.
33. cf. Parker and Pollock, *Old Mistresses*, p. 44.
34. Angoulvent, *Berthe Morisot*, p. 70.
35. *Morisot Correspondence*, p. 131. For a less well-known pastel portrait of Isabelle Lambert, which Berthe Morisot completed at this time, see Plates.
36. Ibid., p. 129.
37. Angoulvent, *Berthe Morisot*, pp. 73–4.
38. Ibid., pp. 128–9.

CHAPTER 17. THE THURSDAY FAITHFUL

Of the wealth of material on Berthe Morisot's friends, Barbara E. White, *Renoir,*

His Life, Art and Letters (New York, Harry N. Abrams, 1984), D. Wildenstein, *Claude Monet, Biographie et Catalogue Raisonné* (4 vols, Lausanne and Paris, Bibliothèque des Arts, 1974–85) and Henri Mondor, *Vie de Mallarmé* (Paris, Gallimard, 1941) are the most comprehensive studies. The public response to Symbolism is treated in Lethève, *Impressionistes et Symbolistes*.

1. Mondor, *Vie de Mallarmé*, 10 December 1886, p. 501.
2. *Morisot Correspondence*, p. 120.
3. Ibid., p. 149.
4. Ibid., p. 123; John House, *Monet: Nature into Art* (New Haven, Conn., Yale University Press, 1986), p. 155; Isaacson, *Claude Monet*, p. 124.
5. Edmond and Jules de Goncourt, *L'Art du dix-huitième siècle*, 1859–75, a seminal work of art criticism; in addition, Paul Bourget, 'Edmond et Jules Goncourt', *La Nouvelle Revue*, 1 October 1885, attracted Berthe's attention, and she copied passages into her notebook.
6. *Carnet vert*, in Angoulvent, *Berthe Morisot*, p. 75.
7. *Carnet vert*, in *Morisot Correspondence*, p. 130.
8. Arthur Gold and Robert Fizdale, *Misia: The Life of Misia Sert* (New York, Morrow Quill Paperbacks, 1981), p. 106.
9. Huisman, *Morisot: Enchantment*, p. 50.
10. McMullen, *Degas*, p. 37.
11. *Morisot Correspondence*, p. 120; Moore, *Confessions of a Young Man*, p. 104; Guerin, *Lettres de Degas*, Degas to Eugène Manet, n.d., pp. 55–6.
12. Mondor, *Vie de Mallarmé*, Berthe Morisot to Mallarmé, 28 February 1889, p. 550.
13. *Morisot Correspondence*, p. 171.
14. *Carnet vert*, in Angoulvent, *Berthe Morisot*, pp. 73, 76. Degas's witticisms became legendary but increasingly sardonic with age: McMullen, *Degas*, pp. 389–92.
15. Renoir, *Renoir, My Father*, p. 269.
16. Stéphane Mallarmé, 'Berthe Morisot', *Divagations*, preface to the catalogue of the retrospective exhibition, March 1896 (Paris, Bibl. Charpentier, 1943), in *Oeuvres*, pp. 141–2.
17. Henri de Régnier, 'Mallarmé et les Peintres', *L'Art Vivant*, 1 April 1930, pp. 265–6.
18. Gold and Fizdale, *Misia*, p. 60.

19. Berthe must have been aware of Mallarmé's interest in women, and in Méry Laurent in particular, for she noted in her *carnet intime*: 'Mallarmé said to me that his music is to him like a lady manifesting her joy by her hair – an enormous head of wavy hair.' See Wallace Fowlie, *Mallarmé* (London, Dennis Dobson, 1953), pp. 37–48 on the poet's obsession with women's hair. Berthe's coquettish tendency shows in a letter to Mallarmé, 14 July 1891: 'I am writing to you like a sentimental young girl, to make you realize that I miss you today, and without mentioning it to Eugène': *Morisot Correspondence*, p. 162.

20. *Morisot Correspondence*, p. 131.

21. *Carnet beige*, in Huisman, *Morisot: Enchantment*, p. 24.

22. Ibid. The fire at the Opéra Comique broke out at 8.30 p.m. on 25 May 1887, in the middle of Act I of Ambroise Thomas's popular opera, *Mignon*. Starting in a wing, in minutes it had taken hold of the stage; distraught members of the cast, still in eighteenth-century costume, rushed out of the building and streamed down the Boulevard des Italiens where they were observed by bemused spectators, including *The Times* Paris correspondent. Flames and smoke trapped scores of people in the green room and the upper galleries, and soon a pall of reddish smoke was visible for miles around Paris. The final death toll reached 131. Julie and Berthe may have watched a charity performance held in the Bois de Boulogne that June to raise money for victims: *The Times*, 26, 27, 28, 30, 31 May, 1, 2, 4, 6, 9 June 1887.

23. *Carnet beige*, in Huisman, *Morisot: Enchantment*, p. 26. The sculptor Antoine Coysevox (1640–1720), was perhaps the most successful Baroque sculptor of Louis XIV's reign, renowned for his statuary and portrait busts, such as his bronze of the king (1686). Coming from a family of sculptors – Antoine Coysevox was his uncle – Nicolas Coustou (1658–1733) was responsible for sculptures in the Tuileries Gardens. His brother Guillaume Coustou (1677–1746) created the famous Marly Horses, made for the royal château at Marly but now in the Place de la Concorde.

24. *Carnet beige*, in Angoulvent, *Berthe Morisot*, p. 81.

25. *Morisot Correspondence*, p. 135.

26. Renoir, *Renoir, My Father*, p. 53. The Lamoureux concerts were established by Charles Lamoureux (1834–99), the French conductor and violinist, in 1881 at the Théâtre du Château d'Eau. They were immediately successful and acquired a reputation for their high standard of performance, immortalizing his name. However, Lamoureux struggled to establish Wagner in his repertoire against a backcloth of anti-German feeling. From 1887 he devoted himself to weekly concerts and stage music at the Théâtre de l'Odéon; Paul Valéry, 'Au concert Lamoureux 1893', *Oeuvres*, vol. 2, pp. 1272–6.

27. See Plates.

28. *Morisot Correspondence*, p. 133; White, *Renoir*, p. 175.

29. Mathews, *Cassatt and Her Circle*, p. 149, Mary Cassatt to Berthe Morisot, autumn 1879; Hale, *Mary Cassatt*, pp. 106, 131; *Morisot Correspondence*, pp. 112–13.

30. Angoulvent, *Berthe Morisot*, p. 84; Huisman, *Morisot: Enchantment*, pp. 30–4.

31. Bataille and Wildenstein, *Catalogue des peintures*, p. 56; *Morisot Correspondence*, pp. 133–4.

32. Zeldin, *Emile Ollivier*, pp. 7–8; Eugène Manet, *Victimes!* (Clamécy, Imprimerie A. Staub, 1889).

33. *Morisot Correspondence*, p. 135.

34. Stuckey and Scott, *Berthe Morisot*, p. 128; Bailly-Herzberg, 'Les Estampes de Berthe Morisot', pp. 220–2; *Morisot Correspondence*, p. 147; Angoulvent, *Berthe Morisot*, pp. 92–3.

35. *Morisot Correspondence*, pp. 135–6.

36. Ibid., pp. 142–3.

37. Ibid., p. 143.

38. Ibid., p. 144.

39. Ibid., pp. 145–7.

40. Ibid., p. 146; *Carnet vert*, in Angoulvent, *Berthe Morisot*, pp. 86–7; during her stay in Nice, Berthe Morisot kept a notebook in which she listed subjects and drew sketches which were possibly intended for a book: Stuckey and Scott, *Berthe Morisot*, pp. 144, 185 n. 280.

41. *Morisot Correspondence*, p. 148.

42. Ibid., pp. 145–6.

43. Ibid., p. 145.

44. Ibid., p. 148; Mondor, *Vie de Mallarmé*, p. 550, 28 February 1889; Zeldin, *Emile Ollivier*, p. 194; Gustave and Eugène Manet were more politically radical than Edouard; the Manets' political spectrum was between Gambetta and the journalist, Rochfort, who

supported Boulanger: Nord, 'Manet and Radical Politics', p. 447.
45. *Morisot Correspondence*, p. 150; the invitation was for Thursday 2 May 1889.

CHAPTER 18. BITTER-SWEET FRUITS OF SUCCESS

1. See Carter, Forster and Moody (eds), *Enterprise and Entrepreneurs in Nineteenth- and Twentieth-Century France*.
2. *Morisot Correspondence*, p. 133.
3. Isaacson, *Claude Monet*, pp. 40, 220.
4. Huisman, *Morisot: Enchantment*, p. 64.
5. This would be the eighth collaborative event: see Martha Ward, 'The Rhetoric of Independence and Innovation: the Eighth Exhibition', in Moffett, *The New Painting*, pp. 421–42.
6. *Morisot Correspondence*, p. 128.
7. Pissarro to Monet, 7 December 1885, in Rewald, *History of Impressionism*, p. 518.
8. Pissarro to Monet, 5 March 1886, in Hale, *Mary Cassatt*, pp. 107–8.
9. Camille Pissarro, *Letters to His Son Lucien*, ed. J. Rewald (New York, Pantheon, 1943), pp. 73–4, in Rewald, *History of Impressionism*, pp. 521–2.
10 See Plates.
11. Robert Cassatt to Alexander Cassatt, in Hale, *Mary Cassatt*, pp. 108–9.
12. Moore, *Confessions of a Young Man*, 1888 edn, pp. 28–9; Moore, *Le Bat*, 26 May 1886, pp. 285–6; Flint, *Impressionists in England*, p. 71.
13. For press reviews of the 1886 exhibition, Lethève, *Impressionistes et Symbolistes*, pp. 125–30; Ward, 'The Rhetoric of Independence and Innovation', pp. 427–39, 495–6 in Moffett, *The New Painting*; for criticism of Berthe Morisot in particular, ibid., pp. 428–9, 460; Angoulvent, *Berthe Morisot*, pp. 77–8; Félix Fénéon, 'Les Impressionistes en 1886', in *Oeuvres de Félix Fénéon*, intro. Jean Palhau (Paris, Gallimard, 1950), p. 77.
14. Fénéon, 'Les Impressionistes en 1886', p. 71: 'Mme Morisot as well as Gauguin and Guillaumin represent impressionism as it was in prior exhibitions: Pissarro, Seurat, and Signac innovate.'
15. Gauguin to his wife, May 1886, in Rewald, *History of Impressionism*, p. 526.
16. *Morisot Correspondence*, p. 131.
17. Durand-Ruel to Fantin-Latour, 1886, in Rewald, *History of Impressionism*, p. 531; Venturi, *Archives de l'Impressionisme*, vol. 2, pp. 216–17.
18. Octave Maus, 'Les vingtistes parisiens', *L'Art Moderne*, Brussels, 27 June 1886, pp. 201–4; Maus was the secretary of the Cercle des Vingt, which was founded in October 1883 under the patronage of Delvin, director of the Academy of Ghent. The first exhibition, in February 1884, included works by Berthe Morisot's acquaintances, Whistler, Sargent and Rodin. In the spring of 1893 the Cercle was dissolved but replaced by the Salon de la Libre Esthétique.
19. Pissarro, *Letters to His Son*, ed. Rewald (1981 edn), p. 122.
20. Her known exhibits were *Flowers, Cottage Interior, Paule Gobillard in a Ball Gown, On the Verandah*, all oils, and the sculpture of Julie's head.
21. *Carnet beige*, in Angoulvent, *Berthe Morisot*, p. 81.
22. *Morisot Correspondence*, p. 136.
23. Ibid., p. 138.
24. Ibid., pp. 137–8; Stuckey and Scott, *Berthe Morisot*, p. 126.
25. *Morisot Correspondence*, pp. 151–2.
26. Wildenstein, *Claude Monet, Biographie et Catalogue Raisonné*, vol. 3, pp. 250–9; Angoulvent, *Berthe Morisot*, pp. 88–9; Courthion and Cailler, *Portrait of Manet*, pp. 219–21.
27. Huisman, *Morisot: Enchantment*, p. 40.
28. Théodor de Wyzewa, *L'Art dans les Deux Mondes*, 19 March, 28 March 1891, pp. 223–4; *Morisot Correspondence*, p. 159.
29. *Morisot Correspondence*, pp. 169–70.
30. *Carnet noir*, in *Morisot Correspondence*, pp. 159–60.
31. Ibid., p. 160; shortly after this experience (June 1891) Berthe Morisot accepted an invitation to join the London Panel Society (which planned annual exhibitions of its members' work) *but only on condition that Camille Pissarro was also a member*: see Lucien Pissarro, *The Letters of Lucien to Camille Pissarro* ed. Anne Thorold (Cambridge, Cambridge University Press, 1993), pp. 239–40.
32. Ibid., p. 169; Angoulvent, *Berthe Morisot*, p. 99.
33. Angoulvent, *Berthe Morisot*, pp. 99–100.
34. Mathews, *Cassatt and Her Circle*, Mary Cassatt to Camille Pissarro, 17 June 1892, p. 229.

35. *Morisot Correspondence*, p. 171.
36. Camille Pissarro, *Letters to His Son*, p. 333; cf. the anonymous critic of the *Art Journal*, June 1895, who wrote, 'A collective exhibition of her works held at the Galleries of Messrs. Boussod, Valadon and Co. in Paris, in 1892, was a revelation to many, and raised her reputation permanently into the front rank', in Flint, *Impressionists in England*, p. 353.
37. *Carnet noir*, in Angoulvent, *Berthe Morisot*, p. 109.
38. Duret, *Manet and the French Impressionists*, pp. 187–8. Duret observed, 'The purchase gave Berthe Morisot genuine satisfaction . . . it was a public recognition of her merit, and it was impossible to regard her any longer as an amateur.'
39. Cunard, *G.M. Memoirs of George Moore*, p. 162; George Moore, *Modern Painting* (London and New York, 1910), p. 234.
40. *Carnet noir*, in Angoulvent, *Berthe Morisot*, pp. 96–7.

CHAPTER 19. VALEDICTION

1. Mondor, *Vie de Mallarmé*, pp. 571–4; Henri de Régnier, 'Faces et Profils: Berthe Morisot', *Nouvelles Littéraires, Artistiques et Scientifiques*, 13 July 1935, p. 4; Mallarmé's verse is repeated in *Morisot Correspondence*, p. 154.
2. Valéry, 'Degas Danse Dessin', in *Oeuvres*, pp. 1208–9; however, Degas's poetry-writing did lead to some jocular comment among his friends: Hale, *Mary Cassatt*, p. 141; Mondor, *Vie de Mallarmé*, pp. 550, 684.
3. *Morisot Correspondence*, p. 136.
4. Ronald Anderson and Anne Koval, *James McNeill Whistler: Beyond the Myth* (London, John Murray, 1994), p. 291.
5. Ibid., pp. 331–2, 500 n. 22, cites Morisot to Mallarmé, 21 May 1888, in a private collection; Mallarmé, *Correspondance* ed. Henri Mondor and Lloyd James Austin (11 vols, Paris, Gallimard, 1969–85), vol. 3, p. 200, Morisot to Mallarmé, 21 May 1888; *Morisot Correspondence*, p. 136; White, *Renoir*, p. 178.
6. Stuckey and Scott, *Berthe Morisot*, p. 155. Maurice Denis also paid Berthe Morisot the compliment of producing a coloured lithograph for the cover of a publication dedicated to her: see below, chap. 20, n. 9;

Mallarmé, *Correspondance*, vol. 4, Pt 1, p. 350.
7. Bataille and Wildenstein, *Catalogue des peintures*, pp. 40–3, 58–9, 70.
8. Mathews, *Cassatt and Her Circle*, p. 214.
9. Bailly-Herzberg, 'Marcellin Desboutin and his World', p. 500.
10. *Morisot Correspondence*, p. 155.
11. Ibid., p. 156.
12. *Morisot Correspondence*, p. 165.
13. Ibid., pp. 162–3; White, *Renoir*, pp. 151–2.
14. Angoulvent, *Berthe Morisot*, p. 91 on their mutual musical interests; White, *Renoir*, pp. 193, 202; Renoir, *Renoir, My Father*, p. 269: their relationship was 'on a purely spiritual basis'.
15. Mondor, *Vie de Mallarmé*, p. 550, Mallarmé to Berthe Morisot, 17 February 1889.
16. Hale, *Mary Cassatt*, p. 105.
17. Angoulvent, *Berthe Morisot*, p. 96; *Morisot Correspondence*, p. 159.
18. *Morisot Correspondence*, p. 159.
19. *Carnet noir*, in Angoulvent, *Berthe Morisot*, p. 97.
20. *Morisot Correspondence*, p. 114.
21. Mondor, *Vie de Mallarmé*, p. 613.
22. *Carnet noir*, in Angoulvent, *Berthe Morisot*, p. 96.
23. Huisman, *Morisot: Enchantment*, p. 63.
24. *Carnet noir*, in *Morisot Correspondence*, p. 168.
25. Julie Manet, *Journal*, p. 110.
26. *Carnet noir*, in *Morisot Correspondence*, p. 168.
27. Lucien Pissarro, *Letters of Lucien to Camille Pissarro*, p. 410.
28. *Morisot Correspondence*, pp. 160, 162; Mondor, *Vie de Mallarmé*, p. 653.
29. *Morisot Correspondence*, p. 169.
30. Mallarmé, 'Berthe Morisot', *Divagations*, in *Oeuvres*, p. 144.
31. *Morisot Correspondence*, p. 171.
32. See Plates.
33. *Carnet noir*, in Angoulvent, *Berthe Morisot*, pp. 103–4; Huisman, *Morisot: Enchantment*, pp. 40–2.
34. Mondor, *Vie de Mallarmé*, p. 653.
35. Gold and Fizdale, *Misia*, pp. 59 and passim; *Morisot Correspondence*, p. 179.
36. Julie Manet, *Journal*, 28 August 1893, p. 12.
37. Ibid., 23 October 1893, p. 23.
38. Valéry, 'Berthe Morisot', in *Oeuvres*, vol. 2, pp. 1302 ff.; Paul Valéry was to marry Jeannie Gobillard in May 1900 in a double

ceremony in which Julie Manet married Ernest Rouart, son of Degas's old friend and Berthe Morisot's artistic colleague, Henri Rouart. In 1898 Julie's friend, Yvonne Lerolle, daughter of Degas's friend, Henri Lerolle, had married another son, Eugène Rouart. Subsequently Julie Manet Rouart and her husband raised their family at the Château Le Mesnil, while the Valérys lived at 40 rue de Villejust (now rue Paul Valéry). The façade today bears a commemorative plaque which says: '*Dans cette maison construite et habituée par Berthe Morisot 1841–1895 vécut et mourut Paul Valéry 1872–1945.*'

39. Julie Manet, *Journal*, 9, 12, 13 March 1894, 2 November 1894, pp. 27–8, 50.

40. Eugène Ysaÿe (1858–1931) was a pupil of Wieniawski and Vieuxtemps. In 1886 he became first Professor of Violin at the Brussels Conservatoire, but he was also a composer and conductor. He travelled widely in Europe and the USA and was known for his stimulating interpretations of the major classics and of Saint-Saëns. He inspired works from Fauré, César Franck and Debussy. In 1894 he started a new series of orchestral concerts in Brussels, and it was the inaugural concert which Berthe Morisot and Julie attended: see *The New Grove Dictionary*, vol. 20, pp. 582–3.

41. Julie Manet, *Journal*, 2 November 1894, p. 50.

42. *Morisot Correspondence*, p. 181; White, *Renoir*, p. 193; see Plates.

43. *Morisot Correspondence*, p. 183.

44. Ibid.

45. Julie Manet, *Journal*, p. 121.

46. *Morisot Correspondence*, p. 186.

47. Mondor, *Vie de Mallarmé*, p. 709.

48. *Morisot Correspondence*, p. 187.

CHAPTER 20. POSTSCRIPT

1. Mondor, *Vie de Mallarmé*, p. 709.

2. Mallarmé, *Correspondance*, vol. 7, p. 172, n. 2; *The Times*, 5 March 1895.

3. White, *Renoir*, p. 201, 3 March 1895.

4. Julie Manet, *Journal*, p. 75.

5. Angoulvent, *Berthe Morisot*, appendix, *Pièces justificatives*, n.p.

6. Julie Manet, *Journal*, 2 March 1896, p. 77.

7. These words were spoken by Renoir and repeated by Ambroise Vollard, *En écoutant Cézanne, Degas, Renoir*, Paris, 1938, in Pascal Bonafoux, *The Impressionists: Portraits and Confidences, with writings, letters and witness accounts by the painters, their friends and writers and critics of the Impressionist period* (Geneva, Skira, and New York, Rizzoli, 1986), p. 82.

8. Venturi, *Archives de l'Impressionisme*, vol. 1, p. 223, Claude Monet to Paul Durand-Ruel, 9 March 1895, Sandviken, Norway; Camille Pissarro, *Letters to His Son*, p. 333; Lucien Pissarro, *Letters of Lucien to Camille Pissarro*, p. 410.

9. Mallarmé, *Oeuvres Complètes*, p. 30. The poem, 'Apparition', was set to music by Berthe Morisot's young admirer and companion André Rossignol, who dedicated his composition to her. This limited edition was illustrated with a coloured lithograph by Maurice Denis, another admirer of Morisot: Mallarmé, *Correspondance*, vol. 4, Pt 1, p. 350.

10. Julie Manet, *Journal*, 2 March 1896, p. 77.

11. Valéry, 'Berthe Morisot', vol. 2, p. 1302; *Carnet noir*, in Huisman, *Morisot: Enchantment*, p. 64.

Bibliography

MANUSCRIPT SOURCES

Archives Nationales, Paris

Ministry of the Interior, Dossiers personnels
F1b I 167 (31) MORISOT
F1b I 273 I MANET

Archives de la Ministère des Finances, Bercy

Dossiers of personnel, formerly in the Archives Nationales, are not accessible to the general public
F30 2406 MANET
F30 2407 MORISOT
F30 2409 THOMAS

Bibliothèque Nationale, Paris

There is little manuscript material relating personally to Berthe Morisot, although the correspondence of Paul Valéry and his wife Jeannie Gobillard (over 1,000 letters, 1900–43) was deposited in 1987, N.A.F. Marcel Guerin Collection 24839.

Archives de la Seine

Actes de naissance: Julie Manet
Actes de mariage: Berthe Marie Pauline Morisot and Eugène Manet 1874
Actes de décès: Cornélie Thomas Morisot 1876; Marie Pauline Berthe Morisot 4 (2) March 1895

Archives de la Ville de Paris

Actes de naissance: Fragonard 1806, 1872
Actes de mariage: Yves Morisot (Gobillard) 1866; Edma Morisot (Pontillon) 1869
Actes de décès: Edme Tiburce Morisot, 1874

Archives de la cathédrale de Bourges

Baptism (Endoiement) de Marie Pauline Berthe Morisot 27 January 1841

Archives Municipales de Bourges, Département du Cher

Actes de naissance: Berthe Morisot, 14 January 1841

Archives Départementales de la Haute-Vienne, Limoges

Tables décennales (1843–52): Actes de naissance: Marie Charles Tiburce Morisot 1845

Private Collection

The *Carnets intimes* of Berthe Morisot, distinguished by the colour of their covers, remain in private hands:
Carnet vert 1885–1886
Carnet gris 1885–1887
Carnet beige 1885–1888
Carnet vert 1888–1889
Carnet noir 1890–1891
Carnet noir 1890–

PRINTED PRIMARY SOURCES

Primary Sources relating to the Artist

Bataille, Marie-Louise, and Wildenstein, Georges, *Berthe Morisot: Catalogue des peintures, pastels et aquarelles de Berthe Morisot*, préface par Denis Rouart, Paris, Editions d'Etudes et des Documents, 1961

Carnets intimes (see above)

Printed versions of the *carnets* can be found in a number of sources.
Facsimile editions of Berthe Morisot, *Carnet intime*, Institut de France, Musée Jacquemart-André, Paris, 1961, in the Bibliothèque Nationale, Paris, and the British Library, London.
Facsimile editions, 1961, for the years 1885–6, *c*. 1888, 1890–1, are also to be found in the Musée Jenisch, Vevey, Switzerland.
The *carnets* are also reproduced or quoted extensively in the following books:
 Angoulvent, *Berthe Morisot* (1933)
 Bataille and Wildenstein, *Catalogue des peintures* (1961) (*Carnet gris, Premier Carnet vert 1885–6; Premier Carnet noir 1890–1*)
 Huisman, *Morisot: Enchantment* (1962)
 Stuckey and Scott, *Berthe Morisot – Impressionist* (1987)

The Correspondence of Berthe Morisot with her family and friends, Manet, Puvis de Chavannes, Degas, Monet, Renoir and Mallarmé, ed. Denis Rouart, tr. Betty W. Hubbard, London, Lund, Humphries, 1959 [1957], which this author has used. (The original French edition, *Correspondance de Berthe Morisot avec sa famille et ses amis*, documents réunis par Denis Rouart, Paris, appeared in 1950.)
A second edition, *The Correspondence of Berthe Morisot with her family and friends, Manet, Puvis de Chavannes, Degas, Monet, Renoir and Mallarmé*, comp. and ed. by Denis Rouart, tr. by Betty W. Hubbard, with a new introduction and notes by Kathleen Adler and Tamar Garb, London, Camden Press, 1986, New York, Moyer Bell, 1987.
Elizabeth Mongan (ed.), *Berthe Morisot, Drawings, Pastels, Watercolours, Paintings*, preface by Denis Rouart, introduction by E. Mongan, commentary by R. Shoolman, London, Thames & Hudson, 1961
Registration records of Berthe Morisot's birth, marriage and death, are printed in *Pieces justificatives* at the end of Monique Angoulvent, *Berthe Morisot*, Paris, Morancé, 1933

Correspondence, Memoirs, etc.

Bashkirtseff, Marie. *The Journal of Marie Bashkirtseff*, tr. Mathilde Blind, 2 vols, London, Cassell, 1890, repr. London, ed. G. Pollock, Virago Press, 1985

Baudelaire, C. *Oeuvres Complètes*, ed. Claude Pichois, Paris, Gallimard, Bibliothèque de la Pléiade, repr. 1961

Blanche, Jacques-Emile. *Portraits of a Lifetime 1870–1914*, tr. W. Clement, London, Dent, 1937

Boland-Roberts, Rosalind de and Roberts, Jane (eds). *Growing up with the Impressionists, Diary of Julie Manet*, London, Southeby's, 1987

Bouillon, Jean-Paul. 'La correspondance de Félix Bracquemond: une source inédite pour l'histoire de l'art français dans la seconde moitié du XIXe siècle', *Gazette des Beaux-Arts*, 6th series, 82, December 1973

—— 'Les Lettres de Manet à Bracquemond', *Gazette des Beaux-Arts*, 6th series, 101, 1983

Courthion, Pierre and Cailler, Pierre (eds). *Portrait of Manet by Himself and his Contemporaries*, tr. Michael Ross, London, Cassell, 1953; there are also French editions of *Manet Raconté par Lui-même et par ses Amis*, 2 vols, Geneva, Pierre Cailler, 1953; London, Cassell, 1960

Curtiss, Mina (ed. and tr.). 'Letters of Edouard Manet to his Wife during the Siege of Paris 1870–71', *Apollo*, 113, June 1981

Denvir, Bernard (ed.). *The Impressionists at First Hand*, London, Thames & Hudson, 1991

Fénéon, F. *Oeuvres de Félix Fénéon*, intro. Jean Palhau, Paris, Gallimard, 1950

Gibson, Rev. W. *Paris during the Commune*, New York, Haskell House Publishers, 1974

Gigoux, Jean. *Causeries sur les artistes de mon temps*, Paris, C. Levy, 1885

Goncourt, E. and J. de. *Journal: Paris under Siege 1870–1871*, ed. and tr. George J. Becker, Ithaca, NY, Cornell University Press, and London, 1969

—— *Mémoires de la Vie Littéraire 1864–1878*, 4 vols, Paris, Fasquelle and Flammarion, 1956

Guérin, Marcel (ed.). *Lettres de Degas*, Paris, Bernard Grasset, repr. 1945 [1931]

Henrey, Robert (ed. and tr.). *Letters from Paris 1870–1875*, written by C. de B., a political informant to the head of the London house of Rothschild, London, Dent, 1942

Mallarmé, Stéphane. *Oeuvres Complètes*, ed. Henri Mondor and G. Jean Aubry, including *Divagations*, preface to the catalogue of the 1896 exhibition at Durand-Ruel's, Paris, Editions Gallimard, Bibliothèque de la Pléiade, 1945

—— *Correspondance*, 11 vols, ed. Henri Mondor and Lloyd James Austin, Paris, Gallimard, 1969–85

Manet, Julie. *Journal 1893–1899. Sa Jeunesse parmi les peintres impressionistes et les hommes de lettres*, préface de Jean Griot, Paris, C. Klincksieck, 1979

Matthews, Nancy Mowll (ed.). *Cassatt and Her Circle, Selected Letters*, New York, Abbeville Press, 1984

Merimée, Prosper. *Lettres à la Duchesse de Castiglione-Colonna*, intro. by Pierre Trahaud, Paris, Boivan, 1938

Moore, George. *Confessions of a Young Man*, ed. Susan Dick, Montreal and London, McGill-Queen's University Press, 1972

Moreau-Nélaton, E. *Manet Raconté par Lui-même*, 2 vols, Paris, Henri Laurens, 1926

Pissarro, Camille. *Letters to His Son Lucien*, ed. John Rewald with the assistance of Lucien Pissarro, New York, Pantheon, 1943; repr. Marmaroneck, NY, Paul P. Appel, 1972, and Santa Barbara, CA, and Salt Lake City, Utah, Peregrine Smith, 1981

Pissarro, Lucien. *The Letters of Lucien to Camille Pissarro*, ed. Anne Thorold, Cambridge, Cambridge University Press, 1993

Régnier, Henri de. *Mallarmé et les peintres. Nos rencontres*, Paris, 1931

Richardson, Joanna (ed. and tr.). *Paris under Siege: A Journal of the Events of 1870–1871 Kept by Contemporaries*, London, the Folio Society, 1982

Rouart, Denis and Wildenstein, Daniel. *Edouard Manet: Catalogue Raisonné*, 2 vols, Lausanne and Paris, 1975

Valéry, Paul. *Oeuvres*, 4 vols, ed. Jean Hytier, Paris, Editions Gallimard, Bibliothèque de la Pléiade, 1962 [1960]

Venturi, Lionello, *Les Archives de l'Impressionisme: Lettres de Renoir, Monet, Pissarro, Sisley et Autres. Mémoires de Paul Durand-Ruel. Documents*, 2 vols, Paris and New York, Durand-Ruel, 1939

Vollard, A. *Recollections of a Picture Dealer*, tr. Violet Macdonald, London and Boston, 1936; there is also a French edition, *Souvenirs d'un marchand de tableaux*, Paris, Albin Michel, 1937

Washburne, E.B. *Recollections of a Minister to France 1867–1877*, 2 vols, New York, Charles Scribner's Sons, 1887

Wildenstein, Daniel, *Claude Monet, Biographie et Catalogue Raisonné*, 4 vols, Paris and Lausanne, Bibliothèque des Arts, 1974, 1979

Newspapers

The Times newspaper, London: 'Reports from Our Own Correspondent in Paris': 1808; 1848–52; 1870–83; 1888–9; 1893–5

Reference

The Art Index. A Cumulative Author and Subject Index to a Selected List of Fine Arts Periodicals and Museum Publications, ed. Alice M. Dougan and Bertha Joel; managing editor Justine M. Stor, etc. New York, January 1929–

Bargeton, René, Bougard, Pierre, Le Clère, Bernard and Pinaud, Pierre-François (eds). *Les Préfets du 11 ventose an XVIII au 4 septembre 1870: répertoire nominatif et territorial*, Paris, Archives Nationales, 1981

Bellier de la Chavignerie, Emile, and Auvray, Louis. *Dictionnaire Générale des Artistes de l'Ecole Française depuis l'origine des arts du dessein jusqu'à nos jours*, preface by Robert Rosenblum, 5 vols, repr. New York and London, Garland Publishing, 1979 [Paris, 1882–5]

Bénézit, E. *Dictionnaire Critique et Documentaire des Peintres, Sculpteurs, Dessinateurs et Graveurs*, 10 vols, Paris, Librairie Grund, nouvelle édition, 1976

Bibliographie Annuelle de l'Histoire de France. Editions du centre National de la Recherche Scientifique, Institut d'histoire moderne et contemporaine, 37 vols, Paris, 1953–

Encyclopaedia of World Art, 16 vols, New York, Toronto and London, McGraw-Hill, 1963–83

Firmin Didot H. *Nouvelle Biographie Universelle*, 46 vols, Paris, 1852–66

Lami, Stanislas. *Dictionnaire des sculpteurs de l'école français au dix-neuvième siècle*, 4 vols, Paris, repr. 1970 [1914–21]

Michaud, J.F. *Biographie Universelle*, 45 vols, Graz, Austria, Akademische Durk-u.-Verlagsanstadt, 1966–70

New Grove Dictionary of Music and Musicians, ed. Stanley Sadie, 20 vols, London, Macmillan, 1980

Thieme, Dr Ulrich, and Becker, Dr Felix. *Allgemeines Lexicon der Bildenden Künstler*, 37 vols, Leipzig, E.A. Seeman, 1907–

Vapereau, G. *Dictionnaire Universel des Contemporains*, Paris, Librairie Hachette, revd edn 1858, 4th edn 1870

SELECTED SECONDARY WORKS

Publications concerning Berthe Morisot

Books

Adler, Kathleen and Garb, Tamar, *Berthe Morisot*, Oxford, Phaidon Press, 1987

Angoulvent, Monique, *Berthe Morisot*, Paris, Morancé, 1933

Arts Council of Great Britain, *Berthe Morisot: An Exhibition of Paintings and Drawings*, Matthiesen's Gallery, Bond Street, catalogue, London, 1950

Edelstein, J.J. (ed.). *Perspectives on Morisot*, New York, Hudson Hills Press in association with Mount Holyoke College Art Museum, 1990

Fourreau, Armand, *Berthe Morisot*, Paris, F. Rieder, 1925

Higonnet, Anne, *Berthe Morisot*, New York, Harper & Row, 1990

—— *Berthe Morisot's Images of Women*, Cambridge, Mass., Harvard University Press, 1991

Bibliography

Hopkins, Waring and Thomas, Alain (eds). *Berthe Morisot*, exhibition catalogue, Paris, Galerie Hopkins-Thomas, 1987

Huisman, Philippe. *Morisot: Enchantment*, tr. Diana Imber, New York, and Lausanne, French and European Publications, 1962. There is a version in French by the same author: *Morisot: Charmes*, Lausanne, International Art Books, 1962

Rey, Jean Dominique, *Berthe Morisot*, tr. Shirley Jennings, Naefels, Switzerland, Bonfini Press, 1982

Rouart, Julie. *Berthe Morisot and Her Circle*, intro. Denis Rouart, Toronto, 1953

Shone, Richard (ed.). *Berthe Morisot 1841–1895*, exhibition catalogue, with intro. 'Berthe Morisot: A Great Impressionist', London, J.P.L. Fine Arts in association with the Galerie Hopkins-Thomas, Paris, 1991

Stuckey, Charles F. and Scott, William P. with the assistance of Suzanne G. Lindsay. *Berthe Morisot – Impressionist*, New York, Hudson Hills Press, 1987

Valéry, Paul (ed.). *Préface du catalogue du grande exposition des Oeuvres de Berthe Morisot*, été 1941, Musée de l'Orangerie, Paris, 1941, in 'Degas Manet Morisot', *Collected Works of Paul Valéry*, 12 vols, ed. Jackson Matthews, tr. David Paul, Bollingen Series XLV, Vol. 12, New York, Pantheon Books, 1960

Wildenstein, G. *Berthe Morisot 1841–1895*, catalogue of the exhibition in the Wildenstein Gallery, London, 1961

Articles

Adler, Kathleen. 'The Suburban, the Modern and "une Dame de Passy"', *Oxford Art Journal*, 12, 1, 1989

Bailly-Herzberg, Janine. 'Les Estampes de Berthe Morisot', *Gazette des Beaux-Arts*, 6th series, 93, May–June 1979

Blanche, Jacques-Emile. 'Les Dames de la grande rue, Berthe Morisot', *Les Ecrits Nouveaux*, Paris, March 1920

Buettner, Stewart. 'Images of Motherhood in the Art of Morisot, Cassatt, Modersohn-Becker, Kollwitz', *Woman's Art Journal*, 7, 2, Fall 1986–Winter 1987

Bumpus, Judith. '"What a Pity They Aren't Men", Manet 1868', *Art and Artists*, 201, June 1983

Charmet, R. 'Berthe Morisot', *Arts*, March 1961

Davidson, Bernice. '"Le Repos": A Portrait of Berthe Morisot by Manet', *Rhode Island School of Design Bulletin*, 46, December 1959

Fell, H. Granville. 'Berthe Morisot 1841–1895', *Apollo*, 11, April 1930

Fine, Amy M. 'Portraits of Berthe Morisot: Manet's Modern Images of Melancholy', *Gazette des Beaux-Arts*, 6th series, 110, July–August 1987

Havice, Christine. 'The Artist in Her Own Words', *Woman's Art Journal*, 2, Pt 2, Fall–Winter 1981–2

Hyslop, Francis E., Jr. 'Berthe Morisot and Mary Cassatt', *College Art Journal*, 13, 3, Spring 1954

Jamot, Paul. 'Etudes sur Manet: Manet et Berthe Morisot', *Gazette des Beaux-Arts*, January and June 1927

Kessler, Marni Reva. 'Reconstructing Relationships: Berthe Morisot and Edma Series', *Woman's Art Journal*, 12, 24, Spring–Summer 1991

Lewis, Mary Tompkins. 'Berthe Morisot', *Art Journal*, 50, 3, Fall 1991

Lowe, Jeanette. 'The Women Impressionist Masters: Important Unfamiliar Works by Morisot and Cassatt', exhibition held at Durand-Ruel, *Art News*, 38, November 1939

Mellquist, Jerome. 'Berthe Morisot', *Apollo*, 70, December 1959

Montalant, Delphine. 'Une longue amitié: Berthe Morisot et Pierre-Auguste Renoir', *L'Oeil*, 358, May 1985

Newton, Eric. 'French Painters Part VIII: Edouard Manet. With reference to Berthe Morisot', *Apollo*, 57, January 1953

Paoletti, John T. 'Comments on Rohn', *Berkshire Review*, Fall 1986.

Régnier, Henri de. 'Faces et Profils: Berthe Morisot', *Nouvelles Littéraires, Artistiques et Scientifiques*, 13 July 1935

Rey, Robert. 'Berthe Morisot', *Gazette des Beaux-Arts*, 1926

Roger-Marx, Claude. 'Les Femmes Peintres et l'Impressionisme: Berthe Morisot', *Gazette des Beaux-Arts*, 3rd series, 38, December 1907

Rohn, Matthew. 'Berthe Morisot's *Two Sisters on a Couch*', *Berkshire Review*, Fall 1986

Rouart, Louis. 'Berthe Morisot (Mme Eugène Manet 1841–1895)', *Art et Décoration*, May 1908

Rouart-Valéry, Agathe. 'De "Madame Manet" à "Tante Berthe"', *Arts*, March 1961

Scott, Barbara. 'Letter from Paris. The Particular Charm of Berthe Morisot', *Apollo*, 126, 1987

Scott, William P. 'The Enchanting World of Berthe Morisot', *Art and Antiques*, IV/1, January–February 1981

Werner, Alfred. 'Berthe Morisot: Major Impressionist', *Arts*, 32, March 1958

Impressionism, artists and art history

Books

Adler, K. *Camille Pissarro: A Biography*, London, Batsford, 1978

Alcantara, Odette d', Countess. *Marcello, Adèle d'Affry, Duchesse Castiglione Calonna 1836–1879. Sa vie, son oeuvre, sa pensée et ses amis*, Geneva, Editions Générales, 1961

Anderson, Ronald and Koval, Anne. *James McNeill Whistler: Beyond the Myth*, London, John Murray, 1994

Argencourt, Louise d', Boucher, Marie-Christine, Druick, Douglas and Foucart, Jacques. *Puvis de Chavannes*, exhibition catalogue, National Gallery of Canada, Ottowa, 1977

Bachmann, Donna G. and Piland, Sherry. *Women Artists: An Historical, Contemporary and Feminist Bibliography*, Metuchen, NJ and London, Scarecrow, 1978

Baker, E. and Hess, T. (eds). *Art and Sexual Politics*, New York, Collier, 1973

Bataille, G. *Manet*, Geneva and New York, Skira, 1955

Baudot, J. *Renoir, ses Amis, ses Modèles*, Paris, 1949

Bazin, Germain. *Corot*, 2nd edn, Paris, Pierre Tisne, n.d.

—— *Impressionist Paintings in the Louvre*, 4th edn, London, Thames & Hudson, 1963

Berhaut, Marie. *Caillebotte, sa Vie et son Oeuvre. Catalogue Raisonné des Peintures et Pastels*, Paris, Bibliothèque des Arts, 1978

Blunden, Maria and Godfrey. *Impressionists and Impressionism*, 2nd edn, London, Macmillan and Geneva, Skira, 1980

Boggs, Jean Sutherland. *Portraits by Degas*, Berkeley and Los Angeles, University of California Press, 1962

Boime, Albert. *The Academy and French Painting in the Nineteenth Century*, Oxford, Phaidon Press, 1971

Bonafoux, Pascal. *The Impressionists: Portraits and Confidences, with writings, letters and witness accounts by the painters, their friends and writers and critics of the Impressionist period*, Geneva, Skira, and New York, Rizzoli, 1986

Broude, Norma and Garrard, Mary D. (eds). *Feminism and Art History: Questioning the Litany*, New York, Harper & Row, 1982

Cachin, Françoise, and Moffett, Charles S. (avec la participation de Michel Melot), *Manet 1832–1883*, Galeries nationales du Grand Palais, Paris, and Metropolitan Museum of Art, New York, 1983

Chambers, Frank P. *Cycles of Taste*, New York, Russell and Russell, repr. 1967, [1928]

Clark, T.J. *The Painting of Modern Life: Paris in the Art of Manet and His Followers*, London, Thames & Hudson, 1985

Cogniat, Raymond. *French Painting at the Time of the Impressionists*, tr. Lucy Norton, New York, 1952

—— *Monet and His World*, London, Thames & Hudson, 1966

Collet, Georges-Paul. *George Moore et la France*, Geneva, Librairie Droz and Paris, Librairie Minard, 1957

Courthion, Pierre. *Edouard Manet*, London, Thames & Hudson, 1962

—— *Impressionism*, tr. J. Shepley, New York, Harry N. Abrams, 1972

Cunard, Nancy. *G.M.: Memories of George Moore*, London, Rupert Hart-Davis, 1956

Daix, Pierre. *La Vie de Peintre d'Edouard Manet*, Paris, Fayard, 1983

Daulte, François. *Renoir*, London, Thames & Hudson, 1972

Duret, Théodore. *Les Peintres Impressionistes*, Paris, Librairie Parisienne, 1878, expanded into

Histoire des Peintres Impressionistes, Paris, Floury, 1906 and *Manet and the French Impressionists, Pissarro, Claude Monet, Sisley, Renoir, Berthe Morisot, Cézanne, Guillaumin*, tr. J.E. Crawford Flitch, London, Grant Richards and Philadelphia, Pa, J.B. Lippincott, 2nd edn 1912 [1910]

Fénéon, F. *Les Impressionistes en 1886*, Paris, Publications de la vogue, 1886

Fine, Elsa Honig. *Women and Art: A History of Women Painters and Sculptors from the Renaissance to the 20th Century*, London, Prior, and Montclair, NJ, Allanheld & Schram, 1978

Fleming, G.H. *James Abbott McNeill Whistler: A Life*, Moreton-in-Marsh, Gloucestershire, Windrush Press, 1991

Flint, Kate (ed.). *Impressionists in England: The Critical Reception*, London, Routledge & Kegan Paul, 1984

Florisoone, Michel. *Renoir*, tr. G.F. Lees, Paris, Hyperion, 1938

Fosca, François. *Renoir. His Life and Work*, tr. M. Martin, London, Thames & Hudson, 1961

Garb, Tamar. *Women Impressionists*, Oxford, Phaidon Press, 1986

Gaunt, William. *The Impressionists*, London, Thames & Hudson, 1970

—— *Renoir*, Oxford, Phaidon Press, 1966

Geffroy, G. *Claude Monet. Sa Vie, son Temps, son Oeuvre*, Paris, G. Cres, 1922

Goncourt, Edmond and Jules de. *French Eighteenth-Century Painters*, rev. edn, London, Phaidon, 1948 (concerning Fragonard)

Greer, Germaine. *The Obstacle Race: The Fortunes of Women Painters and Their Work*, London, Secker & Warburg, 1979

Grunfeld, Frédéric V. *Rodin. A Biography*, London, Hutchinson, 1987

Hale, Nancy. *Mary Cassatt*, New York, Doubleday, 1975

Hamilton, *Manet and his Critics*, New Haven, Conn., Yale University Press, repr. 1986 [1954]

Hanson, Anne Coffin. *Edouard Manet 1832–1883*, exhibition catalogue, Philadelphia Museum of Art, 1966 and Art Institute of Chicago, 1967

Hanson, Lawrence and Elisabeth. *Golden Decade: The Story of Impressionism*, London, Secker & Warburg, 1961

Harris, Anne Sutherland and Nochlin, Linda. *Women Artists 1550–1950*, New York, Random House, 1976

Homer, William Innes. *Seurat and the Science of Painting*, Cambridge, Mass., Massachusetts Institute of Technology Press, repr. 1970 [1963]

House, John. *Monet: Nature into Art*, New Haven, Conn., Yale University Press, 1986

Huysmans, Joris-Karl. *L'Art Moderne*, Paris, G. Charpentier, 1883

Isaacson, Joel. *Claude Monet: Observation and Reflection*, Oxford, Phaidon Press, 1978

—— *The Crisis of Impressionism 1878–1882*, exhibition catalogue, Ann Arbor, University of Michigan Museum of Art, 1980

Laver, J. *Whistler*, London, White Lion Publishers, repr. 1976 [1930]

Lethève, Jacques. *The Daily Life of French Artists in the Nineteenth Century*, tr. Hilary E. Paddon, London, Allen & Unwin, 1972

—— *Impressionistes et Symbolistes devant la Presse*, Paris, Armand Colin, 1959

Lipton, Eunice. *Alias Olympia. A Woman's Search for Manet's Notorious Model and Her Own Desire*, London, Thames & Hudson, 1993

Lucie-Smith, Edward. *Fantin-Latour*, Oxford, Phaidon Press, 1977

McMullen, Roy. *Degas: His Life, Times and Work*, London, Secker & Warburg, 1985

Massengale, Jean Montague. *Jean-Honoré Fragonard*, London, Thames & Hudson, 1993

Matyjaszkiewicz, Krystyna (ed.). *James Tissot*, Oxford, Phaidon Press, 1984

Mauclair, Camille. *The French Impressionists 1860–1900*, tr. P.G. Konody, London, Duckworth, 1902

—— *L'Impressionisme. Son Histoire, son Esthétique, ses Maîtres*, Paris, Librairie de l'art ancien et moderne, 1904

—— *Puvis de Chavannes*, Paris, Plon, 1928

Michel, André. *French Artists of Our Day: Puvis de Chavannes*, London, Heinemann, 1912

Mitchell, Peter. *Alfred-Emile Stevens, 1823–1906*, London, John Mitchell, 1973

Moffett, Charles S. (ed.) *et al. The New Painting: Impressionism 1874–1886*, Oxford, Phaidon Press, 1986; contains reprints of facsimiles of catalogues and extracts from reviews of the Impressionist exhibitions in Paris; also reprints of Stéphane Mallarmé's article 'The Impressionists and Edouard Manet' (*Art Monthly Review*, 30 September 1876) and Edmond Duranty's essay 'The New Painting' (1876)

Monneret, Sophie. *L'Impressionisme et Son Epoque: Dictionnaire International*, 2 vols, Paris, Robert Laffont, Editions Denoël, repr. 1979 [1978]

Parker, Rozsika and Pollock, Griselda. *Old Mistresses: Women, Art and Ideology*, London, Routledge & Kegan Paul, 1981

Perruchot, Henri. *Manet*, tr. Humphrey Hare, London, Perpetua Books, 1962; there was a French edition, *La Vie de Manet*, Paris, Librairie Hachette, 1959

Petersen, Karen and Wilson, J.J. *Women Artists: Recognition and Reappraisal from the Early Middle Ages to the Twentieth Century*, New York, Harper & Row, 1976, repr. London, 1978

Pool, Phoebe. *Impressionism*, London, Thames & Hudson, 1985

—— (ed.). *The Complete Paintings of Manet*, notes and catalogue by Sandra Orienti, London, Penguin Classics of World Art, 1985

Portalis, Baron Roger. *Honoré Fragonard, son Vie et son Oeuvre*, Paris, J. Rothschild, 1889

Reff, Théodore. *Degas: The Artist's Mind*, New York and London, Metropolitan Museum of Art/Harper & Row, 1976

—— *Notebooks of Edgar Degas*, 2 vols, Oxford, Clarendon Press, 1976

—— *Théodore, Manet and Modern Paris*, exhibition catalogue, National Gallery of Art, Washington, DC, 1982

Renoir, Jean. *Renoir, My Father*, tr. Randolph and Dorothy Weaver, London, Reprint Society, 1962

Rewald, John. *C. Pissarro*, New York, Abrams, 1963

—— *Post-Impressionism – from Van Gogh to Gauguin*, 3rd edn, New York, Museum of Modern Art, 1978

—— *The History of Impressionism*, 4th edn, rev., paperback, London, Secker & Warburg, 1985 [1973]

Rivière, G. *Renoir et ses amis*, Paris, H. Floury, 1921

Roger-Marx, Claude. *Eva Gonzalès*, preface to catalogue, exposition, May–June, Galerie Daber, Paris, 1959

Rouart, Denis. *Degas*, Paris, Collection Palettes, 1949

—— *Manet*, tr. Marion Shapiro, London, Oldbourne Press, 1960

Schneider, Pierre. *The World of Manet 1832–1883*, 4th English edn, London, Time Life Books, 1978

Sloane, J. *French Painting Between the Past and the Present: Artists, Critics and Traditions from 1848 to 1870*, Princeton, NJ, Princeton University Press, 1951

Storm, John. *The Valadon Story*, London, Longman, 1958

Sweet, F.A. *Miss Mary Cassatt: Impressionist from Pennsylvania*, Norman, OK, University of Oklahoma Press, 1966

Tabarant, A. *Manet et ses Oeuvres*, 3rd edn, Paris, Librairie Gallimard, 1947

—— *La vie artistique au temps de Baudelaire*, 2nd edn, Paris, Mercure de France, 1963

Venturi, Lionello. *Impressionists and Symbolists*, tr. F. Steegmuller, New York, Scribner, 1950

Verrier, Michelle. *Fantin-Latour*, New York, Harmony Books, 1978

Viallefond, Geneviève. *Le Peintre Léon Riesener (1808–78): Sa vie, son oeuvres, avec des extraits d'un manuscrit inédit de l'artiste, de David à Berthe Morisot*, Paris, Edition Morancé, 1955

Warner, Malcolm. *Tissot*, London, the Medici Society, 1982

Wattenmaker, Richard J. *Puvis de Chavannes and the Modern Tradition*, Toronto, Art Gallery of Ontario, 1975

Weintrub, Stanley. *Whistler, A Biography*, London, Collins, 1974

White, Barbara Ehrlich. *Impressionism in Perspective*, Eaglewood Cliffs, NJ, Prentice-Hall, 1978

—— *Renoir, His Life, Art and Letters*, New York, Harry N. Abrams, 1984

White, Harrison C. and White, Cynthia. *Canvases and Careers: Institutional Change in the French Painting World*, New York and London, Wiley, 1965

Wildenstein, D. *Claude Monet: Biographie et Catalogue Raisonné*, 4 vols, Lausanne and Paris, Bibliothèque des Arts, 1974–85

—— *Pierre Prins 1855–1913*, exhibition catalogue, 5–20 June 1975, London, Wildenstein, 1975

Wilson, Michael. *The Impressionists*, Oxford, Phaidon Press, 1983

—— *Nature and Imagination: The Work of Odilon Redon*, Oxford, Phaidon Press, 1978

Wyzewa, T. de. *Peintres de Jadis et d'Aujourd'hui*, Paris, 1903

Yeldham, Charlotte. *Women Artists in Nineteenth-Century France and England*, New York and London, Garland, 1984

Zola, Emile. *Le Bon Combat de Courbet aux Impressionistes*, Paris, Collection Savoir, 1974

Articles and essays

Bailly-Herzberg, J. 'Marcellin Desboutin and his World', *Apollo*, new series, 95, June 1972

Bernier, Rosamond. 'Dans la lumière impressioniste', *L'Oeil*, 53, May 1959

Bessis, Henriette. 'Delacroix et la Duchesse Colonna', *L'Oeil*, 147, March 1967

Bodelsen, Merete. 'Early Impressionist Sales 1874–94 in the Light of Some Unpublished "Procès-verbaux"', *Burlington Magazine*, 110, 783, June 1968

Broude, Norma. 'Degas's "Misogyny"', *Art Bulletin*, 159, March 1977

Dérieux, Henri. 'Joseph Guichard, peintre lyonnais (1806–1880)', *Gazette des Beaux-Arts*, 5th series, 5, March 1922

Duro, Paul. 'The "Demoiselles à Copier" in the Second Empire', *Woman's Art Journal*, 7, 1, Spring–Summer 1986

Fénéon, Félix. 'Souvenirs sur Manet', *Bulletin de la Vie Artistique*, 15 October 1920

Gerstein, Marc. 'Degas's Fans', *Art Bulletin*, 64, March 1982

Kane, Elizabeth. 'Marie Bracquemond, The Artist Time Forgot', *Apollo*, 117, February 1983

Mainardi, Patricia. 'Edouard Manet's "View of the Universal Exposition of 1867"', *Arts Magazine*, 54, 5, January 1980

Montalant, Delphine. 'Julie Manet', *L'Oeil*, 374, 52, September 1986

Moore, George. 'Sex in Art', in *Modern Painting*, London, Walter Scott, and New York, Scribner's Sons, 1898

Nicolson, B. 'Degas as a Human Being', *Burlington Magazine*, 105, June 1963

Nochlin, Linda. 'Why Have There Been No Great Women Artists?', in E. Baker and T. Hess (eds), *Art and Sexual Politics*, New York, Collier, 1973

Nord, Philip. 'Manet and Radical Politics', *Journal of Interdisciplinary History*, 3, Winter 1989

Price, Aimée Brown. 'Puvis de Chavanne's Caricatures: Manifestoes, Commentary, Expressions', *Art Bulletin*, 73, 1, March 1991

Reff, Théodore. 'Copyists in the Louvre, 1850–1870', *Art Bulletin*, 46, December 1964

Régnier, Henri de. 'Mallarmé et les Peintres', *L'Art Vivant*, 1 April 1930

Spencer, Eleanor P. 'Modern Look through Impressionist Eyes', *Art News*, 61, 2, April 1962

Stuckey, Charles F. 'Manet Revised: Who Dunit?' *Art in America*, 71, November 1983

—— 'What's Wrong with this Picture?' *Art in America*, 69, September 1981

Tucker, Paul., 'The First Impressionist Exhibition and Monet's Impressionism: Sunrise: A Tale of Timing, Commerce and Patriotism', *Art History*, 7, 4, December 1984

Tudesq, A.-J. 'La Bourgeoisie du Nord au milieu de la Monarchie de Juillet', *Revue du Nord*, 46, October–December 1959

Wechsler, Judith. 'An Aperitif to Manet's "Déjeuner sur l'herbe"', *Gazette des Beaux-Arts*, 6th series, 91, January 1978

General Literary and Cultural Background

Anderson, R.D. *Education in France, 1848–1870*, Oxford, Clarendon Press, 1975

Artz, Frederick B. *The Development of Technical Education in France 1500–1850*, Cambridge, Mass., Cambridge University Press, 1966

Beauvoir, Simone de. *Memoirs of a Dutiful Daughter*, tr. James Kirkup, London, André Deutsch, 1963

Bricard, Isabelle. *Saintes ou Pouliches: L'Education des Jeunes Filles au XIXe Siècle*, Paris, Albin Michel, 1985

Carter, Edward C., II, Forster, Robert and Moody, Joseph N. (eds). *Enterprise and Entrepreneurs in Nineteenth- and Twentieth-century France*, Baltimore, MD and London, Johns Hopkins University Press, 1976

Castillon du Perron, Marguerite. *Princess Mathilde*, tr. Mary McLean, London, Heinemann, 1956

Clark, Frances I. *The Position of Women in Contemporary France*, Westport, Conn., Hyperion Press, 1981

Clark, Linda L. *Schooling the Daughters of Marianne*, Albany, NY, State University of New York Press, 1984

Cooper, D. *The Courtauld Collection*, London, Athlane Press, 1954

Daumard, Adeline. *La Bourgeoisie Parisienne de 1815 à 1848*, Paris, Ecoles Pratiques des Hautes Etudes, VIe section, Centre de Recherches Historiques, Flammarion, repr. 1970 [1963]

Davidoff, Leonore. *The Best Circles: Society, Etiquette and the Season*, London, Croom Helm, 1973

Fowlie, Wallace. *Mallarmé*, London, Dennis Dobson, 1953

Gold, Arthur and Fizdale, Robert. *Misia: The Life of Misia Sert*, New York, Morrow Quill Paperbacks, 1981

Guest, Ivor. *The Ballet of the Second Empire, 1847–1858*, London, A. & C. Black, 1955

Haug, James C. *Leisure and Urbanism in Nineteenth-Century Nice*, Kansas, Regents Press, 1982

Hemmings, F.W.J. *Baudelaire the Damned: a biography*, London, Hamish Hamilton, 1982

—— and Neiss, R.J. (eds). *Emile Zola – Salons*, Geneva, Droz, 1959

—— *Culture and Society in France 1848–1898: Dissidents and Philistines*, London, Batsford, 1971

—— *The Life and Times of Emile Zola*, London, Elek, 1977

Horvath-Peterson, Sandra. *Victor Duruy and French Education Liberal Reform in the Second Empire*, Baton Rouge, LA and London, Louisiana State University Press, 1984

McMillan, James F. *Housewife or Harlot: the Place of Women in French Society 1870–1940*, Brighton, Sx, Harvester Press, 1981

Manet, Eugène. *Victimes!*, Clamécy, Imprimerie A. Staub, 1889

Mondor, Henri. *Vie de Mallarmé*, Paris, Gallimard, 1941

Moses, Claire Goldberg. *French Feminism in the Nineteenth Century*, Albany, NY, State University of New York Press, 1984

Perrot, Marguerite. *Le Mode de Vie des Familles Bourgeoises*, Paris, A. Colin, 1961

Poulet, Georges. *Who Was Baudelaire?*, Artist and His World Series, gen. ed. Jean Leymarie, tr. Robert Allen and James Emmons, Geneva, Albert Skira, Editions d'Art, 1969

Smith, Bonnie G. *Ladies of the Leisure Class: The Bourgeoises of Northern France in the Nineteenth Century*, Princeton, NJ, Princeton University Press, 1981

Stendhal (Henri Beyle). *Life of Rossini*, London, John Calder, repr. 1956

Strumingher, Laura S. *What Were Little Girls and Boys Made of? Primary Education in Rural France 1830–1880*, Albany, NY, State University of New York Press, 1983

Toye, Francis. *Rossini: A Study in Tragi-Comedy*, London, Heinemann, 1934

Tudesq, André-Jean. *Les Grands Notables en France 1840–1849: Etude historique d'une psychologie sociale*, 2 vols, Paris, Presses Universitaires de France, 1964

Walker, Philip. *Zola*, London, Routledge, 1985

Weinstock, Herbert. *Rossini: A Biography*, London, Oxford University Press, 1968

General Political, Topographical and Economic Background

Aguet, Jean-Pierre, *Les Grèves sous la Monarchie de Juillet (1830–1847): contribution à l'étude du mouvement ouvrier français*, Geneva, Droz, 1954

Archivistes en chef des départements. *Les Préfectures Françaises*, préface de Charles Braibant, Paris, 1953

Baldick, Robert. *Pages from the Goncourt Journal*, London, 1962

—— *The Siege of Paris*, London, Batsford, 1964

Bertaud, Jean-Paul. 'Napoleon's Officers', *Past and Present*, August 1986

Bierman, John. *Napoleon III and his Carnival Empire*, London, Macdonald, Sphere Books, 1990

Bury, J.P.T. *France 1814–1940*, 4th edn, London, Methuen University Paperbacks, 1969

—— and Tombs, R.P. *Thiers 1797–1877: A Political Life*, London, Allen & Unwin, 1986

Chapman, Brian. *The Prefects and Provincial France*, London, Allen & Unwin, 1955

Chapman, J.M. and B. *The Life and Times of Baron Haussmann: Paris in the Second Empire*, London, Weidenfeld & Nicolson, 1957

Chazelas, Victor. 'Un Episode de la Lutte de Classes à Limoges, 1848', *La Révolution de 1848, Bulletin de la Société d'Histoire de la Révolution de 1848*, Vol. 7, novembre–decembre 1910

Bibliography

Church, Clive H. *Revolution and Red Tape: The French Ministerial Bureaucracy 1770–1850*, Oxford, Clarendon Press, 1981

Cobban, Alfred. *A History of Modern France*, vol. 2: *1799–1945*, Harmondsworth, Mx, Penguin Books, 1961

Corbin, Alain. *Archaïsme et Modernité en Limousin au XIXe siècle 1845–1880*, 2 vols, Paris, Marcel Rivière, 1975

Dansette, A. *Louis Napoleon à la Conquête du Pouvoir*, Paris, Librairie Hachette, 1961

Echard, William E. *Historical Dictionary of the French Second Empire 1852–1870*, London, Aldwych Press, 1985

Gaillard, Jean-Michel. *Jules Ferry*, Paris, Fayard, 1989

Guiral, Pierre. *Adolphe Thiers*, Paris, Fayard, 1986

Hillairet, J. *Dictionnaire Historique des Rues de Paris*, 2 vols, Paris, Editions Minuit, 1961

Holmes, Richard. *The Road to Sédan: The French Army 1866–1870*, London, Royal Historical Society Studies in History, 1984

Horne, Alistair. *The Fall of Paris: The Siege and the Commune 1870–71*, 2nd edn, Harmondsworth, Mx, Penguin Books, 1981

Howard, Michael. *The Franco-Prussian War*, London and New York, Methuen University Paperbacks, repr. 1985 [1961]

Hutton, Patrick H. *Historical Dictionary of the Third Republic 1870–1940*, London, Aldwych, 1986

Johnson, D. 'A Reconsideration of Guizot', *History*, XLVII, 161 (1962)

Le Clère, Bernard and Wright, Vincent. *Les Préfets du Second Empire*, Paris, Fondation National des Sciences Politiques, A. Colin, 1973

Le Clère, Marcel (ed.). *Paris de la Préhistoire à Nos Jours, l'Histoire des Départements de la France par les Documents*, collection dirigée par Jean Brignon et Jean-Michel Bordessoules, Paris, 1985

Legendre, Pierre. *Histoire de l'Administration de 1750 à Nos Jours*, Paris, Presses Universitaires de France, 1968

Machin, Howard. *The Prefect in French Public Administration*, New York, St Martin's Press, 1977

Magraw, Roger. *France 1815–1914: The Bourgeois Century*, gen. ed. Douglas Johnson, Fontana History of France, London, Fontana Books, 3rd impr. 1988

Malo, Henri. *Thiers 1797–1877*, Paris, Payot, 1932

Merriman, John M. *The Agony of the Republic: The Repression of the Left in Revolutionary France 1848–1851*, New Haven, Conn., and London, Yale University Press, 1978

—— (ed.) *French Cities in the Nineteenth Century*, London, Hutchinson, 1982

—— *The Red City: Limoges and the French in the 19th century*, New York and Oxford, Oxford University Press, 1985

Musées de la Ville de Paris. *Chaillot–Passy–Auteuil: Promenade Historique dans le 16e Arrondissement*, Paris, 1982

Payne, H.C. *The Police State of Napoleon III*, Seattle, University of Washington Press, 1968

Pinkney, David H. *Napoleon III and the Rebuilding of Paris*, Princeton, NJ, Princeton University Press, 1958

Price, Roger. *The French Second Republic: A Social History*, London, Batsford, 1972

—— (ed.) *Revolution and Reaction: 1848 and the Second French Republic*, London, Croom Helm, 1975

—— *A Social History of Nineteenth-Century France*, London, Hutchinson, 1987

Reclus, Maurice. *Jules Ferry*, Paris, Flammarion, 1947

Roberts, Stephen H. *The History of French Colonial Policy 1870–1925*, London, F. Cass, 1963

Sanford, Elwitt. *The Making of the Third Republic: Class and Politics in France 1868–1884*, Baton Rouge, LA, Louisiana State University Press, 1975

Tombs, Robert. *The War against Paris 1871*, Cambridge, Cambridge University Press, 1981

Trapp, F.A. 'The Universal Exhibition of 1855', *Burlington Magazine*, 107 (1965)

—— '"Expo" 1867 Revisited', *Apollo*, February 1969

Williams, Roger L. *Gaslight and Shadow: The World of Napoleon III 1851–1870*, London and New York, Macmillan, 1957

Wright, Vincent. *Le Conseil d'Etat et l'Affaire de la Confiscation des Biens d'Orléans en 1852*, Paris, 1969

—— 'Les Prefets démissionaires en décembre 1851', *Revue administrative*, 121 and 122, 1968

Zeldin, Theodore. *Emile Ollivier and the Liberal Empire of Napoleon III*, Oxford, Clarendon Press, 1963

—— *France 1848–1945*, Vol. I: *Ambition, Love and Politics*; Vol. II: *Intellect, Taste and Anxiety*, Oxford, Clarendon Press, 1973–77

INDEX